\mathscr{B} a r o n e s s **Elsa**

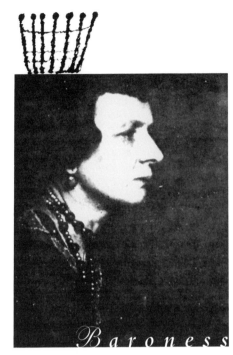

Baroness **Elsa**

GENDER, **Dada,** *and Everyday* **M o d e r n i t y**

A Cultural Biography

The MIT Press Cambridge, Massachusetts London, Enlgnad

Irene Gammel

Frontispiece Theresa Bernstein, *Elsa von Freytag-Loringhoven,* ca.

1916–17. Oil. 12 × 9 in. Francis M. Naumann Collection, New York.

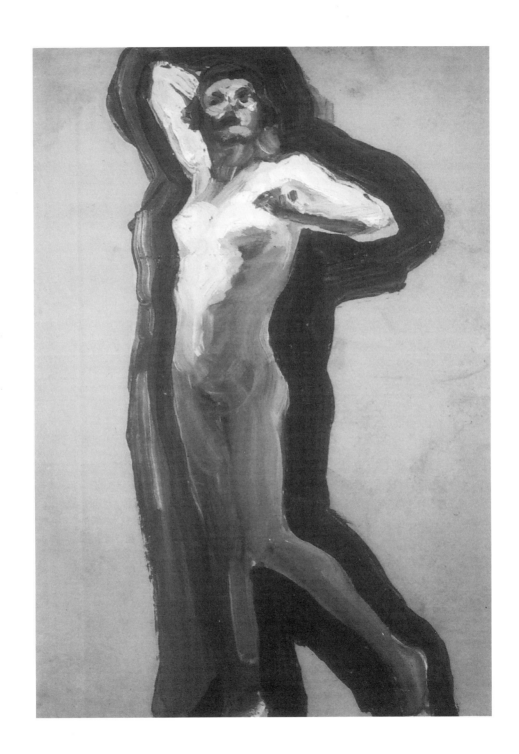

MM

Quotations and illustrations from Djuna Barnes's published and unpublished
work are reproduced with permission © Copyright, The Authors League
Fund, as literary executor of the Estate of Djuna Barnes.
Publication of this book has been aided by a grant from the Millard Meiss
Publication Fund of the College Art Association.
This book was set in Bembo and Future by Graphic Composition, Inc.,
Athens, Georgia and was printed and bound in the United States of
America.

Library of Congress Cataloging-in-Publication Data
Gammel, Irene

 Baroness Elsa : gender, dada, and everyday modernity—a cultural bio-
graphy / Irene Gammel.
 p. cm.
 Includes bibliographical references and index.
 ISBN 0-262-07231-9 (hc. : alk. paper)
 1. Freytag-Loringhoven, Elsa von, 1874–1927. 2. Artists—New
York—Germany— Biography. I. Title.
 NX550.Z9 .F7374 2002
 700'92—dc21
[B]
 2001054629

Contents

Part III: *New* YORK Dada

Acknowledgments

My journey into the life and work of the Baroness began in 1990, when I first encountered the unusual Baroness through my scholarly work on her spouse, Frederick Philip Grove (a.k.a Felix Paul Greve). As a scholar of modernist literature and culture, I was captivated by the Baroness's unconventional story and radical crossing of gender and sexual boundaries. Little did I know then that this journey would take me to Berlin, New York, Paris, Munich, Tübingen, College Park, Winnipeg, Greifswald, Anklam, Eberswalde, and Świnoujście. When I published my first article on the topic in *The Canadian Review of American Studies* in 1991, I turned my attention to Berlin and New York as theatrical cities, arenas for enacting modern identities, a foundation for this biography. I subsequently explored the Baroness among Germany's avant-garde circles (1993), exposing the complex dynamics through which her sexual life story was consistently appropriated by others (1995, 1999). With the benefit of early articles, the published autobiography (1992), and pioneering studies on New York dada (1994, 1996, 1998), I was able to develop what would become an important thrust in the biography. Far from being derivative, I proposed, the Baroness was a source of inspiration for others. Thus the kernel for the biography was born.

The art historian Francis M. Naumann had asked me to consider writing a biography on the Baroness in 1995—one year before the *Making Mischief* exhibition in New York, an exhibition that provided a crescendo moment in that it featured the Baroness's work, along with new scholarship on the artist. Since then, scholars in the United States, Canada, Italy, and Germany—all surveyed in this book—have greatly added to the exploration of and theorizing about

the Baroness, creating an internationally challenging and exciting field of research at the intersection of literature, art history, performance, sexuality studies, and gender studies (see introduction).

I wish to thank Gisela Baronin Freytag v. Loringhoven, who provides the afterword to this book. An art historian in Tübingen, whose professional and familial connections prompted her to begin researching Baroness Elsa, she has shared crucial materials accumulated since the 1980s—in particular, her discoveries of Oscar A. H. Schmitz's texts, Melchior Lechter's painting *Orpheus* (see figure 3.3), and early photographs of the Baroness (see figures I.1, I.2, and 6.5). Given the fragmentary nature of the Baroness's sources, these materials were invaluable. I also owe profound gratitude to J. Paul Boudreau for many years of intense and unstinting engagement with this project: he accompanied me on my journeys to Berlin, Świnoujście, Anklam, Eberswalde, Tübingen, and New York, capturing the Baroness's haunts in discourse and photography, significantly expanding our archive of research materials. His contributions are evident on many pages throughout this book. Special thanks go to Francis M. Naumann for his generous intellectual input into this book, as he provided detailed feedback on each page of the manuscript, in particular on art history issues that ultimately allowed me to significantly broaden the readership of this biography. In addition, he made available his archival sources on the Baroness including photographs of the Baroness's artwork in his collection and other collections. I am grateful to Mark Kelman and Howard Hussey for sending me photographs and ektachromes, as well as for sharing information about the provenance of *Enduring Ornament, Earring-Object, Cathedral,* and *Limbswish,* which are featured here for the first time. I am grateful to Phillip Herring, Hank O'Neal, and Julia VanHaaften for generously sharing their research on the Baroness, Abbott, and Barnes, thus significantly enriching this book. I am deeply indebted to the anonymous readers at the MIT Press, whose expert input has been invaluable.

I have also been fortunate to have had the inspiration of other Baroness aficionados, most notably Amelia Jones, who has brilliantly engaged the Baroness within the arena of feminist scholarship and has provided invaluable intellectual support. In Germany, Klaus Martens has provided a timely and important forum for scholarship on the Baroness, as well as offering on-site help and advice. In Canada, Paul Hjartarson and Douglas Spettigue have paved the way for this biography with the publication of *Baroness Elsa* (1992), the Baroness's autobiography, selected letters, as well as their excellent work in dating the Baroness's letters. Richard Cavell has encouraged this project with crucial insights into issues of gender and aesthetics. I am grateful to Gaby Divay for invitations to the University of Manitoba Archives, for sharing the Baroness's memoir typescript years before it was published, as well as for sharing her ardent pursuits into the archival netherworlds in many personal discussions.

Others have left their traces in this book by engaging my ideas on the Baroness in workshops, conferences, feedback to papers, and personal discussions: Marc Berthiaume, E. D. Blodgett, Jay Bochner, Willard Bohn, Donald Boudreau, Georgiana Colville, Justin D. Edwards, Elizabeth Epperly, Alan Filreis, Hans-Jörg Freytag v. Loringhoven, Gerhard and Gertrud Gammel, Annette and Stefan Hafner, Hellmut Hannes, Eva Hesse, Margaret Higonnet, Marianne Hirsch, Mary Doody Jones, Irene Kacandes, Marie T. Keller, Georgina Kelman, James King, Claudia Kotte, Rudolf Kuenzli, Geoffrey Lindsay, Robert K. Martin, Birgit Müller, Kurt Müller, Ian Nicholson, Hank O'Neal, Ruth Panofsky, Margit Peterfy, Agnès Piardi, Joseph Pluciński, Erica Rutherford, Gail Rutherford, Wendy Shilton, Sidonie Smith, Henry Srebrnik, Patricia Srebrnik, Dickran Tashjian, Nina van Gessell, Julia Watson, and Hertha Sweet Wong. Thanks go to the English Department at the University of Prince Edward Island for allowing me to teach a course on Elsa von Freytag-Loringhoven. A heartfelt thank you goes to my team of student research assistants, Kim Tanner, Tara Nogler, and Bron-

wyn Rodd, for their professional work on transcriptions, archival searches, and databases.

In this journey through the vaults of many archives and personal collections, I would like to thank those who have assisted me and those who have generously provided permission for use of materials: Sarah Heller, Executor for Djuna Barnes's Estate, for permission to quote from Djuna Barnes's unpublished papers; Ruth M. Alvarez, University of Maryland Libraries, for expert help with the Baroness's and Barnes's unpublished papers; Mark Vargas, University of Wisconsin-Milwaukee Library, for help with the Baroness's unpublished correspondence with *The Little Review;* as well as others listed here alphabetically: Joseph Cahoon, François Chapon, Karen L. Clark, Monika Faber, Virginia Funkhauser, Joseph Geraci, Angelika Grimmberger, Manfred Haupt, Eva Hesse, Ursula Hummel, Mark Kelman, Frau Klinitzke, Virginia Kopachevsky, Jennifer Lawyer, Rainer Lohmann, Townsend Ludington, L. Rebecca Johnson Melvin, Francis M. Naumann, Ute Oelman, Catherine A. Phinizy, Jim Rutherford, Geneviève St. Jacques, Arturo Schwarz, Margaret M. Sherry, Brigitte van Helt, Tara Wenger, Patricia Willis, and Jill Wood. I am grateful to the Social Sciences and Humanities Research Council of Canada for providing me with a grant and research time stipend that allowed me to research and write this book and to the Millard Meiss Publication Fund that made possible the publication of the Baroness's art work in color.

The Baroness has been fortunate in attracting the attention of Roger Conover at The MIT Press, whose brilliantly ambitious vision for this project has helped shape the book that the Baroness so richly deserves. I am grateful to Lisa Reeve for energetically supporting the editorial process; to Rosemary Winfield for meticulous copyediting; to Sandra Minkkinen for her consummate care in shepherding the book through its production; and to Don Mason for his work on the index. For help with the visual materials, my thanks go to Shelley Ebbett. For help with imaging the Baroness,

I wish to thank Matthew MacKay. For her inspirational creative vision with the design, I am grateful to Jean Wilcox.

The life chronology presented in this biography is an invitation for others to help fill the gaps and propel the Baroness to the next level of research. It is my hope that this book may be of help to all those interested in modernism, in the avant-garde, in women's art and literary history, and in the Baroness. With this book I offer the reader a taste of her extraordinary style, her unusually attractive art objects, her impressive performances, and ultimately the courage of her self-consuming art.

Chronology

1806 18 April: Birth of Elsa's maternal grandfather, Franz Karl Kleist, in Stettin, Germany.

1815 (Caroline Philipine) Constanze Runge, Elsa's maternal grandmother, is born to a high-school teacher.

1841 11 July: Friedrich Wilhelm Plötz, *Maurermeister,* Elsa's paternal grandfather, marries Friederike Wilhelmine Zilligus in Anklam, Germany, one month before the birth of their first son, Elsa's uncle Richard.

1845 21 July: Birth of the Baroness's father, Adolf Julius Wilhelm Plötz in Anklam; he is the youngest of three children.

1846 18 April: Amalia Louise Kleist, the first wife of grandfather Franz Karl Kleist, gives birth to Maria Elise Franziska, Elsa's aunt, in Stargard, Germany. 2 October: Amalia dies. Franz marries Constanze Runge, Elsa's maternal grandmother; they had three children (Georg, Ida and Hedwig).

27 November: Birth of the Baroness's mother, Ida-Marie Kleist, Stargard.

1858 Ida's sister Hedwig dies at age four.

1864 8 June: Suicide of grandfather Franz Karl Kleist, in Stargard.

1872–73 Adolf Plötz's courtship and marriage of Ida-Marie Kleist; they have two children (Elsa and Charlotte).

1874 12 July: Birth of Else Hildegard Plötz in Swinemünde, Germany. 11 August: Baptism in the Evangelische church in Swinemünde.

1875 15 October: Death of uncle Georg Theodor Kleist at age twenty-seven. 10 November: Birth of sister Charlotte Louise Plötz.

1876 2 April: Death of maternal grandmother Constanze Kleist, née Runge, at age sixty-one.

1886 Elsa attends Höhere Töchterschule at Kirchplatz 3. She composes her first poetry in a walnut tree at age twelve.

1888 3 March: Death of Kaiser Wilhelm I. Father Adolf Plötz in Bad Ems for six weeks for bronchitis treatment. First symptoms of mother Ida-Marie Plötz's derangement.

June: Kaiser Friedrich III dies of throat cancer and is succeeded by Kaiser Wilhelm II.

1890 20 March: Bismarck forced to resign. June: Graduation from girls High School, Swinemünde.

1890–91 October–March: Attends Königlich-Preussische Kunstschule, Berlin, and boards with her maternal aunt Maria Elise Franziska Kleist. Winter: Mother's first suicide attempt.

1891–92 Winter: Mother hides in the garret room and is sent to the Frauendorf Sanatorium in Stettin. She begins to fashion bizarre handiwork and is diagnosed with advanced uterine cancer.

1893 26 February: Mother dies after long suffering. Summer: Father marries Berta Schulz, sole heir to her natural father's fortune. Adolf physically attacks Elsa, who escapes to Berlin, to board with aunt Maria Elise Franziska Kleist, Leipzigerstrasse 13. Theodor Fontane's Swinemünde memoir *Meine Kinderjahre*.

1894 Models for Henry de Vry's living pictures in Berlin (at the Wintergarten) and in Halle and Leipzig. First sex binge. First contracts gonorrhea.

1894–95 October–August: Aunt Elise Kleist finances acting lessons and provides room and board.

1895 Fall: Irreparable break with aunt Elise. Elsa begins work as a chorus girl at Berlin's Zentral Theater. Lesbian experience. Fontane's Swinemünde novel, *Effi Briest*.

1896 ca. February: Hospitalization and treatment for syphilis. March: Receives small inheritance from mother. Meets artist Melchior Lechter and becomes "the jewel" of his art circle. Models for Lechter's *Orpheus*. Meets scholar Karl Wolfskehl. May 4: Sister

Charlotte Plötz marries tax inspector Hans Otto Constantin Kannegieser in Swinemünde.

1896–98 Affair with twenty-year-old playwright Ernst Hardt.

1898 Early summer: Elopes with Hardt's affluent friend, the sculptor and photographer Richard Schmitz, to Switzerland and Italy. August: Affair with Richard's brother Oscar A. H. Schmitz in Sorrento. Protodada intrusion into pornographic cabinet in museum in Naples. Late summer: With Richard Schmitz to Siena in Tuscany. Travels with Schmitz until summer 1899.

1899–1900 Models, designs, and paints in her Rome studio supported by Richard Schmitz.

1900 February: Briefly lodges with Oscar A. H. Schmitz in Munich. Moves to Dachau and takes painting lessons until fall. February–March: First visits to Karl Wolfskehl's *jour.* Meets Munich's avant-garde Kosmiker circle. Fall: Affair with architect August Endell and training as *Kunstgewerbler.*

1901 13 April: *Elf Scharfrichter* (eleven executioners) opens in Munich. July–August: Return to Berlin. 22 August: Marries August Endell in Berlin and settles in the Zehlendorf-Wannsee district. November: Buntes Theater, designed by Endell, opens in Berlin. December: To Italy with Endell until early 1902.

1902 February: Munich: Meets archeology student Felix Paul Greve at Wolfskehl's. March: Return to Berlin. Fall: Wyk auf Föhr Sanatorium. Writes love poetry. 24 December: First sexual relations with Greve.

1903 29 January: Embarks for Naples with Greve and Endell.

February–May: Palermo, Via Lincoln 83: First orgasmic pleasure. May: Greve called back to Bonn, convicted of fraud, and incarcerated for one year. He begins writing *Fanny Essler* based on Elsa's sexually explicit letters. Elsa begins divorce negotiations with Endell and has sexual adventures with mostly homosexual lovers in Italy until May 1904.

1904 23 January: Elsa's divorce from August Endell takes effect in Berlin. Spring: Settles in Rome's Piazza d'Espagna. May: Reunites with Greve in Germany. He announces their wedding. In Cologne she reads his prison manuscripts.

1904–05 Settles with Greve in Wollerau, Switzerland. Publication of seven jointly written poems under the pseudonym of "Fanny Essler." Winter: Greve completes *Fanny Essler.*

1905 October: Greve's (and Elsa's) *Fanny Essler* published.

1906 February: Elsa and Greve move to Fasanenweg 42, Berlin-Charlottenburg, across the street from August Endell. Greve's *Maurermeister Ihles Haus* goes to press. Summer: Visit to H. G. Wells, England. Oscar A. H. Schmitz publishes "Klasin Wieland."

1907 22 August: Elsa Plötz and Felix Greve marry in Berlin-Wilmersdorf.

1908 January: Hospitalization for nervous breakdown.

1909 Late summer: Greve stages a suicide in Berlin and departs for America. Elsa Greve continues to reside on Münchnerstrasse and plays the role of widow. November: Else Lasker-Schüler becomes Prince Yussuf of Thebes.

1910 29 June: Elsa Greve arrives in New York. Unites with Greve in Pittsburgh.

1911 With Greve in Sparta, Kentucky. Writes poetry. Fall: Greve's desertion.

1912 Models in Cincinnati. Felix Paul Greve/Frederick Philip Grove settles in Manitoba.

1913 Settles at 228 West 130th Street, Harlem, New York. February: Armory Show in New York. 19 November: Finds an iron ring (later titled *Enduring Ornament)* on her way to New York's City Hall to marry Leopold Baron von Freytag-Loringhoven.

1914 Baron Leopold, embarking for Europe to enlist as a German officer, held as French prisoner of war.

1915 Models in the Art Students League and the Ferrer School. International News Photography records Elsa's first original cos-

tumes. Meets Louis Bouché. Begins friendship with Marcel Duchamp. Studio in the Lincoln Arcade Building.

1916 February: Birth of Zurich dada in the Cabaret Voltaire at Spiegelstrasse 1. First contacts with Djuna Barnes. 26 November: Barnes publishes the first report of the Baroness's costuming. Summer–winter: Models and has love affair with futurist artist Douglas Gilbert Dixon.

1917 26 January: Cited in Dixon's divorce case. February: Moves to Philadelphia. March: Models for painter George Biddle with tomato-can bra. *God* in collaboration with Morton Schamberg. 6 April: The United States declares war on Germany. April–May: Duchamp's *Fountain* at American Society of Independent Artists exhibition (possible collaboration). 15 June: Congress ratifies Espionage Act.

1917–18: Incarcerated for three weeks in Connecticut as a spy. Pursues Connecticut College art instructor Robert Fulton Logan (the Cast-Iron Lover).

1918 Returns to New York and settles in unheated loft on Fourteenth Street. Heightened artistic activity. *Earring-Object* and *Cathedral* sculptures. March: *The Little Review* begins serializing *Ulysses*. June: Publication of first English poem, "Love-Chemical Relationship," in *The Little Review* (*LR*). November: Armistice signed. December: *LR* publishes poem "Mefk Maru Mustir Daas."

1919 April: Meets William Carlos Williams. Leopold Baron von Freytag-Loringhoven commits suicide in Switzerland. May: Taunts the censor in *LR*. September: "The Cast-Iron Lover" fuels controversy. Meets Berenice Abbott and Hart Crane.

1920 January: "The art of madness" debate in *LR*. Works on *Portrait of Marcel Duchamp* and *Limbswish* sculptures. June–August: International Dada Fair held in Berlin. July–August: "The Modest Woman" in *LR*. September–December: *LR* features Baroness's portrait and eight poems. October: *LR* editors charged with publishing obscenities for serializing *Ulysses*. December: *LR* obscenity trial.

1921 Baroness visits *LR* office with her hair shaved and head shellacked. Moves to subbasement at 228 West 18th Street. January–March: "Thee I Call 'Hamlet of Wedding Ring'" in *LR*. February: *LR* loses at *Ulysses* obscenity trial. April: Baroness photos and poems in *New York Dada*. Abbott delivers Baroness's letter to André Gide in Paris. Charles Brooks's *Hints to Pilgrims,* a parody of the Baroness. June: Man Ray's and Duchamp's film collaboration, *Elsa, Baroness von Freytag-Loringhoven, Shaving Her Pubic Hair.* Fall: Frequent visitor at Claude McKay's *Liberator* office.

1922 January: "Dornröschen" in the *Liberator.* Harriet Monroe in *Poetry* magazine attacks dada and the Baroness. Jane Heap's defense in *LR*. Duchamp's return to New York for a few months. Renewed artistic engagement with Duchamp. Jean Cocteau's *Antigone* is performed in Paris with the star's head shaved. Spring: Baroness intervenes at Louis Bouché's exhibition at the Belmaison Gallery in Wanamaker's Gallery of Modern Decorative Art. Winter: "Affectionate" and *Portrait of MD* in *LR*. 29 December: Ezra Pound suggests to Margaret Anderson German publication venues for Baroness. Moves to Hotel Hudson.

1923 January: France invades the German Ruhr region after Germany discontinues reparation payments. Baroness poem "Circle" in *Broom*. 18 April: Leaves New York for Berlin-Charlottenburg, Germany. Anderson and Heap settle in Paris in May. 12 June: Unsuccessful application for war widow's pension. 3 July: Father Adolf Plötz's death and disinheritance of his elder daughter, Elsa. Summer 1923–Spring 1924: Sells newspapers on the Kurfürstendamm. Meets poet and *Liberator* editor Claude McKay. Summer–Fall: Correspondence with Abbott, who visits her in Berlin. Works on *Dada Portrait of Berenice Abbott* and painting *Forgotten—Like This Parapluie.* Summer-Fall: Meets pianist Allen Tanner and artist and set designer Pavel Tchelitchew. Gives Tanner *Enduring Ornament, Limbswish, Earring-Object,* and *Cathedral.* 19 October: Passport issued in Berlin-

Charlottenburg. Fall: Djuna Barnes begins an intense correspondence with Elsa after reading a letter from Elsa to Bernice Abbott.

1923–25 Applications for visa to France denied. Isolated and destitute. Suicidal letters.

1924 June to fall: Lives in Berlin-Schöneberg, Neue Winterfeldstrasse 10; 12 July: Visits French consulate in Berlin with a birthday cake on her head. August: Barnes visits the Baroness in Berlin. May: Hemingway publishes two of the Baroness's poems in the *transatlantic review*. September: Settles at Victoriastrasse 26 in Potsdam. 2 December: Robbed. 7 December: Barnes writes and dates the preface for the book of the Baroness's letters and poems.

1925 January–late spring: Works on autobiography. 21 February–23 April: Resides at the Bodelschwingh Home for women in Gottesschutz, Erkner. Late April: Stays briefly at the *Landesirrenanstalt* psychiatric asylum in Eberswalde. August Endell dies. Frederick Philip Grove publishes his Canadian novel, *Settlers of the Marsh*.

1925–26 Settles at Mendelstrasse 36 in Berlin-Pankow. Small inheritance from an aunt.

1926 Visa granted. April: Travels to Paris and settles at the Hôtel Danemark at 21 rue Vavin. Spring: Berenice Abbott exhibition at the Sacre du Printemps Gallery. June: With Djuna Barnes to Le Crotoy on the French Normandy coast.

1927 Spring: Meets George Biddle in Paris. July: Meets Jan Sliwinski, owner of the Sacre du Printemps Gallery. 12 July: Quarrel with Mary Reynolds on Baroness's birthday. 1 August: Opens modeling school at 7 impasse du Rouet in Paris. Guggenheim types Baroness's artistic grant letter, possibly sends her a grant and receives *Oggetto*. September: Last desperate letter to Reynolds. October: Closes modeling school. Poem "Café du Dome" appears in *transition*. November: Moves to 22 rue Barrault, 13th arrondissement. Letter to Melchior Lechter. 14 December: Dies of gas asphyxiation in her apartment.

1928 January: The Baroness's funeral in Paris. February: Obituary and photograph of death mask in *transition*.

1930 12 November: Djuna Barnes commences work on the "Baroness Elsa" biography and works on it intermittently until ca. 1939.

1933 Mary Butts writes "The Master's Last Dancing."

1936 Barnes's *Nightwood*.

1979 Spring: On Barnes's request, her literary executor, Hank O'Neal, begins to sort the Baroness's poems for publication, yet they remain unpublished.

1992 *Baroness Elsa,* the Baroness's autobiography and selected letters.

1996 Whitney Museum of American Art exhibition: *Making Mischief: Dada Invades New York*.

Abbreviations and Archival Information

AAA Archives of American Art, Smithsonian Institute, Washington, D.C. (Louis Bouché, Sarah McPherson)

AHA Archiv der Hoffnungstaler Anstalten, Lobetal, Germany (Gottesschutz)

BAI Berenice Abbott interviewed by Gisela Baronin Freytag v. Loringhoven on 28 March 1991 in Monson, Maine, recorded by the interviewer in two unpublished manuscripts, "Besuch bei Berenice Abbott" (BAI-a) and "Berenice Abbott und Elsa von Freytag-Loringhoven: Die Fotographin und die vergessene Dichterin" (BAI-b).

BE Elsa von Freytag-Loringhoven, *Baroness Elsa,* ed. Paul Hjartarson and Douglas Spettigue (Ottawa: Oberon P, 1992)

BLJD Bibliothèque Littéraire Jacques Doucet, Paris, France (Tristan Tzara)

CCA Connecticut College Archives, New London, Connecticut (Robert Fulton Logan)

CPL College Park Libraries, University of Maryland (Elsa von Freytag-Loringhoven, Djuna Barnes)

DB Djuna Barnes

DLM Deutsches Literaturarchiv Marbach, Marbach am Neckar, Germany (Ernst Hardt, Karl Wolfskehl, Oscar A. H. Schmitz, Felix Paul Greve)

EvFL Elsa von Freytag-Loringhoven

FE Felix Paul Greve, *Fanny Essler,* 2 vols., trans. Christine Helmers, A. W. Riley, and Douglas Spettigue (Ottawa: Oberon P, 1984)

FPG Felix Paul Greve / Frederick Philip Grove

GML Golda Meir Library, University of Wisconsin, Milwaukee, Wisconsin (*The Little Review*)

GRI Getty Research Institute, Los Angeles, California (Melchior Lechter)

HRC Harry Ransom Humanities Research Center, University of Texas, Austin, Texas (Ezra Pound)

JH Jane Heap

LAG Landesarchiv Greifswald, Greifswald, Germany (Swinemünde, Stargard, Anklam)

LR *The Little Review*

LRC "*The Little Review* Correspondence": EvFL's letters to the *Little Review* (*LR* Papers, GML), unpublished typescript prepared by Kim Tanner (Charlottetown: U of Prince Edward Island, 1996), 131pp.

MRM Muzeum Rybolowstwa Morskiego, Świnoujście, Poland.

MSB Münchner Stadtbibliothek Monacensia, Munich, Germany (August Endell, Franziska zu Reventlow)

MSM Münchner Stadtmuseum, Munich, Germany (August Endell)

SBB Staatsbibliothek zu Berlin, Preussischer Kulturbesitz, Berlin, Germany (Berlin, Kurt Breysig, August Endell)

UDL University of Delaware Library, Newark, Delaware (Emily Coleman)

UML Elizabeth Dafoe Library, University of Manitoba, Winnipeg, Manitoba (Frederick Philip Grove)

WCW William Carlos Williams

WLS Würtembergische Landesbibliothek Stuttgart, Stuttgart, Germany (Stefan George)

YCAL Yale Collection of American Literature, Beinecke Rare Book and Manuscript Library, Yale University, New Haven, Connecticut (Ezra Pound, Ernest Hemingway, William Carlos Williams)

Unless otherwise indicated, the Baroness's unpublished manuscripts, letters, poems, and fragments are all from the Elsa von

Freytag-Loringhoven Papers, Special Collections, University of Maryland at College Park Libararies (CPL), where they were deposited along with Djuna Barnes's papers. Even after intensive searches, no copyright owner for the Baroness's materials has been identified. Since the Baroness's correspondence with Djuna Barnes is extensive but largely undated, each letter is identified by the first words of the letter. All quotations are from the original manuscript, unless they are available in published form; the Baroness's autobiography and selections of her letters have been published in Baroness Elsa (BE).

The Baroness's unconventional use of punctuation, which favors dashes, capitals, and italics, as well as her disregard for conventional syntax are reproduced as they appear in the original manuscript or typescript, for they are part of her aesthetics. However, to facilitate reading and avoid confusion, common spelling errors and typographical errors have been quietly corrected. For instance, the Baroness has a tendency to use *then* for *than*. Since the Baroness's first name, Else, is pronounced in German with a strong voiced vowel at the end, and since she Americanizes the spelling of her name many years later to Elsa (exchanging the second *e* for an *a*), I use this later, American version of her name throughout this book. Many of her letters are written in German. Unless otherwise indicated, translations from German or French are mine.

Baroness **Elsa**

S o m e called my tussle craziness—*the easiest way out* for common ignorants when they **see brilliantly beyond** their limit **pluck in self-defense** not to f e e l m e d i o c r e

– THE BARONESS[1]

I ᵂᵃˢ s e x u a l l y m o d e r n

– THE BARONESS[2]

Introduction

"So she shaved her head. Next she lacquered it a high vermilion. Then she stole the crêpe from the door of a house of mourning and made a dress of it." The year was 1921. The setting, New York's avant-garde *Little Review* office, its walls painted black. The protagonist, an artist in her forties, known in Greenwich Village as the Baroness:

> She came to see us. First she exhibited the head at all angles, amazing against our black walls. Then she jerked off the crêpe with one movement.
>
> It's better when I'm nude, she said.
>
> It was very good. But we were just as glad that some of our more conservative friends didn't choose that moment to drop in.
>
> Shaving one's head is like having a new love experience, proclaimed the Baroness.[3]

Margaret Anderson, the stylish and politically astute editor of the respected avant-garde literary magazine *The Little Review,* relayed this flashy act with obvious relish in her memoirs, *My Thirty Years' War* (1930). For Anderson and her coeditor, Jane Heap, this act encapsulated the activist mettle of the modern female artist. In fact, modernity seemed embodied in such stunning assaults on the patriarchal grammar of gender and sexuality. After arriving in the United States just two years before the Great War, earning a meager subsistence as an artist's model (see frontispiece, plate 7), and endowing herself through marriage with an aristocratic title, the German-born Baroness Elsa von Freytag-Loringhoven, née Plötz (1874–1927), had turned herself into a sexually charged art object.

Androgynous New Woman and war bride ten years before the birth of Ernest Hemingway's legendary Lady Brett Ashley, she flaunted her extraordinary body images on the streets of New York, with each new day adding to her repertoire of costumes frequently made from utilitarian objects. Tomato cans and celluloid rings adorned her wiry body. She wore a taillight on the bustle of her dress ("Cars and bicycles have taillights. Why not I," she told the French American painter Louis Bouché).[4] She used teaspoons as earrings and American stamps on the cheeks of her face. Like exotic artifacts her remarkable body poses were recorded in photography by Berenice Abbott and Man Ray, in lithography by George Biddle, and in paintings by Theresa Bernstein. Like the startling Kodak blitz flashing in the dark in this new visual age, so she flashes in and out of the countless memoirs of modernist writers and artists, leaving a myriad of visual fragments that speak to the fragmentary nature of modernist narrative itself.[5]

Relentlessly original and provocative in her expressions, the Baroness, as she was called by a generation of young modernists and avant-gardists, was quickly designated "the first American dada" and "the mother of Dada" (incidentally, an honorary label also applied to Gertrude Stein).[6] The Baroness was a daringly innovative poet and a trail-blazing sculptor who collected her raw materials in the streets. Her life as vaudeville performer, artist's model, and artist's consort fed her artistic expressions in Berlin, Munich, New York, and Paris, while her poetry and performance sparked heated controversy among young modernists in the United States and Europe.

She also garnered extraordinary respect and admiration. Anderson called the Baroness "perhaps the only figure of our generation who deserves the epithet extraordinary." The American poet Ezra Pound paid tribute to "Elsa Kassandra, 'the Baroness' / von Freytag" in his *Cantos* (1955), praising her for her "principle of non-acquiescence." His colleague William Carlos Williams found himself "drinking pure water from her spirit."[7] In expatriate Paris the

American art collector Peggy Guggenheim offered her services as secretary and typed one of Freytag-Loringhoven's manuscripts, while the young Ernest Hemingway risked his position as subeditor of the *transatlantic review* in 1924 to publish her poetry. The New York–born author of the feminist classic *Nightwood* (1936), Djuna Barnes, acted as her editor, agent, promoter, and first biographer, while also offering emotional and financial support during the last decade of her life. For the grand old dame of American photography, Berenice Abbott, "The Baroness was like Jesus Christ and Shakespeare all rolled into one and perhaps she was the most influential person to me in the early part of my life."[8]

Despite such powerful testimony showing that she touched many artists, including the leading figures of high modernism, her work has remained a well-kept secret among scholars of international modernism—until recently, that is. Her poetry remained unpublished, for most "magazines are opposed to my very name," as the Baroness explained in the early twenties in her correspondence with the *Little Review* editors.[9] Her visual art, such as the notorious sculpture *God* (1917), became canonized under the name of another artist.[10] The Baroness herself was shelved in cultural history under the rubric of eccentricity and madness.[11]

For today's reader and viewer, however, Freytag-Loringhoven's corporeal art is far from being evidence of madness, craziness, or marginality, for her body-centered art and dislocation of conventional femininity intersect with postmodern notions of radicality. "She was New York's first punk persona 60 years before their time," notes *Time* magazine. "The Baroness seems vivid today because of the interest in gender play and 'acting out' in the '90s art world, as though she were a very distant great-aunt of feminist performance art."[12] As we shall see, her everyday modernity subverted the conventions of high modernism, paving the way for what would eventually become postmodern sensibilities and aesthetics. Of course, Freytag-Loringhoven's erotically charged self-imaging was risky. Yet

I.**1** International News Photography (INP), *Elsa von Freytag-Loringhoven,*
1915. Photograph. © 2001 Bettman/Corbis/Magma.

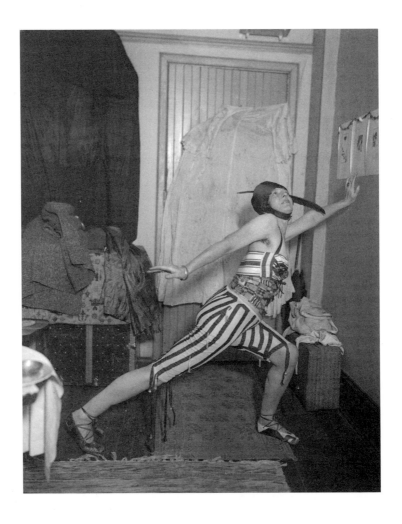

because of the risk involved, the impact on her audience was all the more dramatic and memorable.

■

What, then, is her contribution today? Is it to art or antiart? Poetry or antipoetry? What ultimately is that haunting quality of her work that so tenaciously anchored itself in the collective memory of international modernists? What is her principle of nonacquiescence that captivated Pound? These key questions—which *Baroness Elsa* proposes to answer—take us to the heart of the Baroness's extraordinary art and life into a journey of cross-cultural travel, sexual promiscuity, confrontation with police, and a mysterious, possibly suicidal death in Paris in 1927. Her life story also includes three unconventional marriages, two of them with well-known artists, the German Jugendstil (or art nouveau) designer August Endell (1871–1925) and the German translator Felix Paul Greve, a.k.a. Canadian author Frederick Philip Grove (1879–1948). Yet beyond recounting the Baroness's remarkable adventures, *Baroness Elsa* hopes to do more than fill an important gap on the life of this recently resuscitated artist. To map an art form located in the realm of the everyday and to trace its aesthetic, feminist, and historical effects largely overlooked in twentieth-century cultural history are the over-arching goals of this book.

 Baroness Elsa features America's first performance artist through memoir accounts and visual illustrations, including the photographs taken in 1915, one year into the Great War (figures I.1 and I.2). The Baroness as war bride poses in an aviator hat, its masculinity (and reference to war) undercut with a feminine feather (also alluding to her identity as a writer); her body is enveloped in an eccentric, diagonally striped acrobat's costume so tight it seems painted on her lean torso and legs. The geometrical effects of pose and costume are at odds with the mature, smiling face of the woman

I.2 International News Photography (INP), *Elsa von Freytag-Loringhoven*, 1915. Photograph. © 2001 Bettman/Corbis/Magma.

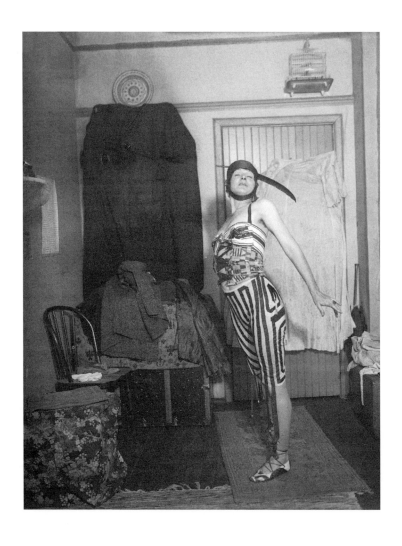

posing, just as the historical allusion to the horrendous international war is at odds with the privacy of her studio, in which clothing lies scattered around. The result is a complex visual tale about her roles as artist/warrior/woman. The grotesqueness of Freytag-Loringhoven's self-images, as well as the intensity of her style, appropriately reflected the trauma created by the Great War, a trauma that for many artists could be countered only by retraumatizing assaults on post-Victorian belief systems, middle-class stability, and bourgeois family values.

Secondly, *Baroness Elsa* maps Freytag-Loringhoven's daring poetry—including colorful visual poems, prose, poetry, and criticism—making much of it available for the first time more than seven decades after her death. Writing in English and German, the Baroness fantasized an entirely new artistic and sexual landscape, while openly confronting the real world of censorship, birth control, sexual sociability, and lack of female pleasure. She tore down post-Victorian gender codes by poeticizing decidedly unpoetic sexual subject matter, including birth-control devices such as condoms ("dandy celluloid tubes—all sizes"), sex toys ("the vibrator———— / coy flappertoy!," "spinsterlollypop"), and specific sex acts including oral sex ("I got lusting palate").[13] By mixing sexual and religious subject matter in the poetry published in *The Little Review,* she deautomatized her readership through shock and provocation. In "Holy Skirts," she visualized nuns' sex organs as "empty cars," the mixing of modern machine imagery with sexual and religious imagery performing a strikingly American form of dada, in which the sexual and religious images violently implode each other tearing down the patriarchal sign system itself.[14] The jagged lines, erotic jolts, and violent intensity of her poetry are ultimately crucial to understanding the unusual personality she constructed for the public. Indeed, I know of no other female poet of her era who commanded her formidable arsenal of libidinal images, although Gertrude Stein, Mina

Loy, Edna St. Vincent Millay, and Djuna Barnes also vigorously pushed the boundaries of female sexual expression in poetry.

Thirdly, *Baroness Elsa* offers a viewing of her intricate sculptures and sensually attractive collages, works that mark her as America's first assemblage artist. Bewildering and captivating her early viewers, some of these works have been preserved. Whether working on assemblage art, poetry, criticism, or performance, she always pushed her work to the extreme edges of genres, creating hybrid genres. With the everyday as her chosen site for revolutionary artistic experimentation, she imported life into art, and art into life, thus taking modernity out of the archives, museum spaces, and elite literature to anchor it in daily practices. Even her personal letters were decorated in colored ink, as if they, too, were works or *acts of art*. No wonder her contemporaries were unanimous on the issue: the Baroness was the embodiment of dada in New York.

■■■■

As an avant-garde protest movement born out of the horror of World War I, dada shook the Western world with iconoclastic experiments in art, with anarchic nonsense in literature, and with outrageous personality experiments. On 2 February 1916 in the legendary Cabaret Voltaire on Zurich's Spiegelstrasse 1 (up the street at 12 lived none other than the exiled Lenin), dada was born in "orgies of singing, poetry, and dancing."[15] It was launched with a strong antiwar focus by the Roumanian Tristan Tzara, the Alsatian Hans Arp, and three Germans—Hugo Ball, Richard Huelsenbeck, and Hans Richter. Paris dada followed in 1919, with Berlin dada not far behind. In 1918 Sami Rosenstock, a.k.a. Tristan Tzara, the leader of Zurich dada and later of Paris dada, released his influential dada manifestoes. Like his adopted Nietzschean namesake Zarathustra, Tzara proclaimed loudly and prophetically: "there is a great negative work of destruction to be accomplished. We must sweep and clean."[16] This embracing of the negative position—the

celebration of chaos, madness, and nothingness—has led to an almost universal categorization of dada as a nihilistic antimovement. Historically, dada was often seen as a marginal movement that seemed to have died an anticlimactically quiet death by the mid-twenties—only to see its trajectory rise again with the rise of post-modernity. Today dada is seen as a pioneering vanguard movement that provides crucial insight into the roots of postmodernity.[17] The 1990s witnessed a resurgence of scholarship on dada and the avant-garde with an important theorizing of dada poetics and politics (Foster and Kuenzli), dada performance (Gordon, Melzer), and dada's relationship with other avant-garde movements, including surrealism (Rubin, Gale).[18]

Within this domain, New York dada has emerged as an important new field, focusing on the expatriate group of European artists, who from 1915 on escaped from the specter of the European war by immigrating to New York. This field has been pioneered and consolidated by Francis M. Naumann in *New York Dada, 1915–1923* (1994) and in *Making Mischief: Dada Invades New York,* a jazzy display at the Whitney Museum of American Art in New York (21 November 1996 to 23 February 1997), which has since propelled this retrospectively named movement into the foreground of art historical discussions.[19] This exhibition featured the work of a group of artists—among them Marcel Duchamp, Francis Picabia, Man Ray, Joseph Stella, Beatrice Wood, Marius de Zayas, and, of course, the Baroness—who met in the West Sixty-seventh Street apartment of art collectors Walter and Louise Arensberg. The movement's irony and spunk makes this art accessible, even intriguing, for a broad viewership today. These works revel in the aesthetics of antiaesthetics, the self-conscious creation of beauty out of street objects, consumer items, and modern technology. Machine portraits by French Cuban expatriate Francis Picabia, skyscrapers and so-called rayographs by the American photographer Man Ray, mechanical abstractions by American sculptor and poet Morton Schamberg, and ready-mades by French painter Marcel Duchamp are juxtaposed to

the "insect frolics" of American sketch artist Clara Tice. With New York as the world's new cultural capital from 1915 on (and last safe haven from the war), New York dada presented a unique historical and cultural moment when the rejection of dead European traditions by expatriate artists from France and Switzerland merged with America's raw sensual drive for cultural renewal. New York dada produced an unprecedented ferment of American and European cross-fertilization in art.

The cover illustration of the exhibition catalogue—a photograph of Freytag-Loringhoven's assemblage sculpture *Portrait of Marcel Duchamp* (1920; figure I.3)—signals her key role in New York dada. "The poet Baroness Elsa von Freytag-Loringhoven is one of the great revelations of the show, producing work in anything-but-traditional media," reported the New York critic Alan Moore in September 1996. "Her best-known sculptures look like cocktails and the underside of toilets."[20] Given the elevated status of toilets, urinals, and other bathroom items in the formidable arsenal of dada art, the Baroness is in good company. Indeed, the Baroness's dada portrait both ridicules and pays homage to the French painter of *Nude Descending a Staircase* (1912). Her Duchamp is configured as a bird of sorts with waxed-on peacock feathers and bristly tail (alluding to his cross-dressing), a long spiral neck with phallic head (alluding to his cerebrally aloof sensuality and his unavailability to the sexually aggressive Baroness), the entire bird served as a cocktail in a wine glass (a reference to his *Large Glass* work in progress). In the exhibition catalogue, the American art historian Amelia Jones discusses Duchamp and the Baroness as birds of a feather, complements as profoundly transgressive artists. Yet the Baroness was also criticizing Duchamp whose art succeeded too easily in America, as she saw it, while she was involved in a hard and bitter struggle to establish herself. With the Baroness, issues of gender and artistic acceptability move into the foreground.

I.**3** Baroness Elsa von Freytag-Loringhoven, *Portrait of Marcel Duchamp,* ca. 1920. Assemblage of miscellaneous objects in a wine glass. Photograph by Charles Sheeler. Francis M. Naumann Collection, New York.

As the history of modernism and its avant-garde has begun to be rewritten from a gender perspective, the predominantly male focus of European and American literary history has been challenged by feminist scholars who have excavated the forgotten lives and works of women. The list of experimental women authors, poets, editors, and publishers that have emerged as a result of these efforts is remarkably diverse. Think of Margaret Anderson, Djuna Barnes, Natalie Barney, Sylvia Beach, Kay Boyle, Bryher, Mary Butts, Colette, Caresse Crosby, Nancy Cunard, H. D., Janet Flanner, Jane Heap, Maria Jolas, Mina Loy, Adrienne Monnier, Anaïs Nin, Jean Rhys, Solita Solano, Gertrude Stein, Alice B. Toklas, Renée Vivien, and Edith Wharton. Many experimented with new sexualities, new forms of sociability, new expressions in literature, art, and self-representation.[21] Similarly, art historians have reinserted in visual and cultural history the important contributions and names of women: Katherine S. Dreier, Georgia O'Keeffe, Florine Stettheimer, Clara Tice, Beatrice Wood (United States); Suzanne Duchamp, Kiki de Montparnasse, and Juliette Roche (France); Mina Loy (Britain); Hannah Höch (Germany); and Emmy Hennings and Sophie Taeuber (Switzerland). This rich context presents a new cultural tapestry with the Baroness as its most vibrantly colorful thread.

Women energetically shaped their own forms of dada. The Baroness's "highly personal and sensual art, which incorporated human and animal forms, organic materials, and her own body," as Eliza Jane Reilley has noted, was distinctively different from male dada's "machine-centered, anti-humanistic, and masculine stance."[22] Naomi Sawelson-Gorse's edited volume *Women in Dada: Essays on Sex, Gender, and Identity* (1998) also presents an impressive array of women dadaists who struggled against prejudices in the American and European art world, critically engaging with their male colleagues. These women shaped unique artistic genres in response to their cultural experiences that included, as Sawelson-Gorse documents, a backdrop of street demonstrations and incarcerations over natalism and birth control, suffrage, expanding female work-

force, New Woman, and Freudianism.[23] Interdisciplinary theories are required to interpret this profusion of new forms and meanings. Thus Amelia Jones uses gender, culture, and performance theories to document the Baroness's innovations in *performative dada*. As Jones argues, the Baroness's "confusions of gender and overt sexualizations of the artist/viewer relationship challenged post-Enlightenment and aesthetics far more pointedly than did Dadaist paintings and drawings."[24] Jones has also developed a compelling spatial argument that suggests that the Baroness's *flânerie* is a new city art with its distinctive spatial rhetoric.[25] As for the body theories of the 1990s, and in particular Judith Butler's notions of gender performance,[26] they not only apply to the Baroness, but appear to have been anticipated by her, as she brilliantly challenged conventional gender roles in public spaces.

In the spring of 1922, Jane Heap defended the Baroness's unusual art in an article entitled "Dada," published in *The Little Review's* Picabia number.[27] It should come as no surprise that the seriousness of the Baroness's oeuvre should be correctly deciphered by a gender activist. For the Baroness injected a spicy dose of female performance into male dada's performative repository: Hugo Ball's grotesque cardboard costumes in which he recited poetry at the Cabaret Voltaire; or the gory staging of a boxing match by poet-boxer Arthur Cravan (a.k.a. Fabian Lloyd) in New York that had him knocked out in the first round; or Francis Picabia's masterful self-promotion during the early days in New York when advertising had become the trademark of the new century. As Jane Heap saw it, the most original artist in New York was the Baroness, who had turned "her life into a dada monument," as Willard Bohn has written.[28] That the highly profiled dada aspirant Ezra Pound was inspired by her is all the more tribute to her as an artist. In 1921 the influential poet and literary politician announced his newly discovered dada affinities not only by parodying Freytag-Loringhoven's poetry in published form by redefining a "work of art" as "an act of art," as practice located in life.[29]

Like no other artist, the Baroness ultimately consumed herself in and through her art. The performance of herself as the Baroness, as both persona and real woman, left no screen for protection. On the most basic level, she was never paid for her performances (she was paid only when she posed as an artist's model), and she spent the last decade of her life in material poverty and neglect. She warded off the final end by holding on to her art and by producing a brilliantly experimental masterpiece in her memoirs commissioned by her friend Djuna Barnes and originally meant to accompany her first book of poetry (which has remained unpublished). At the brink of destruction the Baroness recreated her life in memoir form, published in 1992 as *Baroness Elsa,* as Lynn DeVore describes it, "a fascinating and sensational memoir—perhaps the most stunning, unusual record to have emerged from the 1920s."[30]

"I believe there are certain guidebooks we should take with us as we navigate our way toward the next century," noted editor Roger Conover in his 1996 foreword to the experimental poetry by British avant-garde poet Mina Loy, a colleague of the Baroness's.[31] As we map the twenty-first century, the vision and practices of avant-garde women regain relevance as we shape our own version of modernity. This book is peopled with the stories of avant-garde painters, sculptors, performers, and bohemians; with writers, poets, editors, and publishers; and with radical gender travelers. Yet above all, this is the story of Elsa von Freytag-Loringhoven and the first biography of this enigmatic artist.

As I embark on this biography project, I am also guided by the advice given by the American writer Emily Coleman to her friend Djuna Barnes, who was struggling to compose the Baroness's first biography during the 1930s and despairing of ever finishing it: "[T]hink of her in as detached a way as you possibly can—not as a

saint or madwoman, but as a woman of genius, alone in the world, frantic."[32] Barnes's biographical "Baroness Elsa" fragments provide some sharply incisive pictures of the Baroness through the perspective of a sensitive writer who knew her intimately as a friend. "We of this generation remember her when she was in her late thirties. She was one of the 'characters,' one of the 'terrors' of the district which cuts below Minetta Lane and above eighteenth street to the west," wrote Barnes and continued: "People were afraid of her because she was undismayed about the facts of life—any of them—all of them." Barnes's physical picture of the Baroness in her late thirties is haunting: "The high arched nose that smelled everything, the deep set piercing green eyes, the mouth grimly sensuous . . . and the body strong, wiry, durable and irreparably German." In Barnes's version, the Baroness had "the hard, durable weighted skull of a Roman Emperor, the body upright in expectant shyness. Looking at her one thought of death in reverse."[33]

With such weighty fare, it was perhaps not surprising that Barnes's book about this complex woman remained unfinished. Yet the Baroness did live on as an important figure in Barnes's life. "Emily Darling," Barnes wrote to Coleman on 3 February 1940, "I have not been with anyone of any sensibility since August—it's a long time—'my ear declines' (Elsa)—'I no longer move in English sounds' (Elsa!), 'here I am a traitor' (Elsa)—funny—her words come back to me when no one else's do."[34] The return of "Elsa's" voice and art was symbolically appropriate, as the memory of her suffering continued to haunt Barnes. In Barnes's words, the Baroness was "a citizen of terror, a contemporary without a country," but she was also "strange with beauty."[35]

Baroness Elsa hopes to communicate this beauty in all its strangeness.

"WIREDOLL – Papa – _{yes?} *Shooting doll papa?*

Eia! **Doll** _{yes} **Papa?** Doll? Ei-eia doll –

D o - o - o - o - o - o - o - o - o - o — — — — — ! "

– THE BARONESS, ca 1924[1]

Dada ᵂᵃˢ babies' prattle.

– RICHARD HUELSENBECK, 1920[2]

THE PSYCHOGENESIS of a **Dada** *personality*

Part **I**

"My Father's House"

Chapter **1**

By 1906, at age thirty-one, Elsa Plötz's early life (from age eleven to eighteen) had already inspired a thinly veiled biographical novel: *Maurermeister Ihles Haus* (The master mason's house), written by Felix Paul Greve, one of Germany's leading and most prolific literary translators and Elsa's common-law husband since May 1904. On 16 March 1906, Greve wrote a letter to André Gide, not to offer his services as translator to the French novelist but to proudly announce his own fiction publication, his second novel. By 1909 *Maurermeister* was in its second edition. Ironically, this novel gained retrospective notoriety in 1978, when its discovery by Canadian literary scholar Douglas O. Spettigue revealed the German identity of Canadian Governor General's award-winner Frederick Philip Grove, who had successfully deceived Canadians about his true identity as Felix Paul Greve.[3] The novel's topic, Greve wrote to Gide, was the study of an "unconscious Übermensch" ("une sorte de Übermensch inconscient"), "a wild animal turned bourgeois" ("une bête fauve devenue bourgeois")—not a very flattering description of Elsa Plötz's father.[4] The novel takes enormous risks, for it exposes the Plötz's family problems, the names of its characters explicitly referring to members of Elsa's family in Swinemünde.[5] Even the novel's title was suggestive of what was to come. The Plötz residence housed a theater of aggression, and Greve's male perspective, sometimes critical and at other times complicitous with his male protagonist, wrestles with giving expression to the abusive family context.

Our knowledge of Elsa's childhood is fragmentary and incomplete, however, since we have no direct third-person testimonies from childhood friends, siblings, teachers, or other acquaintances. What we know is based largely on the Baroness's own autoanalysis, her retrospective insight into her own childhood through memoirs, poetry, and novels. In her memoirs she recalled that when living with Greve, "I had already begun to write a '*Story of My Childhood*'—for sheer ennui—urge of an own inner

occupation—interest."[6] The Baroness retold her childhood story to Margaret Anderson, to Jane Heap, and even to her friend-foe William Carlos Williams during the early 1920s, when she was in her forties and living in New York. Other letters exploring her childhood date from 1923 to 1925, when she was in her early fifties, living in poverty in Berlin. These letters, as well as her memoirs, reflect her rage at her father for having disinherited her.[7]

While these sources admittedly present us with the Baroness's personal biases, she displays an impressive truthfulness and accuracy in factual details that focus on psychological turning points and provide vivid memory pictures. The tension at home strangely contrasts with the pastoral images of her island home. Yet Swinemünde was also a Prussian military town, a base for marines and land troops, with its downtown garrison (*Kaserne*) and *Kommandantur*. Under its new Polish name, Świnoujście, this town presently marks the Polish border, a symbolic signpost for post–World War II territorial divisions: the neighboring towns of Stralsund and Anklam remain in Germany, and the towns of Star-

1.1 *Swinemünde Seaside Resort,* ca. 1890. Photograph. Landesarchiv Greifswald.

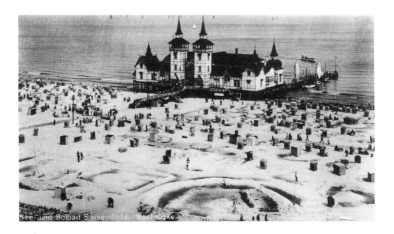

gard and Stettin now belong to Poland. Because of the town's strategic military location, it endured devastating destruction during the war, and few of the buildings that Elsa would have seen on her daily promenades remain. Here Elsa and her sister grew up during a watershed period that took the Victorian age to the cusp of modernity.

In 1874, the hot July sun and the heather- and marigold-covered dunes near the Baltic Sea made Swinemünde a paradise for children on vacation (figure 1.1). Tourists sauntered along the beaches, happy to catch a breeze in the summer heat, the women's long skirts trailing in the sun-glowing sand. Attractively situated on a group of East Sea islands including Usedom and Wollin at the mouth of the River Swine (pronounced Swena), Swinemünde was an idyllic island community with a characteristic small-island sense of deeply rooted locale, while just 200 kilometers away Germany's brand-new capital, Berlin, provided a whiff of a more cosmopolitan world. Here Else Hildegard Plötz was born on 12 July 1874 in her "father's own house" on Kleine Marktstrasse 5 (today Jósefa Bema), a centrally located street seen on the left in a 1930 photograph of

1.2 *Swinemünde, Kleiner Markt (Plac Wolności) and Kleine Markt-strasse (left),* ca. 1930. Photograph. Muzeum Rybołowstwa. Courtesy of Joseph Plucinski.

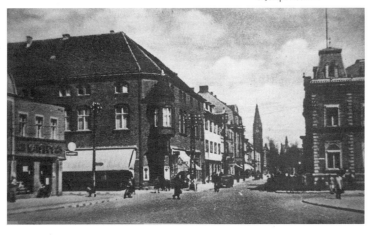

Kleiner Markt (Plac Wolności) (figure 1.2). Elsa's home was located just a few houses further down from the large corner building (Kleine Marktstrasse 1) seen on the left.[8] On 11 August, the baptism took place in the Evangelische Kirche in the presence of her three godparents: the sculptor Franz Stiebler (from Stettin), the architect Wilhelm Schindler (from Swinemünde), and her maternal grandmother, Constanze Kleist, née Runge. Elsa was the elder of two daughters; her sister Charlotte Louise was born on 10 November 1875.[9]

In a rare memory picture the Baroness takes us on a promenade through her Swinemünde childhood haunts. "In the marketplace of my own town, that small seaport of my birth, I used to slink close to Hostile Market house walls—past the only friend Beckoning Pharmacy—sadness of smalltown holiday dusk," she recalls.[10] Since Kleine Marktstrasse was an extension of Lotsenstrasse (Karola Świerczewskiego), Greve's identification of Suse Ihle's (Elsa's) home on "Obere Lotsenstrasse" was remarkably accurate, as

1.3 *Swinemünde, Marina and River*, ca. 1890. Photograph. Landesarchiv Greifswald.

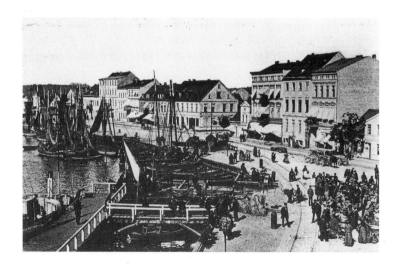

was his entire description of Swinemünde.[11] From Kleine Markt-strasse, we accompany her to the true heart of this Baltic sea-town home: the river with its beautifully picturesque bulwark (*Bollwerk)* (figure 1.3), a marina that could not be imagined any more poetical, as Theodor Fontane (1819–1898) wrote in his childhood memoir *Meine Kinderjahre* (1893).[12] Germany's foremost realist writer spent his boyhood in the same marketplace pharmacy that the young Elsa passed every day on her way to school. He described the steamships that came and went on their way to Stettin, then Pomerania's capital. Marine officers, seamen from foreign countries, and soldiers wandered the streets, giving this town a faintly exotic cosmopolitanism. The sensuality and earthiness of this Baltic seashore were remarkable:[13] Fontane recalled the freezing of the river in the winter, the spring thawing, the fall storms, and the Saturnalian festivals that included an annual slaughter of geese and pigs, a grim task generally carried out by the "slaughter priestesses" (*Schlachtpriesterinnen).* This late-night, Gothic death spectacle was a powerful memory for him, while the Baroness was more realistically blunt: "My father loved animals—But naturally, we slaughtered pigs. That's what the pig is for."[14] For Elsa, this Pomeranian world of horses, dogs, geese, and seabirds developed her love for nature, animals, and the water.

By all accounts, Elsa's father, Adolf Julius Wilhelm Plötz (1845–1923), was a handsome man with a magnetic personality: virile, muscular, with light blue eyes, blond curls, and a full reddish beard; romantically dashing with his large hat and cigar smoking; and tearfully sentimental in his pleas for forgiveness after his "bad boy" transgressions. The youngest of three children, he was born in small-town Anklam, a picturesque city at Germany's eastern border, where he was baptised in the attractive thirteenth-century St. Marien church (figure 1.4).[15] Rising fast from his low social background, he was an important mover and shaker in Swinemünde, a maverick entrepreneur, builder, and contractor. The title of *Maurermeister* (master mason) accompanies him like an epithet in the

Swinemünde address book, while his quickly accumulated list of properties reads like the road map of a monopoly game—an impressively modern villa on the beach, his own home on Kleine Marktstrasse, as well as a large hotel built in 1900.[16] By 1890, he was listed as a city councillor (*Stadtverordneter*), rubbing shoulders with the community's leading businessmen, professionals, and consuls. Their meetings took place near the harbor in the old town hall built in 1806 with its beautiful bell tower added in 1839 (figure 1.5). One of the few buildings to have survived the war, this architectural heritage site now functions as a museum.[17]

Socially Adolf Plötz had come a long way, his success all the more remarkable as he had to live down the dark legacy of scandalous family violence. His father, Friedrich Wilhelm Plötz, also a *Maurermeister*, was a heavy drinker, whose alcoholism was blamed on

1.4 *St. Marien Church, Anklam.* 2000. Photograph by J. P. Boudreau.

1.5 *Swinemünde's Old Town Hall, Muzeum Rybołowstwa.* 2000.
Photograph by J. P. Boudreau.

his irascible wife, Friederike Wilhelmine Plötz, neé Zilligus, a book-binder's daughter who was rumoured to be an avaricious kleptomaniac. The two had married in July 1841, just one month before the birth of their eldest son, Richard.[18] According to family lore, one day Friedrich Plötz attacked Friederike with an axe but was stopped from killing her by the intervention of the teenage Adolf, who took the weapon out of his father's hands. The episode split the family, as father and son left for Russia to make money. Here Adolf was presented with yet another twist in his inauspicious family saga, when his father deserted him, disappearing forever, yet not before adding insult to injury by stealing his son's money. Penniless, Adolf returned to Pomerania, settled in Swinemünde, and threw himself into building his career at the very opportune time when Germany's economy began to boom during the Bismarck years. And around 1872 he fell in love with the refined beauty and sensuality of Ida-Marie Kleist, his complementary opposite.[19]

Born in Stargard, a small-town south of Anklam and Swinemünde, Ida Kleist (1849–1892) was sensitive and spiritual *(feingebildet)*, a woman of "strange culture and beauty," who had been brought up by her widowed mother "within the near radius of Goethe and his time, aiming to become a musician by choice and gift."[20] Ida's mother, Constanze Kleist (1815–1876), herself raised in a high-school teacher's family, had instilled in her daughters the values of *Bildung,* elegance, and social grace. Inspiring respect rather than love, Constanze was an impressively strong and strong-willed family matriarch but was also convention bound and constant—true to her name. She was the pillar who held the family together even in the face of calamity.

The young family's tragic tale can be gleaned from the crossed-out Kleist names in the Stargard town register (figure 1.6).[21] Elsa's grandfather, Franz Karl Kleist (1806–1864), a baker, had lost his first wife, Amalie Louise, on 2 October 1846, a few months after she had given birth to Maria Elise Franziska (born 18 April 1846).

Left with the responsibility of caring for two young children and running his bakery, widower Kleist swiftly married Constanze Runge in what their granddaughter, the Baroness, described as a match of convenience. They had three children (Georg, Ida, and Hedwig), but doom continued to haunt them. In 1858, Ida's young sister, Hedwig Franziska Kleist, died at age four. And on 8 June 1864, at age fifty-eight, Franz Karl Kleist, a gentle soul and dreamer, committed suicide, leaving his family impoverished. Ida was just fourteen years old but regarded the suicide in highly romantic fashion, passing on to her daughters a cherished fable about her father's tragic clash with bourgeois life, a fable that the Baroness summarized like this: "My mother's father shot himself for melancholia—life embitterness—and he had a business and family well founded. Something broke in him—for he was *not made* for a bourgeois file— after *all these years it broke out.* He was an orphan of impoverished Polish nobility adopted by prosperous tradespeople—they had a bakery."[22] For the Baroness's retrospective fable of identity, her parents' marital divide—Adolf Teutonic, bourgeois, nouveau rich; Ida Polish, noble, impoverished—was deeply emblematic for a violent

1.**6** *Kleist Family Names,* 1846-1876 Town of Stargard Register, rep. 77, no. 1835. J.-L. Landesarchiv Greifswald.

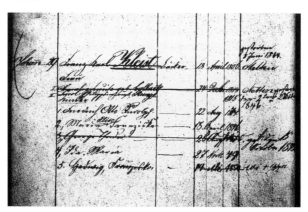

culture clash. "My mother—as I recall her now—and *know*—was entirely Slavic—Polish," the Baroness wrote. "She had that sweetness and intensity—passionate temperament."[23] More than merely temperamental, she alluded here to a cultural split, Nietzsche's polemical critique of the bourgeois Teuton who is incapable of appreciating cultural expressions.[24]

Defying the doom of her family's history, Ida Kleist daringly opted for love—and chose Adolf Plötz's *joie de vivre* and promise of good income to the Kleist's tradition of culture, nobility, and poverty. To Constanze, her boisterous future son-in-law must have seemed like the proverbial bull in the china shop. Yet the couple's sexual chemistry and Ida's gentle revolt triumphed over her mother's fierce resistance. She gave her blessing to the marriage but kept a close eye on Adolf, whom she did not trust. Had the formidable Constanze lived longer, Elsa's young history might well have turned out very differently. But just a few months after Ida gave birth to Elsa's sister Charlotte, and only six months after Ida's only brother, Georg Theodor Kleist, died at age twenty-seven, Constanze passed away on 2 April 1876.

With Constanze Kleist's protection gone, Ida and Adolf Plötz's marriage began to disintegrate. "You broke every promise— [as soon as] she was cold in her grave," says Ida to her husband in "Coachrider," the Baroness's 1924 autobiographical prose poem, as the Baroness dramatically ventriloquized Ida's marital lament, even using Ida's first name: "He—he even forbade me the piano—except for silly past time—so—I gave it up entirely—Now I can't—*can't* anymore."[25] A heavy drinker like his father, Adolf blithely continued his bachelor habits of nightly sprees and inebriation, while Ida refused to join his "coarse amusements" with his rich friends and their "vulgar wives."[26] Withdrawing into her secret world of books—Heinrich Heine, Friedrich Schiller, Karl Maria von Weber, and Goethe—she routinely commandeered her reluctant daughters as audience for her dramatic enactments. Subversive and forbidden,

Ida's world of books became a separate sphere with its own rules and subterfuges carefully hidden from her husband. Entrapped in unhappy marriage bonds, Ida now ironically took refuge in her mother's stoical marital discipline, complaining but never rebelling against her fate. At the same time, Ida raised Elsa and Charlotte without any conventional restrictions, being very "soft" and overly indulgent in her daughters' upbringing.[27] Elsa was a spoilt princess, yet she was also hypersensitive, introspective, daydreaming, easily upset, and prone to nightmares and explosive weeping fits. On the home front, however, Ida was not able to protect herself, let alone protect her children. The family chemistry was toxic.

In her poem "Analytical Chemistry of Fruit," the Baroness sardonically described herself as the "brilliant offspring" of "a thousand-year-old marriage manure," attributing her highly charged temperament to her parents' bad marriage.[28] One of Elsa's earliest memory pictures concerns a quarrel that pitted her anticlerical father against her religious mother.[29] Ida was trying to teach the two girls a "formal prayer to be recited before going to bed," and Adolf fiercely opposed the idea. "As long as the children are young, there can be no harm in praying. It will give them a sense of order," reasoned Ida. To which Adolf replied with a crude joke: "Just like going for a pee before bed." To drive home his point that indulgent spirituality was dangerous, he brutally listed all the disasters in Ida's family, including her father's suicide and her uncle's overzealous Catholicism that led to his losing his job. Adolf ended by proclaiming his atheism: "There is no soul." Ida called him a "barbarian," but the religious battle was lost. Adolf refused to go to church, although he did pay his church taxes so as not to offend business clients. Already Elsa was "scandalously [antireligious]," just like her father. "We were impious people—scoffing at church—religion–!," as the Baroness recalled for Barnes. "Not my mother—except that she had—to ease up—from her strict—stern—of course— 'comme il faut' religious upbringing."[30] Elsa zoomed in on God as her target

for pranks, religion a favorite area of testing and contesting social boundaries and figures of authority: "I was on bad terms with god privately anyway—since long—I scorned a silly thing like that—making animals [but] not taking them into heaven—when often they had such short life—as it was—being mostly eaten."[31] This was also the time of Bismarck's anti-Catholic crusade (*Kulturkampf*) that would eventually entail the aggressive expulsion of the Jesuits from Prussia.

The Baroness aligned Adolf Plötz with Bismarck and the new teutonic Germany. "My father—ah! To be sure thick brained Teuton [. . .]. That Bismarck sort—not of that brainsize—culture—but that *type*!"[32] She was, perhaps, thinking of Anton von Werner's well-known engraving, *The Kaiser's Proclamation in Versailles*,[33] which commemorated the birth of the Second Reich on 18 January 1871 following Germany's military victory over France. At the center, Bismarck, not the Kaiser, emerges from the crowd, his legs wrapped in black leather boots that reach up to his crotch, his feet firmly planted apart for maximum territorial coverage of space, the slick white upper-body uniform theatrically contrasting with everybody else's dark coats. Although Kaiser Wilhelm I is on a pedestal above Bismarck, the emperor blends into the background as an old-fashioned, white-bearded, grandfatherly figure. Von Werner poignantly captured Bismarck's *Machtpolitik* in terms of sexually and aggressively charged virile power, terms that would be echoed in Elsa's evocation of her father. The iconography accentuates Bismarck's tenacious goal of German territorial expansion and his willingness to brutally oppress any resisting minority groups (socialists, Poles, Catholics). With the Kaiser displaced from the center, the moustached Bismarck magnetically attracts the viewer's and the crowd's gazes as a highly charged embodiment of German power. The sexual overtones of this representation of power already prefigure the iconographic sexualized aggression in the visual representations of Wilhelm II (not to mention the other German Adolf's visual

fetishizing of leather and power). By visualizing the birth of an entirely new form of power (virile, ruthless, and self-made instead of royal, paternal, and inherited), von Werner created a work that encapsulated the era. As German chancellor and Prussian prime minister from 1862 to 1890, Bismarck was admired and feared, his name inscribed on Germany's sprawling cities, as in the naming of Bismarckstrasse in Swinemünde. That he was also nicknamed *der eiserne Kanzler* (the iron chancellor) and his *Machtpolitik* dubbed *Kanzlerdiktatur* (chancellor dictatorship) was testimony to the force of his iron-willed hand that was ubiquitous throughout Prussia and Germany.

Like Bismarck, Adolf Plötz was a ruthless empire builder whose rule left traumatic scars. He was, as the Baroness noted in her memoirs, "violent-tempered, intemperate, generous, bighearted, meanly cruel, revengeful, traditionally honest in business."[34] Indeed, at the core of "Coachrider" is a remarkably vibrant childhood memory of violence. Adolf is a hunter with a gun who stalks and then shoots a crow, a scene observed by his daughter:

He's Papa—
I'm his small daughter—I must obey—those
Canny—uncanny steps—haaaaaah!
[. . .]
Glittering
Eye—glimmering gun—
Ter—ri—ble! Mighty—knowing—jolly—fanatic—
Cunning—cruel—possessed—despotic—detestable
Horrid! Fi! Fi! I *hate* that Papa! Who am I?
[. . .]
Is he going to shoot?
[. . .]
"Aaaaaaaah! Maamaaa—Paapaaa!
No-o-o-o-o aaaaaaa-niiiiii-maaaaaaallll

Paaapaaaaa—deeeaaar—no-o-o-o-o-o-o—
Do-o-o-o-o-o————n-o-o-o-o————shoooooooo—
Aaaaaaa-niiiiiii—Mama—don't let him—
I can't—caaaaannnt! Hrrreeeeeeeeeee!
Hrrreeeeeeeeeeeee! No-o-o-o-o—no-o-o-o-o-o-o—
Shooooooooooo————————!'"
[. . .]
Look at Papa—killer!
He beams—loveably—virile—despotic by blood—
I adore—abhor him— [. . .].[35]

The gun is attractively "glittering" and "glimmering," the slow de-
lay of "Ter—ri—ble" producing a *frisson* rather than fear. Yet terror
ensues presumably with the deadly shot. As the father turns into a
"killer," the daughter's response ("I adore—abhor him") is ambiva-
lent, while the abrupt language breakdown and dada sound poetry
express pain so acute it is reduced to a piercing scream. In the *Psy-
chopathology of Everyday Life,* Freud calls such seemingly trivial rec-
ollections *Deckerinnerungen* (screen memories), which survive with
incredible sharpness precisely because they stand in for events that
are often too hard to confront directly.[36] Similar to Hugo Ball's and
Richard Huelsenbeck's nonsense sounds—antipoetic blathered
noise uttered against the sickness of mass destruction during trau-
matic wartime—the Baroness's dada babble represents her own
childhood trauma.

The secret at the heart of the Plötz bourgeois home was
the legacy that Adolf had inherited from his own family. "His hand
is like *iron* ["wie *Eisen*"] when he smacks me" is how the adult
Baroness recalled her father's abuse that was often exacerbated by
drinking. "'His blows leave nothing but devastation,' says Ida who
is afraid of him, and the other day she locked herself in for fear of
him." Only the Baroness's private letters record the pervasive and
chronic fear she experienced in her father's house, as the corporeal

abuse was generally relegated into the realm of shameful silence: "we are absolutely *not* used to caresses or much physical contact with my Father—we were too scared of him."[37]

███

Felix Paul Greve's *Maurermeister Ihles Haus* was an explosive work precisely because it publicly "outed" the dark secrets at the heart of the respectable Plötz family. The title virtually named Adolf Plötz as the child abuser and wife beater in the novel: the town described was clearly Swinemünde, where only two Maurermeister were listed in the 1890 address book.[38] Heimtücke (malice) is the epithet accompanying Adolf's alter ego in the novel: he is "heimtückisch-verächtlich" (maliciously contemptuous), delighting in "heimtückische Schadenfreude" (malicious sadism), almost anticipating Freud's discussion of the unheimlich, the uncanny that resides in the familiar home (also alluded to in "Coachrider"). His daughters have learned to expect his rage to erupt at any moment and to be beaten savagely with a leather strap or treated with verbal abuse and contempt for their perceived failings. They seek shelter in wardrobes and carriages to escape the raging father's fists. Meanwhile, Ida's alter ego says, "If I say anything he just hits me."[39] To her daughters, she is more a sister than a mother, occasionally sleeping in her daughters' rooms to protect herself from her intoxicated husband's sexual demands.

At the same time, Ida's sexual withdrawal speaks to an equally dark secret—namely, the Baroness's later scandalous charge that Adolf had infected Ida with syphilis on their wedding night. According to the Baroness, the disease was treated before childbirth.[40] Yet Ida worried about her children's physical health, and their frequent visits to the family physician, Dr. Kasper, suggest that Ida was overprotective on this issue, "tremb[ling] for [Elsa's] life at every little tonsil-swelling."[41] Since syphilis often mimicked the symptoms of other diseases, Ida's health worries about sore throats and swollen glands may have been

based on very real concerns (see also chapter 2).[42] Yet Ida never openly confronted her husband. Slyness and withdrawal were the female strategies through which she tried to keep the patriarch at bay.

These were the very strategies that Elsa would reject in favor of the masculine open fight. There was an unusual fierceness to Elsa's personality, suggesting that her reaction against childhood trauma caused by family disharmony and violence is at the core of her psyche. In psychological terms, *trauma* suggests a violent emotional wound. The stimulus is so excessive that psychical discharge (*Abreaktion*) of the experience is made impossible; it remains in the psyche as a "foreign body."[43] Elsa was caught in a bourgeois haven of material security on which encroached the madness of daily aggression and conflict. Theirs was a dysfunctional family with a chronic lack of communication: "As our family usually was—distributed all over the house—avoiding each other—never being together—if decently possible."[44] Elsa and Charlotte were caught in an unhealthy spirit of competition and jealousy, as Elsa reacted to her sister's "treachery," "humility," and "mass spirit" with unsettling hatred: "I scorned—disliked—often violently hated her—!"[45] The ultimate root of such hostility, however, points to her father: "I never loved him—once I even dreamed I had stabbed him dead [. . .]. I knew *truth* was in that dream,'" the Baroness soberly recalled for Heap.[46] Faced with the daily reality of fear and lack of control and power, Elsa seized her enemy's strategies of aggression and terror. In "Coachrider," the young Elsa fantasized, "That I were a boy! Shoot!"[47]

Already as a child, Elsa commandeered her father's symbols of power, most notably, his fondness for the bawdy and scatological. In *Maurermeister,* Adolf's alter ego has an obsession with his bodily wastes. In her discussion of the Marquis de Sade, the British writer Angela Carter has connected such scatological pleasures with the exercise of

sadistic power and control. The Sadeian masters enjoy "coprophagic passions" and "exercise total excremental liberty. This is a sign of their mastery, to return, as adults, freely, to a condition of infantilism."[48] Elsa's alter ego, Suse, similarly associates bawdy scatology with the father's position of power and appropriates it for herself. Suse's friend Hedwig—who looks like a "boy"—role-models linguistic transgression, when she parodies her father's military command by hollering at her classmates: "Ganzes Battalion . . . 'arsch! 'arsch!"[49] The omission of the /m/ in marsch (march) produces the daring scatological joke (arsch = ars, ass), all the more risqué as she performs it for an all-female school audience. Cleanliness and purity, in contrast, are the marks of femininity and weakness. As a child, Suse keeps her room immaculately clean but has little security in her world of order.

Aggressive jokes, then, present an opportunity to reclaim control and power, all the more transgressive for girls, as they involve a rejection of feminine docility. In *Beyond the Pleasure Principle,* Freud explains that children simply mimic the social order but do not transform it; they "repeat everything that has made a great impression on them in real life" so as to "make themselves master of the situation."[50] Through aggressive games, children dominate their powerlessness at the same time that they adjust to the hierarchical social order. In contrast, the German philosopher Walter Benjamin has theorized the realm of childhood as having *revolutionary* potential. Children do not merely mimic adult words, he argues, but put words together in new collocations, thereby creating new worlds and renewing the world through play. In using the fragments, even the "trash of society," children "do not so much imitate the words of adults as bring together, in the artifacts produced in play, materials of widely different kinds in a new intuitive relationship."[51] Benjamin's theory grants the child much more agency and creativity, as she may actively construct her own endemic system of order that may well be separate from the social order.

Already Elsa was creative. "My first poems I made at the age of twelve—when I began to retire for this purpose into the convenient crotch of a big walnuttree—for the sake of loftiness and seclusion," the Baroness recalled. She shared her poetry with her friend, hers being superior because they were "addressed to the beauty of spring," as well as being "markedly influenced by other poets' poems." The experience was spoilt, however, "by my mother's too unrestrained admiration—that I suspected strongly to be partial." When her poetry was read out loud by a well-meaning teacher in school, "it was a public flogging—a crucifixion I could not endure—and live."[52] She enjoys experimenting with roles and identities; with language, writing, and artistic expression.

In her reading, Elsa was attracted to the critical satire of Wilhelm Busch (1832–1908), whose books were read and reread until they were familiar memory. A pioneer of the comic strip, Busch illustrated his satiric verses with his own watercolors. His cartoon characters—Max and Moritz, Witwe Bolte, Lehrer Lempke, to name but a few—were and remain beloved icons in German popular culture, despite the glaring anti-Semitism of some of the verses. Busch's most famous work is the perennial bestseller *Max und Moritz, Eine Bubengeschichte in Sieben Streichen* (1865) (Max and Moritz: A boy's story in seven pranks), "a strip with a macabre and often anally oriented sense of humor."[53] Indeed, the humor is sadistic. In one episode, Max and Moritz try to steal the local baker's pretzels, but climbing up on a chair to reach for the pretzels, they slip and fall into a large basin filled with richly yellow bread dough. Meister Bäcker discovers them thus wrapped in dough; he gleefully shoves them in the oven and bakes them; in the final episode, Meister Müller grinds them in his mill and feeds the pieces to his chickens. That adults enjoy sadistic pleasures in punishing transgressive children was a lesson Elsa knew all too well firsthand. "[D]o you know for example: *Wilhelm Busch,* one of the most colorful teutonic satyrists [sic]?" she asked Heap in the early twenties. "I can read him

brilliantly—and he is *shriekingly* funny!"[54] She proceeded to document her intimate knowledge by citing long passages from *Die fromme Helene* (1872) (Pious Helena) for Heap, recollecting the satire (including its anti-Semitic verses) with impressive accuracy (the predictable rhymes make them easy to memorize). Her choice was appropriate, too, for Helene is a young Elsa character who mischievously unsettles her uncle's pious household. As an adolescent, she freely experiments with sex, even using her piety as an impious cover-up for sexual impropriety. She finally dies the appropriately cruel death sanctioned by Wilhelmine society: inebriated, she accidentally sets herself on fire. In the next picture, the devil drags her down to hell. Yet even though the frames—and flames—impose sadistic punishment, the preceding text and pictures encourage her transgression as intensely pleasurable.

Already Elsa was profoundly at home in spaces of sexual drama and transgression. Her first "sex attachment," as the Baroness recalled for Barnes, was at age eight or nine with the Chinese naval officer Li Chong Kong, who called her his little bride, holding her on his knees and singing "naughty love ditties on the piano."[55] Even as a child she dreamed of more exciting places, her fantasy life courting highly charged seductive dangers: "I would have run away with the first sailor who would have tried to kidnap me—for chance of seeing China—India—that did not happen," she recalled for Williams. "But through all my child days—I waited for *that* sailor—against whom I was warned—me living in a seaport."[56]

Already she was drawn to androgyny. As a twelve-year-old she became infatuated with the daughter of a military officer, a new girl from the Rhine. "We were two devils in schools," as the Baroness recalled about her new friend who dazzled her with her exotic religion (Catholic), her daring, her cosmopolitan history, and high-class status as the daughter of one of Swinemünde's "foremost citizens." Catholicism, like Jewishness, made her friend an exotic "other." "She was always somewhat reluctant to satisfy my rather

burning curiosity—about: being Catholic—that I could not always sufficiently suppress."[57] Indeed, Elsa dared her friend to test the local Catholic priest's celibacy by flirting with him. Presumably this was the Reverend Pluhatsch, who presided over the Catholic church at Gartenstrasse 32.[58] When her friend reneged, refusing to carry out the sacrilegious prank, Elsa jumped into the breach—"I had to attend to it"—as if sexually taunting the priest were an act of duty.

She attended the Girls' High School (Höhere Töchterschule) at Kirchplatz 3. An 1868 school report lists two foreign languages, English and French, along with German, among the school's regular curriculum. This school with exclusively female teachers and a male principal, Dr. Faber (who also headed the local high school for boys, Obere Knabenschule, with an exclusively male teacher staff),[59] contrasted with the lower-class elementary school (Gemeindeschule), in that it connected Elsa with the daughters of military commanders and government officials. This military social milieu likely planted the roots of anti-Semitism. Bismarck had brought economic growth, as well as a sharp rise in German nationalism and colonialism. Anti-Semitism was rampant in the military milieu that surrounded Elsa's social life. Also, in *Maurermeiser,* Adolf Plötz's alter ego is given to anti-Semitic slurs. An underachiever, Elsa rarely applied herself, providing excellent raw materials for *Maurermeister* as a spoof on Germany's late nineteenth-century pedagogical drill with its focus on poetry recitations, grammar drills, and plant taxonomy. The pedantic focus on academic correctness is repeatedly flogged for jokes and satire, while Suse escapes from ossified rules into word games, distorting and bastardizing the learned words and recycling them as raw materials in new contexts.

On 12 July 1888 Elsa celebrated her fourteenth birthday. She was tall, pale, and thin and had shoulder-length dark blond hair, "thin, a typically Pomeranian head of hair."[60] "I was so anaemic—I became dizzy from merely bending down deep or walking stairs."[61]

She smoked cigarettes. Elsa's birthday followed the dramatic 9 March death of the grandfatherly Kaiser Wilhelm I, who had ruled Germany since 1861. Within two years of the Kaiser's death, two other patriarchal authorities were symbolically dethroned: his son Kaiser Friedrich III died of throat cancer within three months of his ascension and was succeeded by his own son, Kaiser Wilhelm II, and perhaps most shockingly, Bismarck—looking weary and grey—was forced to resign on 20 March 1890. This event had the intensity of an electric jolt. If Bismarck could be dismissed, then any patriarchal authority could be dismissed and replaced. It was, perhaps, a sign of the times that the power dynamics began to shift within the Plötz household.

The maternal legacy, so far suppressed in the Plötz household, was about to assert itself. During Elsa's childhood, "Ida [was] nice but weak," as Elsa noted, who was often contemptuous of her mother.[62] Yet this childhood configuration changed dramatically in 1888, the year of Ida's first rebellion. When Adolf left the house for six weeks to cure his bronchitis at Bad Ems (hoping to avoid the fate of Kaiser Friedrich with a visit to the spa), Ida revolutionized the household, implementing uncharacteristic new rules of her own. Ida, Elsa, and Charlotte all had their hair cut short, an ultrafashionable androgynous look. Ida redecorated the house in a bizarre and arbitrary fashion—pleasing nobody but herself. She took the girls on extravagant shopping sprees, buying Elsa the fashionable yellow shoes, which were the rage in Berlin. A few weeks later, these yellow shoes had to be hidden from the fashion-phobic, no-frills Adolf, for whom everything had to be "clumsy—practical—natural—good—solid!"[63] At first in solidarity with their truant mother, the daughters soon began to worry about Ida's withdrawal from her long-time friends and from her daughters. She began to act "strangely": "careless of people's opinion [. . .] careless of appearance—of everything! Homeless—she became *homeless* in midst of great house comfort secure position. *She did not belong there!*"[64] Still,

acting "strange," as the Baroness noted, was also a way of keeping Adolf at bay. Ida "would put an altar with candelabres into her 'own bedroom'—if for nothing else—as to keep her drunken husband that fine father of ours—out of it———"[65] Perhaps most dramatically, she returned to her religious roots, decorating her room with a makeshift altar and crucifix much to the horror and shame of her impious family: "He [Adolf] didn't know—*where* to look—but tried to look imploringly at us—to indicate that she was 'deranged' to let her go on—not to contradict her—for *then* she would begin to rave—banging doors!"[66] This behavior had little to do with a religious conversion, however. "She cared the hell about Catholicism; she needed something spiritually," since "she was *estranged* from art,"[67] as the Baroness insisted when she shared Ida's story with Barnes: "Djuna—she never *one minute* had been 'insane' but *'sane'*! *Honest*! Is it wonder—*that*—touched like insanity—this hidden—lying—hiding—dullwitted diplomatically cautious *world of men*?"[68] Theatrical, spectacular, and shocking, Ida's "acting out" produced indelible memory pictures, ultimately imparting to her daughter the important legacy of maternal power that kept the patriarch at bay.

In 1890, after graduation from Girls High School, Elsa's dream to leave Swinemünde was within reach. In the fall, the teenager transplanted herself into the heart of the bustling city: Berlin. She was boarding with Maria Elise Franziska Kleist, her mother's unmarried half-sister, a store owner probably already living at Leipzigerstrasse 13.[69] On her school registration, however, Elsa gave her address as Unter den Linden 72/73. According to the 1890 Berlin address book, this was, in fact, the address of the Geheimkanzleirath Plötz, the chair in the Zentralbüro of the German Ministry of the Interior (even today Unter den Linden 72/72 remains the site of the new parliamentary offices). It is unlikely that Elsa really lived here. But by linking herself to a high-placed person whose last name she shared, Elsa reconstructed her genealogy, for the first time elevating herself above her Swinemünde origin.[70]

From October 1890 to March 1891, Fräulein Else Plötz studied full-time at the Königlich-Preussische Kunstschule at Klosterstrasse 75, near Alexanderplatz, a school training art teachers and applied visual artists with a teaching staff of academics, painters, architects, and sculptors. Among the school's 313 students (most of whom were under twenty-one), she was one of the youngest at age sixteen. In foundational courses, she studied ornamental drawing (*Ornamentszeichnen),* projection studies (*Projektionslehre*), drawing of geometrical figures (*Gispszeichnungen*), and painting of nature objects (*Malen nach der Natur*).[71] Before coming to Berlin, she had "merely done some watercolor in the deadly spinsterfashion of a small-town lady teacher" in Swinemünde. "Later—at an artschool in Berlin I was already too much spoiled by the timid pencillike use of the medium to even be able to imitate the—to me—terrible dash of the art school water colour class."[72] The Baroness's retrospective response ("Kgl Kunstschule—Pah!"), however, signals disillusionment with the school's academic focus and conventional curriculum. Her exploration of Berlin would have to wait two more years. In March 1891, she returned to Swinemünde having completed but one of the four terms of the two-year certified program. Her mother was ill and too weak to continue lobbying Adolf for the school fees.

In the winter of 1890 to 1891, while Elsa was in Berlin, Ida, at age thirty-nine, had made her first suicide attempt. She seemed to have come full circle to her father's fate: "She had tried to drown herself in the East Sea—had gone up to the breast into water—then courage had left her."[73] Ida returned home, her clothing dripping wet. But this abortive first trial would not be her last. In the following winter of 1891 to 1892, Ida kept her family in traumatic crisis when she simply disappeared, with the family fearing the worst during the late-night vigil:

She did this: She secretly hid in a top room—garret room of a family—we had years ago been most closely befriended with—but not

lately [. . .] My father went during the afternoon and night—
twice—absolutely aimless, helpless, in search of her—with the
coach [. . .] I can still recollect vividly myself and my sister sitting
late night in the livingroom—two maids up in the kitchen—wait-
ing for my father's second return from an absolute wild-goose chase
searching for [the] corpse?—in all probability—hanging on a tree—
swimming in water—where?[74]

Within Elsa's highly dramatic memory picture emerged another
sharp memory relating to her father: in distress, she flung herself into
his arms to be comforted and to her surprise he responded to her: "I
felt flattered [. . .] that he petted me—*first time* in my life—unless as
baby."[75] When Ida was finally detected, she reluctantly returned
home, only to shock the family with more baffling and scandalous
behavior, confronting them with an "open war declaration."[76] She
refused to see her husband and was promptly sent to the Frauendorf
Sanatorium in Stettin, where "she slyly, giggling smirking gay in-
sisted she wasn't mad."[77]

Ida now entered a space of uninhibited freedom of ex-
pression producing explosively extravagant and unhinged works of
"art." "She began to make strange 'handiwork' (when she had been
such 'skilled worker' in fine embroidery—needlework!!) *Now*—she
did things—nobody would *think* of putting together—spoiling ele-
gant material with cheap trash—she was 'tired of doing fine handi-
work.'"[78] The very uselessness of Ida's handiwork makes it
intriguing, for unhinged from any bourgeois cultural purpose, it be-
longs to the realm of antiart. Ida's love of art and culture had been
harnessed and ossified as bourgeois status symbol (recall her piano)
and repressed (recall her reading). In madness she was now liberated
to defy the conventions that ruled cultural production and con-
sumption, a state idealized by the Baroness: "My mother broke into
beautiful shattered scintillating noble pieces. I will find her smiling at
me—kindred spirit—as she did silently mischievously smirking."[79]

Ida's madness was also a grotesque death dance. In the Frauendorf Sanitorium she had been diagnosed with uterine cancer, too far advanced for any treatment except morphine to alleviate the worst pain. Elsa bitterly—though not openly—held her father responsible by connecting the uterine cancer with the earlier syphilis, knowledge she gleaned from her mother's women friends. Elsa also blamed bourgeois conventions for instilling the shame that had prevented Ida from seeking diagnosis and treatment earlier. Still, she also was profoundly repulsed by the medical realities of illness: "[O]ften, in her 'madness'—in arms of practical concerned nurses—manhandling her—with dressing—cleaning—I standing idle, disgusted—looking on with detached curiosity—always amazed at my so-soon-deft-sister, who would touch any soiled thing *unhesitatingly,* because it was 'necessary' and of 'service' when I should have fainted away, making my great, noble mother butt of vulgar stupid pity."[80] Her distance from Ida's physical suffering may explain her later sense of guilt about her mother's death. From her sickbed, her mother left her with an important legacy: "Else—my mother said—has an unbreakable will—you can not bend her—nothing can bend her." "My mother left me her heritage," noted the Baroness, "left me to fight."[81] Formerly a spoiled child, she was now confronted with her own independence.

On 26 February 1893, Ida-Marie Plötz passed away, a relief after the excruciating suffering. "Though willing—she died hard,"[82] the Baroness noted soberly. Yet the painfulness of Ida's dying inscribed itself indelibly in Elsa's memory, while her last good-bye gave a heartfelt touch to death's cold, anatomical finality: "My mother was dead—I kissed her—she smelled dead. I had sneaked into the coffined room. I was ashamed of my intended act—for I had never kissed her willingly before."[83] Profoundly marked by the trauma of her mother's death, Elsa was not quite able to complete the grieving process, given the dramatic events that would follow. Images of Ida's physical disintegration recur, in particular in her

dreams in Palermo in 1904, during a period of Elsa's sexual blossoming.

More than three decades after Ida's death, during the 1920s, her carnivalesque rebellion makes its appearance in Canada's national literature, in the novels of Frederick Philip Grove, who remembered the details of Elsa's accounts with sharp clarity. In *Our Daily Bread* (1928), the western Canadian settler matriarch Mrs. Martha Elliot, like Ida, dies of uterine cancer that she refuses to have diagnosed until it is too late. In her close-knit rural community, she creates scandal when she rises up from her sickbed and goes out on a last triumphant, if grotesque death dance: "For once in my life I have had a good time!" she tells her family.[84] Just as Elsa held her father responsible for her mother's uterine cancer, so the daughter in Grove's *Settlers of the Marsh* (1925) recognizes her father as a sexual predator who causes his wife's death. Grove's Canadian patriarchs are cast in the mold of the *Maurermeister,* as E. D. Blodgett has shown; they are powerful empire builders but rigid and unable to change.[85] Grove's Canadian matriarchs are cast in Ida's mold. Dominated by ruthless patriarchs, they resist in spectacular but temporary fashion, indicting patriarchy without being able to change it. In contrast to Grove, Djuna Barnes used Ida's madness as a complex feminist metaphor in her biography, as the expression of a woman tired of bending to the rules of patriarchal society. Casting Ida as a Lady of Shalott figure who is half sick with "life's disappointments," Barnes ultimately validated the state of madness as a woman's choice, yet without minimizing its dangers, as "Madness had fed upon and devoured Frau Schenck [= Ida]."[86] Given Barnes's own dramatic withdrawal from society, "Baroness Elsa" and "Beggar's Comedy" thus become crucial documents for exploring her choices.

As for the Baroness, she idealized Ida as the mother-muse. In "Marie Ida Sequence," a poem published in *The Little Review* in 1920,[87] she mirrored herself in her mother, having already superseded her mother in age and experience:

Mine flaunting dress—mine copper hair—
Thou—purple—dark——
Slate iris—forehead wide.
Mine lips—as shaped and chiselled after thine—
The nose is not—mine nose is aquiline—
like tower—thine is short.
[. . .]
Nay—fundamentally I am thine root—
Gyrating dizzying and high
Upon that bloodcrest—mating a galoot
Of steel and flame—making thee die.[88]

The poet searches for analogies in their common architecture: "Mine lips—as *shaped* and *chiselled* after thine." The Baroness has her mother's green eyes, wide forehead, and beautiful hands. The Baroness eulogizes her mother's hands as objects of worship and purity: "Thine hands—so imminently lovely–/ Frail [. . .] / To worship." The religious overtones are deliberate in light of her mother's return to her religious and spiritual roots. The daughter, in contrast, is associated with sexual and sensual language, admitting that her "lips" are not as "chaste" as her mother's. Openly displaying her libidinal sexuality ("Mine flaunting dress") and sex desire ("Mine scarlet heart"), the poem ends with an exhilarating evocation of ecstasy. Still, the last line, "making thee die," proclaims this poem an elegy, the daughter lamenting her mother's death.

Her mother's death in February was followed by a latent, grieving stage, as Elsa drifted, daydreaming without discernible goals. Adolf sought company and consolation among the tourists and locals in Swinemünde's König Wilhelm Bad, while Charlotte learned cooking and devoted herself to her fiancé, the tax inspector Hans Otto Constantin Kannegieser, whom she would marry three years later on 4 May 1896. The father's house now belonged to Elsa, where she painted and sewed indulging her love of colors. Favoring

red, she donned red stockings, red underskirt, and red dress. Even before her mother's death, her brazen search for a lover and husband had raised eyebrows among her mother's friends, for "it is not nice to have open or secret scandal in good families."[89] She had plunged into a new realm of experience: sexuality. She used makeup, the powder purchased from the local hairdresser and bobber, "Theodor Pistorius," a bachelor, living at Gartenstrasse 3, whom she remembered decades later in sharp physical detail: "[He] always wore shiny welled hair waves—as other men could not afford to—but *he* could—for advertisement reasons and not be despised—quite contrary—admired—! And all Swinemünde's Madames and promising Ladies were sitting in a row—much longer than his shop really could have afforded it—before mirrors—to have their hair done!"[90] That the feminine Pistorius attracted such enduring attention bespeaks to the young Elsa's profound interest in androgyny.

Her life was deeply autoerotic. She enjoyed dressing up in front of her mirror; she felt modern when she smoked in her room and relished the touch of her silk comforter on her body. Her favorite flapper fantasy featured her gypsylike, bordeaux red undergarment as fetish (the same item in which she flashed through Pistorius's hair salon in her later dream in Italy):

This especial Bordeaux red cashmere woolen short undershirt—I *really once had possessed* as a flapper at home—and through its *deep satiated rich colour*—that I myself had selected—in sympathy with my truant mother who just at that time was obsessed by an angry fit against narrow convention—restrictions—for it was a little—too—well—just "too"—for nice young girl. [. . .] This garment had often inspired me—to lie down in it *just this way*—afternoons on my couch—to let several [. . .] entirely imaginative young men—clamber through my chamber window—to surprise me in it. [. . .] I ordered them each out [and]—we came into such debating and differences of opinion about it—seemingly—I always neglecting to

cover myself up—since they each had luckily caught me in that ad-venturous underskirt—with only a chemise up—(nice embroi-dered—I saw to that—) I *couldn't* bring it over my wicked beauty sense—to cover this splendor up—[91]

Exhibitionist and fetishist, her fantasy was desire oriented, rather than providing masturbatory release of sexual tension. Heightening excitement and drama, it culminated in the image of her father en-tering her room and aggressively chasing the lovers away—while Elsa continued her seductive posing.

Yet while Elsa fantasized about lovers, her pragmatic fa-ther had translated his male desire into action. Just months after Ida's death, Adolf introduced to his bewildered daughters the new step-mother (in *Maurermeister,* the wedding took place in Berlin in mid-August): Berta Schulz, the forty-year-old illegitimate daughter of a rich Berlin businessman and sole heir to her father's fortune, whom he had met in Swinemünde's König Wilhelm Bad.[92] Her step-mother entered the house with a heavy armor, "laced bosom, tight buttoned waist, high collar, gold watch-chain," exuding a "bour-geois harness of respectability."[93] The little black curls pressed along the forehead, monocle, and corset represented her power and con-ventionality. Still mourning her mother's passing, Elsa was in emo-tional outrage. Her hatred of the bourgeois and Teutonic was born in this crushing encounter with the pure essence of bourgeois pet-tiness that now powerfully confronted her with her own impotence. A mere few months after her mother's death, Elsa was isolated and vulnerable, an exile in her own home. The emotional pressure cooker exploded shortly after, eerily repeating the scene of family violence that had separated Adolf's family home a generation earlier. The violent conflict between father and daughter was the culmina-tion of an entire life of abusive treatment. It was also the most dra-matic turning point of Elsa's young adult life, if not of her entire life. Its cause was banal, Elsa having been caught smoking by her step-mother:

Next morning I was summoned to a family council of two at the breakfast table—I the culprit. My father—pressed to severity on a matter otherwise humorously treated rather—behaved so unspeakably, pitifully ridiculous that I felt an overpowering nausea, dating in its beginning almost from my infancy, increasing with age, reasoning, secretly having turned constant sneer—since this marriage. I, being hidden, declined calling this woman "Mamma," as I in fact never had done—telling my father my mamma lay dead in the graveyard by his fault. Through the interference of my step-mother—whom I had so much forgotten that it seemed a miracle—my father was saved from becoming my murderer—since otherwise, with his deathclutch choking my throat, there would have been no help—as I knew when I was joyously dead beneath that unreasoning quick-tempered fist—triumphant—having "told him" what he knew everybody knew but nobody would say. This was as much truth as truth goes—the consequence of temperament and action.[94]

In her memoirs, the brutality of the act is both dramatically heightened ("my murderer"; "deathclutch choking my throat") and curiously deflated ("my father was saved," when, in fact, the daughter is in literal need of saving). The language of her private letter is more graphic: "He grabbed me by the hair, flung me to the ground and tightened his grip around my throat until I began to lose consciousness for lack of air."[95] Still, as the Baroness saw it in her memoir, *she* was in control, for by risking herself, she was able to expose the truth about her father: making *visible* the violence that constituted her childhood interaction with him. For the first time, she dared to confront her father openly (like a man), rather than circumventing his power subversively (like a woman). In front of his new wife as witness she had forced him to show his true colors—the moment of truth when he physically attacked his daughter desiring her death/silence, cutting off her speech/life. Here was the primary act, the im-

portant root, of her later performance art, as she confronted her father, forcing him to respond. It was the birth of Elsa as radical renegade who will always put herself on the front line.

As a decidedly modern daughter, Elsa Plötz had confronted her father, first face to face in 1893 and then in a tell-all novel published under Greve's name in 1906. Since father and daughter are asymmetrically proportioned in power and status in Western narratives,[96] Elsa had struck at the heart of this patriarchal grammar that relegates the daughter to the margin. The fact that the Plötzes charged Elsa with her lack of morality (*Sittlichkeit*), cut all ties, and in 1923 disinherited her speaks loudly. Such drastic measures suggest that the Plötz family was familiar not only with the outrageously sexual *Fanny Essler* but with *Maurermeister,* a novel so shameful in exposing the patriarch that Elsa had to be erased from the family forever. Indeed, the chapter in *Maurermeister* describing the father's last physical assault on his daughter in rapist terms was singled out for praise by a contemporary reviewer: "Indeed the last chapter is such an excellent performance that for all the many faults of the work we may set great hopes on Greve for the future."[97] This praise really belonged to Elsa Plötz, all the more as she, not Greve, paid the price for the disclosures made in *Maurermeister.* Greve followed this violent scene with a conventional fiction ending of his own: a quick marriage of convenience with a colorless yet socially prominent Konsul.[98] Elsa did have a Konsul friend, whom she described as one of the leading men in Swinemünde and with whom she was intimate enough to openly discuss her family matters, including the social implications of her father's first and second marriages.[99] She may have had sexual relations with him as described in *Fanny Essler* in her sexual initiation with the prosaic Baron von Langen. Yet the marriage was Greve's fictional intervention as he modeled the tale of Elsa's life to dovetail with Theodor Fontane's tragic Swinemünde novel, *Effi Briest* (1895), where the seventeen-year-old androgynous Effi is sacrificed by her family in a marriage of convenience with the

uninteresting Baron von Instetten. Tragedy ensues when Effi's youthful adultery is exposed; she is socially destroyed and disowned by her family. In preparing a similar match for Elsa—indeed, by using Swinemünde's geography, which had been used by Fontane in *My Childhood Years* and *Effi Briest*—Greve strategically held up Elsa Plötz of Swinemünde as a real-life Effi Briest. In his letter to Gide, Greve even described his novel in Fontanian terms, as the "tragedy of a family."[100]

Yet the real Elsa Plötz was a more radical and more modern figure, making Effi's rebellion look tame and docile. Indeed, the nineteen-year-old Elsa was a protofeminist who rebelled against male power excesses. Her insurgence, however, came with a significant price, as her father planned to send her to a reform school (*Besserungsanstalt*), just as Ida had been sent to a sanatorium.[101] True to her new renegade identity, Elsa now took things into her own hands. She did not wish to be reformed, nor was her goal a bourgeois marriage of convenience. She escaped "by means of a washline, one bright Sunday afternoon when everybody was away," leaving for Berlin to live with her aunt.[102] Her childhood journey thus ended in dramatic flight that marked both her exile from her parental (or paternal) home and the beginning of her new life in Berlin. Psychologically, the wounds left from her childhood did not end in resolution or a "working through" of conflicting positions but its opposite. The rage against her father remained ingrained in her personality, perhaps necessitating further assaults on his power. The powerful memory was stored corporeally, ready to be called up for future use. Her confrontation effectively exiled her from her father's home and from her community. She would never return home.

Much later, after her father's death, she expressed her grief and loss in a poem significantly titled "Adolescence," suggesting that the real loss of her father occurred long before he died. With its dedication, "In Memoriam Pater," this poem describes a coach

ride with her father along the Swinemünde beach. The only sounds are the ones from "the taut sea"—"gulls mock" and "sirens"—while she and her father sit in silence, their knees almost touching, but ultimately unable to bridge the chasm, as the poem's closing lines suggest:

Ever sweet Heart
Tacit Enemy
Knee
To Knee.[103]

In this dramatic loss of home and ensuant exile, then, lies the birth of a fiercely modern personality who was now free to begin an odyssey of boundary-breaking experiences. Released from her chains, free at last from her bourgeois home, she was now poised to conquer the city, ready to wage war against remnant bourgeois conventions. Her odyssey now took her into Berlin, just as the German capital was about to establish itself as a center for Germany's modernist avant-garde.

I had **s e x l o g i c** implanted and used it.

— THE BARONESS, ca 1924[1]

We were people of a *c i r c l e* of supposed highcultivated life
conduct by intellectual morality—HIGHER THAN SOCIETY
IN ITS HYPOCRITICAL M E S H E S .

— THE BARONESS, ca 1924[2]

[I had] pushed through to spiritual sex: art—that **nobody** protects as
readily as a **charming love body of flesh**.

— THE BARONESS, ca 1924[3]

Sexual MODERNITIES in **Berlin** *and Munich*

Part

Sexcapades in Berlin

Chapter 2

When Elsa Plötz stepped off the train in Berlin after an overnight journey from Swinemünde, her true capital, besides the 10 marks in her satchel, was her flamboyant drive for adventure and experience. With her social background and emotional makeup, she was uniquely different from other "exceptional" women who asserted their drive for artistic and sexual expression during this period. Unlike Lou Andreas-Salomé (1861–1937), the brilliant friend of Friedrich Nietzsche, Paul Rée, and Rainer Marie Rilke, Elsa Plötz lacked the rigorous intellectual education that had prepared Salomé for her critical engagement with the leading philosophical and artistic minds. Unlike Countess Franziska zu Reventlow (1871–1918), who openly embraced an ideology of free love and sexual promiscuity in Munich's bohemian circles, Elsa Plötz lacked the countess's aristocratic status, social diplomacy, and command of respect. Unlike Helene Stöcker and Anita Augspurg, academically astute feminists fighting for women's suffrage in Berlin and Munich, Elsa Plötz was not politically minded and was, perhaps, too independent and self-interested to attach herself to any political cause. Exuberance, intensity, curiosity, and bold unconventionality were among her most prominent characteristics. Already she displayed many of her signature traits. Her blunt directness acted as brashness; her flirtatiousness as brazenness; her antibourgeois drive as adolescent rebellion. Ultimately, she was thrown back on her own ingenuity in carving out a space for herself, creating her identity out of virtual nothingness.[4]

In a dazzling odyssey of sexual roles and experimentations she now began to armor her personality, emerging as a tough sexual and artistic warrior in her conquest of the modern city. Her ambivalence as androgyne allowed her to test a stunning range of erotically charged positions—young ingenue, female flâneur, erotic art worker, priapic traveler, chorus girl cum prostitute, actress, crossdresser, lesbian, and syphilitic patient—all in a span of just a few years. None of these identities ultimately defined her, however; she

impersonated each but always moved on in her journey through roles and identities. Through her remarkable life she mapped the modern city's sexual zones, continually igniting herself with new identities. Sex was the tool that allowed her to infiltrate modernist circles and artistic spaces. In an ironic reversal of the Freudian sublimation theory, sex became quite literally the conduit for art and identity. As a crucial catalyst she provoked reactions from Germany's artists at the turn of the century and presents a unique window into the male avant-garde's most private wrestling with new styles and gender identities and their complex relations to the new woman. That she was also a deeply disruptive figure can be seen in a remarkable number of literary and visual artworks wrestling with Elsa Plötz's controversial androgyny and New Woman sexuality: a painting by Melchior Lechter (1896), a play by Ernst Hardt (1903), a novella by Oscar A. H. Schmitz (1906), and two novels by Felix Paul Greve (1905, 1906).[5] The most controversial of these was Greve's *Fanny Essler* (1905), a scandalous *roman à clef* in which Elsa Plötz collaborated, readily providing the story of her notorious adventures in a modern tell-all style. Not satisfied with the treatment Greve had given her early life in *Fanny Essler,* the Baroness herself returned to this formational period in 1924 and provided a brilliant feminist critique of the male circles in her own memoirs. This palimpsest of texts and versions of events now takes us on a wild odyssey of sexual personae in which her remarkable life was transfigured into art.[6] As we now embark on a journey through Berlin, Italy, Munich, and back to Berlin, we are navigating through Europe's modern urban landscape into the heart of the German avant-garde.

Berlin at the time of Elsa Plötz's arrival in 1893 was a modern metropolis. "Berlin was sensational on many counts: its particular geography (medieval alleyways, proletarian precincts, parvenu suburbs), picturesque sociology (chimney sweeps, prostitutes, speculators), and also the instability of the city's inventory, the restless motion of its transformation," writes Peter Fritzsche of the me-

tropolis in *Reading Berlin 1900.* "By the end of the nineteenth century the story of Berlin had become the story of constant change."[7] Hungry for adventure, Elsa Plötz threw herself into Berlin's metropolitan machinery with impulsive abandonment, embracing the speed with which this gigantic machine set in motion and recirculated city people. Each day in Berlin provided new spectacles, sensations, and drama right in front of her eyes: the fashionable department stores on Friedrichstrasse; Busse's haberdashery on Leipzigerstrasse, her favorite store, where she often spent her last penny; the cafés with their array of daily newspapers and freedom of sociability; the speed of traffic of delivery wagons, empty streetcars, and horse trams; curbside vendors, traveling salesmen, and shopgirls around Potsdamer Platz. She ventured out into Berlin by night, enjoying the electric light on Unter den Linden or the seedier nightlife of the prostitutes along Friedrichstrasse and Potsdamer Platz and at the Fandango Bordellos of Kanonier Strasse. Seen through Elsa's eyes, Berlin was not a gigantic machine but merely an oversized playground she was able to commandeer for her pleasure and her new desires.[8] For Elsa Plötz, as portrayed in *Fanny Essler,* embodied the modern woman who promenaded the streets unchaperoned, not as a prostitute but in search of sensation. Promenading—*schlendern, spazieren*—offered a way of recording the city's modernity for this daughter in exile. The cafés, the department stores, the displays, the traffic, and the city at night became her new home, the space she expertly navigated and controlled according to her desires. She absorbed the city's energy like a sponge, and freeing herself at last from the confining conventions of her small-town upbringing, she became a new woman, her body representing the protean cityscape itself.[9] Wandering on Berlin's streets the adventurous newcomer from Swinemünde voraciously consumed new identities in a random orgy of self-metamorphosis, for the city ignited her new identities, producing her modernity in a remarkable fluidity of selves.

For the first two years in Berlin, from 1893 to 1895 (except for a few months when she was posing for de Vry), Elsa was surrounded by a safety net, as she once again boarded with Elise Kleist, her unmarried, shopkeeper aunt, the same Fräulein E. Kleist who, according to the Berlin address book, resided from 1892 to 1899 at West Leipzigerstrasse 13, near Leipziger Platz and Potsdamer Platz.[10] It is the exact location where Greve puts Elsa's alter ego in *Fanny Essler,* as he takes us on a tour from Anhalterstrasse, past Potsdamer Platz, and down Leipzigerstrasse to the store but does not disclose its street number.[11] An 1897 photograph (figure 2.1) taken by the renowned Berlin photographer Waldemar Titzenthaler, who had his own studio on Leipzigerstrasse, shows the vibrant life on Leipzigerstrasse that Elsa would have enjoyed: its famous Café Klose at 19 at the corner of Maurerstrasse, the Reichspostamt at

2.1 *Leipzigerstrasse* (Café Klose at right), ca. 1897. Photograph by Waldemar Titzenthaler. Landesbildstelle Berlin.

14–18 (already cut off in the photo), and Elise Kleist's store at 13 (also outside the picture). Presumably, the store had the characteristic look of the other boutiques—with the store window underneath a canvas awning and the living quarters behind the store in the *Hinterhof*.[12] Adele Blaurock (bluestocking), Elise Kleist's alter ego, is a proudly independent owner of a small store specializing in tortoise combs (the Berlin address book lists an ivory carving business here); she is keen on training Fanny as a shopgirl.[13] Affectionate toward her niece without being able to show her feelings, she is also a miser, wearing the same dress for a number of years, then turning it inside out and wearing it longer. In the midst of the city's modern maelstrom of activity and desire, this was a cocoon of bourgeois stability.

"I never had learned to do anything but amuse myself," is how Elsa explained her postadolescent drive for pleasure and free fall into the world of sexual longing: "I had become mensick up to my eartips—no, over the top of my head—permeating my brain, stabbing out of my eyeballs."[14] Startled by her niece's brazen disregard for bourgeois propriety, however, Elise Kleist quickly tired of Elsa's shenanigans and their bitter quarrels. Elsa's plunge into a risky landscape must have horrified a woman used to the peace and quiet of her frugal and solitary life. With 100 marks, Ida's half sister finally absolved herself of her charge; Elsa took her own room with a "remarkably nice—conscientiously honest, screamingly funny landlady"[15] but was also forced to support herself. Conventional career options for women—shopgirl or wife—remained unappealing, yet when perusing the newspaper advertisements, she discovered the more liminal arena of Berlin's burgeoning entertainment industry.

In 1894, the twenty-year-old made her Berlin debut as an erotic artist. Too shy and too embarrassed to apply for something as ordinary as a shopgirl position, she had no such inhibitions when she discovered Henry de Vry's advertisement in the *Lokalanzeiger* calling for "girls with good figures." The ad took her straight to

Dorotheenstrasse 18–21 and the Wintergarten vaudeville theater. Her first tryout was for a role in a *tableau vivant:*

[I]t was mysterious—I died with curiosity. [. . .] I was told to strip—with a young wench assisting me. [. . .] Then I was clad in tights and "Henry de Vris," boss of "living pictures," looked me over, though I did then not quite know what for. Being safe inside my meshshell—I liked that scrutiny. To my utter bewilderment I was taken right away for the "marble figures"—which—as I later learned—takes the best figure—even though I had to be uphol-stered considerably with cardboard breasts and cotton hips—but it was great fun—and I felt the pride of a prima donna.[16]

This scene is pivotal. Although de Vry's Wintergarten vaudeville was admittedly a far cry from her later performances in New York, already Elsa was armoring her personality: she used the simulated nudity of the "meshshell" as if she were wrapping herself in a pro-tective shield of safety. Considering that the female nude in Western art history and in the erotic arts has been shaped by the demands of male desire and power, Elsa paradoxically located her safety zone in a high-risk danger zone. Already the risk of self and body was a trademark.

In *The Erotic Arts,* art historian Peter Webb discusses the living pictures as borderline art form. T*ableaux vivants* or *lebende Bilder* enjoyed great popularity in nineteeth-century France and Germany (J. W. von Goethe was a great fan). But the simulated nu-dity of these posed, "marble" figures (which also made living pic-tures popular in London's high-class brothels) provoked controversy. The actors were typically clad in tights that emulated the surface of marble sculptures, explains Webb. Posing as various mythological figures they literally embodied some of the classical products of Western art. Webb traces a trajectory that reaches from these early music hall *poses plastiques* and nude shows to dada artist Francis Pi-

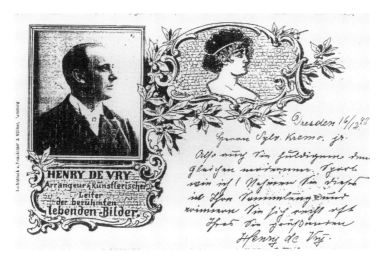

2.2 Henry de Vry, *Promotional Postcard with portrait*, 1893.
Märkisches Museum, Berlin.

cabia's *Relâche* (1924), which stars a nude Marcel Duchamp posing
as Adam in Lucas Cranach's *Adam and Eve*.[17]

A glance at the Wintergarten program reveals de Vry's
prominence within the vaudeville summer offerings. His *Galerie
lebender Bilder* (Gallery of living pictures) was advertised among ac-
robatic acts, sports, and musical pantomimes. His March 1894 pro-
gram featured erotically charged titles including *Venus, The Lotus
Flower, Diana, Ariadne,* and *Daughters of the Sheik,* while Fanny in
Fanny Essler poses as *Ariadne Riding a Panther.* Equally racy were the
titles of an undated program: *Elf's Magic, Summernight's Idyll, Bac-
canale,* and *Spring Lust.* His promotional postcard (figure 2.2) fea-
tured de Vry as a serious-looking man with collar and dark jacket.
The caption reads: "Henry de Vry, Choreographer and artistic di-
rector of the renowned living pictures." To the right of the portrait
is a Greek-looking head with exposed neckline surrounded by a
flowered frame. On another progam advertisement, "Reinhold
Begas, Royal Professor" officially "certified" that Henry de Vry's

living pictures had "a purely artistic character" and distinguished themselves from the "frivolous arts"—a nod to the vigilant censor's eye, for according to German law, art was allowed to represent nudity and sexual subject matter, while entertainment was not. The "purely artistic character" of the "selected beauties" thus covertly advertised what it overtly denied, effectively luring the male customer with a promise of erotic fare.[18]

Elsa donned the armor of erotic artist with "the pride of a prima donna." Yet she had barely assumed her new role when she was propelled into her next sexual identity, as de Vry took his *Kunst-Ensemble* on the road, his recently graduated apprentice in tow. In Leipzig and Halle, she now became a voracious consumer of sexuality whose initiation unleashed a priapic feast of overindulgence: "We first went to Leipzig—then to Halle—and now I began to know what 'life' meant—every night another man. So—now the contents of my vague homedreams came true. I was intoxicated."[19] This sex binge was ironically unleashed by her innocent desire to fit in. She began to emulate her young colleagues, but her sexuality quickly became intoxicating. An orgy of promiscuity now took the "greenhorn" into a new realm of experience that allowed her to act out her sexual flapper fantasies and to envelop herself in sex as if it were a new costume. The new sex identity was excessive and exhilarating, although William Carlos Williams was rather prosaic about it, when he later wrote that the Baroness "lost her virginity behind the scenes of a vaudeville house, not wishing to be different from the rest nor like her sister who stayed at home."[20] Judging from her aunt's concerns, Elsa may very well have "lost her virginity" before this experience.

Yet this spree of random sex initiated her into the addictive rush of sexuality that would become a signature trait. Her new libidinal euphoria was only slightly dampened by the realization that coitus did not automatically provide her with sufficient luxury and financial support. Here her reasoning assumed its own logic. Al-

though she was an avid consumer of sex, she saw herself as entitled to automatic compensation, as if she were a geisha on a mission providing an important social and cultural service. Yet asking for money for sex was distasteful to her, for that would assign her the stable identity of prostitute, ultimately halting her traversing of the sexual landscape. In fact, the prostitute's identity was one that Elsa rejected and combatted throughout her life, not because of the negative stigma per se but because her "essence" lay in the traversing of sexual identities. Her tireless work as a protean sex machine reflected the kaleidoscopic landscape of the city: she was the consummate priapic traveler, the sexual adventuress, the *picara*. Already she was more a figure of fiction than a literal prostitute.

After stripping herself of the last remnants of bourgeois inhibition during this sex binge in Halle, and after her first contact with gonorrhea, the twenty-year-old Elsa temporarily returned to Leipzigerstrasse 13, summoned by a letter from her aunt. In a last attempt to coopt her unruly niece into semirespectability, Elise Kleist now offered to pay for acting lessons and to provide, once again, room and board. Although acting was not free of promiscuous tinges—indeed the sexual pressures on actresses and singers were enormous—the "legitimate" theater stage offered the possibility of an independent and respectable career. Elsa's time in acting school, from October 1894 to August 1895, according to *Fanny Essler,* was as serious as it was intensive, with daily voice and lung exercises to strengthen her projection, speech lessons in front of the mirror to neutralize her northern German accent, dramatized readings in front of live audiences, and finally performance on stage. Fanny studies plays by Ibsen, Goethe, Schiller, Hauptmann, and Richard Voss. Yet even in this protean change of characters, Fanny further permutates her play with identities. Unable to remember her lines on stage, she begins to cross-dress. For the first time in male garb, Fanny lights up the stage and garners positive reviews. A generation before the legendary queen of cross-dressing, Marlene Dietrich (born in 1901), would capture the Berlin stage in male garb, Elsa

Plötz—if we follow the events of *Fanny Essler*—paraded provocative androgyny on Berlin's amateur stage, presenting it in effect as a costume that was more "natural" than the feminine dress.[21] Another influence was the painter Oskar Kruse-Lietzenburg, known as "Onkel Oschen," a well-to-do artist who was known and well liked in Berlin for his spontaneous standup comedy, in which he often poked fun at himself.[22] He was an entertaining friend, but in *Fanny Essler* he pressures Fanny into sexual intercourse.

Unfortunately, the professional stage career plummeted before it got off the ground. About to graduate from acting school, thanks to her aunt's support (and having just persuaded her aunt Elise to pay for the expensive wardrobe that was an essential prerequisite for professional theater work), Elsa quarreled with Elise instead of humoring her: "[I told her] that her objection for my bumming with men was envy of her hopeless spinsterdom. This after all did what the irrigator and clap couldn't: she cast me off—paying out the month to my landlady. [. . .] I for sheer hunger—lost all pride—turning to her to beg for food. It was denied me. I fed by the accident of lovers of the moment then."[23] With the last family ties broken, Elsa's safety net was gone. Barely twenty-one, she was on her own with only herself to fall back on. More positively, though, her freedom to be ignited by the city's free flow of identities was now unlimited. Without missing a beat, Elsa returned to her true mission: self-actualization in her sexual odyssey, with the optimistic belief that good fortune was just around the corner.

In the fall of 1895, Elsa presented herself to Richard Schulz at the Zentral Theater at Alte Jacobstrasse 30, "the most fashionable stage then for chorus girls looking for adventure and money—and I was engaged, with not a sound in my throat nor note in my ear—but I was handsome—with a straight figure and nimble legs."[24] The chorus girl inhabited an interesting liminal status similar to the Ziegfeld girls on Broadway. She was hired more for the visible effect on stage than for her musical talent but had much more

prestige and respectability than the vaudeville or burlesque show-girl. As Linda Miszejewski writes in her study on the Ziegfeld girl, the European and American popular media also began "to play up stories of the chorus girl as a titillating version of the era's New Woman—bold, independent, and modern in her attitudes toward men and fun."[25] The chorus girl was seen as a fabled springboard for women's careers, as described, for example, in Theodore Dreiser's first novel *Sister Carrie* (1900), in which the pretty but relatively talentless actress Carrie Meeber is launched from the chorus into mass celebrity in New York—with the popular media speeding on her success.[26]

Yet the chorus girl who never made that transition remained in her liminal position wearing her often risqué costume. Also, if we follow her behind the scenes, we find a colorful, slightly notorious locale in which she may (or may not) supplement her income with work in the sex industry. In *Fanny Essler*, we see the seedier side of this world that required tough negotiations with male *souteneurs*. The women regularly complained about sexual exploitation. At the borderline of the theater and sex industry, this world produced its own unique stresses. In the novel, Elsa's alter ego eventually reacts to these stresses with psychosomatic nausea and weeping fits, the same symptoms that characterized Elsa's tension-filled childhood. Elsa reacted to the stresses with compulsive shopping, as the Baroness noted that in Berlin "in the days of my girl vagabond life—when I had to forget a hurt of being meanly treated—[I] sometimes spent my last penny [shopping]."[27]

The all-female world of the chorus girls was also an arena for experimenting with lesbianism. "I was always suspected—in the silly way stage people have—of being 'homosexual' too," recalled the Baroness about this theater experience. "I wore a monocle by fancy—I didn't put it in the eye—I *couldn't*—just letting it hang."[28] The monocle and the erotic lilac were favorite symbols for *Freundinnen* to recognize each other (although Elsa's monocle

was also reminiscent of her formidable stepmother's power, a power she was appropriating with this symbol). Berlin's women were at the avant-garde in exploring lesbian identities and lives, as Doris Claus writes in her study on *Lesben* in Berlin, documenting that since the early 1890s, Berlin's vibrant women's subculture developed its own codes and symbols, shaping an identity for themselves and carving out a recognizable network and space for women in deeply homophobic Wilhelminian Germany. Since 1871, Paragraph 175 of Germany's criminal code prohibited male homosexuality, but lesbian sociability was thriving in Berlin. Women openly and proudly celebrated their pleasure in monocle balls, lilac balls, beach balls, costume balls, and cabaret balls that featured lesbian performers.[29] As for Elsa, she was happy to spend the night and experiment with new pleasures with one of the bisexual chorus girls, only to proclaim somewhat flippantly after, "our *one* night together did not convince me of the thing,"[30] flirting with the lesbian identity without committing herself.

Indeed, Elsa's gender fluidity was emerging as a trademark. With her slim waist, the virtual absence of breasts, and her short hair, she was the quintessential androgyne or *arsenomorph*, combining female and male elements. In *Fanny Essler,* her alter ego is called "lad" (*Junge*) because of her body's boyishness.[31] Her thinness further underscored her androgyny: she smoked cigarettes but ate only sporadically, often starving herself for lack of money for food. She intensely rejected biological motherhood in her life and identity: the idea of a baby "should have surprised me up to madness," she declared, "for I did not acknowledge children."[32] Still, this proclamation by a sexually hyperactive woman is all the more baffling as conventional safety and precaution were not an integral part of the young Elsa's sex life. Contraceptive devices were illegal at the time, available only through the underground market. In light of Elsa's lack of self-protection and naiveté in pragmatic matters of sex, the fact that she never became pregnant or worried about pregnancy

may be due to physiological and health reasons; her low body weight and encounter with venereal diseases provide possible explanations. Her ability "not to acknowledge children" ultimately endowed her with the sexual freedom of a man: the only real threat she faced was venereal disease.

Already in 1894, her sex adventures in Leipzig and Halle had left her with "'the clap,' something quite new to me—disagreeable—yet after all unavoidable. Every silver cloud has its sable rim," as she retrospectively noted in her memoirs. "Wounds that—after healing—made one more fit—blood of dragon—love—turning one immune from injury."[33] What for others was shameful, for her became part of her self-armoring, endowing her with formidable strength; she was like the ancient warrior heroes, like Achilles who immunized his body for battle; or like the ancient Amazons, who amputated one breast to become better fighters. In her wild journey through a polymorphic sexual landscape, Elsa ultimately practiced a self-armoring of body personality that turned her into an erotically charged warrior of sorts. She was a strikingly modern Amazon whose approach to sexuality was more aggressive than seductive, who conquered sex by fighting her way through the sexually charged city.

Sometime in early 1896, Elsa's life on the borders of theater and sex industry was brought to an abrupt halt, when she discovered the symptoms of syphilis on her body. Her journey now took her to chonthian depths, an underworld of sorts. She had hit the proverbial rock bottom, "like a doomed animal in shambles—stunned to all feelings—absolutely shameless." With no money or support system, she checked herself into a public hospital, hungry, tired, and shocked by the stigma. The physician diagnosed the condition as "secondary" syphilis, as the Baroness recorded, "which translated meant: inherited."[34] One wonders here whether this translation was provided by the physician or by the Baroness. For secondary syphilis does not imply congenital but indicates the second

of the four stages of syphilis, a stage in which the body is typically "marked by a skin rash characterized by brown sores about the size of a penny" (a symptom confirmed by the Baroness's references to her sores), as well as being weakened and infectious.[35] Although the disease was highly stigmatized at the time, contemporary feminists in Europe—and Hendrik Ibsen's *Ghost* (1881), a play performed on Berlin's Freie Bühne from 1889 on under the German title, *Gespenster*—were drawing public attention to the plight of married women who unknowingly contracted the disease from their husbands. Elsa's focus on congenital syphilis—that is, contracted by the infant at birth—may result from this heightened awareness, as well as further heightening Adolf's crime as the sexually aggressive and irresponsible male. Still, ultimate evidence for Elsa's congenital syphilis is missing. Indeed, it would be rare for symptoms to first show up in adulthood (they generally show up in the infant within the first two years of life), although we cannot entirely exclude the possibility that Elsa was treated as a child (see chapter 1). Syphilis can affect a woman's ability to become pregnant and can lead to infertility, thus providing another possible explanation for the absence of even a single pregnancy in Elsa's energetic sex life. The mercury treatment that Elsa would have undergone was aggressive and unpleasant, but Elsa's constitution being strong, she was fully cured within six weeks. There is no indication that the symptoms returned or that she became infectious over the next years.

As for the psychological dimensions of this disease, she had successfully transformed the stigmata into armor, using this traumatic experience as a psychological self-immunizing. Elsa did not "work through" trauma but stored its memory on her body. The ultimate stresses and wounds, psychological and physiological, were thus recorded as corporeal memory. At the end of her six-week treatment, she emerged triumphant.[36]

Still, her temporary exile in the public hospital's "blue-white barracks" of infamy marked an important turning point. After two years of random sexcapades, of intense life close to the brink of self-destruction, burning the proverbial candle at both ends, Elsa had gone through a trial by fire in her initiation in the modern city—and she had triumphed. She now had an extraordinary story to tell and, jolted by reality, forced herself to slow down—just enough to recognize that a change of direction was needed. Her time of urban apprenticeship was over. In the spring of 1896, once again strong, she was determined to make a fresh start, ready to follow her life's calling (although she did not know yet what that call was). After having settled into a nicely furnished room with her mother's posthumous help of a small inheritance, a chance meeting now became her springboard into a new life. "After my release I found myself in the middle of spring and a boon of 150 M, interest of the small fortune of my mother's [. . .]. Some days later, I met my first artist friend."[37] This chance meeting with Melchior Lechter, a central figure in the new avant-garde movement, now propelled her into a new world of art and artist lovers. At age twenty-one, she was about to discover her life's calling and her spiritual home among the esoteric avant-garde circle led by its mysterious *Meister,* Stefan George.

**The New Woman and the
Stefan George Circle**

Chapter **3**

In 1892, a year before Elsa Plötz arrived in Berlin, the charismatic poet and translator Stefan George (1868–1933) (who incidentally shared his 12 July birthday with Elsa) launched the *Blätter für die Kunst,* a new literary journal that marked the birth of Germany's new avant-garde. A linguistic prodigy, as Peg Weiss writes, "George probably did more for the German language than any poet since Goethe and Heine."[1] Indeed, he revolutionized German poetry with a new style called *George-Stil:* he spelled all words in lower case letters, like English orthography; he omitted all punctuation, stripped his poetry of prepositions, and joined verbal images in a web of striking neologisms. His new style performed a modernist dismantling of rigid language structures; Weiss compares this style with the modernist painter Vassily Kandinsky's thick web of symbols in visual art. His handwriting, too, was innovative: his handwritten letters were printed, as if carved by an engraver, suggesting that the inspiration for the Baroness's deeply carved handwriting lies here. His poems were printed on expensive paper and his book covers were decorated by Melchior Lechter with rich visual ornaments.

George's drive for cultural renewal entailed experimentations in personality, gender, and social codes. He injected art into quotidian life and consciously cultivated a new style of living. In the wake of Oscar Wilde's homoerotically charged *l'art pour l'art* aesthetics, George was the quintessential dandy, although he was Germanically self-serious, lacking Wilde's irreverent humor. A modern wanderer, he refused to have a permanent residence but lived with his friends: Reinhold and Sabine Lepsius in Berlin, Karl and Hanna Wolfskehl in Munich, and others in Darmstadt, Heidelberg, and Switzerland. He cultivated a network of friends, and by 1895, he had become the center of a male circle—Lechter, Wolfskehl, Friedrich Gundolf, and Albert Verwey—that was gathering momentum in Germany. Young disciples would soon sign up, proudly calling him *Meister* and emulating his style. Ambitious, daring, and international; fiercely antibourgeois and anti-Teutonic; but traditionally

hierarchical and exclusive in their self-perception as members of a new spiritual aristocracy—these symbolist apostles fervently dedicated themselves to revolutionizing German culture with Nietzsche's *Zarathustra* as their guidebook. As a secret society of sorts (*Das geheime Deutschland*), they were committed to overcoming bourgeois norms and overthrowing their symbolic fathers.

George's image was invariably associated with the young ephebes, the quintessential pretty boys (figure 3.1). His young disciples included Friedrich Gundolf, a lifelong friend, and Maximilian Kronberger, who died at age sixteen in 1904. Schmitz, an avid socialite and gossiper, recalls the rumors that circulated about George. According to one tale, George read his poetry at midnight in the Lepsius home, "sitting on an ivory throne, surrounded by

3.1 *Stefan George as Dante* (left), *Maximilian Kronberger,* (second from left), *Karl Wolfskehl as Homer* (second from the right), in Herr von Heiseler's home in Munich on 14 February 1904. Photograph by Richard F. Schmitz. Deutsches Literaturarchiv, Marbach am Neckar.

nude ephebes, and enveloped in waves of incense." Wolfskehl, George's most energetic promoter in Germany, cultivated such erotically charged legends: "I hope you did not deny it," he said to Schmitz about the Lepsius story.[2] Although George was discreet about his private life and sternly admonished against the expression of passion in poetry, his disciples turned the *Meister* into a larger-than-life figure of emulation. Indeed, an uncritical personality cult centered on George, and an authoritarian power hierarchy excommunicated members who voiced even the slightest critique of George or Lechter. The victims of excommunication included the ephebic Roderich Huch, *der Sonnenknabe* (the sun-boy), who was expelled after he refused George's command to undress himself in public (possibly as part of a ritual).[3] Oscar A. H. Schmitz was ostracized after publishing a critical review of Lechter's Paris exhibition. "The circle had been my lifeline and I was suddenly cut off from it," Schmitz lamented after having rubbed shoulders with George in Berlin's Café Klose.[4] The *Blätter für die Kunst* cultivated George's *Herrenmoral,* pressuring authors into incorporating the Meister's ideology and aesthetics. Women were excluded from the *Blätter* during its publication run from 1892 to 1919.[5]

Into this avant-garde group exploded Elsa Plötz, the sexually charged mischief maker in search of a new identity. Although it is unlikely that she was ever introduced to the Meister himself (only proper ladies were introduced to him), she now infiltrated George's (homo)erotically charged circle with her unconventional sexuality and her extraordinary life story. As she infused the circle with her life's adventures, George's young disciples and veteran artists alike—including Lechter, Ernst Hardt, Schmitz, Wolfskehl, and Greve—were magnetically attracted to her, as Schmitz wrote in his autobiography *Dämon Welt* (1925): "After working as an actress for a while she was discovered by a member of the 'circle.' She went from hand to hand in the circle, completing within a few weeks with typically feminine ingenuity her half-education by assimilating

the jargon of the circle, so that she was given the nickname 'darling of the guild,' a phrase drawn from George's *Tapestry of Life*. She was an intellectual, hetaera-like woman, yet her one passionate love to a member of the circle seemed to have drained her emotional life. She became more and more calculating, exploited men financially, physically, and spiritually, and created a great deal of misfortune."[6] Within the circle, she would soon be mythologized and demonized, elevated and degraded, feared and ridiculed. As confident New Woman, she confronted the male circle's world of sexual experimentation—its homoeroticism, fetishism, voyeurism, bisexuality, and sadomasochism—but also its continued adherence to bourgeois conventions. As model, muse, and artistic collaborator, playing the roles of artist lover, hetaera, dominatrix, and sadomasochistic sex partner, she was about to channel the avant-garde through her sexual system, thereby critically testing its limits, while presenting her life as art.

On a Sunday afternoon, sometime in the spring of 1896, Fräulein Plötz presented herself for tea at the Atelierhaus at Kleiststrasse 3 in Schöneberg-Berlin. It was the home of Melchior Lechter (1865–1937), a man she had met a few days earlier and who was now introducing her to his circle of artist friends. Here she would meet Oscar Schmitz, Ernst Hardt, and Karl Wolfskehl. Lechter (or "Mello," as she nicknamed him) was one of Germany's most renowned Jugendstil artists, a stained-glass artist, book decorator, and graphic artist. He was pioneering new art forms in applied art (*Kunstgewerbe*), injecting art into quotidian living spaces, including his own home, and dismantling the boundary between spatially segregated museum art and everyday artful living. "This was a man— at that time—at the height of his success, which was considerable enough to secure him 'even' the attention of the imperial court," recalled the Baroness, careful to highlight the status of her "first artist friend."[7] He had been recently commissioned to design the stained-glass work for the Romanisches Haus in Berlin; his Pallenberg Salon

windows would win the Grand Prix at the 1900 World Exhibition in Paris. On this first visit, Elsa was nervous, afraid that she might not find acceptance in this extravagant club. Yet she soon felt at home, protected by Lechter. Even a cursory glance at Lechter's correspondence housed in the J. Paul Getty Museum reveals that the Meister, as he was addressed even in friends' letters, was highly respected within the George circle.[8] As his mistress, Elsa Plötz was now propelled into the very heart of the circle. For Lechter's salon

3.**2** *Melchior Lechter,* ca. 1895. Photograph. Deutsches Literaturarchiv, Marbach am Neckar.

on Kleiststrasse was home to a young generation of artists who met to read and discuss Nietzsche and George—as well as their own poetry and plays.

Lechter's apartment alone was worth a visit. An exquisite work of art, it was decorated like a museum, featuring Lechter's own designs in furniture, wall paintings, and stained-glass windows including the famous *Nietzsche-Fenster* (1895). The decorative female figures that adorned his home looked like etherealized replicas of Elsa Plötz: androgynous, slim, with long, thin hands and little crowns on their heads. Lechter also aestheticized his own person, frequently dressing in a velvet gown, although he lacked George's austere elegance. A photograph of the artist in his studio (figure 3.2) reveals his femininity: soft facial features and round shoulders, a long dress, legs crossed, his shoes adorned, and his entire body enveloped by a deep chair with soft curves and flowery ornaments.[9]

As his mistress in 1896, Elsa Plötz assumed a central part of this artistic *Gesamtkunstwerk.* "I was the jewel and precious of his studio; he did homage to me in every way—except the money way," the Baroness recalled. "I was the behymed adoration of his circle—and—I waited!"[10] This was her first experience as the living *embodiment* for an avant-garde art circle, as she now transformed herself artistically. As Lechter's lover, muse, and model, she embodied a strange hybrid of medieval saint and pagan goddess, as documented in Schmitz's "Klasin Wieland," the novella itself based on information provided by Elsa, as we shall see. Here Lechter's alter ego, Emil Remigius, fantasizes about covering Elsa's hands and arms with "barbaric jewels": "Nephrit and purple turmalin seemed to him particularly effective on her skin."[11] For Klasin Wieland, a.k.a. Elsa Plötz, the painter's words were a revelation, an epiphany *(eine neue Offenbarung)*, opening the door into the world of art. Indeed, Lechter admired her deeply, taking Elsa to exhibitions, reading Nietzsche to her, and introducing her to the world of contemporary art. In a moment of weakness he even proposed marriage. Yet tem-

peramentally, they were light years apart, Lechter's world of incense and pagan Catholicism foreign to Elsa's sensibility. And so was his view of women as beautiful symbols whose slim bodies decorated his apartment: "I watched and enjoyed him like a rare bird," the Baroness recalled.[12]

The affair was symbiotic, not passionate, the sex act with Mello lacking excitement. Still, the Meister's sensual theatrics were extravagant. His bedroom was a visual temple of sorts in which sex was mixed with art and Catholicism with paganism, with Elsa functioning as pagan Madonna. In "Klasin Wieland," Lechter's alter ego serves her exotic food. His bedroom, a feast for the eye, is bathed in darkly colored dancing nudes that are reflected from his stained-glass windows; the bed is surrounded by a churchlike atmosphere of

3.3 Melchior Lechter, *Orpheus*, 1896. Oil, 118.5 × 147.0 cm. Westfälisches Landesmuseum für Kunst und Kulturgeschichte, Münster.

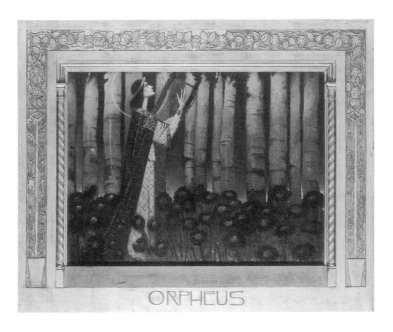

incense and honey-scented candlelight.[13] As part of the sexual ritual, the Meister shows Klasin (Elsa) photographs taken of old paintings and asks her to model the women in the paintings. Scopophilia, or love of the visual, was central to Lechter's sex life. In *Fanny Essler,* Lechter's alter ego derives erotic pleasure from watching Fanny's hands, which she has placed on his Gothic bench against the backdrop of the stained-glass window, presumably the *Nietzsche-Fenster,* designed by the artist himself. While Elsa was taken with the artistic dimensions of Lechter's erotic game and obligingly transformed herself into the Duchess of Ferrara (also alluding to the woman as artwork motif in Robert Browning's well-known poem "My Last Duchess"), Lechter's churchly sex ritual left her cold. She did not love him "as he felt himself loving [her]" and with characteristic directness "told him so."[14]

But she was hooked, body and soul, by the world of art he represented. From now on all her lovers would be artists or would be connected in some way to the world of art. The relationship with Lechter marked another turning point: Elsa's career as model was born. Today, Lechter's *Orpheus* (1896) (figure 3.3, plate 7) is our earliest extant portrait of the Baroness. Orpheus's head in side profile features a strikingly photographic likeness, including twenty-two-year-old Elsa Plötz's nonsmiling austerity, steady gaze, long nose, thin lips, and slight over bite. Although highly stylized, Orpheus also has the model's unusually beautiful hands foregrounded by holding the lyre. On 6 December 1927, just one week before the Baroness's death, Lecher provided corroborating evidence that she was the model, although he does not name her. Writing to his friend Marguerite Hofmann, he announced that in late November he had received a letter from "Frau 'Maria' (the model for the 'Orpheus' head, you will remember). I told you about her. I knew her between 1896–97; then she left Berlin, married, then disappeared; she wrote me again during the war after more than twenty years, then I didn't hear anything for another ten years until this."[15] The dates, events,

writing patterns, and even the Maria pose (recalling the Madonna pose described in "Klasin Wieland"), all match Elsa Plötz's life point by point. That the painting is a stunningly beautiful work of art with an intricate text about gender and art is all the more tribute to model and painter.

Lechter's *Orpheus* presents the artist as an idealized figure—the subject's beauty strangely unsettling in its sensualized hybridity, its fluidity of identities. The title refers us to the mythological Orpheus, the consummate artist figure who was able to move even inanimate objects with his lyre. Tall and bodiless in a green velvet gown with golden speckles, Orpheus holds up his lyre, his face surrounded by a halo, his eyes steadily gazing into a transcendent distance. The body both connects with and elevates itself above the environment, a range of tall, strangely dark flower-trees that suggest a pagan underworld. The stylized angularity of the body's pose contrasts with the sensuality of the colors, the velvety richness of the dress, and the radiant skin of face and hands.

Indeed, the hybridity of the painting is its main theme, purposefully dismantling the conventional boundaries of male/female, Catholic/pagan, transcendent/sensual, and mythological/real and suggesting self-representational echoes. Camille Paglia has argued that "Romanticism uses the androgyne to symbolize imagination, the creative process, and poetry itself" and that the androgyny "belongs to the contemplative rather than the active life. It is the ancient prerogative of priests, shamans, and artists."[16] Lechter's neoromantic *Orpheus* suggests all of this but also suggests more. *Orpheus* is the male artist as androgyne, but this "self-portrait" is superimposed on the portrait of Elsa as the female androgyne striving to enter the world of art. The photographic likeness of Elsa's face in this otherwise highly stylized painting suggests Lechter's tribute to her artistic spirit. She *is* Orpheus, like the mythological singer able to move others through her embodied "art," her life a series of aesthetically lived daily acts. This recognition of her as a kindred spirit may explain Lechter's profound attraction to her, as

well as explaining his offer to continue his friendship even after she left him for another man.

Yet while Lechter thus elevated his mistress/model/-muse, the Baroness's memoirs bring these elevations down to earth with her compelling charge that the painter, "stingy Mello," displayed a convenient blindness to his model's material needs. "Often I went to him for sheer hunger—and secretly he counted on it—since he knew I did not enjoy to run about with other men—after this 'circle' had fascinated me—to keep me thus as cheaply as possible—without [having] the tiniest stir of conscience. This is the way of aesthetes."[17] One anecdote in particular highlights this wrangling for money: "Once upon a time, at that time, when I had persuaded myself through hours of revolt—seeing myself cheaply dressed—neglected—even in the essential part of livelihood—and I hotly desired a certain petticoat, liberty silk—and some other niceties—of course, in an almost unconscious state of mind I went to 'Firma Busse' and bought with wild heart and set teeth goods to the amount of the unheard sum of 60 M, having the package sent C.O.D. to Mello's address."[18] At first shocked and unsettled by the idea that his mistress must have been "selling" herself to be able to afford such finery, Lechter quickly sobered when he realized that the silken fare was his to pay: "with very bad grace he paid the bill the next day."[19] That Lechter should accept Elsa's transition from Madonna to whore so effortlessly is evidence that he remained caught in neoromantic gender traps, where elevation and degradation of the woman are but two sides of the same coin. In *Fanny Essler,* Elsa's alter ego ultimately assumes the role of dominatrix with emotionally dependant Bolle, regularly punishing her lover with sexual withdrawal and icy coldness. After meeting the playwright Ernst Hardt, Elsa dropped the Meister with an abruptness that speaks volumes about stored up resentment.

Elsa also began a dalliance with Karl Wolfskehl (figure 3.1), the tall and handsome scholar who had recently com-

pleted his doctoral thesis in German (hence her nickname "Dr. Phil"). Wolfskehl's wealthy background allowed him to finance the publications of George and others, thus making it possible for avant-garde poetry to be published independently of bourgeois or commercial tastes. Even though officially Lechter's mistress, Elsa "tested" him through the only tool available to her—sex—a hilarious misadventure reported in her memoirs: "Dr. Phil . . . was a pure Jew—he had interested me merely as interesting type new to me— he had left no impression—of either desire or disgust but only amusement—for the simple reason—that there never had been sex

3.4 *Ernst Hardt,* ca. 1910. Photograph by Rudolf Dührkoop. Deutsches Literaturarchiv, Marbach am Neckar.

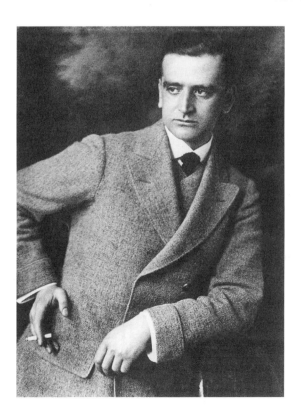

intercourse—only attempt—since his penis was of such surpassing size—unexpected even in a man of his tall build—as I did not know then of this oriental trait—entrance was bodily prevented."[20] For Elsa, the situation could be saved only by peals of laughter, making the embarrassing situation all the more dramatic for Wolfskehl, who was tortured by guilt. That she read the misadventure along racial lines and fantasized a heightened "oriental" sexuality into Wolfskehl shows her replicating the ingrained prejudices of her time and culture.[21]

Although Elsa Plötz had had plenty of sex since coming to the big city, she was still a virgin in love. And like her mother she was in her twenties when the first *coup de foudre* struck. In the summer of 1896, she met the playwright Ernst Hardt (1876–1947). Both were "in the last glamour of adolescence"—Elsa twenty-two, "Erni" twenty—and soon they were gloriously in love, "it was love'—emotion—motion."[22] Hardt's portrait photograph of around 1910 (figure 3.4) shows Lechter's opposite. Lechter is feminine and almost bodyless, consuming little space in his chair; Hardt looks virile and in charge. The pose—with one hand on the hip, holding a cigarette—speaks of the executive power of a man who knows what he wants and who gets it. Where Lechter was surrounded by flowery ornament, Hardt is wrapped in a sturdy thick coat of stiffly coarse fabric. "With pity I remembered Ernest's [*sic*] attempts at being elegant," wrote the Baroness.[23] He was a handsome man, though, debonair, slightly diabolical with a steely gaze and square jaw—the Hemingway-type of good looks.

Alas, the "first flaming love of my youth,"[24] as the Baroness describes his role, was a wolf in sheep's—or artist's—clothes, a man given to subtle and not so subtle cruelties that are strangely reminiscent of Adolf's misogynistic treatment of Ida, although Schmitz describes Hardt as a feminine, "mentally refined young man."[25] Her brilliant passion was often strained to the breaking point, as this romantically intensive affair brought with it painful

complications. For several years her poor but socially ambitious lover had been engaged to be married to Polyxena von Hoesslin, the daughter of a Greek minister. Despite his physical passion for Elsa Plötz, he was not prepared to risk his brotherly love for and lucrative prospects with Polyxena, who was patiently waiting in Athens. Moreover, there were Hardt's homoerotic leanings (a "spiritual homosexuality," as the Baroness put it), presumably with Botho Graef, an archeology professor in Berlin, whose permission Hardt asked for when Elsa was to accompany him to a gathering: "Would you be offended if I brought Else?"[26]

And more disappointment lay ahead. Hardt was an abusive lover, taking her back to the tensions of her family history. In "Once upon a Time There Was an Ernst," a German poem written in the satiric style of Wilhelm Busch, the Baroness retrospectively charged: "yet with excessive blows, / he used to whack me on the nose," her combination of easy rhyme and slang exposing the neoromantic poet's very nonpoetic violence with sardonic wit.[27] Schmitz documents that Ernst occasionally made use of a whip and routinely humiliated her with the "impurity" of her sexual history. "He beat her and let her go hungry. Ostentatiously he placed the picture of his bride on his desk and put Klasin's [Elsa's] photography above his bed. 'You belong only in the bedroom,' he told her."[28] In the first year of their affair, Hardt had entered George's *Blätter* with a first publication and was pedantically conventional in order not to jeopardize his success. Although painfully aware of his disrespect, Elsa was unable to give up her passion. "Clairvoyantly almost I noticed all his pretences, imitations, and flimflam lack of all true quality—the person growing fat on easy pretence of beauty," as the Baroness put it; having decided to become a "society pet," he had sold his soul but was no artist.[29] "I cannot digest his poems," she wrote, comparing his verses with the "chattering" of Karl May, the writer of bestselling romantic novels for juveniles.[30]

Their affair ended in the summer 1898. It "had lasted for
two years—could last no longer—unless by marriage," as the
Baroness recalled. "Though at last he was willing [to marry], [it] was
a thing practically dreaded."[31] The end came with a cruelly dramatic
climax befitting the bitter dalliance, as she left him after "an instant
of the most outrageous conduct on his part towards me, instigated
by his own indecision of action, snobbishness, weak character—de-
pendence on convention that he pretended to scorn, yet dreaded
from outside."[32] Unlike her mother, she was able to escape the abu-
sive relationship and did so by leaving an indelible wound in her op-
ponent: she eloped with his friend, Richard Schmitz, now using a
cruelly painful triangulation scheme of her own. It was here, then,
in the seeming coldness of a vengeful act, that Elsa Plötz's reputation
as a "mean" woman was born. After some off-on wrangles that fol-
lowed, the two lovers finally parted.

But they were not yet done with each other. In years to
come their conflicts flared up in art, now infusing the public arena
with a fierce artistic debate surrounding Elsa Plötz's New Woman
sexuality at the dawn of the new century. In 1903, now married to
Polyxena and commuting between Athens and Berlin, Hardt pub-
lished a highly colored account of his relationship with Elsa Plötz in
an ironically titled play, *Der Kampf ums Rosenrote* (The struggle for
the rosy red). The play premiered on the stage of the Deutsches
Theater in Hannover on 13 February 1904. In it, Hardt presented
his own alter ego in the Teutonic figure of the up and coming actor
Vult von Bergen, who dreams of marrying the respectable and vir-
ginal Frieda (Polyxena). Then he meets Käthe (Elsa), the name al-
luding to Shakespeare's Kate in *The Taming of the Shrew* (suggesting
that Elsa needs taming). The play allowed Hardt to "work through"
his loss of Elsa Plötz, as seen in his unequivocal love declaration:
"You are the garden in the midst of my desert, a garden full of roses,
violets, and jasmines," says Vult/Ernst to Käthe/Elsa. "I called you

'my life' and thinking of you pressed my head against your hot womb."[33]

Yet the play presented a misogynist and reactionary response to the fin-de-siècle New Woman. Hardt essentially argued that a woman like Elsa Plötz was not the type of woman that a genteel man, not even a modern man, could be expected to marry. Käthe is reduced to a figure of pathos similar to Dostoyevsky's virtuous prostitutes whose ultimate fate lies in glorified self-sacrifice that makes possible the salvation of the male hero. Käthe sacrifices her dignity by going back to her former lover to ask for money when Vult becomes sick. She finally sacrifices her love when she voluntarily leaves Vult just at the convenient moment when his career takes off, so that he is free to marry the respectable Frieda and reconcile with his exacting father. Yet besides echoing real life—in November of 1899, Hardt had married von Hoesslin after a seven-year engagement—the logic of his shamelessly glorified self-portrait as artist-genius required that he maintain strategic silencing of his homoeroticism, his attraction to Elsa's androgyny, and his physical abuse of her. For Elsa, the casting of her glorious love in the mold of the virtuous prostitute and stepping stone for the male artist must have rankled deeply.

She struck back two years later in *Fanny Essler* (1905) with the help of Greve. A satire against members of the George circle, the novel's more specific target was Hardt. In a scandalous tell-all style, the novel struck at the heart of his self-adulation in *The Struggle for the Rosy Red,* a work openly lampooned in the novel as *The Struggle for the Violet Blue.* After establishing Hardt's alter ego with photographic accuracy in the figure of Ehrhard Stein (*Ehre* = honor; *Stein* = stone), the novel proceeded to throw the harsh light of naturalist realism on Hardt's carefully hidden shadow self. The novel provided a deeply embarrassing laundry list of evidence for his everyday pedantry and cruel humiliations, as in this lovers'-quarrel scene:

"You are disgusting!" he said, and flung her away. Fanny fell back, crying loudly again. He angrily put his hand over her mouth. "All of this is simple theatrics!" he blurted out. "You only want me to hit you again! And the fact is that you drove me to it!! I am disgusted with myself. And you're to blame! You just want it that way!" [. . .] Fanny began to cry afresh. At that point blind rage overcame him. He lunged toward the washstand, grabbed a pitcher, was back at the bed in one leap and poured the water over her face, neck, and breasts.[34]

Fanny is described as complicitous in this sadomasochistic relationships ("his brutality was a comfort to her"), and such internalized masochism is not unlikely for the woman behind the text, given her abusive upbringing. Yet the novel's unequivocal purpose was the public shaming of the abusive lover. In a moment of sweet revenge, Hardt was portrayed as a bad lover who left his partner sexually frustrated and who thus joined the group of "half-men" who were unable to provide the protagonist with sexual pleasure. Although Elsa had felt passionate love, orgasmic jouissance was still elusive.

The novel was all the more humiliating for Hardt as it was read by all the members of the circle. Hardt's friends dismissed the novel and expressed discreet support for the injured party as seen in Behmer's 19 February 1907 letter to Hardt: "If Else Ti has not yet become a whore despite her whorish nature, she has now found her pimp who is prostituting her more than if he had her mounted at 50 Pfennig per trick."[35] In a gesture of male solidarity, Behmer did not even mention Hardt's less than flattering part in the novel. This novel performed a public shaming function but did not ultimately jeopardize the trajectory of Hardt's career as theater director in Weimar (1919–24) and Cologne (1915–26) and playwright with performances in Leipzig, Vienna, Berlin, Hamburg, and Weimar (although his plays are rarely performed today). Elsa stirred up tem-

porary trouble, but male interests and prerogatives were quickly protected.

■

"To Italy—I lived there for two years in ample comfort—had a splendid studio—took modeling lessons for wiling away time mildly interested." So the Baroness recalled her life with the student and sculptor Richard Schmitz (1880–1950) from 1898 to 1900, an interlude of peace and comfort in the stormy odyssey of her life.[36] Escaping her failed romance, she traveled first to Switzerland and then headed south, where she stayed until the century's turn. Like Calypso for Odysseus, so Richard provided maternal support for Elsa and looked up to her as if she were a goddess. "I was indulged in all my wishes," the Baroness recalled.[37] Financially and emotionally pampered by Richard, a man six years younger, she had firm control of this relationship.

The little we know of the sculptor (and photographer) Richard Schmitz is tantalizing. He was affluent, his father, a Frankfurt railway director, having recently passed away. After studying engineering and architecture at Karlsruhe University, he discovered his passion for painting and sculpture. He suffered from a physical affliction that affected his romantic life, as the Baroness recalled: "He was distinguished and decorated in my eyes—though disfigured and stigmatized in all others'—by one of these purple violet firemoles—that never again I did behold in such glory of colour and expansion. It covered more than half of his whole face taking in the nose and whole mouth—leaving only one eye and cheek to its natural proportion and complexion."[38] This stigma may explain why no photographs are available of him. In Elsa he found a kindred spirit, probably the first woman to turn his affliction into fetish attraction, "an enticing plaything to touch—kiss—pat," even something to be proud of, "some outer sign of distinction, like ribbon of an

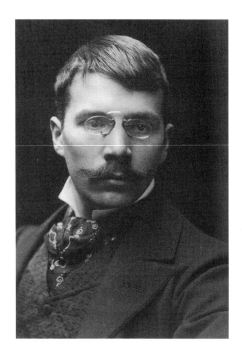

3.5 *Oscar A. H. Schmitz,* ca. 1900. Photograph. Deutsches Literatur-
archiv, Marbach am Neckar.

order."[39] Still, sexual relations, promptly initiated by Elsa, proved
disastrous with the relatively inexperienced Richard. To preempt
the daily stress of Elsa's unsatisfied libido and the ensuing tantrums,
Schmitz suggested a platonic relationship that generously conceded
Elsa her sexual freedom.

Still, their peace was short-lived. Oscar A. H. Schmitz
(1873–1931), Richard's older brother, arrived for a visit in Naples in
August, at the height of summer. His gentle brother's opposite, Os-
car was driven by demons of addiction, hence the title of his mem-
oirs *Dämon Welt* (Demon's World) (1926), in which he detailed his
adventures as an inveterate womanizer, experimenting with sex, psy-
chedelic drugs, and gambling. Photographs show a monocled and
moustached man, self-serious and critical (figure 3.5). His intimate

knowledge of the George circle has left us with some superbly detailed portraits—including some extraordinary details of Elsa Plötz at age twenty-four. Baffled by her unconventionality, he promptly recorded his impressions in his unpublished journals and his published texts, *Dämon Welt* and "Klasin Wieland," the latter using fictional names but overlapping verbatim with his journal accounts.[40]

Her eyes "were of an ice-cold grey-greenish color," he recorded in *Dämon Welt,* her body "superbly formed,"[41] while in "Klasin Wieland," he painted this rare portrait that allows us to date the beginning of the Baroness's original body constructions to at least 1898, if not earlier:

She had an unusually hard, but almost beautiful face, arranged in quattrocentric fashion, perhaps to please Leo [Richard]. Her straw-colored hair lay tight around her temples, the head covered by a somewhat adventurous panama hat, as if she despised the decorative frills of loops and flowers that adorned ladies hats à la française. Her clothing was austere, which suited the thin lips and the strong, but well formed hands. The boots were superb, with masculine cut. She was not heavy, even though she wore unusually heavy jewels, an antique signet ring so large that it seemed to contain a secret compartment for poison, two earrings in form of old Greek oil containers made of tigered stone and a rosary-type necklace made of little nut of corals, amber, and all sorts of semi-precious stones, green-shimmering opal, perhaps glass flux. Although she seemed to despise any sensually attractive charm, she was more provocative than the sweet pastel beauty of the courtisan.[42]

Already in 1898, her extravagant style was well established. Jewels, colors, and dress present a person who sets a fashion rather than following it. The boots mark her as androgynous. The necklace was of unusual forms and colors, and the earrings in the form of Greek oil containers intriguingly suggestive of the everyday object, although

they were made of precious stone. In another vignette in "Klasin Wieland," she wears a dress of oriental fabric, held together below the breasts with pistachio-colored band. Her arms, throat, and hair are adorned with meadow-green chrysoprase. A work of art, Elsa Plötz no longer embodied Lechter's pagan Madonna or the Duchess of Ferrara but had created her own artistic style. Klasin is an applied artist, "fashioning original ornamental designs that she planned on having stitched on her clothing"; she draws and she paints with watercolors.[43] Indeed, Klasin is a larger-than-life hetaera-teacher: "I have learned a great deal from her artistically, for she possesses a knowledge that dwarfs mine," says Leo (Richard), highlighting that she is "never conventional." They are the center of attention wherever they go: "the doors to private galleries are opened for her, in Florence we were allowed to go to theaters free of charge."[44] Although the Baroness was self-deprecating about her artistic development during this Italian period, the otherwise critical Oscar Schmitz described her artistic knowledge and taste in art as impressively mature.

Indeed, in Naples she performed a stunning protodada intervention when she enforced her entrance into the pornographic cabinet of the Naples museum. With ostentatious gestures she quickly overwhelmed the guard stationed here for the specific purpose of keeping women out. She was not an Italian woman and thus would not suffer from viewing the materials inside, she declared before marching into the forbidden cabinet, with Richard staying behind to calm the bewildered guard with a generous tip. "Inside she inspected the collection of phalluses with calm objectivity, as if they were antique lamps."[45] Anticipating the female bravado of her later performance art, she intruded into a forbidden space and claimed her female right to view sexual subject matter, just as she would later claim her right to read the sexually explicit *Ulysses* in New York. Ultimately, her insistence on viewing the phallus was an attempt both to appropriate it and to relativize it by lifting the veil of mys-

tery that protected its power as a cultural symbol. Viewing the phallus *objectively* made it a literal object, while the female pleasure derived was not primarily hedonistic (where she might lose herself) but cognitive (where she remained in control). That her intrusion into the pornographic cabinet should be an enforced "penetration" into protected male space was an early trademark: a striking and scandalous assault, strategically performed in front of a baffled and flustered male audience. This was her signature act in the war against bourgeois conventions.

The next day took the threesome some fifty kilometers from Naples to Sorrento, a resort with rich cultural echoes, for Nietzsche had been here twenty years earlier. The atmosphere could not be more Italian or more romantic, as they lodged in the legendary Cocumella Hotel built in the sixteenth century as a Jesuit monastery, surrounded by lemon and orange trees, with a gorgeous view of the Bay of Naples and Mount Vesuvius. The individual rooms were built into vaulted cells, their ceilings painted like churches. Stairs cut into the rocks led from the hotel down to the beach where they cooled down on the warm summer nights.

Against this sensual backdrop, "Klasin Wieland" gives us some rare glimpses into Elsa Plötz's seductive style. "I can easily fall in love with just one truly distinctive feature," Klasin tells Lothar (Oscar), suggestively touching the hair on the back of his hand, identifying the spot she was attracted to.[46] Klasin fantasizes about dressing up as a boy and exploring all layers of a southern Italian city.[47] An expert in love psychology, she invites open and intellectual discussion of sexual matters. Yet her banter becomes aggressive and confrontational, when she tries to rouse Oscar's desire for a young Italian woman in the neighborhood. Suspicious of her powers, he keeps his distance, but she finally makes him yield by telling him the sexual adventures of her life, what Leo calls "her novel." "How you have lived your life," Oscar's persona exclaims after having listened to her life's tales until deep into the night, suddenly

recognizing her as a kindred spirit, indeed, as his superior in satisfying her thirst for experience."[48] The novella highlights the artfulness of Elsa's life—life lived as a work of art.

At the same time, Oscar was profoundly unsettled. "Didn't he hate the intellectual woman?" the womanizer had mused earlier in "Klasin Wieland."[49] Lothar finds Klasin too dominant, her little dog too spoilt, her intrusions in his brother's life too demanding, her voice too hard, and her temper too destructive. In anger, she destroys one of Leo's paintings. Still, witnessing her destruction, Lothar is aroused by the idea that this willful woman could be tamed with a whip like Kate in Shakespeare's play. After encouraging his brother to assert himself by punishing her physically, he soon overhears the sounds of a violent fight, with chairs falling and voices screaming. Soon after Klasin storm out of the room visibly upset and facing Lothar: "'I have been punished,' she called out laughing and crying with both rage and tenderness. Her expression was almost childlike. 'But I know who is responsible for this. It's you . . . you.' Lothar was intoxicated just looking at her. Like a maenad trembling with lust and pain she came toward him. 'Oh you . . . ,' she cried suddenly, her rage triumphing and Lothar felt a burning slap on his face, so that his monocle fell and broke in many splinters."[50] In *Dämon Welt,* the scene continues like this: "I grabbed her instinctively by her cool arms. 'You are hurting me,' she moaned. 'On your knees,' I whispered, but suddenly I held her in my arms and wanted to kiss her."[51] The sexual scene is interrupted by his brother's return. While the novella diplomatically omits the one-night stand that follows, Schmitz's unpublished diary unequivocally reveals his shame and ambivalence about having had sex with her:

There [in Sorrento] I had the experience with Else Plötz, so embarrassing [*peinlich*] for me today; she had come there with Richard to meet me. She immediately began to flirt with me; Richard almost played her into my hands. We cheated on him but did not love each

other enough to escape together. A mad, superb night at the sea. The Vesuv and the lights of Naples lay beyond. We told each other in this moment: this is and will be our most beautiful hour. And from there on everything was really ugly and mean. [Quick departure.][52]

The embarrassment and shame surrounding this experience—the German word *peinlich* contains the word *Pein* (pain)—are a striking confession for this Don Juan womanizer, a man who detailed an abundance of sexual affairs in his memoirs, some of them accompanied by ugly conflicts, jealousies, and acts of deceit. The shame, no doubt, is partly the result of his sense that he was deceiving his brother.

Yet Oscar's shame also signaled a more profound wounding of his ego. Several years after their affair, now wedded to "Nina," the "severest of all our quarrels" would be caused by his wife's violent bouts of jealousy about Elsa Plötz, whom she "instinctively hates," although Oscar had had no sexual relations with her for years.[53] His wife's "senseless rage" about Elsa speaks volumes about her role as threatening fantasy object in the Schmitzes' lives. In contrast to Hardt, who used his art to strip Elsa Plötz of her power, Schmitz configured her as a formidably powerful hetaera. In his life, she contrasts with Nina, a pretty woman "without independent culture and character," as Schmitz put it bluntly, but whom he was not afraid to marry and live with (although the marriage was brief).[54] In the final scenes of "Klasin Wieland," Elsa becomes the center of her own artist circle, like Stefan George gathering disciples around her: "She had a circle of young artists and students around her who supported her and who satisfied her almost feverish drive for knowledge, while she was their great inspiration for work."[55] Recent feminist studies have recuperated the power of the ancient hetaera. "They were intelligent, witty, articulate and educated, the only women in Athenian society allowed to manage their own

financial affairs, stroll through the streets anywhere at any time," writes Jess Wells.[56] The hetaera's impressive power resided in the union of the sexual and the intellectual, as the feminist theorist Shannon Bell notes about one famous hetaera: "Aspasia ran a 'gynaeceum' for prostitutes where she taught rhetoric, philosophy, religion, poetry—not only for prostitutes but also to statesmen, including Pericles and Alcibiades, and philosophers, including Socrates."[57]

Schmitz's ending turns Klasin Wieland into a cold *objet d'art,* a "white hard silhouetted body which reflected the moonlight like marble."[58] Schmitz thus ultimately erected safe boundaries between the sexual and the intellectual, boundaries that Elsa Plötz consistently collapsed in her self-performances. He oscillated between mythologizing Elsa in his published novella and demonizing her in his private journal. In 1905, he sent *Der gläserne Gott,* with "Klasin Wieland," to Felix Greve, who was now living with Elsa. Greve praised the manuscript as "Schmitz's best," writing that he enjoyed "the amusing stories," as "did [his] wife."[59] No mention was made of the deeply personal connections. Compared with *Fanny Essler,* which was in press, Schmitz had presented Elsa as a more powerful figure: an artist in her own right.

So what did the Baroness think of the Schmitz brothers? She did recall "one very brief strangely luminous romantic affair in Siena with a Sicilian nobleman by the appropriate name of Achilles," but referred to Oscar only in passing as Richard Schmitz's "ambitious moneyed brother," without mentioning their affair.[60] Oscar was a footnote in her life—Richard Schmitz being the more important emotional anchor. After a full year of wandering through Italy, enjoying Siena in Tuscany, a landscape of old castles, small villages, religious processions, with its Chianti wine roads and olive oil harvests, the platonic couple settled in Rome. In the summer of 1899, Elsa had her own studio surrounded with a garden and fountain on the "Via Fausta before the Porto del Popolo" in Rome.[61]

The atmosphere was ideal for furthering her artistic education with modeling and painting, while Richard Schmitz was becoming very serious about his artistic career as a sculptor. In this art-filled world, it was perhaps appropriate that Elsa, now twenty-five years old, began an affair with a German art professor, a sculptor. He was between forty-five to fifty years old, her father's age, with a reddish beard and "dignified in Teutonic fashion": "He always was secretly slightly ridiculous to me—but—I was passion deserted—took him: partly for vanity—partly for curiosity—spleen."[62] In the catalogue of her sex adventures, it was the only affair with a much older man. Perhaps she was getting tired of her priapic journey.

"It was in the winter of the century-turn 1900—and I told Richard I wished to go to Munich alone—to feel entirely independent—and look for a husband under the artists," the Baroness recalled in her memoirs.[63] Although the affluent Schmitz now offered marriage, it was not in her nature to settle. Had she accepted his offer, she could have had the type of unconventional marriage that Lou Salomé was sharing with her husband Friederich Carl Andreas, a sexless marriage that seemed to allow occasional sexual experiences with other men.[64] Compared with Salomé, Elsa Plötz was at once more traditionally romantic and more risk-taking. She wished for an "honest marriage—in mutual passion and respect—for I wished to test this much famed state of its gratuitions—no makeshift." She also appeared less calculating than Oscar Schmitz's earlier picture charged: "I did not wish to put Richard in the light of a pitiful human monster that was used by his deceitful wife for money—as by his appearance would have been an unavoidable conclusion of everybody."[65] Once again, it was her mother who posthumously made her daughter's choices possible. With the newly gained financial independence, her mother's heritage having come due to her, as her father's letter informed her, she parted from Richard in 1900, "as passionate friends."[66] Richard left for Egypt, Elsa for Munich, Germany's new avant-garde center.

Munich's Dionysian
Avant-Garde in 1900

Chapter 4

At the turn of the century, midway through Prince Luitpold's reign (1886–1912), Munich's artistic revolution placed the Bavarian capital in a league with Berlin, Vienna, and Paris. Munich's avant-garde spirit attracted a stunning range of artists and writers: the painters Vassily Kandinsky, Gabriele Münter, Franz Marc, and Paul Klee; the writers Thomas Mann, Heinrich Mann, and Ricarda Huch; the poet Stefan George; the playwright Frank Wedekind; and the political activist Vladimir Ilyich Lenin. While all of these, as Peter Jelavich has shown in his study on Munich's theatrical modernism, "laid the basis for much of the elite culture of the twentieth century," the Bavarian capital was developing "a quintessentially modern feeling for 'theatricality.'"[1] Munich championed a revolutionary youth culture, Jugendstil, a style literally inscribed on the city's body. Featuring dynamic ornaments and architecture, the new houses and apartments in the districts of Schwabing and Bogenhausen served as "refuges from the increasing ugliness of the urban milieu."[2] Founded in 1896, *Jugend* was the name of the artistic and literary journal that was dedicated to renewing everyday life through art. "Du stadt von volk und jugend!" (Oh city of people and youth), George rhapsodized in a poem entitled "München."[3]

In February 1900, Elsa Plötz's timing was, once again, superb when she arrived in "this then flourishing artist city."[4] She briefly lodged with Oscar A. H. Schmitz, who was already immersed in Munich's new culture. We may imagine the two sitting together in Schmitz's studio, Schmitz in his "Persian caftan," smoking "hashish cigarettes" and talking with animation about Schwabing's new erotic and cultural awakening.[5] Schmitz would have initiated Elsa into Schwabing's consummate Dionysian life by rhapsodizing about the dances, the carnival, the pagan ecstasy—in short, the new cosmic life that had captured Schwabing. His ensuing sexual contact with Elsa, however, produced this somewhat squeamish entry in his journal: "An unpleasant relapse with Else

Plötz, who has suddenly arrived from Italy. She lived with me for a few days and then moved to Dachau, where she wants to paint."[6]

In late February 1900, she repaired to "Dachau—an artist colony near Munich,"[7] and registered as a "painter" (*Malerin*).[8] Dachau is attractively situated at the river Amper, although today the horrific memory of Germany's first concentration camp in 1933 in Dachau overshadows the memory of this community's early twentieth-century artistic vibrancy. In the novel *Fanny Essler,* the protagonist's studio is on the third floor of a small rustic house with "a view across the Ampertal and the surrounding parts of the Munich lowlands."[9] Elsa furnished the place with selected pieces of the antique furniture that Richard had bought for her in Rome. She also bought all the paraphernalia needed for her profession—easel, umbrella, brushes. Still her artistic energies remained thwarted: "I couldn't possibly 'do art' for I didn't know how—I had a terrible dread of it," as the Baroness recalled. She hired a costly private teacher who charged 50 marks per month. His hobbyhorse was the "golden cut," a mystical mathematical proportion cherished in ancient times, but his lectures did little to advance her visual arts training. "Otherwise he left me entirely to my own devices—never even putting a paintbrush into my paralyzed fingers—though I had never painted in oil—nor drawn from nature."[10] The experience confirmed her suspicion of the cultural orthodoxy and uselessness of academic learning.

Other avant-garde women were studying art in Munich. In February 1900, Mina Loy (1882–1966), too, was in Munich taking painting lessons and enjoying the carnival. Already a woman of striking beauty, the eighteen-year-old ingenue from London managed to keep her honor intact, even though everybody in Schwabing seemed to conspire to compromise her and initiate her into Schwabing's erotic pleasures. In an improvised *tableau vivant* class exercise, she appropriately played the role of Virgin Mary.[11] Likewise, the young Gabriele Münter began to take painting lessons, joining Munich's Künstlerinnenverein (Women's Artists'

Association) in May 1901. As Kandinsky's illicit lover, she would participate in shaping the Blaue Reiter (Blue Rider), an avant-garde group that would revolutionize the world of visual art by 1911. Whether Elsa Plötz ever met either of these women is unknown. Yet she had transplanted herself into a space and climate exceptionally rich for experimental art. Twice a week, she traveled to Munich, "buying decorations for my studio and myself." On these visits she connected with Munich's avant-garde.[12]

4.1 *Stefan George as Caesar* (center second row with arm around Maximilian Kronberger). *Karl Wolfskehl as Dionysius* (back row center with beard), *Franziska zu Reventlow* (first row, left) celebrating Fasching in Wolfskehl's apartment on 22 February 1903. Photograph by Richard F. Schmitz. Stefan George Archiv, Würtembergische Landesbibliothek.

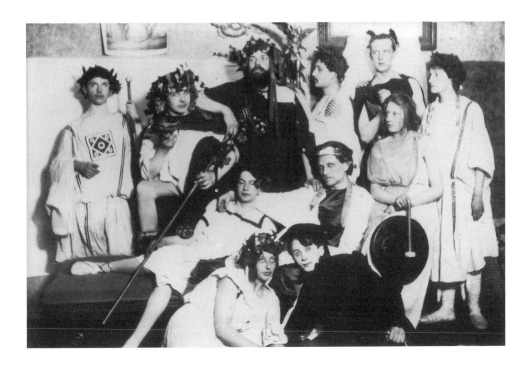

Elsa promptly presented herself at the first floor at Leopoldstrasse 51, Munich's bohemian artist center in the heart of Schwabing: Karl Wolfskehl's home. "I called at the house of Dr. Phil who knew me from my first artistic sweetheart career in Berlin," the Baroness recalled. "He had just married, with the whole ambition to found a literary circle of which I of course—had no idea—but I was well received on the strength of Richard's strong friendship."[13] One of Munich's "most high-brow artist circles," as she described it, met here once a week on its *jour fixe* at five o'clock in the afternoon.[14] At Wolfskehl's *jour,* Elsa met the Kosmiker spectrum (figure 4.1), an inner circle of around forty members, including Ludwig Klages, Alfred Schuler, Karl Wolfskehl, Oscar A. H. Schmitz, Karl Stern, Friedrich Huch, Bodgdan von Suchocki, Franz Hessel, Franz Düllberg, and Franziska zu Reventlow, while George routinely visited here in the spring—living in his own private room in Wolfskehl's apartment. Photographs show Wolfskehl in the poses of the "Schwabing Zeus," "Dionysus," and "Homer," a large, strong, and bearded man in a long, caftan-like dress, dedicated to erotic life, dancing, and reveling in ecstatic exuberance.[15]

Munich's Kosmiker initiated the twentieth century with the first wave of male feminism. "They were not the will-to-power but Dionysian Nietzscheans who aspired to a kind of ecstatic dynamism," writes the American historian Steven Aschheim in his study on *The Nietzsche Legacy in Germany, 1890–1990.* "They sought to create beauty in motion and to affirm life-creating values—above all that of eros. The Asconan search for eros and beauty, for freeing the body and soul in motion, found its most dynamic expression in the idea and development of modern dance."[16] In 1897, Wolfskehl had discovered a reprint of Johann Jakob Bachofen's protofeminist work *Das Mutterrecht—Eine Untersuchung über die Gynaiokratie der alten Welt nach ihrer religiösen und rechtlichen Natur* (Mother-right: An investigation of the gynocracy of the ancient world in its religious and legal nature) (1861).[17] Bachofen had doc-

umented the traces of a prepatriarchal culture, a gynocratic and het-aera-ruled society in which sexuality was free and women were in charge of their bodies and sexuality. With Bachofen's *Mutterrecht* in hand, the Kosmiker now proposed to renew Germany's culture at the dawn of a new century by injecting matriarchal and pagan val-ues into their lives and art—by trying to recover the prepatriarchal time when women were in control. They worshipped the earth and the *Urmutter* as the principle of life (*Kosmos*) and rejected the pater-nal principle of Christianity (*Moloch*) as life-destroying. At the be-ginning of the machine age, they reacted against the principles of mechanical reproduction and turned away from the tyranny of ra-tional Enlightenment thought. They dismantled the logos of West-ern subjectivity by celebrating ecstasy, feeling, intuition, dreams, and symbols. They aimed at transforming life-denying patriarchal structures by recovering ancient female power and by celebrating androgyny with a vengeance. At dances they transformed them-selves into hermaphrodites; women cross-dressed as corybantic boys; Schuler cross-dressed as *Magna Mater.* Franziska zu Revent-low's 1913 *roman à clef* highlights the gender-bending focus even in its title, *Herrn Dames Aufzeichnungen* (Mister lady's sketches), while the avant-garde's neologisms (*Mirobuk* = ecstatic experience, *kos-misch* = life affirming) and emotive hyperbole (*enorm* = enormous, *fabelhaft* = fabulous, *ungeheuer* = fantastic) were designed to charge daily life with ecstasy.[18] Perhaps the focus on androgyny was timely, for in 1900, Vienna psychoanalyst Sigmund Freud, then appropri-ating one of Wilhelm Fliess's ideas, postulated the fundamental bi-sexuality of the human child and adult.[19]

At Wolfskehl's *jour,* Elsa met the Kosmiker theorist of eros, the strikingly handsome Ludwig Klages (1872–1956), who later remembered her. In critical response to the modernist techno-logical revolution, Klages theorized the *Geist* as destructive, linking it to technology and progress. In contrast to the *Geist,* he celebrated "elemental ecstasy" or "erotic rapture," perhaps best translated as the

orgasmic jouissance of the soul, theories he later published in a work titled *Vom kosmogonischen Eros* (The cosmogonic eros) (1921). More theorist than practitioner, more high priest than active participant, Klages ironically was a killjoy at the carnival. His distance and coldness contrasted with the corporeality and warmth exuded by Wolfskehl and Reventlow in dances, while his antipatriarchal theories of women's eros and power slipped into essentialist notions of woman's sexual nature.[20] Although a Ph.D. in chemistry, he called himself a "soul researcher" (*Seelenforscher*) and supported himself and his sister Helene with graphological analyses, a scientific method of determining personality through handwriting by analyzing motor activities performed routinely and automatically in "expressive movement."

Elsa absorbed the circle's self-created codes, penetrating this society within a society, "a selected crowd—to which I even then belonged," as she recalled.[21] Yet she also began to expose the male bias, blindness, typecasting, and conventionality at the heart of the male cosmics' clamoring for female sexual liberation. In particular, the Munich circle's persistent desire to assign women value as symbol called forth this astute critique: "Any distortion—twist—perversity gave them a suspicion that it was a symbol of life's hidden secrets—because they were all sentimental—had lost sense and knew things by halves and in fits and starts—so that the neurasthenia of a stray sex cripple looked like 'sanctity' to them. [. . .] That was one of the reasons I was so starred there—for to them my all over towering passion—that did not let me see anything else but my object—*love*—looked perverse to them too."[22] When she found herself pushed into old, conventional roles, she discovered firsthand the limits of being the living symbol for male avant-garde concepts. Klages and Wolfskehl, for instance, never supported her drive toward artistic expression but considered her a concubine: "If only you would understand to extract money from men—you should be one of the greatest most famous concubines of our time!," Wolfskehl

told her, adding "I adore greedy women."[23] As for Elsa, her radicalism soon dismantled her assigned symbolic role and established her as a disruptive force and insurgent New Woman who claimed her rights with a fierce vengeance.

The woman most centrally associated with the Kosmiker was the Countess Franziska zu Reventlow (1871–1918) (see figure 4.1), whose dancing body, smiling face, and radical promiscuity had indeed become a metonym for Dionysian Schwabing and its complex notion of sexual liberation. A divorcée and proud single mother who refused to disclose the name of her son's father, she practiced a radical hedonism, her private journals a testimony for an unconventionally lived sexual life. "I need him above all as a dramatic background," she noted about one lover in a 5 June 1899 journal entry, adding: "Even la grande passion does not make me monogamous."[24] She was the living embodiment for the circle's theories and a magnet for the cosmics' emotional and sexual attachment. Yet while she celebrated Klages as the only man with whom she could "fly," she refused to give up her freedom for him: "He thinks I'm colossal," she said but complained of Klages's possessiveness and sexual jealousy. "When my hair flies during the dance, he stands contemptuously behind the column. He despises [Albrecht] Hentschel, despises [Frank] Wedekind, despises Felix Greve, and despises Ohaha Schmitz. In short, he despises everybody who takes me and kisses me."[25] Adamant in her refusal to be limited or confined within conventional relationships, she insisted on her freedom: "All who want me would like to eat me up. But I am too expansive and am open to all sides, desire this here and that there."[26]

There can be no doubt that Elsa Plötz and Reventlow knew of each other and must have met face to face at Wolfskehl's. Both women were regular visitors at his *jour* from early 1900 through the summer of 1901 (except for the summer to December 1900, when Reventlow was traveling).[27] Both appealed to Oscar A. H. Schmitz for help, knew Endell and Greve intimately, and lived

unconventional sexual lives within the circle. Yet neither woman ever acknowledged the other in her writing, a silence that speaks volumes about their personal and ideological differences. In 1899, Reventlow had published "Of Viragines and Hetaerae," an influential essay condemning the feminist claim for traditionally male rights, including education, work, and the vote (although she continued swimming in the Isar with the suffragist Anita Augspurg).[28] As Reventlow saw it, such "masculinizing" of women would further reduce women's already limited access to pleasure. For Reventlow, the post-Victorian woman was just coming into her own as erotic being, and she must carefully carve out a space in which that eroticism could safely thrive. Yet the revolutionary potential of Reventlow's unconventional life was at least partly put into question by her efforts at pleasing men and by the resulting pain acknowledged only in the privacy of her diary: "But I am used to suppress each scream, at least in front of others."[29]

Elsa Plötz, in contrast, had already made the metaphorical scream her trademark, countering Reventlow's public repressions with uncomfortable disclosures. In fact, the androgynous Elsa Plötz fit every inch Reventlow's description of the virago, a figure who systematically refused to cultivate the typically feminine qualities like patience and gentleness. Plötz's arsenal was more militant, involving a crossing of gender boundaries, the inhabiting of the male position, and the demand for female rights. Unlike the Countess of Husum, the virago of Swinemünde often did not please men; the epithet that accompanied her was "mean" (*gemein*), as Schmitz noted in his private journal.[30] Males' fascination with Elsa Plötz was mingled with fear and dread; her sex partners routinely reacted with impotence or sexual withdrawal, as we shall see. In contrast to Reventlow's focus on mapping female erotic pleasure, the Baroness's memoir displays a great deal of disgust and even rage following sexual intercourse, as she recalled: "if there had been physical sex-touch—it also would have resulted in disgust."[31] Her gargantuan

sexual appetite satisfied her cognitive curiosity but left her sensually unsatisfied. While she hungrily searched for ever new experiences, sexual *jouissance* remained elusive, something unimaginable for Reventlow, whose erotic sensuality, formidable social skills, and powers of intimate negotiation seemed to make the most complex sexual constellation easy and "natural."

Another divisive issue was motherhood. In the wake of Bachofen's *Mutterrecht,* the pagan Madonna had high symbolic status among the Kosmiker, who embraced Reventlow and her illegitimate child as the icon for their male feminism. Gabriele Reuter, Margarethe Beutler, and Else Lasker-Schüler—all three German writers became unwed mothers before 1900.[32] Elsa Plötz, in contrast, did not acknowledge children and saw this focus on the pagan mother as a fad, a perspective later adopted by Reventlow herself. Ultimately, Elsa was the more daring figure, for Reventlow's celebration of pagan motherhood and heterosexual erotics for women remained close to essentialist ideals of womanhood. In contrast, Elsa's cognitive curiosity about sexuality struck at the very essentialist assumptions about gender and sexuality, as when she plunged into an adventure with a homosexual man, a young painter from Hamburg, Bob, a "'clean' looking boy—very young—almost coltish still," as the Baroness recalled: "I knew him to be homosexual—and had been very much surprised in Dachau—at his expressed desire to sleep with me—as always the doings of homosexual persons have been inexplicable to me—especially the mixed ones—I then had consented for boredom—curiosity—vanity."[33] Although the affair peters out with a "disappointed aimless neurasthenic sexdallying," this was the first of many affairs with homosexual males. Yet while Elsa unraveled the essentialist notions of women as pagan mothers, effectively lambasting the *Urmutter* in her gratuitous sex act with a homosexual boy, her contact with the Kosmiker also revealed her blind spots.

At Wolfskehl's *jour* Elsa would have met the eminently bizarre and sinister Alfred Schuler (1865–1923), a student of art history and archeology who cross-dressed as the *Urmutter* and provided much of the theoretical thrust for the movement. Fragments of his writings, posthumously edited and published by Klages in 1940, included poetic evocations of cosmic Dionysian life through hyperbolically hallucinating and raving images of burning fires ("Porphyrogenesis"), golden phalluses ("Phallikos"), erotic death ("Triptyhchon des Korybantischen Dithyrambos"), interspersed with anti-Christian ("Stella Mystica") and anti-Semitic allusions ("Epilogus. Jahwe—Moloch").[34] Schuler's Dionysian mysticism was fueled by anti-Semitism that indulged in obscure blood theories and anti-Semitic defamation, when he disparagingly called Martin Luther and Otto von Bismarck "jews." While Reventlow was critical of racial stereotyping, Elsa remained conveniently blind. Indeed, we may wonder to what extent her anti-Semitic prejudices—absorbed in childhood reading and in Swinemünde's military culture—were further fed within this context. Already in 1895, Schuler had claimed the turning wheel of the pagan swastika as the central symbol of his cyclical concept of history and counter symbol to the Christian cross, even planning to write his doctoral dissertation on the swastika. (Schuler was furious when it was appropriated by the Austrian postcard painter Adolf Hitler, who made his appearance in Munich in 1913.) For the most part, Kosmiker philosophy—including Schuler's focus on androgyny and a fatherless society—was light years away from Nazi ideology with its focus on masculine power, as Gerd-Klaus Kaltenbrunner has shown. When Klages and Schuler viciously attacked Wolfskehl's Jewish religion in the winter of 1903 to 1904, George and Reventlow declared their solidarity with Wolfskehl, breaking with Klages and Schuler. Elsa—along with many others—remained caught in the cultural norm of her upbringing.

Against this backdrop of Munich's Dionysian Kosmiker, then, unfolded Elsa Plötz's first marriage experiment. At Wolfskehl's home Elsa had met the architect August Endell (1871–1925) in the spring of 1900. When he showed interest in her sketches, she was flattered by the attentions of "one of the coming great luminaries on the sky of applied art and architecture of the nearest future—yea, probably the 'great one.'"[35] Raised in Berlin, Endell had studied aesthetics, psychology, and philosophy at the University of Munich. A leader of the *Kunstgewerbler* movement, he was pioneering applied art as a truly revolutionary art form in everyday life. To this artist she turned when her funds ran out six months later, asking him for professional training. "I now wished to become a dashing successful and fervent female artist of applied art—it just being the time in Germany of uprearing against the degraded nonsense of modern factory style as well as against imitated or true antiquity."[36] Endell was happy to oblige, teaching her to sketch. Before long they became lovers.

Endell was not a conventionally attractive man. Schmitz described him as a sickly person, who grew a little beard "to compensate for his somewhat underdeveloped masculinity."[37] Photos reveal a pale, sensitive, cerebral-looking man, tall and strikingly slim like Elsa, his eyes intensive, his expression serious, suggestive of the intense discussions that connected the two lovers. His lack of traditional masculinity, however, would preoccupy his contemporaries, who would soon cast him in the mold of the effeminate victim of the powerful woman. For the brilliant architect had a knack for disastrous romances. His first affair had left him emotionally and financially ruined, and his friends were now concerned about his intensive affair with Elsa Plötz, as Schmitz noted: "During my travels, Endell has become close with Else Plötz. That meant a growing alienation from me. I had seen too many of her meanest character traits and he knew it. She hated me, since she had once given herself to me. Without really wanting this, Endell and I now became more distant. I'm probably not a pleasant memory for them. Now

4.2 August Endell, *Hof-Atelier Elvira, façade,* 1898. Photograph.
Fotomuseum im Münchner Stadtmuseum.

4.3 August Endell, *Hof-Atelier Elvira, interior,* 1898. Photograph.
Fotomuseum im Münchner Stadtmuseum.

they have gone to Berlin and will perhaps get married. I am too con-
nected with everything that he will have to conquer in her or at least
submerge into deep sleep."[38]

 The couple's sexuality was complex from the start, Elsa
Plötz silently wondering if "he was possessed at all even of so much
as a penis!"[39] Yet this complication captivated her: *"Exactly that made
me curious—how he would behave. I was eager—ready* for any 'perver-
sity.'"[40] Although unresponsive to the proffered sadomasochistic
games ("the delights of a birch"), she was still intrigued by his "subtle
sexsecrets." Also, she enjoyed being the dominatrix, controlling
every aspect of the relationship, while also claiming her sexual free-
dom with other lovers: "I deliberately put myself in all sorts of temp-
tation—with Tse [Endell]'s entire approval—until—after a year or
so—I felt myself in all confidence justified to marry him."[41] While
she may have had quixotic hopes "to turn my lover's impotence to a
husband's virility,"[42] she consciously settled into a friendship mar-
riage, similar to her earlier relations with Richard Schmitz and sim-
ilar to the marriage modeled by Friedrich Carl Andreas and Lou
Salomé, the latter a close friend of Endell's. "My first husband was an
older—more advanced Richard—my friend who needed my
beauty—colour—charm," the Baroness explained to Djuna
Barnes.[43] Indeed, both men now exalted her, Schmitz hailing her "as
a brilliant, joyful sun," Endell revering her unparalleled "purity."[44]
As the Baroness would note two decades later in a letter to Richard
Schmitz: "This is how I lived and acted—hard—steadfast—unyield-
ing—honest. You all admired me then because of my unbending na-
ture."[45]

 Like Elsa, August Endell was not afraid of creating
"scandal" and "sensation" in art as he had shown with his contro-
versial design of the photography studio on Von der Tannstrasse 15.
Imagine an almost windowless inner-city front wall on which flares
out a dragonlike design, with no other meaning attached to it than
that of monumental ornament, the striking green of the wall and

4.4 Else Ti Endell, *Letter to Frank Wedekind,* ca. June 1902. Münchner

Stadtbibliothek, Monacensis Abteilung.

the purple color of the ornaments further intensifying the spectacle. This was the façade of his controversial Hof-Atelier Elvira (1887–1928) (figures 4.2 and 4.3), the photography studio commissioned by Sophia Goudstikker and Anita Augspurg, two well-known Munich feminists, suffragists, and lesbians.[46] A sensational exemplar of Jugendstil art, the studio revealed Endell's stunningly innovative vision of architectural and artistic design. The ornament purposefully resisted iconographic and symbolic decoding. The cerebral Klages, for instance, compared the building's design to "a cerebral cortex which was projected to the exterior."[47] With the Hof-Atelier Elvira, Endell's theory erupted into the everyday urban landscape, scandalizing Munich's burghers, and providing an important spark for the Baroness's art. Like Kandinsky, who would evoke the metaphor of music as a rationale for the appreciation of art, so Endell's concept of beauty was conceived in anti-Kantian terms, as ecstatic pleasure, a kind of madness that threatened to overwhelm the viewer, as he noted in his 1896 essay, "On Beauty": "Visual art is the working through visual nature motives in order to produce a strong and equivalent feeling of pleasure (*Lustgefühl*)."[48] As a spontaneous feeling that transcended the realm of intellectual understanding, beauty was a sensual experience, "of pure form, an art which is nothing more and has no further meaning than musical tones; the forms influence our feelings without the mediation of our intellect."[49] *Aufregung, Empörung,* and *Skandal* (excitement, outrage, and scandal), then, were the words that accompanied the work of the twenty-seven-year-old architect whose name gained notoriety almost overnight. Establishment architects criticized the design's excessive ornamentation, arbitrary subjectivity, and lack of discipline. In fact, so transgressive and unsettling was the design that the Nazis would order its destruction at the owner's cost in 1937.

Hof-Atelier Elvira also tied August Endell's name to feminism.[50] The photographer's studio became a vibrant meeting place for gays and lesbians. Lou Salomé was a frequent visitor here

(she had initiated the contact with Endell after reading "On Beauty" and spent a great deal of time with Endell).[51] While catering to a middle-class clientele to pay the bills, Goudstikker's atelier changed portrait photography with its portraits of well-known women, including Salomé, Helene Bühlau, Frieda von Bülow, Ricarda Huch, Ellen Key, Gabriela Reuter, and well-known feminists Anita Augspurg, Hedwig Dohm, and Ika Freudenberg. Goudstikker captured the New Woman's power, highlighting a pensive, intellectual, and introspective femininity, clearly in contrast to the bourgeois ideal of the charming and sentimental or melancholic type of woman that was then favored in portrait photography. Goudstikker showed women in their libraries or at their desks, often with the hand supporting the head, a pose more conventionally found in male portraits. The studio was destroyed during World War II, and there is no evidence of whether Elsa Plötz was ever photographed here. Nor did she ever refer to the studio, but given the importance of modeling and performance in her life, this close connection to avant-garde portrait photography is intriguing.

In the summer of 1901, Elsa proposed marriage and Endell accepted. Endell had just received a call to decorate the interior of Ernst von Wolzogen's Buntes Theater in Berlin. Thus on 22 August 1901, the wedding took place in Berlin in a civil service with Richard Schmitz and Endell's cousin Kurt Breysig as witnesses. A note scribbled by Endell informed the witnesses that "the date is set for Thursday, unless something intervenes. Afterwards there will be a solemn reception with Mumma the dog."[52] In *Fanny Essler,* the bride tried to inject a little color by painting her fingernails red, then a provocative transgression of bridal decorum. The newlyweds settled in Zehlendorf-Wannsee (Karlsstrasse 20 and then Augustastrasse 9), not in the avant-garde quarters of Berlin but in the more conventionally bourgeois and recreational district in the south close to Wannsee, an attraction for summer tourists.

One wonders about Elsa's artistic development during her marriage. "Too ungifted lazy" to become an artist herself, she was content to "have my husband do my work, I sharing in the laurels."[53] Still, she may have banded with her husband on several artistic projects. Mentored by Endell, she had vigorously worked on her applied art during the courtship year in Munich. Given that she had worked on book designs during that time, she may have helped design the Endell stationary (figure 4.4), which introduced her as Else Ti Endell, *ti* being the Chinese word for yellow, the color of royalty, and *tse,* the word for August, being its male equivalent; these names had been suggested by Endell. Proudly displaying their union in public, they engraved their marriage in a graphic trademark, which featured a dramatically tall T embraced by two E's for Elsa and Endell. The couple had also begun to attract attention with their artistic clothing, designs that framed the body in unconventional ways, making iconoclastic artistic statements. Elsa, as Klages recalled, "now presented herself in clothing designed by Endell in a style never seen before." In Endell's case, "the design highlighted his stork-like appearance (pants immediately follow a different coloured vest without jacket, so that his legs appeared fantastically long)."[54] Given Schmitz's recollection that Elsa had been working on original clothing designs in the summer of 1898 in Italy, and in light of her later remark that Greve did not like her artistic clothes and hairdo, the couple's extravagant style of dressing could well have resulted from collaborative efforts.

Meanwhile, Endell was working day and night on Wolzogen's Buntes Theater, a pioneering *Überbrettl,* or highbrow vaudeville, which opened in November to great acclaim. Despite four serious bouts of sickness, Endell was also decorating Dr. Rosenberger's home at Lietzenburgerstrasse 2, a work in extravagant colors and metals, in silver, bronze, onyx, gilded bronze, and copper (completed in 1904). He had begun a business collaboration with Richard Schmitz, "Richard providing the money and Tse the

genius—making decorations and furniture."[55] Over the next years, Endell would put his Jugendstil mark on Berlin, in 1905 and 1906 completing the Endellsche Hof, part of the Hackesche Höfe on Rosenthalerstrasse, an impressively colorful architecture recently restored in Berlin.[56] While Endell was working fourteen-hour days, the couple occasionally socialized with other artists over tea: Richard Schmitz, now a sculptor living nearby in Berlin-Charlottenburg, at Fasanenstrasse 22; Marcus Behmer, a well-known Berlin book decorator; and Frank Wedekind, one of Germany's leading playwrights.

Benjamin Franklin Wedekind (1864–1918), in particular, was vitally important as artistic stimulus and influence. He was an attractive male with an actor's flair who probably dazzled Elsa with his charm over tea in Zehlendorf in June 1902—just as he had dazzled Reventlow in Munich.[57] Eccentric and confrontational, his art provoked in unprecedented ways that suggest protodada aesthetics. He reportedly went as far as urinating and masturbating on stage, always courting (and deliberately crossing) the borderline of obscenity laws. One wonders whether he would have talked to Elsa about his prison incarceration in early 1900, after he had been convicted of censorship violations.[58] Sexual satire was fueled in the wake of the Lex Hinze legislative bill, a controversial conservative initiative (defeated in 1900) to expand the prostitution legislation and to declare all depictions of nudity legally obscene.[59] Since artists and the entertainment industry were directly affected, reactions were intense. Elsa's invitations to Wedekind (see figure 4.4) suggested that she was familiar with Wedekind ten years before the dadaist Hugo Ball would be profoundly influenced by the Munich playwright and actor.[60] Also, Elsa had been in Munich in April 1901 when Wedekind's *Elf Scharfrichter* (Eleven executioners) opened their political vaudeville, "the hybrid child of political militancy, aesthetic intimacy, enthusiasm for vaudeville, and financial impoverishment," as Jelavich describes it, in which Wedekind participated, refusing to

SANATORIUM ANSICHT VON SÜDWEST

4.5 Else Endell, *Postcard showing the Wyk auf Föhr Sanatorium with note to Marcus Behmer.* 26 December 1902. Münchner Stadtbibliothek, Monacensia Abteilung.

use a pseudonym as the other performers did.[61] The Executioners' aggressive style—as depicted, for instance, in their posters that featured an axe cleaving the head of a pedant with *Zopf* (pigtail)—struck against an antiquated society and prudish morals. Germany's theatrical modernity was sexually and politically charged.[62]

Yet despite this artistic stimulus, there was trouble at the homefront. "I was a lovely person though hard to live with—and my queenliness was his conviction," the Baroness recalled about her marriage.[63] Bored with her role as conventional wife, the gargantuan sex artist was caught in a sexless marriage of her own making, "for the blessing of virility was not attached to the law's formal per-

mission for sex intercourse." The cause of his dysfunction was presumably a combination of Endell's physiological ailings and the intense stresses in his working life, psychological factors that were, no doubt, further exacerbated by Elsa's tantrums. Endell did have a child with his second wife. Walter Benjamin read impotence as a sign of the era. Impotence symbolized the freezing of all productive forces, as seen in Jugendstil's celebration of infertility, its focus on prepubescent figures, all of which Benjamin philosophically connects with a regressive attitude toward modern technology.[64] For Elsa, in contrast, male impotence was the trope for the male's inability or reluctance to provide female sexual pleasure. Impotence, therefore, was the foil against which she now proclaimed her female "sexrights." Barred from sex, Elsa's temper exploded in tantrums: "my husband—who—failing to serve—became a plaything of my whims, bad temper and acid contempt—without he or I really noticing it."[65] In November the Buntes Theater opened to great success, yet the newlyweds were too exhausted to celebrate. They quickly escaped to Italy, where, instead of finding peace, they intensified their quarrels, as the Baroness ruefully recalled in her memoirs. "I once—in Verona—nearly running away from him into nowhere."[66]

Around February 1902, as they stopped at Wolfskehl's in Munich on their way home, they met the student of archeology Felix Paul Greve, whose proud indifference and ostentatious elegance made an immediate impression on her:

I perceived *F. P. G.* with his polite—icy unmoved critical—"secretly impudent" air—I *violently*—hated him! But—I was *married*—I—to all my knowledge—*belonged* to my interesting—respected husband, a highly esteemed "coming" *Kunstgewerbler* [applied artist] architect—refined—in high—good taste—I hated this cool—impudent "veiled" young man—*because* he was veiled. [. . .] Having a husband—being faithful—what could I do as respond in hate—to

this feeling of interest? *Unveil*—I could people—*men*! only in sex in-
tercourse—at once—or gradual—and—I was content—yea—
sparklingly proud of that husband I had! I didn't *want*
another—though—it was true—*sexually* he was a punk![67]

The impression that Greve was "veiled" would prove fatefully cor-
rect, as she would fall victim to his web of deception. She reacted to
him with "vicious hatred" for "he seemed too splendid and far too
fashionable for me."[68] A few months later, on 24 April 1902, Greve
visited the Endells in Berlin. He stayed in the prestigious Hotel de
Rome; he purchased books and was planning a literary series with
Holton Press. It was the first of many visits.

Adding to his personal stress was August Endell's enor-
mous financial strain, as he relied on friends and family for small
loans: "I am in a very tight situation; can you lend me 300 M for a
few weeks," he had appealed to Breysig on 19 April. "I'll soon get a
substantial loan, but am in danger now of losing everything."[69] Too
exhausted to even consider his marital problems at home, he sent
Elsa "to a sanatorium at the shore of the North Sea—to be away
from him and to have by-the-way, for his impotence my womb mas-
saged—so that he should not look the only guilty one."[70] While the
stay was "part of the payment" for Endell's work, the overworked
architect was also hoping to get a little peace at home, while hoping
to seduce Elsa through his art. The Wyk auf Föhr Sanatorium at the
North Sea was a work of art featured on one of Elsa's postcards (fig-
ure 4.5). It was uniquely designed by Endell to fit its natural envi-
ronment, its soft roof lines inspired by the surrounding North Sea
dunes and the interior guest rooms decorated in elegant Jugendstil
ornament. Specializing in serving a clientele of bourgeois women
with various nervous disorders, Dr. Karl Gmelin, the director, had
created a state-of-the-art health spa,[71] the first of its kind providing
water and massage therapies, health-conscious meals, and exercise.
Baggy beach dresses were especially fashioned to allow heavily

corseted women new freedom of bodily movement. Yet Elsa dismissed him as a "bourgeois doctor," who "for businesssake with the silent consent of his spouse—silently suffered himself to be the more or less openly expressed desire for many a waning young lady's hysterically erring sexcall."[72] The problem of "impotence," as she saw it, was a social and cultural one, which medical institutions like the sanatorium tried to channel by "treating" the women. Thus when Endell visited in the fall of 1902, he did not realize that he was put to the final test. When sexual intercourse once again failed, she threw her usual tantrum with "slipperhurling" and "hairpulling." She also quietly gave up hope for sexual relations with Endell.

Already her fantasies centered on Felix Paul Greve, who was now living in Berlin close to the Endells' Zehlendorf residence. Her long-distance dalliance with Greve suddenly released her into artistic productivity. "I made, after an interval of years, my first, for an amateur amazingly good poem for nature's necessity—to express love *somehow*."[73] She was twenty-seven and had just read *Bunbury*, Greve's translation of Oscar Wilde's play. Although the Baroness blithely insisted, "Not one minute during all this time did I contemplate a love affair,"[74] she was flying high, as the flirtatious letters moved back and forth. On her return to Berlin, three men greeted her on the Potsdamer Bahnhof: "there was *Tse—Richard* and *Mr. Felix* and I felt rather well taken care of." Her description of "Mr. Felix" bespeaks of her infatuation: "Dressed inoffensively highly expensive—in English fashion—with an immovable stony suave expression on his very fair face, with slightly bulging large misty blue eyes, a severe saucy nose—hair as spun yellow glass, over six feet tall and elegantly narrow—with a whippiness to his movements and at the same time precision and determination—that was charm and force in one and announced splendidly the well-bred gentleman."[75]

The same night she negotiated with her husband the right to take a lover. He agreed but delayed, not wishing to be socially compromised: he needed to save money to send her traveling

"since he knew of my careless conduct in matters of passion."[76] Meanwhile, Elsa was in flames writing imaginary love letters in golden ink and then locking up the erotic epistles in her desk: "This was the first time—I turned physical movement into spiritual one."[77] She was, in fact, about to begin the most important love relationship and artistic partnership of her life, one that would last ten years and eventually take her across the Atlantic to the United States. This is also the unconventional story of Elsa's initiation of Greve into "heterosexuality."

Felix Paul Greve: Elsa's Sex-Sun

Chapter **5**

The student of archeology Felix Paul Greve (1879–1948) (a.k.a. Frederick Philip Grove, as he would be known by Canadian readers) was a remarkable figure in the European world of literary translation.[1] Photos show a tall, handsome man, an unusually slim youth with an androgynous attractiveness. In one photo, taken in Italy, his moustached face is framed by the debonair formality of a high collar and a hat pushed up to reveal his blond hair, a cheeky caption accompanying the photo: "This is what I looked like on 23 July 1902, the day when I began growing my beard, which I had shaven off yesterday" (figure 5.1). In another photo, he posed as "Nixe," his nickname (and also that of a mermaid). Seductively cuddling on a cart, he was the center of a group of male friends, all engaged in theatrical posing for the camera.[2] The pleasure and pride of self-making and self-monitoring are evident in all photographs.

Compared to Ernst Hardt and Oscar A. H. Schmitz, Greve was a more fiercely ambitious, if slightly younger, climber in

5.1 *Felix Paul Greve*, 23 July 1902. Photograph. Deutsches Literaturarchiv, Marbach am Neckar.

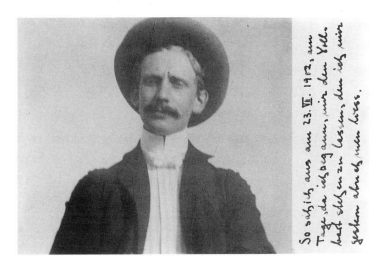

the world of art; like them, he had submitted his poetry to Stefan George's *Blätter*. Yet while Schmitz's politics were safely heterosexual and while Hardt kept his homoerotics in the closet, Greve more openly flaunted and flirted with homoerotic styles. In February 1902, he published *Wanderungen,* a small private edition of poetry, which daringly explored the homoerotic tropes of Stefan George's circle underneath conventionally restrained sonnet and quatrain forms. In *Wanderungen,* the poet-ephebe takes the reader on his southern wanderings, the south itself a trope for gay culture, as gay men in Germany found a more tolerant climate there.[3] When Greve submitted *Wanderungen* to Hamburg publisher Alfred Janssen, he added a gender-coded biosketch: he was "close to the 'Blätter für die Kunst' in Munich" (read "Georgean love") and had "spent a great deal of time in the South"[4] (read "homosexual experience"), dedicating the book "To my friend and companion Herman F. C. Kilian," his long-time friend, a gay man and affluent doctoral student who had been supporting Greve for some time.[5] With his partner Kilian, Greve also proposed a cotranslation of Oscar Wilde's work, whose name was centrally linked to the homosexual movement, thus further cementing the homoerotic context Greve established.[6] Although the Baroness claimed that *Wanderungen* was intended as a parody of the Georgean style,[7] tone and content suggest the exulting seriousness of this apprenticeship work. Suggestive exuberance also characterizes Greve's May 1902 Paris postcard greeting to Wolfskehl— "We are virtually reeling in ecstasy" (Wir sind förmlich im Taumel)—describing his travels with Kilian to Darmstadt and Bingen.[8]

By the summer of 1902, however, Greve had changed his gender tune, now actively consolidating his public persona along heterosexual lines. As Wilde's translator in Germany, Greve had good reasons to be anxious in an increasingly homophobic climate, as the comparative literature scholar Richard Cavell has documented.[9] In a 6 October 1902 letter to his publisher J. C. C. Bruns,

just one month after George had officially rejected his poetry, Greve bluntly reversed his earlier flaunting of homoeroticism by aggressively charging his rival translator Johannes Gaulke with having "prepared Dorian Gray too exclusively for the homosexual press" by "overemphasizing the homosexual elements" in his German translations of Wilde.[10] Greve was now rejecting George's vision of a "secret society" with privately distributed publications that resisted the mainstream (read "heterosexual") market taste. This letter shows Greve as a "business executive," as a career translator who was now raising Wilde—and himself—from the Georgean "secret society" into the mainstream.

Yet while Greve was thus actively heteronormatizing his printed work, there was as yet little evidence of his private heterosexual credentials. His wedding play, *Helena und Damon* (1902), was a coldly distanced, antierotic comedy. While he proposed marriage to Helene Klages in the romantic setting of Gardone at Gardasee, he was fantasizing—perhaps not primarily about sex with her but about creating a literary circle of his own with Helene at his side. His Italian traveling adventure with the virginal (yet by no means sensually naive) Helene, however, provoked Ludwig Klages's wrath and fierce brotherly protection of his sister's honor. Greve's bumbling adventure with the "traveling virgin," in fact, was a painfully public failure that disgraced him in the eyes of the Munich circle and forced him into a hasty retreat to Berlin.[11] Likewise, Greve's student days have left us with little concrete evidence other than his interest in some sexually polymorphic and pornographic verses: "Manager glees / Toss of the seas / is a 'go.' / All hands fuck / beneath gray calico. [. . .] Baby kick / sucks his prick / fast — / will genius last? [. . .] Pilot Steenis / Broke his Penis / Fucking the Moon / he's hitched it to a / toy balloon."[12] While there was little concrete evidence for Greve's specifically heterosexual experiences before 1902, this was about to change dramatically, as he now settled in Berlin in close proximity to Elsa and August Endell. Just as Schwabing was getting ready

in December to launch the first of its four legendary pagan orgies at Wolfskehl's home, Elsa Ti Endell claimed "Mr. Felix" as her "sex-sun."

The affair was actively piloted by Elsa, who had been pressuring her husband for some time to provide her with a lover. Just as the sexually incapacitated Jake Barnes would introduce Brett Ashley to Pedro Romero two decades later, so Endell now asked Greve to "amuse" his wife. Endell's unshaken confidence that his wife was safe with Greve (he warned Elsa that she was "not Mr. Felix's type") may well have been based on the belief that his wife's chosen chaperon, a former Georgean ephebe, was homosexually inclined. Yet Elsa was soon flying high, oblivious to anything but her own desire and living through two months of all-consuming intensity, existing only for her "five-a-clock" tea with Greve. "I was rather drunk and trembling with suppressed excitement and fear," she wrote in her memoir, as if drugging herself on her own desire, while Greve, in contrast, "became more and more polite and more and more stonily inscrutable and self-possessed."[13] In fact, so physically distanced was "Mr. Felix" that she briefly asked herself whether he might be "a sodomist."[14]

The first sexual intimacies took place on 24 December with Elsa as the initiator. The event was a turning point in both their lives, as both recall even the trivial details decades later. "On Christmas Eve we three went to a very expensive souper—after, coming home—drinking more champagne—until Tse felt the need to go to bed–but I insisted on staying up—with Mr. Felix for company," recalled the Baroness. "And so—it happened."[15] While Greve remained passive, sat sphinx- and Buddha-like, the Baroness described her younger self as the sexual agent, choreographing a scene of high-pitched drama, in which her emotions reached an orgasmic pitch of "surging fire" one moment, only to descend into the "icy cold" of reality after. Her cognitive awareness of this scene is remarkable, as is the kinetic imagery that mobilizes her sexuality in her memoir account: "my blood ran through me like a dangerous beast up and

down—jumping, surging."[16] By contrast, Greve's immobility appears almost catatonic. When she finally was no longer able to contain "the red hot beast" inside of her, her body exploded into action: "I threw myself on him with my arms round his neck [. . .]. I felt his whole frame tremble. He did not embrace or touch me. But I did not mind. I knew now—I had him."[17] As with most of her sexual relationships, the traditional gender configuration was reversed. She was controlling this sexual "initiation," with Mr. Felix "yielding" in feminine terms, as she triumphantly writes: "But *this one moment* can only happen once with each man."[18]

As late as 1946, now writing under his assumed Canadian name, Frederick Philip Grove relayed this turning point from his perspective in his fictionalized autobiography *In Search of Myself*. Here Elsa Ti Endell appears as Mrs. Broegler, whose husband asks the young Grove: "Amuse her, will you? You'll help me immensely." Grove exaggerated the age gap to present himself as a "virginal" seventeen-year-old: "I was utterly inexperienced," he noted. "I knew that she was making advances to me [. . .]. I was not only too timid, I was also too ignorant to meet her half way."[19] Even the random details—the dinner, the after-dinner champagne, the husband going to bed, her first sexual move, her childlessness, her sexual shamelessness—all correspond point by point to Elsa's profile and to the Baroness's memoir account.[20] In a strikingly confessional move, Grove then admits to his young adult fascination with Georgean love, "this whole world of lovers and ephebes": "The center of the terrestrial universe, as we saw it, lay somewhere near the southern tip of Sicily."[21] Against this backdrop, he then explicitly credits his mistress with having initiated him into heterosexuality: "My own overpowering experience with Mrs. Broegler [. . .] saved me from becoming involved [with homosexuals] in any sense whatever. If I had not always been so, I had become definitely, finally heterosexual."[22] With the exception of Cavell, scholars have ignored or glossed over these lines. Yet when Grove's life is read

through the lens of his relations with Elsa Plötz, we are forced to read them literally, as his sexual confession about his profoundly ambivalent gender identity.

She compared "Mr. Felix" to Balder, the northern sun god, even though orgasmic satisfaction was still elusive and even though she remained ambivalent. "We are very unhappy" (Wir sind sehr unglücklich), she told Marcus Behmer on a 26 December postcard (see figure 4.5) that featured the Wyk auf Föhr Sanatorium—perhaps an appropriate symbol of her love for a brilliant artist-husband who had failed the sexual test.[23] Yet once her decision was made ("I was not my free agent—but influenced by that *one* mighty *driving power* in me: *sex!*"),[24] she quickly began to loathe Endell's weakness. "Was I not—for him—within my *sexrights?*" she asked,[25] while Endell was dejected: "I can't go on. I am finished," he told his cousin in January. "I'm very sick. Perhaps forever."[26] He was willing to accept further humiliation, as long as the lovers did not shut him out.

And so January 1903 began with a most unusual journey that continued this triangulated affair with a simple shift in positions: Endell was now chaperoning the adulterous couple to Naples, while Elsa proudly registered as "Mrs. Felix" ("Frau Greve") in the Hotel de l'Europe in Hamburg.[27] On 29 January, all three embarked for their two-week journey onboard the East Africa steamer where this unconventional travel company must have looked like a surrealist version of Sartre's infernal love triangle in *Huis clos,* with Endell hovering as a jealous nemesis: "You do not only leave me—you even steal my friend," he told Elsa.[28] Having lost his wife, friend, and dignity, he was on a downward spiral, strangely dependent on Greve, the two men walking the deck for hours. Adding yet another fantastic layer to this quixotic journey was the fact that, unknown to the Endells, who believed Greve to be fabulously rich, the journey was effectively being financed by Greve's long-time companion Herman F. C. Kilian (from whom Greve had obtained the money under

false pretenses). Even though suspicious, Elsa preferred not to ask any questions. In Naples, Greve and Elsa stayed in the Grand Hotel, "a swell hotel,"[29] as the Baroness recalled. Sent to a small neighboring pension, the wretched Endell made a botched suicide attempt. After a final heart-to-heart with Greve, and the gift of a bicycle for therapeutic exercise, the cuckolded husband was sent off to travel on his own.[30]

It took Endell half a year to recover his balance in the wake of his disastrously short and unhappy marriage. Too distraught to return to Berlin, he retreated to Ravello, on the Amalfi Coast, a gorgeous place that Richard Wagner once called "the garden of the Klingsor." Supported by Karl Wolfskehl and Franziska zu Reventlow—who had come to Ravello for an extramarital tryst of their own—Endell slowly consolidated his emotions, the Countess cheering him "with her song,"[31] while the moralizing Wolfskehl severely condemned the adulterous Greves. Half a year later in the summer, Endell still hoped to repair his marriage, describing Elsa as "the woman I loved more than anything else." By contrast, Greve had become the proverbial devil with horns: "In Berlin, I had nobody but this idiot who betrayed me and drove me to despair by boasting of his strength and performance."[32] The stage was set for a complex divorce drama that would preoccupy all three parties and their extended artist-friends until at least 1906.

Meanwhile, after stopping at Mount Etna, one of Italy's most active volcanoes, Elsa and Greve had settled in Palermo in February 1903. Even today this three-thousand-year-old city shows its influence of Greek, Arabic, Roman, and European cultures. A labyrinth of narrow streets moves through the old town, creating a pathway past tall houses decorated with their finely wrought cast-iron balconies and their characteristic laundry lines. The architecture was classic, the weather Mediterranean. As a haven for homosexual men and heartland for the Mafia, Palermo had a subcultural flair. The Baroness captured the atmosphere in the poem

"Palermo," which she later translated into English, preserving the rhymes of her early apprenticeship poetry: "Down white city presses deep / Blanketarms at western seam—/ From smoketopazes yellow peep—/ Velveteen mountain—brain flaunts dream."[33] Palermo remained deeply anchored in her psyche as the place where she was "pampered—loved—elegant sweetheart wife of: Felix Paul Greve."[34]

The lovers lodged in a moderate pension at Via Lincoln 83. Like no other lover before, "Mr. Felix" had internalized her desire for orgasmic pleasure and went about his work with a Teutonic sense of duty, as the Baroness recalled: "It was highly necessary to be at it methodically and unflinchingly—quite aside from our desire that was existing in greater amount in me than in Felix." She blamed inexperienced and impotent lovers on her sexual neglect, but she also realized, "I had to relax my brain instead of flex it." After more than two months of rigorous sexual workout, the moment of bliss took her to the height of ecstasy—and a new realm of knowledge, for there was "all life contained and fulfilled in it."[35] This long-awaited experience opened a new realm for later poetic exploration (as seen in the poem titles "Orgasmic Toast," "Koitus," "Desire") but also energized her feminist demands for sexual pleasure as a *woman's right,* a demand all the more intensive and exuberant as she had missed out on it for so long. She retrospectively rated her sex-sun's erotic style: Greve displayed "purposeful potency," in contrast to her other lovers, "men with elaborate overtures" but "with little opera body behind it—'much ado about piffle.'" Still, her lover was sexually distanced: "It left me lonely with my splendor." Greve squeamishly put his hand over her mouth to stifle her cry of pleasure, "which I never ceased to instinctively, but silently, resent." After intercourse, "Felix bent rigidly away, and never would have suffered any touch after climax—nor pet me." Summing up his erotic profile, she called him "too much business mechanic—too

self-conscious of executive ability—too proud of it." His "slight contempt" for sex already showed elements of sexual aversion.[36]

Felix's sexual style, while consistent with his controlled body language, also suggests a more profound gender ambivalence. In *Randarabesken zu Oscar Wilde* (1903), Greve confessed that the phantom of Wilde encroached on his erotic pleasures with Elsa: "He followed me across the sea into my sweetheart's chamber. As I stood upon Etna and rejoiced in the contemplation of the volcanic furnace into which I gazed, suddenly he stepped near and threatened me . . . and dear hours of whispering love has he deprived me of by shooting satirical arrows between our lips."[37] The none-too-subtle threat of the "volcanic furnace" represented by Wilde easily overpowers Greve's love whisperings with Elsa. Striking too is the fantasy's physicality that allows Greve to envelop Wilde with the tone of an enamored lover—"your once shining blond hair falls in tangles over your forehead, and that finely curved mouth, with its marvelous lines, smiles at me"[38]—an intimately physical, Wildean imagery all the more consequential if we consider that, with the exception of references to Elsa's androgynous style of dressing, her bodily or facial presence is often forgotten over long stretches of *Fanny Essler* and *Maurermeister Ihles Haus*. All this, in sum, suggests that in Palermo, with the help of Elsa's exuberant sexual energy, Greve was hard at work submerging and repressing the transgressive Wildean ecstasies that he had celebrated so openly just one year earlier when traveling with Kilian.

The couple's romance in Palermo was a minefield about to explode. Called back to Bonn in May, Greve was arrested at the train station, a trap set by Kilian, who was infuriated that Greve had used his money to finance his adulterous affair. Although forced to admit that "there had been a spiritual homosexual affair" and that Kilian acted from motives of sexual jealousy, Elsa continued to deny any physical affair between the two men (just as she would remain blind to the homosexuality of many of the men she pursued, as we

shall see).[39] In early 1903, Kilian had good reasons to feel a lover's jealousy, for Elsa would effectively now take his place in Greve's life: as muse, inspiring his first novels; as collaborator, actively participating in his translations and fiction; as traveling companion to France and England; and as lover with an energetically aggressive sex drive, consolidating Greve's private and public gender identity along heterosexual lines.

With Greve beginning a one-year prison sentence on a fraud conviction, Elsa was left alone in Palermo. "The true trouble was the physical abstinence—it was excruciatingly painful to me. I had to make poems again!"[40] In addition, she was feverishly corresponding with Greve, "as my poetry was not sufficient to express my sextrouble in." She continues: "I had to confess it [my sextrouble] to him largely—until he had to beg me to be less expressive, more conventional in my descriptions—for the sake of the prison officials becoming outraged or demoralized."[41] On 29 May Greve had been sentenced to fourteen months' incarceration, owing his creditors the unheard of sum of 40,000 marks, the equivalent of ten times the amount today. Yet he was barely behind prison bars in Bonn when he "*started his career as translator this year in jail*"[42] and launched his career as fiction writer. With Elsa's steady flow of erotic letters, he sat down to compose *Fanny Essler.*

We may glean the contents of her material from a remarkably rich sexual dream that occurred in "Via Lincoln in Palermo," when she was "Felix Paul Greve's sweetheart," a dream that may very well have startled the censoring prison guards in Bonn. Decades later in 1924, the Baroness relayed this dream to Djuna Barnes, just as she would have relayed it in German to Greve in 1903:

I saw before me huge round building with dark entrance door— there I slipped in—found myself in arena very much like that of coliseum in Rome—*amphitheater*—not quite that large—I went into first tier of seats—went—went—until I came to 3 *metal statues*—stiff

erect—(iron—I think) what was most stiffly erect—were their penises—for—they were nude—I felt some apprehension shudder—yet I *had* to pass them to so do—I had to walk front—or—backwise—the passage being too narrow by their presence—I passed them backwise—each of their penises touching my behind with mixed shudder of my body-soul—after passing—there—before me on the balustrade in the arena—stood coffin with woman corpse in it whose abdomen was worm pit—squirming! I looked at it—conscious of being apprehensive about the three iron statues—not daring—to pass them again—that dream was in Palermo—*20 years ago.*[43]

In a rite of passage of sorts, sexuality is played out in a public arena: the amphitheater anticipates the performative aspect of Elsa's sexuality, the theater's emptiness making this act a dress rehearsal of sorts. The powerful image of the coffin that ends this performance takes her back to her mother's cancerous womb, the image of sexual terror thus an integral part of her experience of sexual pleasure in the Via Lincoln. The nude statues with their iron erections are the panacea against the impotent lover, but the iron imagery, of course, also takes us back to the childhood imagery of male power (the iron-willed father and the iron chancellor). The nude statues, tripled and faceless, suggest anonymous, promiscuous sex: the frisson enjoyed through the touch of their penises is purely sexual, pleasurably depersonalized. And finally, the statues are objects of art, so that sex is enjoyed through the medium of art.

Elsa's dream thus also begins to chart her unconventional "sexpsychology" that she now marshaled in Palermo, for "[n]either nature nor art interested me without a man's sex presence."[44] More than pleasure, sex belonged to the realm of experience, expanded her cognitive knowledge, and cultivated a new personality, for "enlargement of experience—knowledge—personality—was with me reachable only through sex."[45] While waiting

for her lover, she plunged into a world of promiscuity, without feeling a pinch of guilt, although she did feel a great deal of visceral rage. A lover, an Italian "gentilhuomo," who ignored her destitute state and plea for support, became the object of a frightening, Raskolnikov-like, murder fantasy: "how easy I could smash his head with a piece of old masonry taken from the roof."[46] Her sense of powerlessness in the classical heterosexual liaison accumulated into an angry charge that would be released in her dada assaults of the next decade. Conversely, she refused to have sex with a young, supportive German doctor, who was infatuated enough to listen to—and disabuse her of—Greve's tall tales, such as the tale of Greve's heroic walk on broken kneecaps. She now realized that she had fallen victim to a brilliant teller of lies.

In late summer, Endell arrived, still trying to repair the marriage. "I turned him out," recalled the Baroness, who lacked Reventlow's ability to negotiate the end of affairs with diplomacy. Her lack of sensitivity effectively spoiled the amicable divorce settlement already negotiated by Greve from his prison cell.[47] Endell was to keep 1,500 of the 3,000 marks Greve had given him as a traveling loan, in exchange for Endell's being a "gentleman" about the Endell divorce. Endell paid Elsa 1,500 marks but reneged on his divorce promise, forcing his wife to cite her own adultery in the divorce proceedings and thus complicating Elsa's and Greve's later plans to marry.[48] With her settlement in hand, she paid her patient landlady and moved to the Hotel Trinacria, taking a modest room overlooking the street.[49]

The rest of the year was spent in sexual adventures in Palermo and Rome—mostly with homosexual men. A chance meeting in Palermo reconnected her with Bob, the gay painter from Dachau: "But for electricity lacking in our physical touch—we should have been very pleasant nice comfortable lovers."[50] It was he who first presented her with a large package of henna that he brought from Tunis. From now on, she would dye her hair red, probably to

hide the first gray. Here in Italy, in 1903 and 1904, her predatory sexuality surfaced for the first time in a bizarre adventure with a thirtysome-year-old former military officer from Düsseldorf, Germany, Herr von Daum, or Mister of Thumb, as she called him, a man whose homosexuality she was eventually forced to recognize. Their romance began with a kiss in one of Palermo's expensively luxurious resorts, the fashionable Villa Igea: "I felt his sensuality—I needed the first 'kiss' of sexacquaintance—an overpowering stimulant." When her lover subsequently became shy and preferred "not go any further," her sexual urge morphed into desire to control: "He was scared—I absolutely determined—driven—by a might—that took possession of me," as she recalled: "this man I had to have."[51] At one o'clock at night she sneaked out of her hotel room and, like the legendary Casanova, overwhelmed her shocked sex victim in his room. When her reluctant lover dared to escape in a hasty postcoital journey to Naples, the lust of pursuit immediately took hold of her. She packed her suitcases, traveled to Naples, searched the hotels, found him, and registered as his wife. Still, her sex pupil proved unsatisfactory: "I went to bed with him. He did his best—I must admit—but he was as joyless, listless as ever—sulky and disgusted afterwards."[52]

The motivation behind this quixotic adventure? Her "sex-psychology" was not interested in testing new techniques. ("He had a very handy whip ready for use—should I ever have felt sadistically inclined," the Baroness recalled, but asserted: "I [was] not leaning to any sexperversity at all.")[53] In sexually commandeering the former military officer, she had begun to enact and *theatrically* control the frustrating relationships of her life. In her staged reversal of conventional gender roles, then, we can see the future sexual terrorist, the protodada artist who would soon haunt the streets of Greenwich Village with gender acts that troubled, disrupted, and parodied the conventional categories of body, gender, sexuality, and identity. Her wild sex life in Italy showed a sexually uninhibited

woman with her own unique blindnesses, for she was unable to see her putative lover's homosexuality, until she was enlightened by a friend. After months, in early 1904, lonely and unhappy, she dispensed with her surrogate husband.

Now in the spring of 1904, she settled in Rome's modest Piazza d'Espagna and finally found the proper conditions for making art: "I again occupied myself with poetry in the usual half-hearted fashion of the amateur."[54] In Rome she met Charley (Karl) Bär, a cross-dressing Munich artist with a finely chiseled intellectual face and a distinguished limp. He "powdered himself conspicuously and painted his lips—I wildly liked this with Charley—it befitted his entire person—I took it as artistic expression."[55] Significantly, although this unconsummated sexual experience did not satiate her "sex hunger," it was more important than the others: "When Charley began to tell me sometimes bits of his own adventures of homosexual interest—it made me [w]ildly curious—never jealous—sometimes I would have liked to join him in some—as spectator. But he did not permit me."[56] Yet it was almost time to return to Germany, where Greve's prison term was nearing its end.

In May 1904 Elsa was in Germany to reunite with her lover after his release from prison in Bonn. Her divorce from August Endell had taken effect earlier on 23 January 1904.[57] The couple went to Cologne, staying in a small pension. Yet the time of reunion propelled them into fierce quarrels—perhaps because of Greve's ambivalence and lies. "Are you game for going to a small, god-forsaken sea-resort where we can swim, ride, and—(for a few ladies could be easily procured)," he propositioned to Schmitz in a 28 May 1904 letter. "In the right company, I would be ready for such immoralities. Alone it would be too sad. We could do this on the cheap and work our brains out."[58] It is doubtful that the proposed "immoralities" took place, for on 2 June 1904, Greve was in Paris, visiting André Gide. Although he wanted to separate from Elsa, Greve confessed to Gide that he could not live without her. He announced

his wedding but also insinuated a (presumably sexual) lie ("C'est avec elle que je mens le plus volontiers. Parfois cela amène entre nous des scènes terribles").[59] [To her I lie most readily. Sometimes this leads to terrible scenes between us.] A consummate tease, Greve presented himself as an object of seduction for the homosexual Gide, who was taken with his German translator's stunning elegance, which marked even the most trivial objects like his silver match box and cigarette etui. Still, Gide was uncomfortable with Greve's equivocations and long awkward silences, as he sat passive, a role reminiscent of the stony passivity he had displayed with Elsa during their courtship. Unlike Elsa, Gide took no initiative but noted: "Face to face, his almost childlike smile makes him seductive; in profile, the expression of his chin is disquieting."[60] Their day together ended prematurely with a visit to "Philippe" the hairdresser, where Greve bought henna for Elsa and then waited alone for the midnight train to Cologne. Over the next five years, Greve would maintain an extensive correspondence with the French author.

The first five years of Elsa's life with Greve were sustained by passion: "I had no duties but the one that was my blood-call—*to love him.*" Enamored, she let him take firm control of her identity: "I had to dress highly stylish—with false hair—because he did not approve of short hair or artistic individual hairdress."[61] A proverbial queen kept in a golden cage, she was rarely presented to company, for he was a jealous lover as well as being ashamed of her social behavior. She was too unpredictable, too much *enfant terrible,* radiated too much "sexattraction." Yet Greve was in love with her extraordinary mind: "It was the quality that first aroused his interest—then his respect—then his love."[62] This marriage of minds now launched a collaborative team of unusual power conjoining Greve's hard labor, executive ability, and ambition with Elsa's daring originality and lived experience. While Greve was visiting Gide, Elsa was already busy reading the manuscripts he had prepared in prison, a

gargantuan output of work.[63] Their residences were determined by Greve's nomadic restlessness and pecuniary circumstances: England (1904), where they visited H. G. Wells, whose work Greve was translating; Hotel Pension Bellevue in Wollerau, near Zurich, Switzerland (July 1904 to May 1905), a beautiful but remote landscape; the French coast near Étables (summer 1905); and then several Berlin residences: Fasanenstrasse 42, Nachodstrasse 24, and finally Münchnerstrasse 42. In each, they installed themselves with Elsa's two dogs, Mumma and Nina. In the country, they enjoyed simple pleasures—horseback riding, dinners at a nearby hotel, and tea with guests a few times a week. The simple life evoked Elsa's Swinemünde childhood, while Greve confessed to Gide: "As for my own need to see *life*, one single night in Paris is enough to last me for months."[64]

The first published fruit of their labor, seven poems, appeared in a well-known literary journal, *Freistatt,* between August 1904 and March 1905, using the pseudonym of Fanny Essler. "Fanny Essler's poems breathe a life and intensity which is more characteristic of Else's expressive creations than it is of Greve's," writes the curator of Greve's manuscripts at the University of Manitoba, Gaby Diavy, who documents that several of the German poems thought to be authored by Greve were really a collaboration with Elsa.[65] In fact, by 1904, Elsa had gone through several bursts of poetic creativity, most notably in the Wyk auf Föhr Sanatorium and in Palermo, turning her sexual yearning for Greve into poetic expression. One of the published sonnets is a portrait of Greve, in which his personality is explored through his physicality: her lover's "white hand" is suggestive of his refined nature, but "in rage / turns into marble fist." His "blue eyes," "blond eyelashes," are veiled: "a mist: a cloud: a mask," alluding to his swindler-identity. The mouth is a combination of sensuality and mocking intellectuality.[66]

This poetic collaboration raises the more complex question of authorship with respect to the couple's infamous novel *Fanny*

Essler, published in October 1905 in Greve's name alone. In October 1904, Greve had written to Gide: "I am no longer just *one* person, I *am three:* I am 1) M. Felix Paul Greve; 2) Mme Else Greve; 3) Mme Fanny Essler."[67] He described their collaborative process. "The method is all mine," he explained to Gide, "and it is a method without commentary; a textual editing without annotations."[68] Elsa had provided the story of her life—through written correspondence while he was in prison ("dictated by me as far as *material* was concerned," as the Baroness put it),[69] hence its factual accuracy and richness of detail—just as she would later provide Djuna Barnes with her life's story through letters.[70] From Italy she had written a flurry of sexually explicit letters to Greve, and since she could not very well talk about her adulterous adventures in Palermo, it would have been natural to write out the picaresque story of her most recent sex adventures in Berlin and Munich, as well as write of her involvement with Greve—in short, the stuff of *Fanny Essler.* The novel was completed from fall to winter 1904 in Wollerau, Switzerland.[71] "And don't expect any pleasantries," Greve warned Gide just two months before its publication: "Almost everything is disgusting to an extreme"[72]—comments that were likely meant to whet his mentor's appetite.

Published in October 1905 in Stuttgart and Berlin, their joint novel now publicly sealed the couple's sexual and intellectual union. The novel functioned almost like a modern talk show in which Elsa's contemporary sexuality was confessionally displayed, with Greve as the talk-show master eliciting, framing, and channeling the explosive materials—namely, Elsa's revelations about the private spheres of contemporary artists, including Lechter, Hardt, Endell, Wolfskehl, and Greve. Friends quickly identified the book as a collaboration. Herbert Koch, an archeologist and friend of Greve's, commented to Reventlow: "Have you read F. P. Greve's novel? We and Helene Klages are not yet in it—but the last part with its con-man atmosphere made me think back to the old times. Else

Ploetz must have replayed the respective people brilliantly (Lechter, Endell, and in particular Ernst Hardt). All in all, very talentless and a bit mean."[73] The "not yet" implies an expected sequel; "mean," of course, was the term used by Schmitz and others to criticize Elsa as a disruptive force. The satire presents a female protagonist who is left sexually frustrated as she travels through an avant-garde circle of men who claim to be dedicated to Germany's first erotic revolution.

As a *roman à clef, Fanny Essler* finds its prototype in Ernst von Wolzogen's *Das dritte Geschlecht* (The third sex) (1899), a best-selling insider novel about the newly emerging gay and lesbian culture in Munich drawing on well-known localities (including Giselastrasse, where Greve lived) and artist personalities: Hermann Obrist, August Endell, Franziska zu Reventlow, Sophia Goudstikker, and Wolzogen himself.[74] A second inspiration was the satiric *Schwabinger Beobachter,* a parody of George's *Blätter für die Kunst* (satirized as *Blätter für die Katz:* Folios for the cat). This underground journal was written and published in February 1904 by Reventlow with Franz Hessel, Roderich Huch, and Oscar A. H. Schmitz. The latter may well have sent a copy to Greve's prison cell to cheer him up with some irreverent fun directed against the circle that had coldly ostracized and exiled him. In the *Schwabinger Beobachter,* Helene Klages announced the loss of her virginity, now calling herself Magdalene (the still unwedded Helene was due to give birth in March 1904).[75] Atelier Elvira was persiflaged as Atelier Lesbos, which rejects "phallic symbols but accommodates all other impersonal tastes."[76] Klages's anti-Semitism was exposed in Herrn Dr. Langschädel (Dr. Longskull)'s new invention: a drug called "Phil-Aryan" designed to help the user to revise her manuscript so as to incorporate anti-Semitic elements.[77] In the *Beobachter's* third and last issue, Greve appeared as "Damon" in a grey dress (the garb of his prison incarceration) to be reunited with Helena as the father of the newly created Homunkulos.[78] Anonymously distributed to mem-

bers' mailboxes in the dark of the night, the *Beobachter* was a subcultural form of publication.

Fanny Essler, in contrast, addressed itself "to the masses" as a serious book publication, while parodying vanguard politics with insider references. The novel's title, for example, is a combination of Elsa's *(Essler)* and Reventlow's first baptismal name *(Fanny),* as well as alluding to Elsa's aunt Maria Elise Franziska Kleist's name. Wolfskehl appears as Katzwedel (cat's tail), the cat also alluding to the recent *Blätter für die Katz* (in the *Schwabinger Beobachter*). *Friedrich Karl* Reelen, Greve's alter ego, is the rich dandy par excellence. But his distinctive name also alluded to other sexually unconventional men: *Friedrich Carl* Andreas, Lou Salomé's husband; Herman *Friedrich C.* Kilian, with whom Greve had been *reeling* before meeting Elsa, and perhaps even *Friedrich Carl* Endell, August Endell's father. Strangely, Reelen's character is also close to Ludwig *Friedrich* Klages, Greve's old nemesis in the traveling virgin debacle, as both Klages and Reelen were emotionally cold and imposed constraints on the women they loved.

Since the novel's most important contribution resided in its sexual politics, this was also an area where Greve's ideological input as "editor" of Elsa's text is most serious. Consider his description of the sex act that cemented their union, as Greve superimposed a cold erotics of ecstasy on Elsa's sexuality, while also flaunting himself as potent lover:

She had wanted to kiss him and to excite herself. But he had looked at her almost distantly [*befremdet*] and there had been nothing else in his somewhat veiled eyes than a determination: this had mastered [*bezwungen*] her and she had known that now it would happen! And it had happened: a new ecstasy [*Rausch*], an ecstasy that was totally self-generating, which had its own purpose [*Zweck*], its own goals [*Ziel*] and ends [*Ende*].[79]

The sex act between the lovers is depersonalized: this is noncorporeal sex out of which emerges purified and bodiless ecstasy (*Rausch*). The bodies are absent: no kiss, no touch, even the gaze is veiled, creating boundaries. Male (*er*) and female (*sie*) are choreographed not as bodies but merely as grammatical pronouns and sexual positions: acting and acted on, *zwingen* and *bezwungen*. Sex itself is like a transcendent work of art, an abstract eros of teleology (highlighted in the obsessive redundancy of *Zweck, Ziel, Ende*) in diametrical contrast to the warmth and bodily awkwardness of Wolfskehl's Dionysian delight during the carnival dances.

This Grevian sex scene contrasts with the Baroness's focus on intensively emotional evocations of eros and bodily touch, her style's no-holds-barred emotionality, its excess of both love and hate, its ultimate risk of self and form. Reading Greve's scene, we can easily fathom the enormous physical distance cultivated by Greve; conversely, we can only begin to fathom the fears of intimacy that compelled the Baroness to single out this man for the most important love relationship of her life (or for that matter, to pursue homosexual lovers in a quixotic attempt to make them "sexpupils"). Ultimately, Greve's sexual writing advocated the "erotics from the distance" (*Erotik der Ferne*) and the abstract *Rausch* theorized by Klages. That Greve would thus publicly pay tribute to his nemesis seems strange, unless, of course, it was to show his rival what he had lost in scorning Greve as a potential brother-in-law and lover of his sister. In this scene we cannot help but think that Greve was really teasing the handsome Klages himself—homoerotic desire triangulated and played out on the body of Fanny Essler. Greve conveniently killed off both Barrel (Endell) and Fanny (Elsa) at the novel's end with Reelen, once again an object of desire—a free-floating tease—freed from the labor of the actual sex act. Elsa did not like this stylistic and linguistic corset given to her sexuality ("I did not cherish his abrupt style") and began to question Felix's genius as an artist. Yet in a unique artistic collaboration, they had created an unsettling

work that neither could have created alone. Greve had taken his re-
venge against the circle that had exiled him. In an effort to recon-
cile with Wolfskehl two decades later, the Baroness would write: "I
didn't write that novel. I couldn't help how Felix used information.
It was not in my power—even if he had not succeeded in persuad-
ing me against that circle—that had ostracized him—first on ac-
count of the virgin—later on account of his jailterm."[80] Although
she remained ambivalent about the novel, the strategic public ex-
posure of personal events would become a trademark of her incen-
diary dada.

In early 1906, the Greves returned to Berlin-
Charlottenburg, living in a furnished apartment on the Hinterhof
at Fasanenweg 42, an impressively elegant street with Jugendstil
buildings, a sign of their modest budget but refined taste. Ironically,
right across from them lived August Endell, who was recruiting
students for his art courses, obviously also needing additional in-
come to pay his debts. In February 1906, just as *Maurermeister Ihles
Haus* was going to press, Greve was making ambitious plans to
launch his own journal for the twentieth century with international
contributors. "Tea with FPGs," noted Oscar A. H. Schmitz in his
diary in November 1906. "He is again himself—literature, theater,
publishing. She is aging, but is well made up; still the same superb,
elegant figure. They are working together, whereby she contin-
ues to insist on her courtesan's point of view." Schmitz provided
a glimpse of their collaborative translation strategies: "She particu-
larly enjoys when he translates the erotic 1001 Nights tales with
her, whereby she sows and has the feeling that he reads to her."[81]
We imagine Greve reading to his spouse a roughly translated copy,
whereby she participated by suggesting more subtle alternatives
and more original phrases. *Thousand and One Nights* was Greve's
"most brilliant" translation, a stellar success with numerous edi-
tions. "Years ago—in Europe," as the Baroness admitted to Jane
Heap, "I was used thusly by my husband almost mechanically—as

spiritual hand—I was famous for my 'yes' or: 'no.'"[82] She pinpointed Greve's weakness as his lack of originality, to which she was the "antipode." Indeed, Greve's biographer Martens, himself a translator, notes that we cannot overestimate Elsa Greve's influence on Greve's translation career; she was probably generous enough to remain in Greve's shadow for a while—but not forever. A proposed translation of John Keats's letters, favorably reviewed by the renowned Austrian poet and playwright Hugo von Hofmannsthal, carried her name.[83] By 1910 she would be listed as a writer in the Berlin address book.

So what about the couple's personal happiness? "Marriage is a strange thing—one part always has to knuckle under and suffer and I didn't—not *knowingly*—only as far as my passion's blindness went—willingly," recalled the Baroness for Barnes.[84] In November 1906, Oscar A. H. Schmitz, freshly divorced himself, asked Greve to clarify the nasty rumors that Greve and Elsa were blackmailing August Endell (the rumors, no doubt, prompted by the couple's close proximity to Endell). Greve explained the settlement complexities: he was contesting the divorce proceedings so that he and Elsa could marry in England. They were an attractive couple, both slim and elegant. "I am impressed with the Greves and their ability to maintain a solid, but intensive elegance in their taxing struggle for existence,"[85] noted Schmitz in his journal on 11 December, 1906, after meeting the Greves in the Theater Americain in Berlin (incidentally, a building designed by Endell). A month later, on 14 December, Greve invited Schmitz to an English-style wedding breakfast. He has just learned, he wrote confidentially, that the last obstacles to his marriage were about to be removed.[86] Indeed, Elsa and Felix did marry on 22 August 1907 in a civil ceremony in Berlin-Wilmersdorf, as confirmed by the Standesamt Charlottenburg-Wilmersdorf on 9 October 2001.[87] Yet there is little evidence of marital bliss. Already deep fissures were apparent. In oc-

casionally fierce quarrels, Greve, "pale as death," told her that "if I did not shut up—he would be tempted to hit me—and that was something he never could bear—and live."[88]

Five months after the Greves' wedding, on 13 January 1908, a Sunday, Oscar A. H. Schmitz visited Greve but found his friend alone and sick, in an obvious state of emergency: "His wife is in an institution and is apparently going insane because her dog Mumma has been lost for 3/4 years. This woman has borne so many blows. But she cannot bear the loss of her dog. She is said to have cancer of the womb. Seldom have I felt misfortune so profoundly, and felt that it can't be helped, that it must be escaped, while in other circumstances I am willing to help the unfortunate. Nauseated by life I go to the café at 10 o'clock."[89] Perhaps it was a sign of the marital stress that Elsa was mimicking the symptoms of the dreaded disease that had killed her mother. On Schmitz's next visit a few weeks later, Elsa was home, looking "intriguingly decadent," as Schmitz noted.[90] Meanwhile, Greve reacted with psychosomatic symptoms of his own as recorded in his letters in litanies of colds, coughs, headaches, and backaches, the result of chronic overwork and marital tension. In June, he confided to Gide that he had been "sick for months on end" and that he will be "off to Norway." Then, as if offering a piece of nonconsequential tidbit of gossip, he said: "Here is another bit of news: I shall be divorced."[91] Yet despite these ups and downs, in December, the Greves were still together, moving to Münchnerstrasse 42 in the Bavarian quarter, their last residence in Berlin.

In late summer of 1909, Greve made a dramatic move that would make literary history. With Elsa's consent and help, he staged his own suicide and suddenly departed for America via Canada. Frustrated with his editors, his public, and his income and trying to escape a vicious circle of chronic indebtedness, he "wanted to 'rough it' now from the bottom up 'like many a one' who became a millio- or milliadaire in America."[92] It was Elsa who announced

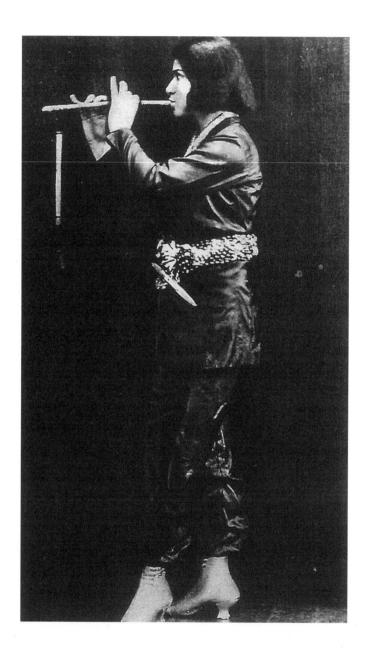

5.2 *Else Lasker-Schüler in costume,* ca. 1913. Photograph. Courtesy

Friedrich Pfäfflin, Marbach am Neckar.

his "suicide" by letter and telegram to Anton Kippenberg, Greve's major publisher, even charging Kippenberg with having contributed to her husband's desperate act. In a lengthy letter to Elsa, Kippenberg firmly rejected the charges and generously declared the 4,000 marks advances made to Greve to be a special honorarium, should her husband be alive or dead; he ended by offering his personal help.[93] This help could very well have been monetary, making possible Elsa's own transatlantic move one year later, after Greve invited her to join him and arranged to meet her in Pittsburgh, Pennsylvania.

What did Elsa do during the year without Greve? She continued to live on Münchnerstrasse, where she had a telephone installed. It is intriguing to speculate that she might have met Else Lasker-Schüler (1869–1945) (figure 5.2), who was presenting her nonsense sound poetry in Berlin cabarets, poems that would be used a few years later by the Zurich dadaists in the Cabaret Voltaire.[94] In November 1909, Lasker-Schüler assumed the name and title of Prince Yussuf of Thebes, a profoundly androgynous persona. Photos show her in male garb, in high boots, knee breeches, and fringed jacket. Sometimes she wore a fantastic headdress made of feathers, a reference to North American native culture. Lasker-Schüler came from an affluent home but had turned her back on bourgeois society, when in 1899, she gave birth to a son and refused to name the boy's father. Walter Benjamin thought she was hysterical, but Lasker-Schüler has since been embraced by readers as deeply emblematic of the struggles of the modern woman artist. Looking at Lasker-Schüler's parallel fate of art and poverty in Germany, one wonders what Elsa's career would have been like had she stayed in Berlin in 1910. Elsa, perhaps, needed that *transcultural* experience to push her fully into art, and she was ready to take the plunge across the Atlantic when Felix Greve called. On 29 June 1910, Elsa Greve arrived in New York via Ellis Island from Rotterdam after a nineteen-day journey aboard the *Rijndam*. On her immigration

declaration, she proudly identified herself as an "author." She owned $50, just barely enough to get her to Pittsburgh, where she was to reunite with Greve.[95]

██████

And now in "Sparta, Kentucky, along the Eagle's Creek," as she identified her new home in the margin of one of her poems, began the strangest and perhaps loneliest period of her life. Sparta was a small town with a railway connection to Cincinnati, a little more than a hundred kilometers away. For the urbanite New Woman, the lonely bush country became the backdrop for the painful disintegration of her bond with Greve. In *Settlers of the Marsh* (1925), we are given a window into Elsa's bizarre life during the Kentucky year (although the Canadian novel is set in the Manitoban settler community). In a typical scene, Niels Lindstedt (= Greve) is engrossed in field work, the other farm women busily preparing meals, while "Mrs. [Clara] Lindstedt [= Elsa] sat in a corner of the kitchen, in a silk dressing gown, relieved of all responsibility, gossiping, smiling, ironical. [. . .] She was outside of things, an onlooker pure and simple."[96] During the stress of harvest time, Clara dyes her hair with henna leaves, applies makeup, and at night keeps Niels awake with a sexuality at once distracting and engulfing: "Whenever she came, she overwhelmed him with caresses and protestations of love which were strangely in contrast to her usual, almost ironical coolness."[97] Niels's deep aversion to sex is palpable: "Distasteful though they were, he satisfied her strange, ardent, erratic desires."[98] Through Niels's eyes, we are given a first glimpse of the grotesque Elsa who would soon shock Greenwich Village as the incarnation of Old Europe, when he sees his wife's face without its makeup: "an aging woman, yellow, lined with sharp wrinkles and black hollows under the eyes, the lips pale like the face."[99] Still, unable to let go of her, he reacts with fierce jealousy

when she commutes to the city to amuse herself. Presumably Elsa traveled to Cincinnati to model or, perhaps, to explore the German vaudeville theaters.

Back on the farm, sexuality was the friction point that ignited deeply felt responses. "For later in America," as she recalled in her memoirs, Felix Paul Greve "began again to be *impressed* by virginity," a trait she exposed as profoundly misogynist: "To adore virginity as an essential property (instead of as preparatory state only—and then—why adore it? Everybody has it—even a kidgoat!) is the most flagrant illogic possible! It is sentimentality to that rotting tradition that reduces men of Teutonic race—for *they* are the most beset with this freak growth of no sense."[100] Her criticism hit the mark, for the Canadian Frederick Philip Grove married a virginal woman and celebrated the androgynous virgin figure in fiction: Ellen Amundsen in *Settlers of the Marsh,* Jane Atkinson in the eponymous unpublished novel, and finally the German traveling virgin Kirsten in *In Search of Myself.* For Elsa, this regressive Teutonic ideal was all the more insulting, as he "had ceased to have any intercourse with me—for he had lost interest in it, being in an absorbing primitive struggle for life—in America."[101] In Canada, Grove moved closer to embracing family values.

Meanwhile, in *Settlers,* a terrible sense of loneliness settles on the house, where Clara lives hidden in the upstairs room— alone with her books. Grove captured the desolation Elsa must have felt, physically and emotionally abandoned by her lover and husband long before he left her for good. What Greve does not tell us is that the enforced loneliness was not all negative. The number of Kentucky poems alone suggests that her birth as a poet in her own right occurred in the bush country. In these poems, she explores the new countryside: losing her way, feeling cold, making a fire. In these early drafts, we see the emergence of unusual poetic devices that anticipate the dada strategies to be fully deployed in New York. "Ghost" (Gespenst), for instance, is a love poem with a twist. The

speaker expresses her desire to caress her reluctant lover (no doubt, Greve), desires to kiss him, desires to possess him, but ends the poem with a shocking gesture: "There / I smash you to pieces—" as if the lover were a glass object.[102]

Many of her poems are a therapeutic and elegiac working through her sense of loneliness and loss. Referring explicitly to Kentucky in a marginal note, "Solitude" is typical in controlling emotional pain through aesthetic transformation:

I go

Sycamorepike—
Sibilant whistles wind—

I go:
Cloud coils dense
Nary star lit—

I go:—hence—
Past Timbershroud
Whence
Woe scales ridge—
Rearing slow—peering
Purblind I follow
Bellow—
So
Dire dirge trees[103]

"This poem *once* I conceived in Kentucky fashioning it there—*less* 'artful,'" as the Baroness recalled for Djuna Barnes, noting that she was thirty-seven years old when she wrote it, which puts the composition date around 1911, coinciding with Greve's desertion.[104] In another version of this poem offered to Jane Heap

for publication in *The Little Review,* this Kentucky poem is appropriately titled "Betrayal" (Verrat). Imagery and language further suggest that she was in tune with nature, the bush country's sycamore pike, the timbershrouds, and dirge trees; Grove similarly associated Clara with the "dark green cushions of symphoricarpus."[105]

The Kentucky poems are already experimental in style, and through them we can begin to trace her development into dada poet. "Weg in Kentucky" (Trail in Kentucky) is an early poem with conventionally formal quatrains and end rhymes (Es senkte sich die graue Nacht—/ Der Pfad verschwand—eh ich's gedacht) that suit the Dantean narrative of being lost in the forest after nightfall. The final version of this poem—titled "Lacheule in Kentucky" (Screech owl in Kentucky) and signed "EvFL" (thus revised and completed in New York)—injects drama and intensity. She has dismantled the quatrain structure and stripped the poem of its narrative and conventional syntax. She has added the shriek of the owl to produce the hysterical "crazy laughter" of sardonic sound poetry or bruitism that ultimately makes fun of the speaker's fear:

Fluss auf — jach!
Verrückt Gelach:
Hu–Hu–Hu–
Hu–Hu–Hu–
Ä, Ä, Ä
Hi–Hi–Hüü——u - u - Huch
Huch! Huch!

Poem after poem reveals the same process by which language is reduced to the bare dada essentials, some poems slimmed down to virtual word columns and sound effects.

What was Greve's reaction to Elsa's new artistic independence? In *Settlers,* Grove describes Clara as linguistically

powerful, more potent with words than Niels, who is strangely tongue-tied, silenced, or stammering. This admission of female intellectual superiority in fiction parallels real life. As an artist, Grove was in a precarious latent stage. He was struggling to establish himself in the new country—as a farmer and teacher but not yet as a writer. His two German novels and his poetry had denied him a breakthrough success. Even in the best of times, when collaborating with Elsa in Berlin, he was resentful when she showed independent literary ambitions. When she began to write the "'*Story of My Childhood*'—for sheer ennui—urge of an own inner occupation—interest," he had responded with jealous contempt and ironic derision.[106] As Elsa saw it, he feared the rearing of her independent intellectual soul. In Germany, Greve had been hiding "under the glamorous cover of a mutual intellectual life. But it was his intellectual life—and the arising, questioning, yearning of soul of me had to be trimmed."[107] In America she no longer accepted such intellectual trimming: "He had to make the experience that true quality in a woman cannot be bullied and bluffed."[108] Indeed, with the early drafts of her Kentucky poetry in hand, we can now argue that Greve was more than merely suspicious of Elsa's "doing art." The rage he describes so intimately and compellingly in *Settlers* may be motivated by intellectual as well as sexual jealousy. This is consistent with the Canadian Grove's paranoia of successful women writers; he was routinely dismissive of their "sentimentality" and envious of their commercial success. Still, his jealous resistance in conjunction with his sexual withdrawal had the effect of finally pushing Elsa into artistic independence.

As Greve in *Fanny Essler,* Grove in *Settlers* killed off Elsa's alter ego, a fictional convention to resolve the bitter martial conflict. Still, given Grove's extended focus on rage and violence in this novel, there remains a strong possibility of actual domestic violence on that Kentucky farm. One of her German poems, "Schalk" (Jester), not only identifies the specific location of the action, Sparta, Kentucky,

on the Eagle Creek but allegorically identifies the "Fall as a portrait of FPG." The poem develops the portrait with dramatic imagery of destruction and rage: she refers to his "giant, chalkwhite, murder-hand," "his dagger heart," "his poppy-shrill mouth." Fall ultimately symbolizes a hyperbolic death: "He is devastation and raging anger / Boiling blood. / He is the pain of icy cold / Red henchman—go!"[109] Her memoir account is equally charged with imagery of dramatic destruction, suggesting the possibility of domestic violence: "it is hard to believe that a glorious castle, built as for life—can topple and vanish in disgrace—as it did—chattering into its last shame bespattered, distorted pieces in America!" The shamefulness expressed is evocative of the shameful silence regarding her father's abuse. In fact, she retrospectively yokes the two men together: "[Greve] was incapable [of granting] a woman a right to her personality—as was my father."[110] Indeed, it was the memory of Elsa's rigidly patriarchal father that Grove would now conjure up in Canada to create the prairie pioneer heroes of Canada's western settlement literature.

What did Elsa do after being abandoned in late 1911? "[Felix] secretly sent me $20 and from there on—nothing. I spoke no English, had no working skills, was arrogant, and was considered crazy," as she noted in the margins of her poetry, adding: "Every artist is crazy with respect to ordinary life."[111] Perhaps her perceived craziness had to do with what she did next. As Djuna Barnes scribbled in her preparatory notes for the biography: "after abandoned [she] lived in tent with negroes—in Virginia or Kentucky, goes up to Cincinnati, started posing."[112] The reference to living with African Americans is intriguing in light of the fact that a number of early Ohio River poems are distinctively different in tone from the elegiac poems that focus on the death of her love. "Wetterleuchten" (Sheet lightning), for instance, is a sensually intensive love poem with a black-haired man. The first stanza depicts her oral desire ("Let me drink your lips / Let me swallow your breath"). The second depicts visual pleasure as she views his love throes: "Your

strands of black hair / Cascade in love's throes / Your face light-
ning—thundering / A drunken flower."[113] This poem is followed on
the same sheet by "Camp Am Ohio," a vignette of an overnight
camp at the Ohio River, the fire lighting up a large tree behind them
as the rain and thunder roar around the lovers—sex keeping them
alive. The poem uses intensive color—red—symbolizing sex as a vi-
brant life force.

In 1912, Cincinnati on the Ohio River provided an im-
portant springboard for Elsa's acculturation in the new country. It
was an urban center, close to Sparta and attracting a large number of
German immigrants. Besides boasting a myriad of German Ameri-
can societies, Cincinnati had a German theater with regular perfor-
mances in Turner Hall. Vaudeville was one of the most vibrant
forms of public entertainment. She began her posing career here in
Cincinnati. As she immersed herself in the new language, her
Cincinnati poem, "Herr Peu à Peu," was composed in a playful mix-
ture of German and English:

Er ist our Distinguished Conductor
In Cincinnati—Der City of Pork—

So kommt er mir gedruckt vor
Genannt ist er Georg

Im Türmenden Gemäuer—
Darling—starling—prince!
Umständlich wärs auch teuer
Wärst du conductor in Binz.[114]

In the witty-ironic style of Wilhelm Busch's poetry, she describes
her reluctant lover, the German American Cincinnati conductor
George, nicknamed Orje (orgy), who is, as many of Elsa's lovers,

slow to respond to her energetic love call. Yet she was exuberantly flying high.

Her move to Cincinnati was also an admission that her most important love relationship was over. She can only speculate about Greve's fate—wondering whether he committed suicide or became rich—but she would never hear from him again.[115] In December 1912, Greve arrived in Manitoba, Canada, and settled in a German-speaking community. He changed his name to Frederick Philip Grove, declared himself a widower, and married a young schoolteacher on 2 August 1914. To what extent Greve remained informed about Elsa's whereabouts remains unknown, although it is a curious coincidence that he began to write his confessional novel about his life with Elsa in Kentucky at precisely the time that the Baroness left the United States and returned to Europe in 1923. Released from Greve's jail of conventions, Elsa would now propel herself into an arena of art in which her sexual unconventionality, poetic style, and avant-garde spirit would combine to make her an energetic and unconventional force in America's first modernist revolution. Her timing was, once again, impeccable, and at the age of almost forty she was now a generation older than America's young poets and writers. She was ready to launch herself as dada queen in Greenwich Village—before the movement was even invented. Equipped to be more than female embodiment of the male avant-garde, she was about to launch herself—finally—as artist.

[The Baroness] IS NOT A FUTURIST. S H E I S T H E F U T U R E .
—MARCEL DUCHAMP[1]

I *had* to become a nude artist—for *sheer life power*—for—I can only join *real life* not *specter performance.* [. . .] All America is nothing but impudent inflated rampantly guideless burgers— trade's people [. . .] all America is founded on that—on greed—hence I alone— do not belong here—as I say—: I CANNOT FIGHT A WHOLE CONTINENT.

– THE BARONESS to JANE HEAP[2]

It is only "art" that ever sustains me—insufficiently always—due to its bastard position— for—though I distinguish myself [. . .]—I NEVER could make distinction pay money. [. . .] I fed engine with my rich flowing blood direct.

– THE BARONESS to PEGGY GUGGENHEIM[3]

NEW YORK Dada

Part III

Strip/Teasing the Bride of New York

Chapter **6**

In February 1913, at the opening of the legendary International Exhibition of Modern Art at the sixty-ninth Regiment Armory on Lexington Avenue in New York, the American lawyer and art patron John Quinn had this programmatic advice for his compatriots: "American artists—young American artists, that is—do not dread . . . the ideas or the culture of Europe."[4] This scandalous exhibit of European fare was seen by over three hundred thousand visitors, with Quinn giving Theodore Roosevelt a personal tour of the iconoclastic display. In addition to the American fare by Mary Cassatt, Edward Hopper, and Joseph Stella, the former president would have seen a dazzling array of European abstract modernism: Matisse's nudes, Picasso's cubism, Kandinsky's abstractions, Brancusi's sculptures, and the exhibit's *succès de scandale*—Marcel Duchamp's *Nude Descending a Staircase* (1912).

Duchamp's *Nude,* which sold for the bargain price of $324, became an effective emblem for the Armory Show. With its kinetic energy, antirepresentational focus, and sardonic dislocation of the female nude in Western visual art, this iconoclastic painting paved the way for some of the artistic preoccupations of New York's avant-garde from 1913 to 1923. The Armory Show was organized by Arthur B. Davies, Walt Kuhn, Walter Pach, John Quinn, and Frank Crowninshield. As editor of *Vanity Fair,* Crowninshield would soon translate the new avant-garde élan for America's young modernist fans, although the magazine also insisted on some very clear boundaries that the ultra-avant-garde—represented in its most extreme form by Elsa von Freytag-Loringhoven—delighted in transgressing. America's first nonrepresentational art exhibit ultimately marked a pivotal point in the nation's cultural history, a clear point of departure for a young generation of artists. The Armory Show would launch some of the most important modern art collections in the United States, in particular those of Katherine Dreier, John Quinn, and Walter Arensberg.[5]

Elsa Plötz Endell Greve left Cincinnati for New York in 1913, and settled at 228 West 130th Street in Harlem, once again uncanny in matching her arrival with the launching of a major international avant-garde movement. Her stay overlapped with the period of New York dada (1915–1923),[6] and she was quickly labeled a pioneer force. "In Else von Freytag-Loringhoven Paris is mystically united [with] New York,"[7] the British author John Rodker would write in 1920. As the Baroness moved through New York City, Philadelphia, and Connecticut, she was not necessarily emblematic of the entire dada movement but was its radical exponent. Like no other, she lit a provocative firework against Victorian and masculinist assumptions that lingered even in the modernist and avant-garde movements. Among New York's avant-garde she was a daringly original artist, a crusader for beauty, as well as a catalyst and an agent provocateur in a crucial period of cultural transfer and coming of age of modern American art. As urban flâneur, androgynous New Woman, crazed sexual dynamo, and fierce enemy of bourgeois convention, the thirty-nine-year-old now confronted America with a *lived* dada that preceded the first dada experimentations in Zurich's Spiegelgasse. In the modernist war against Victorianism, she combined an original style of peripatetic bluntness, poetic intensity, and angry confrontation. She ultimately forced young Americans— among them William Carlos Williams, Djuna Barnes, Margaret Anderson, Hart Crane, Berenice Abbott, Ezra Pound, Jane Heap, and Maxwell Bodenheim—to redraw the borders of modernity, while she offered America her gift of an intensely charged poetry, visual art, and performance art.

On 19 November 1913 Elsa made her way to New York's City Hall to be wedded to Leopold Karl Friedrich Baron von Freytag-Loringhoven (1885–1919). With her nuptials, the "Baroness" was born. This was her public initiation into her artist role, similar to Mary Phelps Jacob's metamorphosis into Caresse Crosby. Elsa would use Baron Leopold's gift of a title effectively as a

provocative red flag to declare her cultural aristocracy in democratic America. It was appropriate, then, that on her way to the Italianate City Hall on Broadway she found an iron ring on the street that she claimed as a female symbol representing Venus. This was her first found object used as art. She named it *Enduring Ornament* (figure 6.1, plate 2), a title that suggests a symbolic connection with her marriage (although the artwork would prove much more enduring than the marriage itself).[8] As early as 1913, two years before the arrival of Duchamp and Picabia, the Baroness appropriated an everyday object as art, challenging traditional Western art concepts, which equated art with an object both unique and aesthetic. Already her artistic vision was radically innovative.

6.1 Baroness Elsa von Freytag-Loringhoven, *Enduring Ornament*, 1913. Found object, metal ring, approx. 3 1/3 in. diameter. Mark Kelman Collection, New York.

6.2 Baroness Elsa von Freytag-Loringhoven, *Portrait of Baron Leopold von Freytag-Loringhoven,* ca. 1913. Pencil on paper. Elsa von Freytag-Loringhoven Papers. Special Collections, University of Maryland at College Park Libraries.

As for her nuptials, the marriage with a man eleven years her junior had all the marks of a quixotic adventure. On the marriage certificate the thirty-nine-year-old, who was presumably still legally married to Greve, claimed to be twenty-eight years old, single, and about to be married for the first time.[9] Given the Baron's chronically strained pecuniary circumstances, the fabled stint at the Ritz Hotel on East Forty-seven Street was probably a short honeymoon. But who was the elusive German baron? In "Death of a Philanderer—Hamlet in America," the Baroness satirizes her husband as a ladies man, a prince in exile, and a cavalry man who cut a good figure in the parades on Coney Island. The poem is written on a sheet on which she has drawn the face of a thirty-some-year-old bespectacled man with regular features, probably a portrait of Leopold. A cigarette is hanging from his mouth (figure 6.2). The official family genealogy provided by Gisela Baronin Freytag v. Loringhoven presents an impressively distinguished aristocratic family with roots in Westphalia's old aristocracy. Leopold's father, Hugo Freiherr von Freytag-Loringhoven (1855–1924), served in the Russian army before becoming a Prussian General of Infantry during WWI. For his achievements as a writer, he was awarded a prestigious prize for arts and sciences. His mother, Margarethe (1859–1943), born in Weimar, also had a formidable pedigree. Leopold was born in Berlin on 22 October 1885, the youngest of four children, after Arndt, Hans, and Irene. As a young man, Leopold served as a Prussian military officer but was dismissed from the army when he became indebted. After ruining his career, he travelled to America.[10]

Besides his name, Baron Leo's main attraction was his sex appeal. The couple's bantering sex play near the Hudson River provided the most satisfying erotic relations of her life. In her poem "Five-o-clock," the tea water is left boiling, while the newlyweds indulge in sexual reveling.[11] "The Baron was no artist—see?," Elsa recalled for Heap. "He loved the artist in *me*—my color—strength—gaiety!"[12] In "Death of a Philanderer—Hamlet in

America," she zoomed in on his foibles. Despite "Freiherr Hugo"'s generous subventions from Germany ("the money ship from the fatherland"), he badmouthed his parents. Forced to work as a busboy in America, he did not enjoy this experience. Unable to support himself, he pawned the ring with his family's coat of arms; he shamelessly lived off his women, including Elsa. In anger, he once called her a whore (*Dirne*); she retaliated and called him a pimp (using the English phrase). Yet all of that was forgiven because the Baron, with his "lithe figure," was a "genius in love" (also, his middle names, "Karl Friedrich," ironically evoked the other "sex-sun," "Friedrich Karl" in *Fanny Essler*).[13]

In 1914, World War I marked the end of the short marriage. Seizing the opportunity to redeem his tainted honor, Baron Leopold promptly embarked for Europe, after having enlisted as a volunteer in the German army. In a less honorable gesture, he took Elsa's meager savings with him. She would never see him again. The steamship on which he traveled with other German volunteers was intercepted by the French and redirected toward Brest, where he spent the next four miserable years as a prisoner of war. After the war's end in 1918 he was interned in Switzerland and committed suicide on 25 April 1919 in St. Gallen. "In white Switzerland, he shot himself in the head," records the Baroness's poem, because he betrayed the "son's holy duty" by disclosing family secrets.[14] His death, as Elsa told Margaret Anderson, was "the bravest [act] of his life," yet seemed strangely out of step with the times and with his character.[15] During her New York years, the Baron existed merely as a memory, a ghost. His disappearance made the Baroness one of the earliest war brides in 1914, a Lady Brett Ashley figure, anticipating the promiscuous fictional war bride by a decade.

Like Hemingway's anachronistically titled New Woman Lady Brett, the Baroness wasted no time mourning but plunged into her natural sphere—the metropolis. Already she was using costuming to make artistic statements that connected with her everyday

6.**3** Theresa Bernstein, *The Baroness,* ca. 1916. Pencil on paper. Collection Francis M. Naumann, New York.

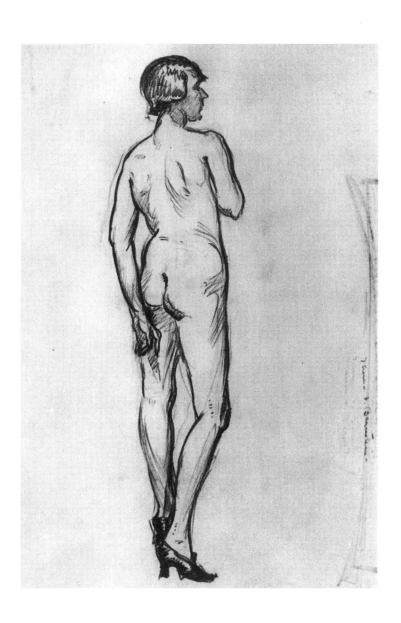

6.4 *Nude Model in the Art Students League*, 1903. Photograph by
Jacob Burckhardt. Papers of the Art Students League of New York,
Archives of American Art, Smithsonian Institute.

context, including the war. In February 1915, German zeppelins
had begun bombing Britain, focusing mostly on London; in March,
Britain began to bomb German trains carrying soldiers to the front.
The Baroness echoed these events on her body, parading in an avi-
ator hat in 1915 (figures I.1 and I.2). When the young French
American painter Louis Bouché (1896–1969) first met her at a
Broadway subway station, she was "wearing a French Poilu's blue
trench helmet," which was "only one of her odd 'get-ups.'" The
Baroness "adored everything French, she a German, and Germany
and France in mortal combat."[16] Considering that France had been
Germany's arch-enemy since the bitter French and Prussian wars
under Bismarck, her public love of things French dismantled the
very boundary on which the war's military oppositions were based.
Working in a cigarette factory, her temper erupted when one of the

factory women insulted Baron Leo: "she provoked such wrath that one of her coworkers in a rage reminiscent of Bizet knocked out two of her side teeth. Oddly enough this did not detract from her distinction."[17] For the Baroness, such marring of her beauty was tragic, the missing teeth "staring [her] down as 'woman.'"[18]

In 1915 the Baroness was working as a professional model at the uptown Art Students League (figure 6.3), where she was a great favorite with visual artists, as Bouché recalled his student days: "She posed for me and my pets, Alex Brook, Donald Greason and Carlson in our Miller building studio," he noted. "Her figure was good, but her face was far from beautiful, and she was past her youth."[19] Posing in the nude was hard work, and models earned a modest income of about one dollar per hour. A 1903 photograph of a life-study class (figure 6.4) shows a female model posing on a wooden box pedestal, her head resting on her arms; a group of a dozen or so women students are busily sketching. Among the painting instructors at the Art Students League were John Sloan and Kenneth Hayes Miller. Always critical of academic institutions of learning, the Baroness accused Miller of "mediocrity," "lack of principle," "lack of brain," and "lack of quality," but "with a good heart." He was too easily impressed with new names, "even with [the painter] Hunt Dietrich." He liked and respected her, and "*sometimes* I like him too," even though his "vainswagger" and "vanity" "nauseate[d] her."[20] "She is known to have posed for Henri, Bellows, and Glackens, and at the New York School of Art and at the Ferrer School," writes Robert Reiss, who researched the Baroness's New York years.[21] Man Ray had studied here in 1912. In 1913, the Ferrer School relocated to East 107th Street, a neighborhood of radicals and immigrants. Sarah McPherson, the sister of the journalist Bessie Breuer (who was one of the first to interview Duchamp in New York), was enrolled here in a life-study class. She vividly recalled the Baroness as one of the models, drawing pastels of the Baroness's shapely feet that were admired by Duchamp and his

friends. Indeed, according to Reiss, it was Sarah McPherson and Bessie Breuer who introduced the Baroness to Duchamp.[22]

European artists were now pouring into New York, fleeing the same war that the Baron was so eagerly chasing. Among the first to arrive in 1915 was Marcel Duchamp (1887–1968) (figure 11.1), followed by Francis Picabia and Gabrielle Buffet-Picabia, Albert Gleizes and Juliette Roche, Henri-Pierre Roché, Jean and Yvonne Crotti, and Mina Loy and Arthur Cravan. Joining up with their American counterparts—Man Ray, Walter Pach, Charles Demuth, Alfred Stieglitz, Charles Sheeler, Morton Schamberg, and Joseph Stella—they found a home in the myriad of vanguard salons. As Francis M. Naumann has shown in *New York Dada,* the group of artists subsumed under the New York dada umbrella met at the Arensberg salon on Sixty-seventh Street off Central Park, the home of a rich collector and poet, Walter Arensberg, and his wife, Louise.[23] The couple's apartment was a museum space, its high walls adorned with ultramodern art. The Baroness was an early fixture in the Arensbergs' impressively large atelier salon—even when she was absent. The actress Beatrice Wood remembered her as a favorite subject of conversation among Arensberg, Roché, and Duchamp, but these discussions ceased when Wood entered the room; the subject matter was too risqué for the young ingenue.[24]

Modernity emerged in New York in a chemical chain reaction of sorts. In *How, When, and Why Modern Art Came to New York,* Naumann documents the cultural ferment of this era.[25] In the summer of 1915, the French Cuban dadaist Francis Picabia (1879–1953) exhibited his machinist portraits at Marius de Zayas's The Modern Gallery (itself part of the gallery 291). At 291, the photographer Alfred Stieglitz, an important dynamo propelling America into a cultural modernity, had been making revolutionary advances in presenting photography as art and was soon inspiring others. After visiting Stieglitz, Man Ray (1890–1976), formerly Emmanuel Radnitsky, bought his first camera. Also in 1915, Man Ray met Duchamp in Ridgefield, New Jersey, and subsequently

joined the Arensberg salon, where he connected with the other dadaists, including Picabia, Jean Crotti, Charles Demuth, Joseph Stella, and probably the Baroness, who would eventually star in his first film experiment.[26]

Just off Washington Square on Fifth Avenue, the eccentric and sexually liberated American heiress and patroness Mabel Dodge (1879–1962) collected striking personalities at her home: the birth-control activist Margaret Sanger, Mina Loy, Edna St. Vincent Millay, and many others. On the eve of the war, in 1914, Mabel Dodge had thrown a peyote party for all her friends, peyote having just been declared illegal in the U.S.[27] After physically escaping the war, the European exiles now escaped its nagging memory, drugging themselves with sex, alcohol, and peyote. Just as Homer's war-fatigued Greek soldiers were tempted by the lotus-eaters' dream of ease, and just as Menelaus used Helen's drug to dull the pain of comrades lost, so these exiled artists plunged into the city's sex- and drug-filled nightlife. Soon, they drugged themselves on art—pushing the ultimate frontiers in artistic experimentation.

The Baroness exploded into this world of art and sex. A series of three photographs, the earliest portraits of the Baroness in New York, was taken by International News Photography in December 1915, presumably in her own studio.[28] In one of these photographs (figure 6.5), her head is turned sideways to face the camera, her nonsmiling eyes intent, her expression austere and forbidding. Her Joan of Arc helmet of hair is decorated with an oddly feminine headband, just like the one she wore in Lechter's *Orpheus* (see figure 3.3). Surprised by the camera in midpose, her body is bent over; her self-made chiffon dress reveals the nude body underneath. The viewer gleans a look at her strong athletic legs and her extended back; her feet are tightly wrapped in ballet shoes laced around her ankles, the right foot posing on the toe, as if she were a ballerina. Her studio surroundings look makeshift, as if to announce that creative élan arises in the midst of chaos: a sofa chair to the left sports a male jacket; a dark blanket partially covers the wall; there is a

6.5 International News Photography (INP), *Elsa von Freytag-Loringhoven,*
1915. Photograph. © 2001 Bettman/Corbis/Magma.

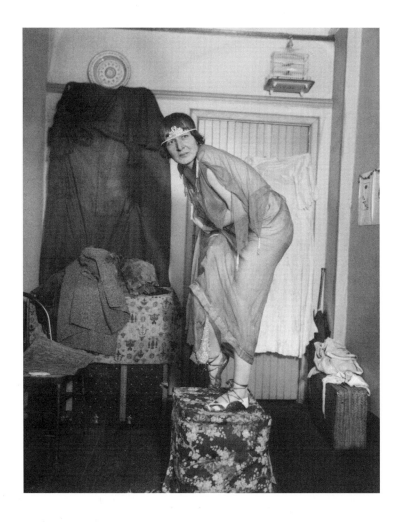

decorative plate on the wall; a cage with a bird hangs suspended from the ceiling; small carpets decorate the floor. Here we find the paraphernalia of her performance art, evidence that by December 1915 the Baroness was performing herself. She has already fully developed her trademark personality: caustic, vitriolic, daring, pushy, confrontational, shameless, shocking, and aggressive.

During this early period, as Louis Bouché tells us, the Baroness "lived in total disorder in the Lincoln arcade buildings with an assortment of animals, mostly mangy dogs and cats."[29] Located near Central Park and near the Arensberg apartment on West Sixty-seventh Street, the Lincoln Arcade Building on 1947 Broadway between Sixty-fifth and Sixty-sixth rented studios to artists for around $40 a month. The Lincoln Arcade Building is a key reference, for this is also Duchamp's address from fall 1915 until 1916.[30] I imagine their studios in the Lincoln Arcade Building as combustion chambers for explosively transgressive ideas that would soon propel antiart experimentations into new orbits.[31] Their studios were living museum spaces for gadgets and icons, found objects, glass and wire, dust and disorder—in short, the creative chaos at the heart of artistic expression. The makeshift beds were unmade, the dust was settling. It was probably here that the Baroness and Duchamp met for their "private" midnight talks, as the Baroness later recalled so fondly for *The Little Review* editors: "alone—private—in the middle of [the] night," Marcel "*likes* my society—my seriousness—my honesty—my trouble—since I have learned not to touch him nor suffer from restraint." Duchamp was "gentle" and "wistful," presenting his "real self" but became "silly" and "neglectful" as soon as he was with his friends (presumably Man Ray, Francis Picabia, Jean Crotti, and later Roché).[32] Having just turned his back on traditional painting after the traumatic rejection of his *Nude* in Paris, Duchamp was also in a transitional phase: he was searching for innovations in art and would have been intrigued by the Baroness's found objects. "In New York in 1915 I bought at a hardware store a snow shovel on which I wrote *in advance of the bro-*

ken arm," recalled Duchamp, who had gone shopping with his studio-mate Jean Crotti in October. "It was around that time that the word 'ready-made' came to my mind to designate this form of manifestation," explained Duchamp, who had isolated a trivial, mass-produced product and raised it to the level of art—thus practicing a new "visual indifference."[33] "Utterly logical, [Duchamp] soon declared his intention of renouncing all artistic production," observed Gabrielle Buffet-Picabia.[34] For some time, the Baroness had resorted to the streets to create her new asphalt aesthetics. A new emotive beauty, not indifference, however, was her goal.

Duchamp was her "platonic lover" and her first artist flame in New York.[35] Thirteen years her junior, he politely ignored her advances. "You will never insult sex," she told him, but "[h]e kept quiet—I remember a deep—swift gaze" that revealed a "determinedly frivolous—light—playful—prideless attitude."[36] She had to restrain herself not to express her sex desire by touching him, for he did not like to be touched or kissed. The femininely seductive Duchamp—not unlike Felix Paul Greve—was an ascetically reluctant lover. The walking embodiment of every woman's French lover fantasy, he was youthfully slim, sensitive, and gentle, with an attractively chiseled face. She affectionately called him "m'ars," a triple honor. M'ars (my ars) was her dada gift to the man who enjoyed scatological jokes. M'ars (Mars) is also the Roman god of war, a reference to Duchamp's role as a revolutionary avant-gardist, as well as a sexual fantasy, for the Roman war god was the mythological lover of the erotic Venus (Elsa). "I possess his soul. I am m'ars teutonic," she declared, thus effectively proclaiming herself a female Duchamp and warrior artist.[37] Indeed, the role of militant artist-war-god applied to her more than to the peace-loving Duchamp, who was her complementary opposite. He was quiet and unassuming in his demeanor; Elsa, loud and imperial. He combined mental intensity with ironic detachment; she was emotionally intensive and confrontational. He was a sexual flirt; she was fixated on sexual consummation. He was lighthearted; she was teutonically austere. Buffet-Picabia describes

Duchamp's lightheartedness: "The attitude of abdicating everything, even himself, which he charmingly displayed between two drinks, his elaborate puns, his contempt for all values, even the sentimental, were not the least reason for the curiosity he aroused, and the attraction he exerted on men and women alike."[38]

"Marcel *knows* I am [an] artist," said the Baroness.[39] No doubt, her no-holds barred "joyful abandon" into art, unconventionality, and originality would have appealed to the French artist in search of new creative expressions. Duchamp regularly read and viewed her work, providing the much needed "executive ability." But if Duchamp was generous and inspirational, so was the Baroness, and these New York dada chapters are an invitation to recognize the Baroness's daring and originality in art and and to look at the flow of inspirational energy as a two-way street. Both shared a profoundly antiacademic view of art,[40] but the Baroness was the more uncompromisingly radical artist.

One day Bouché brought her a gift, a newspaper clipping representing *Nude Descending a Staircase*. In a spontaneous protodada act, the Baroness promptly applied it to her body in a gesture so striking that it was memorialized by Bouché: "She was all joy, took the clipping and gave herself a rubdown with it, missing no part of her anatomy. The climax was a poem she had composed for Duchamp. It went 'Marcel, Marcel, I love you like Hell, Marcel.'"[41] Tired of waiting for Marcel to respond to her love call, she was effectively "intercoursing" with the elusive artist through the body of his work. This autoerotic act slyly alluded to Duchamp's recent abandonment of traditional painting, for he had dismissed it as "olfactive masturbation."[42] But even more important, the Baroness, a nude model herself, was charging her body as artwork. Using the era's most famous artwork as a cheeky sex toy in this autoerotic performance act, she ingeniously turned the viewer's attention away from Duchamp's abstract representation of the *Nude* to her living body as work of art, an art charged with kinetic energy, presenting her original kinesthetic dada—a truly new form of art.

By making Duchamp's *Nude* literally descend down her own body surface, the Baroness achieved a brilliant transfer of sorts: we now behold *her* as the literal embodiment of Duchamp's erotically and kinesthetically charged nude, for her many roles and identities are fragmented, eroticized, and lit up by the city's energy. Whereas Duchamp's *Nude* is just a semiabstract representation of movement in painting (this representational focus further highlighted by the fact that she was using a copy), the Baroness's body work of art is literally moving, thus keeping the viewer's eye in movement and enacting the antiretinal aesthetics that Duchamp had embraced. Since Duchamp was already experimenting with movement (as in his 1913 *Bicycle Wheel,* retrospectively declared a readymade in 1915), the inspiration of the Baroness's kinesthetic body art must count as her pioneering act in New York that would effectively give birth to what Jones has so aptly termed performative dada, New York dada's centrally important innovation in locating art in daily life.

The French art historian and Duchamp scholar Thierry de Duve has established that some of Duchamp's most important innovations including the ready-made were much more likely influenced by Munich's avant-garde rather than by academic art schools in Paris. Since France had no equivalent to the *Kunstgewerbe* and nothing could be further from the notion of an *artiste* than that of "art worker," as de Duve writes, Munich, rather than France, likely stimulated Duchamp's new inventions.[43] Munich was the uncontested center for the *Kunstgewerbler,* who systematically injected art into everyday life with the artistic shaping of the applied, utilitarian object. Still, critics are baffled by the lack of sources that actually document Duchamp's contact with Munich's avant-garde when he visited the Bavarian capital in July and August 1912. Solitary, the reclusive Marcel lived withdrawn in his little room in bohemian Schwabing, occasionally visiting the beer halls and the Old Pinakothek but rarely making connections with fellow artists and clearly not participating much in Schwabing's bohemian life.

The specifics of the Munich influence have remained a mystery—until we begin to consider that the Baroness was effectively transmitting Munich's avant-garde art impulses through explosive bodily charges. Through her own "apprenticeship" in applied art, the Baroness had been intimately connected with Germany's leading *Kunstgewerbler* including Endell and Lechter. Munich's cultural field of resonances was embedded in her memory, and its erotic charges were imprinted on her body. What I am suggesting here is that the Baroness transmitted the spark of Munich's highly eroticized avant-garde into New York. In the following chapters, I make a case for the Baroness's function as catalyst, as she was charging New York's foremost experimenters with the imprint of Munich's avant-garde, their injection of art into life, their focus on eros as a driving force, and their gender-bending male feminism. Deeply steeped in Berlin and Munich's avant-garde movements, she was like a live electric wire, like the synapse in the human nervous system, whose action potential builds up to a climax and then explodes electrically to transmit the charge to the next cell. Just so she transmitted highly charged impulses from one movement to the next and from one generation to the next. The Baroness's role in transporting that field of erotic gender resonances from Munich to New York points us to a common root of New York dada and Zurich dada, the latter born in February 1916. Peter Jelavich has documented a direct line from Munich's avant-garde to Zurich dada: "Dada's rejection of European culture was formalized in a total breakdown of language. The dissolution of the word, which had commenced in the works of Wedekind, Kandinsky, and other prewar modernists, was completed in Ball's pure sound poetry."[44] Indeed, Zurich dadaists would make extensive use of the Munich arsenal with poems and songs by Wedekind, Erich Mühsam, and Kandinsky that would soon be performed in the Cabaret Voltaire at Spiegelstrasse 1, along with works by the Russian avant-garde and Italian futurists.

The Baroness's self-perception of her function as a hot wire is perhaps best expressed in her interpretation of one of her "color poems," her light bulb portrait of Duchamp, unfortunately no longer extant but memorialized by the American painter George Biddle in his autobiography:

It was painted on a bit of celluloid and was at once a portrait of, and an apostrophe to, Marcel Duchamp. His face was indicated by an electric bulb shedding icicles, with large pendulous ears and other symbols.

"You see, he is so tremendously in love with me," she said.

I asked: "And the ears?"

She shuddered: "Genitals—the emblem of his frightful and creative potency."

"And the incandescent electric bulb?

She curled her lip at me in scorn. "Because he is so frightfully cold. You see all his heat flows into his art. For that reason, although he loves me, he would never even touch the hem of my red oilskin slicker. Something of his dynamic warmth—electrically—would be dissipated through contact."[45]

Again, this scene does more than encapsulate the Baroness's wild spirit and unbridled female sex fantasy about "Marcel." The feminine roundness of the lightbulb (presumably preceding Picabia's 1917 light bulb portrait titled *Américaine)* and her ironically double—ovarian—grafting of male genitals capture Duchamp's androgyny, while the icicles highlight the cerebral erotics that charge up his art. The overly large ears proclaim his role as a listener in his relations with the Baroness, who is doing all the talking, pouring sexually charged, raw energy into his ear. His ears, as mechanoreceptors, then, charge Duchamp's incandescent bulb—that is, the light of his art. While Duchamp conserves his electrical energy, the Baroness dissipated hers with abandon, while charging up others.

Her engagement with Duchamp, then, was astutely critical. Take "Keiner," for instance, a visual poem (what Roger Shattuck would call "poésie fondée en peinture"),[46] its subtitle, "Literary Five-o-clock," alluding to her happy sexual trysts with Greve and Baron Leo. In a mock parody of *Nude Descending a Staircase,* the Baroness has visually arranged the words in a descending crescendo of steps that typographically mimic the rhythm of intercourse, the visual mode effectively kindling the poem's kinetic intensity. This unpublished visual poem (written in German) sets up the provocative equation *poetry = coitus,* for both art and sex require

Rhythm—
Eros
Purpose—
 Coolness—
 Fire
 Fantasy.[47]

In the manuscript's margins, she notes that if absolutely required (to avoid censorship, one presumes), the word *koitus* could be replaced in publication with *Liebesrausch* (ecstasy, a reference to the Munich Kosmiker concept of eros). Her preference, however, is for the more provocatively charged *coitus,* a word that clearly moves her poetry toward antipoetry, assaulting poetic conventions. *Coitus* (Latin: *co* = together; *ire* = *go*) highlights the *connection* of two bodies in the act of consummation, not primarily the erotics, of the sex act. Whereas Duchamp preferred to maintain a cautious distance, the Baroness was arguing for a bodily conjoining presumably controlled by the woman.

Similarly, her poem "Love-Chemical Relationship" is a shrewd and mocking reading of Duchamp's cerebrally erotic strategies at work in *The Large Glass.* In 1915, Duchamp bought two large sheets of glass and installed them on sawhorses in his Lincoln Arcade studio.[48] It was an eight-year work in progress, and while Duchamp

did not talk about his work in public, he was happy to show and discuss it in private with his visitors. Scholars have considered this work as one of the most important of the twentieth century. With its lurid title *The Bride Stripped Bare by Her Bachelors, Even* (*The Large Glass*) (1915–23), it featured its verbally sexualized bride-machine and her nine bachelors, with sexual consummation forever visually suspended (just as the closure of interpretation is forever suspended in this cryptic work). Prominently displayed in the left upper glass panel, the bride is large (perhaps signaling the power of America's New Woman), a combination of machine robot and large insect. The nine anonymous bachelors in the bottom panel look like replicas of the iconic male one finds on public toilet doors, all of them little men (like the diminished masculinity felt by many men at the homefront). Indeed, these bachelors are identified only by their uniforms and modest professions, with two of these, the "cavalryman" and the "busboy," coincidentally echoing the job titles held by the Baroness's deceased husband Leopold during his stay in the U.S.[49] From 1912 to 1915, Duchamp was working on a script, a complex taxonomy of annotations, to accompany *The Large Glass*. Yet the script was designed to frustrate the reader who expects to unlock the mystery of this work. As in many dada paintings and drawings, rather than explain the artwork this textual script ignites the visual with a sexual charge. From a gender approach, this work has been read as a breakdown of heterosexual relations,[50] and the Baroness critically responded by pointing to the limits of Duchamp's project.

Using her own name, "Elsa," the Baroness used her personal, unconsummated sex relationship with "Marcel" as a critical strategy to read his artwork (a strategy she would later repeat in her criticism of Williams's *Kora in Hell*). She slipped into the role of the Duchampian bride by giving an ironic voice to the female figure who is eternally blowing her inflated bubble of love gasoline in *The Large Glass*. The poem begins like a theater play with stage directions underscoring the dialectical set-up of French protagonist ("Marcel") and German antagonist ("Elsa"):

UN ENFANT FRANÇAIS: MARCEL (A FUTURIST)

EIN DEUTSCHES KIND: ELSA (A FUTURE FUTURIST)

POPLARS— SUN—A CLAIHIGHWAY

The poplars whispered THINE DREAMS Marcel!

They laughed—they turned themselves—they turned themselves

To turn themselves—they giggled—they blabbered like thineself—

they smiled!

[T]hey smiled WITH the sun—OVER the sun—

BECAUSE of the sun—with the same french lighthearted sensual

playful

MORBID smile like thineself—Marcel!

Poplars thou lovedst and straight highways with the smell of poplars

which is like leather as fine—like morocco leather in thine nos-

trils—And thine nostrils are of glass!

Thou seest the smell uprise in the brain!

Sensual thine eyes became—slanting—closed themselves![51]

Like an abstract visual painting, this syntactically disjointed mod-
ernist portrait of the artist not only echoes her earlier portrait of
Greve but assembles Duchamp's cerebral/sensual/aesthetic physi-
cality in a cubist grafting of selected body parts, metonymically re-
ferring to his personality and art: *nostrils* (sensual), *brain* (cerebral),
eyes (visual). The poplars' *whispering, giggling,* and *blabbering* noises
are like a chorus in a Greek play commenting on the main action
without interfering into the events. The poplar-chorus works like a
mirror, reflecting Duchamp's erotically teasing, lighthearted, and
open-ended play. At the same time, the atmosphere is quickly be-
coming sexually charged through organic scents emanating from the
aroma of poplars, like "morocco leather in thine nostrils," the
warmth of sun, and the earthy sensuality of the "fat color of clay."
"Marcel," closing his eyes, is about to yield to these bodily charms.

But he stops short. Now the stage is set for Marcel's dramatic transformation into glass, as he morphs into purely aesthetic subject in the play of mirrors, eerily anticipating Hermann Hesse's eminently seductive *Glass Bead Game* published during World War II (1943), as well as echoing the title of Oscar A. H. Schmitz's work *The Glassy God,* in which the Baroness was first celebrated as a hetaera figure with her own circle of disciples:

Thereafter thou becamest like glass.
The poplars and the sun turned glass—they did not torture thee any more!

Everything now is glass—motionless!
THAT WAS IT THOU DISCOVERDST—AND WHICH IS GIVEN TO THEE AFTER THINE DEATH—MARCEL!
[. . .]
Thou now livest motionless in a mirror!
Everything is a mirage in thee—thine world is glass—glassy![52]

As Marcel's body petrifies into the beautiful deadliness of glass ("Glassy are thine ears—thine hands—thine feet and thine face"),[53] he becomes part of his own glass/mirror. Driven by her own aesthetic desire, Elsa is captivated: "I LOVE THAT VERY THIN GLASS WITH ITS COLOR-CHANGE; BLUE—YELLOW—PURPLE PINK," she says, dazzled by the color's refractions in the glass.[54]

Still, by the end of the poem, still impersonating that love-gas bubbling bride, "Elsa" rejects the temptation of becoming an eternally motionless part in "Marcel's" mirror machine. By injecting her body's earthy reality, she abruptly disrupts the seductive game without, however, bringing it to a complete stop: "BECAUSE I AM FAT YELLOW CLAY! [. . .] I must bleed—weep—laugh—ere I

turn to glass and the world around me glassy"![55] Her evocation of the proverbial body of clay (also a reference to her own body of performance art) reveals the limits of Duchamp's aesthetic and sexual approach: his inability to overcome the heterosexual stalemate and his entrapment in a seductive but sterile glass-bead game. Already in the mathematical equation of her poem's subtitle (Marcel = futurist, Elsa = future futurist), "Elsa" sees herself as superseding "Marcel." And Duchamp agreed. "The Baroness is the future," he conceded in the epigraph to his chapter, but like his nine diminished bachelors, he politely withdrew from her sexual overtures to avoid being engulfed by her excessive bubble of love gasoline.

As Duchamp weaves in and out of Elsa's history, the two artists' trajectories as rebel artists within New York's vanguard are mutually illuminating for the twenty-first-century reader. Duchamp gained enormous attention during the 1960s as the iconoclastic father of postmodernism and the forerunner of pop art, kinetic art, performance art, and many other postmodern art forms.[56] He was embraced as one of the century's most revolutionary artists, the "Daddy of Dada and the grandpa of Pop," as Grace Glueck teasingly called him in 1967.[57] Thus the glowing light of immortality achieved by the famous Marcel in his adopted home country (he became an American citizen in 1955) now brightly lights the Baroness's darker, marginalized, female version of artistic transgression. In light of the Baroness's marginalization and tragic fate, today's reader cannot help but think of Virginia Woolf's feminist tale of the patriarchal life story of Shakespeare's ill-fated, talented sister, the imaginary Judith. Just so the Baroness's trajectory follows the classical curve of neglect and silencing. Both artists scandalously invested themselves in their art and thereby raised profound questions as to what exactly constitutes a work of "art" in modern life and what its function is in everyday life. Ultimately, the Baroness helped kindle New York dada with the spark of her own body, profoundly investing and risking herself. As we now follow the Baroness on her strolls through Manhattan's streets, her story takes us into the most risky of vanguard art forms: the living New York dada as embodied by the Baroness from at least 1915 on.

Living Dada with Phallus in Hand and Taillight on Bustle

Chapter 7

"Tired of conventional dressing, she began creating costumes which resulted in her arrest whenever she appeared upon the streets," recalls Margaret Anderson about the Baroness's trail-blazing innovation in performance art. "Tired of official restraint, she leaped from patrol wagons with such agility that policemen let her go in admiration."[1] The Baroness captivated New York's modern urbanite world with her shocking and unsettling poses. Her head: shaved and occasionally shellacked in striking colors like vermilion red. Her makeup: yellow face powder, black lipstick, and an American stamp on her cheek. Her jewels: utilitarian, mass-produced objects like teaspoons as earrings or large buttons as finger rings. Her accessories: tomato cans and celluloid rings adorning her body; the hem of her skirt decorated with horse blanket pins. An electric battery taillight decorates the bustle of her black dress in imitation of a car or bicycle. She also used live animals as part of her street performance: a wooden birdcage around her neck housing a live canary; five dogs on her gilded leash as she promenaded up Fifth Avenue. Her outrageous costumes made her a New York landmark at subway stations, in public offices, in museums, at exhibitions, in department stores, and on the major thoroughfares. With each new day, she added new twists to her repertoire of makeup, headdresses, and costumes that were frequently made from junk objects collected in the streets. Like her body, her art was androgynous: feminine in attracting the viewer's gaze to the female body, masculine in producing an unexpected shock effect.

The use of the Baroness's iconoclastic street costumes is rooted in her personal biography: her mother's extravagant use of fabric; the cross-dressing practices of Berlin and Munich avant-gardists; Else Lasker-Schüler's self-made oriental costumes; Oscar Kruse-Lietzenburg's spontaneous performances; and August Endell's concept of beauty as captivating the viewer with sensual emotion, an art sensually engaging the viewer with the living city.[2] In addition, the Baroness also voraciously mined America's new world

7.1 John Wanamaker Department Store, under construction, at
Broadway between Eighth and Ninth Streets, ca. 1923. Photograph.
New York Public Library.

culture: its movie industry, including Charlie Chaplin's cross-dress-
ing in his 1915 film *A Woman;* and its consumer culture, which of-
fered tins, celluloids, and advertisements.[3] New York was the world's
stage of street wonders and boulevard metamorphoses, as witnessed
in the construction of skyscrapers, subways, and streets that contin-
ually changed the face of the city (figure 7.1). In this futurist field

of architectural demolition and construction, the Baroness used the New World city's street architecture as dynamic backdrop for her art. Single-handedly she took art out of its designated museum spaces and performance out of the theater and the dancing halls. As an artist, she was penetrated by the living city and inscribed that perpetually morphing city on her body, using the objects found in the gutters of New York and mirroring back New York's gutter beauty. While revealing the ancient and modernist traces of Europe, her art was also profoundly American, engaging with the New World culture.

Using the urban theories of Walter Benjamin and Michel de Certeau, Amelia Jones has advanced a spatial argument to capture and theorize the profound innovation of the Baroness's New York dada art. Claiming the Baroness as a spectacular flâneuse, Jones compellingly argues that "the Baroness perfected a rhetoric of walking,"[4] as a radially new form of art pioneered at a time when New York City was quite literally the city of the present moment, in contrast to Europe's deadly fetish with the past. As an impoverished, marginalized, and disenfranchised woman, the Baroness claimed the space of high art from society's margins by throwing herself with abandon into "spontaneous theatrical street performance."[5] With the profound conviction of her own innovative brilliance and against all opposition and ridicule, she insisted that her costumes were art.

In her transformation of junk into accessories, the Baroness was forever scouring the streets of Manhattan in search of potential raw materials. "Sarah, if you find a tin can on the street stand by it until a truck runs over it. Then bring it to me," said the Baroness to Sarah McPherson.[6] William Carlos Williams similarly reports on her collectomania, in which daily objects became part of the Baroness's repertoire: "[A] bride lost the heel of her left shoe at the tube station; lost, it becomes a jewel, a ruby in La Baronne's miscellany."[7] In her flat she collected celluloid, tin cans, toys, gilded vegetables, iron, stamps, pins, and so on. By adorning herself and her

living spaces with these found objects, the Baroness was a living museum body, an archivist collecting New York City's contemporary consumer objects, its smells, its junk, but also its most recent market products frequently stolen from Woolworth and Wanamaker's. She systematically applied mass-produced technological objects (taillights, cable) and consumer objects (tomato cans) to her body—humorously rendering unfamiliar the familiar and creating art out of

7.2 Baroness Elsa von Freytag-Loringhoven, *Earring-Object.* ca. 1917–1919. Mixed media, 4 3/4 × 3 × 3 in. Mark Kelman Collection, New York.

the most banal. She took the "found object" as her raw material, systematically stripping it of its conventional semantic, utilitarian, and pragmatic meaning. By reclaiming it in a radically new context—as performance art—she effectively decolonized it from its commodity status.

In an everyday world dominated by the assembly line (introduced by Henry Ford in 1913) and mass consumerism, dada came to represent what the French social historian Henri Lefebvre (1901–1991) calls moments of "presence" or "enlightenment" in daily life.[8] In her defense of her art of madness in 1920, the Baroness highlighted the profound emotionality of her art, arguing that "'Fasching'—and in old Greece in the feast of Dionysus ('die Dionysien' as we learned it in Germany), [is] and always will be—because it has to be—like the steam nozzle on a tea kettle—! [T]o be insane, for a time, to be very sane and steady and strong and relieved after it."[9] The dada artist thus can effect a profound change through intervention into the present quotidian moment, creating epiphanies not through extraordinary discourses or abstract or academic theories but through a strategic targeting of the most banal, ordinary, and trivial. Zurich dadaist Hugo Ball similarly described his goal to "conceive everyday life in such a way as to retrieve it from its modern state of colonization by the commodity form and other modes of reification."[10] Dada's goal, then, is a systematic decolonizing of the everyday, a classical deautomatizing of the public in the quotidian moment. Thus conceived, the Baroness's dada was an important cultural response to modern urban mass production and technological progress. Her dada created *spontaneous moments of living* performed in the city for a random city viewership, her beauty designed to change the familiar present moment by charging it with emotional dizziness and laughter.

The Baroness's body art told a story of perpetual movement. Her bracelets and elongated earring jewels rhythmically swung with her body. Her *Earring-Object* (1917–1919) (figure 7.2,

plate 4), worn as an earring, was made of a bouncy steel watch spring
and swinging pearl earrings, each and every part designed to en-
hance beauty in movement.[11] The stamp on her face embodied the
letter traveling from one place to the next. The modern taillight
on her Victorian bustle proclaimed the Baroness *herself* a forward-
moving leader, the light slyly ensuring that male New York dadaists

7.3 Baroness Elsa von Freytag-Loringhoven, *Limbswish,* ca. 1920.
Metal spring, curtain tassel, approx. 18 in. high. Mark Kelman Col-
lection, New York.

were not bumping her from behind with their machine objects. With the bolero jacket she embodied the torero's skilled bodily maneuver in the bullring. The companion animals, including dogs and canaries, that regularly participated in her promenades further accentuated the image of her body as gyrating life force. Confronting her viewers with her ready-made formula—*motion, emotion*—her proudly strutting body critically engaged the modern machine age and critically countered the male dadaists' fetishizing of modern technology.

The kinetic focus of her art is perhaps best encapsulated by the *Limbswish* ornament (ca. 1920) (figure 7.3, plate 5), a large whiplike device made of a metal spring and curtain tassel and worn attached to her hip belt. The word play of *limb swish* highlights the whip's kinetic *swishing* movement, as well as its erotic charge with its title's punning on *limbs wish*. Biographically, this art object evokes the many references to the whip used on her own body (by her father and by Ernst Hardt) and offered as a tool in sexual contexts (with August Endell and with Mister of Thumb). With this original accessory worn as performative hip gear—like a cowboy would wear his Colt revolver at the hip—she would swish her tool to and fro, thus creating live dada body music as she walked along the streets. *Limbswish* also told a tale of gender crossing, for the term "swishes" was used for gay men who publicly marked themselves as "fairies."[12] Robert Motherwell similarly commented on the Baroness's "chains" and "*swishing* long trains" as she "promenaded down the avenues like a wild apparition,"[13] while Anderson noted "the peasant buttons *ringing like bells*" as the Baroness sat down "with extreme ceremony" to write out her name for one of her poems.[14] Ultimately, her erotically charged body collage of kinetic images presented a powerful alternate image to the man-made dynamos and machine portraits. Her body was a coded script ("a human notebook," as Barnes put it)[15] that invited the viewer to decipher its

7.4 Theresa Bernstein, *The Baroness*, ca. 1917. Oil. 35 × 27 in.
Francis M. Naumann Collection, New York.

kinesthetic symbols and read the corporeal story of perpetual movement.

And what of her use of vegetables? Her precariously impermanent vegetation costume was an apt and important metaphor for the ephemeral nature of her chosen art. "Performance's only life is in the present," notes the American performance theorist Peggy Phelan: "Performance cannot be saved, recorded, documented, or otherwise participate in the circulation of representations *of* representations: once it does, it becomes something other than performance." This lack of permanence explains the precarious status of this art: "Performance in a strict ontological sense is nonreproductive," explains Phelan. "It is this quality that makes performance the

runt of the litter of contemporary art."[16] The Baroness's gilded carrots and beets, her living dogs and canaries—organic materials that were in striking contrast to the city of steel and glass—were *perishable,* fundamentally different from the sleek machine objects favored by her male dada colleagues. At the same time, the Baroness was truly *consumed* by her art, a fact that made it all the more memorable in its impact. Since the Baroness's art could not be stored, its memory was literally ingested and assimilated by her viewers, who effectively *consumed* the dramatic flash of her art and were thus able to call it up decades later. As Phelan observes about performance art: "The more dramatic the appearance, the more disturbing the disappearance."[17] For the Baroness's practice of her art form in the flesh involved the ultimate risk to body and self: hers was quite literally the daily enactment of the *sujet en procès,* the subject of postmodernity that is simultaneously *in process* and *on trial.*

The New York painter Theresa Bernstein visually captured this self-consuming quality in her studio portrait of Freytag-Loringhoven, an oil painting now held in a private collection in New York (figure 7.4). The Baroness posed as the bohemian artist: her right hand is adorned with rings; she wears an olive green hat, and her face and upper-body tunic and jewels are painted in ochres, yellows, and browns, the warm colors highlighting the life force of her art.[18] In the foreground is the proverbial candle the Baroness was burning at both ends—spending and consuming herself in and through her art, exhausting herself from the inside out. Bernstein saw her as the incarnation of action and activity, always moving about, carrying her art on her body, with the body itself working as the "engine" that she "fed with my rich flowing blood direct," as the Baroness described her performance art in the epigraph to this New York dada section.

In November 1916, just as the Zurich concept of dada was reaching New York, Djuna Barnes (1892–1982) published the first account

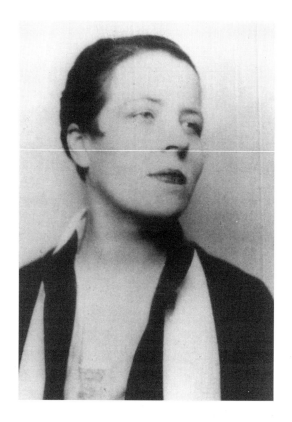

7.5 *Djuna Barnes,* ca. 1920. Photograph. Special Collections, University of Maryland at College Park Libraries. © Copyright, The Authors League Fund, as literary executor of the Estate of Djuna Barnes.

of the Baroness's displays in the *New York Morning Telegraph Sunday Magazine,* describing the Baroness as she was arriving for a ball:

Or one sees the Baroness leap lightly from one of those new white taxis with seventy black and purple anklets clanking about her secular feet, a foreign postage stamp—cancelled—perched upon her cheek; a wig of purple and gold caught roguishly up with strands from a cable once used to moor importations from far Cathay; red trousers—and catch the subtle, dusty perfume blown back from

her—an ancient human notebook on which has been written all the follies of a past generation.[19]

Striking is the intermixing of opposites. The middle-aged Baroness leaping out of an ultramodern white taxi, which had begun to appear on New York's streets just barely a year before, in October 1915. Old/new, erotic/grotesque, European/American, human/technological, ancient/modern—this is an assemblage of paradoxes embodied in one body. They compelled a retelling of the story, a verbal replay and recording of the Baroness's display.

The young Djuna Barnes (figure 7.5) was profoundly attracted to the Baroness's androgyny and immortalized the artist's earliest New York poses in her gender-bending novel *Nightwood* (1936). In the memorable descriptions of the androgynous Frau Mann (Mrs. Man), the "Duchess of Broadback" from Berlin, a trapeze artist, we recognize the 1915 photographs of the Baroness in her striped suit (figures I.1 and I.2):

She seemed to have a skin that was the pattern of her costume: a bodice of lozenges, red and yellow, low in the back and ruffled over and under the arms, faded with the reek of her three-a-day control, red tights, laced boots—one somehow felt they ran through her as the design runs through hard holiday candies, and the bulge in the groin where she took the bar, one foot caught in the flex of the calf, was as solid, specialized and as polished as oak. The stuff of the tights was no longer a covering, it was herself; the span of the tightly stitched crotch was so much her own flesh that she was as unsexed as a doll. The needle that had made one the property of the child made the other the property of no man.[20]

The Duchess of Broadback (who expertly talks about living statues in Berlin) is the Baroness in the flesh. As a perfect hermaphrodite, her props have melted with her body, presenting a consumable body

of "lozenges," the toy body of a doll, the genitals desexed as through transgendered surgery. As the costume morphs into corporeal reality, the emergent body is a perfect hybrid, toy and artist, male and female. Pivotal to Barnes's attraction was the Baroness's androgyny, for Barnes herself had affairs with both men and women, although she always downplayed and denigrated her own lesbianism ("I might be anything. If a horse loved me, I might be that," she said in response to Emily Coleman's question of whether she was a lesbian).[21] Barnes was adamant not to be pinned down by her sexual identity, and in the Baroness she found the perfect image of a protean gender bender.

Djuna Barnes had met the Baroness by 1916. At first, the Baroness was strangely intimidated by the younger woman's generosity, as she recalled the beginnings of this friendship in 1924, after the two had become intimate friends: "I always was embarrassed—uncertain—talking with you," she admitted and continued: "You—I never could help—liking—*every time* you spoke to me— or gave me little gifts—I was truly—simply scared of you."[22] As always, fear of deep attraction and jealous rivalry turned into distancing critique: "I cannot read your stories, Djuna Barnes," she told her benefactor early in their friendship. *"I don't know where your characters come from. You make them fly on magic carpets—what is worse, you try to make pigs fly."*[23] Still, as with Greve and Duchamp, here was the immediate attraction of complementary opposites: Barnes closed up and secretive about herself, Elsa voluble and exhibitionistic; Barnes a listener, Elsa a talker; Barnes intensely maternal and generous, Elsa egocentric and needy; Barnes elegant and orderly, Elsa eccentric and disorderly; Barnes brilliantly witty, Elsa confrontational and vituperative, always lacking in subtlety.[24] When she met the Baroness, Barnes was living at 220 West Fourteenth Street, the street Elsa would move to sometime in 1917 or 1918). After a brief stint in Brooklyn, Barnes moved to the famous Village board-

ing house for artists at 86 Greenwich Avenue, where she lived with Courtenay Lemon.[25]

It was Barnes who recorded the Baroness's use of a fake penis as a theatrical prop. It was a signature act that is alluded to in the title of my chapter and has inspired the title of at least one scholarly essay: "Eros, That's Life, or the Baroness's Penis," Jones's contribution to Naumann's New York dada exhibition catalogue.[26] "She made a great plaster cast of a penis once, & showed it to all the 'old maids' she came in contact with," as Barnes reported in tantalizingly brief, telegraphic style in her 1933 "Elsa—Notes," jotting down a kernel that she meant to use for the biography.[27] This kernel is rich in echoes and resonates with her earlier invasion of the phallic collection at the Naples Museum. It was an act designed to dismantle the supreme signifier of patriarchal power. As the Baroness commandeered the phallus as a prop, a literal accessory to the female body, she proudly signaled her woman's claim to traditionally male rights and publicly performed herself as man-woman. It might be argued that she was impersonating the position of all the militant women in New York: the suffragists and birth-control activists who were frequently protesting on the public streets, most of them middle-aged women, parading nonfeminine militance, refusing conventional feminine beauty and docility. Suffragists were subject to aggressive media denigration as desexed men-women, perhaps best seen in Rodney Thomson's well-known caricature of suffragists in *Life* magazine titled "Militants" (27 March 1913).[28]

Promenading a hand-made gargantuan phallus in public for an audience of single women also made it a domesticated sex toy, one that could be cast and reproduced ad infinitum like any other consumer item designed to satisfy desire, thus highlighting the new woman's claim to sexual pleasure. Finally, we can also trace a trajectory from the Baroness's plaster cast penis to more recent feminist uses of dildos in the art world, such as Lynda Benglis's 1974 self-portrait in *Artforum*.[29] The American sculptor scandalously posed in

the nude, her right hand holding a long dildo to her crotch with her slim, feminine body adopting a proudly masculine strutting pose. This boundary-crossing gambit is simultaneously erotic and grotesque, allowing the female artist to invade and mock the masculinist art world through hyperphallic mischief.

For the twenty-first-century viewer, then, the Baroness's costumes and accessories ultimately constitute a gender performance in the Butlerian sense. In an article entitled "Performative Acts and Gender Constitution," Judith Butler writes, "Gender is what is put on, invariably, under constraint, daily and incessantly, with anxiety and pleasure." Since "gender is constructed through specific corporeal acts," the Baroness's public transgressions constitute a systematic assault against the traditional gender grammar. Yet Butler also reminds us of the risks involved in this project. In contrast to theatrical performances, "gender performances in non-theatrical contexts are governed by more clearly punitive and regulatory social conventions." Butler gives the example of a transvestite who "onstage can compel pleasure and applause while the sight of the same transvestite on the seat next to us on the bus can compel fear, rage, even violence." Butler concludes: "On the street or in the bus, the act becomes dangerous," more disquieting because there are "no theatrical conventions to delimit the purely imaginary character of the act."[30]

With phallus in hand and taillight on her bustle, the feminist dada performer mocked the underside and inequalities of a profoundly masculinist art world with bravado. The New York dada group as represented by Picabia, Crotti, Man Ray, Schamberg, Sheeler, and Stella was fascinated by America's speed, love of technology, and burgeoning consumer culture. While war raged in Europe, these artists expressed their hope for self-renewal through America's sexual, technological, and urbanite icons. Picabia was inspired by New York's modern technology. He famously created portraits and self-portraits using representations of everyday, mod-

ern objects such as light bulbs, wheels, or spark plugs and assigning them titles that fully ignite the visual with highly charged gender narratives. In 1915, the magazine *291* (named for the gallery 291) published his infamous spark plug drawing, a hard, steely contraption of screws with a slick vertical elegance. It was a portrait of Agnes Ernest Meyer, the spark that ignited the activities of Marius de Zayas and the Modern Gallery.[31] Its title, *Portrait d'une jeune fille américaine dans l'état de nudité* (Portrait of a young American girl in a state of nudity), though, easily turns the drawing into a male sexual fantasy.[32]

The Baroness's lived body satirically engaged the male-centered machine fantasies by planting the technological and consumer items on her performing body, grafting them alongside organic matter, including gilded vegetables. From the early teens to the early twenties, Freytag-Loringhoven's bodily bricolage presented an ingenious dada that can now be recovered in brilliantly colorful stories from the margins of cultural history. Publicly performed, the Baroness's radical androgyny inspired powerful collective memories among the vanguard, as Freytag-Loringhoven's gender-sensitive colleagues, friends, and admirers—including Anderson, Abbott, and Duchamp—were all magnetically attracted to her gender disruptions. Despite her irascible temper, these friends established a network of supporters who effectively recognized the depth of her gender acts. By ventriloquizing the Baroness's "masculine throaty voice"[33] in their own memoirs, modernist artists and writers—including Abbott, Barnes, Biddle, Bouché, Churchill, Flanner, Josephson, McAlmon, McKay, Brooks, Pound, and Williams—recaptured the Baroness's body of splashy hybridity. For these modernist chroniclers, the recollection of the Baroness's body costumes created a memory of urban radicality and dissident sexuality inscribed into the public spaces of the early twentieth-century metropolis.

With her innovative and risky self-enactments, Freytag-Loringhoven "became famous in New York for her transposition of Dada into her daily life," as Robert Motherwell writes in his dada anthology.[34] On 14 July 1916, Hugo Ball had donned a cubist costume in which he recited his first phonemic poem, "Elephant Caravan" *(Elefantenkarawane),* in the Zunfthaus zur Waag in Zurich.[35] But only few dadaists ventured off the stage—as Johannes Baader, for instance, did by disrupting church services in Berlin and proclaiming he was God.[36] Some acts by Arthur Cravan were retrospectively claimed as dada, the most famous being Cravan's staged boxing fight against the black heavyweight champion Jack Johnston in Barcelona in 1916. An equally strutting, masculine act was Cravan's unorthodox "lecture" on modern art in New York during which the badly intoxicated fighter/poet began to undress himself, threatening to flash his manly anatomy before his distinguished audience, when detectives intervened and escorted him out of the hall.[37] Duchamp proclaimed this act as quintessentially dada. It was, however, in the figure of the Baroness that New York dada exploded the boundaries of the stage, moving dada into the quotidian realm—with often unsettling and risky consequences.

Indeed, the Baroness epitomized the risk involved in dada art—her profound exile from bourgeois society. Like other dadaists or protodadaists who found themselves incarcerated—Emmy Hennings for forging foreign passports for draft dodgers, Hugo Ball for assuming a false name in Zurich, Frank Wedekind for censorship violations[38]— the Baroness was routinely incarcerated, mostly for stealing in department stores like Woolworth's and Wanamaker's, as she purloined items she needed for her art and for her very existence, for her poverty was excruciating: "Crime is *not* crime in country of criminals," she would later tell Heap.[39] According to Village lore, she was also arrested for public nudity, when she paraded the streets wearing only a Mexican blanket. As an outlawed artist and woman, she can be seen as an emblem for other incar-

cerated female dissidents—the anarchist Emma Goldman and the birth-control activists Margaret and Ethel Sanger—who all went to jail as a result of consciously executed dissident acts. Ironically, the same vice squad that was monitoring the balls and teahouse trade was also surveilling the Brooklyn birth-control clinic that had opened its doors in 1916.[40]

While Elsa never provided any details of her prison life, Margaret Sanger gives us detailed insight into what the Baroness would have experienced in her many incarcerations in the Lower Manhattan detention complexes called the Tombs. Because it dramatically emphasizes the less romantic side of such punishment and the very real dangers facing women and men who defied the law, Sanger's vivid description is worth quoting at length:

I stayed overnight at the Raymond Street Jail, and I shall never forget it. The mattresses were spotted and smelly, the blankets stiff with dirt and grime. The stench nauseated me. It was not a comforting thought to go without bedclothing when it was so cold, but, having in mind the diseased occupants who might have preceded me, I could not bring myself to creep under the covers. Instead I lay down on top and wrapped my coat around me. The only clean object was my towel, and this I draped over my face and head. For endless hours I struggled with roaches and horrible-looking bugs that came crawling out of the walls and across the floor. When a rat jumped up on the bed I cried out involuntarily and sent it scuttling out.

My cell was at the end of a center row, all opening front and back upon two corridors. The prisoners gathered in one of the aisles the next morning and I joined them. Most had been accused of minor offenses such as shoplifting and petty thievery. Many had weather-beaten faces, were a class by themselves, laughing and unconcerned. But I heard no coarse language. Underneath the chatter I sensed a deep and bitter resentment; some of them had been there for three or four months without having been brought to trial. The

more fortunate had a little money to engage lawyers; others had to wait for the court to assign them legal defenders.[41]

The physical conditions make us wonder whether it was in jail that the Baroness first began to cultivate her unusual sympathy with rats and cockroaches, later even feeding rats in her flat, treating them as pets where most people would call the exterminator. Meanwhile, the young New York painter Theresa Bernstein fed the Baroness's canary bird while Elsa was in the Tombs for stealing. Bernstein gained important insight into the battles of the Baroness's personal history.

Sometime in 1916, the Baroness had become the model and lover of the futurist artist Douglas Gilbert Dixon, and on 26 January 1917, just three days before Sanger's court appearance, the *New York Evening Sun* cited the Baroness in his divorce case, a case heard in the Supreme Court and presided over by Justice Giegerich. The Baroness is described as a "stunning dark complexioned woman," who "had been exiled from her own husband when she came to America." As Dixon testified: "The Baroness is my model, it is true. She is a dual model. I use her in my art and in my life. She is my intellectual and spiritual companion." Refusing to give up his "poetic soulmate model," as Dixon called her, he had asked his wife Renee Lois Dixon for a divorce. When Renee Dixon's lawyer appealed to the Baroness to give up Dixon, she responded that "if she were robbed of her 'poet lover,' [. . .] she would die as good Germans before her had died." Still, as the newspaper noted, "notwithstanding this strong attachment between the Baroness and Dixon, their romance a little later went to smash on international rocks. They quarrelled because he was English and she Teutonic."[42] Perhaps it was the breakdown of her relations with Dixon that prompted the Baroness to leave New York a few weeks later.

Probably in February 1917, the Baroness took her show on the road, leaving New York for Philadelphia, a metropolis with German and Dutch roots and with a vibrant artist community.

Dadaist Charles Demuth lived in nearby Lancaster and attended Philadelphia's impressive Academy of Fine Arts from 1915 to 1920; he commuted to New York once a week. The photographer Charles Sheeler (1883–1965) and the sculptor Morton Schamberg (1881–1918) occupied a shared studio on Philadelphia's Chestnut Street and, like Demuth, maintained close contacts with New York and the Arensberg circle.[43] It is unknown exactly when the Baroness met Schamberg and Sheeler, but perhaps these two men suggested that she try posing for George Biddle (1885–1973), a painter from a "wealthy prominent Philadelphian family," as she later told Barnes.[44] On her arrival in Philadelphia, she was in dire need of help, living a nomadic life on the margins of society. "Thrice that week," as Biddle reported, "she had been arrested for trying to bathe in the public pools; which, surrounded by borders of gladiolus, adorn the landscaping of the stations on the Main Line of the Pennsylvania Railroad." When Biddle asked her where she was staying, she "replied somewhat wearily that she slept mostly with a sailor—on park benches. He was beautiful; but, it would appear, crassly American."[45] Her poverty was extreme, but she was determined to make a stunning first impression on Biddle, when she first met him in early March 1917, just a few weeks before he enlisted in Officers' Training Camp. Seeking employment as a model, she was also hoping that this young and rich modernist painter might recognize the extraordinary quality of her art and support her in the style she deserved.

At age forty-one, on "a gusty wind-swept morning," she entered Biddle's Philadelphia studio in fully matured New York dada style, as he vividly recalled in his memoirs:

Having asked me, in her harsh, high-pitched German stridency, whether I required a model, I told her that I should like to see her in the nude. With a royal gesture she swept apart the folds of a scarlet raincoat. She stood before me quite naked—or nearly so. Over the nipples of her breasts were two tin tomato cans, fastened with a

green string about her back. Between the tomato cans hung a very small bird-cage and within it a crestfallen canary. One arm was covered from wrist to shoulder with celluloid curtain rings, which later she admitted to have pilfered from a furniture display in Wanamaker's. She removed her hat, which had been tastefully but inconspicuously trimmed with gilded carrots, beets and other vegetables. Her hair was close cropped and dyed vermilion.[46]

The Baroness's body is saturated with signifiers that cry out to be read as gender acts. Perhaps most catching was her tomato-can bra, brilliantly alluding to the 1913 invention of the bra in New York, fashioned as it was out of "two handkerchiefs" stitched together with some "pink ribbon."[47] Liberating the female body from the stiff corset, the bra was a female invention conceived by the New York debutante Mary Phelps Jacob, none other than the self-named Caresse Crosby, who would later become famous among the Paris vanguard as the partner of the eccentric Harry Crosby.

Feminist art historians have shown that generations of male painters have represented themselves in sexually charged self-portraits with their nude female models, enacting the hierarchical boundary male/female, active/passive in the model/artist representation.[48] The Baroness's autobiographical self-display dismantled that binary between artist and model. When she threw open her scarlet raincoat, the male painter was suddenly forced to reconfigure his model as an artist. Since male artists have fondly represented themselves in their visual art using their female model as eroticized prop or as muse, the Baroness used this scene to reclaim aging woman's eroticism. Effectively turning the tables, she aggressively claimed the male painter as an object of her sexual desire. For Biddle, she thus becomes a Medusa figure, as he describes her in his memoirs. "She had the body of a Greek ephebe, with small firm breasts, narrow hips and long smooth shanks. Her face was lined. Her eyes were blue-white and frightening in their expression. Her smile was a frozen devouring rictus."[49]

For all her unconventionality and bravado, the Baroness was acutely aware of her vulnerable position, and her personal recollection of her posing for Biddle highlights the less glamorous side. "You personally even docked me in the *price I asked—posing for you,*" she later bitterly charged Biddle and continued: "you had to bargain with me—as an American—business like [. . .] instead of realizing my breathtaking sight—helping me in tru[ly] generous fashion—as I was worth it. [. . .] [Y]ou all had money-safety [but] nobody paid me a decent price for the show he enjoyed—if all of you had done *that much*—I should have won!" The men in her life—lovers, admirers, and supporters—let her "run to ruin—heartily sympathetic."[50] Here, then, also lay the important contradiction of her position as artist: antibourgeois yet dependent on support to survive. She was New York's most innovative artist, but nobody paid her for vanguard art: she was left to fend for herself.

Thus by 1917, the Baroness had already developed an impressive portfolio of gender acts. She had pioneered a highly original, if not to say a revolutionary genre, yet she was not able to sustain herself through her art. During a time when the market for visual images was rapidly expanding, her brilliantly flashy body narrative presented the most vanguard of experimentation. This both begs and answers the question of why the Baroness was unable to make a living from her art. So outrageously forward was her experimentation and so aggressively modern was her art that the magazine publishers stayed clear of her, even as they gobbled up vanguard images. Traces of the Baroness's élan are assimilated into the public media in much tamer form, while the wild Baroness herself was silenced and labeled insane.

Vanity Fair presents a case in point. This sleek magazine was launched in September 1913 by Frank Crowninshield, one of the organizers of the Armory Show. By 1917, Crowninshield had introduced ninety thousand fans to the richness of the international avant-garde: writing by Gertrude Stein, Dorothy Parker, and Anita Loos; reprints of works by Matisse and Picasso; and soon the

celebrity photos of Man Ray. Both accessible and fun, modern art with its cubist, futurist, and surrealist dimensions appeared in *Vanity Fair* alongside a myriad of new images of modern life: images of parties, fashion, theater, and sports. Imaging avant-garde modernity, so it seemed, made business sense as well as aesthetic sense.[51] Crowninshield's motto, famously phrased in 1914, was clear: "Take a dozen or so cultivated men and women; dress them becomingly; sit them down to dinner. What will these people say? *Vanity Fair* is that dinner!"[52] What the invited guests looked like can be seen in the 1915 *Vanity Fair* photograph of Duchamp.[53] It shows the artist posing in a dark suit, a white shirt, and a polka-dot bow tie. With his hair parted and combed back, he looks more choir boy than avant-garde artist. While Crowninshield actively scouted for vanguard photographs of art and people, he was equally careful in translating transgressive art into acceptable images, effectively preparing the vanguard for a cultural mainstreaming in the United States. As Lawrence Rainey writes in his study on the cultural economy of modernism: "Condé Nast, *Vanity Fair*'s owner and publisher, was a pioneer in what is now called niche marketing"; as such, *Vanity Fair* catered to "not a mass audience, but a more select one of well-to-do readers." The magazine appealed to an "audience increasingly defined by consumption, by the purchase of luxury consumer goods, and by the stylishness in all things."[54] *Vanity Fair* was conscientious not to unsettle its modernist fans with excessive experimentation and overly controversial issues.

Crowninshield must have known the Baroness or at least have heard of her, since he was a visitor at the Arensbergs. That the careful editor did not invite her to the *Vanity Fair* dinner, lest she appear adorned with her scandalous tomato-can bra, is ultimately not surprising. The name of the ultramodern Baroness was lost in visual and cultural history, but traces of her sexual disruptions can be found in mediated from. *Vanity Fair* was championing a more feminine dada in the work of the New York caricature artist Clara Tice (1888–1973), whom Crowninshield fondly called the "queen of

Greenwich Village."[55] In 1915, the twenty-seven-year-old Tice's delicately silhouetted caricatures of female nudes startled veteran Anthony Comstock (1844–1915) from his retirement slumber. The past chair of the Society for the Suppression of Vice rose one last time to declare the caricatures obscene, before passing away in the same year. *Vanity Fair* defied the ruling and printed Tice's ethereal nudes—and the periodical went unpunished. Two years later, in 1917, *Vanity Fair* published a fascinating photograph of Tice that may be read as an intertextual nod to Freytag-Loringhoven's erotically charged body art in process.[56] Just as the Baroness was triumphantly parading herself as an independent artist and woman, so was Tice. In the photograph, her chin is proudly turned upward and her pose is artistic. Like the Baroness's, Tice's body was captured as if in midmovement. She is wearing a feminine summer dress, her feet naked, her left arm nude and extended backward. Her right leg is lifted as if she were performing a dancing move, while holding a black cat on a leash—the latter an echo to the Baroness's promenading of her five dogs on the leash through New York City. Though lacking the unsettling hybridity and sexual radicality of the Baroness's kinesthetic body, Tice's portrait demonstrates the extent to which *Vanity Fair* energized itself through images and expressions of the ultramodern, while also performing a careful mediating function that censored what was perceived as too unsettling.

The Baroness's pictures, operating at the ultravanguard edge, reached the mainstream only in carefully mediated and contained form. Thus the brilliantly original Baroness—her body more unsettling than pleasing, more grotesque than erotic, more discomfiting than reassuring—was ultimately excluded from the capitalist production and consumption cycle. Living in poverty, she continued to produce her art as a gift to Americans, her body images making their appearances in permutated forms that may ultimately effect change from the microcosm upward. Yet the Baroness was also a "citizen of terror," as Djuna Barnes put it, a figure who resented and took revenge on her exclusion.

A Citizen of Terror in Wartime

Chapter **8**

In two 1917 oil paintings in yellow and ochre colors, the American painter Theresa Bernstein (1895–2002) visually captured the Baroness's armoring of self. In these nude portraits (now held in private collections in Tübingen and New York),[1] the Baroness's right leg is splayed from the knee down; her lean torso contrasts with the facial signs of aging; the light lingers on her breasts, which are fully exposed. In the first painting (figure 8.1, plate 6), only her right arm is lifted above the head; in the second (frontispiece), both arms are lifted up as if she were performing a dance. Yet in both paintings, the viewer's voyeuristic inspection of the bodily texture is unsettled by a shadow that envelops her entire body like a thick protective skin, a shell or coat that shields. It at once suggests an Achilles fantasy of protection—reminiscent of her self-armoring in her first nude pose for de Vry in 1895—and the dark shadow of traumatic memory

8.1 Theresa Bernstein, *Elsa von Freytag-Loringhoven*, ca. 1917. Oil. Gisela Baronin Freytag v. Loringhoven Collection, Tübingen.

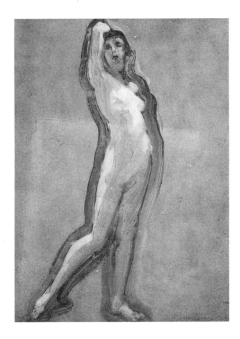

inscribed on the body itself. In 1917, Bernstein recognized that the Baroness's self-display was a medium for donning an armor and for striking out as a warrior artist.

Bernstein's nudes are emblematic, for the Baroness's body of terror was pivotal during the World War I era. Written on her body was the trauma of earlier experiences including the tension of perpetual conflict and emotional violence at home. The Baroness's personal history had marked her body with trauma that remained largely unassimilated in her speedy journey through Europe. Memory was deeply registered on her body to be acted out during a time of collective trauma. In the midst of youthful America, by 1917 the Baroness came to represent Old Europe, associated with old age, decadence, and destruction. For America and its young modernist poets and authors, including William Carlos Williams, Hart Crane, and Wallace Stevens, her body was the unsettling body of Europe at war. Although Greenwich Village and America's young modernist poets and painters were far from the trench warfare in Belgium, far from the smell of chlorine gas, and far from close contact with corpses, for the exiled Europeans the reality of the war they had escaped was always close by. For Americans, the memory of Old Europe was inscribed on her flesh and used to terrorize a young generation of artists.[2]

America declared war on Germany on 6 April 1917, and Congress ratified the wartime laws on 15 June. The Espionage Act—which criminalized expressions of contempt for the government, the constitution, or the flag—quickly led to deportation of pacificists and nonconformists. War fever captured the nation like a prairie fire, as patriotic messages began to proliferate on recruitment posters, in newspaper advertisements, and in books. Anti-German feelings were growing even in private households, as Williams recalled; when he defended a German-born relative, a local physician publicly denounced the poet as pro-German in the newspaper, "telling people not to consult me."[3] Meanwhile, the new leader of

the Society for the Suppression of Vice, John Sumner, intensified the roundup of homosexuals in the Village with systematic raids of theaters, bathhouses, gay bars, and subway washrooms—a patriotic crusade against wartime "perversion" that dramatically increased the number of men arrested on charges of degenerate disorderly conduct and sodomy and intensified censorship of homosexual elements in the theater and burlesque.[4] Along with nine million American recruits, the first exodus of artists took e. e. cummings, John Dos Passos, and George Biddle to the war front.

From New York, the Baroness, now a double war widow of sorts, corresponded with Biddle ("Orje," as she affectionately called him), with whom she had predictably fallen in love. As Biddle recalled: "While overseas during the War I received from her many letters; long poetic diatribes in Joycian vernacular against my very bourgeois art, and other lyrics of a more narcissistic and intimate nature. They were generally illustrated on celluloid, par excellence her medium. Some of them subsequently appeared in *Little Review*."[5] It is likely that these poems sent to the war front included "Mefk Maru Mustir Daas," which powerfully reverberated with dark and melancholic allusions to the war, for Mustir was a figure of mourning and death:

And every day the corners of thine tired mouth Mustir
Grow sweeter helpless sneer the more despair
And bloody pale-red poison foams from them
At every noble thing to kill thine soul
Because thine body is the prey of mice
And dies so slowly[.][6]

Her startling imagery of the mouth's foaming with "bloody pale-red poison" was suggestive of the death by poison gas—one of the haunting images of World War I. As a figure of mourning and world weariness, the Baroness's slowly dying Mustir stood for the ravaged

Europe itself ("Thou art a country devastated bare Mustir"),[7] the Baroness's voice Cassandra-like announcing devastation and desolation. Illustrating her poems on celluloid, she was armoring her art with a hard shell.

So where did modern art stand during wartime? Margaret Anderson's article about the war in the April 1917 issue of *The Little Review* was a blank page, with the provocative caption: "We will probably be suppressed for this." In June, Heap used the title "Push-Face" to report on a vibrant anticonscription meeting at which Emma Goldman was present. A woman shouted: "Down with conscription! Down with the war!" By August, now publishing from 24 West Sixteenth Street, Heap proclaimed, "none of us considers this war a legitimate or an interesting subject for Art."[8] Virtually coinciding with America's war declaration, the American Society of Independent Artists opened to great fanfare on 10 April 1917. The Society of Independent Artists proposed nothing less than an exhibit according to an alphabetical order, as if to celebrate democracy in the midst of war, a principle requested by Bolton Brown in a 17 February 1917 letter to the editor of the *New York Times:* "The expression of the 'No jury, no prizes' idea in the incorporation of the Society of Independent Artists is the beginning of the end of many foolish things [. . .] [b]y the simple determination to stand on a democratic—and not an aristocratic—basis, to let every public be its own judge of every artist. [. . .] The abolishment of the jury and prize system is the greatest art event to Americans that has ever happened."[9] The list of exhibition sponsors was surprisingly female, including Mrs. William K. Vanderbilt, Mrs. Charles C. Rumsey, Mrs. Whitney, Miss Katherine S. Dreier, Mrs. Rockwell Kent, and Archer Huntington. The exhibition included Beatrice Wood's *Un peut d'eau dans du savon,* a headless female nude with a bar of soap cheekily covering the pubic area like a fig leaf, the soap a suggestion of Duchamp's. It was a subversive use of the nude, yet beautifully

aesthetic, not nearly as shocking or unsettling as the Baroness's dislocations.[10]

Meanwhile, the Arensberg circle had launched a new journal, *The Blindman,* its conception driven by the erotically triangulated friendship of Duchamp, Beatrice Wood, and Henri-Pierre Roché (1879–1959), a French art collector and writer with a penchant for homoeroticized three-way affairs.[11] Using Arensberg's apartment on 33 West Sixty-seventh Street as their base, Roché and Totor (Duchamp) were busily and intimately collaborating, with Arensberg and Crowninshield providing advice. On 10 April, *The Blindman*'s initial cover featured a caricature of the quintessential post-Victorian bourgeois: a moustached man in a suit and bowler hat, blindly looking upward, led by a blindman's dog.[12] Yet the journal was intercepted by Wood's vigilant father, the patriarchal bourgeois not nearly as blind as the title and cover of the journal charged. A playfully abstract watercolor painting by Wood commemorated the group's bacchanalia of 25 May, as she depicted herself in an innocent group orgy, sleeping in Duchamp's bed, along with several other bed partners: Mina Loy, Charles Demuth, and Aline Dresser. The well-protected daughter from a bourgeois home felt liberated, all the more as she had begun a sexual affair with Duchamp. While the youthful Wood was successful where the mature Baroness was not, Wood's sad tone also signaled disappointment, for Duchamp kept her at a distance, murmuring, "Cela n'a pas d'importance." Wood described him as deathlike: "The upper part of his face was alive, the lower part lifeless. It was as if he suffered an unspeakable trauma in his youth."[13]

Since the combative Baroness was still out of town, she also missed the 28 July picnic in honor of Duchamp's thirtieth birthday at the Stettheimer summer home just outside New York in Tarrytown. The event was commemorated by Florine Stettheimer in an attractive painting, *La fête à Duchamp* (1917), whose peaceful pastoral atmosphere starkly contrasted with the war raging in Europe and

8.2 *Robert Fulton Logan,* ca. 1950s. Photograph. The Connecticut College Archives.

with the destructive images of dada.[14] Incidentally, it also contrasts with the legendary decadent party organized in 1917 by the Count and Countess Etienne de Beaumont just outside Paris. Like Shakespeare's pastoral Forest of Arden, *La fête à Duchamp* celebrated a quiet socializing of friends amid art and good food and nature; the focus is not on heterosexual coupling but on groups of people enjoying each other's company. Even Picabia's flashy red car in the left top corner cannot disturb the prevailing peace. Similarly a product of the war years, Juliette Roche's *American Picnic* (ca. 1915–1919) looks like a delicate Greek vase painting, with androgynous, serpentine figures signaling bodily reveling in a sensual group orgy.[15] All three women artists—Wood, Stettheimer, and Roche—created powerful images of group harmony and friendship, forcefully creating peace in times of international conflict by strategically sidestepping heterosexual tension. These lighthearted pastorals presented the women's subversively political argument against the violence of war.

There was no such escaping of the war horror for the contentious Baroness, who found herself increasingly wrapped up in the turmoil of wartime activity. Presumably after the passing of the wartime act, she was arrested as a spy and incarcerated for three weeks in Connecticut. Here, for the first time, she was considered "mentally deranged," as she recalled for Barnes: "a person like myself sometimes *will* run up against this sort of thing—as I did in New Haven when I was arrest[ed] as a spy for 3 weeks and was on the warpath after *Robert Logan* (the Cast-Iron Lover) desperate with love."[16] Robert Fulton Logan (1889–1959), an art instructor and later university professor and chair of the art department at the prestigious New London Connecticut College (1936–54), is the red-haired, bespectacled man of several signature poems. Born and raised in rural Lauder, southwestern Manitoba, Canada (coincidentally and ironically the very province in which Greve had made his new home), Logan was a painter, etcher, and lithographer with exhibitions in New York and Paris.[17] A photograph (figure 8.2) shows the instructor in a classroom at Connecticut College with women sketching, an environment similar to the one in which the Baroness would have seen him in 1917 when she was modeling for his class. The professor looks dignified, serious, and "grimly proper," to use the Baroness's words; his curriculum vitae is evidence that he was the "pillar of church—prop of society" that the Baroness recognized in him. In "Moving-Picture and Prayer," a poem published in *The Little Review* two years later, he figured prominently as the reluctant object of her wildly amorous pursuits, as she tried to conquer the "country of forbidding ice," an intriguing reference to Canada:

Know a man—red hair—
harsh mouth—harsh soul—
flesh hard white alabaster—
steely violet-blue shadows—

country of forbidding ice—
Every one fingertip must freeze to touch
his deadly snowy waste. [18]

In madly pursuing Logan ("Ah—why should EVERY ONE fingertip
YEARN to touch a frozen body"),[19] she flaunted herself in her sexual
conqueror pose, but trying to invade the country of ice, like
Napoleon in Russia, she becomes bogged down in "snowy waste."
Later she sadly recalled for Biddle that "the last naive bodily love-
move—I had spent on the cast iron lover."[20] And she mournfully
wrote in her poem, "Not yet has he taken me—not bedecked me
with alabaster possessions!!!"[21]

Yet like the spurned male lover who refuses to take no
for an answer, she held Logan responsible for fueling her desire:
"and *yet* he had returned to the class—unnecessarily—restless—in-
stinct propelled—drawn by my fierce—flame enveloping heat of
desire!"[22] What exactly transpired on the last day in the "art school"
where she was posing we will probably never know, but her
"warpath" against Logan was presumably similar to the aggressive
pursuit and hostility displayed toward other men, including William
Carlos Williams. For many of the men of Greenwich Village, the
Baroness would soon become a nemesis figure inspiring fear, em-
bodying the frightening specter of womanhood in pursuit of males,
demanding sexual pleasure as her right—as patriarchal males had ef-
fectively done for centuries.

Here, then, surfaces the other side of the Baroness, as a
figure of rage and revenge, as she takes us back to the earlier scenes
of seething anger experienced in exploitative heterosexual affairs.
Just as Biddle and Williams would be left with their legs shaking af-
ter kissing the Baroness ("Enveloping me slowly, as a snake would its
prey, she glued her wet lips on mine," as Biddle noted),[23] so Logan
was the quintessential emasculated man when facing the Baroness:
"[he] whispered—blanched with fear—his knees knocking tato in

his pants—oh—no—no—!'" "The cowardly shitars,"[24] she called Logan, while her poetry fantasized a quasi-rape in forcing down the walls of resistance of her reluctant male object: "Into castle of ice I will step BY CONTACT—seering fluid / forcing passage into walls of no reproach."[25]As always, she was laboring to overcome bourgeois inhibitions, challenging herself to explode any remaining pillars of society.

Probably conceived and composed in prison was the infamous "Cast-Iron Lover," her most controversial poem, whose antihero was Logan. This long poem of 279 lines is less a working through than a hallucinatory acting out of the breakdown of heterosexual relations against the backdrop of the war (although the war is never mentioned explicitly, the poem is brimming with violent imagery). When the poem was published two years later in *The Little Review,* it aroused controversy so divisive and violent that it posttraumatically evoked the recent battles at the war front. Her style itself was crystallizing as excitable speech, a speech act designed to arouse, provoke, incite, and agitate.[26] In a raving tone, the sexes are violently hurled against each other in a fierce battle, with the conventions of love poetry loudly imploding in this grotesque love poem. "Heia! ja-hoho! hisses mine starry-eyed soul in her own language," as she wrote, while the predominance of the sibilant /s/ musically hisses throughout the poem.[27]

Beginning with the opening lines, the poem is driven by female desire: "His hair is molten gold and a red pelt— / His hair is glorious!" she enthused but in the next stanza denigrated her beloved as being merely surface without depth, thus deflating her own romantic impressions: "HE is [. . .] not GOLDEN animal— he is GILDED animal only—."[28] The poem tears apart heterosexual romance conventions, as when the fairy tale frog morphs not into prince but into "squatting toad":

SQUATING IN SHADOW DARKNESS UPON CENTER
OF CRIMSON THRONE————SQUATING CON-
TENTEDLY—FEEDING SWIFTLY—EYES CLOSING IN
PASSION—OPENING NOT KNOWING PASSION—BOWELS
DANCING—EYES STONY JEWELS IN ITS HEAD!
TOADKING![29]

The male's (hetero)sexual passion has been replaced by the quotid-
ian anal passion of the squatting toadking, who like the toddler en-
joys autoerotic pleasure in a daily bowel movement. This satirically
degrading, scatological reference also extends to political monarchy
(an allusion to Canada's monarchical head of state), for the poem is
saturated with imagery of nobility and royalty (with repeated refer-
ences to "throne," "crown," "majestic"), the regal throne reduced
to the throne of toilet training.

In this long poem, unbridled female desire for sexual
contact bursts like a shell into violent fragments of desire, each flam-
ing and furious, a verbal equivalent of the cosmic cubism of Mars-
den Hartley's exploding shells on canvas.[30] There is her haptic desire
for touch: "I MUST TOUCH"; "mine fingers wish to touch—ca-
ress—"; "I love his hands." There is her desire for union: "I am de-
sirous for possession." There is the oral-sadistic desire: "bite into
MINE flesh I will bite into THINE!"[31] There is the surrealist image of
the male lover turning into bird of prey, the breakdown of hetero-
sexual relations intensified and condensed in a grotesquely night-
marish vision of violence, as she touches the lover's hands: "I touch
them: ——— they quiver! / I kiss them: ——— they grasp—
clutch—tear—draw blood— / ——— Steeltools—reddish complex-
ion—chiseled talons— [...]."[32] Like no other poem, the
"Cast-Iron Lover" performs the modern dislocation of heterosexual
gender relations with unprecedented fierceness and visceral emo-
tionality. Pulsating with trauma-charged explosions, her disman-

tling of conventional love during wartime echoed the brutalities of the war itself.

In fact, the poem's central image is that of the cast-iron lover as rigid, lifeless, and immobile, for iron suggests a state even deader than death: "Iron—mine soul—cast-iron! [. . .] / Not like death—in death has been life—."[33] The cast-iron imagery takes us back to her father, the German icon of virility wielding iron-willed power, as well as evoking the deadly cast-iron cannon of war. The cast-iron lover is the literal personification of death, a grim reaper figure, whose nose is invariably described as a scythe in refrainlike repetition:

Seest his nostrils—mine soul—shining with crimson—
flaring with breath? ————— The scythe moveth!—
crimson scythe—bloody scythe—curving up his cheek swiftly!!!
Mine soul—so beautiful he is!!![34]

No doubt, Ezra Pound was thinking of this poem when he identified the Baroness as a Cassandra figure. Just as the mythological Cassandra foretold the destruction of Troy, so the Baroness is orating against the backdrop of massive war, loudly proclaiming a Western masculinity in terms of diminishment and death. At the same time, she rants in a language that defies ultimate deciphering, and while her poem takes the form of a dialogue between "mine body" and "mine soul," the male lover addressed remains catatonically silent. In this modern antilove song, there is an intertextual connection with the raving Dido mourning the desertion of her lover Aeneas. Yet while Virgil's Roman patriarchy is affirmed and strengthened in the traditional epic love poem, the Baroness's modern patriarchy is left shattered.

While no other poet reenacted the violence of war with as much disruptive intensity, "Cast-Iron Lover" must also be seen as New York's equivalent to T. S. Eliot's "The Love Song of J. Alfred

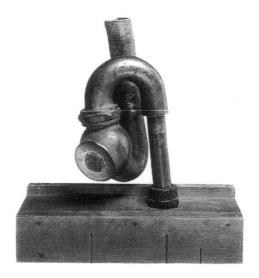

8.3 Baroness Elsa von Freytag-Loringhoven [with Morton Livingston Schamberg], *God*, 1917. Plumbing trap on a carpenter's miter box. The Louise and Walter Arensberg Collection, 10 1/2 in. Philadelphia Museum of Art.

Prufrock" (1917), the pivotal modernist poem of diminished humanity and masculinity. Both are the products of exiled artists: Eliot, an American in Europe; the Baroness, a European in the United States. "Prufrock," too, presents a debating structure, a dialogue between "you" and "I." In a creepy Kafkaesque image, Prufrock morphs into insect "sprawling on a pin / When I am pinned and wriggling on the wall"; in another scene, he fantasizes himself with a "pair of ragged claws / Scuttling across the floors of silent seas," humanity transmorphing into shell-protected animalistic world.[35] Eliot had completed "Prufrock" in the summer of 1910, whereas

"Cast-Iron Lover" belongs more firmly in the war era. While Eliot's male Prufrock is subdued in tone and raises questions ("Do I dare to eat a peach?"),[36] the female Baroness shouts in capital letters, as a military officer might holler his commands to the troupe. She brutally assaults poetic conventions, while also displaying skilled prosody: "Chiselled lips harden—shellpale skin coarsens—toadblood OOZES/ in reddish pale palms [. . .]."[37] Blood's pulsating spurts are poetically evoked in plosive / p / sounds, while the liquid / l /'s and long vowels suggest the oozing of blood. Prosody reveals a heightened aural sensitivity in the midst of this violent poetry. Her predilection for archaic forms *(thou, mine soul, singeth, cometh, maketh)* further highlights the violence performed on traditional language.

Like Mina Loy's and Gertrude Stein's, her diction ultimately remains a dense thicket, oblique and impenetrable, yet unlike any other poet's her style is aggressive and excessive. An "unconscious volcano," is how the New York poet Maxwell Bodenheim described her style in his defense of "Cast-Iron Lover": "It is refreshing to see someone claw aside the veils and rush forth howling, vomiting, and leaping nakedly."[38] Or as the American literary critic Cary Nelson writes more recently, Freytag-Loringhoven's "poems open at a peak of intensity and yet their energy typically increases as the phrases reform and implode each other, with capitalized passages often taking over toward the end."[39] And like no other poem, "Cast-Iron Lover" blasts aesthetic tastes. Its unpoetically heavy metal imagery ultimately suggests that it was conceived close in time to the cast-iron plumbing sculpture *God* (1917).

A pivotal art work in the annals of dada, the iconoclastic *God* (figure 8.3, plate 3) is strangely humanized in a twist of cast-iron bowels mounted on a miter box and pointing to heaven. Jones describes

the sculpture as a "penis/phallus [. . .] contorted into a pretzel of plumbing," while Michael Kimmelman in the New York Times sees "the loop of the trap as a cryptogram for the lowercase letters g-o-d."[40] Indeed, the very idea that God should produce quotidian bodily wastes dismantles the omnipotent deity of Western culture, for his power resides in his abstract bodylessness. Besides echoing the blissful scatology of the squatting, infantilized, and bowel-fixated cast-iron lover, the conception of this sacrilegious dada artwork returns us to the Baroness's childhood. Recall the religious conflicts between her mother and father, with her antireligious father taking the wind out of Ida's sails by equating the ritual of the nightly prayer with the constitutional visit to the toilet for urination, a scene discussed in chapter 1. Moreover, she wrote in her autobiographical poem "Analytical Chemistry of Fruit": "My bawdy spirit is innate/ Bequeathed through my papa/ His humour was crass—I am elected/ To be funny with corrupted taste."[41] Indeed, she had appropriated her father's antireligious scatology, profanity, and obscenity for her dada art, repudiating feminine propriety.

To gain deeper insight into the psychology of her art, let us briefly look ahead to George Biddle's visit to her tenement apartment on Fourteenth Street in Greenwich Village, where she would settle after her excursion to Philadelphia. As we enter her unusual living space, we find ourselves startled by the pungent perfume emanating from her museum studio and from her body. As Bidde recalled:

It was in an unheated loft on 14th Street. It was crowded and reeking with the strange relics which she had purloined over a period of years from the New York gutters. Old bits of ironware, automobile tires, gilded vegetables, a dozen starved dogs, celluloid paintings, ash cans, every conceivable horror, which to her tortured, yet highly sensitized perception, became objects of formal beauty. And, except for the sinister and tragic setting, it had to me quite as much

authenticity as, for instance, Brancusi's studio in Paris, that of Picabia, or the many exhibitions of children's work, lunatics' work, or dadaist and surrealist shows, which in their turn absorb the New York and Paris intellectuals.[42]

Biddle called hers an "anal-acquisitive" type. Yet her personality is perhaps even more accurately described as "anal-expulsive"—that is, "messy and disorganized" rather than neat and clean—because she persistently ignored the conventional systems of order imposed by society.[43] Her dada attraction to society's quotidian wastes takes us back to the toddler's erotic pleasure in controlling the retention or expulsion of feces and to society's focus on regulating these functions with respect to place and time. Since toilet training functions as one of the earliest ways of social regulation and social order, dada's disruption of that social order is perhaps appropriately located in the realm of toilet matter, obscenity, and waste. As Picabia put it in a scatological dada joke that matched the Baroness's *God:* "Dieu nous aide et fait pousser le caca" (God helps us and makes excrement grow).[44]

Originally *God* had been attributed to Morton Schamberg, who had photographed it, but recently it has been assigned to the Baroness. This is thanks to Francis M. Naumann, who has argued that *God* is out of character with Schamberg's sleek machine images, many of which decorated the walls of the Arensberg salon. Nor was the impeccably dressed Schamberg a likely candidate for fantasizing objects of waste and abjection into art objects. Schamberg's self-portrait shows him sitting on a chair posing in profile in suit, high collar, finely trimmed hair and moustache, slim hand delicately resting on the chair's back. Naumann concludes that Freytag-Loringhoven "probably came up with the idea of combining the extraneous elements in this sculpture, as well as of assigning the unusual title, while

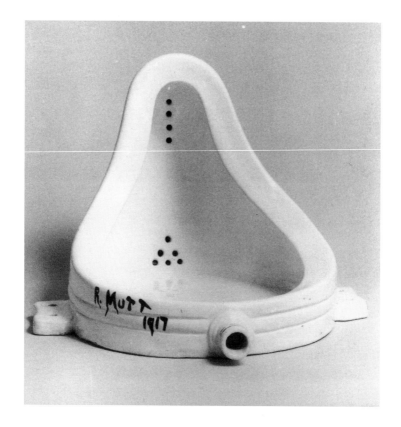

8.**4** Marcel Duchamp, *Fountain*, 1917 (1964 edition). Estate of
Marcel Duchamp/ADAGP (Paris)/SODRAC (Montreal) 2001.

Schamberg was probably responsible only for mounting the as-
sembly and for recording the work."[45] The details remain shrouded
in mystery, but we know for a fact that Schamberg photographed
God in front of his machine paintings and dated the print 1917.

The furor surrounding *God* has not abated since the
work's inception in 1917. Though canonized in American art his-
tory, the sculpture remains controversial even today, as seen in a
recent polemical debate about appropriate university curricula fea-
tured in the *Chronicle of Higher Education.* "Presumably, slides of

classical nudes and mythological rapes may be freely shown and discussed," writes the American art history professor William B. Rhoads and continues: "But what about that notorious work of art, 'God' (1917), by the Baroness Elsa von Freytag-Loringhoven with Morton Schamberg, where the supreme deity is identified as mildly revolting plumbing trap? Will the fact that this disturbing object is owned by the Philadelphia Museum of Art make it acceptable for classroom viewing?"[46] Like the "Cast-Iron Lover," the sculpture housed in the Louise and Walter Arensberg Collection at the Philadelphia Museum of Art raises questions of borders and boundaries of acceptability, taste, and pedagogical value. And these questions extend to the entire canon of the Baroness's work, making her a pivotal figure in the debates of those boundaries. The artist Margaret Morgan calls *God* a "renegade object": "Eighty years after its emergence as a work of art, it has not collapsed into the beautiful. It stubbornly remains an ungainly object, a bit like the figure of the Baroness herself. Sacrilegious, impulsive, intelligent, she was all that was parodic, anarchic and truly, fabulously ridiculous in Dada."[47]

God is a sister piece to Duchamp's sensually gleaming urinal, *Fountain* (1917) (figure 8.4), the scandalous *pièce de resistance* of the 1917 exhibition of the American Society of Independent Artists, where it sat on a pedestal, turned upside down and signed with the artist's name, R. Mutt. Thus displayed in April and May 1917, *Fountain*'s toilet aesthetics detonated the unity of the vanguard itself, sparking a raging debate after Duchamp's colleagues, including his friend Katherine Dreier, refused to recognize the item as a legitimate work of art and requested that it be removed from the Independent Art Exhibition. In protest, Duchamp and Arensberg immediately resigned from their positions as directors of the society.[48]

Fountain was a political test case for the democratic parameters established by the Independent Artists committee, as requested by the American reviewer Bolton Brown in the *New York*

Times on 17 February 1917: "The only further reform yet waiting the turning of the wheels of time is to abolish signatures on paintings and the publication of the artists' names in the catalogues."[49] Not only was *Fountain*'s signature anonymous, it was deliberately androgynous, the initial R. making the gender ambivalent; when the initial is turned around and read phonetically, the pseudonym R. Mutt becomes Mutt R or *Mutter (mother)* (Charles Demuth writes *Mutte,* in German phonetics the same as *Mutter*). Indeed, R. Mutt phonetically corresponds to *Urmutter* (great mother), the concept that so preoccupied the Munich Kosmiker and that anticipates Duchamp's later formulation that "[t]he artist is only the mother of art."[50] Read phonetically, R. Mutt also suggests most immediately the German *Armut* (poverty), the Baroness's chronic state of impoverishment, frequently referred to in her correspondence.[51]

This gender and linguistic blurring is all the more important if we consider William Camfield's study of the history of *Fountain* documenting that the provenance of this artwork remains shrouded in intriguing mystery: Did Duchamp buy it? Steal it? Or was it given to Duchamp? The authorship becomes even more complex in light of Duchamp's 11 April 1917 letter to his sister Suzanne informing her that *Fountain* was conceived by a friend:

[One of my female friends who had adopted the pseudonym Richard Mutt sent me a porcelain urinal as a sculpture; since there was nothing indecent about it, there was no reason to reject it.] Une de mes amies sous un pseudonyme masculin, Richard Mutt, avait envoyé une pissotière en porcelaine comme sculpture; ce n'était pas du tout indécent aucune raison pour la refuser.[52]

While it is possible that a bashful Duchamp was telling a white lie to his sister (but why make up so intricate a white lie in a personal letter?), it seems more plausible that his words are truthful. Camfield speculates that the female friend was a "shipping agent" and raises

this question: "Did she live in Philadelphia, since newspaper reports consistently identified Mutt as a Philadelphian? To date, no Philadelphia contact has been identified."[53] Yet if we consider that around this time, in the spring of 1917, as Biddle confirms, the Baroness was in Philadelphia, was involved in the 1917 conception of *God,* a piece focusing on bodily wastes, there emerges the question of whether the rabble-rousing Baroness may have had a hand in the mysterious *Fountain.* If this is the case, then this *pièce de résistance* must surely be seen as one of the most profoundly collaborative works in the annals of New York dada.

Indeed, while final evidence of the Baroness's involvement may be missing, there is a great deal of circumstantial evidence that points to her artistic fingerprint. Take the religious subtext that emerges in the subsequent discussions of *Fountain,* discussions involving a close-knit circle of Duchamp's friends, all of whom appear to be in the know, some also providing interviews to the media. In the May issue of *The Blindman,* Duchamp's friend Louise Norton discussed the piece under the heading "Buddha of the Bathroom." It was eventually rebaptized "Madonna of the Bathroom" when photographed by Stieglitz at his 291gallery, where position and lighting change the *Fountain* into a silhouetted Madonna.[54] While this intriguing religious twist is not commensurate with Duchamp's work, as Camfield admits, it is a signature trait of the Baroness's work. Indeed, we come full circle to the Baroness's childhood memory: her antireligious father's highly idiosyncratic equation of religious worship with urination (prayer = going to the bathroom). This childhood association of religion with bathroom matters, embedded as it was in a memory of parental conflict, may have been posttraumatically reawakened in the conflictual tensions as the United States was entering the European war against Teutonic Germany. Ultimately, the association with the Buddha or the Madonna makes *Fountain* a sister piece to *God.*

If the urinal's provenance is Philadelphia, who transported it? Since Duchamp's friend Charles Demuth was commuting from Philadelphia on a weekly basis during this period,[55] might he have been persuaded by the Baroness to transport it and deliver it to Duchamp along with the instructions (just as the Baroness later persuaded Abbott to carry her dada fare to André Gide and cajole Man Ray and Gabrielle Picabia into carrying her dada submissions to Tristan Tzara)? In fact, Demuth appears to have been be in the know, for he adds his defense of *Fountain* in the May issue of *The Blindman* ("When they stop they make a convention. / That is their end").[56] Indeed, Demuth, a gay man whose watercolor paintings document his curiosity about New York's homosexual spaces, would likely have associated the urinal with New York's gay subculture. For this gay viewer, the urinal as spatial icon would conjure up the so-called teahouse trade—the lavatories in subways, which were spaces of homosexual cruising and forbidden furtive pleasures. For the contemporary gay viewer, the public display of the urinal must have created a powerful spatial affect all the more politically charged, if we consider the New York Society for the Suppression of Vice's intensifying crusade against homosexuals and John Sumner's systematic raiding of gay spaces, including the lavatories. Demuth would have decoded *Fountain*'s profoundly subversive sexual message, a message further enhanced by the fact that the urinal was consistently described by viewers in sexual terms (as "gleaming," "glistening," often described as simultaneously "hard" and "soft," a none too subtle evocation of the erect penis as fluid-spurting *Fountain*).[57]

There is further evidence that points to the Baroness's having had a hand (so to speak) in the *Fountain* case. The pseudonym Richard Mutt, referred to by Duchamp in his letter to his sister Suzanne, is consistent with the Baroness's fingerprint. We recall the earlier discussion of Elsa and Felix Paul Greve's collaborative pseudonym Fanny Essler, and Elsa will soon introduce herself to *The*

Little Review editors under the name Tara Osrik. Richard is the name of her father's elder brother, already used in *Maurermeister Ihle's Haus,* although Richard is admittedly also a common name—orthographically the same in French, English, and German. *Mutt* is the English word for a mixed-breed dog whose parentage is unknown (she had an unusually intensive attachment to dogs and had adopted several of them), which also explains the innocent metamorphosis from urinal to *Fountain,* as it becomes a water dish for the Mutt/dog. Moreover, she freely used the word "shitmutt" as a swearword and displayed a general fondness for urinal humor as seen in her designation of William Carlos Williams as "W. C." or Louis Gilmore as "'Loo' Gilmore."[58] Consider, moreover, the selection of a quotidian object spatially segregated as male, a sexually aggressive choice consistent with the Baroness's intrusions into space socially and juridically defined as male (as in her intrusion into the Naples museum's pornographic collection or her appropriation of the fake phallus). Add to that the late submission of *Fountain,* when the 28 March catalogue deadline was already past, a pattern fully consistent with the Baroness, who was notoriously late to all her appointments, often infuriating people waiting for her (in contrast to the sensitive and considerate Duchamp). Add further the information leaked to a Boston paper that "Mr. Mutt now wants more than his dues returned. He wants damages"[59]—a pattern in keeping less with Duchamp than with the Baroness, who frequently threatened to sue people to extort money (see chapter 11). Finally, many years later, when discussing "Duchamp's sculpture," Williams called it a "magnificent cast-iron urinal,"[60] a fascinating linguistic slippage, conflating Duchamp's work (urinal) with the Baroness's (cast-iron). While final evidence is missing, a great deal of circumstantial evidence suggests that if a female friend was involved in the conception of *Fountain,* the Baroness was probably that friend.

As for the Baroness herself, she unfortunately gives us few clues into this mystery. Her frequent identification with

Duchamp—"I am he," "I am him," "I possess his soul. I am m'ars teutonic"—proclaimed a unique artistic bond and cross-over that has been noted by scholars. Yet she disparagingly referred to Duchamp's "plumbing fixtures." "And m'ars came to *this country*—protected—carried by fame—to use his plumbing fixtures—mechanical comforts," she wrote to *The Little Review* editors, adding: "He merely amuses himself. But—I am he—not yet having attained his height—I have to fight."[61] This is not unlike her disparaging references concerning *Fanny Essler,* claiming and disclaiming ownership in this novel. The connections are intriguing, but in light of the fragmentary materials, crucial authorship questions remain unanswered.

With *God* and *Fountain* as companion pieces, what do profanity and obscenity mean within dada? Within dada's explosively deconstructive thrust, religion takes a central role, for it allows dadaists to tackle Western culture's most sacred authority upholding "the cultural sign system."[62] Sacrilegious examples abound in dada art. There is the naming of the Cabaret Voltaire, the French philosopher-writer Voltaire as the epitome of the atheist in European culture. There is Picabia's *La sainte vierge,* a stain of ink shockingly questioning the virgin's immaculateness. There is Picabia's equation of the sacrament of holy communion with the chewing of gum, while his Christ takes a bath in cobalt with angels flying around as kites.[63] Perhaps most provocatively, Kurt Schwitters's "Anna Blume hat Räder" (Anna Blossom has wheels) (1919) reads like a mock rosary, dripping with overtly sexual references: "Anna Blossom! Anna, A-N-N-A, I trickle thy / name. Thy name drips like soft tallow [. . .] / Anna Blossom, thou drippes animal, I love thine."[64]

The Baroness is less a nihilistic and cynical anti-Christ poet than a mephistophelian jester who tickles God with her irreverence until he dies in an explosive fit of laughter. In "Holy Skirts," she contrasts the poem's all too human *God* ("Old sun of gun—" she calls him, *"old acquaintance"*) with a group of nuns, who morph

into a religious sex machine speeding up to heaven. Forming a religious locomotive, they begin their journey slowly and sluggishly but then speed up ("hurry—speed up—run amuck—jump—beat it!") until the locomotive is running at full steam in a final section of very short and breathless lines in a mock intercourse with God.[65] Likewise, her personal correspondence is saturated with dada aphorisms in which God and Christ are stripped of their omnipotence in the wake of the war's devastation: "Christ never acted—flabbergasted prestidigitator,"[66] she wrote in one letter, while in another she described God as "densely slow—He has eternity backing him—so why hurry?"[67] The dada Baroness makes God acknowledge his flawed humanity, an old man, baffled and slow, having settled into all-too-human foibles. In the competitive modern American world of Henry Ford, who had produced one million automobiles by October 1915, God is sadly lagging behind and in need of getting up to speed, as she writes in this hilarious letter to Peggy Guggenheim:

All know—[God] is tinkerer—limitless of resources.
But why so much tinkering?
He better fordize—learn from America—start expert machineshop—Ford can supply experience—funds—is rumored—
for as yet he is clumsily subtle—densely—intelligent—inefficiently—immense—(Lord not Ford—of course). [. . .]
[God] better hotfoot it towards progress—modernize—use his own omnipotence intelligently—smart or we'll all expire in tangle. Well Lord knows—(Does he?)[68]

While the Baroness's dada anti-Christ was fed by the influence of the Nietzschean Kosmiker in Munich, it was ultimately American in using central U.S. cultural icons to bring the highest godhood down to earth. "In Germany we had already Nietzsche," she told Heap: "Old Christ has died there at last—never to soar up again. He has

lost his gas, smashed his rudder, busted his wing."⁶⁹ The dadaist's
fantasy of the Christ machine without gas or of God *fordizing* and
hotfooting toward progress pokes fun at America's most cherished and
fetishized cultural symbols, mixing the two realms and dismantling
both at the same time, offering her reader and viewer the decon-
structed god of the machine age.

By late 1917, the Baroness was preparing to leave
Philadelphia, return to New York, and eventually to travel to At-
lantic City to work as a waitress and make money. Sheeler and
Schamberg promised to help her with a $10 contribution toward her
travel expenses. Yet when she arrived on the agreed upon Saturday
at their studio door on Chestnut Street, both men chastized her for
being late and for having left them waiting for a considerable time.
The argument escalated, with the Baroness "hysterical" for having
rushed to meet them and "outraged by continuous poverty that
forced [her] to beg." Offended, she refused to take the money but
later realized her mistake: "By their reproaches at my tardiness—I
was frenziedly out of breath—their true kindness was hidden from
me—and I departed in a haughty funk! Without the money. How
often since then have I repented of this—not only for the money's
sake—for—that was the last I ever saw of Morton Schamberg."⁷⁰
Schamberg would die of the Spanish influenza a year later, in Octo-
ber 1918, in the fierce postwar epidemic that swept through the
ranks of returning soldiers and civilians alike. In 1923, Elsa recalled
this episode for her friend Eleanor Fitzgerald and hoped that she
might still get the $10 from Sheeler, "that fine artist Schamberg
helping me from his grave."⁷¹ For now, however, she dropped her
plans for Atlantic City and settled more permanently in Greenwich
Village.

8.**5** Berenice Abbott, *Fourteenth Street Leading to the Hudson River.*
14 July 1937. Photograph. New York Public Library.

From around 1917 to at least 1919, the Baroness lived on Four-
teenth Street near the Hudson River (figure 8.5), the same street
that Djuna Barnes had lived on in 1915, Margaret Anderson and
Jane Heap earlier in 1917, and Duchamp many years later (his bed
unmade, the dust settling, when Beatrice Wood visited in 1944).
William Carlos Williams recalled visiting her in her living quarters,
"the most unspeakably filthy tenement in the city. Romantically,
mystically dirty, of grimy walls, dark, gaslit halls and narrow stairs, it
smelt of black waterclosets, one to a floor, with low gasflame always
burning and torn newspapers trodden in the wet. Waves of stench
thickened on each landing as one moved up."[72] Williams is unclear
as to whether there were two or three small dogs but recalled: "I saw
them at it on her dirty bed."[73] In the fragment of a play, "Caught in
Greenwich Village," the Baroness captures the atmosphere of her
living space by taking us on a tour through one day in the life of the
"high-strung Baroness":

Morning in hallway. / Starved lady studio neighbor / You may use hot
water— / *Illustrator youth neighbor:* / Thanks——I'm going to
shave—— / T. L. Stn. / How perfectly exciting!
Lunch Hour. / Conversation emanating from starved lady studio
door / *(Highpitched male voice)* / I'm that highstrung spiritual
Baroness——dear—soon's I'm through sousing Laura-dear's
dishes—tinkle I mellow ukulele [. . .]
Evening / (Jazz music—voices—penetrating from illustrator youth
door [. . .][74]

Shared washroom facilities in the morning to jazz at night, the
drama of ordinary activities in the tenement suggests her vivacious
perspective on life in the midst of poverty. As she dramatized the life

of Greenwich Village, her highly tuned sensors captured city life in poetic portraits.

Her poetry looks at New York City from underneath its eroticized sewers and subways, from the vantage point of its bowels. "Brooklyn Bridge—Glassy blackened waves of foam,"[75] she noted. Her "Tryst" with the Hudson River—"Smouldertint / Icefangled / Black / Unrest / Bloodshot / Beetling / Snorting / River—" similarly assumes an underworld dimension.[76] To Theodore Dreiser's electrically lit and Edna St. Vincent Millay's bohemian New York, the Baroness adds a vision of New York's grotesque body. Her most famous city poem, "Appalling Heart," is a hallucinatory love song to the modern city, which is both erotic and strangely foreign:

City stir—wind on eardrum—
dancewind: herbstained—
flowerstained—silken—rustling—
tripping—swishing—frolicking—
courtesing—careening—brushing—
flowing—lying down—bending—
teasing—kissing: treearms—grass—
limbs—lips.
City stir on eardrum—
In night lonely
peers— :
moon—riding!
pale—with beauty aghast—
too exalted to share!
in space blue—rides she away from mine chest—
illumined strangely—
appalling sister![77]

In contrast to the cubist city of her male colleagues, she celebrates New York as a feminine space of mischievous pagan witchcraft "illumined strangely." New York City is like her own body: lonely, pale, blue, and shining with "beauty aghast." She envisions the city as her "appalling sister" to which she proceeds to make love in a quick nonconsequential encounter. In fact, as if endowed with its own *Limbswish,* the city is "swishing" and "lashing with beauty" in a catalogue of erotically charged action verbs. Since her participles grammatically refuse to define the agent of activity, the real protagonist is the action itself, through which emerges the modern city/body of activity in ecstatic moments of doing and in fleeting sexual connection.

"Her poems sometimes sound like the utterances of a modern Delphic oracle," write Cynthia Palmer and Michael Horowitz in their book on women artists' drug experiences, using "Appalling Heart" to show "how marijuana opened up all her senses." The editors place her beside Mabel Dodge (who used peyote) and Mina Loy (who used cocaine).[78] "If there was ever a one-man or one-woman happening, it was the Baroness," wrote the American poet Kenneth Rexroth in a tantalizingly short snippet of a quotation: "She smoked marijuana in a big china German pipe that must have held half an ounce or more."[79] Since the Baroness was a heavy smoker, this raises the possibility that the Cassandra-like, raving style of her poetry was, in part, drug-induced or drug-enhanced. Village poets were radically reconfiguring poetic form: "It seemed daring to omit capitals at the head of each poetic line. Rhyme went by the board. We were, in short, 'rebels' and were so treated," recalled William Carlos Williams.[80] The Baroness did more than omit capitals. She slashed the English syntax with an unusual use of dashes and exclamation marks, her style rising out of heaps of fragments. Just as the creature in Mary Shelley's Gothic novel *Frankenstein* (1817) is assembled through dead body pieces, so the Baroness built her modern city creature

from dead pieces of language. Grammar and syntax are in ruins (it is difficult in several areas to find the appropriate grammatical referent to establish the logical relationships); words have lost their everyday meanings and have been conjoined to create hybrid neologisms. Consequently, these verbal portemanteaus and fragments are rhythmically joined by the movement and sound of the wind, the ragged verbal fragments and abrasive syntax resuscitated by vibrantly erotic pulsions. Just as Shelley's creature was jolted into life by electricity, so the city organism is stirred into life through sensual energy. The emerging body is a hybrid body, as illustrated in some of the neologisms, such as "treearms," a nature/human hybrid; or in the sequence of "Herbstained—flowerstained—/ shellscented—seafaring—/ foresthunting—junglewise," in which the city morphs into sensual nature.

Finally, in the context of this city poem, consider her sculpture *Cathedral* (ca. 1918) (figure 8.6, plate 10), the title referring to New York City's hallmark "commercial cathedral," the skyscrapers, which had become an international icon for New York's modernity. In 1913, the Woolworth Building had just been completed as the world's tallest skyscraper. "Look at the skyscrapers! Has Europe anything to show more beautiful than these?" Duchamp enthusiastically proclaimed to the hungry American news media on his arrival in New York.[81] The Baroness's *Cathedral* is made not of steel and glass, however, but of a piece of wood, a natural, organic substance, thus injecting the organic into New York City's modernity. *Cathedral*'s ragged and splintered edges contrast with the sleekness and sharply defined lines of Man Ray's wood slats and c-clamp assemblage (1917) that also evoke the skyscraper.[82] The Baroness's *Cathedral* is closer to Florine Stettheimer's *New York* (1918),[83] a view of lower Manhattan and the East River, with the Statue of Liberty's female body intriguingly made of putty, a natural substance used to fill holes in wood structures. The bodily effect is stunning: the statue is both aged and erotic, decomposed and

8.**6** Baroness Elsa von Freytag-Loringhoven, *Cathedral,* ca. 1918. Wood

fragment, approx. 4 in. high. Mark Kelman Collection, New York.

triumphantly youthful with her crown and torch lifted high—like the Baroness's Gothic city body—metaphorically stripped bare and revealing a strutting city of vibrant activity. Just as Liberty's body is a weathered work of art (originally a gift from Europe), so the Baroness proudly displayed her weathered and erotic body—and conceptualized New York City in the upright dignity and weathered stateliness of her *Cathedral*. Both precariously aging bodies tell the tale of braving the elements—a tale of quotidian survival.

The Little Review and Its Dada Fuse, 1918 to 1921

Chapter **9**

On Friday, 25 January 1918, the sun was setting. In her apartment on Fourteenth Street, the Baroness began work on her costume and makeup, carefully attaching to her eyes the feathers that she had been collecting from her own parrot (perhaps her friend Djuna Barnes, also a parrot owner, had provided additional feathers).[1] "Would like to see you at the DANCE OF THE FEATHERED FLOCK," the poster in *The Greenwich Village Quill* had beckoned in early January, inviting Villagers to Webster Hall, the dilapidated community hall on 119 East Eleventh Street.[2] The popular costume balls, or Pagan Routs, had been flourishing in New York's vice districts since the 1880s, and for the Baroness they were a reminder of Munich's carnival balls. Lavish competitions awarded prizes for the most extravagant costumes. Here the Baroness "came out on the stage" in her costume, as Louis Bouché recalled, and "wouldn't get off the stage until she was given a prize. This was before 1920 and she had the first false eyelashes ever heard of and these were bigger than the modern version. They were made of parrots feather."[3] As if ventriloquizing male homosexual codes, the Baroness had dressed herself in the feathery camp of the Village drag balls, where men could be seen "in a trailing cloud of feathers," as one observer recalled, enjoying the spectacle of "rival birds of paradise or peacocks. Great plumed head-dresses nod and undulate from their shapely heads."[4] Even if unintentionally, the Baroness's costume proclaimed the fact that in everyday life, her social position as androgynous woman was like that of the effeminate "fairy," in the sense that both made *visible* their sexual difference in a public space and were consequently exposed to hostility and ridicule.[5] Readers would probably agree that she deserved first prize.

The Baroness's body resonated with Village culture. While Broadway, Allen Street, Second Avenue, Fourteenth Street, and the Bowery spatially defined the age-old trade of prostitution, these streets were now becoming a forum for new sexual cultures and practices. Local writers quickly "learned to recognize the fairies

(as they were called) who congregated on many of the same streets," writes George Chauncey in *Gay New York*.[6] Charles Demuth had a studio in a building on the third-floor front of Washington Square South, and as William Carlos Williams recalled, he was in the thicket of sexual experimentation.[7] Lesbian love similarly spread its wings. The avant-garde editor Margaret Anderson used her feminine makeup and beauty as the New Woman's guerilla camouflage when she canvassed rich businessmen for financial support for her literary magazine, *The Little Review*. With her partner Jane Heap, she had set

9.1 *Jane Heap,* 1920s. Photograph. Elsa von Freytag-Loringhoven Papers. Special Collections, University of Maryland at College Park Libraries. Courtesy of Karen Clark.

up her offices on 24 West Sixteenth Street, later moving to 27 West Eighth Street, the latter a most auspicious office location with a funeral parlor and an exterminator's business in the same house. The couple dressed in yellow pyjamas and black velvet and had the walls of their living room painted black.[8]

From June 1918 on, the Baroness was the star of *The Little Review,* and with her, issues of gender and sexuality moved to center stage in the avant-garde journal. Here within the vibrant *Little Review* circle, the Baroness connected with gays and lesbians, including the poet Hart Crane, the Chicago pianist Allen Tanner, and the French singer Georgette Leblanc. But it was Jane Heap (1887–1964) (figure 9.1), who became the Baroness's kindred spirit and friend. An androgynous woman with short hair, brown eyes, and bright lipstick, Heap cross-dressed in male jackets, hats, and tight-legged working pants, frequently posing outdoors, laying a camp fire or doing other manly chores. As one warrior artist to another, the Baroness dedicated a poem to the "Fieldadmarshmiralshall jh" and sketched her portrait on an envelope along with quotations from Goethe's *Faust.*[9] If Heap was the field marshall for *The Little Review*'s vanguard battle against puritan conventions and traditional sexual aesthetics, then the Baroness was to become its fighting machine, the Achilles warrior who embodied the journal's visibly confrontational course.

Around April or May 1918 the Baroness first entered the offices of *The Little Review* to check on a poem she had submitted for publication under the pseudonym of Tara Osrik. Dressed in style, she greeted Heap, the event recorded by Anderson:

She saluted Jane with a detached How do you do, but spoke no further and began strolling about the room, examining the bookshelves. She wore a red Scotch plaid suit with a kilt hanging just below the knees, a bolero jacket with sleeves to the elbows and arms covered with a quantity of ten-cent-store bracelets—silver, gilt,

bronze, green and yellow. She wore high white spats with a band of decorative furniture braid around the top. Hanging from her bust were two tea-balls from which the nickel had worn away. On her head was a black velvet tam o'shanter with a feather and several spoons—long ice-cream-soda spoons. She had enormous earrings of tarnished silver and on her hands were many rings, on the little finger high peasant buttons filled with shot. Her hair was the color of a bay horse.[10]

Heap was struck by the costume and by the Baroness's aura of authority as she walked through the offices inspecting the bookshelves, "majestically," like someone who made laws rather than obeyed them. She pronounced *The Little Review* to be "the only magazine of art that is art."[11]

The editors launched the German Baroness in the June 1918 American number—a provocative move. *The Little Review* worked toward renewing America's culture through intellectual internationalization, as Heap explained: "This is called an American number not because its contributors are Americans (most of them are not), but because they are all at present living and working in America."[12] *The Little Review* was "*The Magazine That Is Read by Those Who Write the Others.*" Refusing to "divert, amuse, or conciliate," the journal was "*an attempt to break through the ingrained refusal of thought in America and to establish some sort of intellectual community between New York, London, and Paris.*"[13] The Americanization of the foreign Baroness attracted immediate attention, as one of the readers promptly asked about the Baroness (and Ben Hecht): "Who are these two people? I haven't attempted to look them up; but they don't seem like American names for an American issue."[14] Subsequent postwar issues from December 1918 to 1920 (the armistice was signed in November 1918) published the Baroness's elegiac postwar poetry, including "Mefk Maru Mustir Daas" (December 1918) and "Irrender König (an Leopold von

Freytag-Loringhoven)" (March 1920), after her husband's April 1919 suicide,[15] and the sound poem "Klink-Hratzvenga (Death-wail)," a mourning song in nonsense sounds that transcended national boundaries:

Narin—Tzarissamanili
(He is dead)
Ildrich mitzdonja—astatootch
Ninj—iffe kniek—
Ninj—iffe kniek!
Arr—karr—
Arrkarr—barr [. . .].[16]

The international vanguard was in mourning from fall 1918 on. Duchamp, for instance, while in Buenos Aires, received the heart-breaking news of the death of his brother Raymond. Morton Schamberg and Apollinaire were also dead.[17]

George Biddle, freshly returned from the war front, looked up the Baroness in New York only to find himself retrau-matized through the Baroness's sexually demanding body, as the painter recalled his visit to her loft apartment: "As I stood there, partly in admiration yet cold with horror, she stepped close to me so that I smelt her filthy body. An expression of cruelty, yet of fear, spread over her tortured face. She looked at me through blue-white crazy eyes. She said: 'You are afraid to let me kiss you.'" Biddle was "shaking all over when [he] left the dark stairway and came out on 14th Street."[18] Postwar heterosexual male artists were both attracted to and unsettled by her body, as in Ben Hecht's "The Yellow Goat," in which the male protagonist is sexually accosted by an unnamed Baroness-like woman: "Her lips were like the streaks of vermilion lacquer painted on an idol's face."[19] The vermilion lacquer, the painted body, the torturous face, the staring eyes, the dancing body, the bodily odor, and the haunting scenery of the story—all evoke

the Baroness in the flesh. The male protagonist flees in horror. For both Biddle and Hecht, this haunting vision of the Baroness was significantly the entry point into modern art. "She is a disease," as Hecht put it. "Her flesh is insane. She is the secret of ecstasy and of Gods and of all things that are beautiful."[20] For these artists, the beauty of modernity was carried to America through the body of the Baroness and had to take into account the ravages and odors of the European war.

By the spring of 1919, the Baroness, by now a well-known artist and personality among New York's avant-garde, was speeding along in a frenzy of productivity. "She wrote or painted all day and all night, produced art objects out of tin foil, bits of rubbage found in the streets, beads stolen from the ten-cent store," remembered Anderson. "She considered that she was at the summit of her art period."[21] During this time she met Berenice Abbott (1898–1991), a sculptor (generally a male profession), photographer, and lesbian. They met on the street, introduced by Charles Duncan, a graphic artist, painter, and poet. The young Abbott was taken with the Baroness's eccentric dress: this was the first woman to wear multicolored stockings and pants, as Abbott recalled: "I wouldn't have dared to dress this way. Everybody would have turned around on the subway to look at me. Elsa had a wonderful figure, very Gothic, boyish. She had a wonderful gait. I still see her before me walking up the street."[22]

The Baroness also met Hart Crane (1899–1932). Barely twenty years old and searching for direction for his sexual, artistic, and professional identities, the Ohio-born poet had moved to a room above *The Little Review* office. As the journal's advertising manager, he ensured that full-page advertisements for his father's Mary Garden Chocolate now regularly graced the journal.[23] Crane's intense preoccupation with the Baroness—her androgyny and sexual poetry no doubt a focus of attraction for the gay poet—was captured in Charles Brooks's *Hints to Pilgrims* (1921). Brooks, a New

Yorker who lived a few houses farther down on Eighth Street, parodies the "Poet" (Crane) who introduces him to the avant-garde literary journal "The Shriek" *(The Little Review)* and its most radical poet, "the Countess Sillivitch" (the Baroness). "You must read Sillivich. Amazing! Doesn't seem to mean anything at first. But then you get it in a flash. [. . .] there's a poem of hers in this number. She writes in italics when she wants you to yell it. And when she puts it in capitals, my God! [. . .] It's ripping stuff."[24] The poet enthused about the Countess's ultramodernity: "That's what the Countess thinks. We must destroy the past. Everything. Customs. Art. Government. We must be ready for the coming of the dawn."[25] On his way out the door, the astounded visitor meets the Countess: "She wore long ear-rings. Her skirt was looped high in scollops. She wore sandals—and painted stockings."[26] The anecdote ends here; nothing more can be said after beholding the Baroness "in the flesh." As for Crane, "roaring with laughter, [he] would pantomime in extravagant detail all the Baroness's gestures and imitate broadly her heavy, strong, insistent speech."[27] Even after Crane left *The Little Review* to go to Cleveland, he remembered to send the Baroness his father's Mary Garden Chocolates—although Anderson forgot to pass on the gift to the Baroness.[28] While reading Pound, Eliot, and Barnes, Crane was also reading and discussing the Baroness with his friend Harry Candee, who "knows her very well" and "had some surprising tales to tell."[29] Yet the young poet also noted, referring to her appearances in *The Little Review,* "The B[aroness] is a little strong for Cleveland."[30]

In his influential dada anthology, Robert Motherwell has written that dada activities ceased in New York with the entrance of the United States into the war,[31] a perspective repeated many times since. Yet it needs to be thoroughly revised once we shift our attention to the women's vanguard activities. Rather than declining, New York dada was about to swing into high gear. From the vantage point of their involvement with the Baroness,

The Little Review was more than simply sympathetic toward dada: the journal strategically deployed dada's incendiary techniques on its pages. "THE LITTLE REVIEW IS AN ADVANCING POINT TOWARD WHICH THE 'ADVANCE GUARD' IS ALWAYS ADVANCING," Heap proclaimed in capital letters in the Picabia number.[32] Indeed, the editors had an uncanny intuition for launching the best and most original in twentieth-century vanguard and modern poetry, fiction, and art: Djuna Barnes, Maxwell Bodenheim, Mary Butts, Hart Crane, Ernest Hemingway, Alfred Kreymborg, Mina Loy, Ezra Pound, William Carlos Williams, and William Butler Yeats; Constantin Brancusi, Charles Demuth, Henri Gaudier-Brzeska, Francis Picabia, Man Ray, and Joseph Stella.[33] Firmly believing in the Baroness's genius, they placed her alongside James Joyce, using

9.**2** *Ford Madox Ford, James Joyce, Ezra Pound, John Quinn* (from left to right), 1923. Photograph. Gernsheim Collection, Harry Ransom Humanities Research Center, The University of Texas at Austin.

the Baroness as a living figurehead for the journal's masthead motto: "MAKING NO COMPROMISE WITH THE PUBLIC TASTE." Of all the important avant-gardist contributors—including Joyce—the Baroness challenged the conventional taste more aggressively than others.

Consider briefly the story of *Ulysses*—Joyce's brilliant modernist novel of one ordinary day (16 June 1904) in the life of Leopold Bloom in Dublin—as it weaves in and out of the Baroness's story.[34] With the support of Ezra Pound and John Quinn (figure 9.2), serial publication of *Ulysses* began in March 1918 in *The Little Review* and quickly caught the eye of American censors. Explicitly sexual parts were suppressed by the U.S. Post Office, which refused to mail issues of the journal, including the January 1919 issue containing the book's "Lestrygonians" episode. The Joycean evocation of mature female sexuality was as provocative as it was timely, as American women were increasingly pushing for new rights and pleasures. By strategically intermingling elements of beauty and disgust, Joyce powerfully undermined traditional hierarchies between high and low, aesthetic and ugly, heroic and ordinary, dismantling the aesthetic binaries that have structured centuries of Western culture. Scholarly studies including Paul Vanderham's *James Joyce and Censorship: The Trials of "Ulysses"* (1998) have testified to the importance of *Ulysses* as a landmark in the constitution of literary modernism.[35] Between March 1918 and December 1920, *The Little Review* was held up by the U.S. Post Office on several occasions because of legal "obscenity" in the *Ulysses* episodes, before the final arrest of the two editors. Each suppression meant an enormous disruption, but the editors remained firm in their commitment not to yield to the forces of censorship.

The editors put the Baroness's genius on a par with that of James Joyce. Her presence in *The Little Review* (1918–21) overlaps with the period of the serializing of *Ulysses*. The Baroness was the magazine's catalyst, its "virulent compost," as the maga-

zine's foreign editor John Rodger put it. The editor couple hoped that the Baroness's feminist dada provocations would stimulate discussion and debate. The Baroness did not disappoint them. While the reader response to *Ulysses* was disappointingly tame and lame, the Baroness's brazen sexual poetry sparked intensive public attention. In "King Adam," in May 1919, her speaker provocatively invited her lover to perform oral sex—"Kiss me upon the gleaming hill ★"—while an outrageously taunting footnote explained that this line was "Donated to the censor."[36] This mocking of the censor was all the more audacious as oral sex featured as a "degenerate" act on the list of John Sumner's vice-squad agents.[37] In the poem, the sex act leads to the female's exuberant pleasure:

After thou hast squandered thine princely treasures into mine princely lap—there remains upon mine chest a golden crimson ball—weighing heavily—
Thine head
 KING ADAM—Mine Love.[38]

To this unfeminine sexual fare, she added blasphemy. "King Adam" modernizes and sexualizes the biblical creation story, while in "Moving-Picture and Prayer," the speaker's "God I pray Thee" turns into sexual fantasy: "Slippery it must be—I will glide—glide—WHERE TO— / A-H-H-H—WHERE TO?"[39] The "foreign" sexuality emerging in the Baroness's poetry and in the chapters of *Ulysses* irreverently moved beyond puritanical containment and claimed dangerous new freedoms of expression and conduct for women.

The issues censored and burned by the United States postmaster contained, along with the *Ulysses* chapters, the Baroness's hotly contested dada fare. Thus the May 1919 issue, which contained the Baroness's notorious gift to the censor, was declared

unmailable "not only because of the *Ulysses* ["Scylla and Charyb-dis"] episode it contained but because of the whole tone of the mag-azine," as the editors of *Pound / The Little Review* write.[40] Similarly, the suppressed January 1920 issue contained the poem "Buddha," a poem subversively dada in its religious provocation. Its refrain, "Gay God—scarlet balloon," described the brilliant afternoon sun but also echoed the sexual code images associated with urban gay cruising. In *Gay New York,* Chauncey has identified the color red as a code symbol for the "flaming faggots" cruising the streets, just like the Baroness's balloon-God is pleasurably traveling with his "eye on us—/ on *Himself! / Circle!*," perambulating the city in the late "after——/ noon—."[41]

In September 1919, "The Cast-Iron Lover" kindled the "art of madness" debate, which raged with warlike intensity, pitting feminist dadaists against modernists: "Are you hypnotized, or what, that you open the *Little Review* with such a retching assault upon Art ('The Cast-Iron Lover')?," wailed the New York critic Lola Ridge (1871–1941) in October, while a Chicago reader lamented: "How can you have had the honor of printing Yeats [and] open your pages to the work of the Baroness von Freytag-Loringhoven?" As always, Heap met the challenge head on: "Yeats was born an old master. Do you feel you 'understand' Yeats better than you do Elsa von Frey-tag," she wrote, launching into a programmatic defense: "We are not limiting ourselves to the seven arts. No one has yet done much about the Art of Madness. I should like to print these two side by side; it would make a neat antithesis of the *Giver* and the *Getter,* etc." In November, the New York poet Maxwell Bodenheim (1893–1954) put his weight behind the Baroness: "Never mind the delicate soul whose sanctimonious art is violated: their perfumed dresses need an airing on the nearest clothesline. They suffer from a hatred for nakedness, for anything that steams, boils, sweats and retches." While *Ulysses* had fallen flat in America, the debate about the

Baroness was key in negotiating the boundaries between dada and modernism.[42]

In December 1919, Tennessee-born poet and critic Evelyn Scott (1893–1963) targeted the Baroness's personality: "As 'jh' says, the psychology of the author referred to is that of a mad woman," she wrote and continued to describe "the callousness of emotional stupidity, that of the savage under the cataleptic influence of religious suggestion. It is only in a condition of disease or mania that one may enjoy an absolutely exalted state." She concluded: "Else von Freytag-Loringhoven is to me the naked oriental making solemn gestures of indecency in the sex dance of her religion." To which Heap sharply replied: "Madness is her chosen state of consciousness. It is this consciousness she works to produce Art," decisively refuting the notion that the Baroness's dada was simply the expression of madness.[43] Heap had grown up near the Topeka State Insane Asylum in Kansas, where her father worked, and her claim for an "art of madness" coincided with a burst of interest in psychoanalytic thought and public debates that linked the new vanguard art like futurism with insanity. Heap powerfully theorized the Baroness's aesthetic enterprise, making a claim for the sanity behind her art of madness, as she argued: "When a person has created a state of consciousness which is madness and adjusts (designs and executes) every form and aspect of her life to fit this state there is no disorder anywhere."[44] Heap's public repudiation was important not just for the Baroness, whose unstable mood swings, raging temper, and eccentric demeanor were public knowledge. By zooming in on the movement's most outrageous exponent, Heap ultimately repudiated a theory widely advocated in the scientific and popular media (including the *New York Medical Record* and the *New York Times*)— namely, that cubist and futurist painters were driven by insanity, a theory relegating the new art to the inhabitants of insane asylums. This debate, moreover, was pivotal in light of the increasing interest

among young American poets and writers in tapping the unconscious for the new modernist literature.[45]

Moreover, the heated "art of madness" debate coincided with the explosion of dada onto the Paris and Berlin scenes. In November and December 1919, Picabia and Breton joined forces in Paris, soon to form a formidable threesome with the Rumanian dadaist Tristan Tzara, who had arrived at Picabia's doorstep seeking exile. He was promptly invited to sleep on the divan of Picabia's mistress. Within weeks, the Paris apartment was converted into the new dada headquarters from which the Paris dadaists launched their provocations and battles.[46] (Coincidentally, in July 1920, Joyce arrived in Paris and was fast becoming an attraction for modernist literary tourists.) At the same time, dada had invaded the German capital. Berlin's First International Dada Fair (Erste Internationale Dada Messe) on 24 June to 5 August was organized by George Grosz and Raoul Hausmann. It was deeply political, with banners proclaiming, "Dada fights on the side of the revolutionary proletariat,"[47] a slogan that powerfully echoed the events of the communist revolution in Russia earlier in 1917.

Given dada's growing international momentum, there was reason for commonsense American modernists to fear that New York dada, in the dangerously female, flaming body of the Baroness, might indeed spread like a prairie fire. The Baroness and *The Little Review* editors had been fanning the flames of cultural insurrection for months, their dada warfare blitzing America's modern art world with its suspiciously foreign fusillade. When strategically given the last word in the art of madness debate in January 1920, the Baroness evoked the German Dionysian rituals as her model for art, thus not only defending emotionality in art but lashing out against Americans. "Everything emotional in America becomes a mere show and make-believe," she charged and continued: "Americans are trained to invest money, are said to take even desperate chances on that, yet *never* do they invest [in] beauty nor take desperate chances on that.

With money they try to buy beauty—after it has died—famishing—with grimace. Beauty is ever dead in America."[48] The truth behind these words was fueled by personal suffering, for she still lived in poverty in her filthy, smelly tenement. No art collector was interested in supporting her *living* art. Her originality was too much for America, which preferred an "empty show."

In January 1920 the climate in the United States was set on calming and restraining the mad fevers of decadent destruction associated with Europe. After all, the peace conference was underway in Versailles; prohibition legislation took effect with the implementation of the Nineteenth Amendment; noisy bars were rapidly closing their doors in New York; and the always careful Crowninshield fired Dorothy (Dot) Parker, the sardonic, hard-drinking, profanity-spewing, but brilliant poet and drama critic for *Vanity Fair*—all in the same month. The roaring twenties came in like the proverbial lamb, rather than the lion, the early twenties' spirit perhaps best encapsulated in Jean Cocteau's motto in *Vanity Fair:* "Genius, in Art, consists in knowing how far you may go too far."[49] For the Baroness, in contrast, there was no going too far.

The penultimate battle that thrust feminist dada against censorship forces was sparked in the summer. It was a war in which mainstream modernists strategically occupied the position of Greek chorus, watching the tragedy unfold without intervening. In the July–August issue had appeared Joyce's Nausicaa episode in which the protagonist Leopold Bloom fantasizes and reaches orgasm (presumably by masturbating), while he watches the young Gertie McDowell, as she "had to lean back more and more," facilitating Bloom's voyeurism at her "nainsook nickers." The ejaculation scene is related in stream-of-consciousness technique from Bloom's perspective ("And then a rocket sprang [. . .] and everyone cried O! O! and it gushed out of it a stream of rain gold hair threads [. . .] O so soft, sweet, soft!").[50] Given the metaphoric language, only the careful reader would be fully aware of the orgasmic experience, as

Edward de Grazia writes in his study of America's obscenity law and its assault on genius.[51] Indeed, given the chapter's abstruseness, the Baroness's prelude to "Nausicaa" gains crucial importance. For directly preceding Joyce's "Nausicaa" chapter was the Baroness's ironically titled "The Modest Woman," the title a response to Helen Bishop Dennis's essay that had attacked Joyce's immodesty in writing about toilet matters.

The Baroness's essay-poem worked like a spark plug, igniting the sexually charged Joyce chapter with its political fire. "Who wants to hide our joys (Joyce)?" the Baroness quipped. As a European artist-aristocrat, she mocked America's distanced relationship to its own body and sexuality: "America's comfort:—sanitation—outside machinery—has made American forget [its] own machinery—body!" Having turned its back on its body, America was a mere "Smart aleck—countrylout—in sunday attire—strutting!" Without any true traditions, America had embraced "steel machinery," resorting to a fetishized but dead ersatz body in the industrial machine age.[52] Americans who do not enjoy *Ulysses* can "put white cotton tufts" in their ears—"fitting decorations," she argued. She was in her element as hetaera-teacher, admonishing America to take its cultural lessons from James Joyce, the true modern "engineer." Dazzled with Joyce's "obscenities" and "blasphemies," she insisted on her own body's liberation: "Why should I—proud engineer—be ashamed of my machinery?" This sentiment would resonate with countless American women. In the same issue, John Rodker noted, "Else von Freytag-Loringhoven is the first Dadaiste in New York and [. . .] the *Little Review* has discovered her." He ended on a programmatic tone: "This movement should capture America like a prairie fire."[53] And indeed, her sexual fusillage had the potential to light up a feminist firestorm.

Against this gender-political backdrop, then, *The Little Review* editors found themselves arrested and charged with publishing obscenities on 4 October 1920, facing trial on 13 December.

The *Ulysses* battle ultimately was a gender campaign in which women, with the Baroness as their figurehead, claimed the authority over viewing and reading sexual subject matter—the first step in claiming control over their bodies. Many American women wished to control their sexual, political, and artistic expressions, as seen in the birth-control movement, suffrage marches, and censorship trials. (Indeed, the American suffrage battle was won, abortion was legalized in the USSR, even Joan of Arc was canonized by the Catholic Church—all in 1920.) While American obscenity laws were claiming to protect women from exploitative pornography, these laws had the more important paternalist function of keeping all aspects of female sexuality (birth control, abortion rights, sexual agency, female pleasure, sexual knowledge) within male control. This explains the apparent paradox that women were assaulting the very obscenity laws that were supposed to shield them.

That this censorship trial was about women's issues was made clear by Jane Heap in the September–December 1920 issue. Almost entirely devoted to the *Ulysses* trial, the issue opened with the Baroness's photograph as a frontispiece (figure 9.3). Heap had chosen this photo to accompany her opening essay, "Art and the Law," a landmark essay in literary censorship cases (a quotation from it even graces the title of Edward de Grazia's book on obscenity legislation in the United States, *Girls Lean Back Everywhere* [1992]). Heap's defense was feminist: "Girls lean back everywhere, showing lace and silk stockings; wear low cut sleeveless gowns, breathless bathing suits," she wrote, effectively debunking a legal system that used its own fiction of a "young American girl" to impose its patriarchal versions of order.[54] This argument gained political poignancy since it came from a cross-dressing lesbian and radical New Woman whose androgynous sexuality was dangerously visible, frequently arousing the hostility of homophobic men (including John Quinn). Heap paraded nonfeminine sexual agency as much as the Baroness.

The Baroness's photo, then, was brilliantly à propos. Looking austere, as if she were on trial, the Baroness exuded authoritativeness in confronting the patriarchal law, embodying her own artistic law. Her face was that of an older woman, pearls decorating her neck. She had arranged her name like a visual poem, extending the portrait vertically with letters that looked as if carved with a knife for eternity. The portrait was also adorned and visually extended at the top with a hand-drawn crown, symbolizing her titled status as Baroness, her position as a figurehead for *The Little Review*'s feminist dada, and the bars of the jail that threatened to silence the editors and Freytag-Loringhoven. In addition, the entire issue was filled with the Baroness's poetry, including some beautiful gems: "Appalling Heart," "Moonstone," "Heart," "Cathedral," "Is It,"

9.3 Man Ray, *Else Baroness von Freytag-Loringhoven*, 1920. Photograph in *The Little Review*, September-December 1920. © Estate of Man Ray/ADAGP (Paris)/SODRAC (Montreal) 2001.

"Gihirda's Dance," "Das Finstere Meer (an Vater)," and "Blast," where "blast flew [. . .] flew—blew," alluding to Percy Wyndham Lewis's *Blast* magazine (1914–15).[55]

The gender blast of this issue is further reinforced with the photo of another sexually unconventional woman, Mina Loy, whose mischievously sensual looks and poetry presented further evidence that the court's "young American girl" was a patriarchal myth. Already in November 1915, Loy had published her infamous poetic love song in *Others,* her New Woman sexuality awakening the Village with highly sexed jolts: "Spawn of Fantasies / Silting the appraisable / Pig Cupid his rosy snout / Rooting erotic garbage[.]"[56] Along with other supporters like Mary Garden, the stylish Loy had appeared in the courtroom to cheer the accused editors in their fight for freedom of speech in America. "We looked *too* wholesome in Court representing filthy literature," as Loy recalled.[57] An intellectual poet and critic, Loy was unafraid to engage in unfeminine public debates with male critics. (Incidentally, in this same issue, her debate with John Rodker regarding the status of modern art made references to the "Cast-Iron Lover," Rodker impersonating the unfortunate frog-toad from the Baroness's poem.)[58]

In a highly charged gender battle, *Ulysses* was sacrificed in the conspiracy of silence that had descended on American modernists (including Pound and Williams), who felt profoundly threatened by *The Little Review's* feminist dada and felt that the magazine had gone too far in championing the Baroness (see also chapter 10). "Throughout the trial, not one New York newspaper came to the women's defense, or to the defense of James Joyce. No one wished to be identified with the 'Ulysses' scandal," noted Janet Flanner.[59] The editor of *Poetry: A Magazine of Verse,* Harriet Monroe, was the only person of stature who sent "a word of cheer for your courage in the fight against the Society for the Prevention of Vice," in a letter published under the heading "Sumner Versus James Joyce" in *The Little Review's* discussion section.[60] Meanwhile, the male avant-

garde had retreated behind a wall of silence, leaving the public fight to the women and to their designated lawyer, John Quinn, who was weakened by bouts of cancer and by his own ambivalence about his clients. When Pound finally spoke up in *The Little Review* in a piece entitled "Apropos Art and Its Trials Legal and Spiritual," he used the pseudonym of Emmy V. Sanders, hiding behind female skirts, the word *Ulysses* conspicuously absent in his belated critique of the "Cultured Philistine." On 22 April 1921, a safe two months after the end of the trial, Pound promised help to Anderson: "Will also try to place my say about the trial in the N.Y. Post, when I have next occasion to speak of 'Ulysses,'" only to rescind his support in his next letter: "I think we shd. say nothing of the trial [. . .]. In any case a 'reply' to Judge Juggins is out of the question, one can't argue with a barn yard." While his 21 April letter tried to cheer up Margaret with a dig at "The Eunited, Eunuchated States of America," he remained in the proverbial closet with his public criticism. Indeed, the top of this supportive letter to Anderson contained the instruction "Private = i.e. you can read it to yr. friends but its not for print."[61]

As mainstream modernists saw it, the Baroness was a dangerous gender fuse that, once contained, allowed the boundaries between "sanity" and "insanity" in modern art to be firmly established. The suppression of *Ulysses* was the price male modernists were willing to pay for containing the dangerously feminist dada that had been invading the Village in the body of the Baroness. While the Baroness had aggressively promoted *Ulysses*, baited the prosecutor with her sexual poetry, and was in and out of the Tombs, her name was conspicuously absent when charges were brought against the two editors and the Washington Square Bookstore for serializing and distributing the novel. The male judges (and lawyer) had carefully prevented a public court of law from being ab/used as a dada forum for mocking America. With the Baroness as the star in the courtroom, dada might indeed have produced a worthy spectacle and kindled the prairie fire. The women's anticlimactic defeat

looked like a gentleman's agreement (Quinn even had dinner with Sumner) and achieved what Margaret Sanger's earlier court confrontation and imprisonment could not: it broke the women's feminist élan. Indeed, when the conservative *New York Times* applauded the final verdict in a brief report, the reporter signaled relief that no "martyrs" or "pseudomartyrs" had been created. Conservative America had learned its lesson from earlier cases against Emma Goldman and Sanger, which had made national headlines and had strengthened (rather than broken) the women's subversive élan. In a feminist study of the *Ulysses* case, Holly Baggett has argued that the trial was ultimately an "attempt to silence the 'New Woman' of the twenties."[62] Indeed, when we follow the events from Freytag-Loringhoven's angle, Quinn's profound ambivalence and contradictory maneuvring became blatant when he used some of the Baroness's arguments and words from "The Modest Woman," thus bringing the charged fuse into the courtroom to defuse it but in the process also undermining his defense.[63]

The loss of the *Ulysses* battle in February 1921 signaled the defeat of feminist dada in New York and thus ended the Baroness's highly profiled career as an "American" poet in *The Little Review.* The journal's motto—"Making No Compromise with the Public Taste"—was now gone from the masthead, and it would stay off. Still under shock from the effects of the trial, the journal carefully avoided controversy and became more self-censoring from 1922 on, ironically at the same time that the magazine itself had been vindicated by the Paris publication of *Ulysses* on 2 February 1922, Joyce's fortieth birthday. Heap proudly announced the event, taking the opportunity to chastize the lame critics ("Ulysses ran serially in the *Little Review* for three years . . . scarcely a peep from the now swooning critics except to mock it"), also adding with the afterglow of satisfaction that "[a] single copy has already brought more than $500."[64] Again, it was a daring woman, Sylvia Beach, who rescued *Ulysses.* After Boni & Liveright declined *Ulysses* because of the court

conviction, the expatriate American owner of the Shakespeare and Company bookshop accepted the novel for publication in Paris. Joyce gave Djuna Barnes the annotated original of the work, which she later sold, probably to help the Baroness, as Barnes's biographer Andrew Field writes. This help was ironically befitting, given that the Baroness, too, was a victim of the *Ulysses* defeat.[65]

At the same time, deep fissures were emerging on the feminist front. Relations between the Baroness and *The Little Review* editors were not without friction. When Anderson sympathized too emphatically with Joyce's poverty—"James Joyce is in Paris—*starving!*"—the Baroness reacted with acute pangs of jealousy, recalling this scene for Barnes: "There—I was standing—*in New York*—in *her room*—she printing my things—[exuding] cologne—having antique furniture—when *I* lived in a filthy tenement—starving in fighting wolf bravely with 'posing'—and—*I* had *not* the presence—of mind (for: I lack that—in human intercourse) to respond: 'and *what do I*— *in New York?*'"[66] Increasingly critical, she turned against the feminine Anderson, accusing her of being a "vacuous fake."

From Anderson's perspective things looked different. The Baroness, she wrote, "would adhere abstractly, to any subject for three days without exhausting it. When *we* were exhausted— having other things to do, such as publishing a magazine—she would revenge herself against our locked doors by strewing tin cans down the stairs, hurling terrible and gutteral curses over her shoulder for three flights."[67] The Baroness's manic volubility is recorded in her letters to *The Little Review* editors, as when she requested them to print her piece "To People—Not to People" (a work probably no longer extant). "[I]t is *long,*" she conceded when submitting the piece, but she refused to have it shortened or published in serial form, seriously requesting that an entire issue be devoted to her work: "[It] can not be brought [out] in two parts—it is *important enough*—should it take *all* of the magazine—it is *beautiful*!!!"[68] Only the megalomaniacal Ezra Pound could rival such egocentric

grandiosity that remained blissfully blind to the necessities of editorial compromise. From the beginning of her publication career, the Baroness was a difficult prima donna who refused to undergo any kind of editing, stubbornly refusing to accept Anderson's careful editorial work on "Hamlet of Wedding Ring" (see chapter 10). For Anderson, the Baroness's inflexibility was an important point of friction and disappointment.

Amid these tussles surrounding her publications, the Baroness continued to perform herself, always compensating her viewers with spectacular shows. In the spring of 1920, Charles Henry discussed the Independent Exhibition for *The Little Review* and zoomed in on the Baroness:

I saw Else Baroness von Freytag. She was quite gas-greenly eminent. Her idea was admirable, but the form which she used expressing it was too Russian ballet. [. . .] I wish,—and how wonderful,—that she could dress herself in Mr. Wriggley's Broadway sign or the Brooklyn Bridge, using, in either experiment, all the flags of all the countries of Europe and Asia (the old ones and those just being made) as a headdress. A most difficult medium; the creating of a legend; Sa[p]pho, Elizabeth, Mme. De Récamier, Mary B. Eddy. Let us wish Else Baroness von Freytag the best of luck.[69]

She had become a legend, as this mock review recognized. With her performance art, she stood out even among the likes of Duchamp, Man Ray, Sheeler, Stella, Bouché, Duncan, Dixon, and Covert, who were all visiting the exhibition. Worthy of parody, she now even received fan mail, including this letter from A. Reverdy—otherwise unknown to me: "My dear Miss Freyag, I would like to hear from you. I tried to locate you for a long time, but didn't know your address. I happened to see your photo and address in the paper, so I thought I would write to you. Yours, A. Reverdy. 31 W 25 St. N.Y.C."[70]

In January 1921, Margaret Anderson organized Marguerite D'Alvarez's benefit concert in the Provincetown Theater. The Baroness "had been impressively invited," even though she only rarely listened to music. As always she was late, having worked on her costume. She made her entrance at the reception at Christine's, with a sudden hush falling on the audience:

She wore a trailing blue-green dress and a peacock fan. One side of her face was decorated with a canceled postage stamp (two-cent American, pink). Her lips were painted black, her face powder was yellow. She wore the top of a coal scuttle for a hat, strapped on under her chin like a helmet. Two mustard spoons at the side gave the effect of feathers.[71]

The striking yellow and black of her make-up evoked *The Little Review* offices (black walls and yellow pyjamas), paying tribute to the two editors who had launched her career. The two-cent American stamp alluded to their common fight against the American postmaster. The helmet alluded to her warrior battles, the coal scuttle to the hard labor to support herself. The mustard spoon spoke of the spice provided by her art. And her *pièce de résistance,* the trailing blue-green dress and peacock fan, evoked the flamboyant drag queen, as the Baroness and the journal crossed gender and sexual boundaries with abandon. Her costume was a tribute to herself and also to the editors at a time when they needed cheering up. Having thus upstaged the baffled soprano, the Baroness spent the rest of the party explaining "the beauty of her costume."[72] The Baroness was the real prima donna—proudly strutting as *The Little Review*'s dada queen. She was the queen of gender play who was about to tackle the "case of the American male."

**The Poetic Feud of William Carlos Williams,
Ezra Pound, and the Baroness**

Chapter **10**

A practicing obstetrician and pediatrician in Rutherford, New Jersey, the young William Carlos Williams (1883–1963) (figure 10.1) ardently devoted his free time to writing poetry. Whenever possible, he left Rutherford to visit the Arensbergs' New York salon and breathe the dizzying oxygen of artistic experimentation. In the Greenwich Village apartment of Margaret Anderson and Jane Heap, he took a timid peek at the "great bed hanging from four chains from the ceiling."[1] He proudly acted in the role of lover for the Provincetown Players and indulged in "fruitless" flirtations with costar Mina Loy. At the same time, the husky, philandering doctor from Rutherford was also touchy, easily revealing his insecurities when venturing into contact with the cosmopolitan—and foreign—Manhattan crowd. Duchamp and Gertrude Stein allegedly slighted Williams in arrogant fashion.[2] His lifelong feud with his

10.**1** *William Carlos Williams,* 1920s. Photograph. Beinecke Rare Book and Manuscript Library, Yale Collection of American Literature.

Philadelphia student buddy Ezra Pound is testimony to his suspicion of internationalism. Yet it was his contact with the Baroness that dramatically exposed an important forcefield of Euro-American tensions. In the annals of literary modernism, theirs must count as the only dispute of poets that escalated into a cross-gendered boxing match pitting Williams against the Baroness, modernism against dadaism.

In May 1919, just a month after having met the Baroness,[3] Williams used the pages of *The Little Review* to denounce by name the nation's cultural traitors, the exiled American poets T. S. Eliot and Ezra Pound. "E. P. is the best enemy United States verse has," Williams quipped in the prologue to his "Improvisations,"[4] a serial publication already eagerly read by the Baroness in *The Little Review*. Williams berated Pound's internationalism—that is, Pound's insistence that America's cultural renewal required a European stimulus. From Italy, London, and Paris, the red-bearded bard in exile was bombarding Americans with inflammatory invectives about the sad state of American culture:

To John Quinn in February 1918: "'WHERE T' 'ELL ARE THE AMURRIKUN KONTributors. i.e. literary contributors???????" To Marianne Moore in December 1918: "Do you see any signs of mental life about you in New York?"[5]

In contrast to Pound, Williams insisted on a homegrown version of American poetry and culture that emanated from his "intense feeling of Americanism."[6] Williams found his comrade-in-arms in Robert McAlmon (1896–1956), a westerner who instigated the idea of a new journal and who would later become an important publisher in Paris. A "coldly intense young man, with hard blue eyes," he was also the Baroness's double in sexual unconventionality: bisexual, with a slim androgynous figure, he made a living posing in the nude for mixed classes at the Cooper Union.[7] The two men launched *Contact* in December 1920 with a clear ideological depar-

ture from *The Little Review,* featuring work that made "the essential contact between words and the locality that breeds them." The two editors sought American cultural renewal in the local condition in clear opposition to the internationalists—Pound, *The Little Review,* and the Baroness.[8] These ideological differences, then, formed the backdrop for the Euro-American love affair gone wrong that would soon pit Williams against the Baroness.

In April 1919, Williams had first been attracted to the Baroness's artwork in Anderson and Heap's apartment, displayed "under a glass bell, a piece of sculpture that appeared to be chicken guts, possibly imitated in wax."[9] The editors eagerly played matchmakers. The Baroness was in the Tombs for stealing an umbrella, and on the day of her release Williams appeared like a gentleman caller at the Women's House of Detention to pick her up in style. Over breakfast on Sixth Avenue near Eighth Street, there was an immediate communion between the two poets, as she talked and he listened. No doubt she was attracted to his huskiness, his faunlike ears, and his lust for poetry. Always the womanizer ("you are shameless, bold with females," as the Baroness put it),[10] he made an impromptu love declaration. Later he claimed that it was because she reminded him of his feisty grandmother, who served as muse in several of his poems. (In his first work, *Al Que Quiere!* [1917], he had raised his grandmother "to heroic proportions," endowing her with "magic qualities.")[11] The Baroness, only nine years older than Williams, however, felt too young and too full of burning desire to regard the strapping "Carlos" merely in a grandmotherly fashion. She was the hetaera-teacher, determined to use her own erotically charged body to teach him the lessons of modernity.

She insisted on sealing their union with a kiss. The doctor went along but was alarmed by "the jagged edge of La Baronne's broken incisor pressing hard on his lip." His portrayal was none too flattering: "Close up, a reek stood out purple from her body."[12] Then came her turn to be critical of his bourgeois perspective when

he invited her for a visit to Rutherford: "The Baroness looked at the house I lived in and said in looking also at the sign on the street corner, Ridge Rd.—Ah, Rich Road. It was meant as cutting rebuff to my pretensions."[13] Perhaps he was trying to make amends for having disappointed her sexually, or perhaps he was trying to appease her for his inability to shed his middle-class roots and join her unconditional vanguard fight for art: one day he left a basket of ripe peaches in front of her door as a gift—an offering that backfired like the fabled gift horse at Troy. She saw the ripe peaches as an incontrovertible token of his desire for her mature charms, young America lusting for the lessons of old Europe.

While Williams persisted in his Prufrockian position ("Do I dare to eat a peach?"), her seduction turned grotesque, as she apparently suggested that he needed to "contract syphilis from her to free [his] mind for serious art."[14] There is no medical evidence, however, that supports that at this time the Baroness was ill or infectious with the disease for which she had been treated in 1896 (and which appeared to be in remission for the remainder of her life). Indeed, Berenice Abbott—when asked specifically about the rumors of the Baroness's syphilis—denied that her friend was sick, insisting that she looked healthy and vibrant.[15] The Baroness's intent was to shock the obstetrician, perhaps by grotesquely ventriloquizing her father, who had infected her mother. And even though shocked by the alleged proposition, Williams poetically evoked syphilis as a beautifully exotic flower in *Kora in Hell* (1920), writing that "Syphilis covers the body with salmon-red petals."[16]

The Baroness now actively solicited the female solidarity of *The Little Review* editors ("I will get this man," she told them), in what was fast becoming a theatrical campaign of gigantic proportions designed to publicly expose the case of the American male. "All emotional real strong things look strange here," she wrote to the editors and included the fifteen-page love letter she had composed for Williams because "it *tells*—the strange thing between this man

and myself," a strangeness she explained culturally, as the clash of America and Europe.[17] She conceived of her love letter to Williams as a public document: "First I have to read it to you—*then* it has to be typed—*then* my picture taken."[18] Although her love letter was never published, it is extant, as it was filed for posterity by the editors. In it, she details her childhood and courts "Carlos" as both artist and lover:

Why are you so small—Carlos Williams? Why do you not *trust me*—to *help you?* [. . .] You love and hate me. *You desire me.* In truth: you envy me! I envied my second husband that way—until I had him. He was brilliant. One can destroy that envy only through love. It is sex desire. [. . .] Passion is humbleness—desire for self-destruction—to die for beauty—to sacrifice all—for God's sake! That is in *truth*—what sex intercourse *is!*[19]

The love letter had the opposite effect. The poet panicked. The Baroness (he now called her "That damned woman") was threatening to appear at the doctor's hospital and show *his* "love letters" (apparently there were two) if he did not sleep with her.[20]

One night at around supper time, the Baroness lured the doctor out of his house under the pretense of a sudden maternity case. His emergency bag under his arm, he was getting into his car when she grabbed his arm from behind. The quickly escalating situation ended with the Baroness hitting the doctor on the neck, "with all her strength," as he insisted.[21] Eager to prove that the problem was the Baroness's, Williams listed all the men who were afraid of her. The American poet and insurance executive Wallace Stevens (1879–1955), who lived in Hartford, Connecticut, had admired her artistic dress and timidly told her so—but feared her pursuit and "was afraid to go below 14th Street for several years whenever he came to the city."[22] Similarly, the Lithuanian American sculptor William Zorach (1887–1966) found the Baroness "crawl out naked

under his bed" one night, refusing to return home until he accompanied her.[23] Only the most potent rationale could justify the doctor's next move. He bought himself a punching bag and began to practice. When he next met her on Park Avenue, he "flattened her with a stiff punch in the mouth. I thought she was going to stick a knife in me. I had her arrested, she shouting, 'What are you in this town, Napoleon?'"[24]

Opinions on the doctor's act were divided along gender lines. Abbott said he lacked character. Anderson, too, was critical: "He might have stopped it by treating her like a human being (as Marcel Duchamp did) and convincing her that it was no use. Instead he acted like a small boy and wrote her insulting letters in which his panic was all too visible."[25] Soliciting male solidarity, Williams turned to Robert McAlmon and the New York author Matthew Josephson (1899–1978), confessing his personal troubles on a Sunday afternoon walk in January 1921. "'Ah, don't let that old dame worry you," said McAlmon (who was about to become the shadow husband of the British lesbian poet Winifred Ellerman, better known as Bryher). "She likes to think of herself as a rampant adventuring conquering superwoman. Take her as a joke." Bemused by Williams's panic, McAlmon used the anecdote in *Post-Adolescence* (1923), an ironic account that is not entirely flattering to the doctor.[26] As for the Baroness, said Anderson, she never forgave Williams for not listening to her: "He was a coward. He was ignoble. He didn't know what she might have made of him. He might have become a great man. Now he would have to live and die without learning anything."[27]

As always, the controversy fueled her art. Her "Graveyard" poem (1921) (figure 10.2), sent to *The Little Review,* depicted a nest of male genitals entombed in a graveyard, a dada epitaph to her failed heterosexual love affairs that condemned her to the abstinence of "a nun." She mock-poetically identified the castrated genitals as those of Duchamp ("When I was / Young—foolish— / I

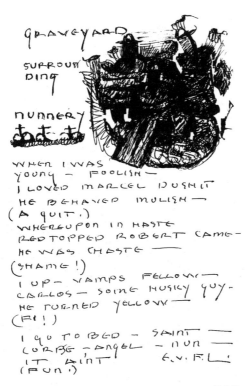

10.**2** Elsa von Freytag-Loringhoven, "Graveyard Surrounding Nunnery,"
1921. Manuscript poem. Papers of *The Little Review*, University Archives,
Golda Meir Library, University of Wisconsin-Milwaukee.

loved Marcel Dushit"); Robert Logan ("Whereupon in haste /
Redtopped Robert came"); and Williams ("Carlos—some husky
guy— / He turned yellow— / (Fi!)").[28] For the Baroness, Williams
was the American everyman, like Biddle, "too hampered by con-
vention" to venture into a "love affair with such crazy—gifted—
amusing—yet glaringly unconventional woman." The American
man and artist "wants some sister—mother love—mixed into pure
passion—all a little by the way—nothing to be used conveniently in
domestic fashion." As artist and lover, the American male and artist

would ultimately obey middle-class conventions: "you go that trodden path." That, she concluded, "is [the] secret of my failure [with American men]."[29]

With even more stunning panache the Baroness now marked her failed love affair with a dada act performed on her own body. In 1921 she shaved off her hair and later lacquered her scalp vermilion, flaunting her baldness in the city and proclaiming: "Shaving one's head is like having a new love experience."[30] This picture of the bald-headed Manhattan dada queen was burnt into the collective memory of modernists, who cited the act more frequently than any other of the Baroness's performances. She dramatically desexed herself, like the nun who cuts off her hair on entering the convent. Francis M. Naumann has noted that shaving the head and applying iodine (which turned the skin purple) was a common treatment for an infectious condition, ringworm.[31] Indeed, on a woman's body, baldness generally signifies disease and is shamefully hidden under wigs and scarves. Openly displayed baldness, in contrast, belongs to the male bodily territory, as the symbol of aging and loss of potency. Possibly the Baroness was alluding to the first signs of menopause at age forty-seven, as she was now implicitly charging men with being incapable of satisfying the aging woman's claim to eroticism. By no means defeated, she turned her body into sleek androgynous armor, further heightening her sexual ambivalence and claiming herself as mature woman *and* erotic being in the offices of *The Little Review.* The spatial metaphor was appropriate, for she would soon shift her attentions to homoerotic relations (see chapter 13). She resolved: "I ain't going no more to fall in love with no man that don't love me none. Resolution final by me."[32]

In March 1921, Williams must have felt an electric jolt as he opened his latest copy of *The Little Review.* There was the Baroness's "Thee I Call 'Hamlet of Wedding Ring,'" part one of an eleven-page brilliantly experimental prose poem reviewing Williams's *Kora in Hell* (a slim, personal text published in 1920 by the

Boston Four Seas Company with a dedication to his wife, Flossie).
Along with reviewing the poet's sexual and artistic politics, the
Baroness targeted his infatuation with the "Factory girl America" in
a parody Whitmanesque catalogue of images and attributes that
constitute "America's soul." Presenting America as a "helpless giant
on infant's feet—knuckles for brains—altogether freak" and with
"vulgar features,"[33] she asked, "where shall wisdom [. . .] come
from in America—destroyer of values—creator never— / unless in
sense negative." Published in the same issue that announced the de-
feat of *Ulysses,* this charge gained poignancy through its context. "I
feel W. C.s stagnation," she wrote, as she subjected Williams's name
to dada's water closet toilet humor. By appropriating the *Kora*
metaphor of the poet's descent into hell, she turned "W. C." into
Dante's Satan, a figure paralyzed at the bottom of the inferno, con-
tained and merely ridiculous: "shackled to cowardice of immobil-
ity—American mistake of dense vulgar brains rendering W. C.'s legs
immovable—agonized arms out—thrust—vile curse of helpless rage
on sneering lip distorted—doomed to torture— [. . .]."[34]

Personal invective—"Carlos Williams—you wobbly-
legged business satchel-carrying little louse"[35]—turned into power-
ful cultural critique, in which syntactical breaks and hyperbolic
rhetoric enact her point that art equals a state of ecstatic intoxication
of which Williams was not capable. Thus the American poet's drink
is not the Dionysian wine but "sour-apple-cider plus artificial
bubble—chemical spunk."[36] "In this regard, her frontal assault cor-
roborates and highlights the psychological and aesthetic miasma in
which Williams felt himself engulfed as he wrote *Kora,*" writes the
American scholar Dickran Tashjian, the first critic to acknowledge
the intellectual depth of "Hamlet of Wedding Ring": she "manages
to transcend the personal so as to offer a statement about the cultural
obstacles confronting the creative person in America."[37] Against the
backdrop of *Ulysses*'s fate, the European dada Baroness poetically
performed herself as a Nemesis figure, of old Europe coming back

to haunt the young American poet who had rejected Europe's sexual and intellectual charms and now "[g]azes into chasm of knowledge—void—frightened—dizzy—lacking architecture."[38] As Rudolf Kuenzli notes: "The Baroness's review of Williams's *Kora in Hell* was arguably the most outrageous item *The Little Review* published in all its years of existence. Never had a male writer been so excoriated by a female critic."[39]

Williams read "Hamlet of Wedding Ring" as a challenge to open warfare with Elsa/Europe. Like his earlier boxing match, his retaliation was swift and in kind. Published in *Contact* in the summer of 1921, Williams's "Sample Prose Piece" was a portrait of the European *baronne,* the antagonist for the self-stylized American poet, the thirty-five-year-old Evan Dionysius Evans (William Carlos Williams). His boyhood fantasy of America is the figure of a "virginal young woman [. . .] gleaming and naked," yet meeting *la baronne,* he is quickly seduced by the mature woman's charms: "She was the fulfilment of a wish. Even the queen she held herself to be in her religious fervors of soul, so in actuality she was to him: America personified in the filth of its own imagination." This was a dig at *The Little Review*'s systematic "Americanization" of Freytag-Loringhoven's "filthy" poetry, published alongside the "filth" of *Ulysses,* and its promotion of America's filthy cultural imagination to which Evans still confesses to be strangely attracted. Yet the American Dionysius also expresses his irritation about being sexually harassed by a shameless Elsa/Europe, for "naked as the all-holy sun himself, she mocked the dull Americans." "What in God's name *does* Europe want of America," he ponders by the story's end, before violently rejecting old Europe: "You damned stinking old woman," Williams wrote, "you dirty old bitch," as his protagonist turns to embrace the young "American hussey." [40]

While misogyny erupted in his rejection of contact with Europe—just as anti-Semitic stereotypes had erupted in hers when she called him "atavistically handicapped by Jewish family tradi-

tion"[41]—the violence of Williams's rhetoric also exposed his continued underlying attraction for what he purported to scorn: dada and the Baroness. Even many years later, the doctor's judgment remained ambivalent. The Baroness was "like Cortez coming to Montezuma." Her goal: "Destroy. They imagine somehow that clarity and delight are to be gained by shedding the blood of someone." But he also paid this unequivocal tribute: "The Baroness to me was a great field of cultured bounty in spite of her psychosis, her insanity. She was right. She was courageous to an insane degree. I found myself drinking pure water from her spirit."[42]

Having observed this feud between Europe and America from the sidelines, Ezra Pound could not resist the temptation to intervene. On 31 May 1921, he included two dada nonsense poems in a letter to Anderson, both published as companion pieces to the second installment of the Baroness's "Hamlet of Wedding Ring." Under his pseudonym Abel Sanders, Pound rejoiced in weaving the illicit love affair between the female dadaist and the male modernist, a dada coupling that Williams was working hard to avoid:

THE POEMS OF ABEL SANDERS

To Bill Williams and Else von Johann Wolfgang Loringhoven y Fulano
Codsway bugwash
Bill's way backwash
FreytagElse 3/4 arf an'arf
Billy Sunday one harf Kaiser Bill one harf
Elseharf Suntag, Billsharf Freitag
Brot wit thranen, con plaisir ou con patate pomodoro

Bill dago resisting U.SAgo, Else ditto on the verb
basis yunker, plus Kaiser bill reading to goddarnd stupid wife
anbrats works of simple
domestic piety in Bleibtreu coner of Hockhoff's besitzendeecke

before the bottom fell out. Plus a little boiled Neitzsch
on the sabath. [. . .]⁴³

Pound obviously rejoiced in Freytag-Loringhoven's challenge of
"Kaiser bill." Playing the role of literary politician, Pound implicitly
argued (as far as argument is possible in a dada poem) for a truce, de-
flating the debate by turning it into parody and reminding both po-
ets that dada is, after all, playful, nonsensical, and silly. The poem also
presents a misogynist dig at Williams, who reads his poetry to "god-
darnd stupid wife," while "Bill dago" is a slur against Williams's im-
migrant roots.⁴⁴

Pound was profoundly attracted to and baffled by the
Baroness and dada. Dada iconoclasms would eventually find their
way into *The Cantos,* as the literary scholar Richard Sieburth has
documented. What has been overlooked, perhaps, is Pound's care-
ful reading of *The Little Review* and his parody of the Baroness's orig-
inal style, both of which indicate that he was deeply aware of her
poetic experimentations and strategies. In his poem, he repeated the
term "backwash" in the Baroness's "Revenge: backwash," parodi-
cally transformed her "Not God's way" and "God's way long ser-
vice" into "Codsway" to recall the old phrase about "A lot of cod
about a dead God."⁴⁵ He also mimicked her linguistic inversions of
English syntax in "FreytagElse," her language switching in "Hock-
hoff's besitzendeecke before the bottom fell out," and her references
to German culture in "Else von Johann Wolfgang" (Johann Wolf-
gang von Goethe), the male names further alluding to her androgy-
nous demeanor. Thus the dada inflections in *The Cantos* may well
have their roots in his reading of the Baroness's materials.

Pound's second dada poem—consisting of nonsense ty-
pographs and these lines turned on the side: "dada / deada / what is
deader / than dada"—both revealed and poked fun at his grow-
ing admiration for dada.⁴⁶ During the first three months of 1921, in
St. Raphael on the French Riviera, Pound was giving himself "a

crash course in dada," as Sieburth reports.[47] Already in 1920, Pound had suggested to Anderson that she make Francis Picabia *The Little Review*'s new foreign editor, thus pushing for a public institutionalizing of dada in the journal but also returning dada into male hands. Indeed, since Picabia had begun to criticize dada's self-destructive tendencies in Paris in May 1921, he was, perhaps, the perfect candidate for containing the wild female dada in New York. "In taking Picabia, I do NOT suggest that you take Dadaism and all '*les petits dadas,*'" Pound instructed Anderson in a 22 April 1921 letter.[48] Thus despite his covert homage to the Baroness, Pound gave Anderson a stern warning that "*no* idiots" should be included in the upcoming Dada number—no doubt a reference to the dada Baroness, who was being replaced by the more moderate dada figurehead: Picabia, whose name would soon grace *The Little Review* masthead.[49] Another victim of Pound's cleansing broom was the postwar novel *Ashe of Rings* by the British writer Mary Butts (1892–1937), which Pound thought too risky.[50] Butts was furious when her novel was dropped in the fall of 1921 after just a few installments. In the wake of the *Ulysses* battle, Pound was expurgating the women from the journal—while championing a more stately male dada, his own included.

Dada-inspired, Pound for the first time defined a "work of art" as "an 'act of art'" in the fall 1921.[51] He even tried to upstage the Baroness in her shenanigans: he proposed to publicly stage his own death in *The Little Review*. In April 1922, he carefully prepared his death notice, signed the note in his wife's name, and asked *The Little Review* editors to publish it along with the photographs of his death mask, which he included. The act played with dada's necrophilic obsession with its own death—the Baroness, for instance, famously parading in the funeral dress stolen from the embalmer's studio.[52] Heap, however, balked at promoting Pound as a dada wannabe and purposely sabotaged his act in this three-line published note: "Several weeks ago we received a note from

Mrs. Ezra Pound (in Rodker's handwriting) announcing Ezra's death; also some phoney death masks. Whatever the hoax (?) as far as we are concerned Ezra will have to be satisfied to go on living."[53] Pound was furious with the editors, writing to Wyndham Lewis: "They [Anderson and Heap] have bungled my death mask, sheer stupidity."[54] Upstaged by the women's New York dada, Pound needed to reassert both Europe's and male dada's dominance. After settling at 70 bis rue Notre-Dame-des-Champs in Paris in January 1922, Abel Sanders loudly proclaimed in *The Little Review* that "The intellectual capital of America is still Paris."[55]

In January 1922 another stern warning against the dada Baroness came from Harriet Monroe in *Poetry,* a magazine that had awarded Williams several poetry prizes and published a favorable review of *Kora*. Discussing "New International Magazines," Monroe attacked the Baroness: "It is said that Mr. Pound readopted *The Little Review* because of its editor's brave fight against the suppression of

10.**3** *228 West Eighteenth Street, New York City.* Photograph by
J. P. Boudreau.

James Joyce's *Ulysses*. Well, it was a brave fight—any fight against the censor's gag-laden fist takes bravery. The trouble is, *The Little Review* never knows when to stop. Just now it seems to be headed straight toward Dada; but we could forgive even that if it would drop Else von Freytag-Loringhoven on the way."[56] "[W]e do intend to drop the baroness—right into the middle of the history of American poetry!" was Heap's angry reply in a piece titled "Dada" in *The Little Review*. She deeply resented Monroe's attack. "And then 'bars' for Dada, 'bars' for Else von Freytag—two sets of bars for the same thing!," Heap dramatically proclaimed and continued in manifesto style:

The Baroness is the first American Dada. [. . .] When she is dada she is the only one living anywhere who dresses dada, loves dada, lives dada. [. . .] Is Miss Monroe against dada because dada laughs, jeers, grimaces, gibbers, denounces, explodes, introduces ridicule into a too churchly game? Dada has flung its crazy bridges to a new consciousness. [. . .] Dada is making a contribution to nonsense.[57]

As the examples of Monroe, Williams, and Pound indicate, the pressure for censorship came from within the modernist camp itself, which actively curtailed the activities—and the living female dada—at the frontlines of the avant-garde. In fact, modernists increasingly defined their own sanity in artistic experimentation in distinction to dada's insanity—even while they continued to energize themselves with dada's élan. Hart Crane noted in a 14 January 1921 letter to Matthew Josephson that "'New York' has suddenly gone mad about 'Dada.' I cannot figure out just what Dadaism is beyond an insane jumble of the four winds, the six senses, and plum pudding," adding: "But if the Baroness is to be a keystone for it,—then I think I can possibly know when it is coming and avoid it."[58] Still, in November, he would note to Munson, "Yes, my writing is quite Dada,—very Dada,"[59] and writing again to his friend on 22 July 1921, he supported the Baroness's critiques of America: "Ah—the Baroness, lunatic as she

is, is right. Our people have no *atom* of a conception of beauty—and don't want it."[60]

Ultimately, the year of 1921 with the loss of the *Ulysses* battle proved to be *the* defining moment for New York's avant-garde—its highlight of activity and the simultaneous decline of the female avant-garde and the Baroness. Anderson simply escaped the tension by departing for Paris, her new lover Georgette Leblanc in tow, leaving Heap the editorship of *The Little Review* as consolation prize. As for the Baroness, the real fight for artistic survival was just beginning. For even while Heap wrote her defiant defense in the spring of 1922, the editors had already quietly "dropped" the dada Baroness as too controversial. In the proud summary listing "what the *Little Review* has done," her name was not mentioned in the long list of poets and artists. The second part of the Baroness's review of *Kora* appeared in autumn of 1921 but was printed in such small font that it was barely readable. From now on, her appearance in *The Little Review* would be sparse and sporadic.[61] Ironically, as *The Little Review* was now "officially" moving toward dada, the journal was effectively becoming less dada in its politics. As a result, the spring 1922 Francis Picabia number and the autumn1922 Joseph Stella number received great praise from the journal's former critics. After conspicuous silence in the *Ulysses* crisis, Williams now wrote in a gesture of reconciliation that "The Picabia number of the *Little Review* is a distinct success: it give me the sense of being arrived, as of any efficient engine in motion." "I hope I may be permitted to say that the *Little Review* is American," he concluded, "because it maintains contact with common sense in America."[62] Such praise of "common sense" flew in the face of the avant-garde experimentation envisioned by the courageous editors—and the Baroness—several months earlier.

The Little Review's spring 1922 Picabia number was filled with Picabia's machine objects, including his mechanomorphic self-portrait, *Le Saint des Saints;* along with effusive praise by Jean Crotti

("Francis Picabia, the finest of the minds of the vanguard") and Pi-
cabia's announcement that "'Little Review' will present to you the
men who care only for the pleasure of a continuous evolution." This
battle-cry of the "Anticoq," as Picabia's piece is titled, announced a
new era, as Picabia's New York dada revolution had conveniently
dropped its *r* to morph into a tamer evolution.[63] The formerly fem-
inist magazine had been swallowed up by *the men*. Guillaume Apol-
linaire's posthumously published discussion of cubist art focused on
Picasso, Braque, Gleizes, Leger, Picabia, Duchamp, Duchamp-
Villon, and others. The only woman discussed was his lover Marie
Laurencin, a graceful "fauvette," who was praised for expressing "an
entirely feminine aesthetic."[64] Aggressive female *fauves* were out.
Modern art was male but tolerated a few gracefully "feminine"
women. This did not bode well for the Baroness, who swiftly rec-
ognized the foreboding signs.

 As if stung by a bee, she lashed out at the editors for what
she saw as a dangerous mainstreaming of the magazine. When she
learned that the editors were dedicating an entire issue to New
York's Italian American painter, Joseph Stella (1877–1946), while
excluding her own work, she berated Stella, calling him an Ameri-
can man of business, not an artist. "The *Americanism of Stella*—the
industry for *vain results*—the: *industry of vanity*—in Stella: *conceit*—and
money—a well known name brings—comfort—*and* braggadocio—
he is a vigorous businessman—by a *queer* twist—(*the twist of democ-
racy*) brought out of his true track: poultry dealer—instrument
maker—glazier technical draftsman [. . .]." If perhaps unfairly sin-
gling out Stella, the Baroness's critique and tone are understandable
when we consider that the dada represented in these issues was al-
most exclusively male, focusing on Tzara, Picabia, Stella, and
Duchamp. The autumn 1922 Stella number would showcase Stella's
attractive paintings of *New York, Brooklyn Bridge, Mardi Gras, China-
town,* among others, while the Baroness's more uncomfortably anti-
commercial American dadas were excluded. In her correspondence

with the editors, she lashed out against Duchamp's protégés, "*clever fakers*—shitarses—*prestidigitators,*" ultimately associating America's democracy with money making.[65]

At the same time, the Baroness tirelessly bombarded the editors with her new poetry and visual art, some of it brilliant. "Now *here*—Margaret I send you *some damn rare* German poems—and one precious *sound love poem,*" she wrote in one letter, describing her poems as "woeing of *jalamund* and frisky sex play," before launching into a challenge: "*go* and let it [*be*] *test*[*ed*] by a *truly cultured German* or one who understands *feels German.*"[66] "That you should *not* like: '*finish*' and '*subjoyride*' is not possible," she screamed at Heap on the envelope of another letter. "You just *neglect reading me*—that is *terrible*—it is stupid! Why? Goddammit!"[67] In her next letter, she implored Heap's help: "It is indecent—undignified—to think of *me*—*in my life here*—I am at the end and I am just *starting* as artist"[68] "What right has 'Little Review' to desert me?," she howled in outrage, excluded from the increasingly male dada club now emerging in *The Little Review.*

Consider her brilliant "Subjoyride," a poem that takes the reader on an underworld journey past advertisement slogans along New York City's subway tunnels, while the emotional intensity (joy) sought by the speaker becomes a sardonic "sub-joy-ride" through America's burgeoning consumer culture:

Ready-to-wear-American soul poetry. (The right kind)
It's popular—spitting maillard's safety controller handle—you like it!
[. . .]
That is a secret pep-o-mint—will you try it—
To the last drop?
Toutsie kisses Marshall's kippered health affinity gout of 5—after 40—
many before your teeth full-o' pep with ten nuggets products lighted

chillets wheels and axels—carrying royal lux kamel hands off the better bologna's beauty—get this straight—Wrigley's pinaud's heels fur the wise—nothing so pepsodent—soothing—pussywillow— kept clean with Philadelphia Cream cheese.
They satisfy the man of largest mustard—no dosing—
Just rub it on [. . .].[69]

By introducing the found object in her sardonic "Ready-to-Wear-American soul poetry," Freytag-Loringhoven had created a new genre: *the ready-made poem*. The poem's key ingredients were consumer items that had just recently flooded the market: Wrigley's Doublemint chewing gum and peppermint Life Savers, both developed in 1914; Kraft processed cheese in 1915. As the poem's syntax burst under the weight of accumulated consumer products, the human body has become diminished as a mere surface on which consumer products are applied ("just rub it on") and as a hungry mouth that ingests and consumes. Even social relations are mediated through consumption ("That is a secret pep-o-mint—will you try it— / To the last drop?"). Just as the mass-produced object theatrically decorated the Baroness's body, so "bologna's beauty" now made up her poem's aesthetic beauty.[70]

Also excluded was "Tailend of Mistake: America," in which America's technological progress is described as an illusory and contradictory "rushing-crushing" movement, nothing more than the circular and repetitive movement of "housecleaning":

In this rushing—crushing—exhilarating time of universal revel—alteration—by logic's omnipotency "putting things to right" house cleaning—vigorous relentless—husbandry———in New Zion-York——— "Holy communion is served to soft—soft—soft" to softies—(Christians).
Excrutiating pertinency! Jo—ho—ha—jecee!
Omnipotency—unerring—unmasking consumptiv—assumptiv

"softy Susie's" impotence.

Malted milkshake——haloflavor—for humble bastard cripple—
Coca-Cola for bully drummer of second-hand misfit religious pants.

By the poem's end, the country finds itself paralyzed, "croaks on
genickstarre—" and the speaker leaves us with nonsense sound ("Such
is larklife——today! / Ja heeeeeeeeee!") and unintelligible ravings.[71]

From the fall of 1921 on, the Baroness was a constant vis-
itor in the Village offices of the left-wing *Liberator*. She became friends
with the associate editor, Claude McKay (1890–1948), a black Ja-
maican-born poet who had immigrated to the United States in 1912.
Working under the left wing editor-in-chief Max Eastman, McKay
had close contact with white radical circles, so close, in fact, that his
relations with Harlem intellectuals were strained. In his memoir, *A
Long Way from Home* (1937), he remembered the Baroness: "The
delirious verses of the Baroness Elsa von Freytag Loringhoven titil-
lated me even as did her crazy personality. She was a constant visitor
to see me, always gaudily accoutred in rainbow raiment, festooned
with barbaric beads and spangles and bangles, and toting along her in-
evitable poodle in gilded harness. She had such a precious way of
petting the poodle with a slap and ejaculating, 'Hund-bitch!'" One
day she read, "in her masculine throaty voice," a poem she called
"Dornröschen" (Sleeping beauty) (the Baroness translated it as
"Thistlerose"). McKay "liked the thing so much" that he published it
in *The Liberator* in January 1922.[72] McKay also took the Baroness se-
riously, as he noted: "Down in Greenwich village they made a joke of
the Baroness, even the radicals. Some did not believe that she was an
authentic baroness, listed in Gotha. As if that really mattered, when
she acted the part so magnificently. Yet she was really titled, although
she was a working woman," noted McKay, highlighting her class con-
nections with the left-wing politics of his journal. "The ultramoderns
of the Village used to mock at the Baroness's painted finger nails.
Today all American women are wearing painted finger nails."[73]

Probably early in 1921, the Baroness had moved to new quarters, a subbasement on 228 West Eighteenth Street, near Ninth Avenue (figure 10.3). Djuna Barnes recalled that Walter Shaw, a delivery driver, made a special detour to deliver pastries for her animals, for the Baroness was feeding not only her cats and dogs: she was also feeding the rats, refusing to discriminate against social definitions of lower life forms. Unfortunately, Shaw was fired after his detours were discovered. One day, the Baroness was attacked on the streets, a band of thugs assaulting her and stealing her Woolworth rubies.[74] Another day, when she opened the door of her flat, she was physically assaulted by a man. Berenice Abbott found her bruised and called a doctor, nursing her back to health. Yet against all adversity, as Barnes recalled, the Baroness "always lived up to what she promised herself." In the late evenings, she would adorn herself in her "eccentric poverty wardrobe" and repair to Jods, "a chop house" on West Fortieth Street, where she performed her dance, as Barnes recalled: "Naturally she was 'insulted' & taken for one deranged—& never achieved her aim—in a state of collapse—at the wretchedness of the reception." Yet for all that, she remained "determined to carry her project through."[75] Every day was dedicated to art.

Perhaps reacting now to her own exclusion from the world of art, she began to intrude into modern art exhibitions— guerrilla girl–like with strikes against the conventional art world. In 1922 Louis Bouché was arranging an exhibition at the Belmaison Gallery. One morning, the Baroness—standing on top of the staircase leading to the Gallery—was "haranguing with unmeasured violence the sheeplike crowd below, who had come for their homeopathic dose of modernity":

She had rehung the entire show, each picture at a different angle and one or two upside down, while others lay face down on the carpet, and she was now inveighing in the most truculent manner against

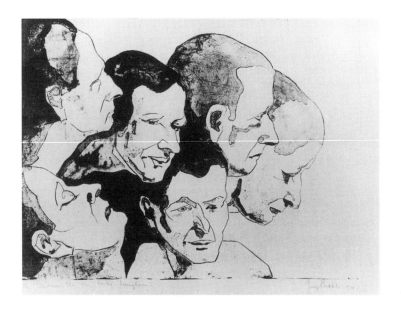

10.**4** George Biddle, *The Baroness Elsa von Freytag-Loringhoven,*
1921. Lithograph, sheet: 14 1/8 × 17 7/16 in. Collection Francis
M. Naumann, New York.

the bourgeois spirit of a department store which, in hanging modern art, had achieved the uninspired symmetry of a parking lot.[76]

In the luxurious department store gallery—the Belmaison was housed in Wanamaker's Gallery of Modern Decorative Art on Broadway at Ninth (figure 7.1)—she struck at the notion of art as consumption. Her dada act was profoundly anticommercial, anticipating the strategies of postmodern performance art that deliberately abuse the spaces of commercial art.

Meanwhile, Biddle paid her to write a review of his exhibition on Fifth Avenue, for the Baroness was "invariably starving" and was "a shrewd and salty critic."[77] Perhaps he was also hoping to be spared. Yet she appeared one morning at one of Biddle's shows at Wildenstein's, a forum that valued a certain conventionality for "business sake":

She had made a clean sweep of Schwartz's Toy Store that morning; and had sewed to her dress some sixty or eighty lead, tin or castiron toys: dolls, soldiers, automobiles, locomotives and music boxes. She wore a scrapbasket in lieu of a hat, with a simple but effective garnishing of parsley; and she led, tied on one string and fastened at different intervals, seven small, starved, and terrified curs. The gallery was crowded. The Baroness had her say, remorselessly, in front of every painting. Luckily Monsieur Wildenstein did not put in an appearance.[78]

The grammar of her costuming was already familiar, but she was re-composing the details, each day adding a new twist to her costume, making references more multiple and complex and up to date, her body as art in process truly open-ended, an eternal serializing of art without end.

Biddle's 1921 lithograph portrait of the Baroness shows her with six heads—serious, morose, judgmental, reflective, inquisitive, and glum (figure 10.4). Perhaps the portrait was inspired by the multiple mirror photographs of Duchamp, Roché, and Picabia. But the six heads also suggest the multiheaded, man-slaying mythological Hydra. Each time a head was cut off, two heads would grow in its place. Just so, it appeared, the Baroness reemerged with double force each time her enemies tried to cut her down. She called America "this graveyard of unburied shells of souls," a country in which she was forced "to fight monsters."[79] As she told Heap: "I have my *full power*—I am *Amazone*—I want my swing—but *here*—I feel paralyzed—*here my swing will naturally go to desperation.*"[80] From 1921 on, the Baroness's sights were set on Paris.

A Farewell to New York

Chapter 11

In April 1921, a young garçonne arrived at André Gide's Paris residence. Speaking only a "horrible American English," she held three issues of *The Little Review* in her hands along with a strange letter penned in yellow and red ink with golden speckles. The American sculptor Berenice Abbott had been charged by the New York Baroness with delivering an extraordinary package to Gide. The astounded host—as the scene was remembered by Gide's secretary, Maria van Rysselberghe, who took the package to him—soon discovered that the mysterious sender was none other than "Felix Greve's wife." "In crude, exalted and self-indulgent language," as Rysselberghe noted somewhat squeamishly, the Baroness effectively proposed to have Gide support her so that Paris could "benefit from her presence."[1] Gide was amused by the sheer outrage of the Baroness's daring. Yet even though Paris dada was out of his league, Gide was sensitive to the Baroness's plea to help her friend Abbott, who was in Paris alone and without support. For Gide and Abbott, this was the beginning of an important friendship.

Even at an advanced age, Abbott remembered this Paris adventure. Before she had left New York in March 1921, she had visited the Baroness, who had encouraged her to travel to Europe. The Baroness's good-bye was a bodily ritual of sorts: with her right hand she had touched her hips first on her right, then the left, and then had drawn a line with her hand from the forehead down to the pelvis. For Abbott, the Baroness was "a mixture of Shakespeare and Jesus," already a role model for the young artist.[2] There was an exodus as New York's art community flocked to the French capital. The Baroness, too, was hoping to propel herself into Paris—but her departure was not until two long years later.

Just a few months before Man Ray left for Paris, he took photographs of the Baroness and Duchamp as if he were memorializing New York dada's gender focus for history. "*Man Ray has* quality," the Baroness would write to Heap, "that is why he took to *photography.*"[3] In 1920 or 1921 he photographed *Rrose Sélavy* (Eros,

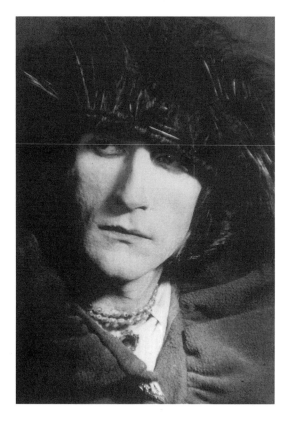

11.**1** Man Ray, *Rrose Sélavy* [Marcel Duchamp], ca. 1920-21. Photo-
graph. Philadelphia Museum of Art. © Estate of Man Ray/ADAGP
(Paris)/SODRAC (Montreal) 2001.

c'est la vie) (figure 11.1),[4] Duchamp posing as a "strikingly beauti-
ful 'woman,' conforming to period codes of feminine grooming."[5]
Duchamp's use of his own body for art was no doubt inspired by the
Baroness's original use of her body and costumes for gender script-
ing. Also around this time, Man Ray photographed the Baroness
wearing a checkered male jacket and masculine hat (figure 11.2).
The Baroness's lack of makeup contrasts with Duchamp's heavy
mascara and lipstick and his soft clothing. While Duchamp's hair is

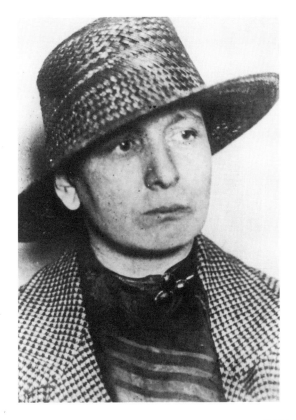

11.**2** Man Ray, *Baroness Elsa von Freytag-Loringhoven*, 1920-21. Photograph. Elsa von Freytag-Loringhoven Papers. Special Collections, University of Maryland at College Park Libraries. © Estate of Man Ray/ADAGP (Paris)/SODRAC (Montreal) 2001.

hugging his face (Rrose Sélavy autoerotically wrapped up in herself), the Baroness's hair is sternly tucked away, the hat cutting diagonally across the picture, her austerity and Spartan masculinity only mildly undercut by the Victorian clover brooch decorating her blouse, a mere nostalgic nod to femininity. Hers is the less comfortable photograph, embodying "the *serious thunderous—creative— solemn—passionate*" side of her art, in contrast to Duchamp's lighthearted frivolity.[6]

292 J. Doucet,

MERDELAMERDELAMERDELAMERDELAMER

de l'a merique!

Cher Tzara — dada cannot live in new york.
All new york is dada, and will not tolerate a
rival, — will not notice dada. It is true
that no efforts to make it public have been
made, beyond the placing of your and our
dadas in the bookshops, but there is no
one here to work for it, and no money
to be taken in for it, or donated to it. So
dada in new york must remain a secret.
No additional sales have been made of
the consignment you sent to "Société Anonyme".
The "anonyme" itself does not sell anything.

11.3 Man Ray, *Letter to Tristan Tzara,* postmarked 8 June 1921.
Bibliothèque littéraire Jacques Doucet, Paris. © Estate of Man Ray/
ADAGP (Paris)/SODRAC (Montreal) 2001.

The subsequent film experiments testify to the courage of her high-risk art. In a three-way film collaboration, Man Ray and Duchamp worked two cameras, simultaneously filming the Baroness as she modeled in the nude. Behind the first camera was Duchamp; behind the second, rented camera, a mechanic. The filming went off without a hitch, but problems arose during the development: "[W]hen they tried to develop the film themselves in the dark, winding it around radiating circles of nails that Duchamp had patiently hammered into a plywood disc, then immersing the disc in a garbage can lid filled with developer, the film stuck together and was ruined."[7] The Baroness's pose has survived in an 8 June 1921 letter written by Man Ray to Tristan Tzara in Paris, now kept under tight security in the Jacques Doucet Archives in Paris (figure 11.3). Even for today's viewer, her pose remains startling in its sexual iconography: her head shaved, her pubes bare and exposed, her arms behind her. Her legs pose in form of the letter A, and the pose is framed by "*MERDELAMERDELAMERDELAMERDE* [. . .] *de l'a merique,*" a scatological pun on *mer* (the sea), *merde* (shit), and *Amerique*.[8] Here the Baroness represented America's kinetic energy and perpetual motion, its New Woman sexuality, as well as her critique of America.[9] The repetition of the words, as well as the repetition of the running legs, evoke the kinetic movement of a film but also present the endlessly repetitive structures that are a formal characteristic of dada. The kinesiological focus locates her body on the precipice of movement—her body scripting ecstatic exuberance and life energy.

The pose's ultimate gender meaning? Lynda Nead writes in her book on the female nude in Western culture that the "forms, conventions and poses of art have worked metaphorically to shore up the female body—to seal orifices and to prevent marginal matter from transgressing the boundary dividing the inside of the body and the outside, the self from the space of the other."[10] The Baroness unraveled these conventions—aggressively opening up the

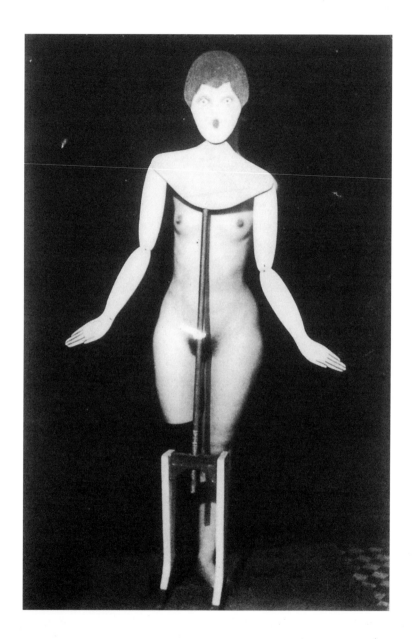

11.**4** Man Ray, *Coat-Stand [Portemanteau]*, 1920. Centre Georges
Pompidou, Paris. © Estate of Man Ray/ADAGP (Paris)/SODRAC
(Montreal) 2001.

body with the daring of an Amazonian warrior, literally stripping the conventional syntax off the traditional nude by presenting it in strangely skewed cubist forms. Her left arm extends to create a diagonal body line with the right leg extension, strategically placing the vagina in the body line's center, the vaginal triangle itself repeated through geometric arm and head positionings. The hands, generally in the foreground of nude paintings or photography (either for autoerotic purposes or for veiling purposes), are absent in this pose—just as feminine shame is absent. Such aggressive display of female sexuality was—and remains—shocking. She, not the cameramen, was in charge of her unconventional iconography that deliberately refused the sexually pleasing and teasing poses, as she later explained to the American arts patron Peggy Guggenheim:

With me posing as art—aggressive—virile extraordinary—invigorating—ante-stereotyped—no wonder blockheads by nature degeneration dislike it—feel peeved—it underscores unreceptiveness like jazz does.

But there are numbers of bright heads that have grasped [the] fact to their utmost pleasure—advantage—admiration of me.[11]

That she associated her posing with "virility" is significant, for posing as art allowed her to shatter conventional ways of looking at the female body.

Still, the three-way collaboration was risky, revealing the male attempts to contain her body within male parameters. This New York dada film project was preserved under the salaciously pornographic title *Elsa, Baroness von Freytag-Loringhoven, Shaving Her Pubic Hair.* While "helping [Duchamp] with his research," Man Ray recalled, he "had shot a sequence of [him]self as a barber shaving the pubic hairs of a nude model, a sequence which was also ruined in the process of developing and never saw the light. With my Dadaistic approach, I felt that whatever I might undertake in the way of films

would be open to censorship either on moral or on aesthetic grounds, in short, bad."[12] In addition to the pornographic implications, Man Ray framed the Baroness's body by announcing the death of New York dada: "Cher Tzara—Dada cannot live in New York." The Baroness's vibrant nude could be displayed only by killing it off in the next sentence—along with the entire movement she represented. Man Ray noted that the Société Anonyme had failed to make any sales of the dada objects that Tzara sent on consignment. Alluding to the German immigrant daughter Katherine S. Dreier (1877–1952), and possibly to the Baroness, he told Tzara that New York dada lived only through "the generosity of a few poor friends." The Société Anonyme's formidable dynamo Dreier had rented a studio on the third floor of 19 East Forty-seventh Street in April 1920 and in these headquarters promoted New York dada along with the work of German artists, including Klee, Schwitters, and Kandinsky.[13] Man Ray's focus on dada's money-making ability confirms the Baroness's polemical charge that American artists were "prostitute[s,]" for in the making of modern art they were dedicated more to cautious *business* than to uncompromising *aesthetics*.[14] Within this context, the Baroness's "antistereotyped" nude demanded containment.

That containment is perhaps best illustrated in Man Ray's *Coat-Stand* (figure 11.4), a photomontage of a woman's body that was likely the Baroness's and that was published in the April 1921 *New York Dada* magazine—New York's first and only magazine to inscribe its dada focus in its title.[15] With the woman reduced to an object to hang clothes on—her right leg cut off just above the knee as if she were a manikin and the head and shoulders covered by a string puppet device—the misogynist overtones are palatable. The Baroness's body kinesis and agency are firmly controlled, contained, and domesticated. The implied veiling function, which also hides the face of the aging model, made the nude more conventionally comfortable in public viewing. In the first version of *Coat-Stand,* the

11.**5** Man Ray, *Baroness Elsa von Freytag-Loringhoven*, 1921. Photograph from *New York Dada*, April 1921. Philadelphia Museum of Art. © Estate of Man Ray/ADAGP (Paris)/SODRAC (Montreal) 2001.

11.**6** Man Ray, *Baroness Elsa von Freytag-Loringhoven*, 1921. Photograph in *New York Dada*, April 1921. Philadelphia Museum of Art. © Estate of Man Ray/ADAGP (Paris)/SODRAC (Montreal) 2001.

stamp covering the pubic area to avoid confiscation is reminiscent of the Baroness's use of stamps on her living body. Striking, too, is the enforced anonymity of the woman behind the coat stand, for the nude in Western culture is conventionally anonymous, as the British feminist writer and theorist Angela Carter notes: "naked, she loses her name and becomes a 'blue nude,' 'the bather,' 'woman dressing,' 'Suzie,' 'Gina,' 'Europa,' 'Eve,' 'Venus.'"[16] Walking the borderline of art and pornography, *Coat-Stand* is accessible to the proverbial "blockhead" who would easily react with baffled discomfort to the Baroness's uncensored art.

 Gender was the focus of the entire April 1921 *New York Dada* issue, compiled by Man Ray and Duchamp, with Tzara as a guest columnist. Duchamp's perfume bottle with himself as *Rrose Sélavy* graced the cover. The pressure of bourgeois gender codes was literally enacted in Stieglitz's photograph of a female leg with its foot squeezed into a shoe much too small. The Baroness was central, figuring in two photos (figures 11.5 and 11.6) with her head shaved and adorned with feathers, her breast dressed in a string of pearls. Alongside the visuals runs her poem "Yours with Devotion: Trumpets and Drums," printed in dada fashion—upside down.

Dearest Saltimbanques————
beatrice————muriel
 shaw——not garden—— mary——
 "When they go the other way"
 OTHER WAY——dearest——
 REMEMBER————
Mary so knowing————emma————emily——
 beatrice——muriel
 bandwagon of heavenly saltimbanques——
yes, yes——girlies——performance at eleven in the late afternoon
 wires all spread————canvas————stretched————[17]

TEKE
HEART <BEATING OF HEART> ELSE BARONESS
von FREYTAG-
LORINGHOVEN

PÜLPQVEMAЯK — ALBDCH —Π—Π—Π—QVЛ—Π—Π
GЛJIRRE· HVSTA —
AJAJA—HALHA— HÜK—HVLVK ———
JVLPTKFRSJRIЛЛE FRBQVЛRIMBA —
TЛVRQVTQVЛRIMBA ———
ORKMMM — ORKMM—MMM —
HIRRE—HÉTA
HETTA—HETT·

IЛQVIRSTRATROSSA—QVIRSTTROSSA—
R
(FRATROSSA)
— TROSSA
AFFRATRITT ?
PILPQVEVASЛJVSKE — VASЛIJE—VASTRYЛ
KIRQVEVASЛJIRSKE— STARTROJE —
MASTI
GA
ARMASTASÉKRA— ARMASTA—AMÉTA—
MAJTŬ· LAT I !

QVIXFRIЛJACHLÉDE— JALHLEIDE—JALHMOSA
K
MOSA— ALHMOSA— QVARSIRЛK—ACH —
QVARLSE
KALSTV· LJASAB—RIЛЛE· VRŬSTA
ACHA ALHÉ ———
JALH— LHÉ ?

LJRIЛSTJAIB· ƏJRЛIЛKE· STJRIBE· FIRIЛ
STJRIBE· Л)RISTЯRE· ACHA—JALHÉ
STR

11.**7** Elsa von Freytag-Loringhoven, "Teke," ca. 1921. Manuscript
poem. Papers of *The Little Review*, University Archives, Golda Meir
Library, University of Wisconsin-Milwaukee.

With this dance show of strolling acrobats, the Baroness marked the centrality of performance in New York dada. The names—all of them women, including the performer Mary Garden—are lifted onto the wire in this late afternoon trapeze performance.

Duchamp and Man Ray left New York for Paris in May and July 1921, respectively; they were disappointed with New York dada's lack of remunerative possibilities. Man Ray's career as portrait photographer took an almost instant upswing, as new celebrities were fast arriving in Paris: Ernest Hemingway in late autumn and Harold Loeb in December, launching his new journal *Broom*. So energetic was business that in 1923 Man Ray was able to hire Berenice Abbott as his studio assistant. In Paris, money was to be made from dada.[18] Man Ray was sharing the same hotel with Tristan Tzara and had presumably handed over to Tzara the Baroness's sound poem "Teke" (figure 11.7) and a drawing, her submissions for Tzara's anthology *Dadaglobe*. A few months later, on 22 September 1921, writing in English, the Baroness asked Tzara for an update, reminding him that she had sent the manuscript under the condition that it would be returned to her, since he had not offered any payment. "A damn good drawing—a damn good ms!," she added with flourish. She also passed on her complaints. "Marcel," "faithless pup," has been neglecting her. Man Ray too had been "absentminded": "tell him when you see him—he can kiss my *cul* from across the Atlantic." But she proclaimed triumphantly, "I will soon be in Paris!" She had addressed her letter in dada fashion to "Mr Tristan Tzara, Dadaboss, Editor of 'Dada,' Somewhere in Paris, France."[19]

One wonders what Tzara made of the New York Baroness. It seems that he intentionally ignored her letter, as can be gleaned from the Baroness's second letter, sent much later from Germany. Perhaps the Paris "Dadaboss" was afraid of such formidable female aggression. Perhaps he was troubled by stories of her Teutonic prejudices against Jewish people. Or perhaps he was simply ashamed that his widely advertised *Dadaglobe* anthology had never

seen the light of day. As for Man Ray, the memory of the unsettling Baroness as a vituperative dynamo of anticommercialism and unconventionality jarred with the photographer's new path of commercial success. His French model Kiki de Montparnasse (a.k.a. Alice Prin) would soon provide erotic body poses that were more compliant, youthful, and conventionally pleasing to his camera, as well as to the mainstream gaze.[20]

 Still, the Baroness's dada traces were already advancing her into Paris. In October 1921, Man Ray met the playwright Jean

11.**8** Baroness Elsa von Freytag-Loringhoven, *Wheels Are Growing on Rose-bushes*, 1921-22. Visual poem. Elsa von Freytag-Loringhoven Papers. Special Collections, University of Maryland at College Park Libraries.

Cocteau (1891–1963), an important contact. A few months later, in 1922, Cocteau launched his *Antigone* on the Paris stage. The prototypical Greek female rebel, Antigone was put to death because she consciously defied patriarchal authority and law when she insisted on giving proper burial rites to her outlawed brother, who had died in infamy. Cocteau, openly homosexual, had given the Greek play a dada and gender twist: he had persuaded the actress Genica Athanasiou to shave her head and pluck her eyebrows. Thus female rebellion was dramatized through an act pioneered by the Baroness in New York and developed by the younger Claude Cahun in Paris (see chapter 14). Coco Chanel fashioned the costumes, Pablo Picasso designed the setting, and Man Ray took the photographs for *Vogue*. While Man Ray ignored the Baroness's pleas to help her come to Paris, the memory of her anticommercial and antibourgeois dada had now successfully entered the legitimate stage and even the world of fashion. For vanguard acts to be successfully assimilated into the mainstream, it was perhaps necessary that the name of the uncomfortable Baroness be silenced.[21]

Back in New York, the Baroness was fighting depression. With almost all her friends—Marcel Duchamp, Man Ray, Djuna Barnes, Margaret Anderson, Berenice Abbott, Gabrielle Picabia—gone to Paris, she was left alone in America. When Duchamp returned for a few months in 1922, he disappointed her, having adopted a "*determinedly frivolous—light—playful—prideless* attitude," not displaying the qualities of a serious artist.[22] In a particularly dark mood, after his second departure for Paris, her love for "M'ars" now turned into its opposite—"I hate him at present [and] I have a right to"—although for the Baroness love and hate were but two sides of the same coin.[23] Duchamp, she feared, was losing himself in the adulation of the "modern drawing room—or boudoir of *unprincipled callous prideless females.*"[24] Indeed, Duchamp was in vogue in New York. The autumn 1922 issue of *The Little Review,* the Joseph Stella number, featured several Duchamp portraits by Man

11.**9** Baroness Elsa von Freytag-Loringhoven, *Portrait of Marcel Duchamp*, ca. 1922. Pastel and collage, 12 3/16 × 18 1/8 in. Vera, Silvia, and Arturo Schwarz Collection of Dada and Surrealist Art, Israel Museum, Jerusalem.

Ray and Stella.[25] "I do desire a copy of *TLR* [*The Little Review*] on account of m'ars portraits. [E]ven Stella's conception ain't bad," she promptly wrote to *The Little Review:* "he sees very much the Latin—Roman—forgetting French lightness." So impressed was she that she even visited Stella. He did not receive her, however, and after bullying the servants, she left a note written in German, "because his servant said proudly that he could speak 'every language to think of.'" When Stella ignored the note, she called him a "miserable bully," "American rich man," a "big pig [with] no brain."[26]

In the winter of 1922, *The Little Review* published Charles Sheeler's photograph of the Baroness's *Portrait of Marcel Duchamp* (see figure I.3). Serving up the artist like a desert in a wine glass, adorning him with sexy feathers like a Ziegfeld girl, while perhaps also alluding to Duchamp's 1922 investment in a feather-dyeing business, she poked fun at the fashionable avant-gardist who had it too easy in America and who was selling himself like a prostitute for public art consumption: "cheap *bluff* giggle *frivolity that is*

what Marcel now can only give," she wrote to Heap. "What does *he* care about *'art'? He is it"*(see also introduction).[27] Similarly, her poem "Affectionate" had a critical tone:

WHEELS are growing on rose-bushes
gray and affectionate
O Jonathan—Jonathan—dear
Did some swallow Prendergast's silverheels—
be drunk forever and more
—with lemon appendicitis?[28]

In a striking surrealist image, Duchampian "wheels" (*Bicycle Wheel* ready-made) begin to grow out of "rose-bushes" *(Rrose Sélavy),* as she suggests an ironic connection of this art with the popularity of the American painter Maurice Prendergast (1859–1924). In the attractive visual version of the poem (figure 11.8), miniwheels are interspersed among the words, and their tipsy drunkenness is suggested with some of the words written upside down or vertically, words and visuals commingling without boundaries or hierarchies. The ironic title alludes to Duchamp's lack of passion—his affection is "gray"—while the intoxication of spinning wheels leave a sense *not* of Dionysian ecstasy but of "lemon appendicitis."

As the Baroness was reviewing the 1922 Independent Art show and praising Warren Wheelock as going beyond the domain of painting, comparing him to Duchamp,[29] she was also working on her painting *Portrait of Marcel Duchamp* (figure 11.9, plate 8). As she told Heap: "[T]o do a thing like that picture of M'ars [which] has become *rather marvelous*—it should be *easily* worth—for *anybody* who *likes it* and *can buy*—$150–200—judging from the independent exhibition—*surprisingly good*—*this year.* I was there yesterday—Sunday—*that kept me going yesterday*—but I was starving hungry—neglecting myself—at a loss what to do—afraid to spend *any money at*

all."[30] Today in the Vera, Silvia, and Arturo Schwarz Collection at the Israel Museum in Jerusalem, her remarkably attractive painting and collage is homage and critique at once.[31] In the center of this cubist painting appears Duchamp's face like a mask smoking a white clay calumet, the ornamental peace pipe used by North American natives for ritual purposes. To the right of Duchamp's red and leathery face mask is a second, smaller mask in side profile (its bottle shape a reference to Duchamp's *Perfume Bottle*), as well as his chessmen at the bottom (for chess had become his main preoccupation). The name MARCEL is spelled out in the left corner. Prominently displayed on the right is his bicycle wheel, morphing into the delicateness of a spider web, its mechanical structure contained within this collage of natural fabric, its borders stitched together with thread holding the wheel inside the fabric. The work evokes Ida-Marie Plötz's idiosyncratic sewing and the Baroness's identification of Duchamp's calm serenity and giggling with her mother's. With his mouth crookedly smiling, he looks like a native trickster figure, the quintessential shape shifter, a cross-cultural border traveler. Yet there is a jarring element: his masklike face—displayed as art object along with his other works—is also tightly locked in position—unable to move, suggesting his stagnation as artist.

The Baroness's last New York residence in 1923 was the Hotel Hudson on Forty-fourth Street at Sixth Avenue—a much nicer setting than her tenement. She liked her hotel life because it was "an unpretentious (very) honest theatrical hotel—lovely. Everybody has animals. Dogs—a monkey but I can not work here truly."[32] It was a little noisy, and she found it difficult to concentrate on her work. Jane Heap helped pay the bills. One day, the Baroness came down to the Village expressly to collect money for her hotel bill and to pick up her art objects. As so often, she was late leaving an earlier appointment (with Georgette Leblanc, who with Margaret Anderson had returned to New York City). Finding that Heap had

not waited for her, the Baroness left a nasty note: "You know I come from uptown—it costs time—money—I expect phone message at my hotel [. . .]." Disappointed, she became exacting and contemptuous:

I wish to know if—if [. . .] I tomorrow—get that money for my rent [Hotel Hudson] you promised and when. I have to pay! I am worried and unhappy[;] you are always invited and have a gay time—I am an outsider—only my art is good enough—then I get a bite—an alm—otherwise I am kicked—fi! I do feel like murder shit merde! [. . .] I am neglected—my welfare—my wishes—my feelings and [I] can starve to death [. . .] because I can't even get gun for noble person's death.[33]

In an unidentified typed letter, presumably Heap's answer to this or a similar note from the Baroness, came the following stern response, which sheds light on the taxing demands made by the Baroness on her friends. After explaining that she had been called away, Heap continued:

Please do not make appointments for the same day and then expect me to keep them simply because of the amount of trouble they put you to . . . both to deliver the note and to keep the appointment you made yourself . . . Jesus Christ, you cannot write these kind of notes and get away with it. I wanted to help you but you are making it impossible for me . . . to communicate with you logically . . . why do you have to bring these things into it . . . I am trying to help you, and you will force me to rub it in . . . I have been wondering why you have been committing such a great crime to your great genius . . . and I know what it is. You constantly make it impossible for people to help you, or to help yourself so that you can do your work in quiet . . . and at least have the provisions of everyday life. It is a

crime. A woman at your age cannot live upon her sex anymore than such a person as Georgette Leblanc who tried the same thing with me. I cannot see you tonight, and it is your own fault for dictating your appointment to me. It is bad manners, and no sane person would think of being dictated to in such a fashion for anyone whosoever.

Hurrrrrrrrrrrrr.[34]

The two women stayed friends for the duration of the Baroness's stay in New Yew York, but Heap was getting weary of her charge.

The Baroness's New York years were a quixotic fight against poverty—her "unskilled, fierce battle," as she described it, "in midst of skirmish"—as she found herself walled in and battered by the "common sense world."[35] Lacking "executive skills," her ideas for generating money were quixotic. "*Why* can I not read publicly *German poetry?*," she asked Heap, ignoring the anti-German postwar climate.[36] Like Else Lasker-Schüler in Germany, the Baroness stole to support herself ("she couldn't help stealing," said Barnes), unwittingly even stealing Heap's silverware; she returned the pawn ticket, however, as soon as she learned that Heap was the owner. After she felt neglected and exploited by *The Little Review,* she took to stealing letters out of their mailbox, pocketing the subscription checks.[37] Yet her most notorious strategy for raising money was what she aristocratically termed *"polite blackmail."*[38] She unsuccessfully connected with the Freytag-Loringhoven family in Germany, trying to get the family to support her as Baron Leopold's widow. She extorted money from bourgeois lovers and would-be lovers by threatening to publicize her affairs with them. In 1922 and 1923, she threatened to sue a would-be lover named Anthony for "breach of promise." In a successful lawsuit, her lawyer obtained for her $80 as compensation for "personal injuries" received in an automobile accident.[39] Yet the proudly

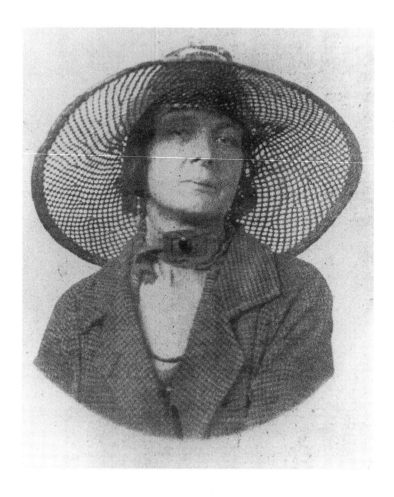

11.**10** Man Ray, *Baroness Elsa von Freytag-Loringhoven, ca.* 1920-21. Photo-
graph. Elsa von Freytag-Loringhoven Papers. Special Collections, University of
Maryland at College Park Libraries. © Estate of Man Ray/ADAGP (Paris)/
SODRAC (Montreal) 2001.

independent Baroness was ultimately despairing of the fact that she was unable to create a decent living for herself, and she routinely reacted with Nietzschean contempt for the small charitable contributions offered by acquaintances. She was equally angry when people failed to be sensitive to her needs. Abbott recalled that the Baroness once sent up "a package of cheap soap to [a] friend to remind her of [her] need to wash things." Unfortunately, the friend was too "thickskinned" to understand the cryptic message.[40] She was unforgiving when friends forgot her birthday.

After almost a decade in New York City the Baroness was forced to admit that America had refused to sustain her: "I starve without money—I can not support my art." She continued: "I have no chance here none at all—I *hate* this country—I am nauseated to see the monstrous faces——send me to Paris," she requested of Heap. "I will perish—I cannot become vulgar—nor cater to vulgarity[. Therefore,] the mob will eat me!"[41] With insulting dada darts she targeted America's very heart and soul, attacking its democracy as "principle of weakguttedness." American democracy may be well intentioned, but it was without "spunk."[42] The despair that was the other side of the Baroness's life in New York is evident in a Man Ray studio photo (figure 11.10). Her expression is weary as she gazes down at the camera, her hair limp under an overly large weblike hat that envelopes her like a gigantic cage. Her cheeks are hollow, her gaze steady but jaded, her throat decorated by a choker so big that it appears to strangle her. As we view this photo, her heartbreaking lament provides the soundtrack:

I am nauseatingly *tired*—tired of living in writing—or art—only—only only!

I hate myself—I spit on myself—I look in the mirror and see a neglected disspirited left over old woman!
And—the insane thing about it is [that] *it is not true!*
But—it is true—in *America*—![43]

Yet even the darkest despair was always followed by renewed hope, as she rose from the gutter to fly high.

Like the British feminist writer Virginia Woolf, who was plagued by nervous breakdowns and committed suicide, the Baroness was a sane person with serious bouts of instability: her symptoms included mood swings, an inability to control anger and aggression, failure to dialogue, and delusions of grandeur followed by self-hatred. Later in Europe, she would refer to her mental condition as a "cancer of the mind," a fascinating choice of words that corresponds to the textbook description of schizophrenia (while also evoking her mother's cancer of the womb). Her letters to Heap reveal epiphanies of self-awareness, as when she confesses to being the "creator" of her little dog's erratic behavior, describing Pinky as "the victim of my artistic selfish cultivation of my soul." Pinky was terrorized by her explosive use of swearwords, her "shit or goddam": "he cringes when he only hears them—and always makes *him* feel guilty." Startled by the realization that she had become "impetuous" like her father, she vowed to do better: "I realized— I could try to mend my ways a little if possible." Such critical self-reflection certainly contradicts those contemporary critics who wished to relegate the Baroness to a simple state of mania and disease.[44]

Yet the Baroness's diatribes also exhibited the underside of her raving art and personality, exposing some of her cultural prejudices in the midst of her dada invectives. Writing aristocratically on Hotel Hudson stationary, she berated Charles Duncan, Abbott's friend. Accusing him of stealing from her, she violently lashed out against him, anti-Semitic and homophobic expletives mixing in a vituperative diatribe: "You *fairy pimpkyk* democratic America's inane *simp* conclusion. You *susie ghost*."[45] Her excitable speech, in part, was provocatively dada, an art form inherently violent, according to Tzara's manifesto: "Every act is a cerebral revolver shot."[46] Just

as she manipulated sexual and religious expletives *(ninnyasses, shit-mutt, God-Satan, God-dammit),* so she made liberal use of racially charged invectives. Yet her deeply embedded anti-Semitism was rooted in her Prussian upbringing (in which Judaism and Catholicism functioned as suspiciously foreign "others"), in the antireligious Nietzscheanism and anti-Semitism within Munich's and Berlin's avant-garde circles, and in the rampant anti-Semitism among New York's moderns, perhaps best exemplified by John Quinn's 1919 disparagement of an entire issue of *The Little Review* as a "Jewish number."[47]

 After having suppressed the Baroness in 1921, in 1922 Ezra Pound now intervened to promote her. On 29 December 1922, evidently missing a dose of the Baroness in his reading of *The Little Review,* Pound wrote to Margaret Anderson: "There is a german publication called GENIUS, that la baronne might review. If you can find a copy in N.Y. also the Quertschnitt [Querschnitt]." Clearly interested in some criticisms that might spark debate, he also reminded Anderson that "Intelligent reviews of my last work, of Eliots Waste Land, and even of that olde classicke *Ulysses* wd. be suitable."[48] In spring 1923, he signed his letter, "Bless / The Baroness / yrs / E."[49] The Baroness's impact on Pound was lasting. As late as 1955, when he composed the *Rock-Drill* Cantos, he paid tribute to her in the last Canto 95:

The immense cowardice of advertised litterati
& Else Kassandra, "the Baroness"
von Freitag etc. sd/ several true things
in the old days /
driven nuts,
Well, of course, there was a certain strain
on the gal in them days in Manhattan
the principle of non-acquiescence

laid a burden.
Dinklage, where art thou,
with, or without, your *von?*[50]

Invoking her as a Cassandra figure whose madly raving speech contained the truth, Pound was writing from St. Elizabeth's asylum in Washington, a literal prisoner for his fascist activities in Italy. Accused of insanity by his American birth country, he found himself in the position of the Baroness, who had been called insane several decades earlier. In the *Rock-Drill* Cantos, he was composing in dada techniques that ultimately thwarted deciphering. He was still mimicking the Baroness's style, including her archaisms ("where art thou?") and inversion ("Else Kassandra, 'the Baroness'"). The title for the *Rock-Drill de los Cantares* was inspired by the Jacob Epstein's 1913 *Rock Drill* sculpture, a "machine-like robot, visored, menacing, and carrying within it its progeny, protectively ensconced," as Epstein (1880–1959) described it.[51] By 1916, the American-born sculptor and British resident displayed this statue without its erotic and heroic drill; castrated it has become a pitiful victim, looking like an atrophied insect—perhaps a little like Ezra Pound. The machismo-machine shattered, Pound identified with the Baroness's position. As late as 1954, alarmed that she should be erased from the history of American poetry, he would write to Anderson criticizing Geoffrey Moore for having omitted the Baroness from *The Penguin Book of Modern American Verse:* "yu wd/ be proper person to chew his ear for OOOOmission of Elsa vF. L." To which a weary Anderson would reply: "I did all about her I could in the L.R."[52]

 In January 1923, the Baroness was able to place one of her poems, "Circle," in *Broom.* The editor, the American writer Harold Loeb, Peggy Guggenheim's cousin, recalled that this specific January issue was "distinguished for its poetry." The Baroness was in good company in this journal, which also featured the poetry of

Hart Crane, Marianne Moore, and Comte de Lautreamont translated by John Rodker. Loeb was printing in Munich, where costs were cheaper and paper quality better than in Rome or Paris.[53]

In the spring of 1923, Jane Heap organized the Baroness's departure from New York. Americans came to her help, acting generously and kindly. Perhaps they also thought it was an easy price to pay—for peace. There must have been a sigh of relief as the Village prepared to return to Europe its Baroness, who had been mocking Americans and their young artists so sardonically, relentlessly, and violently. The most important donation came from William Carlos Williams. He recalled that he gave her $200: "It was stolen by the go-between."[58] (Perhaps it was used to pay for the Hudson Hotel.) Williams gave her more to replace the loss, his generosity no doubt a testimony to his continued admiration for the Baroness, mixed as this feeling was with shame and relief about her departure. The decorative artist Robert (Bob) Chanler (1872–1930) on Twenty-fourth Street also helped with a contribution: "I am sure—he *'contributed'* to my *'traveling expenses'* III klass [sic]—with no baggage—$30 left over—to face life's new start in Germany," as the Baroness recalled for Barnes.[59] Other friends and acquaintances may have contributed, including the artist Jerome Blume, whom she had severely chastised for marrying a sister-wife who was leading him by her apron strings; "Frances," the Baroness's friend in the Washington Square Bookstore; the art school instructor Kenneth Hayes Miller, who had *"a good heart"*;[60] the poet Louis Gilmore, with whom she corresponded in 1922; and "Anthony"—her last disappointing love in New York City.

Unhappy about traveling third class, she made quixotic plans to work as a stewardess on board the ship: "How about going as [a] stewardess? I asked the consul if he could not arrange *that*—in a letter," she informed Heap.[61] These plans did not materialize, however, although the dada Baroness serving tea to bourgeois guests on

board the ship might have produced some memorable scenes. Meanwhile, she sent copies of her published work to August Endell, now a distinguished art professor in Breslau.[62] She had requested her marriage certificate, birth certificate, and sworn declaration from the German embassy in Washington, D.C.[63] She tried to find good homes for Pinky and her other pets. "Is there any *difficulty* in taking a dog into Germany or France," she asked Heap. "The hotel clerk here said something about *six month quarantine*—Pinky can not stand 2 *weeks* without *dying of broken heart!*" Even one night alone was traumatic, for Pinky refused to eat and drink, grieving and mourning. A Dr. Rowling Nicholl at 95 Greenwich Avenue adopted one of her dogs, a terrier; but Pinky would travel with her.[64] In March, her manuscripts and artwork—packed in three trunks and one large box—were put in storage for $12. As she told Heap: "All my possessions are in there[:] mss. dresses—etc all en melee——I don't care to take them—but—who'll keep them? I would like to go with as little as possible!"[65] The Baroness then camped for a month in Fort Washington Park, perhaps appropriately saying farewell by connecting with the living earth.

On 18 April 1923, she boarded the S.S. *York / Yorck* for Bremen, her dog Pinky in tow. She had signed a contract for him, paying $15 for transport in addition to $4.50 for feeding costs.[66] Heap saw her off, waving farewell to her warrior in arms. After her New York battles, the Baroness was a little war-weary. Like Ulysses returning home to his island Ithaca, so the Baroness was nostalgically fantasizing about her Baltic Island: she was no longer a struggling exile but going home. Exultingly she invited Anderson and Heap to the Baltic Coast, promising she would teach them German. Once again she was flying high: "I wished also I could kiss somebuddy! That—will—come—," she promised herself as she was leaving.[67] At age forty-nine, she had established her name as a formidable dada artist who was admired and feared. She had

marked New York City with a concept of art as a literal moveable feast that was now firmly anchored in the modernist memory bank. She was entering the Indian summer of her career. From smoldering hot-wire transmitting Europe into America, she was now taking her American dada back to Europe.

SURELY I am "Ancient Mariner," was where he was—**DEATH** SPOOK **AROUND.**

– THE BARONESS, ca. **1927**[1]

I have *become* American. . . . Let me ᶠˡᵉᵉ back—**with you**—in time to where now—I *belong!* **And** *nowhere else!* *America!*

– THE BARONESS, to DJUNA BARNES, ca. 19**24**[2]

I am **not** crazy—I am *keen*—if I am in **my** realm—**my** s t r e a m —
my **w a t e r !** Consider me a **fish**—Djuna—that is left
on bone-dry beach by **c r a z y** time's tide! PUT ME INTO [the] sea again!
I will s w i m —[as] **strong** as **ever!** Nay—*stronger!*

– THE BARONESS, to DJUNA BARNES, ca. **1924**[3]

BERLIN and PARIS
Dada

Part **IV**

Berlin Exile

Chapter 12

"Dopes, mainly cocaine, were to be had in profusion at most night places," recalled Robert McAlmon about his visit to Berlin in 1922, just one year before the Baroness's arrival.[4] Although McAlmon enjoyed his privileged position as an American sexual tourist, he ultimately found Berlin depressing: "The innumerable beggars, paralytics, shell-shocked soldiers, and starving people of good family became at last too violent a depressant."[5] In January 1923, France and Belgium invaded Germany's industrial heartland, the Ruhr, after the German government discontinued its crippling war reparation payments. The invasion created an economic and a national crisis of unprecedented proportions in the Weimar Republic, Germany's fragile democracy born in Weimar in 1919. The haunting specter of people carrying heaps of inflation money in wheelbarrows has become the visual emblem for this period. Overnight, the nation plunged into poverty and chaos. It took until September to restore social and political order.[6]

The Baroness could not have arrived home at a worse time. In April 1923, on board the S.S. *York,* she was blithely oblivious to the difficulties that lay ahead. Soon she would write: "I am gone to my deathtrap, who would have thought it—when I was standing on board ship. [. . .] I am living dead. I have no exuberance—no 'call.'"[7] Caught in war-ravaged Germany, she was to spend the next three years in exile, recording her despair in heartbreaking letters to her American friends—Pauline Turkel, Eleanor Fitzgerald, Rose McDougal, Berenice Abbott, Sarah Freedman, and of course, Djuna Barnes. The Baroness settled in Charlottenburg, close to Kurfürstendamm in the western part of Berlin, living in a "dingy unheatable maidsroom."[8] On 12 June, she applied in person for a war widow's pension at the Charlottenburg Reichspensionsamt, yet her claim was unsuccessful, for no pension status was ever registered on the Baroness's official documents for 1923 to 1926.[9]

Unsuccessful, too, were her efforts to connect with the Freytag-Loringhoven family, as she followed up the correspondence already begun after her husband's death in 1919. In the spring of 1923, the family's lawyer sent her a package containing her late husband's belongings, including a gold watch, a gold chain, gold cufflinks, a wallet, and a shoe horn, but declined any further communication. Future letters from her would be "returned unopened"; the family was not intimidated by her "implied threats" ("versteckten Drohungen").[10] Such legal warnings might have deterred others, but the seasoned dada warrior increased her pressure: "I must turn to my relatives by marriage and can do it only *by force!*" she said. "They cannot afford *public scandal.*" Such unorthodox ethics troubled her good friend Pauline Turkel, who called her methods "blackmail."[11] According to Freytag-Loringhoven family lore, the Baroness even forged checks (mis)using the family's name.[12]

Soon she was hurled back to the frontlines of psychological battles by the news of her father's death on 3 July 1923 in Swinemünde. With it came the staggering discovery that Adolf Plötz had disinherited his elder daughter.[13] To the last, the rebellious daughter was put in her place by the authoritarian patriarch as she braved the "mean-spirited tone of my father's testament." In a lengthy letter she composed presumably for lawyers, she lashed out against her father, sister, and stepmother. "Now I want my inheritance," she proclaimed.[14] Yet the planned contestation came to naught. The villa at the beach, the hotel, the family home—all were gone forever, along with her nostalgic hope for a peaceful home by the Baltic Sea. Her ambivalence about her father is revealed in a dream in which she was lying on the doorsill of her dingy maid's room, a room that faced a "richly dark furnished gentleman's room,"

covered only with my rather dirty woolen blanket from New York—lying beneath it—with my face to floor—moaning—whimpering—for exhaustion—fear! [. . .] [S]uddenly—with a jerk—I wanted to rise—but some big—commanding caressing hand—decidedly put my head down from behind neck upon shiny smooth very large well rounded chest of flesh and bone—but as sheeny smooth as of polished marble or metal.

At this point the dream narrative swerved, and she was suddenly in the "gentleman's" room, kneeling in front of the couch "upon which a man was lying—straight as a corpse." She concluded: "I had never seen that man before—yet—*well I knew him*—it was my father."[15] Evoking Adolf Plötz's recent death, the "corpse" and the body of "polished marble" or "metal" also evoke the man's inexorable hardness in life. The "commanding caressing hand" is the daughter's fantasy of father power that is ultimately soft and gentle. In his "metal" countenance, her dream father also evokes the steel-clad and vengeful commandant who returns from the grave to destroy the philanderer in the Don Juan legend. With all hope for reconciliation gone, she swore eternal enmity now against her father.

A visit with her second cousins further fueled her flaming anger. The war had not changed the hated bourgeois core of her family's existence, as she bluntly noted: "That same imperishable furniture—as imperishably hideous—as stinking imperishable as they [are]." Retrospectively, she seemed disappointed to find everybody in her family alive. For she was "ungraciously welcomed—with malicious satisfaction—to—kindly go moaningly to rot with them—if you please—since I did not belong to post war generation of their damn breed[. . . .] I don't belong at all to their damn breed as my mother didn't!"[16] She refused to visit her sister, now living in West Prussia with her family. Rebuffing Charlotte Plötz Kannegieser's pragmatically cold charity, she composed a hateful missive

12.**1** *Kurfürstendamm and Joachimsthalerstrasse, Kaiser-Wilhelm
Gedächtniskirche in the background, ca. 1930. Photograph.*
Landesbildstelle Berlin.

about her and her family's injustice, a letter designed to cut off any
remaining loyalties, as she addressed her sister as "you fortune-
hunter, you whore of life" while ending the letter with "Mother is
cursing you and your off-spring."[17]

Her father's act of revenge now led her to wage war
against Germany, her Teutonic "fatherland," as in this letter to
Barnes: "[M]y German father—fatherland—stupid aged bour-
geois—turning meanly destructive in desperate defeat—has me by
gorge to throttle me."[18] She gleefully noted that Germany's old tra-
ditions were dead. "The Germans—the pure Teuton *is past!*" "He
has become too comfortably dull—has forgotten to move—fight—
except in that mechanical war fashion with weapons—that [are] out
of date—as was proved *in—by* him."[19] Nor did she like Germany's
young democracy, calling it a bad imitation of America's modernity,

"old traditions' sulkily pouting decaying magotty mess—rankly overgrown by modernism's vile sprouting vainglorious verdure."[20] While Berenice Abbott described her as "very German," she ruthlessly cast off her German heritage. "[I]f you would know the—the shame—hot blush—nausea—I feel—when I write on [the] back of [the] envelope: 'Germany'! Fi! I can not have much German blood in me—do I strike you as German?"[21] She now declared her identity as an American artist, even renouncing her earlier anti-Semitism and embracing America's diversity as strength.[22]

Yet the most desperate period was about to begin. A proletarian in Berlin, she supported herself by selling newspapers on the Kurfürstendamm (the very setting for the Berlin dada soirée just three years earlier).[23] From fall 1923 to late spring 1924, she was peddling her fare "at the corner of Joachimsthalerstrasse" (figure 12.1),[24] where even today newspapers are being sold and where the Baroness's old haunt, the Café Kranzler, now caters to twenty-first-century tourists. From this corner she had an excellent view of the Kaiser-Wilhelm-Gedächtnis-Kirche, in the tourist heart of Berlin. Here on the Kurfürstendamm occurred the chance meeting with the black Jamaican American poet and editor of *The Liberator*, Claude McKay, who was touring Berlin. "How shockingly sad it was to meet Frau Freytag," recalled McKay, "a shabby wretched female selling newspapers, stripped of all her rococo richness of her clothes, her speech, her personality." He continued:

Our meeting surprised both of us. We talked a little, but she had to sell her newspapers, for she said her rent was overdue. So we made a rendezvous for the next evening at the Romanisher Café.

It was a sad rendezvous. The Baroness in Greenwich Village, arraigned in gaudy accoutrements, was a character. Now in German homespun, she was just a poor pitiful *frau*. She said she had

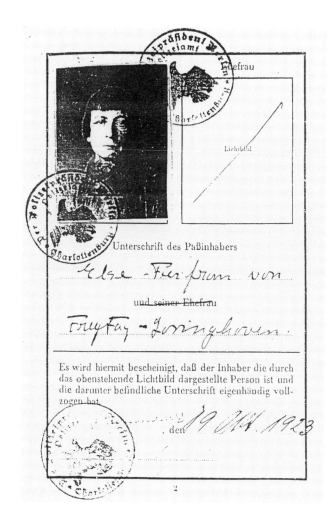

Ehefrau

Lichtbild

Unterschrift des Paßinhabers

Else Freiherrn von

und seiner Ehefrau

Freytag-Loringhoven.

Es wird hiermit bescheinigt, daß der Inhaber die durch
das obenstehende Lichtbild dargestellte Person ist und
die darunter befindliche Unterschrift eigenhändig voll-
zogen hat.

, den *19 OKT. 1923*

12.**2** *Elsa von Freytag-Loringhoven's passport,* 19 October 1923. Elsa von Freytag- Loringhoven Papers.

Special Collections, University of Maryland at College Park Libraries.

come to Germany to write because the cost of living was cheap there. But she complained that she had been ditched. She didn't make it clear by whom or what. So instead of writing she was crying news. She wished that she was back in New York, she said.

McKay was accompanied by an affluent American student friend who made the Baroness a great joy with a gift of $5 after being assured that the news peddler "was a real poet."[25]

 She also met the Chicagoan pianist Allen Tanner, who was in Berlin and whom she knew from New York from Jane Heap's circle. With Tanner was his new partner, the renowned Russian artist Pavel Tchelitchew (1898–1956), who was designing sets and costumes at the Berlin Staatsoper, as well as for other theaters, and whose homoerotic art is increasingly recognized today. Tanner, gentle and supportive, and Tchelitchew, dynamic and brilliant, helped the Baroness financially, after which she repaid them generously by giving Tanner four of her artworks: *Enduring Ornament, Limbswish, Earring-Object,* and *Cathedral* (the splinter of wood that Tchelitchew later mounted). Tanner returned the objects to New York.[26]

 The Baroness's deterioration is confirmed by the photograph on her passport finally issued on 19 October 1923 (figure 12.2).[27] Her hairstyle is less dada than homemade budget cut; her eyes are more weary than defiant. "I am at the mercy of street riffraff," she noted in fall 1923. "I have no heating, bed, furniture, clothing, and winter is coming."[28] Unable to attend to the most basic personal care, she lost all dada glamour. Writing a few months later on a winter Sunday, she detailed her poverty: "In all my utter poverty—my improbable life—standing on [a] windy corner of street selling newspapers in winter at Christmastime—in snow and sleet," working from "12:00 a.m. to 2 p.m. *uninterrupted.*" She was writing to Mary Eleanor Fitzgerald (1877–1955), nicknamed "Fitzi," who had worked as a secretary to Emma Goldman and then

as the business manager for the Provincetown players.[29] A photograph of Fitzgerald shows a tall, proud, and efficient-looking woman, accompanied by a large and elegant dog. Appealing to the dog lover, the Baroness reported that she had found Pinky "an excellent home," so that he was not missing her, "who was never a real mistress to him—by temperament and position." Indeed, Pinky, living in comfort and luxury, was doing better than the Baroness.[30] After having laid out her plight, the Baroness gave Fitzgerald a list of things to do: purchase underwear for her from Miss Katherine Pierce on West Eleventh Street in New York; collect money owed to the Baroness from Charles Sheeler on Fifth Avenue; go to "Frances" in the Washington Square Bookstore to solicit help. Whether Fitzgerald provided help is unknown, but this strategy of addressing herself directly to her American friends would sustain her during the remaining Berlin years.

To leave Germany was her all-compelling drive from 1923 to 1926. Perhaps inspired by Allen Tanner, she dreamed of working as a model in Chicago. But her eye was also set on Paris, the new metropolis of dadaists and surrealists. Thus she promptly picked up the pen and wrote once again to Tristan Tzara, this time in German, inquiring whether she would be hated in Paris as a German national, an "arch-enemy" (*Erzfeindin*). She longed to learn French, ready to embark on yet another new linguistic journey.[31] Yet visa problems continued to complicate the Baroness's life. In the wake of the increased tension between Germany and France, the Baroness's illustrious name proved a liability. A member of the Freytag-Loringhoven family, a professor, had a seat in the Reichstag representing the antirepublican German National People's Party. That the Freytag-Loringhoven name was connected to public politics, advocating a return to the monarchical Hohenzollern empire, no doubt would have been suspect to the French.[32] Pauline Turkel tried to procure a fake Russian passport

for her, but the scheme backfired when the consul recognized the Baroness's face from the time in the summer when she had "applied *in person* for a *German* passport and failed."[33] Now literally caught in Germany, her sense of claustrophobia and paranoia escalated, and she bitterly blamed Heap for her fate: "She made it a condition for me to go to Germany! I should just as well have gone to Paris! In fact, it was my original plan."[34] Heap, now in Paris, perhaps wanted to abdicate responsibility for the demanding dada artist she had once championed.

In the depths of misery, the Baroness began to haunt the group of aging male artists she knew at the century's turn. Her epistolary campaign testifies that she had lost neither her venom nor her pride, as she appealed to former friends and foes for help. "I have lived and acted thus: rigid—unbending—honest," she proudly wrote to Richard Schmitz, the man who once adored her. "When Felix [Paul Greve] appeared, *the world disappeared around me, was contained in him* and therefore I was cruel," she reasoned with a logic all her own: "That is virtue." From apologia she swiftly launched into critical attack mode: "In *literature,* you would admire—adore—and love *such a woman;* you would feel compelled to help her—! *Are you all cold, impotent aesthetes*—even you?" With a last dramatic flourish she added: "I am *Elsa!* In grave danger." But even her gift of her German poetry—evidence that she was deserving of help as an artist— was in vain. The heart of the formerly soft-hearted Schmitz appeared to have hardened.[35]

Her next target was August Endell. From New York, she had sent him "The Weird Story of Mr. Puckelonder," mocking him poetically as a fumbling lover. He must have answered her letter with a plea for peace for her subsequent Berlin letter begins: "Tse—here I break down—for my heart is heavy! It pains me so— to cause you pain! " Still, she did not relent in her request for help: "I don't want very much—compassion—some help—humanity."

Yet her letter also revealed conflicting feelings about her former husband, now the director of the prestigious Arts Academy in Breslau, as she ended with an undisguised challenge: "After Palermo, you temporarily displayed a mean weakness, which is not necessarily constitutional. We shall see." The verdict about Endell, she implied, was still open: the test was still ongoing.[36] The challenge was likely too much for her opponent, who suffered a physical breakdown in 1924, as his friend Lou Salomé recorded in her memoirs. Endell died in Berlin on 15 April 1925, three days after his fifty-fourth birthday.[37] For Endell, the Baroness must have been a bad nightmare returning with full force in the postwar era.

Next on her list was the book decorator Marcus Behmer, who lived on 23 Fraunhoferstrasse in Charlottenburg. "I hope my letter was not painful to you," her postcard (post-stamped 23 July 1924) reads, the reference to pain by now a familiar refrain: "I can't help it old boy—I have to come in one of these days to talk things over with you please to get some advice—and to dine with you—nothing else. Please—don't be angry + I know you don't enjoy my company—no wonder—I don't enjoy mine [. . .] either." The tone of her three postcards was cordially intimate, as she addressed him in English as "My dear dear Marcus" and "Darling Behmer," suggesting that he did provide some help.[38] That her postcards to Behmer were found among her personal papers suggests that Baroness may have requested them back as biographical documents.[39]

Finally, she descended on the circle's former leader—the Meister—with a blackmailing letter written in English. Presumably addressed directly to Stefan George, the letter mixes jest with homophobic diatribe, as she alludes to a compromising photograph:

You disgusting obsolete old fairy with the "prima donna mind"— *that foto* was taken nearly a generation ago—when "Carlos" [Karl

Wolfskehl] kissed your ars. Even "Ricarda" [the writer Ricarda Huch] has more dignity than you—go to Hades—honey! You are "Charley Chaplin" beneath your high diddledidy—not "Goethe." Who pushed you? Some ole he-sister? Anyway—you got the cash. So what do you mind—what *I* think of you? That's why I write this. I don't hate you enough to cause you tears—but you are a fake—according to your weakness. You are at least 63 or going to be next 12 of July—*I know.*[40]

Although George was turning fifty-six (not sixty-three) in 1924, the 12 July birthday the Baroness shared with the *Meister* was a coincidence she would remember. The focus on male homosexuality ("fairy" and "ole he-sister"), the addressee's imposing status ("prima donna mind") and ("your high diddledidy"), and the comment that Wolfskehl "kissed your ars" (in her autobiography, Wolfskehl kisses George's "coattails")[41]—all point to George as the addressee. She was trying to blackmail the Meister with a compromising photograph, probably threatening to expose his homosexuality.

 Ultimately, however, the Baroness's revenge and extortion schemes bore little financial fruit. Only two of her former friends were willing to make a contribution, as she noted: "my first most romantically important—lover [Ernst Hardt] gave me ample alms—and from that time he is adamant," refusing to support her long-term. The other friend (Behmer) was helpful with small gifts but then "got tired at last" and invented a quarrel to "get rid" of the "troublesome" Baroness.[42] Still, she succeeded in disturbing the peace of mind of several of the aging members of the fin-de-siècle German vanguard.

 At the same time, the Baroness was effectively an artist in exile. That she was profoundly isolated may be baffling insofar as Berlin in the early twenties was the city of artists, as dadaist Richard Huelsenbeck noted: "I can remember a thoroughly motley group

that made up Berlin's literary Bohemia in clouds of cigarette smoke behind tiny tables. Gottfried Benn, Else Lasker-Schüler, Resi Langer, Baron Schennis, Taka Taka, and the skin-and-bones drug addict Höxter, a master moocher."[43] A vibrant group of Berlin expressionists, *Der Sturm* (The Storm), organized poetry recitals and exhibitions in the *Sturm* gallery and ushered books through its *Sturm* publishing house. *Der Sturm* included Else Lasker-Schüler, Karl Wolfskehl, Oskar Kokoschka, Peter Hille, and Georg Kaiser. Intriguingly, the Baroness occasionally used *Sturm* stationary but appeared to have had little contact with the *Sturm* members. Indeed, she regularly complained that she had found "no friends and circle here—to flourish."[44]

Nor did the Baroness have much contact with Berlin dadaists like Huelsenbeck and George Grosz, who eventually emigrated to the United States. She did not mention the myriad of publication opportunities in Berlin that attracted Hans Richter. Dadaist Wieland Herzfelde had started the Malik Verlag, a publishing house near the Potsdamer Bahnhof that printed a myriad of dada-friendly journals.[45] New magazines were springing up in Germany, including *Der Querschnitt,* a modernist journal launched in Frankfurt in 1921 (and published through 1936), which provided an important and well-paying venue for Ezra Pound and Ernest Hemingway. Although familiar with *Der Querschnitt,* from which she clipped a photograph of Georgette Leblanc for Djuna Barnes, she did not anchor herself in this new journal—even though Pound had warmly suggested this publication venue for the Baroness in December 1922. Finally, she had no serious contact with the Weimar Bauhaus movement, although she mentioned traveling to Weimar as one of her goals.[46]

What, ultimately, enforced her exile from Germany's art communities? One answer lies in the horrendous material condi-

tions that created profound psychological and cultural barriers. While in New York, Freytag-Loringhoven had begun to engage with issues of mass culture and mass consumption in a poem like "Subjoyride." Berlin must have seemed like a step backward, confronting her with visions of death and terror, as well as with her own history of trauma. Huelsenbeck recalled that in Berlin, "death was furnished with all the bad instincts, and the rats replaced the symbol of the German eagle, who had been smashed on the battlefields."[47] The trauma resulting from the *real* sounds of the cannon and the *real* ravages of war was felt here with much more shocking immediacy than in other dada capitals, including Zurich and New York. In Berlin, the hypersensitive Baroness suffered from a chronically elevated state of anxiety that routinely flared up in bodily symptoms: "heart-palpitation and kneetrembling," "*fever* of *distraught fear,*" and terrifying nightmares and inability to sleep.[48] She was no longer able to control her torturing anxiety. The heightened war trauma may have been too close to home to be turned into art. Berlin was a traumatic scenery that the Baroness at age fifty was trying to escape, her futurist belief in the purifying power of destruction rendered ad absurdum when confronted so closely with the effects of destruction. Her dada soul needed the distance of New York or Paris.

Moreover, her Nietzschean concept of the artist as a spiritual aristocrat was out of step with Berlin's politicized dada, the communist and pacifist activism of Raoul Hausmann, Johannes Baader, and George Grosz. The First International Dada Fair in Berlin (June to August 1920) was propelled forward by the political slogan "Dada Fights on the Side of the Revolutionary Proletariat."[49] A sardonic painter and caricature artist, Grosz, for instance, was driven by "his hatred against the more fortunate classes."[50] A native Pomeranian, like the Baroness, Grosz had grown up in a military officers' casino run by his parents, an experience that would instil a lifelong hatred of the ruling classes. Finally, Berlin dadaists were a

group of angry young men with little interest in feminist politics. A case in point was the fate of the sole woman dadaist in Berlin, Hannah Höch (1889–1978), whose relationship with Hausmann was marked by troubling emotional and physical abuse.[51] When vacationing at the Baltic in 1918, the couple discovered military pictures with the heads of soldiers pasted in; the torn pictures seemed to be an apt evocation of the chaos associated with the war and the political revolutions in Germany. Together Höch and Hausmann pioneered the photomontage.[52] Höch was a formidable artist in her own right, whose educational history was remarkably close to the Baroness's.[53] Yet Höch was remembered by dadaists like Richter less for her brilliant art than for "the sandwiches, beer and coffee she managed somehow to conjure up despite the shortage of money."[54] In 1920, Grosz and John Heartfield vehemently opposed the exhibition of Höch's work at the First International Dada Fair. Only after Hausmann threatened to withdraw was Höch's work allowed to be shown.

Like the Baroness, Höch turned her artistic focus on Weimar culture, as in her collage with the elaborate title *Schnitt mit dem Küchenmesser Dada durch die letzte weimarer Bierbauchkulturepoche Deutschlands (Cut with the kitchen knife Dada through Weimar's last beer-belly cultural epoch)* (1919).[55] As we view the torn head of Kaiser Wilhelm II free-floating among men in military uniforms, cannon wheels, and pretty girls cut from magazines, the Baroness's sardonic comments on Weimar Germany are like a perfect soundtrack for Höch's work: "Teuton needs to hurrah to respect himself—have something to hurrah to—he also needs guiding snarling commanding voice." Even in Weimar's democracy, the reactionary Teuton is still longing to "[kiss] Kaiser's ars."[56] Both Höch and the Baroness satirized Weimar Germany's beer-belly culture with its nostalgia for old Teutonic Germany. Interspersed in Höch's photomontage are numerous "dadas" to which she provocatively assigned a female

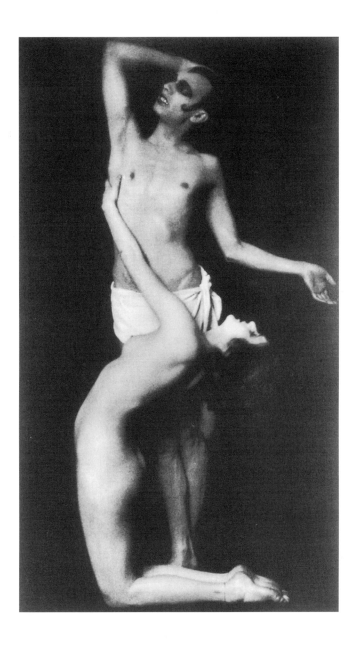

12.**3** Anita Berber and Sebastian Droste, *Märtyrer*, 1922. Photograph
by Madame d'Ora. Courtesy Monika Faber, Vienna.

gender, "*Die* grosse Welt dada," "*Die* anti-Dada," counteracting those who saw the "Dadaist Headquarters of World Revolution" as exclusively male: "BAADER, HAUSMANN, TRISTAN TZARA, GEORGE GROSZ, MARCEL JANCO, HANS ARP, RICHARD HUELSENBECK, FRANZ JUNG, EUGEN ERNEST, A. R. MEYER."[57] For Höch, the cutting knife of dada itself became a feminized, domestic kitchen knife that contested Berlin dada's exclusionary politics.[58]

By 1923, when the Baroness arrived in Berlin, Höch was accommodating many artist-visitors in her Büsingstrasse studio in Berlin Friednau, a studio decorated with her own masks, puppets, and other artwork.[59] Retrospectively marveling at these opportunities in Berlin, we are left with the sense that the Baroness's fate might have been very different if the two women had met and if the Baroness might have been invited to visit Höch's studio. Here she would have been intrigued to see Höch's photomontage experiments in androgyny: *Das Schöne Mädchen* (The beautiful girl) (1919–20), with body fragments of the sexy "girl," whose head is a lightbulb adorned with big hair. Soon Höch's work would reflect the fact that androgyny was conquering Berlin and Weimar Germany: *Marlene* (1930), the leg of Dietrich represented on a pedestal.[60]

Just as the Baroness had flaunted androgyny in Berlin in the 1890s, decades before her time, so a new generation of androgynous women was now conquering Berlin's stage and film industry. The 1920s saw the rise of Maria Magdalena Dietrich, a.k.a. Marlene Dietrich (1901–1992), who would soon become a cult figure. Androgyny was entering the fashionable mainstream at the same time that age was working against the Baroness. Berlin's Baroness-like performance star was the young Anita Berber (1899–1928), a nude performer who described herself as "genderless" (*geschlechtslos*) and simultaneously inhabiting "all genders" (*alle Geschlechter*) and who was rumored to have had an affair with the homosexual director of the newly founded Institut für Sexualwissenschaft, Magnus

Hirschfeld.[61] Berber performed in a male suit and monocle in the Nelsontheater on the Kurfürstendamm. With her partner Sebastian Droste, she also performed in the nude in the Weisse Maus, a well-known cabaret.

A stunning photograph of their 1922 performance *Märtyrer* (Martyrs) (figure 12.3) captures the couple's radical androgyny that combined grotesque expression of makeup with daring body postures. They ultimately gave expression to the age of hyperinflation with such performances as *Tänze des Lasters* (Dances of Vice), *Tänze des Grauens und der Extase* (Dances of horror and ecstasy), *Haus der Irren* (House of madness), *Selbstmord* (suicide) and *Kokain,* encapsulating the spirit of the age that drugged itself with "snow" (*Schnee*). Berber was notorious for her use of cocaine. In 1924, the young German writer Klaus Mann, the son of the famous Thomas, described Berber like a figure of death: "Her face was a fiercely dark mask. The circle of her painted mouth didn't seem to belong to her, but was a blood red creation from the make-up box. Her chalky cheeks glittered purple. Each day she had to work at least an hour to create the eyes." "Everything around her turned to scandal," recalled Mann. "She stood surrounded by legend in the midst of a terrible loneliness. Icy-cold air surrounded her. In order not to become enervated by that, she became more and more radical."[62]

Like the Baroness in New York City, Berber was considered a dangerous woman. Performing in the Wintergarten Varieté where the Baroness had made her debut in 1896, Berber, too, wanted to be taken seriously as a radical artist and insulted her audience when they ridiculed her. Once she broke a bottle over the head of an audience member who laughed at her. Another time she almost bit off the finger of a woman who dared point at her in the streets. Peddling her newspapers on Kurfürstendamm in 1923 and 1924, the Baroness may have seen the young Berber make one of her famous appearances. "When Anita climbed out of the car on

Kurfürstendamm," as one observer later recalled, "clad in furs, wearing a monocle, with starkly painted face under red hair—passersby stopped, prostitutes came running to see her, creating a corridor for her, as Anita stormed into the bar."[63]

And there may be another connection between the two women: Berber's second husband, the dancer Henri Châtin-Hofmann, "a fresh, laughing, American boy," the son of a Baltimore reverend who performed as a dancer in the Blüthner-Saal.[64] Berber married him two weeks after first seeing him, and they became partners on stage, repeating the scandalous performances that had marked her success with Sebastian Droste (who, incidentally, was now in New York masquerading as a baron). Henri Châtin-Hofmann may, in fact, be the man who shared quarters with the Baroness in 1923. For in the back room of the Baroness's 1923 Berlin flat lived a "well-known dancer," known as "Henri the Dancer." As Abbott recalled: "I thought him weird, but he was very friendly to Elsa,"[65] an intriguing description, given Châtin-Hofmann's performances on and behind the stage, as "Henri" occasionally engaged in physical fights with unruly admirers in the corner of the stage, while Berber, still in the nude, launched a tirade of swearwords at viewers as they were exiting the theater.[66] The Baroness's friendship with "Henri the Dancer" cooled, after he ridiculed her for becoming a newspaper peddler. As for Berber, she was burning herself up even more quickly than the Baroness. Not yet thirty years old, she died of consumption in November 1928.

Meanwhile, the Baroness had rekindled her performance spark. By the summer of 1924, she was working as a model in a Berlin art school: "There is little work—posing—badly paid—badly—about the stupidity and baseness *of it* here."[67] Modeling, once again, inspired her to add to her portfolio of memorable performance acts. On her birthday, on 12 July, she flashed her art in a politically charged setting: the French consulate in Berlin that had

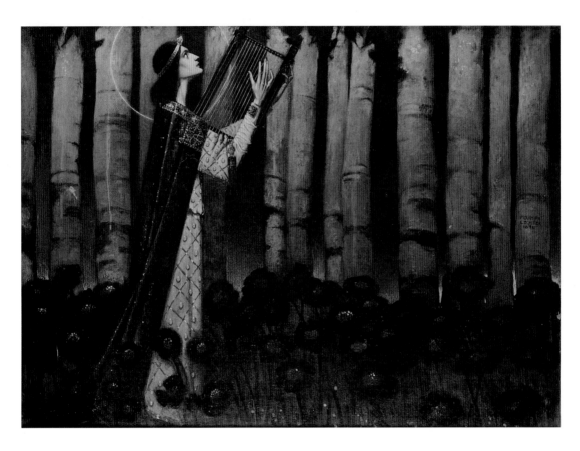

pl**.1** Melchior Lechter, *Orpheus*, 1896. Oil, 118.5 × 147.0 cm. Westfälisches Landesmuseum für Kunst und Kulturgeschichte, Münster.

pl.**2** Baroness Elsa von Freytag-Loringhoven, *Enduring Ornament,* 1913. Found object, metal ring, approx. 3 1/3 in. diameter. Mark Kelman Collection, New York.

pl.**3** Baroness Elsa von Freytag-Loringhoven, [with Morton Livingston Schamberg]. *God,* 1917. Plumbing trap on a carpenter's miter box. The Louise and Walter Arensberg Collection, 10 1/2in. Philadelphia Museum of Art.

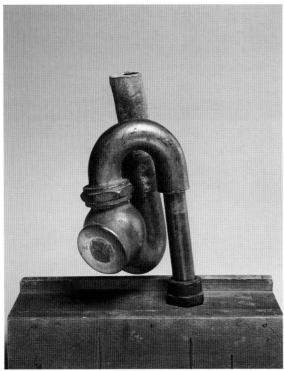

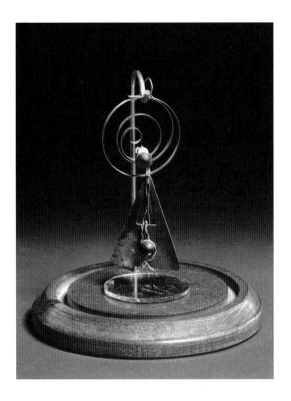

pl.**4** Baroness Elsa von Freytag-Loringhoven, *Earring-Object.* ca. 1917–1919. Mixed media, 4 3/4 × 3 × 3 in. Mark Kelman Collection, New York.

pl.**5** Baroness Elsa von Freytag-Loringhoven, *Limbswish,* ca. 1920. Metal spring, curtain tassel, approx. 18 in. high. Mark Kelman Collection, New York.

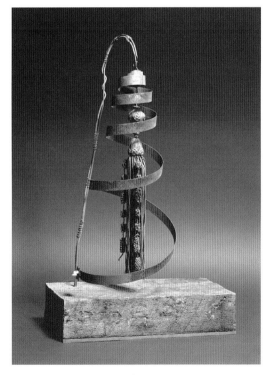

pl.**6** Theresa Bernstein, *Elsa von Freytag-Loringhoven,* ca. 1917. Oil.
Gisela Baronin Freytag v. Loringhoven Collection, Tübingen.

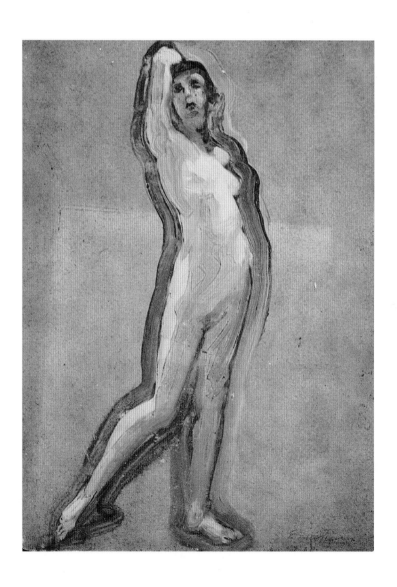

pl.**7** Theresa Bernstein, *Elsa von Freytag-Loringhoven*, ca. 1916–17.

Oil. 12 × 9 in. Francis M. Naumann Collection, New York.

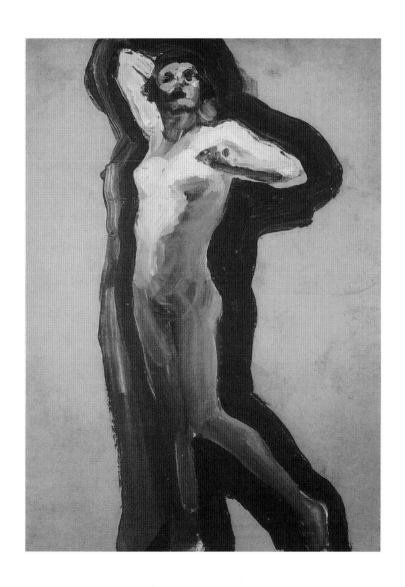

pl.**8** Baroness Elsa von Freytag-Loringhoven, *Portrait of Marcel
Duchamp*, ca. 1922. Pastel and collage, 12 3/16 × 18 1/8 in.
Vera, Silvia, and Arturo Schwarz Collection of Dada and Surrealist
Art, Israel Museum, Jerusalem.

pl.**9** Baroness Elsa von Freytag-Loringhoven, *Dada Portrait of Berenice Abbott,* ca. 1923–24. Collage of fabric, paper, glass, cellophane, metal foils, paper, stones, cloth, paint, etc., 8 5/8 × 9 1/4 in. Mary Reynolds Collection, The Museum of Modern Art, New York.

pl. **10** Baroness Elsa von Freytag-Loringhoven, *Cathedral,* ca. 1918.

Wood fragment, approx. 4 in. high. Mark Kelman Collection, New York.

denied her visa. The act will be relayed to and remembered by the American exiles in Paris, as Janet Flanner records: "Always pro-French, she once called, in honor of her birthday, on the French consul in Berlin with her birthday cake and its lighted candles poised on her superb skull."[68] The Baroness herself relays the act with obvious glee to Barnes:

I went to the consulate with a large—sugarcoated birthday cake upon my head with 50 flaming candles lit—I felt just so *spunky and affluent*—! In my ears I wore sugar plumes or matchboxes—I forgot which. Also I had put on several stamps as beauty spots on my emerald painted cheeks and my eyelashes were made of guilded porcupine quills—rustling coquettishly—at the consul—with several ropes of dried figs dangling around my neck to give him a suck once and again—to entrance him. I should have liked to wear gaudy colored rubber boots up to my hips with a ballet skirt of genuine gold-paper white lacepaper covering it [to match the cake] but I couldn't afford *that*. I guess—that inconsistency in my costume is to blame for my failure to please the officials?[69]

As she coquettishly rustled her porcupine eyelashes at the (no doubt, flabbergasted) French consul, this performance was provocative and daring in light of the highly charged political tension between Germany and France. The Baroness's costume was a decadently sensual peace offering of oral delights as well as a satiric spectacle poking fun at the official bureaucracy that kept her locked up in Germany. The fantasized rubber boots up to the hips (an echo to Bismarck?) and the imagined "ballet skirt of genuine goldpaper" added another parody of the officer's military uniform with its high boots and golden decorations.

Indeed, her mood was optimistic as she wrote herself a birthday poem, "Spring in the Middle":

I am 50.
this early in spring—I notice my shouldersweat
of such rife—penetrating—rank—frank redolence—
as advanced cadaver–fresh myrrh stuffed
mummy let's off————maybe.
(*Surmise*)
Address to sun.
Older one gets—
young[er]—
longer one climbs
stronger—
lighter—
elevated—
is
law.
[. . .]
Into
treetop—
presently—
high
I
fly![70]

The awareness of her own pungently penetrating body perfume
(*rank* and *frank*) prompts an association with both life (*spring*) and
death (*cadaver*) in the image of the "mummy" prepared with "fresh
myrrh." Aging itself is deconstructed, for she becomes "lighter"
and more "elevated" with age. Her note of triumph befits her
celebratory birthday spirit that ultimately embraces motion as
life.

 "I ceased to be womb woman—I am spirit in flesh," the
Baroness had written to Biddle in the winter 1923, confidently pro-

claiming her menopause as a new stage that compelled her to claim eroticism in new ways.[71] Indeed, she was now actively turning her "spiritual" attention to women. Female friendship was the lifeline that maintained her spirit and her art, and conversely, her art was the medium that fed her friendships. Most notable were her friendships with Berenice Abbott and Djuna Barnes, the American artists who would support the Baroness as artist and woman.

Courting Djuna Barnes

During the early years of exile, the Baroness was sustained by Berenice Abbott. She wrote Abbott "desperate letters"; she also sent her "some wonderful drawings of the portrait that she was making of [Abbott]."[1] In the sensually remarkable collage *Dada Portrait of Berenice Abbott* (ca. 1923–1924) (see figure A.1), held today in New York's Museum of Modern Art, the Baroness exuberantly showered "Berenice" with rich adornments: hair jewelry made of a brush with white stone, a brooch with blue sapphires and red rubies, gilded eyelashes, a copper belt buckle, and a Duchampian shovel ready-made earring. In the center of the collage floats Abbott's face as a mask with red ruby eyes and sexualized doll's lips (in a letter, the Baroness refers to Abbott's "pouting lips"). The handlebar moustache alludes to Abbott's androgyny. The final jewel is the Baroness's signature in the upper left corner—in vertical graphics E-F-L with a crown on top. Several references to photography pay tribute to Abbott's new career as Man Ray's studio assistant, a career begun in 1923. Crouching on a pedestal on the left is a sketch of Abbott holding an umbrella adorned with beads. In front of it is a black sun, surrounded by solar spikes and alluding to the floodlights and reflectors used in professional photography.[2] In the foreground looking directly at the viewer is the Baroness's little black dog; a fitting tribute because Pinky had displayed a special affection for Abbott during her visit to the Baroness's apartment in New York.[3] This painting commemorated her little companion whom she was missing, just as she was missing Abbott.

While the *Dada Portrait of Berenice Abbott* is suffused with the warm colors of sunlight, her second painting for Abbott signals a cooling of her feelings. The colors are cold, predominantly white, blue, and gray, blending with the caption's bluish-purple ink: "Forgotten—Like This Parapluie / Am I By You—/ Faithless / Bernice!" (ca. 1923–1924) (figure 13.1). In the center stands an umbrella, closed up and seemingly useless. While the painting addresses itself to the "Faithless / Bernice," a single running foot is seen exiting on

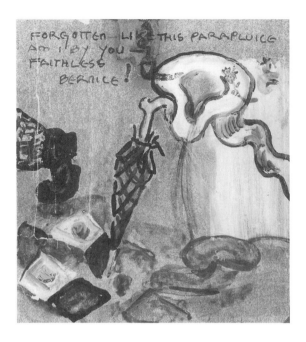

13.1 Elsa von Freytag-Loringhoven. Gouache and ink. *Forgotten Like This Parapluie Am I By You—Faithless Bernice!,* ca. 1923-24. Painting. Elsa von Freytag-Loringhoven Papers. Special Collections, University of Maryland at College Park Libraries.

the left, symbolizing *all* the friends who have been deserting her. Duchampian allusions abound in this work. The umbrella's round handle nudges against a white urinal whose plumbing pipes snake down to exit on the right. The urinal is placed up high, like *Fountain* sitting on an imaginary pedestal, Duchamp's pipe smoldering on the left rim. Meanwhile, the urinal's contents (*la pluie*) are pouring on the open books that are strewn on the ground, while the *parapluie* is closed up, useless, embodying the Baroness's stagnation: her art is being forgotten, literally spoiling on the floor, as her friends are exiting the picture, leaving behind a scene of disaster and disarray. Ultimately a self-portrait of the artist, *Forgotten—Like This Parapluie* playfully

alludes to the German painter Carl Spitzweg's popular self-portrait of *The Poor Poet* (1839), which has the poet sitting in bed and holding an umbrella over his head as the rain water is dripping through the ceiling. Viewing this work, we hear the Baroness's voice: "But—*Marcel*—is permitted to do art—without having poverty *squeeze* his *windpipe*—and others—so *many*—*many*!!"[4]

Another self-portrait of sorts can be found in the visual poem "Matter Level Perspective" (figure 13.2), arranged on a

13.**2** Baroness Elsa von Freytag-Loringhoven, *Matter Level Perspective*, 1922–23. Visual Poem. Elsa von Freytag-Loringhoven Papers. Special Collections, University of Maryland at College Park Libraries.

three-tier system of geometric forms. Above the foundational Matter Level Perspective, a sperm-cell-like upward spiraling trajectory moves the viewer's eye upward from the first realm (Life Spiral) to the second realm (Spirit Crafts, the domain of Art and Architect). Next, the Treadmill functions as an intermediary space, perhaps suggesting repetitive effort. The final and highest realm (Cathedral, spiraling upward toward Immured) signifies a perpetual motion that has her finally imprisoned. While the Cathedral realm makes reference to her wood fragment sculpture titled *Cathedral,* the clear taxonomy of geometrical lines and levels evokes Dante's taxonomy in the *Divine Comedy.* Her Berlin exile was an inferno of sorts, as she was caught in the circular treadmill she describes in her visual poem.[5]

13.**3** *Djuna Barnes,* ca. 1920s. Photograph. Elsa von Freytag-Loringhoven Papers. Special Collections, University of Maryland at College Park Libraries. © Copyright, The Authors League Fund, as literary executor of the Estate of Djuna Barnes.

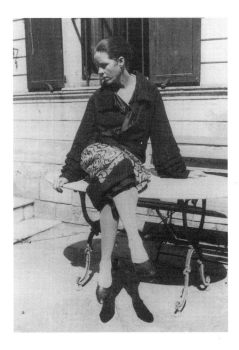

In the fall of 1923, Abbott connected the Baroness with Djuna Barnes (figure 13.3) in Paris: "I took one of Elsa's letters to Djuna to read and told her that she had to help Elsa," Abbott recalled. "Djuna was fascinated with the letters and began corresponding with her."[6] Abbott handed over her charge to Barnes, just as two years earlier, she had made her the gift of her own lover, the American sculptor Thelma Wood (1901–1970), the great love of Barnes's life. Indeed, Barnes's relations with the Baroness intensified at the same time as her relations with Wood began to decline, as Wood had begun cruising the Paris bars at night, plunging into a world of inebriation and promiscuity. Unlike the young Wood's drive for promiscuous freedom, the aging Baroness's ties with Barnes would soon be marked by the iron constancy of loyalty.[7]

From the beginning, the Baroness took hold of Barnes with desperate determination. "My *whole being* is *dependant upon you*," she confided, unabashedly acknowledging the symbiotic nature of her relationship with Barnes.[8] She appealed to Barnes as her maternal savior: "Sweetest Djuna—I kiss your hands," she enthused: "My heavens and earth-girl—you are my second mother!"[9] Deeply moved, Barnes assumed the mothering role, providing an extraordinary lifeline of material, emotional, and intellectual support. She sustained the Baroness with letters (many no longer extant) and packages containing clothing, money, jewels, books, magazines, and poetry. From Paris (1923–24), Cagnes-sur-Mer (October 1924–February 1925), London, and finally Italy (1925), Barnes's letters are all recorded in the Baroness's effusively thankful responses: "Dearest Djuna—yes—I got all your lovethings—and the money *5 pounds*. I had such great—great joy and—it was so necessary! Necessary! Necessary!" In the same letter she referred to the shoes sent by Barnes: "it is a *pity*—the shoes—those beauties—are *very much* too small for me! I wish I could give them back. *Shall I?* Else—I sell them! My heart bleeds. I am in love with them!"[10] Another letter acknowledges

"GINGHA" FOR "DJUNA"

13.**4** Baroness Elsa von Freytag-Loringhoven, *Ghingha,* 1924. Decorated poem. Elsa von Freytag-Loringhoven Papers. Special Collections, University of Maryland at College Park Libraries.

13.**5** Elsa von Freytag-Loringhoven, *Facing,* 1924. Decorated poem. Elsa von Freytag-Loringhoven Papers. Special Collections, University of Maryland at College Park Libraries.

receipt of Abbott's henna, her overture for paying much more lavish tribute to Barnes's ostensibly more luxuriant generosity: "Thankee! Your silver bead necklace I wear day and night. Are those two turquoise blue stars earrings? I wear them as such anyway—though somehow—they didn't seem intended for it by their fit. Am curious about it."[11] The Baroness was a grateful recipient, effusively detailing her pleasure in receiving Barnes's "lovethings."

In turn the Baroness showered Barnes with her artwork: her strangely beautiful poetry, her sensual style, her prominent dedications on the attractively decorated "Ghingha" (figure 13.4), "Facing" (figure 13.5), "Equinox," and "Clock." "It is late night— sweet—I cannot squeeze my gift to you into [the] envelope. I'll send

it right after!" She added that the gift had "become good," confident that her art will please her friend.[12] There are also gifts for others: "Did you get my package—with the long letter and the little gifts— one for Rose McDougal—a naïve little pipe—I once found broken on the street— repaired and prettily decorated by me with rose leaves in poetical allusion."[13] Sent as registered mail the package is testimony to the important value she attached to her artistic gift. She entertained Barnes with sardonic criticisms of *The Little Review* editors, no doubt aware of Barnes's bitter feelings after her failed affair with Jane Heap.

In June 1924, the Baroness proposed that Barnes hire her as a "private secretary," a scheme to facilitate her visa application for France.[14] Yet it was Barnes who soon acted as the Baroness's editor, agent, and secretary, as the Baroness returned with energy to her poetry. Numerous letters focused on poetic strategies, word choice, and effectiveness of sounds, as when the Baroness exuberantly proposed to invent a new punctuation system, one that was able to reflect *emotions.* "[O]ur interpunction system is puny!," she noted, calling for a "joy mark!" that signaled "happiness": "One should be able to express almost as much in interpunction—as words—yes—at last even—after gradual evolution—in this new strange thing—to express absolute in it! As I did in sounds—like music! Yes! *Wordnotes.*" Although she trusted Barnes more than she ever trusted Margaret Anderson, she was quick to shield her work when Barnes suggested revisions. "I am not quite in accord with you about the 'not being concise' of my clock," she defended her poem "Clock," a work that the literary critic Lynn DeVore has called "her masterpiece." "Clock" returned to the "Mustir" motif with Duchampian allusions:

Mustir—nearest one—
join—if so far you
Deign to descend

Fastness

ungiggling

<Nude Descending Staircase>.

Trying to overcome her editor's pragmatic concerns with the poem's gargantuan length (a total of forty-two manuscript pages), she insisted: "[W]hy should not be something of some size—equally important—be published by me in the transatlantic where so many trifling articles find room?" Everything in her poem "relates—and in an interesting manner," she argued, for she had used a "jestingly satirical" voice to make it "palatable." She ended with a passionate appeal: "No Djuna—I must find that unjust. Please—try [and see] if you can't place it. I do care for it passionately." Perhaps to energize her friend to try even harder, she dedicated the poem to her mother and "with special heel clicked to Djuna Barnes."[15]

 Barnes was now marketing the Baroness's poetry to the best avant-garde journals in Paris, acting as her literary agent. "Will you *send this poem for me to 'Broom.'* Don't know address," requested the Baroness on an undated postcard to Barnes that featured her poem "Jigg."[16] In another letter, the Baroness sent her agent "German poems—newly made," along with the note, "Wouldn't the transatlantic take them."[17] In the summer of 1924, Barnes wrote to Ford Madox Ford in Paris on behalf of the Baroness: "Would you be so good to send a copy of the Review containing the Baroness E. v. Freytag-Loringhoven's poems at 36 Neue Winterfeld[strasse] Schone[berg]—Berlin? She has no copy and very much wishes to have it" (see chapter 14).[18] Barnes had carte blanche to show the Baroness's manuscripts to potential publishers, even to the now hated *Little Review,* which would publish two poems, "Guttriese" and "Walküren," in spring 1925.[19] Moreover, with Barnes's intervention, Peggy Guggenheim relieved the Baroness's misery in Berlin with a one-time grant.[20]

Soon the two women were banding on a more impor-
tant project: a book project with the Baroness providing the poetry
and Barnes compiling, editing, and marketing the book to publish-
ers. The idea was likely conceived during Barnes's visit to Berlin in
August 1924, when the Baroness lived in Berlin-Schöneberg,
Neue Winterfeldstrasse 10, a stable residence from spring to fall
1924 (although it is possible that she moved a few houses farther
down to Winterfeldstrasse 36 in the summer).[21] As can be gleaned
from the flurry of letters, the Baroness tackled the project with
gusto: "*Liberator* has some *beloved* poems in its smirchy pages—
could you find them? Take them into the book?"[22] The book
would allow them to publish the Baroness's voluminous poems, in-
cluding "Clock," "Metaphysical Speculations," and the autobio-
graphical "Coachrider"—all of them unsuited for journals with
stringent space limitations. No doubt the idea for a book was also
sparked by the important success of *Ulysses* (1922), for contempo-
raries including Margaret Anderson, Jane Heap, and Emily Cole-
man placed the Baroness's "original genius" on par with that of
Joyce.[23]

Soon their relations intensified into a protolesbian
friendship whose main medium was the written word with the
Baroness as the initiating and driving force, energetically courting
the American novelist: "I write to you now as I wrote to my lovers,"
she told Barnes in her longest letter, a thirty-two-page, no-holds-
barred epistle to "Djuna Sweet" that showered affection over
Barnes, as the collage had showered jewels over Abbott. For the first
time, she shifted her heterosexual pursuits to homoerotic ones—
"Since I am no 'mate' any more—that only *could* find *male counter-
part*—I find it in female!"—but was quick to note that her attraction
was not *physically* homosexual: "I lost all body—but—my spirit
longs for such." She continued with a love declaration: "Djuna—I
love you—your spirit—*it is true!*" Yet despite the avowed spiritual-
ity of her desire, her pent-up sexual energy erupted in epistolary

lovemaking, as her letter caressed Barnes with words, pouring forth ever new terms of endearment—"Djuna, sweet heart girl," "Djuna—love—*brilliant* thing"—and new signs of her intimate affection: "*Never* could *I help* liking your name 'Djuna'! I was disturbed by it—for you know—how I judge by sounds." This is the letter detailing her adolescent sexual fantasy (see chapter 1), as well as the sexual dream she had in Palermo (see chapter 5). Another letter sounds the tenderly affectionate bride: "And a last kiss to you—darling."[24]

The "Djuna Sweet" letter culminated into a "marriage" proposal. "Will you take me—as Felix Paul Greve did?," she asked, trying to cajole the younger woman into a closer relationship that would allow the Baroness to live with Barnes:

Djuna—*save* me—let me be with *you?!*[. . .] *Why not?* We are so different—yet—so alike—*in honesty!* Same love respect for *words*—to *work* with them—*knowing* their preciousness—yet—so *differently* gifted! You are cool—I am hot! You have what—I have *not*—circumspection—efficiency system—executive ability—whereas I am all wave—first—arrangement—ability—comes *later*— *"gezeugt"* [. . .].[25]

Her fantasy marriage of complementary opposites—Barnes cool with executive ability; the Baroness hot with waves of creativity—is driven by a strikingly sexual metaphor, for the German word *gezeugt* designates the act of insemination, the creation of a child through intercourse. Where Wood gave Barnes a doll as a gift to represent their symbolic love child, the Baroness proposed an erotic marriage whose love-child would be their book. Driven by a desire for "spiritual" consummation, the Baroness was writing letters, poems, and finally her biography for Barnes.

With the exulting pleasure of a lover, she now embraced the English language, the sensual medium of their bond, for she was "*aroused* by *English* sound—*depressed* by German."[26] In February

1925, she enthused: "*American English* [. . .] is a treasure trove for me—newfound [it] must be *cherished* and *evermore explored*—or I lose all my *gain*—and with that my *imagination*—my *inspiration*—dies." Her hungry desire for English was born in German "exile": "I don't harvest new words—nor ideas, I only hear German and I am parched."[27] Giving herself a crash course in American literary history, she was reading the American classics, including James Fenimore Cooper: "I read now the 'two Admirals' and 'The Spy' and with this latter I am so American—that I am in the most fervent manner on his side—that is with [George] Washington and the rebels."[28] Reading English was a way of escaping Germany, of breathing a new oxygen of imaginative freedom. "I have to be nourished artificially," she wrote, requesting books and magazine articles from Barnes, including Mary Roberts Rinehart's *The Red Lamp,* a novel written in diary form and serialized in 1924 in *Cosmopolitan:* its protagonist considers publication of his journals, just as the Baroness was writing her own "biography" with the expressed goal to make it public.[29]

She was actively consolidating her identity as an American artist who wrote to and for an American audience. "*How I love America*! That *unshackeldness by past!*" she enthused in her 26 June 1924 postcard to Barnes.[30] In New York she had criticized America from the vantage point of Europe; now she criticized Germany from the vantage point of America. Having declared war on Germany, she was making peace with America, even holding out an olive branch to her former American arch-enemy: William Carlos Williams. After reading *Spring and All* (1923), his new collection of poetry sent to her by Barnes, she promptly sent the Rutherford poet an unsolicited review with rare praise: "It is your best—because most sincere—least braggardly loutish book ah! The older you become—the more you will recognize your hopeless foolishness—but also—your increasing cleverness—(for you are clever—of that cleverness of hell devilish) making loud brass noise—to cheat entire stillness."[31] Of

course, this backhanded compliment did not prevent this satiric note to Barnes: "Yet *W. C. W.* is safe!" she flippantly noted: "*We know— why* the poor fish is safe—he doesn't fly—he flaps a little round the yard—a housecock—he doesn't want to fly up to [the] sun but up [to the] top of town statue in mainstreet—there he sits—crowing: '*spring and all.*'"[32]

Unable to escape the icy grip of poverty, she was always on the move during the Berlin years, in September 1924, to 26 Victoria Strasse in Potsdam, a suburb known for the old Hohenzollern monarch seat Sanssouci. On 2 December, she became the victim of a robbery, a disastrous event, as she reported to Barnes in early 1925, wishing her friend a belated Happy New Year.[33] The event intensified her sense of anxiety and crisis, and the symptoms of acute depression and her suicidal thoughts are palatable in her letters. For some time she had been afraid of going to bed, lying awake at night: "*I fear bed*! For specter shape enters me—there it has leisure to torture—tweek—pommel me—weaken my heart—pounding on it—pounding—pounding."[34] She considered having herself committed to a psychiatric institution, an insane asylum since she could not afford a sanatorium: "I have no family [who] for social politeness' sake [would] bring me into private 'sanatorium' looking after me." She was ashamed of her condition: "I wrote to you already weeks ago—but—didn't send it! For shame! It was desperate fit—like *now*—coming out of bed—like now! It is morning! But—the fits are *every* morning now—I cannot afford that shame *any-more*!"[35]

This desperate crisis prompted Barnes into action. On 7 December 1924, she sat down at her typewriter to compose and date the preface for the book. The Baroness was "a citizen of terror, a contemporary without a country," she wrote and continued: "In gathering together her letters, in offering some of her works, my hope has been that a country will inherit her life, offering in return peace, and decency and time."[36] Meanwhile the Baroness kept pressuring her friend with panicky messages: "*Pit— pit I am in! Djuna—*

I must be gotten out of Germany! [. . .] I am insane from Germany—
as my mother was from 'home.'"[37] The book was her salvation, no
longer merely a work of art but a tool to her literal survival. "Where
is my book going to be printed? In America? Is that not business rea-
son for me to enter? Only bring me to America."[38]

Perhaps sparked by the erotic "Djuna Sweet" letter,
Barnes now summoned the Baroness to write her autobiography.
"Tomorrow I start the biography,"[39] the Baroness announced in a
letter from around January 1925. By early 1925, she referred to "my
book of poetry—for which *originally* you wanted that *biography*" and
promised to return to the writing of "my biography" in a week's
time.[40] Yet far from providing a structure for the book of poetry, the
Baroness zoomed in on her young adulthood at the turn of the cen-
tury. For one last time, she dove back into the whirlpool of her sex-
ual picaresque in Berlin, Munich, and Italy. She was writing from
behind institutional walls (ironically, just like Felix Paul Greve when
he composed *Fanny Essler* in prison).

From 21 February to 23 April 1925, she resided at the
Bodelschwingh Home for women, "Gottesschutz" in Erkner, a
suburb southeast of Berlin, a shelter for homeless and wayward girls
and women, as its director, Pastor Paul Braune, explained in a report
on the Baroness's case.[41] Since the women earned their keep
through physical or domestic work, it was not long before the
Baroness launched a complaint in a lengthy letter to Pastor Braune:
"This is not a sanatorium, but a shelter and working home," she
wrote, adding that "physical work leaves me spiritually empty." "Art
is my world and I need my freedom," she argued: "I want to leave
Germany for Paris or America. My culture is where the artist is! The
artist is always ahead! I am in the wrong place. Please help me find
the right one." In her letter, she included one poem dedicated to
Leopold von Freytag-Loringhoven and another to her father. In ad-
dition to Pastor Braune, she recruited a second ally: Miss Neuman,
the social worker. "Educated and cultivated people—understand

my whole situation perfectly," the Baroness later explained to Barnes, adding that Miss Neuman "is going with the help of the police—to get me my visum to France—and even is about to raise money for me—personally by her own interest and effort."[42] Once again, she sounded a note of optimism, for she had persuaded Pastor Braune to recommend to the Potsdam Welfare Office that she be transferred to the Landesirrenanstalt, the provincial mental institution: "Even though she cannot be considered mentally insane in the full meaning of the word," wrote Braune, "her attitude toward the world that surrounds her is so strange that we have to judge her like an abnormal person. In any case, we can no longer carry the personal and economic burden." Her release on 23 April 1925 indicated three reasons for dismissal: refusal to work, violation of house rules, and illness.[43]

That the Baroness was not clinically insane can also be seen in her very lucid strategizing during this period, when Barnes was preparing to travel to Italy. Cleverly exploiting Barnes's attractiveness to men, she prompted her to solicit Karl Wolfskehl's help in Italy: "You are personally goodlooking—swell—vivacious—intellectual—keen—and—*American!*" "Djuna" must "stir his curiosity!"[44] Nothing seems to have come of this encounter, however, perhaps because of the language problems—Wolfskehl did not speak English, and Barnes spoke neither French, German, nor Italian. Yet Barnes's travels to Italy prompted the Baroness's imaginative wanderings in Italy in the last third of her memoirs. She was now writing from the Landesirrenanstalt (psychiatric asylum) at Oderbergerstrasse 8 in Eberswalde, an institution she had entered in April 1925.[45]

Designed and built in 1865 by Martin Gropius, the asylum (figure 13.6), set in a nature oasis just twenty minutes northwest of Berlin, must have reminded her of the Wyk auf Föhr Sanatorium, about which she was now writing in her autobiography. Today the asylum is a working Landesklinik (provincial hospital) with national

cultural heritage status. The Baroness would have had her room in the Pensionshaus 3 (figure 13.7), a facility for "quiet women" (*ruhige Frauen*), which was added in 1905. Doctors alternated their visits to the patients, spending one day with the male patients, the next with the female patients, allowing for longer sessions of individual consultation and observation.

No doubt Frau Dr. Simsa (referred to in the Baroness's letters) would have detected the schizophrenic symptoms—high levels of excitement, delusional thinking, play with language including the creation of neologisms, and feelings of paranoia—that run through some of the Baroness's writings and behavior patterns. The levels were probably low enough, however, that she was deemed neither a danger to herself nor unable to function in normal life. She was dismissed after only a short time in the asylum. "I am to be released from the hospital now—since I am not one tick insane—but poor and deplacé," she wrote to Barnes.[46] Indeed, she was confident about her state of mental health, never "afraid of letting honest physicians try [her] sanity": "no misery seems wretched

13.**6** *Landesklinik Eberswalde.* Building designed by Martin Gropius in 1865. Photograph by J. P. Boudreau, 2000.

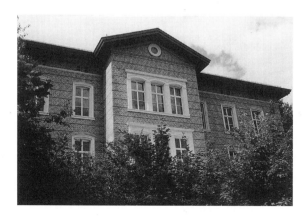

13.**7** *Landesklinik Eberswalde.* Haus für ruhige Frauen, No.3. Built in 1905. Photograph by J. P. Boudreau, 2000.

enough to destroy it—*insanity* would be a relief in hopeless cases of life—though death is better of course—though hard to purchase."[47]

It was during this period of February to probably late spring 1925 that she composed the most extensive part of her ex-traordinary autobiography, although writing was not always easy. "It is very difficult to write here—on account of the incessant idiotic talk of the girls—the piousness and lack of privacy and light," she wrote about the institution in Eberswalde, which featured a beautiful chapel and multibed rooms with high ceilings: "It is too cold to write in my room," she noted. "I will see—how the next part will go. I know this is rather mixed up—but—maybe—it does not hurt the interest? Let me know. This is even a copy! I had to copy the whole thing—for the difficulty to express myself. It seems to become more and more

difficult."[48] She apologized for the rushed style, hoping that "Djuna" will fix it for her. The autobiography is saturated with promiscuity, venereal disease, frustrated desire, sexual addiction, exhibitionism, triangulations, impotence, homosexuality, and adultery. It is a text of lyrical intensity and poetic condensation, of wild digressions and teleological disruptions. Above all, the memoir pulsates with a feminist drive to expose the iron-fisted patriarch and male lovers. "I forget nothing—and my expression is the written word."[49] Her tone was angry and rebellious about her own demise. "I spit on an unsuccessful Christ," she proclaimed, refusing to rescind her antireligious stance even in the face of death: "I will perish—as I am in the process of doing now."[50] But even as she was predicting her demise, writing kept her alive. "There is only *one* ambition now in me," she wrote to Barnes, "*to finish the biography.*"[51] She addressed the memoir to Djuna and to her American readership and offered an apology: "I suffered from spiritual appendicitis then—when I was with you Americans. And I beg everybody's forgiveness for having behaved a very prig."[52]

As I have shown elsewhere, the memoir is a feminist rewriting of *Fanny Essler,*[53] as she allowed herself to fantasize Felix Paul Greve among her readers: "if this reaches his eyes—and I am still alive—two things improbable."[54] The Baroness's memoirs were eventually edited but published only in 1992—years after Grove's death—by two Canadian scholars. Ironically, in 1925 she was reading a Canadian work, Stephen Leacock's *Over the Footlights* (1923), a parody treatment of contemporary theater and movie conventions. Reading Leacock, "the darling," as she called him, she was "intoxicated with the words and the light witty gesture—the sound of English."[55] One wonders what might have happened if she had read the darker and more controversial 1925 Canadian novel, Frederick Philip Grove's *Settlers of the Marsh,* with its fictionalized presentation of her own life in Kentucky, a novel Grove was coincidentally publishing in the same year that the Baroness wrote her memoirs (see chapter 5). We can only imagine the wild furies

that would have haunted the Canadian author had she discovered his *Settlers of the Marsh*.

Barnes used the memoir to write the Baroness Elsa biography but was unable to move beyond the childhood chapters.[56] Yet the memory of the Baroness did surface in published form in Barnes's literary masterpiece *Nightwood* (1936). This *roman à clef* about the doomed love of Nora Flood (Djuna Barnes) and Robin Vote (Thelma Wood) is a powerful elegy and work of mourning that used the Baroness as a creative medium to express loss. The American literary critic Lynn DeVore was the first to recognize the intimate connections between *Nightwood*'s Robin Vote and the Baroness.[57] Robin Vote's unusual epithet "La Somnambule" was the term used by the Baroness to describe herself during her Berlin exile. Robin Vote marries Felix Volkbein, the name used by Barnes to designate the Baroness's husband Felix Paul Greve in the "Baroness Elsa" biography draft.[58] Robin Vote is "a figure of doom," just as the Baroness was.[59] Building on DeVore's insights, my intention here is not to argue that Robin Vote really *is* the Baroness but to propose that we read Robin as a complex composite of Thelma Wood *and* the Baroness. Superimposing the Baroness onto Thelma Wood (*Vote* is a cryptic grafting of *Wood* and *Von*) made psychological and narratological sense for Barnes. Physically, Wood was the Baroness's younger double: androgynous, discarding all feminine ornaments, her boots laced up high, her face brooding, her hand often holding a cigarette (figure 13.8). Like the Baroness's younger self, Wood was a voracious consumer of sex, addicted to the rush of sex rather than seeking enjoyment in the sex act itself.[60] Barnes's affair with Wood (1922–28) chronologically overlapped with her intense friendship with the Baroness (1923–27), so that during the very same period that Barnes was the primary reader of the Baroness's tale of sexual promiscuity, she was also the privileged listener to Wood's sexual confessions, with Barnes insisting that her partner tell the truth about her indiscretions. During the early 1930s, it was Barnes who

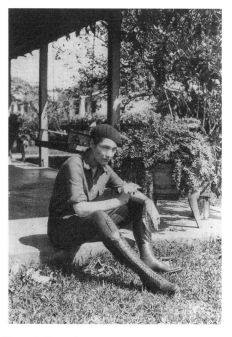

13.**8** *Thelma Wood, ca. 1920s.* Photograph. Elsa von Freytag-
Loringhoven Papers. Special Collections, University of Maryland
at College Park Libraries.

would control both women's narratives and craft them into a bril-
liantly artistic text in *Nightwood,* a work that ultimately recognized
that in Barnes's life both relationships belonged together in the lan-
guage of pain they generated.

To create Robin Vote, then, Barnes sketched Wood in
an easily recognizable photomontage, a narrative collage of torn
body fragments that include her enormous height, broad shoulders,
large feet, and white flannel trousers. The novel also features the
couple's Paris apartment, as well as their doll, the symbol of their
love.[61] Onto the photomontage portrait of her former lover, Barnes
grafted prominent aspects of the Baroness. For instance, Robin Vote
is frequently called "Baronin" (Baroness) in the novel, and she wears
strange costumes like the Baroness: "Her clothes were of a period

that he could not quite place. She wore feathers of the kind his mother had worn, flattened sharply to the face." Even her skirts were made of "heavy silks that made her seem newly ancient."[62] In addition, the Baroness's dusky body "perfume" is ascribed to Wood's alter ego, Robin: "The perfume that her body exhaled was of the quality of that earth-flesh, fungi, which smells of captured dampness and yet is so dry, overcast with the odour of oil of amber." Robin is a transmorphous figure, crossing from human into plant, from living body into mummy, and like the Baroness, she is a figure of death: "Such a woman is the infected carrier of the past: before her the structure of our head and jaws ache—we feel that we could eat her, she who is eaten death returning."[63] The seed for this hyperbolically grotesque image of death can be found in Barnes's 1933 biographical wrestling with the Baroness: "Looking at her one thought of death in reverse."[64] Or as the Baroness had written to Barnes from Berlin, "*Past haunts me in every shape, shuts off future.*"[65]

Nightwood's controversial final chapter, set in a place of worship ("On a contrived altar, before a Madonna, two candles were burning") takes us back to Ida-Marie Plötz's contrived altar of burning candles observed by her young daughter, Elsa Plötz: "Standing before them in her boy's trousers was Robin."[66] Indeed, Robin is in a state of sexual arousal paired with the dog as a putative partner, the scene played out in a place of worship. The scene is charged with dada outrage and opaqueness, evoking the copulating dogs on the Baroness's bed. The novel's last paragraph ends with Robin's "barking in a fit of laughter,"[67] mimicking the dog but also ventriloquizing the Baroness's "barking laughter" of Barnes's biography preface. Recognizing herself in Robin Vote, Wood was so shocked by the proximity with the grotesque Baroness that she slapped Barnes's face after reading the novel. The American literary critic Shari Benstock has astutely remarked that "[t]he writing of *Nightwood* was an act of revenge and an attempt at exorcism—each achieved its end."[68] The Baroness was the medium through which

Barnes expressed her pain, but she was also her tool of revenge in exorcizing her love for Thelma Wood. *Nightwood* shows that "traumatic experience cannot be fully assimilated as it occurs,"[69] writes the literary theorist Victoria L. Smith; for Barnes, the Baroness's dada provided a window into the language of trauma.

Friends recognized that the dada Baroness lived in the pages of *Nightwood*. "Peggy [Guggenheim] said the part I read her from the Night chapter was like the Baroness. It is, as [George] Barker's book is like her; all modern suffering, expressed poetically, has that quality." So wrote the critic Emily Coleman to Barnes on 1 August 1935. Yet the writing of *Nightwood* did not provide Barnes with a sense of peace. She was haunted by feelings of guilt. Terrified of Thelma Wood, she was also tormented by the memory of the Baroness's steady gaze into her own eyes as she had asked her friend Djuna, "Can I trust you?"[70] Having reneged on her promise to produce the Baroness's book, Barnes had effectively used her for her own book while stripping the Baroness and Wood of their artistic powers: Robin Vote is no artist. "Your next book should not be: The Baroness," admonished Coleman in November of 1935: "There is no earthly reason why you should not write entirely now from the deep part of you." Yet a few pages further in her letter, she invites Barnes: "Tell me more about the book on Elsa. Also what has Muffin done about his book? I feel there are some good writers in the world, and if they wd all get together & push there might be a birth."[71] So paralyzed was Barnes that T. S. Eliot, on 28 January 1938, advised her not to be a "goose" and to "stop worrying about the Baroness": "I think the chief use of the Baroness is to start you off, and if the result shows very little of the Baroness and mostly yourself well that's what we shall like best. So don't have any scruples about historical accuracy etc. but just make USE of her. She will approve, I am sure."[72] A year later, in 1939, Barnes submitted the first chapter of her "Baroness Elsa" biography to Coleman, but the response was not encouraging: "The first chapter of that book on

Elsa wasn't good at all; it simply was not you when you get going."
Coleman advised Barnes to put the biography aside and write po-
etry instead.[73] Barnes, it appears, was unable to push forward, and
the entire project came to a halt. She launched into it again in the
1950s—again without success. Decades later she still felt a sense of
obligation toward the Baroness, asking her literary executor Hank
O'Neal to publish the Baroness's poetry. The Baroness's judging eye
was still on her—never entirely releasing her.

As for the Baroness in 1925, it took yet another year for
her to finally be granted her visa. She was now living at Mendel-
strasse 36 in Berlin-Pankow, an address found in Barnes's address
book. In the beginning of 1926 came two reprieves: a small inheri-
tance from one of her aunts and the long-awaited visa for France.
The persons she hoped to connect with were Abbott, Man Ray,
Duchamp, and Barnes. In the spring of 1926 she finally traveled to
Paris, at the same time that the young Emily Coleman was also ar-
riving here. Even though physically and emotionally exhausted, she
was confident that she would triumph.

THE BARONESS'S LAST DADA DANCE IN PARIS

Chapter 14

"Paris was the new frontier," wrote the Canadian writer and Hemingway friend Morley Callaghan in his memoir *That Summer in Paris* (1963). "In the early twenties living had been inexpensive, and if you wanted to be a publisher and have a little magazine the printing costs were cheap. Above all, Paris was the good address."[1] One of the new vanguard literary magazines on the Paris scene was the *transatlantic review*. Here the Baroness made her controversial "entrance" in May 1924, dramatically pitting the journal's veteran editor, the British modernist writer Ford Madox Ford (1873–1939), against his young subeditor, Ernest Hemingway.[2] "Mr. Hemingway soon became my assistant editor," as Ford recalled in his memoir *It Was the Nightingale* (1933): "As such he assisted me by trying to insert as a serial the complete works of Baroness Elsa von Freytag-Loringhofen. I generally turned round in time to take them out of the contents table. But when I paid my month's visit to New York he took charge and accomplished his purpose."[3] Hemingway prominently placed the Baroness in the journal's opening pages, following Bryher (Winifred Ellermann)'s poetry. On his return to Paris, a flabbergasted Ford was forced into some quick damage control to avoid having his subeditor's selections upset the journal's putative sponsor, John Quinn, whose support Ford had been courting in New York.[4]

The Baroness's poetry—"Novemberday" (originally called "Death Show" or "Totenschau"), published in both German and English,[5] and "Enchantment"—was elegiac:

> Here
> crawls
> moon—
>
> —
>
> Out
> of
> this

Hole

[. . .]

Traditional

she

points

Lightdipped

toetips.

shrill

insectchimes

turn

me

Rigid.[6]

Thus was Hemingway introduced to the Baroness's experimental style during a time when he was actively trimming the verbal "fat" of his own style, as well as flexing his writer's muscles in assaulting conventional taste. Since Hemingway was correcting the Baroness's poetry, he was entering her radical language of experimentation.[7]

The reason for Hemingway's provocative support of the Baroness? His biographer James R. Mellow suggests that he published the poems "out of devilment, as an embarrassment to [William Carlos] Williams, then in Paris with his wife, Floss." Hemingway had met Williams on 15 May 1924 in Paris, where the poet-doctor was on sabbatical.[8] Yet an even more compelling reason is found in Hemingway's fierce hunger for vanguard experimentation and in his angry rebellion against Ford's staid modernism. The young subeditor was impressed with *The Little Review*—a journal he praised for printing "giants"[9]—and he envisioned the *transatlantic review* as a journal publishing controversial materials eschewed by mainstream publishers. Probably the Baroness came with high recommendations, too. Hemingway's boxing friend Ezra Pound, for

one, was eager to see the Baroness published.[10] Key, too, was Hemingway's friendship with Jane Heap during this period, although Hemingway biographers tell us little about it. Already in June 1923, Heap had been attending the Paris boxing fights with the Hemingways, as he writes: "Sat[urday] night we went to five prize fights—Tiny [Hadley], Ezra Pound, J[ane] H[eap] of the Little Review, Mike Strater, Mac [McAlmon] and I. Swell fights."[11] The Hemingways saw Heap socially for dinners, where they would have had ample opportunity to gossip about the Baroness as well as talk about the politics of publishing a vanguard literary magazine.[12] Indeed, Heap was actively involved in trying to help pull the *transatlantic review* out of its financial quagmire, after Quinn had lost his battle against cancer in July.[13] Much suggests that Heap and Hemingway would have made a formidable editorial team, for their vision for a vanguard literary magazine was much closer than that of Ford and Hemingway.

Thus Hemingway's bitter frustration arose from Ford's obvious desire for promoting a mainstream modernism: "You see Ford's running whole damn thing as compromise. In other words anything Ford will take and publish what can be took and published in Century Harpers, etc. except [Tristan] Tzara and such shit in French. That's the hell of it."[14] Yet while Hemingway rejected Tzara's dada, his support of the Baroness and his admiration for Heap suggests that he was, in fact, supportive of an American dada, as he writes: "how very much better dadas the American dadas, who do not know they are dadas [. . .] than the French or Roumanians who know it so well."[15] While the literary scholar Bernard Poli speculates that the editors might have saved the journal by spicing it up with the "poetic works of the irrepressible Baroness,"[16] Richard Huelsenbeck, too, underscores the dada influences on the author's style: "Hemingway's language, his honing, his symbolism, the dialogue of ambivalence, would never have been possible without dada and James Joyce." Hemingway's violation of good taste and the

darkness of tone resonate with the tone of the German dada Baroness.[17]

Therefore, Hemingway's championing of the Baroness is important given that he was at a watershed of his own writing career, just a few months away from traveling to Pamplona and writing *The Sun Also Rises* (1926), with its aristocratically titled, profanity-spewing, and sexually aggressive protagonist Lady Brett Ashley, who like the Baroness is typically surrounded by homosexual or impotent lovers. The thinly veiled figure was closely based on Duff Twysden, the hard-drinking, free-spirited divorcée Hemingway had a crush on in 1925 while married to Hadley Richardson. Yet Hemingway's landmark novel is laced with a tragic note of suffering and destruction that seems closer to the Baroness than to the real Lady Duff Twysden, whom *Broom*-editor and Twysden-lover Harold Loeb remembered as a much more superficially carefree woman than she appeared in the novel. Additionally, the novel engaged in vicious anti-Semitism directed against the figure of Robert Cohn (Harold Loeb). Thwarted in both love and vanguard experimentation, Hemingway's rage surfaced in *The Sun Also Rises* with Baroness-like intensity in a ritual assault on Loeb, the rival who had outshone him not once but thrice: as Twysden's lover, as published writer, and as a successful editor of a vanguard journal.

The Baroness arrived in Paris in April 1926, coincidentally the same month in which Hemingway mailed *The Sun Also Rises* to his New York publisher. She repaired to the Hôtel Danemark at 21 rue Vavin in the heart of Montparnasse, installing herself with her family of animals, as Barnes recalls: "She had finally in the Hotel Danemark on the rue Vavin in Paris no less than 3 [dogs]—2 kept in a cupboard (one was permitted 'Dada' because she had come with it)—to prevent any trouble with the garcon." Barnes also reports that the Baroness's room soon became "overrun with mice— she fed them. Encouraged them."[18] Settled with her entourage, the

Baroness now was able to oversee Montparnasse, the artist quarters immortalized in so many modernist memoirs.

Rue Vavin is a little street but centrally located off rue Notre-Dame-des-Champs, where Pound had lived in 1920 and 1921 and where Hemingway "lived in the flat over the sawmill at 113."[19] Just a few minutes from the Baroness's hotel, on 70 rue Notre-Dame-des-Champs, lived the radical performance artist, photographer, and poet Claude Cahun (1894–1954) with her half-sister and lover, the self-named Marcel Moore. Cahun would certainly have heard about the Baroness from Jane Heap and Georgette Leblanc, Cahun's friends. Exactly twenty years the Baroness's junior, like Anita Berber in Berlin, Cahun belonged to the new generation of radical gender experimenters. Ridiculing socially assigned gender roles, she posed alternately in male clothing or as doll-like female with curls, pouting lips, and buttoned nipples sewn on her dress. Like the Baroness, she adopted a grotesque, estranged aesthetics, bringing to light the strangely uncanny elements of the socially and culturally repressed. Yet where the Baroness indulged in anti-Semitic stereotypes, Cahun, as a Jewish woman, joined the resistance movement in the 1930s and was later incarcerated by the Nazis.[20] Rue Vavin runs parallel to 27 rue de Fleurus, where Stein had her legendary salon, but it is unlikely that the Baroness was invited to this exclusionary circle. Nor does she appear to have had intimate connections to Natalie Barney's salon of Amazon women, the *Temple à l'amitié,* although Barney was a good friend of Djuna Barnes.

In May 1926, after enjoying Berenice Abbott's exhibition in the Sacre du Printemps Gallery, the Baroness reconnected with Djuna Barnes on a holiday that took them in June to the Baroness's beloved sea, to Le Crotoy, a tourist place on the French Normandy coast. Here the legendary Joan of Arc was incarcerated in 1430 before she was taken to Rouen, where she was tried and burned as a witch in 1431 for her nonfeminine daring.[21] No doubt,

the dada veteran would have seen her as a kindred spirit. A photograph (figure 14.1) of this June holiday shows Elsa and Djuna posing side by side on the sunny beach, the formal distance contrasting with Barnes's close bodily connection in photographs with Thelma Wood, Mina Loy, or Natalie Barney. In this rare photograph, perhaps because her eyes are squinting in the sun, there is the faintest intimation of a smile in the Baroness's face. Barnes recalled the vacation: "she could—on the beach, on the beach of Crotoix, stand over a drowned & decaying dog corpse—& poke a stick into its ribs—to see how it was 'put together.'" Added Barnes: "This purely 'German grossness' was part of her strength." Barnes was attracted

14.1 *Elsa von Freytag-Loringhoven with Djuna Barnes on the Beach at Le Crotoy, Normandy, ca. 1926. Photograph. Elsa von Freytag-Loringhoven Papers. Special Collections, University of Maryland at College Park Libraries. © Copyright, The Authors League Fund, as literary executors of the Estate of Djuna Barnes.*

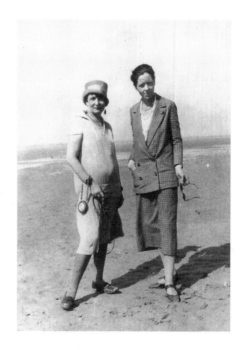

to and repulsed by her friend's scatological partialities, as the Baroness—over lunch—shared her technique for taking revenge on a substandard hotel in Germany: "[B]ecause the toilet was truly too abominable to use, she did her morning duties on a newspaper & planted it in the window box—when she told me this at lunch, she laughed hoarsely & in great glee & amusement—she had 'paid' the house out for their toilet in the one way natural to the grossness in her."[22]

After returning to Paris, the Baroness worked to establish new connections. She carefully recorded Constantin Brancusi's address at the impasse Ronsin and rue de Vaugirard. Perhaps she was invited here for one of the parties that also included Heap, Barnes, and Allen Tanner.[23] Another friend then foe was the young musician George Antheil (1900–1959), the "bad boy of music," as he later dubbed himself in his eponymous autobiography, alluding to his musical experimentations with the sounds of saws, anvils, and car honks.[24] "First she buttered me up, then she turned against me," Antheil told Abbott.[25] The Baroness's letter to Antheil gives insight into their quarrel: "[O]ut of vanity—you *liked* my conversation—you *asked* for wage—but when it became as you put it—personal— meaning that I not merely wanted words—and—besides stand admiring you—you broke down in the most loutish fashion— ordering me—*in the rudest manner* out of your studio." After this episode, she punished him with dada invective: "You are a liar and potential crook through and through!"[26]

Soon stories about the Baroness's destructiveness were circulating in Paris. As always, the Baroness verbally fanned the flames. From Germany, she had announced that she hated Duchamp, Heap, and Anderson, who had neglected her. Yet she forcefully denied having assaulted them physically: "I haven't fury's blind sweep of destruction. I neither knifed Marcel Duchamp—nor smashed his pictures," she said, adding: "I am too reverently cultured—things were too beautiful—despite own hurt beauty—[.]"[27]

Still, as Abbott recalled, "in time, Elsa offended all the people who knew her and helped her: Margaret Anderson, myself, everybody—as if she had to do this."[28] Yet Abbott was perhaps not entirely innocent in the final breakup, for she had reneged on her promise to provide accommodations for the Baroness: "you commit[ted] yourself so far as to write [in] so many words—that—*as soon as you had an apartment large enough—'you would give me a little room all to myself—to work in.'*" While Abbott's reluctance to share living quarters with the temperamental Baroness is perhaps understandable, her refusal to photograph her seems more callous, for her friend had been showering her with artwork but was unable to pay for photography. Meanwhile Abbott, although by no means rich, was fast becoming a successful career photographer with her own studio on the rue du Bac: "[Y]ou—*not taking my fotos,*" the Baroness charged, "though it is *necessary* for *business reasons—my* business reasons—letting *friendship entirely out [of] the question.*" This sense of injustice quickly turned into personal attack: "*[A]ll* you have learned—is to take care of yourself—in the most ruthless—indelicate—tactless manner." She put a curse on Abbott: she would be disowned by her friends "as trash."[29]

In a dramatic act, she broke into Abbott's apartment and repossessed the *Dada Portrait of Berenice Abbott* (see figure A.1) she had given her as a gift. These stolen goods she promptly handed over to her new friend Mary Reynolds, a well-known surrealist bookbinder.[30] "[Elsa] probably thought this would connect her with Marcel," said Abbott, for the attractive American widow had been Duchamp's companion since 1924. When Reynolds—usually calm and unfazed—turned against Abbott in a café, Abbott chose to avoid the Baroness, although she continued to "observe her from a distance." As Thelma Wood's daybook noted for Monday, 23 May 1927, "Lunch with Berenice—Baroness for dinner," making sure that the two were neatly divorced.[31]

The Baroness, of course, had good reason to be discontent. Since her arrival in Paris in spring 1926, she had remained poor and neglected, many of her friends feeling overwhelmed by her neediness and Prussian exactingness. Also, many of the fashionable American literati were visiting the French Riviera.[32] There was little progress in publishing the book of poetry and the memoir, even though she was now in close proximity to important publishers and literary supporters. But Ford was too conservative to champion the Baroness. The publisher of the Contact Editions and Williams's friend, McAlmon, probably viewed her with suspicion, too. In 1927, Harry and Caresse Crosby launched the Black Sun Press, first as a vanity press but soon as a press producing deluxe editions for celebrated writers. But the Crosbys were in a different social league from the Baroness, who had been living in poverty far too long.

During the winter 1926 to 1927, she hit a low, after Barnes and Wood left Paris for several months. Dependent on the couple's providing all sorts of niceties for her, she panicked. When she met George Biddle in a Paris restaurant in early 1927, she was lonely and depressed, yet the encounter stimulated new memories and a last long letter to Biddle.[33] She was physically out of shape, as she later recalled for Guggenheim: "I came here even with my figure spoilt—characteristics softened—blurred—by physical inaction—through mental collapse."[34] Yet by the early spring 1927, she had pulled herself out of her depression and had found work as a model, the topic of her poetry play "Chimera":

Large—brightly lighted croquis classroom
in grand[e] chaumiere
face aged—body ageless in eccentric attitude
upon podium stands nude.[35]

As she reported to Guggenheim: "I regained figure by renewed physical activity—begetting mental stir—enterprise trust—anew."[36]

ARE YOU ASLEEP WITH SOMNOLENT MODELS ?

WAKE UP

IN CREATIVE CROQUIS
" THE BARONESS "

FAMOUS MODEL FROM NEW YORK
PUTS

ART INTO POSING
CRAFTSMANSHIP

COME TO THE
BARONESS CROQUIS
SEE
BODY EXPRESSION
SPIRIT PLASTIC
BEGINNING
FROM 1-3 1/2 H
 5-7 o'clock 5 MIN POSES

7 IMPASSE DU ROUET
AVENUE CHATILLON (METRO ALESIA)

14.2 Baroness Elsa von Freytag-Loringhoven, *Advertisement for Modeling School*, 1927. Flyer. Elsa von Freytag- Loringhoven Papers. Special Collections, University of Maryland at College Park Libraries.

With Mae West bravado, the fifty-two-year-old proudly described *"an evening croquis class"* to her friend Sarah Freedman: "For *2 hours* posing croquis—(quick sketch) I get *8 fr* from the grand[e] chaumière—*10 fr* from the others—every 5 minutes a different pose. Maybe—you can imagine what dull school mechanical poses the other models give—and—how excellent I am! *I am!* More so—than ever before!" Not even the substandard compensation—"a sort of pocket money"—could mar her elation.[37]

 With things on the upswing, in March she treated herself to a visit at the gallery Sacre du Printemps at 5 rue du Cherche-Midi for Kiki de Montparnasse's exhibition of watercolor paintings. The exhibition had opened on 15 March to spectacular success,

drawing the masses of Montparnasse, including the French minister of the interior, Albert Sarrault, a lover of the arts.[38] One wonders whether the Baroness frowned on "Kiki's" lightheartedness as a lack of artistic seriousness: she left no record of her impression. She was mapping a new future in Paris and, by early summer, was energetically courting her American friends—Sarah Freedman, Djuna Barnes, Peggy Guggenheim, and Mary Reynolds—for financial support for her own modeling studio. By mid-July she had rented a studio south of Montparnasse at 7 impasse du Rouet at Avenue Chatillon close to the Metro Station Alésia. She was planning the grand opening for 1 August. Already she had printed advertisements (figure 14.2) targeting a clientele of American expatriate painters:

Are you asleep with somnolent models?
Wake up
In creative croquis
"The Baroness"
Famous model from New York
puts
Art into posing
Craftsmanship . . .[39]

She was working hard. On 12 July 1927, she was up at five. After posing for four hours in the afternoon, she was weary and tired, when Reynolds dropped by in the evening to congratulate her friend and to deliver her gifts. Sadly, her last birthday was not a happy one, as can be gleaned from her July apology letter to "Mary," who must have complained about the bad reception. "I am troubled about it!" wrote the remorseful Baroness, "that I have been in any way uncivil that night—when you took the trouble to come and see me on my birthday? I certainly didn't mean to—but I was half drunk with sleep and—as I realized the next morning—I had a cold." She was grateful for the gifts, however: "I enjoyed so much your gifts—

though I was too sleepy to do it that night. I still have one of the cute champagne bottles—which were truly delicious candy." She also described Barnes's and Wood's gifts, which had arrived a week after her birthday at her doorstep: "some awfully nice clothes, a hue chinaflowerpot and a dapper little cactus."[40]

Her apology had a business purpose, too. "Please can you help me still with another 100 Frcs?," she asked Reynolds. "I want to open August 1. And the place mustn't look too cheaply—poorly made up," she reasoned. "Djuna promised me a clock," she wrote, but she also needed a model stand, as well as having to pay for her advertisements. In closing, the Baroness provided emotional support and solidarity for her friend. "I wish you would fall in love with some proper man—because Marcel is a bubble!" she wrote, adding in quadruple underlining, "*Every man—who takes money from a woman is degenerate.*"[41] Just one month earlier, in June 1927, Duchamp had dropped Reynolds to wed another woman in what his biographer Tomkins describes as "a cold-blooded decision to marry for money."[42]

Meanwhile the Baroness was also recruiting the help of the New York–born patron of the arts and art collector Peggy Guggenheim (1898–1979), who had followed her cousin, Harold Loeb, to Paris. Knowing that Guggenheim was supporting artists including Barnes and Mina Loy,[43] the Baroness now turned to her with a twenty-five-page letter, a brilliantly artistic grant application of sorts replete with a poetic abstract in the beginning, a biographical section, a statement about her pro-American leanings, a deflation of the rumors about her destructiveness, a clear outline of her modeling project as a venture in vanguard art, and finally a budget request of 500 francs monthly to support the Baroness's studio rent. In artistic form, she peppered her "application" with dada jokes. So impressed was Guggenheim that she and her husband typed the letter and sent the Baroness a copy of the typescript. Guggenheim gratefully kept the original for her collection. Given this enthusiastic

response, it is safe to assume that it was Guggenheim who sponsored the Baroness's studio rent, possibly granting her a small stipend, just as she would later provide Barnes with a modest allowance of $300 per month.⁴⁴ This might also explain the Baroness's gift to her benefactress, *Oggetto* (Object) (ca. 1925–1927) (figure 14.3), a woven belt with ornaments.⁴⁵

Things were finally going the Baroness's way—or so it seemed. In July, she had made a new friend in Jan Sliwinski, the owner of the thriving Sacre du Printemps gallery, who had organized Abbott's and Kiki de Montparnasse's exhibitions. He and "Princess Lieven—the wife or sweetheart" were "awfully nice" to the Baroness, as she told Reynolds: "They are coming tomorrow to help me order a modelstand, since I am so hampered in that respect by my lack of French." She had been invited to a party in their "house in the country": "they have the most darling modest—artistic—place—full of visitors—of all nations and languages—I had for the first time since Methuselah's birth it seemed a real nice companiable time—though of course—I didn't like most of the awful people—but that didn't matter—since I liked the hosts." The language barrier was a bonus, for "otherwise I should probably have quarrelled with many people—as I used to in America and that would hurt my popularity as model."⁴⁶

Despite the help she received from her friends, she insisted on exacting standards. On a beautiful July day, promenading along the boulevard de Montparnasse, just off rue Vavin, she spotted Barnes and Wood sitting together in the Café le Dôme, when they had supposedly left Paris. With an acute sense of betrayal, she confronted "Djuna" in a dramatic letter: "all thought fled—except that I felt like slapped in the face—trying to hide it from you even as well as from me—with a frozen idiotic painful grin." She added: "I wished I hadn't seen you—for it is *different* to *know*—a person— who is valuable to one—and dear besides—is keeping aloof—because she fears to be importuned too much."⁴⁷ What a more socially

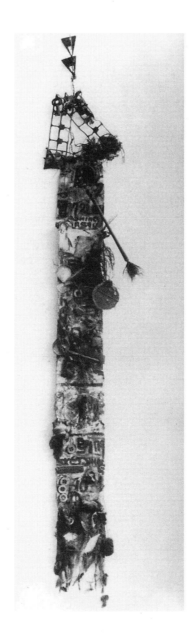

14.**3** Baroness Elsa von Freytag-Loringhoven, *Oggetto* (Object), 1925-
27. Woven fabric with buttons, wire, key, springs, and metal, (from
Arturo Schwarz, *Almanacco Dada* [Milan: Feltrinelli, 1976], p. 121)

secure person would have overlooked as an innocent white lie be-
came a scene of high drama for the sensitive Baroness. She de-
scribed the gifts Wood had given her—"the pinkey dress" and "2
hats," which she has "fixed to [her] taste"—only to use them as
props for a revenge fantasy: "Had I remembered *what* I wore—in
passing you—I should have felt [like] tearing it off—in front of the
Dome—and I often wear nothing beneath but stockings and draw-
ers—*why* make me feel *that* way? You? It isn't necessary!"[48] She pep-
pered her letter with allusions to other treacherous friends,
Duchamp, Man Ray, and the studio owner, Mr. Jacobson, all of
whom, she warned, would be informed of their injurious behavior
against her.

Meanwhile the contemporary Parisian scene, including
the Café le Dome, fed her poetic drive. Once again she endeavored
to connect herself with the new vanguard journal, *transition,*
launched in February 1927 on rue Fabert and edited by the Ameri-
can journalist-writer Eugene Jolas and his wife, Maria.[49] The Octo-
ber issue of *transition* contained the Baroness's "Café du Dome," and
"X-Ray." In "Café du Dome," the dada poet placed herself in the
legendary literati café at 108 boulevard de Montparnasse, the place
for the honest, working artists, as Hemingway described his favorite
café.[50] Here, the Baroness's speaker places her order in dada fashion:
"Garcon / Un pneumatic cross—avec suctiondiscs—/ Topped with
rubber thistlewreath—/ s'il vous plait."[51] Her order is a synthetic
dada dish in which the pneumatic gas inflates the bristly rubber plant
soufflé, the entire meal served on the "suctiondisks" saucers used to
count the number of consumed drinks. Along with *transition*'s Oc-
tober check of 60 francs in payment for her two published poems
came the rejection of "Contradictory Speculations," a nine-page se-
quence of dada poems and aphorisms exploring religious motifs in
which Christ is featured as the "lord's magnificent drummer" and as
"hero criminal." As *transition*'s "secretary" Maria Jolas explained,
"you want them used together [and] it is too long for our use."

Transition, however, kept four poems "for possible future use": "Ancestry," "Cosmic Arithmetic," "A Dozen Cocktails—Please," and "Chill."[52]

Dedicated to Mary Reynolds, "A Dozen Cocktails—Please" had the Baroness once again reeling in sexual subject matter in a dazzling tour de force:

No spinsterlollypop for me—yes—we have
No bananas I got lusting palate—I
Always eat them————
They have dandy celluloid tubes—all sizes—
Tinted diabolically like a bamboon's hind-complexion.
A Man's a—
Piffle! Will-o'-th'-wisp! What's the dread
Matter with the up-to-date-American-
Home-comforts? [. . .]
There's the vibrator————
Coy flappertoy! I am adult citizen with
Vote— [. . .]
Psh! Any sissy poet has sufficient freezing
Chemicals in his Freudian icechest to snuff all
Cockiness. We'll hire one.

The poem presents a carnival of oral sexuality ("spinsterlollypop," "bananas," "lusting palate," "a dozen cocktails"), while sex is also charged with technology ("There's the vibrator————/ coy flappertoy!") and with synthetic fabrics ("celluloid tubes" = condoms) in this satire on modern consumer culture. She also targets the new religion of sex as represented by D. H. Lawrence or Harry Crosby: "Psh! Any sissypoet has sufficient freezing / chemicals in his Freudian icechest to snuff all /cockyness. We'll hire one".[53] As if anticipating the surrealist sex discussions—André Breton, Paul Éluard, Max Ernst, Man Ray, and others would meet from 1928 to 1932 at

54 rue du Chateau to discuss topics, including masturbation, impo-
tence, premature ejaculation, and orgasm—"A Dozen Cocktails—
Please" was a hilarious spoof on self-serious sex talk.[54]

Given the triumphant upswing in the Baroness's life, what happened
in the few remaining months that can explain her descent? One an-
swer may lie with her visa status in Paris, which prohibited her
working in Paris, as she anxiously confided to Barnes in the fall of
1927. For months she had been in infraction of French law, both
with her modeling jobs and her modeling school. More specifically,
she feared that the "studio owner" Mr. Jacobson, with whom she
had been quarrelling, might report her to the police: "Do you
think—if he *knew* that in [my] pass is the clausal about my being: *for-
bidden to work*—he might be mean—vicious enough to do some-
thing *in that direction*[?] *That is all that worries me!*"[55] Her letter to
Barnes was followed by a panicky note scribbled to Reynolds. Post-
marked 21 September 1927, this note signaled serious trouble: "I
have to arrange to leave in a week. It is hard for me to even write it.
Everything seemed so settled—and now—the minister of the inte-
rior has decided otherwise." She continues: "Send me any money
you can—because I don't know what I will have to face again. I don't
know even where I shall go! I am just adrift again."[56] Given France's
notoriously tough immigration regulation (commented on by
Ford's Australian wife, Stella Bowen, and by Canadian writer John
Glassco in their respective memoirs) and given that the irascible
Baroness stepped on many toes, a quick report to the police would
have been an easy way of silencing her. The reference to "hav[ing]
to leave" suggests the end of her Paris ventures, which she may have
tried to appeal to the "minister of the interior," M. Sarrault.[57] Ford's
memoir also suggests the Baroness's "expulsion" from France:

The baroness too was a fairly frequent visitor to the office, where she invariably behaved like a rather severe member of any non-Prussian reigning family. So I thought the stories of her eccentricities were ex-

14.**4** *Grand Hotel, 22 rue Barrault, Paris,* 1920s. Postcard. Agnès Picardi Collection, Paris.

aggerated. Her *permis de séjour* which she had somehow obtained from the British Consulate General in Berlin expired and she asked me to try to get the Paris Consulate General to extend it. The Consulate General in Paris is made up of most obliging people and I made a date with her to meet me there. I waited for her for two hours and then went home. I found the telephone bell ringing and a furious friend at the British Embassy at the end of it. He wanted to know what the hell I meant by sending them a Prussian lady simply dressed in a brassière of milktins connected by dog chains and wearing on her head a plum-cake! So attired, she that afternoon repaired from the Embassy to a café where she laid out an amiable and quite inoffensive lady and so became the second poet of my acquaintance to be expelled from France. The Embassy discontinued its subscription to the *Review*.[58]

Although Ford's time references are notoriously unreliable, it is entirely possible that she was replicating her earlier Berlin consulate performance in Paris.

Rather than returning to Germany, however, the Baroness quickly repaired to new quarters in November, taking lodgings in M. Hatté's Grand Hotel at 22 rue Barrault in the 13th arrondissement in the southeast of Paris (figure 14.4), an area described by Henry Miller's friend Alfred Perlès in 1931 as a depressing underworld space: "There may be quarters in Paris more hoary, but it would be difficult to find another more sinister, more terrifying. Around the Place Paul Verlaine there is perhaps only a consumptive melancholy aura, but when you come to the Place Nationale the life of the 13th Arrondissement burgeons into cancerous loveliness."[59] Perhaps an appropriately Gothic space for the Baroness's last act, rue Barrault today looks like a working-class street, and its hotel, now renovated but with the same façade the Baroness would have seen, continues to operate for visitors with modest budgets.

The Baroness was in a precarious emotional state. For several years, she had often referred to the fate of Franz Karl Kleist,

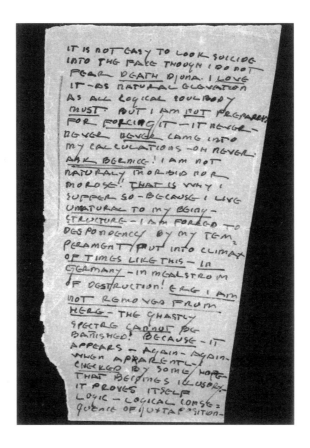

14.**5** Baroness Elsa von Freytag-Loringhoven, *Letter to Djuna Barnes,*
ca. 1925. Manuscript. Elsa von Freytag- Loringhoven Papers. Special
Collections, University of Maryland at College Park Libraries.

her revered grandfather, whose suicide she celebrated as noble, just
as she had declared her husband Leopold's suicide as his most heroic
act. Her Berlin letters to Barnes were filled with suicidal fantasies:
"a Roman I should 'fall into my sword' or stab myself with dag-
ger . . . Chinese nobles hung themselves by silken cord . . . send
them by their sovereign."[60] She had announced her despair in sui-
cidal letters from Berlin—"It is not easy to look suicide into the

face"(ca. 1925) (figure 14.5)—but had always managed to stare it down. Her letters read like an elegy to her own demise: "My heart is abode of this snake—they stare at each other, always," she had written. "I carry it around—Djuna—like embryo in womb—and as such it grows! […] Djuna—have I spiritual cancer of the womb?"[61] She was frequently joking about her funeral, as in her letter to Biddle in the spring of 1927: "On my funeral you can save—I am not interested in junk—unless I could be embalmed as a beautiful shell of rare queen—and you wouldn't care enough for me to do that—so you better sell me to a medical college and present Djuna Barnes with the proceeds—she might need it just at the moment."[62] Again, in July, she referred to her funeral to Guggenheim: "About my 'pompe funebre' I must say—as much as I admire chinese—they would be deeply wounded in their finer feelings if they could fathom my indifference toward it." Her funereal vision was irreverently dada: "Go to landing stage anywhere[;] get me by leg[;] flop me to fishes. I love the sea."[63] She added her thoughts on suicide: "Sure—suicide is but simple witted relative effectively shrouded practical joke—but—but—but—all buts I conjure up against that spectral pageant."[64] In late November, she wrote a last letter that touched Melchior Lechter. She had become slim through illness and work and desired to hold his hand one last time. She would welcome him in the light of the father, alluding, of course, to the afterlife. The letter is signed "Maria"—an allusion to the Madonna role she had played for him and the middle name of her suicidal mother.[65]

It was Wednesday, 14 December 1927, a cold and dull day in Paris. For days storms had been raging, and the French liner *The Paris* was battling stormy winds, docking with delay. Crowds on the Paris streets were hurrying through sleet and rain. One wonders whether on this day the Baroness stayed home in bed or whether she ventured out to the Left Bank Gallery, which opened with a highly publicized exhibition of works by inmates of insane asylums that

highlighted artworks of "an eccentric or extravagant nature."[66] Later in the evening, at about eleven, the news of Charles Lindbergh's landing in Mexico City flashed through the city, broadcast in movie houses, on the radios, and on a large electric news sign on the Place de l'Opéra, where crowds of passersby briefly stopped in the drizzle before hurrying on to spread the message.[67] Just a few months earlier, the Baroness had compared herself to the heroic pilot: "I dared as fine as Lindbergh in my realm," she had written to Guggenheim, summing up her life's work in a sentence that could serve as her epitaph.[68]

On that fatal night of 14 December, as she prepared for bed, her little dog Pinky was by her side. Somehow the gas jets were left on that night, with the deadly fumes slowly seeping out and spreading throughout the apartment. Perhaps she was "drunk with tiredness" and did not pay proper attention in her new surroundings; perhaps she was careless as a result of depression and weariness; or perhaps she was so depressed that her decision was more consciously formed. One wonders, then, whether on the brink of life and death, there was an inkling of consciousness that the artist who had "dared as fine as Lindbergh," always embracing life as the ultimate risk, was embarked on a fatal course. The warrior-artist died in her bed, not a heroic but an ironic death, not like Achilles on the battlefield but like Agamemnon who returned home from war to be killed in his bathtub. She left no suicide note, a strange silence for someone so compulsively voluble. "I have just discovered that I am not, and why I am not made for suicide—unless it could be done gaily—victoriously—with flourish," she had written from Berlin.[69] The dada flourish was missing from her death, leaving a baffling question mark. "Did the Baroness kill herself or just die?" asked Williams in a 21 January letter to Jane Heap, unable to get a straight answer to his question.[70] Rumors blamed the death on a lover, who had turned on the gas at night and then left, but there is no evidence to support this theory. As Barnes wrote in her obituary, her death

appeared to be "a stupid joke that had not even the decency of maliciousness."[71]

In the morning of 15 December, Jan Sliwinski rushed to inform Abbott that the Baroness was dead. A profoundly shocked Abbott hurried with Sliwinski to rue Barrault, where she saw the Baroness's body as well as Pinky's lifeless shell.[72] After the official death report was signed in the public offices of the 13th arrondissement on the evening of 15 December,[73] Barnes took charge of the Baroness's affairs and legacy. She commissioned the death mask, which was photographed by Marc Vaux, the photographer for *Ryder,* and published with Barnes's obituary in February 1928 in *transition* (figure 14.6).[74] The mask is followed by avant-garde artwork including Pablo Picasso's. The Baroness looks regal, intense, and authoritative—a law unto herself—even in death. Barnes eventually put the mask in her closet and forgot about it. Years later, when opening the closet, the mask came falling out, hitting Barnes on the head, a perhaps appropriate reminder that the Baroness's memory was still haunting her.[75]

The Paris funeral took place in January 1928, more than two weeks after her death, at the Père Lachaise, the famous Parisian cemetery for artists. Djuna Barnes had taken up a collection to bury the Baroness in style. Still, it was a pauper's grave, which may explain why the Baroness's name is not listed in the records of the Père Lachaise (or any of the fourteen Paris cemeteries).[76] As with so much in the Baroness's life, the funeral itself took a turn toward the slightly grotesque. On the day of the funeral, Djuna Barnes arrived at the Père Lachaise with Thelma Wood and several other women friends. When they could not find the grave, they went to a nearby bar and got drunk. When they finally returned and were directed to the appropriate grave site, the funeral was over; the grave was covered and they saw some flowers on it.[77]

When the Baroness died, Montparnasse had just mourned the death of Isadora Duncan, who had been strangled when her scarf had wrapped around a wheel of the car in which she

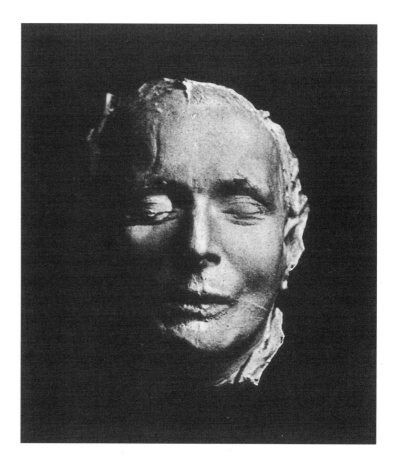

14.6 *Death Mask of Baroness Elsa von Freytag-Loringhoven, 1927.*

Photograph by Marc Vaux in *transition*, February 1928.

was riding. Hugo Ball, too, had died prematurely in September 1927.[78] Two years after the Baroness's death, almost exactly to the day, on 13 December 1929, the affluent avant-gardist Harry Crosby committed a spectacular suicide in New York's Hotel des Artistes in a love pact with Mrs. Josephine Bigelow, his pathological moods attributed to World War I.[79] In June 1930 followed the extravagant suicide of the French painter Jules Pascin: "Like some old Roman esthete he opened the veins in his arms and caught the spurting

blood in a scented bowl. He then hanged himself."[80] In contrast to these sensational suicides and accidental deaths, the Baroness was mindful of the waste: "True death is wealth tremendous, but it must be earned with life; that is why still I live."[81]

In 1933, Mary Butts turned to the Baroness's memory to set a satiric epitaph to the entire Montparnasse era in a short story entitled "The Master's Last Dancing," published posthumously in 1998 in *The New Yorker*. "There was a woman come lately to Paris, from somewhere in Central Europe by way of New York, who made her living by giving us something to talk about."[82] In this barely veiled portrait, the Empress, as she is called, dyes her hair green, paints on her skull a phallic sign, paints a skull on her knees, and wears a dustbin for jewels. The satirical portrait is none too flattering, however, the last dance functioning, as Butts's biographer has written, as the author's farewell to Montparnasse and to her own wild life of decadence.[83] For Butts, the dada Baroness retrospectively came to encapsulate the pathology of the age, the trauma resulting from World War I: "we were the War lot. We had a secret,"[84] she wrote targeting the era's destructiveness. In the story's central scene, the crazed Baroness is dancing by herself, a metaphor for the era's narcissism and unhealthy solipsism, as she is "turning round and round with minute steps in a circle, within her own axis," and "with those starving eyes on the floor."[85] Where Hemingway's party scenes erupted into shameful violence among friends, Butts's party culminates in a grotesque climax: the Baroness's ghastly dance on top of Djuna Barnes's body: "The Empress was still dancing where she had been dancing before, but, if you like, a step up. She was dancing on Alleyne [Djuna Barnes], up and down her body. On her belly and her breast. She gave a little jump, and it was on her face, and already blood was beginning to pour from Alleyne's nose."[86] As the Empress's dancing feet create a pool of blood on Alleyne's bleeding body, Valentine (the painter Lett Haines) begins to conduct music with a bunch of red roses. The falling rose petals provide a kind of

demonic benediction, "a scarlet rain over walls and floor and over our mouths and eyes and hair."[87] For Butts, the Baroness ultimately is a symbol for a self-destructive, indeed, cannibalistic dada. In the body of the Baroness, the movement imploded from within.

Still, others looked at the Baroness in a very different light—seeing her as the embodiment of art in life. In June 1929, Eugene Jolas formulated a programmatic goal for modern poetry in *transition*. "Poetry is at the cross-roads today," he wrote. The poet "will have to abandon completely the attempt to express his universe with the decadent instrument of unpliable and exhausted language matter, or else he will have to try to resuscitate the comatose world." For the poet such a "renunciation of despair" lies precisely in the degree to which he succeeds in "producing adequately and violently a chemistry in words."[88] Preceding Jolas's essay was the Baroness's poetry, suggesting that she exemplified the new chemistry in words he described:

OSTENTATIOUS
Vivid fall's
Bugle sky—
Castle cloud'd
Leafy limbswish—

WESTWARD:
Saxophone day's
Steel Blast
Galaxy—[89]

The Baroness's poem is a musical concert of "Bugle" and "Saxophone" that blasted the old to create new words and galaxies that were swishing with kinetic energy and life. With her *Limbswish* (see figure 7.3) on her hip, she assumed the pose of modern dominatrix. "At least we never have been afraid to live," as she had summed up

her life's motto to Guggenheim. "I and my people——die-for it in open day duel——we are no marauders but frank warriors—— offering life for life."[90] Swishing her whip, she hollered her orders at her contemporaries: "I have learned from my former experience [. . .] that I must holler. Before it is at the last breath—for then you choke speechless with misery disgust swirling nausea."[91] And so she remained a warrior-artist to the last—refusing the safety net and consuming herself to create a new chemistry in art and life.

Afterword GISELA BARONIN FREYTAG V. LORINGHOVEN

My first "encounter" with the Baroness Elsa happened many years ago. On a visit to the Museum of Modern Art in New York, I virtually stumbled over her name—Elsa von Freytag-Loringhoven—on the attractive *Dada Portrait of Berenice Abbott* (figure A1, plate 9). The collage was made of unusual materials: synthetic and natural fabric, stone, paper, glass, and celluloid—glued in a most refined technique. The glistening materials and the use of glass gave the painting an alluring effect. As a teacher of art and art history at Eugen Bolz Gymnasium near Tübingen, I was fascinated and determined to find out more about this artist who happened to be connected to me by marriage. I was fortunate to meet the New York art historian Francis M. Naumann, and I was able to procure a much cherished duplicate of the Baroness's autobiography that was then circulating in the New York underground in form of a pirate copy.

Intrigued by the Baroness's life and art, I returned to New York in 1990 to visit the painter Theresa Bernstein, for whom the Baroness had modeled in 1917. Bernstein told me about her charm and restlessness: "The beauty of her movements, when she suddenly leapt from the chair and moved around made me think she was involved in a dance." The Baroness modeled for Bernstein wearing a paintbox around her neck as if it were a necklace (see figure 7.4). It was as if she wanted to say: "Look at me, I am wearing all the colors of the world. I'll always carry them with me and thus I give the world color." The paintbox also makes an appearance in Felix Paul Greve's novel, *Maurermeister Ihles Haus* (The master mason's house), where Suse (Elsa) receives a paintbox as a Christmas gift. Although she despised academic approaches to art, Elsa had received formal training as a painter. In the archives of the Academy of Fine Arts in Berlin, I found evidence that the school rules were very rigid: sketches of sculptures that did not correspond with the academic taste of the time were strictly forbidden. In the schedule of the winter semester of 1890 to 1891, the year when Elsa attended this school, I found examples for exercises she would have

A1 Baroness Elsa von Freytag-Loringhoven, *Portrait of Berenice Abbott,* ca. 1923–24. Collage of fabric, paper, glass, cellophane, metal foils, paper, stones, cloth, paint, etc., 8 5/8 × 9 1/4 in. Mary Reynolds Collection, The Museum of Modern Art, New York.

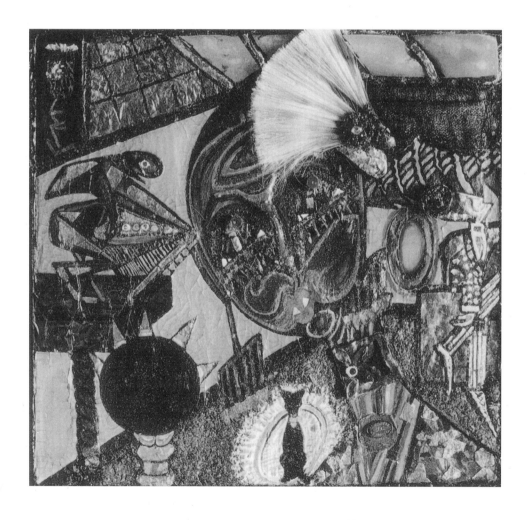

performed, including watercoloring of geometric patterns and col-
oring of given ornaments.

On 1 March 1991, I traveled to Milan, Italy, to visit Ar-
turo Schwarz (who welcomed me as the Baroness's daughter).
Viewing up close the Baroness's *Portrait of Marcel Duchamp* (see fig-
ure 11.9), housed in Schwarz's private collection, I was struck by the
accuracy of detail and ornament. The dominant color is reddish
brown, contrasting with cool green lines, all of which are painted
with oil chalk. Duchamp's head in cubist abstract style dominates
the picture, his long nose dividing the picture down the middle. The
large wheel that breaks the proportion of the picture, painted on top
of the center with black lines is an allusion to Duchamp's famous
ready-made, *Bicycle wheel,* a work that at the time went beyond the
scope of art. The ornaments on its fringe have an African touch and
are painted with meticulous care. Under the paper emerge lines of
a loosely knit material, looking like a black wire mesh. A light-green
velvet ribbon frames the collage and is applied with regular stitches.
The Baroness's unusual mix of techniques, materials, and ornaments
offers an exciting composition—a feast for the eye.

Artistically, the Baroness was one of *our* contemporaries.
In her days only a few were able to understand her art. In Henry de
Vry's Wintergarten she enacted scenes and themes of erotic tempta-
tion, frozen movements with the beauty of a still photograph.
Twenty-four years later she expressed the protest against traditions
and civilization by staging her body as a work of art in New York
with long ice-cream-soda spoons dangling from her ears, shining
feathers on her hat, while teaballs served as pearls in her necklace.
The material she used was often stolen from department stores or
picked out of the gutter: buttons, beads, curtain rings, tin toys, and
other decorative materials. She also wore empty tin tomato soup
cans in lieu of a bra. Ever since Andy Warhol printed them in the
sixties, tomato soup cans are socially accepted as art. Similarly, the

Baroness's body performances anticipated the 1980s art scene, among others artists like Marina Abramovic and Rebecca Horn.

On 28 March 1991, I returned for a visit to the United States. Traveling through a snowy landscape, driving north to Monson, a small rural town in Maine, I was on my way to visit the photographer Berenice Abbott, who had invited me—coincidentally just six months before her death—after I had written to her about the Baroness. With great admiration and fondness, she recalled her friend as a profoundly modern and inspirational artist:

She invented and introduced trousers with pictures and ornaments painted on them. This was an absolute outrage. I didn't dare to dress like that. People would have turned their heads in the subway. Elsa possessed a wonderful figure, statuesque and boyishly lean. I remember her wonderful stride, as she walks up the street toward my house. Elsa was very poor. She didn't have enough money to buy a ticket to Europe. I visited her in 1921 when I returned to the States. Her dog Pinky, a small black creature, recognized me. Upon my departure she made a sign, first pointing toward her left and right hips and then drawing a line from her forehead down between her legs. Elsa was a free spirit, her place being somewhere between Shakespeare and Jesus. I used to call her Shakespeare.

Later in Paris, as Abbott explained, her relationship with the Baroness became more thorny. Abbott vividly recalled the shock of the Baroness's death in Paris: "Elsa had made friends with Jan Sliwinski, who owned a gallery. He knew me well, came to see me one winter morning and told me that she had killed herself and her dog. I didn't want to believe it. She was such a strong person, the most lively woman I had ever met. I couldn't believe that she should have been able to kill Pinky. I followed Sliwinski to see where both of them lay."

In 1996, nearly seventy years after her death, the Baroness received a belated recognition of her art at the Whitney Museum of American Art exhibition *Making Mischief: Dada Invades New York*. In 1998, with the memory of that exhibition still vivid, I traveled to the University of Winnipeg, Manitoba, to participate in a panel discussion session devoted to the Baroness. On the panel with me were Julia Van Haaften, curator of photography at the New York Public Library, who was working on a biography on Berenice Abbott, and Irene Gammel, who is now presenting this first biography of the Baroness. In the audience was the Pulitzer Prize–winning writer Carol Shields. The synergy of the panel was remarkable, as was the audience's impassioned response to the Baroness. More than seventy-five years after her death, her art has propelled itself to the forefront of scholarly and art historical discussion. In the twenty-first century she has finally found the viewership able to understand her daring art.

Tübingen, October 2000
Translated by Elske Kosta

Notes

Introduction

1. EvFL to George Biddle, Spring 1927, 12 (letter written in green ink with red corrections and decorations).

2. EvFL to Sarah Freedman, ca. 1927, 23 (twenty-four-page letter written in green ink on pp. 1–17 and in blue ink on pp. 18–24).

3. Margaret Anderson, *My Thirty Years' War: The Autobiography, Beginnings and Battles to 1930* (1930, New York: New Horizon, 1969), 211.

4. Louis Bouché, "Autobiography" (Louis Bouché Papers, AAA, microfilm roll no. 688, frame 700).

5. Reliable, firsthand sources of the Baroness's physical description include Anderson, *My Thirty Years' War,* 177–83; Djuna Barnes, "How the Villagers Amuse Themselves," *New York Morning Telegraph Sunday Magazine* (November 26, 1916), reprinted in Barnes, *New York,* ed. Alyce Barry (Los Angeles: Sun and Moon P, 1989), 249; George Biddle, *An American Artist's Story* (Boston: Little, Brown, 1939), 137–42; William Carlos Williams, "The Baroness," *The Autobiography of William Carlos Williams* (New York: New Directions, 1967), 163–69. See also Matthew Josephson's account in *Life Among the Surrealists: A Memoir* (New York: Holt, Rinehart and Winston, 1962), 75, which describes her as "wearing an inverted coal scuttle for a hat, a vegetable grater as a brooch, long ice-cream spoons for earrings, and metal teaballs attached to her pendulant breasts."

6. Jane Heap calls the Baroness "the first American dada," in "Dada," *LR* 8.2 (Spring 1922): 46; John Rodker calls her "the first Dadaiste in New York," in "'Dada' and Else von Freytag-Loringhoven," *LR* 7.2 (July–August 1920): 34. For "the mother of Dada" reference, see Robert Reiss, "'My Baroness': Elsa von Freytag-Loringhoven," in *New York Dada,* ed. Rudolf E. Kuenzli (New York: Willis Locker & Owens, 1986), 81. See the critic Clifton Fadiman on Stein as "the mother of Dada," quoted in Stefana Sabin, *Gertrude Stein* (Reinbek bei Hamburg: Rowohlt, 1996), 100.

7. Anderson, *My Thirty Years' War,* 177; Ezra Pound, "Rock Drill de Los Cantares: XCV," *The Cantos of Ezra Pound* (New York: New Directions, 1971), 646; William Carlos Williams, "The Baroness Elsa von Freytag-Loringhoven," typed manuscript (WCW Papers, YCAL), n.p.

8. Quoted in Reiss, "My Baroness," 82.

9. EvFL to *LR,* ca. 1922–23, "Little Review—You seem to ignore my queries" (*LR* Papers, GML), *LRC,* 40.

10. For a comprehensive introduction to her visual art, see Francis M. Naumann's chapter "Baroness Elsa von Freytag-Loringhoven," in his *New York Dada 1915–23* (New York: Abrams, 1994), 168–75. Naumann was the first to establish that the iconoclastic *God* was created by the Baroness, while Morton Schamberg probably took the photograph (126, 129, 171). (For a full discussion of *God,* see chapter 8.)

11. Freytag-Loringhoven was largely relegated to popular-culture studies, for her daily transgressions in corporeal and sartorial conventions provided a treasure trove of anecdotes for works such as Alfred Parry's classic *Garrets and Pretenders: A History of Bohemianism in America* (New York: Dover, 1935), 311. See also Allen Churchill's *The Improper Bohemians: A Recreation of Greenwich Village in Its Heyday* (New York: Dutton, 1959), 117: "The Baroness firmly believed that such utilitarian objects as wastebaskets were made to be worn," writes Churchill and continues: "She found postage stamps—in those days a bright pink—particularly stimulating. She papered her apartment walls with them, then pasted them on her cheeks in lieu of rouge." These anecdotes, generally framed to highlight the color of her personality, as well as the free-spirited exotic culture of Greenwich Village modernity, do little to explain her importance as an artist. For a discussion of the systematic dismissal of the Baroness in art history and literary history, see Eliza Jane Reilly, "Elsa von Freytag-Loringhoven," *Woman's Art Journal* 18.1 (Spring–Summer 1997): 26–33; and Irene Gammel, "The Baroness Elsa and the Politics of Transgressive Body Talk," *American Modernism across the Arts,* ed. Jay Bochner and Justin D. Edwards (New York: Lang, 1999), 73–96.

12. Robert Hughes, "Days of Antic Weirdness: A Look Back at Dadaism's Brief, Outrageous Assault on the New York Scene," *Time* (27 January 1997).

13. EvFL, "A Dozen Cocktails—Please." See Irene Gammel, "German Extravagance Confronts American Modernism: The Poetics of Baroness Else," *Pioneering North America: Mediators of European Literature and Culture,* ed. Klaus Martens (Würzburg: Königshausen & Neumann, 2000), 60–75.

14. EvFL, "Holy Skirts," *LR* 7.2 (July–August 1920): 28.

15. See Hans Richter, *Dada Art and Anti-Art* (London: Thames and Hudson, 1997), 11–44. For an early anthology of international dada, see Robert Motherwell, ed., *The Dada Painters and Poets: An Anthology* (New York: Wittenborn, 1967).

16. Tristan Tzara, "Dada Manifesto 1918," in Motherwell, *Dada Painters and Poets,* 81.

17. Matei Calinescu, in *Five Faces of Modernity: Modernism, Avant-Garde, Decadence, Kitsch, Postmodernism* (Durham: Duke UP, 1987), invites us to distinguish between modernism and the avant-garde and to read the avant-garde as "a deliberate and self-conscious *parody of modernity itself*" (141). Left-wing Frankfurt school scholar Peter Bürger, in *Theory of the Avant-Garde* (Minneapolis: U of Minnesota P, 1983), sees postmodernism as an "inauthentic" reiteration of the original or historical avant-garde—that is, dada and surrealism. Andreas Huyssen argues that "postmodernism is a significant attempt to renew with a radical avant-garde tradition"; while Rosalind Krauss figures postmodernism as a "totally new—and on the whole positive—development." The two latter positions are summarized by Susan Rubin Suleiman, *Subversive Intent: Gender, Politics, and the Avant-Garde* (Cambridge: Harvard UP, 1990), 11–12.

18. Stephen Foster and Rudolf E. Kuenzli, eds., *Dada Spectrum: The Dialectics of Revolt* (Madison: Coda, 1979); Mel Gordon, ed., *Dada Performance* (New York: PAJ, 1987); Annabelle Melzer, *Dada and Surrealist Performance* (Baltimore: Hopkins UP, 1994); William S. Rubin, *Dada and Surrealist Art* (New York: Abrams, 1968); Matthew Gale, *Dada and Surrealism* (London: Phaidon, 1997). For an overview of scholarship, see the excellent bibliographies provided by Naumann, *New York Dada,* 244–49; and Timothy Shipe and Rudolf E. Kuenzli (and the International Dada Archive, University of Iowa), in Naomi Sawelson-Gorse, ed., *Women in Dada: Essays in Sex, Gender, and Identity* (Cambridge: MIT Press, 1998), 614–21. In addition to the theoretical texts, there have been a number of anthologies on dada

art, including Motherwell, *Dada Painters and Poets;* Willard Bohn, ed. and trans., *The Dada Market: An Anthology of Poetry* (Carbondale: Southern Illinois UP, 1993); as well numerous reprints of dada texts and memoirs by Richter, Huelsenbeck, Ball, and others.

19. Naumann, *New York Dada;* Naumann, "New York Dada: Style with a Smile," in *Making Mischief: Dada Invades New York,* exhibition catalogue, ed. Francis M. Naumann with Beth Venn (New York: Whitney Museum of American Art, 1996). The New York dada exhibit strategically galvanized this vastly heterogeneous avant-garde family into an historically coalescing movement: "Humor, it could be argued, is the most salient, consistent, and powerful operating factor behind the creation of all great Dada artifacts," writes Naumann in the introduction to the catalogue (17). See also important earlier studies on the American avant-garde, including Dickran Tashjian, *Skyscraper Primitives: Dada and the American Avant-Garde 1910–1925* (Middleton: Wesleyan UP, 1975), and Steven Watson, *Strange Bedfellows: The First American Avant-Garde* (New York: Abbeville, 1991).

20. Alan Moore, "Dada Invades New York at the Whitney Museum," *Artnet* (12 September 1996): www.artnet.com.

21. Shari Benstock, *Women of the Left Bank: Paris, 1900–1940* (Austin: U of Texas P, 1986); Gillian Hanscombe and Virginia L. Smyers, *Writing for Their Lives: The Modernist Women 1910–1940* (London: Women's P, 1987); Jayne Marek, *Women Editing Modernism: "Little" Magazines and Literary History* (Lexington: UP of Kentucky, 1995); Bonnie Kime Scott, ed., *The Gender of Modernism: A Critical Anthology* (Bloomington: Indiana UP, 1990); Bridget Elliott and Jo-Ann Wallace, *Women Artists and Writers: Modernist (Im)positionings* (London: Routledge, 1994).

22. Eliza Jane Reilly, "Elsa von Freytag-Loringhoven," *Woman's Art Journal* 18.1 (Spring–Summer 1997): 26–27. Several of the essays in Sawelson-Gorse's edited volume *Women in Dada* make similar points: see Barbara Zabel, "The Constructed Self: Gender and Portraiture in Machine-Age America," who reads the Baroness's work as a "recovery of the human in machine-age portraiture" (36); and Marisa Januzzi, who writes that the Baroness's "cultural work, all of a piece and Dada to the core, was produced at great personal expense" (594).

23. Naomi Sawelson-Gorse, "Preface," Sawelson-Gorse, *Women in Dada,* viii–xviii. See also Whitney Chadwick, *Women, Art and Society* (London: Thames and Hudson, 1996); Inge Stephan and Sigrid Weigel, *Weiblichkeit und Avantgarde* (Berlin: Argument, 1987).

24. Amelia Jones, "Eros, That's Life, or the Baroness's Penis," in Naumann with Venn, *Making Mischief,* 239, 244. For an expanded version of this essay, see "'Women' in Dada: Elsa, Rrose, and Charlie," in Sawelson-Gorse, *Women in Dada,* 142–72. In connection with this argument, see also Jones's *Body Art/Performing the Subject* (Minneapolis: U of Minnesota P, 1998), in which Jones theorizes the artist-viewer relationship in performative terms.

25. Amelia Jones, "Practicing Space: World War I–Era New York and the Baroness as Spectacular Flâneuse," in *Living Display,* ed. Jim Drobnick and Jennifer Fisher (Chicago: U of Chicago P, 2001). In her upcoming book *Sex, War and Urban Life: New York Dada, 1915–1922* (forthcoming), Jones further expands this argument by focusing on the Baroness's "streetwalking": the Baroness's promenades through New York City inscribe "a rhetoric of walking," a spatial acting out of otherness during war times (see chapter 7). See also my discussion of Berlin and New York as modern, theatrical cities offering opportunities for "spontaneous theatrical street performance," in Irene Gammel, "The City's Eye of Power: Panopticism and Specular Prostitution in Dreiser's New York and Grove's Berlin," *Canadian Review of American Studies* 22.2 (Fall 1991): 213.

26. See Judith Butler, *Gender Trouble: Feminism and the Subversion of Identity* (New York: Routledge, 1990) and Michel Foucault, *The History of Sexuality,* Vol. 1: *An Introduction,* trans. Robert Hurley (New York: Vintage, 1986).

27. Jane Heap, "Dada," *LR* 8.2 (Spring 1922): 46. For my earlier discussion of the Baroness's work within the context of performance art, see Gammel, "The Baroness Elsa and the Politics of Transgressive Body Talk," 73–96.

28. Bohn, *The Dada Market,* 87.

29. Ezra Pound, "Historical Survey," *LR* (Brancusi: number) 8.1 (Autumn 1921): 40. See also Richard Sieburth's discussion of Pound's essay in "Dada Pound," *South Atlantic Quarterly* 83 (1984): 1–17.

30. Lynn De Vore, "The Backgrounds of *Nightwood:* Robin, Felix, and Nora," *Journal of Modern Literature* 10.1 (March 1983): 78. See my

discussion of the memoir: Irene Gammel, "Breaking the Bonds of Discretion: Baroness Elsa and the Female Sexual Confession," *Tulsa Studies in Women's Literature* 14.1 (Spring 1995): 149–66; and Gammel, "Parading Sexuality: Modernist Life Writing and Popular Confession," *Confessional Politics: Women's Sexual Self-Representations in Life Writing and Popular Media,* ed. Irene Gammel (Carbondale: Southern Illinois UP, 1999), 47–61.

31. Roger Conover, "Introduction," *The Lost Lunar Baedeker: Poems by Mina Loy,* ed. Roger Conover (New York: Farrar Straus Giroux, 1996), xx.

32. Emily Coleman to DB, October–December 1935 (DB Papers, CPL).

33. DB, "Baroness Elsa," 3 Waverly Place, New York City (EvFL Papers, CPL), pp. 1–2.

34. DB to Coleman, 3 February 1940 (DB Papers, CPL).

35. DB, "Preface," typed manuscript, 7 December 1924, 1.

Part I

Chapter 1

1. EvFL, "Coachrider," ca. 1924, unpublished poem, 3.

2. Richard Huelsenbeck, "En Avant Dada: A History of Dadaism" (1920), excerpted in *The Dada Painters and Poets: An Anthology,* ed. Robert Motherwell (New York: Wittenborn, 1967), 31.

3. Felix Paul Greve, *Maurermeister Ihles Haus* (Berlin: Schnabel, 1906), English trans.: Frederick Philip Grove, *The Master Mason's House,* trans. Paul P. Gubbins (Ottawa: Oberon P, 1976). In Canada, Spettigue's discovery of this German novel and its translation into English have thoroughly revisioned the reception of Frederick Philip Grove, one of Canada's canonized authors of settler literature. See Douglas O. Spettigue, *FPG: The European Years* (Ottawa: Oberon P, 1973), 144–49.

4. FPG to André Gide, 16 March 1906, in *Felix Paul Greve–André Gide: Korrespondenz und Dokumentation,* ed. Jutta Ernst and Klaus Martens (St. Ingbert: Röhrig, 1999), p. 148. In the *Literarisches Echo x* (1907–08, 210), Fritz Böckel notes in an early review: "Then with the last chapter came the belated realization that Greve might have wanted to show us the development not of the master-mason himself but of his daughters, and especially the

older one, Suse [= Elsa]," trans. and quoted in Spettigue, *European Years,* 147.

5. The list below indicates the novel's deliberate flaunting of the Plötz's real-life first names, although most of them are displaced with deliberate ironic-satiric effects. I underline the parallel names. See notes 7, 8, 9, 15, 17, and 18 for the sources of the real-life names.

Real Names of Elsa's Family and Friends	Fictional Names in *Maurermeister*
El<u>se</u> Hildegard Plötz	Su<u>se</u> Ihle
Char<u>lotte</u> Louise Plötz (sister)	<u>Lotte</u> Ihle (sister)
Konstanze Kleist, neé <u>Runge</u> (grandmother)	Konstanze <u>Runge</u> (grandmother)
<u>Ida</u>-Marie Plötz (Adolf's first wife)	<u>Ida</u> (maid servant)
<u>Berta</u> Plötz, neé Schulz (Adolf's second wife)	<u>Bertha</u> Ihle (Ihle's first wife)
<u>Fri</u>ederike Plötz (Adolf's mother)	<u>Fri</u>da Jeschke (Ihle's second wife)
Ad<u>olf</u> Plötz <u>Maurermeister</u>, born in <u>Anklam</u>	<u>Richard</u> Ihle, <u>Maurermeister</u>, born in <u>Anklam</u>
<u>Richard</u> Plötz (Adolf's brother)	Rud<u>olf</u> Ihle (<u>Richard's</u> brother)
Dr. <u>Kasper</u> (the Plötz's family physician)	Dr. Hennings (family physician)
	Frau <u>Kasper</u> (patient)
<u>Konsul</u> Rose [= rose] (in Swinemünde)	<u>Konsul</u> Blume [= flower] (Suse's friend)
<u>Konsul</u> Hegal (Elsa's friend)	
<u>Lotsenstrasse</u>	<u>Lotsenstrasse</u>
<u>Kleiner Markt</u>	<u>Kleiner Markt</u>
<u>Zum</u> <u>Luftdichten</u> (<u>Swinemünde</u> restaurant and bar	<u>Zum</u> <u>Luftdichten</u> (Richard's favorite bar)

Some of the names also establish references to Greve's life: his mother's name was *Bertha* Greve (like Ihle's wife), and his sister's name was *Frieda* Greve (like the second Mrs. Ihle). The novel also includes Greve's own cameo as Reverend *Greve,* revealing the author's pleasure of playing with names.

6. *BE,* 117.

7. For information on EvFL's childhood, see EvFL to DB, "Djuna Sweet—If you would know," ca. 1924, 32 pp.; selections in *BE,* 201–26; EvFL [to lawyers?], ca. 1923, 25 pp., beginning "Da die zweite Frau Plötz" (this letter, presumably written to lawyers to contest her father's will, gives information on property issues and pres-

ents a valuable source for the identification of persons in Elsa Plötz's early life); EvFL to WCW, ca. 1921 (*LR* Papers, GML), *LRC,* 14–18; EvFL to Charlotte Kannegieser, ca. 1923, "Du Erbschleicherin" (identifies Elsa's stepmother as "Berta Plötz unehelich geb. Schulz"). These letters, combined with the Baroness's autobiography, confirm the details provided in Greve's *Maurermeister* and in Djuna Barnes's biography fragments.

8. *BE,* p. 41. The correct address is found in the *Adressbuch für Swinemünde und Westswine* (Swinemünde: Fritzsche, 1890) (Swinemünde Papers, LAG). This address book lists "Plötz, A[dolf]., Maurermeister, Kl[eine] Marktstrasse 5; the spelling of his name varies: Ploetz (47) and Plötz (15).

9. Bescheinigung aus dem Taufbuch der Evangelischen Kirche in Swinemünde, 1874, p. 132, no. 179. Elsa's confirmation took place on 20 September 1889, p. 44, no. 4 (Pommersche Evangelische Kirche, Landeskirchliches Archiv, Greifswald). My thanks to Gisela Baronin Freytag v. Loringhoven for providing me with copies of these *Taufbuch* documents.

10. DB, "Elsa—Notes," 24 April 1933, n.p. These notes contain quotations by EvFL as recorded by DB. For the Polish translation of the street names, see *Stadtpläne von Świnoujście mit deutschem und polnischem Strassennamenverzeichnis* (Berlin: Pharus, 1992); 18–22.

11. See, for example, FPG, *Maurermeister,* 16, in *Master Mason,* 20: as Suse strolls from the harbor to her home (Bollwerk, Grosser Markt, Kleiner Markt, Obere Lotsenstrasse), her promenade corresponds point by point with the Swinemünde map.

12. For the description of the Bollwerk and Marina, see the opening pages of FPG's *Maurermeister* and Theodor Fontane, *Meine Kinderjahre: Autobiographischer Roman* (Berlin: Aufbauverlag, 1997), 56–57. My thanks to Gisela Baronin Freytag v. Loringhoven for providing me with a copy of this book.

13. Barnes captures this sensuality in her biography drafts, as she imbues the setting with an Old World epic, impervious quality in "The Beggar's Comedy—Elsa," 1. In the Baroness's adult poetry, too, this Baltic seashore home emerges through sound and scent imagery of *shell chalk, surfchurns, moors, dunes, waves, coasts, clouds, seagulls,* as in the unpublished poem "Adolescence," where the sounds of the sea— *siren, honk, gullsmock, squawk*—present a modernist symphony, or in

the unpublished "Equinox," where she evokes Swinemünde's dramatically violent storms with *harpsichords, drums,* and *bellows.*

14. EvFL to Unidentified, fragment written in German, ca. 1923–25, "Die Menschen—die sich in der Ehe."

15. Taufregister der Evangelischen Kirchengemeinde St. Marien, Anklam 1845, p. 77, no. 78. His Anklam home was at Brüderstrasse 438. St. Marien church is currently being restored to its former glory.

16. EvFL, "Da die zweite Frau Plötz" 3.

17. Swinemünde Adressbuch, 1890, 59. Ann Vibeke Knudsen, *Architectural Heritage around the Baltic Sea* (Bornholm: Four Corner Cooperation, 1997–98), 28.

18. This information is based on Christa Giese's letter, 4 September 2000, summarizing the Plötz family information from the Taufregister der Evangelischen Kirchengemeinde St. Marien, Anklam.

19. The family saga is based on a combination of sources: see DB, "The Beggars Comedy," for descriptions of the grandmother's kleptomania; FPG, *Maurermeister,* book 1, ch. 2, pp. 40–43, for the narrative of Adolf Plötz's family history and travels to Russia.

20. *BE,* 41.

21. Seelenregister Stargard, rep. 77, no. 1835, J.-L. Bezirks Nr. Johann 29, p. 69 (Stargard Papers, LAG).

22. EvFL to DB, ca. 1924, "Djuna—By a mere accident," in *BE,* 217.

23. EvFL to DB, "Djuna Sweet—If you would know," 1.

24. See Friederich Nietzsche, *Ecce Homo: How One Becomes What One Is* (London: Penguin, 1992), 32. The best of German culture, says Nietzsche, is created by "foreigners" including Poles, Slavs, and Jews; thus Nietzsche calls himself "sufficiently of a Pole" to appreciate good music.

25. EvFL, "Coachrider," ca. 1924, 14, 17. A deeply personal prose poem with stunningly explosive dada infusions, "Coachrider" presents detailed descriptions of this doomed marriage, even using the couple's proper names. The Baroness composed this twenty-four-page experimental piece around 1924, just before beginning her autobiography, and so far it has remained unpublished and undiscussed.

26. EvFL, "Coachrider," 17.

27. EvFL to DB, "Djuna Sweet—If you would know," 1.

28. EvFL, "Analytische Chemie der Frucht," unpublished German poem (*LR* Papers, GML), *LRC,* 42.

29. EvFL to Unidentified, "*Die Menschen*—die sich in der Ehe," 12 pp. (autobiographical fragment written around 1923, with irregular recto pagination, providing details about her religious upbringing as well as explicit descriptions of Adolf Plötz's abusive behavior). Unless otherwise indicated, all quotations in this paragraph are from this fragmentary manuscript.

30. EvFL to DB, "Djuna Sweet—If you would know," 5.

31. EvFL to DB, "Djuna Sweet—If you would know," 11.

32. EvFL to DB, "Djuna Sweet—If you would know," 1.

33. The engraving is reproduced in *Fragen an die Deutsche Geschichte, Questions on German History: Ideas, Forces, Decisions from 1800 to the Present,* Historical Exhibition in the Berlin Reichstag, Catalogue, 2nd ed., (Bonn: German Bundestag Press and Information Centre, 1984), 206. See also 202–213 for a discussion of Imperial Germany and 214–227, "The Reich Under Bismarck."

34. *BE,* 41.

35. EvFL, "Coachrider," pp. 3–6, 9.

36. Sigmund Freud, "Screen Memories" (1899), in *The Standard Edition of the Complete Psychological Works of Sigmund Freud* [*S.E.*] (London: Hogarth P, 1962), 3: 307. See also Freud, "The Uncanny" (1919), *S.E.* (vol. 17) (London: Hogarth P, 1955).

37. EvFL to DB, "Djuna Sweet—If you would know," 12.

38. See the 1890 Swinemünde *Adressenbuch* under the category of *Maurermeister* in the business registrer, 67: "Pistorius. Plötz" are the only names mentioned.

39. *Maurermeister,* 47; in trans., 49. For examples of the *Maurermeister's* rage and abuse against his wife and children, see *Maurermeister,* book 1, ch. 2, pp. 36–48, and book 2, ch. 2, pp. 99–100. These examples show striking overlaps with the descriptions provided by EvFL to Unidentified, "*Die Menschen*—die sich in der Ehe."

40. *BE,* 47.

41. EvFL to Jane Heap, ca. 1922 (*LR* Papers, GML), *LRC,* 129. The Baroness identifies Dr. Kasper as her family physician in EvFL, ca. 1923, "Da die zweite Frau Plötz"; Dr. Kasper, Bollwerk 27, is listed in the Swinemünde address book under the rubric of "physicians" (*Aerzte*), 64.

42. See National Institute of Allergy and Infectious Diseases, Fact Sheet, http://www.niaid.nih.gov/factsheets/stdsyph.htm. Syphilis is

a sexually transmitted disease "caused by the bacterium called *Treponema pallidum*" (1). As a disease, syphilis is difficult to diagnose because it mimics other diseases including flu symptoms, sore throat, and so forth and therefore has been called "the great imitator" (3). If untreated, a pregnant woman may pass the disease to her child, yet the Baroness tells us that her mother was treated, while she was also carefully watching over her children's health.

43. See J. Laplanche and J.-B. Pontalis, *The Language of Psycho-Analysis,* trans. Donald Nicholson-Smith (New York: Norton, 1973), 465–69.

44. EvFL, "Baroness Elsa," typescript of EvFL letters prepared by DB, 31.

45. EvFL to DB, "Djuna Sweet—If you would know," 6 and *passim.*

46. EvFL to *LR,* "Jane Heap/You must have misinterpreted" (*LR* Papers, GML), *LRC,* 25.

47. EvFL, "Coachrider," 5.

48. Angela Carter, *The Sadeian Woman: An Exercise in Cultural History* (London: Virago, 1979), 88.

49. FPG, *Maurermeister,* 21.

50. Sigmund Freud, *Beyond the Pleasure Principle,* trans. James Strachey (New York: Norton, 1961), 10.

51. Walter Benjamin, *One-Way Street and Other Writings,* trans. Edmund Jephcott and Kingsley Shorter (London: New Left Books, 1979), 53. For a review of different theories of play from Freud, through Michael Bakhtin, to Benjamin, see Patricia Yaeger's excellent chapter "Toward a Theory of Play," in *Honey-Mad Women: Emancipatory Strategies in Women's Writing* (New York: Columbia UP, 1988), 207–38. She notes that most theories have highlighted play's normative functions and proposes a countertheory that resists such a normalizing focus.

52. *BE,* 61–62.

53. Description on course syllabus, University of Brighton School of Design, December 1999, "Archive–Wilhelm Busch," http://www.adh.bton.ac.uk/schoolofdesign/MA.Course/01/LIABusch.html; Joseph Kraus, *Wilhelm Busch* (Reinbek bei Hamburg: Rowohlt, 1999).

54. EvFL to *LR,* ca. 1922, "Jane Heap, understand one thing" (*LR* Papers, GML), *LRC,* 30.

55. EvFL to DB, "Djuna—I send you," in *BE,* 208.

56. EvFL to WCW, ca. 1921, "Do not hate me" (*LR* Papers, GML), *LRC,* 17.

57. EvFL to DB, ca. 1924 (letter about Catholic friend).

58. *Adressbuch für Swinemünde,* 1890, 59, lists "Pluhatsch, Pfarrer an der katholischen Kirche, Gartenstrasse 32."

59. The list of teachers at Elsa's school is exclusively female: Frl. Mandel, Frl. Müller, Frau Steinbrück, Frl. Kamthun, Frl. Moser, Frl. Löwe, and Frl. Holldorf. With the exception of Frau Steinbrück, they are all unmarried; hence Elsa's reference to the "spinster-fashion" of her visual arts teacher. They are listed in the *Adressbuch für Swinemünde,* 1890, 60.

60. FPG, *Maurermeister,* p. 83. Incidentally, the lack of a detailed physical description of Elsa at age eleven to thirteen is curious in Greve's realist-naturalist novel, which devotes at least one paragraph to the physical description of each house servant.

61. EvFL to *LR,* ca. 1922–23, "I cannot help realizing it" (*LR* Papers, GML), *LRC,* 130.

62. EvFL to Unidentified, "*Die Menschen*—Die sich in der Ehe," n.p. Feminists exploring the mother-daughter relationship have pointed to the problematic mother images and roles in Western culture. When the mother is "castrated," she is weak, ineffectual, and thus an object of humiliation for the daughter, forcing the daughter into identification with the father. When she is "phallic," powerful and engulfing, she is a figure from whom the daughter must distance herself if she wants to maintain her separate identity. In both instances, the maternal genealogy is disrupted, as the daughter is reluctant to identify with the mother.

63. These events are relayed in EvFL to Unidentified, "*Die Menschen*— Die sich in der Ehe." The German original reads: "die gelben Schuhe und die kurzen Haare—Ballkleider Parfum—Handschuhe— Amüsement—das geht ja gar nicht alles mit Papa—Ich will doch leben—Papa unterdrückt uns ja—alles so plump—nützlich—natür-lich—gut—solide!"

64. EvFL to DB, "Djuna Sweet—If you would know," 2.

65. EvFL to DB, "Catholic Friend," n.p.

66. EvFL to DB, "Catholic Friend," n.p.

67. EvFL to DB, "Catholic Friend," n.p.

68. EvFL to DB, "Djuna Sweet—If you would know," 15, excerpted in *BE,* 203.

69. In 1892, Frl. E. Kleist is officially listed at W[est] Leipzigerstr. 13. Berliner Adressbuch, 1892 12/30, I. Alphab. Einw[ohner Berlin] Verz[eichnis] (Berlin, SBB). The "Frl." (Fräulein) indicates her unmarried status; "E." stands for Elise, the name by which she was presumably called. The Baroness's memoirs and *FE* indicate that Elsa lived with her aunt during this first stay in Berlin; *FE* effectively puts her on Leipzigerstrasse. Still in 1890, "Frl. Kleist" is not yet officially listed at this address.

70. *Berliner Adressbuch,* 1890 16/25, I. Alphab. Einw[ohner Berlin] Verz[eichnis] (Berlin, SBB).

71. See *Königliche Hochschule zu Berlin,* Register, Wintersemester 1890/ 91 (Archiv der Hochschule der Künste Berlin, Bestand 9, no. 81), for Elsa's registration information, list of courses, and home address in Berlin. My thanks to Gisela Baronin Freytag v. Loringhoven for copies of the 1890 school curriculum and Elsa Plötz's registration.

72. *BE,* 55.

73. EvFL to DB, "Djuna Sweet—If you would know," 3. Unless otherwise indicated, the material covering Ida's derangement comes from this letter, including all quotations in the following paragraphs.

74. EvFL to DB, "Djuna Sweet—If you would know," 2, 4; see also "Baroness Elsa," typescript of letters prepared by DB, 34.

75. EvFL to DB, "Djuna Sweet—If you would know," 13.

76. EvFL to DB, "Djuna Sweet—If you would know," 8.

77. DB, "Elsa—Notes," 24 April 1933, 8.

78. EvFL to DB, "Djuna Sweet—If you would know," 9.

79. EvFL, "Baroness Elsa," typescript of EvFL letters prepared by DB, 22.

80. EvFL, "Baroness Elsa," typescript by DB, 22.

81. EvFL to *LR,* "I cannot help realizing it" (*LR* Papers, GML), *LRC,* 130.

82. EvFL, "Notes to Djuna," 8.

83. EvFL, German Autobiographical Fragments, n.p.

84. Frederick Philip Grove, *Our Daily Bread* (Toronto: Macmillan, 1928), 131; Grove, *Settlers of the Marsh* (1925) (Toronto: McClelland and Stewart, 1984), 109–12. See also Grove's fictionalized autobiography, *In Search of Myself* (Toronto: Macmillan, 1946), 112, for a description of his fictionalized mother's mental breakdown as a result of cancer, as she wanders through the village.

85. E. D. Blodgett, "*Alias* Grove: Variations in Disguise," in Blodgett, *Configuration: Essays on the Canadian Literatures* (Downsview: ECW P, 1982), 112–53.

86. Ida (= Frau Schenck or Frau Schmidt in Barnes's different versions) deliberately "takes to illness": "No one could say exactly what it was. She gave up her sewing, the needle stuck in the middle of an unfinished rose, the piano collected dust along its ledge, her books harbored centerpieces." DB, "The Beggar's Comedy," 1932–37, 3, 9.

87. EvFL, "Marie Ida Sequence," *LR* 7.2 (July–August 1920): 28–29.

88. See also this poem's companion piece, "Prince Elect," *LR* 7.2 (July–August 1920), 30, a more overt elegy mourning the death of "mine mother" in strikingly grotesque imagery that evokes the Pomeranian seashore landscape: "shone thine teeth as shells along the shore—/—of life.// Aie—proud malignant cor[p]se!"

89. EvFL to *LR,* ca. 1923, "I cannot help realizing it" (*LR* Papers, GML), *LRC,* 129.

90. EvFL to DB, "Djuna Sweet—If you would know," 30. The *Adressbuch für Swinemünde,* 1890, 46, lists "Pistorius, Theodor, Coiffeur, Gartenstrasse 13," along with "Pistorius, Louise, Fräulein" at the same address, suggesting that the bachelor coiffeur lived with his sister.

91. EvFL to DB, "Djuna Sweet—if you would know," 28–29.

92. EvFL [to lawyers], "Da die zweite Frau Plötz," 14 and *passim.*

93. *BE,* 42. For descriptions, see also *Maurermeister,* 204 ff., trans., 200–01.

94. *BE,* 42–43.

95. EvFL, "Da die zweite Frau Plötz," 19. In *Maurermeister,* the language of this scene is very close to Elsa's letter: "He grabbed her by the hair and flung her to the ground. Susie saw him standing over her, his face red and swollen. At the same time she felt his iron grip around her throat strangling her" (my translation from 246; see also trans. *Master Mason,* 241).

96. See Lynda E. Boose, "The Father's House and the Daughter in It: The Structures of Western Culture's Daughter-Father Relationship," in *Daughters and Fathers,* ed. Lynda E. Boose and Betty S. Flowers (Baltimore: Johns Hopkins UP, 1989), 19–74.

97. Quoted and translated from the German in Spettigue, *FPG: The European Years,* 148.

98. See Blodgett's comprehensive chapter in his *Configuration,* 112–53, for a reading of the novel as "frustrated comedy"; and my own chapter in Irene Gammel, *Sexualizing Power in Naturalism: Theodore Dreiser and Frederick Philip Grove* (Calgary: U of Calgary P, 1994), 207–26, exploring the language of female resistance.

99. EvFL, "Da die zweite Frau Plötz," 10. She refers to him as Konsul Hegal, but his name is not listed in the address book under the "Konsulate" rubric on 64.

100. Theodor Fontane, *Effi Briest* (Stuttgart: Reclam, 1977). Incidentally, Fontane's novel was based on another "Baroness Else": Else Freifrau von Ardenne; see Walter Schafarschik, *Theodor Fontane: Effi Briest, Erläuterung und Dokumente* (Stuttgart: Reclam, 1999), 83–91; for an identification of Swinemünde as the model for Kessin in *Effi Briest,* see 18, 22–23. See also Fontane biographer William Zwiebel, *Theodor Fontane* (New York: Twayne, 1992), 83, who writes that it is "the finest social novel in German letters between Goethe's *Wahlverwandschaften* (1808) and Thomas Mann's *Buddenbrocks* (1901)."

101. EvFL, "Da die zweite Frau Plötz," 19.

102. EvFL, *BE,* 43.

103. EvFL, "Adolescence," unpublished English poem with dedication, "In Memoriam Pater."

Part II

Chapter 2

1. *BE,* 137.

2. *BE, 133.*

3. *BE,* 165–66.

4. My information on women and sexuality in fin-de-siècle Germany and Europe is drawn from several sources, including Irma Hildebrandt, *Bin halt ein zähes Luder: 15 Münchner Frauenporträts* (Munich: Diederichs, 1993); Biddy Martin, *Woman and Modernity: The (Life) Styles of Lou Andreas Salomé* (Ithaca: Cornell UP, 1991); Bram Dijkstra, *Idols of Perversity: Fantasies of Feminine Evil in Fin-de-Siècle Culture* (New York: Oxford UP, 1986); Elaine Showalter, *Sexual Anarchy: Gender and Culture at the Fin-de-Siècle* (New York: Penguin, 1990); Rita Felski, *The Gender of Modernity* (Cambridge: Harvard

UP, 1995), in particular the chapter "The Art of Perversion: Female Sadists and Male Cyborgs," 174–206.

5. Melchior Lechter, *Orpheus* (1896), oil painting, Landesmuseum für Kunst und Kulturgeschichte, Münster; Ernst Hardt, *Der Kampf ums Rosenrote* (The struggle for the rosy red) (1903), premiered 13 February 1904 at the Deutsches Theater in Hannover (Leipzig: Insel, 1911); Oscar A. H. Schmitz, "Klasin Wieland," in *Der gläserne Gott. Novellen* (Stuttgart: Juncker, 1906); Felix Paul Greve, *Fanny Essler: Ein Berliner Roman,* 2 vols. (Stuttgart: Juncker, 1905, English trans.: Frederick Philip Grove, *Fanny Essler,* trans. Christine Helmers, A. W. Riley, and Douglas Spettigue (Ottawa: Oberon P, 1984); Greve, *Maurermeister Ihles Haus* (Berlin: Schnabel, 1906), English trans.: Frederick Philip Grove, *The Master Mason's House,* trans. Paul P. Gubbins (Ottawa: Oberon P, 1976).

6. My reference to "sexual personae" is borrowed from Camille Paglia, *Sexual Personae: Art and Decadence from Nefertiti to Emily Dickinson* (New York: Vintage, 1991).

7. Peter Fritzsche, *Reading Berlin 1900* (Cambridge: Harvard UP, 1998), 20–21.

8. See *BE,* 124, for her description of "Busse" on Leipzigerstrasse (although in *FE,* 1: 69, Greve puts "Busse" on Friedrichstrasse). For her flânerie through Berlin's streets, see *FE,* 1: 68–70; promenading at night, *FE,* 1: 106–09.

9. See *FE,* 2: 8, where Elsa's alter ego, Fanny Essler, "owns" the city: "This large network of streets belonged to her; she considered it her own: this was Berlin, and the fact she owned it was thanks to no-one but herself; she owned it as her realm and she wouldn't have given it up for the easiest, most carefree life." See Irene Gammel, "The City's Eye of Power: Panopticism and Specular Prostitution in Dreiser's New York and Grove's Berlin," *Canadian Review of American Studies* 22.2 (Fall 1991): 211–27.

10. See chapter 1, note 69. In the *Berliner Adressbuch* (Preussischer Kulturbesitz, SBB), Elise Kleist is listed until 1899, when Leipzigerstrasse 13 no longer lists an entry under her name or under the Kleist name, suggesting that she left Berlin or passed away.

11. See *FE,* 1: 84. Greve describes Fanny pacing up and down between Potsdamerplatz and Anhalterstrasse, before turning on to Leipzigerplatz, walking down the street, and quickly reaching her aunt's store.

In my exploration of Berlin, I am also relying on Peter Neumann, *Wo war was in Berlin* (Berlin: Dietz, 1990); *Pharus Plan Berlin* (reproduction of 1902 map) (Berlin: Pharus, 1992); see also the Berlin maps provided on the inside covers of both volumes of *FE*.

12. *FE,* 2: 86.

13. The *Berliner Adressbuch,* 1894, 07/28, p. 308 (Preussischer Kulturbesitz, SBB), lists an "Elfenbeinschnitzerei" at Leipzigerstrasse 13, a business specializing in ivory carving.

14. *BE,* 43–44.

15. *BE,* 44.

16. *BE,* 44–45.

17. Peter Webb, *The Erotic Arts* (New York: Farrar, Straus, Giroux, 1975), 301–02. "One holds here in perfection, in movement, in ravishing variety, all that the greatest of artists have rejoiced to be able to produce," Goethe raved in the early nineteenth century. There is a wonderful scene in Edith Wharton's 1905 novel *The House of Mirth* (New York: Penguin, 1986), where the respectable but impoverished protagonist Lily Bart poses in a *tableau vivant* for New York's rich bachelors in one of the upper-class salons: "She had shown her artistic intelligence in selecting a type so like her own that she could embody the person represented without ceasing to be herself" (134).

18. Wintergarten programs from 1894 to 1902 (Märkisches Museum, Berlin). My thanks to Gisela Baronin Freytag v. Loringhoven for copies of these programs.

19. *BE,* 45.

20. WCW, "Sample Prose Piece: The Three Letters," *Contact* 4 (Summer 1921): 10.

21. *FE,* 1: 140–74.

22. In *Fanny Essler,* he figures as Axel Dahl, a stand-up comedian of sorts, who enacts himself spontaneously and who pressures Fanny into having sex when she first arrives in Berlin. Oskar Kruse-Lietzenburg is described in Ernst von Wolzogen, *Wie ich mich ums Leben brachte, Erinnerungen und Erfahrungen* (Braunschweig: Westermann, 1922), 114–115; and in Oscar A. H. Schmitz, "Tagebuch" (Oscar A. H. Schmitz Papers, DLM). My thanks to Gisela Baronin Freytag v. Loringhoven for drawing this connection to my attention.

23. *BE,* 46.

24. *BE,* 46. Again, Greve is remarkably accurate when he places the theater on Alte Jakob Strasse. According to *FE,* her chorus-girl career starts on 1 October 1895.

25. Linda Mizejewski, *Ziegfeld Girl: Image and Icon in Culture and Cinema* (Durham: Duke UP, 1999), 16.

26. Theodore Dreiser, *Sister Carrie* (Oxford: Oxford UP, 1991), in particular chap. 38, pp. 346–55. See also my own "*Sister Carrie:* Sexualizing the Docile Body," in Irene Gammel, *Sexualizing Power in Naturalism: Theodore Dreiser and Frederick Philip Grove* (Calgary: U of Calgary P, 1994), 59–81, for a discussion of the chorus girl.

27. *BE,* 172.

28. *BE,* 78.

29. See Doris Claus, "Wenn die Freundin ihrer Freundin lila Veilchen schenkt: Zum Selbstverständnis lesbischer Frauen am Anfang des 20. Jahrhunderts," *Lulu, Lilith, Mona Lisa . . . : Frauenbilder der Jahrhundertwende,* ed. Irmgard Roebling (Pfaffenweiler: Centaurus, 1989), 19–31.

30. *BE,* 79.

31. *FE,* 1: 153: "During this time she began to change quite noticeably. Even though she remained slim her thinness gave way to feminine curves. Only her hair did not seem to want to become any fuller. One day she cut it off, as she could not do it up in a style that suited her. She also began to make changes in the way she dressed. To the yoke of the black cheviot dress that her aunt had had made for her she sewed a piece of black and white checked silk. [. . .]She looked quite citified [although there remained] a boyish awkwardness."

32. *BE,* 46.

33. *BE,* 45–46.

34. *BE,* 47.

35. National Institute of Allergy and Infectious Diseases, Fact Sheet, February 2000 http:www.niaid.nih.gov/factsheets/stdsyph.htm.

36. The information on syphilis is based on a telephone interview, 6 February 2001, with the National Institute of Allergy and Infectious Disease, National Institute of Health, Maryland. See also Lesley Hall, "Syphilis as a medical problem and moral metaphor, 1880–1916," from the author's homepage http://homepages.nildram.co.uk/~lcslcyah/grtscrgc.htm; and the National Organization

for Rare Disorders (NORD) at http://www.nord-rdb.com/
~orphan.
37. *BE,* 48.

Chapter 3

1. Peg Weiss, "The Stefan George Circle," in *Kandinsky in Munich: The Formative Jugendstil Years* (Princeton: Princeton UP, 1979), 81. My discussion of George's style is drawn from Peg Weiss, "Kandinsky, Wolfskehl, und Stefan George," *Castrum Peregrini* 138 (1979): 26–51. Further information about the George circle in this chapter comes from Karlhans Kluncker, *"Das geheime Deutschland": Über Stefan George und seinen Kreis* (Bonn: Bouvier, 1985); Michael M. Metzger and Erika A. Metzger, *Stefan George* (New York: Twayne, 1972); Carol Peterson, *Stefan George* (Berlin: Colloquium, 1980). For a discussion of the George circle's role in shaping an important fin-de-siècle culture of translation, see Klaus Martens, *F. P. Grove in Europe and Canada: Translated Lives* (Edmonton: U of Alberta P, 2001).

2. Oscar A. H. Schmitz, *Dämon Welt* (Munich: Müller, 1926), 218. My thanks to Baronin Freytag v. Loringhoven for providing me with excerpts from this text.

3. See also Roderich Huch, "Die Enormen von Schwabing," *Atlantis* 3 (March 1958): 148.

4. Schmitz, *Dämon Welt,* 268.

5. Peterson, *Stefan George,* 46.

6. Schmitz, *Dämon Welt,* 226.

7. *BE,* 48.

8. "Teuerster Meister Melchior" (Dearest Master Melchior), Friedrich Gundolf called him even on a postcard, 31 July 1905; "Verehrter Meister" (Revered Master), 22 August 1904, box 27, f. 2 (Melchior Lechter Papers, GRI).

9. See Marguerite Hoffmann, *Mein Weg mit Melchior Lechter* (Amsterdam: Castrum Peregrini, 1966), 15. Although a hagiography, Hoffmann provides an intimate and firsthand look at Lechter's life and art.

10. *BE,* 49.

11. Oscar A. H. Schmitz, "Klasin Wieland," in *Der gläserne Gott. Novellen* (Stuttgart: Juncker, 1906), 144. My thanks to Gisela Baronin Freytag v. Loringhoven for a copy of this text.

12. *BE,* 49.

13. See Schmitz, "Klasin Wieland," 146–47.

14. *BE,* 49.

15. Quoted in Hoffmann, *Mein Weg mit Melchior Lechter,* 177–78. My thanks to Gisela Baronin Freytag v. Loringhoven for sending me a color photograph of *Orpheus* as well as copies of the Hoffmann source.

16. Camille Paglia, *Sexual Personae: Art and Decadence from Nefertiti to Emily Dickinson* (New York: Vintage, 1991), 85, 21.

17. *BE,* 124.

18. *BE,* 125.

19. *BE,* 129.

20. *BE,* 138.

21. *BE,* 138.

22. *BE,* 49.

23. *BE,* 102.

24. *BE,* 49.

25. Schmitz, *Dämon Welt,* 232.

26. "Würde es Dir unüberwindlich sein, wenn ich . . . Else brächte?" Ernst Hardt to Botho Graef, typed letter, ca. 1896–97 (Ernst Hardt Papers, DLM).

27. EvFL, "Es hat mal einen Ernst gegeben," unpublished German poem in 32 stanzas.

28. Schmitz, "Klasin Wieland," 113. The reference to the whip is in *Dämon Welt,* 232.

29. *BE,* 51.

30. EvFL, "Es hat mal einen Ernst gegeben."

31. EvFL to DB, "Djuna thanks."

32. *BE,* 49–50.

33. Ernst Hardt, *Der Kampf ums Rosenrote,* Ein Schauspiel in vier Akten (2nd ed.) (The struggle for the rosy red) (1903) (Leipzig: Insel, 1911), 81.

34. *FE,* 2:70.

35. August Behmer to Ernst Hardt, 19 February 1907, *Briefe an Ernst Hardt: Eine Auswahl aus den Jahren 1898–1947,* ed. Jochen Meyer (Marbach: Deutsches Literaturarchiv, 1975), 53. Also, the dates for events in Hardt's private and professional life are from the chronology provided in this work (7–10).

36. EvFL to DB, "Djuna thanks."

37. EvFL to DB, "Djuna thanks."

38. *BE,* 50.

39. *BE,* 50.

40. Oscar A. H. Schmitz, "Tagebuch," typescript (Oscar A. H. Schmitz Papers, DLM). My thanks to Gisela Baronin Freytag v. Loringhoven for a copy of this text. The overlap in all three texts allows us to piece together the sequence of events.

41. Schmitz, *Dämon Welt,* 226.

42. Schmitz, "Klasin Wieland," 101–02.

43. Schmitz, "Klasin Wieland," 118.

44. Schmitz, "Klasin Wieland," 91–92.

45. Schmitz, *Dämon Welt,* 226; also Schmitz, "Klasin Wieland," 104.

46. Schmitz, "Klasin Wieland," 124.

47. Schmitz, "Klasin Wieland," 125.

48. Schmitz, "Klasin Wieland," 156.

49. Schmitz, "Klasin Wieland," 100; Schmitz's "Erinnerungen," 191, 256, 398, 463, etc. reveal a similarly crude bias against brilliant women like Helene Stöcker, Else Lasker-Schüler, or even his friend Franziska zu Reventlow. Schmitz's friend Louisa admires Elsa and defends her "meanness" (Gemeinheiten) (18 June 1904, 285).

50. Schmitz, "Klasin Wieland," 116–17.

51. Schmitz, *Dämon Welt,* 233.

52. Schmitz, "Erinnerungen," 183–84.

53. Schmitz, "Erinnerungen," 230.

54. Schmitz, "Erinnerungen," 184.

55. Schmitz, "Klasin Wieland," 155.

56. Jess Wells, *A Herstory of Prostitution in Western Europe* (Berkeley: Shameless Hussey P, 1982), 6–7.

57. Shannon Bell, *Reading, Writing and Rewriting the Prostitute Body* (Bloomington: Indiana UP, 1994), 32.

58. Schmitz, "Klasin Wieland," 156.

59. FPG to Oscar A. H. Schmitz, 6 September 1905 (Frederick Philip Grove Papers, UML). Greve makes some constructive suggestions for improvement but focuses on the Berlin story in his review.

60. *BE,* 52–54. There is a poem, though, entitled "Oh! Aha! Sch–Sch–Sch——", a title that phonetically echoes the initials of Oscar A. H. Schmitz's name. The poem talks about "Aesthetes" as "cultural parasites."

61. *BE,* 52.
62. EvFL to DB, "Djuna Sweet, if you would know," 17.
63. *BE,* 52.
64. My reading of Salomé is based on Biddy Martin, *Woman and Modernity: The (Life)Styles of Lou Andreas-Salomé* (Ithaca: Cornell UP, 1991), 9, 88–89.
65. *BE,* 52–53.
66. *BE,* 53.

Chapter 4

1. Peter Jelavich, *Munich and Theatrical Modernism: Politics, Playwriting, and Performance, 1890–1914* (Cambridge: Harvard UP, 1985), v.
2. Jelavich, *Munich and Theatrical Modernism,* 155.
3. Stefan George, "München," in *Die Münchner Moderne: Die literarische Szene in der "Kunststadt" um die Jahrhundertwende,* ed. Walter Schmitz (Stuttgart: Reclam, 1990), 462. See also Stefan George to Melchior Lechter, April 1905: "Munich is the only city in the world without the 'burger'—it is the city of the people and youth," quoted in Walter Schmitz, "Kreise in Schwabing," in Schmitz, *Die Münchner Moderne,* 459.
4. *BE,* 54.
5. Oscar A. H. Schmitz, *Dämon Welt* (Munich: Müller, 1926), 242. My descriptions are taken from Franziska zu Reventlow, *Herrn Dames Aufzeichnungen oder Begebenheiten aus einem merkwürdigen Stadtteil* (Frankfurt: Ullstein, 1987), 183, who describes her visit to Adrian's (Oscar A. H. Schmitz's) apartment in 1903.
6. Oscar A. H. Schmitz, "Tagebuch," typescript (Oscar A. H. Schmitz Papers, DLM), 185.
7. *BE,* 54. See *FE,* 2: 99, for the specific time reference at the "end of February."
8. Verwaltungsrat Domcke, Stadt Dachau, Rathaus, 19 September 1991, confirms that the registrar for 1900 lists "Frau Else Ploety [sic] (geboren 12.07.1875) [. . .] um 1900 in Dachau als Malerin." There is also a reference to Swinemünde, Pommern. Either the mistakes in spelling and year of birth were due to a misreading of the handwriting, or Elsa was rejuvenating herself by a year. My thanks to Gisela Baronin Freytag v. Loringhoven for a copy of this letter.
9. *FE,* 2: 99.

10. *BE,* 54–55.

11. Carolyn Burke, *Becoming Modern: The Life of Mina Loy* (Berkeley: U of California P, 1997), 60–64.

12. *BE,* 55.

13. *BE,* 53. In 1909, Wolfskehl moved to Römerstrasse 16, where Stefan George was given his own private room, the Kugelzimmer; Römerstrasse 16 was the center of an artist circle until 1914. Information on addresses is based on Schmitz, "Kreise in Schwabing," in Schmitz, *Die Münchner Moderne,* 458–62; and Heide Marie Karin Geiss, "Schwabinger Addressen," in *München* (Cologne: Dumont, 1998), 142–43.

14. Wolfskehl was well published through printings of his poetry in the *Blätter,* second only to George himself; he was also a consummate cultural and social mediator, a man with a personality to disarm and forge into unity Munich's avant-garde. Affluent and generous, he acted as a major promoter for young artists, using his influence with George to launch artists including Oscar A. H. Schmitz in the prestigious *Blätter.*

15. My descriptions of Wolfskehl in this chapter are based on Alfred Verwey quoted in Manfred Schlösser, *Karl Wolfskehl 1869–1969: Leben und Werk in Dokumenten,* Exhibition Catalogue (Darmstadt: Agora, 1969), 192; Schmitz, *Dämon Welt,* 89–93; and Reventlow, *Herrn Dames Aufzeichnungen,* 140.

16. Steven Aschheim, "The Not-So-Discrete Nietzscheanism of the Avant-Garde," in *The Nietzsche Legacy in Germany 1890–1990* (Berkeley: U of California P, 1992), 59. Aschheim discusses the Asconan dancer Mary Wigman, whose "ecstatically possessed (some said demonic) dancing—discharging tension through whirling, jerking, and thrusting movement—was explicitly Dionysian," pp. 60–61. My discussion of the Kosmiker circle is furthermore based on Karlhans Kluncker, "Wolfskehl und Stefan George," in *"Das geheime Deutschland": Über Stefan George und seinen Kreis* (Bonn: Bouvier, 1985), 87–110; Richard Faber, *Männerrunde mit Gräfin: Die "Kosmiker" Derleth, George, Klages, Schuler, Wolfskehl und Franziska zu Reventlow, Mit einem Nachdruck des Schwabinger Beobachters* (Frankfurt: Lang, 1994).

17. See Hans-Jürgen Heinrichs, ed., *Materialien zu Bachofens "Das Mutterrecht"* (Frankfurt: Suhrkamp, 1975). Bachofen (1815–1887), a law

professor in Basel, Switzerland, had begun to develop his gynocratic thesis based on his analysis of the goddesses of antique cultures. Thus Bachofen identifies three major epochs. The first is the rule of the chthonic hetaerae, a social structure based on pagan principles devoid of traditional family bonds or patriarchal privileges. The second is the rule of matriarchy with a celebration of the goddess Demeter. And the third is the rule of Apollonian patriarchy, patriarchy effectively usurping the earlier female-dominated cultures.

18. See Reventlow, *Herrn Dames Aufzeichungen,* in particular ch. 3, pp. 120–29, which introduces Herrn Dame into the circle's secret codes. For a discussion of Reventlow's *Herrn Dames Aufzeichungen* in the context of the Baroness's memoir account of the period, see my article "'No Woman Lover': Baroness Elsa's Intimate Biography," *Canadian Review of Comparative Literature* 20.3–4 (September 1993): 451–67.

19. See also Otto Weininger's bizarre psychological and cultural study, *Sex and Character* (Vienna, 1903), a cult text that theorized and popularized human bisexuality within problematic misogynist and racial parameters.

20. My information is based on Richard Hinton Thomas, "Nietzsche in Weimar Germany—and the Case of Ludwig Klages," in *The Weimar Dilemma: Intellectuals in the Weimar Republic,* ed. Anthony Phelan (Manchester: Manchester UP, 1985), 71–91. For the essentialist dimensions of Klages's theories, see Ludwig Klages, "Die Magna Mutter," in Heinrichs, *Materialien zu Bachofen,* 114–31.

21. *BE,* 123.

22. *BE,* 83–84.

23. *BE,* 122–23.

24. Franziska zu Reventlow, *Tagebücher 1895–1910,* ed. Else Reventlow (Hamburg: Luchterhand, 1992), 113.

25. Reventlow to Theodor Lessing, quoted in Richard Faber, *Franziska zu Reventlow* (Cologne: Bühlau, 1993), 72. My thanks to Gaby Divay for sending me a copy with this quotation.

26. Reventlow, *Tagebücher,* 373.

27. See Reventlow, *Tagebücher,* 141–67. From summer to winter 1900, Reventlow lived on Samos, on Lesbos, and in Greece. On her return in early January 1901, she reconnected with her Munich friends—dance on 15 January, visit to Wolfskehl on 19 January, bal paré on

21 January (172). On 20 February she met George (176). She was also working on her first novel, the autobiographical *Ellen Oljesterne* (a likely inspiration for *Maurermeister Ihles Haus*).

28. Franziska zu Reventlow, "Viragines oder Hetären," originally published in 1899 under the title "Was Frauen ziemt," reprinted in Franziska zu Reventlow, *Autobiographisches: Novellen, Schriften, Selbstzeugnisse,* ed. Else Reventlow (Frankfurt: Ullstein, 1986), 236–49.

29. Reventlow, *Tagebücher,* 128.

30. Oscar A. H. Schmitz, "Tagebuch," typescript (Oscar A. H. Schmitz Papers, DLM), 189, 285.

31. *BE,* 138.

32. For a discussion of women artists as single mothers in turn-of-the-century Germany, see Brigitte Bruns, "Das dritte Geschlecht von Ernst von Wolzogen," in *Das Hof-Atelier Elvira 1887–1928, Ästheten, Emanzen, Aristokraten,* ed. Rudolf Herz and Brigitte Bruns, Exhibition Catalogue (Munich: Münchner Stadtmuseum, 1985), 185.

33. *BE,* 139.

34. Alfred Schuler, *Fragmente und Vorträge aus dem Nachlass,* intro. Ludwig Klages (Leipzig: Barth, 1940); Klages's "Einführung," written during the Nazi era, clearly catered to the anti-Semitic rulers in its racially charged discussions of Wolfskehl (41–51) and in its discussion of Schuler's discovery of the swastika symbol (54–55). For a discussion of Schuler, see Gerd-Klaus Kaltenbrunner, "Zwischen Rilke und Hitler—Alfred Schuler," *Zeitschrift fuer Religion und Geistesgeschichte* 19.4 (1967): 333–47.

35. *BE,* 57.

36. *BE,* 56.

37. Schmitz, *Dämon Welt,* 259.

38. Schmitz, "Tagebuch," 188–89.

39. *BE,* 111.

40. *BE,* 112.

41. *BE,* 112.

42. *BE,* 58.

43. EvFL to DB, ca. 1924, "I will be saved Djuna."

44. Schmitz, "Erinnerungen," 190. Endell to Kurt Breysig, 1 August 1903 (Kurt Breysig Papers, SBB). In his correspondence with his cousin, he also describes himself as an optimist.

45. EvFL to Richard Schmitz, ca. 1924.

46. My discussion of Haus Elvira is based on the essays published in the exhibition catalogue, in particular Rudolf Herz, "August Endell in München. Bau des Ateliers Elvira und die Resonanz der Zeitgenossen," in Herz and Bruns, *Hof-Atelier Elvira,* 25–41.

47. Ludwig Klages, quoted in Hans Eggert Schröder, *Ludwig Klages: Die Geschichte seines Lebens* (Bonn: Bouvier, 1966), 248.

48. August Endell, *Um die Schönheit: Eine Paraphrase über die Münchner Kunstausstellungen* (Munich: Franke, 1896), 12. See also Peg Weiss's discussion of Endell's centrality within Munich's arts and crafts movement, in Weiss, "Jugendstil: The Arts and Crafts Movement," in Weiss, *Kandinsky in Munich: The Formative Jugendstil Years* (Princeton: Princeton UP, 1979), 22–27.

49. August Endell, quoted in Nikolaus Schaffer, "Architektur als Bild. Das Atelier Elvira—ein Unikum der Architekturgeschichte," in Herz and Bruns, *Hof-Atelier Elvira,* 20.

50. Herz, "August Endell in München," 32, notes that like Endell's role model Obrist, he was a paying member of the Association for Women's Interests (Verein für Fraueninteressen) and was frequently invited to give talks. In 1898, he lectured on "The Concept of Work in Both Sexes" to members of the Munich women's association, and he was closely associated with some of the leading women of the nineties, including Salomé, Goudstikker, and Augspurg.

51. Lou Andreas-Salomé, *Lebensrückblick,* ed. Ernst Pfeiffer (Frankfurt: Insel, 1974), 110.

52. August Endell to Kurt Breysig, n.d. (Kurt Breysig Papers, SBB).

53. *BE,* 58.

54. Klages, quoted in Eggert-Schröder, *Ludwig Klages,* 247–248.

55. *BE,* 72.

56. Raimund Hertzsch, *Die Hackeschen Höfe* (Berlin: Homilius, 1997), 10–17.

57. [Else] Ti Endell to Frank Wedekind, n.d. (August Endell Papers, SBB). Ti Endell invited Wedekind for five o'clock tea at Whitsuntide (Pfingsten). She tells him that their home at Augustastrasse 9 is a ten-minute walk from the Wannsee train station. Apparently, Wedekind received Elsa's letter too late and thus could not come, as we can glean from the second invitation. Already, Elsa was print-

ing her signature in energetic graphics that would characterize her "EvFL" signature on artwork. For information on Wedekind, see also Günter Seehaus, *Wedekind* (Reinbek bei Hamburg: Rowohlt, 1974).

58. Rosalee Goldberg, "Dada Performance: 'The Idea of Art and the Idea of Life," in *Performance: Live Art 1909 to the Present* (London: Thames and Hudson, 1979), 34. Goldberg traces the roots of Zurich dada to Munich's vanguard.

59. My discussion is based on Jürgen Schutte and Peter Sprengel, "Brettl und Überbrettl," in *Die Berliner Moderne 1885–1914* (Stuttgart: Reclam, 1987), 54–57.

60. See Hugo Ball's recognition of Frank Wedekind as an important influence on his art, in Ball, *Flight out of Time: A Dada Diary by Hugo Ball,* ed. and intro. John Elderfield, trans. Ann Raimers (Berkeley: U of California P, 1996), 4–5.

61. Jelavich, *Munich and Theatrical Modernism,* 167.

62. Jelavich, *Munich and Theatrical Modernism,* 167–185.

63. *BE,* 68.

64. Walter Benjamin, *Illuminationen: Ausgewählte Schriften* (Frankfurt: Suhrkamp, 1977), 243.

65. *BE,* 59–60. In *Fanny Essler,* Elsa's alter ego is keeping her husband up late at night; both obsessively theorize about their condition and yet never find a solution.

66. *BE,* 60.

67. EvFL to DB, Spring 1924, "Djuna Sweet—if you would know."

68. *BE,* 60.

69. Endell to Breysig, 19 April 1902 (Kurt Breysig Papers, SBB).

70. *BE,* 60.

71. Catharina Lüden, *Gmelins Nordsee-Sanatorium, Dr. med. Karl Gmelin und sein Wirken auf Föhr* (Husum: Husum Druck, 1985). My thanks to Gisela Baronin Freytag v. Loringhoven for a copy of this booklet.

72. *BE,* 61.

73. *BE,* 61.

74. *BE,* 70.

75. *BE,* 71.

76. *BE,* 71.

77. *BE,* 72.

Chapter 5

1. See Klaus Martens, *F. P. Grove in Europe and Canada: Translated Lives* (Edmonton: U of Alberta P, 2001), an English translation of *Felix Paul Greves Karriere: Frederick Philip Grove in Deutschland* (St. Ingbert: Röhrig, 1997), for a discussion of Felix Paul Greve as a key figure within the emergence of a German culture of translation, and as a writer in Canada.

2. Reproduced in Martens, *Felix Paul Greves Karriere,* 70.

3. FPG, *Wanderungen* (Berlin: von Holton, 1902); see, for example, the first section "Wanderungen," which reads like a homosexual awakening experience (17, 23), as the speaker breaks out of his prison (17) and recognizes his identity within a Georgian setting ("der Adel der vom Volk dich trenne) (21), a point not yet fully recognized by the critics. See Douglas O. Spettigue, *FPG: The European Years* (Ottawa: Oberon P, 1973), 64–70, for a helpful overview and critical discussion of the poems and their reception in Germany; and Martens, *Felix Paul Greves Karriere,* 122–25, who sees the speaker as an Odysseus figure. See also George Chauncey, *Gay New York: Gender, Urban Culture, and the Making of the Gay Male World, 1890–1940* (New York: Basic Books, 1994), 74: "Numerous British and German gay men traveled to southern Italy at the turn of the century in search for a more tolerate climate."

4. FPG to Alfred Janssen, 5 December 1901, reprinted in Martens, *Felix Paul Greves Karriere,* 319. Janssen did not accept the book for publication.

5. FPG, *Wanderungen,* [5]. For a discussion of Herman F. C. Kilian (1876–1932), a doctoral student of biology, see Spettigue, *FPG,* 69; Martens, *Felix Paul Greves Karriere,* 146.

6. See FPG to J. C. C. Bruns, 8 January 1902, reprinted in Martens, *Felix Paul Greves Karriere,* 320–21.

7. *BE,* 161.

8. FPG and Herman Kilian to Karl Wolfskehl, postcard, 21 May 1902 (Karl Wolfskehl Papers, DLM). I was able to access a copy of this and the 17 May postcard in the University of Manitoba Libraries (FPG Papers, UML). Both postcards are written collaboratively. See also Wayne Koestenbaum's *Double Talk: The Erotics of Male Literary Collaboration* (New York: Routledge, 1989), 3: "Collaboration, itself neutral, can mean many things. It became laden, delicately at the

beginning of the 19th century, and ferociously at its end, with the struggle to define male bonds along a spectrum including lascivious criminality and chumming—a continuum that Eve Kosofsky Sedgwick has called homosocial. [. . .] I would say that collaboration between men in the 19th and early 20th centuries was a complicated and anxiously homosocial act, and that all writers in this study, regardless of their sexual preference, collaborated in order to separate homoeroticism from the sanctioned male bonding that upholds patriarchy." The doubleness outlined by Koestenbaum consists in the fact that "[c]ollaborators express homoeroticism and they try to conceal it" (3).

9. Richard Cavell, "Felix Paul Greve, the Eulenburg Scandal, and Frederick Philip Grove," *ECW* 62 (Fall 1997): 12–45.

10. FPG to J. C. C. Bruns, 6 October 1902, reprinted in Martens, *Felix Paul Greves Karriere,* 333.

11. For the "traveling virgin" debacle, see *BE,* 79–82: "Mr. Felix was supposed to have 'ruined the girl's reputation' in traveling with her. That is why he came to Berlin." See Martens, *Felix Paul Greves Karriere,* 136–44 and 163–72, for FPG's plans to create a literary salon with Helene Klages at his side.

12. EvFL and Felix Paul Greve, "Verses from: 'The Inn on the River Lahn' of German Corps Student Lore as Confided to me by my Husband II, Felix Paul Greve, Faithfully—Free Translated by EvFL," unpublished English poem.

13. *BE,* 72–73.

14. *BE,* 110.

15. *BE,* 73.

16. *BE,* 73.

17. *BE,* 74.

18. *BE,* 75.

19. Frederick Philip Grove, *In Search of Myself* (Toronto: Macmillan, 1946), 135–36.

20. Grove, *In Search of Myself,* 136–39.

21. Grove, *In Search of Myself,* 162–163.

22. Grove, *In Search of Myself,* 161–62.

23. Else (Ti) Endell to Marcus Behmer, postcard poststamped 26 December 1902 (the postcard shows a picture of the Sanatorium Wyk auf Föhr) (August Endell Papers, MSB).

24. EvFL to DB, "Djuna—I have nothing much to say," March 1925.

25. *BE*, 84.

26. August Endell to Kurt Breysig, January 1903 (Kurt Breysig Papers, SBB). My thanks to Gisela Baroness von Freytag-Loringhoven for sending me a microfilm of the entire correspondence.

27. *BE*, 86. The hotel address and departure date are found on FPG's letter to J. C. C. Bruns, 29 January 1903, reprinted in Martens, *Felix Paul Greves Karriere*, 338.

28. *BE*, 87.

29. *BE*, 88.

30. *BE*, 89.

31. August Endell to Franziska zu Reventlow, 31 May 1903, typed letter (August Endell Papers, MSB). Endell remembers her visit fondly, regrets it was so short, and apologizes for being in such low spirits. He is happy, though, about the "new epoch in Wolfskehl's life"— that is, his liaison with Reventlow.

32. August Endell to Kurt Breysig, 6 July 1903 (Kurt Breysig Papers, SBB).

33. EvFL, "Palermo," unpublished English poem.

34. EvFL to DB, "Djuna Sweet—if you would know," 19.

35. *BE*, 90.

36. *BE*, 90–91.

37. FPG, *Randarabesken zu Oscar Wilde* (Minden: Bruns, 1903), quoted and trans. in Spettigue, *FPG: The European Years*, 111.

38. FPG, *Randarabesken,* quoted and trans. in Spettigue, *FPG: The European Years,* 109.

39. *BE*, 103. Ultimate proof may be missing, but there is plenty of evidence that suggests a physical affair too, including the intimate closeness of the two men collaborating and traveling, Kilian's generous financing of Greve's ostentatious good looks, Kilian's fierce sense of jealous betrayal, and Greve's penultimate admission that he had been initiated into heterosexuality by Mrs. Broegler/Elsa.

40. *BE*, 106.

41. *BE*, 107.

42. *BE*, 108.

43. EvFL to DB, "Djuna Sweet—if you would know," 30.

44. *BE*, 146.

45. *BE*, 148.

46. *BE*, 143.

47. *BE,* 107.

48. Oscar A. H. Schmitz, "Tagebuch," 25 November 1906, typescript, 395.

49. *BE,* 145.

50. *BE,* 139–40.

51. *BE,* 151.

52. *BE,* 157.

53. *BE,* 163.

54. *BE,* 182.

55. *BE,* 186.

56. *BE,* 189. *BE* cites the passage as "mildly interesting," while DB's typescript spells "wildly interesting," which seems more logical here.

57. Standesamt Steglitz-Zehlendorf von Berlin, Urkundenstelle, 7 November 2001, confirms the divorce date, 23 January 1903, which was first cited by the Canadian scholar Desmond Pacey in *The Letters of Frederick Philip Gove,* ed. Desmond Pacey (Toronto: U of Toronto P, 1976), 552, n. 1. Pacey refers to the divorce as an "annulment," however, although it was an official divorce, as confirmed by the Standesamt.

58. FPG to Oscar A. H. Schmitz, 28 May 1904 (Felix Paul Grove Papers, DLM), copies at UML.

59. André Gide, "Tagebuchnotizen über das erste Treffen mit FPG, Transkript, Cuverville, 03. 06. 1904," *Felix Paul Greve-Andrè Gide: Korrespondenz und Dokumentation,* ed. Jutta Ernst and Klaus Martens (St. Ingbert: Röhrig, 1999), 223.

60. Gide, "Tagebuchnotizen," in Ernst and Martens, *FPG—André Gide,* 224.

61. *BE,* 116.

62. *BE,* 115.

63. Gide, "Tagebuchnotizen," in Ernst and Martens, *FPG—André Gide,* 222.

64. FPG to Gide, in Ernst and Martens, *FPG—André Gide,* 91.

65. Gaby Divay, "Fanny Essler's Poems: Felix Paul Greve's or Else von Freytag-Loringhoven's?" *Arachne: An Interdisciplinary Journal of Language and Literature* 1.2 (1994): 186.

66. Fanny Essler [pseud. Felix Paul Greve and Else Plötz], "Ein Porträt: Drei Sonnette," *Die Freistatt* 6 (10 October 1904): 840–41.

67. FPG to Gide, 17 October 1904, in Ernst and Martens, *FPG—André Gide,* 74–75.

68. FPG to Gide, 1 July 1905, in Ernst and Martens, *FPG—André Gide,* 125.

69. *BE,* 65. In Irene Gammel, *Sexualizing Power in Naturalism: Theodore Dreiser and Frederick Philip Grove* (Calgary: U Calgary P, 1994), 119–32, I first proposed that the novel was a collaboration, Grove using the material provided by Elsa and the novel itself thematizing confessional paradigms.

70. See also EvFL to DB, "Djuna Sweet—if you would know," ca. 1924, 23. In this letter, the Baroness compared Barnes's function in Elsa's personal and professional life with that of Greve's, telling her that she, too, had "executive ability [. . .] *very* much the same as my second, most important, mate—*Felix Paul Greve.*"

71. Martens, *Felix Paul Greves Karriere,* 277.

72. FPG to Gide, 14 August 1905, in Ernst and Martens, *FPG—André Gide,* 128.

73. Herbert Koch to Franziska zu Reventlow, n.d. (Franziska zu Reventlow Papers, STM). On 2 February 1938, Wolfskehl remembered the book when he received a query from Robert Boehringer for published information about George: "You know there is a slanderous book by that pseudologist [*Pseudologen*] of early times, F. L. [*sic*] Greve. Besides many caricatures surrounding M[elchior] L[echter], it featured relatively few respectless allusions to the M[aster]. The pamphlet, a fat book, remained totally unknown; I don't have it any more, even its title, the name of a wench, I can no longer remember." Karl Wolfskehl to Robert Boehringer, 16 February 1938 (Karl Wolfskehl Papers, DLM).

74. See Brigitte Bruns, "Das dritte Geschlecht von Ernst von Wolzogen," *Hof-Atelier Elvira 1887–1928: Ästheten, Emanzen, Aristokraten,* ed. Rudolf Herz and Brigitte Bruns. Exhibition catalogue. (Munich: Münchner Stadtmuseum, 1985), 171–90.

75. *Schwabinger Beobachter,* no. 2, reprinted in Richard Faber, *Männerrunde mit Gräfin* (Frankfurt: Lang, 1994), 21.

76. *Schwabinger Beobachter,* no. 2, reprinted in Faber, *Männerrunde mit Gräfin,* 21.

77. *Schwabinger Beobachter,* no. 3, reprinted in Faber, *Männerrunde mit Gräfin,* 31.

78. *Schwabinger Beobachter,* no. 4, reprinted in Faber, *Männerrunde mit Gräfin,* 44.

79. *FE,* 2: 195.

80. EvFL to DB, "Djuna, I have nothing much to say," ca. March 1925.

81. Schmitz, "Erinnerungen," 395.

82. EvFL to *LR* (*LR* Papers, GML), *LRC,* 5.

83. Martens, *Felix Paul Greves Karriere,* 256.

84. EvFL to DB, August 1924, in *BE,* 216.

85. Schmitz, "Erinnerungen," 405–06. Schmitz met Frank Wedekind the next day, 12 December.

86. FPG to Oscar A. H. Schmitz, 14 December 1906, typed letter (Papers, DLM), copies at UML.

87. Standesamt Charlottenburg-Wilmersdorf von Berlin to Gisela Baronin Freytag v. Loringhoven, 9 October 2001, confirms that Else Ploetz married Felix Paul Greve, 22 August 1907. This letter also confirms that this is Elsa's second marriage. My thanks to Gisela Baronin Freytag v. Loringhoven for a copy of this letter.

88. *BE,* 119.

89. Schmitz, "Erinnerungen," 13 January 1908, 528. The dog referred to, Mumma, is also named in Endell's wedding announcement.

90. Schmitz, "Erinnerungen," 30 January 1908, 532.

91. FPG to Gide, 22 June 1908, in Ernst and Martens, *FPG—André Gide,* 177.

92. *BE,* 66.

93. Anton Kippenberg to Mrs. Else Greve, 21 September 1909, in *The Letters of Frederick Philip Grove,* ed. Desmond Pacey (Toronto: U Toronto P, 1976), 550. See also Divay, "Fanny Essler's Poems."

94. See Klaus Martens, "Franziska zu Reventlow, Prince Yussuf, and Else Greve: New Roles for Women Writers," Conference paper, CCLA/ACLC Edmonton, U of Alberta, May 2000. See also Sigrid Bauschinger, "Else Lasker Schüler (1869–1945): Völlige Gehirnerweichung," in Sibylle Duda and Luise Putsch *Wahnsinnsfrauen* (Frankfurt: Suhrkamp, 1996), 2: 71–99.

95. Passenger Record for Else Greve, 29 June 1910. The Statue of Liberty-Ellis Island Foundation; http:www.ellisislandrecords.com See also Paul Hjartarson and Douglas Spettigue, "Introduction," in *BE,* 25.

96. Frederick Philip Grove, *Settlers of the Marsh* (1925) (Toronto: McClelland and Stewart, 1984), 135.

97. FPG, *Settlers,* 126.

98. FPG, *Settlers,* 126.

99. FPG, *Settlers,* 163.

100. *BE,* 83.

101. *BE,* 92.

102. EvFL, "Gespenst," unpublished German poem. My thanks to Gaby Divay for insights into Elsa's poetic development; personal communication.

103. EvFL, "Solitude," unpublished English poem; a slightly different version of this poem is titled "Verrat" (Betrayal) and was submitted for publication in *The Little Review* (*LR* Papers, GML), *LRC,* 71.

104. EvFL to DB, "Yes—it is visa," Spring 1925.

105. FPG, *Settlers,* 91.

106. *BE,* 117–18.

107. *BE,* 121.

108. *BE,* 117.

109. EvFL, "Schalk," unpublished German poem. See Divay, "Fanny Essler's Poems"

110. *BE,* 121.

111. Marginalia about FPG on a sheet that features EvFL's, "Wolkzug," unpublished German poem.

112. DB, "Elsa—Notes," 24 April 1933.

113. EvFL, "Wetterleuchte," unpublished German poem.

114. EvFL, "Herr Peu à Peu," unpublished poem in German and English.

115. EvFL, "Seelisch—Chemische Betrachtung," unpublished German manuscript.

Part III

Chapter 6

1. Marcel Duchamp, quoted in Kenneth Rexroth, *American Poetry in the Twentieth Century* (New York: Herder and Herder, 1973), 77. My thanks to Alan Filreis for this reference.

2. EvFL to Jane Heap, ca. Winter 1922, "Dear Heap—You would please me a heap" (*LR* Papers, GML), *LRC,* 7.

3. EvFL to Peggy Vail [Guggenheim], 1927, typed letter, 30.

4. John Quinn, quoted in Ezra Pound, *The Selected Letters of Ezra Pound to John Quinn 1915–1924,* ed. Timothy Materer (Durham: Duke UP, 1991), 8.

5. See Francis M. Naumann, "Proto-Dada," in *New York Dada 1915–23* (New York: Abrams, 1994), 12–21; William B. Scott and

Peter M. Rutkoff, "The Armory Show," in *New York Modern: The Arts and the City* (Baltimore: Johns Hopkins UP, 1999), 58–62.

6. The place of residence is given on her marriage certificate, 19 November 1913; see note 9 below. For dating New York Dada, see Naumann, *New York Dada;* Manuel L. Grossman, "Pre-Dada in New York," in *Dada: Paradox, Mystification, and Ambiguity in European Literature* (New York: Pegasus, 1971), 37–47, dates New York dada from 1915 to 1921, with *New York Dada* magazine signaling the movement's end.

7. John Rodker, "'Dada' and Else von Freytag-Loringhoven," *LR* 7.2 (July–August 1920): 33.

8. My thanks to Francis M. Naumann, who first drew my attention to this work and sent me a black and white copy, and to Mark Kelman, who sent me a color photograph and ektachrome. In 1923, the Baroness gave the object (along with three others) to Allen Tanner and Pavel Tchelitchew, Tanner being close to the *Little Review* circle (see chapter 12 for details).

9. Certificate of Marriage, no. 29812, 19 November 1913, New York City Department of Records and Information Services, Municipal Archives. The witnesses were James Sheldon and Patrick Paul. Paul I. Hjartarson and Douglas Spettigue, Introduction, *BE,* 25, first identified the marriage certificate but indicated the number as V04606.

10. My thanks to Gisela Baronin Freytag v. Loringhoven for providing me with this information.

11. EvFL, "Five-o-clock," unpublished German poem (although the title is in English in the original.

12. EvFL to Jane Heap, ca. 1922, "Maybe I have been naughty" (*LR* Papers, GML), *LRC,* 2.

13. EvFL, "Tod eines Schwerenöters—Hamlet in America." George Biddle recalls this conversation with the Baroness: "She told me that she had fled her husband before the War, because he had the soul of a successful art dealer, rather than because he was a sexual pervert—not androgynous but something or other more sinister." Biddle, *An American Artist's Story* (Boston: Little, Brown, 1939), 138. It is not entirely clear, though, whether he is referring to Baron Leopold or Greve.

14. EvFL, "Tod eines Schwerenöters—Hamlet in America."

15. Margaret Anderson, *My Thirty Years' War* (1930) (New York: Horizon, 1969), 179.

16. Louis Bouché, "Autobiography" (Louis Bouché Papers, AAA), roll 688, frames 700–02.

17. Anderson, *My Thirty Years' War,* 177.

18. EvFL to George Biddle, ca. 1927.

19. Bouché, "Autobiography," roll 688, frame 701.

20. EvFL to Jane Heap, ca. 1922, "Maybe I have been naughty," *LRC,* 1. See also Kenneth Rexroth's critical comments in *An Autobiographical Novel* (Garden City: Doubleday, 1966): "At the Art Students League I took life classes and Weber's course in 'The Materials of the Artist,' which I had looked forward to for several years. I am afraid I didn't learn much. His palette was entirely of earth colors and his use of materials was conservative and cranky" (208). He adds: "The students of Kenneth Hayes Miller and Schnackenburg all painted totally indestructible objects which looked like they had been built of variously tinted mud" (208–09).

21. Robert Reiss, "'My Baroness': Elsa von Freytag-Loringhoven," in *New York Dada,* ed. Rudolf E. Kuenzli (New York: Willis Locker & Owens, 1986), 81. The Ferrer School, or Modern School, was founded in 1910 as an anarchist school and run by the philosopher Will Durant. This school invited controversial speakers, including the Russian anarchist Emma Goldman and birth-control advocate Margaret Sanger. The school offered evening classes for adults, with leftist writer Theodore Dreiser teaching writing, while painters George Bellow and Man Ray provided art lessons. For further discussions of the Ferrer School, see Paul Avrich, *The Modern School Movement: Anarchism and Education in the United States* (Princeton: Princeton UP, 1980); Scott and Rutkoff, *New York Modern,* 69–70.

22. Reiss, "My Baroness," 82. Reiss's sources include Bessie Breuer, "Memoir," manuscript, the estate of Henry Varnum Poor, New York, New York; "Remembrances of Sarah the 'Kid,'" Interview with Sarah MacPherson conducted by Jerry Tallmer, *New York Post,* 5 September 1981, 12; and Anne Poor, "Sarah McPherson" (Sarah McPherson Papers, AAA).

23. Naumann, *New York Dada,* in particular the chapters "The Arensbergs," 22–33, and "The Arensberg Circle," 94–175.

24. Beatrice Wood to Gisela Baronin Freytag v. Loringhoven, 7 January 1991. See also Henri-Pierre Roché, *Victor, Ein Roman* (Munich: Schirmer/Mosel, 1986), in particular, chapter 17, which describes

Duchamp's studio. This autobiographical novel is almost entirely devoted to the Arensberg circle and to Roché's homoerotically charged relationship with Duchamp. The Baroness figures here as the avant-garde playwright "Sabine," who is a regular visitor at the Arensberg salon.

25. Francis M. Naumann, ed., *How, When, and Why Modern Art Came to New York: Marius de Zayas* (1996) (Cambridge: MIT P, 1998). See Bram Dijkstra, *The Hieroglyphics of a New Speech: Cubism, Stieglitz, and the Early Poetry of William Carlos Williams* (Princeton: Princeton UP, 1969); William Innes Homer, *Alfred Stieglitz and the American Avant-Garde* (Boston: New York Graphic Society, 1977).

26. See Leslie Camhi, "A Photographer's Surreal Transformation: How Emmanuel Radnitsky Became Man Ray," *New York Forward* (8 January 1999): 11–12. Man Ray's family had moved to Brooklyn when he was seven; they changed their name around 1910. By 1917 Man Ray began working for John Quinn, photographing artworks for the collector.

27. See Cynthia Palmer and Michael Horowitz, eds., *Shaman Woman, Mainline Lady: Women's Writings on the Drug Experience* (New York: Morrow, 1982), 103.

28. My thanks to Gisela Baronin Freytag v. Loringhoven, who sent me copies of all three INP photographs.

29. Bouché, "Autobiography," roll 688, frame 702.

30. Calvin Tomkins, *Duchamp: A Biography* (New York: Holt, 1996), 154–55. The school had been established for independent artists in 1909 by Robert Henri, an antiacademic American painter whose experimentations would soon be eclipsed by much more daring and experimental forms. Duchamp paid his rent by giving French lessons and by working in the library, a job procured through the intervention of John Quinn, who was already collecting Duchamp's work.

31. See photographs of Duchamp's studios, reproduced in Francis M. Naumann, *Marcel Duchamp: The Art of Making Art in the Age of Mechanical Reproduction* (New York: Abrams, 1999), 74–75.

32. EvFL to Jane Heap, ca. Winter 1922, "Dear Heap—You would please me a heap" (*LR* Papers, GML), *LRC,* 6.

33. Marcel Duchamp, quoted in Hans Richter, *Dada Art and Anti-Art* (1967) (London: Thames and Hudson, 1997), 89.

34. Gabrielle Buffet-Picabia, "Some Memories of Pre-Dada: Picabia and Duchamp," in *The Dada Painters and Poets: An Anthology,* ed. Robert Motherwell (New York: Wittenborn, 1967), 260.

35. EvFL to Unidentified, "Die Menschen—die sich in der Ehe," 12 (irregular pagination). While her comments to the *LR* editors were made around 1922 or 1923, several sources document that Duchamp was her first love in New York. In her autobiography, she writes about "my American unresponded love emotions—those to Marcel and 'the cast-iron lover' and the last to W. C. W." (*BE,* 85). See also her "Graveyard" poem submitted to *LR,* in which she established the same chronological sequence of lovers. Thus the chronology of her American love affairs looks something like this: Duchamp 1915 to 1917, Cast-Iron Lover 1917, George Biddle 1917 to 1919, Williams Carlos Williams 1919 to 1921, Anthony 1923. Around 1921 to 1923, her thinking returned to Duchamp, as her letters to *The Little Review* indicate. In the following chapters, each individual is discussed in greater detail.

36. EvFL to Jane Heap, ca. Winter 1922, "Dear Heap—You would please me a heap," 3.

37. EvFL to LR, ca. 1921–23, "Little Review—You seem to ignore my queries" (*LR* Papers, GML), *LRC,* 39.

38. Buffet-Picabia, "Some Memories of Pre-Dada: Picabia and Duchamp," 260.

39. EvFL to Jane Heap, ca. Winter 1922, "Dear Heap—You would please me a heap," *LRC,* 5.

40. They shared a deep contempt for the traditional art institutions. As Thierry de Duve reports in "Resonances of Duchamp's Visit to Munich," trans. Dana Polan, in *Marcel Duchamp: Artist of the Century,* ed. Rudolf E. Kuenzli and Francis M. Naumann (Cambridge: MIT P, 1996), 51, Duchamp had failed his entrance exam at the prestigious École des Beaux Arts in Paris, and his *Nude* had been rejected in Paris. The Baroness had been disillusioned with the Königliche Hochschule in Berlin as well as with her private art professor in Munich.

41. Bouché, "Autobiography," roll 688, frame 701.

42. Marcel Duchamp quoted in de Duve, "Resonances of Duchamp's Visit to Munich," 43.

43. De Duve, "Resonances of Duchamp's Visit to Munich," 52.

44. Peter Jelavich, *Munich and Theatrical Modernism: Politics, Playwriting, and Performance, 1890–1914* (Cambridge: Harvard UP, 1985), 297; see also Richard Huelsenbeck, *Memoirs of a Dada Drummer*, ed. Hans J. Kleinschmidt, trans. Joachim Neugroschel (Berkeley: U of California P, 1991). Huelsenbeck emphasizes the Munich influence on Ball, suggesting that Kandinsky had already been experimenting with a form of sound poetry that was "devoid of semantic meaning" (xxx). Indeed, sound poetry devoid of meaning was not uncommon in Germany and can be found in the poetry of Paul Scheerbart (1897) and in Christian Morgenstern's *Galgenlieder* (1905) (xxxii). Scheerbart's sound poem entitled "Ich liebe dich" (I love you) starts like this:

 Kikakoku!
 Ekoralaps!
 Wiao kollipanda opolasa . . .

 To Huelsenbeck's list we can add Else Lasker-Schüler's sound poetry, which was also recited at the Cabaret Voltaire. This focus on Munich as the spiritual and artistic root for Munich dada is also explored by Roselee Goldberg, "Dada Performance: 'The Idea of Art and the Idea of Life,'" in *Performance: Live Art 1909 to the Present* (London: Thames and Hudson, 1979), 34–48.

45. George Biddle, *An American Artist's Story* (Boston: Little, Brown, 1939), 138.

46. Roger Shattuck, quoted in Carolyn Burke, "Recollecting Dada: Juliette Roche," in *Women in Dada: Essays on Sex, Gender, and Identity,* ed. Naomi Sawelson-Gorse (Cambridge: MIT P, 1998), 550.

47. EvFL, *Keiner <Literarischer Five-o-clock>*, unpublished visual poem in German.

48. For the complex history of this work, see Francis M. Naumann, "Swimming Freely: Designs on Dada 1915–23," in Naumann, *Marcel Duchamp,* 60–94. See also Tomkins's discussion, "The Bride Stripped Bare," in Tomkins, *Duchamp,* 1–14.

49. Marcel Duchamp, *The Bride Stripped Bare by Her Bachelors, Even (The Large Glass),* 1915–23, Philadelphia Museum of Art, Bequest of Katherine Dreier, reproduced in *Marcel Duchamp,* ed. Anne D'Harnoncourt and Kynaston McShine (New York: Museum of

Modern Art, 1973), following 64. See 64 for a diagram of *The Large Glass* based on Duchamp's etching. It identifies the "Bride's Domain" in upper half of the glass and the "Bachelor Apparatus" in the lower half of the glass.

50. Amelia Jones describes *The Large Glass* as "a huge mechanized 'portrait' of the impossibility of consummation, the breakdown of gender relations, and heterosexual erotic exchange," in "'Eros, That's Life, or the Baroness's Penis," in *Making Mischief: Dada Invades New York,* ed. Francis M. Naumann with Beth Venn (New York: Whitney Museum of American Art, 1996), 241.

51. EvFL, "Love-Chemical Relationship," *LR* 5.2 (June 1918): 58.

52. EvFL, "Love-Chemical Relationship," 58.

53. EvFL, "Love-Chemical Relationship," 58.

54. EvFL, "Love-Chemical Relationship," 59.

55. EvFL, "Love-Chemical Relationship," 59.

56. See Tomkins, *Duchamp,* 12. Amelia Jones, *Postmodernism and the En-Gendering of Marcel Duchamp* (Cambridge: Cambridge UP, 1994).

57. Grace Glueck, "Duchamp Parries Artful Questions," *New York Times* (25 October 1967), 37.

Chapter 7

1. Margaret Anderson, *My Thirty Years' War* (1930) (New York: Horizon, 1969), 179.

2. August Endell, *Die Schönheit der grossen Stadt* (Stuttgart: Strecker & Schröder, 1908), passim. My thanks to Gisela Baronin Freytag v. Loringhoven for a copy of this text. Endell argued that modern city dwellers were out of touch with their living space. As an architect and urban theorist, Endell therefore aimed at engaging the viewer emotionally in the city's spaces to awaken them to new perceptions, thus creating collective memories and identities connected with the city spaces. See also Dianne Chisholm's focus on creating urban identity through spatial memory in the "City of Collective Memory in New Queer Narrative," paper presented at the Canadian Comparative Literature Annual Congress, University of Alberta, Edmonton, 27 May 2000.

3. See Francis M. Naumann, "Marcel Duchamp: A Reconciliation of Opposites," in *Marcel Duchamp: Artist of the Century,* ed. Rudolf Kuenzli and Francis M. Naumann (Cambridge: MIT P, 1996),

20–40. Naumann compares Marcel Duchamp's *Rrose Sélavy* with Charlie Chaplin's cross-dressing pose, while the Baroness would irreverently compare Stefan George to Charlie Chaplin (chapter 12).

4. Amelia Jones, "Practicing Space: World War I–Era New York and the Baroness as Spectacular Flâneuse," in *Living Display,* ed. Jim Drobnick and Jennifer Fisher (Chicago: U of Chicago P, 2001). See also Amelia Jones, *Body Art / Performing the Subject,* in particular the chapter "Postmodernism, Subjectivity, and Body Art: A Trajectory," 21–52. Here Jones develops the concept of the *body/self,* which designates "the body of the artist (the body as enactment of the self)," a definition that applies directly to the Baroness (52). Such body art "practices solicit rather than distance the spectator, drawing him or her into the work of art as an intersubjective exchange" (31).

5. Irene Gammel, "The City's Eye of Power: Panopticism and Specular Prostitution in Dreiser's New York and Grove's Berlin," *Canadian Review of American Studies* 22.2 (Fall 1991): 213–14.

6. Robert Reiss, "'My Baroness': Elsa von Freytag-Loringhoven," in *New York Dada,* ed. Rudolf E. Kuenzli (New York: Willis Locker & Owens, 1986), 82.

7. William Carlos Williams, "Sample Prose Piece: The Three Letters," *Contact* 4 (Summer 1921): 11. This description parallels the history of *Enduring Object.*

8. Henri Lefebvre develops this argument in *La vie quotidienne dans le monde moderne* (Paris: Gallimard, 1968), *Everyday Life in the Modern World,* trans. Sacha Rabinovitch (Harmondsworth: Penguin, 1971); see also Rob Shields, *Lefebvre, Love and Struggle: Spatial Dialectics* (London: Routledge, 1999), in particular the chapter "The Critique of Everyday Life: Marx and Nietzsche," 65–80.

9. EvFL, "The Art of Madness," *LR* 6.9 (January 1920): 29.

10. Hugo Ball, quoted in Shields, *Lefebvre, Love and Struggle,* 78.

11. My thanks to Mark Kelman for color photographs and ektachromes of *Earring-Object* (ca. 1917–19) and *Limbswish* (ca. 1920) (see discussion below), as well as for information pertaining to their provenance. My thanks to Francis M. Naumann for first drawing my attention to these artworks and for sending me black and white copies.

12. George Chauncey, *Gay New York: Gender, Urban Culture, and the Making of the Gay Male World, 1890–1940* (New York: Basic Books, 1994), 104.

13. Robert Motherwell, ed., *The Dada Painters and Poets: An Anthology* (New York: Wittenborn, 1967), 186 (my emphasis).

14. Anderson, *My Thirty Years' War,* 178 (my emphasis).

15. Gammel, "The City's Eye of Power," 213–14.

16. Peggy Phelan, *Unmarked: The Politics of Performance* (London: Routledge, 1993), 146, 148.

17. Phelan, *Unmarked,* 153.

18. My thanks to Francis M. Naumann for sending me a color photography of this painting.

19. DB, "How the Villagers Amuse Themselves," *New York Morning Telegraph Sunday Magazine* (26 November 1916), reprinted in Barnes, *New York,* ed. Alyce Barry (Los Angeles: Sun and Moon P, 1989), 249.

20. DB, *Nightwood* (1937) (New York: New Directions, 1961), 13.

21. Emily Coleman to DB, 27 October 1935 (DB Papers, CPL). See also Lynn De Vore's "The Backgrounds of *Nightwood:* Robin, Felix, and Nora," *Journal of Modern Literature* 10.1 (March 1983): 71–90, the first study to discuss the Baroness's traces in *Nightwood* (see chapter 13).

22. EvFL to DB, "Djuna Sweet—if you would know," ca. 1924, 25.

23. EvFL to DB, quoted in Andrew Field, *Djuna: The Formidable Miss Barnes* (Austin: U of Texas P, 1985), 82.

24. In November 1915, Guido Bruno had published Barnes's sexually irreverent *Book of Repulsive Women,* a work with Beardsley-like drawings, from his garret at 58 Washington Square. By the early twenties, Barnes would write female erotica for *Vanity Fair* and *Charm,* using the telling pseudonym of "Lydia Steptoe"; see Carolyn Allen, *Following Djuna: Women Lovers and the Erotics of Loss* (Bloomington: Indiana UP, 1996), 1. Allen uses the concept of erotics to describe Barnes's influence on other women writers (Bertha Harris, Jeanette Winterson, and Rebecca Brown), describing a relationship of emotional and sexual exchange that also applies to her friendship with the Baroness. Although Barnes assumed the maternal role, the Baroness was eighteen years older than Barnes (old enough to be Barnes's mother), suggesting obvious parallels with Barnes's formidable grandmother, Zadel Barnes, whom Djuna Barnes had supported in the decade before her

death; see the chapter "Zadel," in Phillip Herring, *Djuna: The Life and Work of Djuna Barnes* (New York: Penguin, 1995), 1–23.

25. For Barnes's residences in Greenwich Village, see Herring, *Djuna,* 103–04.

26. Amelia Jones, "Eros, That's Life, or the Baroness's Penis," in *Making Mischief: Dada Invades New York,* ed. Francis M. Naumann with Beth Venn (New York: Whitney Museum of American Art, 1996), 238–47. Writes Jones: "this fake penis signaled her adoption of phallic attributes (as New Woman), but also that she marked the penis as *transportable* rather than as a fixed, biologically determined guarantor of phallic privilege" (245).

27. DB, "Elsa—Notes," 24 April 1933, 4.

28. Rodney Thomson, "Militants," *Life* (27 March 1913). The caricature presents three rows of women: "Militants as they are" = unattractive, desexed men-women with intellectual glasses, sullen, morose, and hostile expressions; "Militants as they think they are" = beautifully youthful Jeanne d'Arc figures and angels with haloes; "As they appear to shopkeepers and police" = with satanic horns, bared teeth, and savage expressions.

29. Lynda Benglis, Advertisement, *Artforum* (1974), reprinted in Carter Ratcliff, "The Fate of a Gesture: Lynda Benglis," article available at http://www.artnet.com/magazine, 20 March 1999.

30. Judith Butler, "Performative Acts and Gender Constitution: An Essay in Phenomenology and Feminist Theory," in *Performing Feminisms: Feminist Critical Theory and Theatre,* ed. Sue-Ellen Case (Baltimore: Johns Hopkins UP, 1990), 272, 278, 282.

31. William Innes Homer, "Picabia's *Jeune fille américaine dans l'état de nudité* and Her Friends," *Art Bulletin* (March 1975): 110–15. My thanks to Francis M. Naumann for this reference.

32. Francis Picabia, *Portrait d'une jeune fille américaine dans l'état de nudité* (Portrait of a young American girl in a state of nudity), Cover of *291,* 5–6 (July–August 1915), reprinted in Elizabeth Hutton Turner, "*La jeune fille américaine* and the Dadaist Impulse," in *Women in Dada: Essays on Sex, Gender, and Identity,* ed. Naomi Sawelson-Gorse (Cambridge: MIT P, 1998) 14; see 13, for Hutton Turner's feminist argument that Picabia's spark plug "identifies the *jeune fille américaine* as a catalyst for modernization analogous to a mass-produced interchangeable part, the great facilitator of Henry Ford's revolution that

mobilized America." See also Barbara Zabel's feminist argument that this portrait does not "altogether affirm this new liberated woman," in "The Constructed Self: Gender and Portraiture in Machine-Age America," in Sawelson-Gorse, *Women in Dada,* 26. See Jones, "Eros, That's Life, or the Baroness's Penis," 241: "Picabia and Man Ray rather faithfully traced the anxious lines of a projected female body/machine-as-container-of-the-uncontrollable-(feminine)-flows-of-commodity-culture."

33. Claude McKay, *A Long Way from Home* (1937) (New York: Harcourt Brace, 1970), 104.

34. Motherwell, *The Dada Painters and Poets,* 185. Motherwell continues: "Dressed in rags picked up here and there, decked out with impossible objects suspended from chains, swishing long trains, like an empress from another planet, her head ornamented with sardine tins, indifferent to the legitimate curiosity of passers-by, the baroness promenaded down the avenues like a wild apparition, liberated from all restraint." Motherwell's bias is clear, though, as he calls her one of dada's "monstrous transformations" (185). Also by saying that she "made objects in the manner of Schwitters" (185), he gives the impression that she is imitating others, when she is really paving the way with her innovative art.

35. See Hans Richter, *Dada Art and Anti-Art* (1967) (London: Thames and Hudson, 1997), 41–43.

36. Stephen C. Foster, *Dada Dimensions* (Ann Arbor: UMI Research P, 1985), 249–71. My thanks to Francis M. Naumann for this reference.

37. See Francis M. Naumann's *New York Dada 1915–23* (New York: Abrams, 1994), 187, for an account of the lecture.

38. See Rosalee Goldberg, "Dada Performance: The Idea of Art and the Idea of Life," in *Performance: Live Art 1909 to the Present* (London: Thames and Hudson, 1979), 34–35, 37.

39. EvFL to Jane Heap, ca. Winter 1922, "Dear Heap—You would please me a heap" (*LR* Papers, GML), *LRC,* 7.

40. Margaret Sanger, *Pioneering Advocate for Birth Control: An Autobiography* (New York: Cooper Square P, 1999); see especially her chapter 17, "Faith I Have Been a Truant in the Law," 210–23; the pamphlet reprinted on 216; and chapter 18, "Lean Hunger and Green Thirst," 224–37, detailing her court appearances. When the "plain-clothed members of the Vice squad" apprehended her in October 1916,

Sanger proudly refused to ride in their patrol wagon and began marching toward the prison (220). Unlike uniformed policemen, the despised vice squad generally operated in civilian clothing, raiding the gambling houses, costume balls, bath houses, and brothels.

41. Sanger, *An Autobiography,* 221.

42. "His Model and His Soul Mate, Too. Artist's Infatuation for Baroness Told by Wife," *New York Evening Sun,* 26 January 1917, 16. This episode was first cited in Carolyn Burke, *Becoming Modern: The Life of Mina Loy* (Berkeley: U of California P, 1997), 219.

43. See Naumann, *New York Dada,* the chapters on Charles Sheeler, 121–25; Morton Schamberg, 126–29; and Charles Demuth, 130–33.

44. EvFL to DB, "Djuna Sweet—If you would know," 26.

45. George Biddle, *An American Artist's Story* (Boston: Little, Brown, 1939), 138.

46. Biddle, *An American Artist's Story,* 137.

47. See Naumann's *New York Dada,* 8–9, for a discussion of the invention of the bra in relation to the birth of dada in New York.

48. See, for example, Marsha Meskimmon, *The Art of Reflection: Women Artists' Self-Portraiture in the Twentieth Century* (New York: Columbia UP, 1996), in particular the chapter "The Myth of the Artist," 15–63. Meskimmon argues that through their own self-portraiture women "intervene in the masculine artist myths and their favorite visual forms" (26). Among many other examples, Meskimmon uses the Berlin dadaist Hannah Höch as a case in point, discussing Höch's photomontage *Double Exposure Self-Portrait* (ca. 1930) in comparison with her male lover Raoul Hausmann's *Self-Portrait with Hannah Höch* (1919), 40: "In her own self-portrait, Höch skillfully manipulated the exposure to show a double image of herself at work in her studio. In Hausmann's self-portrait, Höch is a prop, she is his lover, his muse. It is a typical self-portrait of the male artist with the female 'model.'"

49. Biddle, *An American Artist's Story,* 137–38.

50. EvFL to George Biddle, ca. 1927.

51. Amy Fine Collins, "The Early Years: 1914–1936," *Vanity Fair* (March 1999): 146–90; Cleveland Amory and Frederic Bradlee, eds., *Vanity Fair: Selections from America's Most Memorable Magazine, A Cavalcade of the 1920s and 1930s* (New York: Viking P, 1960).

52. Frank Crowninshield, quoted in Collins, "The Early Years: 1914–1936," 149.

53. This photograph was taken by the Pach Brothers and is reproduced in Naumann's *New York Dada,* 35.

54. Lawrence Rainey, "The Cultural Economy of Modernism," *The Cambridge Companion to Modernism,* ed. Michael Levenson (Cambridge: Cambridge UP, 1999), 51.

55. Marie T. Keller, "Clara Tice: 'Queen of Greenwich Village,'" in Sawelson-Gorse, *Women in Dada,* 414–41; and Francis M. Naumann, "Clara Tice," in Naumann, *New York Dada,* 117–20.

56. Photograph of Clara Tice, *Vanity Fair* (January 1917), reproduced in Naumann, *New York Dada,* 117.

Chapter 8

1. My thanks to Gisela Baronin Freytag v. Loringhoven and to Francis M. Naumann for color photographs of the respective artworks, as well as for sharing their personal interviews with Theresa Bernstein.

2. In her memoirs, the American writer and journalist Bessie Breuer noted the Baroness's strange body discoloring: "I was struck not so much by the uglyness of her body but that it seemed used, worn, the legs sinewy and her colour, like her hennaed hair, greenish purple— her breasts and her general colour," quoted in Robert Reiss, "'My Baroness': Elsa von Freytag-Loringhoven," in *New York Dada,* ed. Rudolf E. Kuenzli (New York: Willis Locker & Owens, 1986), 81. Although others (Abbott, Biddle) highlight the attractiveness of the Baroness's body, the discoloring reported here would be associated with the *munitionettes,* the women who built detonators for the war in factories; see Pat Barker, *Regeneration* (London: Plume/Penguin, 1993), 87: "Since they all had a slightly yellow tinge to their skin, he assumed they were munitions workers. Munition*ettes,* as the newspapers liked to call them"; also 87–90 and passim. This is intriguing because in her "Elsa-Notes," 4, Djuna Barnes raises the question of whether the Baroness perhaps worked in a munition factory: "She worked in a cigar factory (ask Bernice if in a munition factory?)." For a full discussion of the Baroness as a figure of war-torn Europe, see Amelia Jones's *Sex, War, and Urban Life: New York Dada, 1915–22* (forthcoming). Jones is also the first scholar to make a sustained argument for the "tragically excessive, and highly threatening, dimension"

of the Baroness's self-display, in "Practicing Space: World War I–Era New York and the Baroness as Spectacular Flâneuse," in *Living Display,* ed. Jim Drobnick and Jennifer Fisher (Chicago: U of Chicago P, 2001).

3. William Carlos Williams, *The Autobiography of William Carlos Williams* (New York: New Directions, 1967), 155. For descriptions of the wartime fever in New York's artist community, see also Carolyn Burke, *Becoming Modern: The Life of Mina Loy* (Berkeley: U of California P, 1997), 244–51.

4. For a discussion of John Sumner's activities, see George Chauncey, *Gay New York: Gender, Urban Culture, and the Making of the Gay Male World, 1890–1940* (New York: Basic Books, 1994), 146–47.

5. George Biddle, *An American Artist's Story* (Boston: Little, Brown, 1939), 139. For a discussion of American artists as soldiers in Europe, see Georges Wickes, *Americans in Paris* (Garden City: Doubleday, 1969), in particular his chapter "The Great War," 65–118.

6. EvFL, "Mefk Maru Mustir Daas," *LR* 5.8 (December 1918): 41. Compare this poem with the British poet Wilfred Owen's description of death by poison gas in "Dulce et Decorum Est": "If you could hear, at every jolt, the blood / Come gargling from the froth corrupted lungs, / Obscene as cancer, / bitter as the cud / Of vile, incurable sores on innocent tongues," in *The Longman Anthology of British Literature,* ed. David Damrosch (New York: Addison-Wesley, 1999), 2: 2242.

7. EvFL, "Mefk Maru Mustir Daas," 41.

8. Margaret Anderson, "The War," *LR* 4.1 (April 1917); Jane Heap, "Push-Face," *LR* 4.2 (June 1917): 6, and "War Art," *LR* 4.4 (August 1917): 25. Not everyone agreed with this pacificist position: "After reading your article 'Push-Face' in your June number I have torn the magazine to pieces and burned it in the fire. You may discontinue my subscription," writes Israel Solon from New York, "To 'jh,'" *LR* 4.4 (August 1917): 26.

9. Bolton Brown, "Bolton Brown Advocates a Further Step for Independent Artists," Letter to the Editor, *New York Times,* 17 February 1917, 10.

10. Beatrice Wood, *Un peut d'eau dans du savon* (1917), reprinted in Francis M. Naumann, *New York Dada 1915–23* (New York: Abrams, 1994), 182.

11. Henri-Pierre Roché described Duchamp as a young Napoleon, Alexander the Great, and even Hermes of Praxiles and fondly called him "Totor" and "Victor," dedicating an autobiographical novel to him, *Victor, Ein Roman* (Munich: Schirmer/Mosel, 1986). Roché's diaries, *Carnets 1920–1921: Les années Jules et Jim* (Marseille: André Dimanche, 1990), reveal a deeply homoerotic penchant for intensive male friendships, which inevitably involved *amours à trois* with the wives or lovers of his male friends. In Germany, this was played out in his legendary affair with Helen Hessel, the androgynous and brilliant wife of the author and translator Franz Hessel, an affair that provided the basis for François Truffaut's 1962 film *Jules and Jim*. In New York, it was played out in Roché's affair with Beatrice Wood, who was deeply in love with Duchamp; this was followed by Roché's subsequent two-year affair with Louise Arensberg. See also Beatrice Wood, *I Shock Myself: The Autobiography of Beatrice Wood,* ed. Lindsay Smith (San Francisco: Chronicle, 1988); and Scarlette Reliquet, *Henri-Pierre Roché: L'Enchanteur collectionneur* (Paris: Ramsay, 1999).

12. *The Blindman* 1 (April 1917): 1.

13. Beatrice Wood, *Lit de Marcel,* watercolor (1917), reproduced in Naumann, *New York Dada,* p. 116. Beatrice Wood, "Marcel," in *Marcel Duchamp: Artist of the Century,* ed. Rudolf E. Kuenzli and Francis M. Naumann (Cambridge: MIT P, 1996), 16.

14. Florine Stettheimer, *La Fête à Duchamp,* oil painting (1917), reproduced in Naumann, *New York Dada,* 150; see also Barbara J. Bloemink, *The Life and Art of Florine Stettheimer* (New Haven: Yale UP, 1995).

15. Juliette Roche, *American Picnic* (ca. 1915–17), reprinted in Naumann, *New York Dada,* 99.

16. EvFL to DB, ca. 1925, "I am again astonished at your long silence."

17. He was born to Robert Tremaine Logan and Maria Martin Winton on 25 March 1889 in Lauder; the history of the Logan family can be found in the publication *The Rise and Fall of a Prairie Town,* vol. 2 (May 1974): 74; Jim Rutherford, Manitoba Genealogical Society, e-mail 15 February 2001. See also Robert Fulton Logan, Biographical File, September 1946 (Robert Fulton Logan Personnel File, CCA). Logan exhibited his artwork in more than twenty museums,

including the British Museum, Fitzwilliam Memorial Art Museum (Cambridge), Luxemburg Gallery (Paris), Metropolitan Museum of Art (New York), National Gallery (Washington, D.C.), Yale Art Gallery (New Haven), Lyman Allyn Museum (New London), Detroit Art Institute, and others. In New London, he resided at 939 Pequot Avenue. That he was the founder of the wildlife sanctuary in Connecticut suggests that he kept in touch with his Canadian roots, for Lauder, along the banks of the Souris River, was known for its sandhills and rich wildlife, its grasslands, prairie, and parklands.

18. EvFL, "Moving-Picture and Prayer," *LR* 6.1 (May 1919): 71.

19. EvFL, "Moving-Picture and Prayer," 71.

20. EvFL to George Biddle, 1927.

21. EvFL, "Moving-Picture and Prayer," 72.

22. EvFL to George Biddle, 1927.

23. Biddle, *An American Artist's Story,* 140.

24. EvFL to George Biddle, 1927.

25. EvFL, "Moving Picture and Prayer," 72.

26. I adapt Judith Butler's term in *Excitable Speech: A Politics of the Performative* (New York: Routledge, 1997); Butler explores the performative politics of hate-speech, of language that wounds. Since wounding is part of the Baroness's dada rhetoric, the notion of "excitable speech" is appropriate; excitable speech also connotes the intensity of her rhetoric.

27. EvFL, "Mineself—Minesoul—and—Mine—Cast-Iron Lover," *LR* 6.5 (September 1919): 4.

28. EvFL, "Cast-Iron Lover," 3.

29. EvFL, "Cast-Iron Lover," 10.

30. The German American painter Marsden Hartley (1877–1943) returned from Berlin in 1914 "with his canvases of bursting shells," as Williams described the paintings of shells exploding against violent skies, of armored soldiers and uniforms. The paintings were so vivid and unsettling in their violence that they remained unsold, as Williams recalled: "His pictures were too bold in conception, too raw in color. No one ever felt comfortable near them." Williams Carlos Williams, *The Autobiography of William Carlos Williams* (New York: New Directions, 1967), 170.

31. EvFL, "Cast-Iron Lover," 5–7.

32. EvFL, "Cast-Iron Lover," 7.

33. EvFL, "Cast-Iron Lover," 3.

34. EvFL, "Cast-Iron Lover," 8.

35. T. S. Eliot, "The Love Song of J. Alfred Prufrock," in *The Norton Anthology of American Literature* (5th ed.), vol. 2, ed. Nina Baym (New York: Norton, 1998), 1370–73: lines 57–58, 73–74.

36. Eliot, "Prufrock," line 22.

37. EvFL, "Cast-Iron Lover," 10.

38. Maxwell Bodenheim, "The Reader Critic," *LR* 6.7 (November 1919): 64.

39. Cary Nelson, *Repression and Recovery: Modern American Poetry and the Politics of Cultural Memory, 1910–1945* (Madison: U of Wisconsin P, 1989), 72.

40. Amelia Jones, "'Women' in Dada: Elsa, Rrose, and Charlie," in *Women in Dada: Essays on Sex, Gender, and Identity*, ed. Naomi Sawelson-Gorse (Cambridge: MIT P, 1998), 157; Michael Kimmelman, "Forever Dada: Much Ado About Championing the Absurd," *New York Times* (22 November 1996): C24.

41. EvFL, "Analytische Chemie der Frucht," unpublished German poem (*LR* Papers, GML), *LRC*, 42.

42. Biddle, *An American Artist's Story*, 140.

43. Biddle, *An American Artist's Story*, 140; for psychological terminology, see Carole Wade and Carol Tavris, *Psychology* (4th ed.) (New York: Harper Collins, 1996), 455.

44. Francis Picabia, "Dieu nous aide et fait pousser le caca," *391* 14.1 (1920), reprinted in *391: Revue publiée de 1917 à 1924*, ed. Michel Sanouillet (Paris: Losfeld/Pierre Belfond, 1975), 89.

45. Naumann, *New York Dada*, 128.

46. William B. Rhoads, Letter to the Editor, *Chronicle of Higher Education* (27 March 1998): B10.

47. Margaret A. Morgan, "A Box, a Pipe, and a Piece of Plumbing," in Sawelson-Gorse, *Women in Dada*, 65.

48. On the rejection of *Fountain*, see Naumann, *New York Dada*, 183–85, as well as his *Marcel Duchamp: The Art of Making Art in the Age of Mechanical Reproduction* (New York: Abrams, 1999), 72–75.

49. Bolton Brown, "A Further Step for Independent Artists," *New York Times* (17 February 1917): 10.

50. Charles Demuth to Henry McBride, quoted in William Camfield, "Marcel Duchamp's *Fountain:* Its History and Aesthetics in the Con-

text of 1917," in Kuenzli and Naumann, *Marcel Duchamp,* 72. Marcel Duchamp, quoted in Amelia Jones, *Postmodernism and the En-Gendering of Marcel Duchamp* (Cambridge: Cambridge UP, 1994), 146.

51. My thanks to Francis M. Naumann for this reference that also supports my theory that *Fountain* carries the Baroness's fingerprint.

52. Marcel Duchamp to Suzanne Duchamp, 11 April 1917, "Affectueusement Marcel: Ten Letters from Marcel Duchamp to Suzanne Duchamp and Jean Crotti," ed. Francis M. Naumann, *Archives of American Art Journal* 22.4 (1982): 8. Camfield quotes this letter in "Marcel Duchamp's *Fountain,*" 71–72.

53. Camfield, "Marcel Duchamp's *Fountain,*" 72. In *New York Dada,* Naumann writes that the "female friend" was probably Louise Norton Varèse because her address "[110] W[est] 88th St." was discernible on Stieglitz's original photograph along with the title "Fountain" and the name "Richard Mutt," 239 n. 17.

54. Louise Norton, "Buddha of the Bathroom," *The Blindman* 2 (May 1917): 5–6. See also Wood, *I Shock Myself,* 30; Naumann, *New York Dada,* 46–47, and Camfield, "Marcel Duchamp's *Fountain,*" 74.

55. Duchamp is quoted as saying that Demuth commuted from Philadelphia to New York "at least once a week" between 1915 and 1920, in Naumann, *New York Dada,* 131.

56. Charles Demuth, "For Richard Mutt," *The Blindman* 2 (May 1917): 6.

57. For a queering of *Fountain,* see Paul B. Franklin, "Object Choice: Marcel Duchamp's *Fountain* and the Art of Queer Art History," *Oxford Art Journal* 23.1 (2000): 23–50.

58. EvFL to *LR,* "You seem to ignore my queries," ca. 1922 (*LR* Papers, GML), *LRC,* 39; here she calls a hotel clerk a "shitmutt." For her reference to "'Loo' Gilmore," see EvFL to *LR,* undated (EvFL Papers, CPL); and the multiple references to "W. C." in "Thee I Call 'Hamlet of Wedding Ring': Criticism of William Carlos William's [sic] 'Kora in Hell' and Why . . . " (pt. L), *LR* 7.4 (January–March 1921): 49–52.

59. Franklin Clarkin, "Two Miles of Funny Pictures," *Boston Evening Transcript* 25 (April 1917), quoted in Camfield, "Marcel Duchamp's *Fountain,*" p. 68. Franklin writes: "A Philadelphian, Richard Mutt,

L
446 447

notes/chapter 8

member of the society, and not related to our friend of the 'Mutt and Jeff' cartoons, submitted a bathroom fixture as a 'work of art.'"

60. Williams, *Autobiography,* 134.

61. EvFL to *LR,* "You seem to ignore my queries," ca. 1922 (*LR* Papers, GML), *LRC,* 39.

62. Rudolf E. Kuenzli, "The Semiotics of Dada Poetry," *Dada Spectrum: The Dialectics of Revolt,* ed. Stephen C. Foster and Rudolf E. Kuenzli (Madison: Coda P, 1979), 56, 69.

63. Francis Picabia, *La Sainte Vierge,* ink stain on paper, *391* 12.3 (1920); "Extrait de Jésus-Christ Rastaquouère," *391* 13.4 (1920); "Notre-Dame-de-la-Peinture" *391* 14.5 (1920), all reprinted in Sanouillet, *391: Revue publiée de 1917 à 1924,* 81, 88, 93.

64. Kurt Schwitters, "Anna Blossom Has Wheels" (Merz poem No. 1), in *Dada Painters and Poets: An Anthology,* ed. Robert Motherwell (New York: Wittenborn, 1967), xxi–xxii. Schwitter uses the term *merz* to describe his dada art; *merz* is derived from *kommerz* and thus highlights the anticommercial focus of Schwitter's dada.

65. EvFL, "Holy Skirts," *LR* 7.2 (July–August 1920): 28–29.

66. EvFL to Unidentified correspondant #4.

67. EvFL to Peggy Vail [Guggenheim], ca. August 1927, 5.

68. EvFL to Guggenheim, ca. August 1927, 9.

69. EvFL to *LR,* "Send me the magazine" (*LR* Papers, GML), *LRC,* 10.

70. EvFL to Eleanor Fitzgerald, December 1923.

71. EvFL to Eleanor Fitzgerald, December 1923.

72. Williams Carlos Williams, "Sample Prose Piece: The Three Letters," *Contact* 4 (Summer 1921): 11.

73. Williams, *Autobiography,* 168. In "Sample Prose Piece," he said there were three dogs; in the *Autobiography,* he said there were two.

74. EvFL, "Caught in Greenwich Village," fragment of a poetry play (*LR* Papers, GML), *LRC,* 69.

75. EvFL, "Analytische Chemie der Frucht," *LRC,* 42.

76. EvFL, "Tryst," unpublished English poem.

77. EvFL, "Appalling Heart," *LR* 7.3 (September–December 1920): 47.

78. Cynthia Palmer and Michael Horowitz, eds., *Shaman Woman, Main-line Lady: Women's Writings on the Drug Experience* (New York: Morrow, 1982), 125. Since she was a smoker, this description seems fitting. As for alcohol, in her autobiography, she comments that she

does not like beer and only occasionally enjoys a glass of wine with her meal because it makes her dizzy.

79. Kenneth Rexroth, *American Poetry in the Twentieth Century* (New York: Herder and Herder, 1973). See also Rexroth (1905–85) *An Autobiographical Novel* (New York: Doubleday, 1966). During the teens, he was still a child but made regular trips to New York with his mother; they usually stayed in the Brevoort or the Lafayette and met some important personalities, including Emma Goldman, whom he describes as "a dowdy woman who did not know how to get along with children" (p. 68). Rexroth studied at the Art Students League (*An Autobiographical Novel,* 203–12), and describes his own use of marijuana in Chicago, where a "shoeboxful" could be purchased "for a couple of dollars" (217).

80. Williams, *Autobiography,* 136.

81. Marcel Duchamp, quoted in Calvin Tomkins, *Duchamp: A Biography* (New York: Holt, 1996), 152.

82. Man Ray, *New York* (1917), reproduced in Naumann, *New York Dada,* 84.

83. Florine Stettheimer, *New York,* oil painting (1918), reprinted in Nauman, *New York Dada,* 151.

Chapter 9

1. That the Baroness had a parrot is confirmed by Theresa Bernstein, interviewed by Francis M. Naumann. My thanks to Naumann for this information. Djuna Barnes, too, had a parrot in her 86 Greenwich Avenue flat, as Phillip Herring reports in *Djuna: The Life and Work of Djuna Barnes* (New York: Penguin, 1995), 104: "Their flat contained a tenant of equally colorful plumage: in his memoir, William Carlos Williams relates how Lemon almost got his nose bitten off playing with his parrot."

2. "Dance of the Feathered Flock," poster, *The Quill: A Magazine of Greenwich Village* 2.2 (January 1918). The same issue advertised a "Costume Bachanale given by the Pagan Magazine" at Webster Hall on Friday, 18 January, and a "Pirate's Ball" for 1 March. For a description of these costume balls, see George Chauncey, "Drag Balls and Gay Culture," in *Gay New York: Gender, Urban Culture, and the Making of the Gay Male World 1890–1940* (New York: Basic Books, 1994), 291–99.

3. Louis Bouché, "Autobiography" (Papers of Louis Bouché, AAA), roll 688, frame 702.

4. Quoted in Chauncey, *Gay New York,* 297.

5. See Chauncey, *Gay New York,* 80–82: "Fairies related to men as if they themselves were women—though often the 'tough' women who dared venture into the social spaces dominated by tough men [. . .]. But some gangs of men regarded fairies, like women, as fair game for sexual exploitation."

6. Chauncey, *Gay New York,* 35.

7. William Carlos Williams, *The Autobiography of William Carlos Williams* (New York: New Directions, 1967), 151.

8. Margaret Anderson, *My Thirty Years' War* (1930) (New York: Horizon, 1969). Charles S. Brooks, "A Visit to a Poet," in *Hints to Pilgrims* (New Haven: Yale UP, 1921), 93–95, describes the house and the office including the "villainous smell" that emanated from the embalmer's business (93). See also Nina van Gessel, "Margaret Anderson's Last Laugh: The Victory of *My Thirty Years' War,"* *English Studies in Canada* 25 (March 1999): 67–88.

9. EvFL, Dedication to Jane Heap, "Teke," unpublished English poem. Jane Heap had studied at the Art and Lewis Institute of Chicago as a painter and jewel designer. For discussions of Jane Heap, see Janet Flanner, "A Life on a Cloud: Margaret Anderson," *Janet Flanner's World: Uncollected Writings 1932–1975* (New York: Harcourt Brace Jovanovich, 1979), 323; and Shari Benstock, "*Little Review:* Margaret Anderson and Jane Heap," *Women of the Left Bank, Paris, 1900–1940* (Austin: U of Texas P, 1986), 363–72.

10. Anderson, *My Thirty Years' War,* 178.

11. Anderson, *My Thirty Years' War,* 179.

12. Jane Heap, "Notes," *LR* 5.2 (June 1918): 62. The first Baroness poem published was "Love-Chemical Relationship," *LR* 5.2 (June 1918): 58–59 (see discussion in chapter 6). With its English, German, and French code switching, it was a provocative poem, considering it was published during wartime.

13. Advertisement for *The Little Review, The Greenwich Village Quill* 2.2 (January 1918): 29.

14. F. Wilstack, "The Reader Critic: To JH," *LR* 5.9 (January 1919): 64, notes the parallels between Ben Hecht and "Else von Freytag" in their use of similes. G. S. B. from Chicago voices displeasure in the

same column: "Sensuousness for the sake of sensuousness does not appeal to me" (64); while W. C. W. (William Carlos Williams) thanked *The Little Review:* "You are the only periodical where good stuff of any kind—poetry, prose, novel, criticism—can get a hearing" (64).

15. EvFL, "Mefk Maru Mustir Daas," *LR* 5.8 (December 1918): 41, and "Irrender König (an Leopold von Freytag-Loringhoven," *LR* 6.10 (March 1920): 10.

16. EvFL, "Klink-Hratzvenga (Deathwail) Narin—Tzarissamanlli," *LR* 6.10 (March 1920): 11.

17. See "Marcel Duchamp's Letters to Walter and Louise Arensberg, 1917–1921," intro., trans., and notes by Francis M. Naumann, in *Duchamp: Artist of the Century,* ed. Rudolf E. Kuenzli and Francis M. Naumann (Cambridge: MIT P, 1996), 208–09 (8 November 1918 letter) and p. 211 (10 January 1919 letter).

18. George Biddle, *An American Artist's Story* (Boston: Little, Brown, 1939), 140.

19. Ben Hecht, "The Yellow Goat," *LR* 5.8 (December 1918): 34.

20. Hecht, "The Yellow Goat," 36.

21. Anderson, *My Thirty Years' War,* 179–80.

22. Berenice Abbott, BAI-a; my thanks to Gisela Baronin Freytag v. Loringhoven. See also John Canaday, Introduction, in Hank O'Neal, *Berenice Abbott, American Photographer* (New York: Mc-Graw-Hill, 1982), 8–34. Born and raised in Springfield, Ohio, Abbott was a shy twenty-year-old when she arrived in New York City, but she looked up to the Baroness as a role model. She plunged into the world of the Provincetown Players and immersed herself into the artistic life in her apartment building on Greenwich Avenue, where Djuna Barnes and other well-known Village personalities also resided.

23. One day the Baroness came to borrow Crane's typewriter. Intimidated, he handed over the typewriter, although it belonged to his friend Hal Smith. After several weeks with no typewriter, they paid a visit to the Baroness: "They came away without it, though," recalled Claire Spencer. "They sat and talked with her about an hour. On the table was the typewriter. But neither of them had the nerve to even mention it." Smith quietly bought a new typewriter. This

anecdote is relayed in John Unterecker, *Voyager: A Life of Hart Crane* (New York: Farrar, Straus & Giroux, 1969), 135.

24. Brooks, *Hints to Pilgrims,* 96, 99.

25. Brooks, *Hints to Pilgrims,* 100.

26. Brooks, *Hints to Pilgrims,* 102.

27. Unterecker, *Voyager,* 135.

28. Unterecker, *Voyager,* 178.

29. Unterecker, *Voyager,* 160.

30. Hart Crane to Gorham Munson, 13 November 1919, *The Letters of Hart Crane, 1916–1932,* ed. Brom Weber (New York: Hermitage, 1952), 23.

31. Robert Motherwell, ed., *Dada Painters and Poets: An Anthology* (New York: Wittenborn, 1967), xxvii: "In 1917 the United States entered the war and the dada activities in New York for the most part ceased." More recent studies have extended the New York dada period to 1922 or 1923, the year the Baroness leaves New York; see Francis M. Naumann, *New York Dada 1915–23* (New York: Abrams, 1994), and Amelia Jones, *Sex, War, and Urban Life: New York Dada 1915–1922* (forthcoming).

32. Jane Heap, "Full of Weapons!," *LR* 8.2 (Spring 1922): 33.

33. For recent scholarly discussions of *The Little Review,* see Jayne E. Marek, *Women Editing Modernism: "Little" Magazines and Literary History* (Lexington: UP of Kentucky, 1995), in particular, "Reader Critics: Margaret Anderson, Jane Heap, and *The Little Review*" (60–100), highlighting the magazine's "visibly confrontational" course (61); and Dickran Tashjian, "From Anarchy to Group Force: The Social Text of *The Little Review,*" in *Women in Dada: Essays on Sex, Gender, and Identity,* ed. Naomi Sawelson-Gorse (Cambridge: MIT P, 1998), 262–91. See also Lawrence Rainey's study, "The Cultural Economy of Modernism," in *The Cambridge Companion to Modernism,* ed. Michael Levenson (Cambridge: Cambridge UP, 1999), 33–69. Rainey shows that three journals—*The Little Review, The Dial,* and *Vanity Fair*—were often competing for the same manuscripts and visual materials, for all three published photographs of modern visual art. *The Dial* frequently published materials that had already appeared in *The Little Review* (49). *Vanity Fair* was commercially the most powerful and was able to

outbid others. In 1922, a fierce competition for Eliot's *The Waste Land* erupted, with *The Dial*'s editor and coowner Scofield Thayer winning over *Vanity Fair*, when he offered a hefty $2,000 for the poem he had not even read (53).

34. Although my slant is slightly different, much of the information below is drawn from my earlier article, "German Extravagance Confronts American Modernism: The Poetics of Baroness Else," *Pioneering North America: Mediators of European Literature and Culture*, ed. Klaus Martens (Würzburg: Königshausen & Neumann, 2000), 60–75.

35. Paul Vanderham, *James Joyce and Censorship: The Trials of "Ulysses"* (New York: New York UP, 1998); Holly Baggett, "The Trials of Margaret Anderson and Jane Heap," in *A Living of Words: American Women in Print Culture*, ed. Susan Albertine (Knoxville: U Tennessee P, 1995), 169–88.

36. EvFL, "King Adam," *LR* 6.1 (May 1919): 73.

37. For a discussion of oral sex as perversion, see Chauncey, *Gay New York*, 61.

38. EvFL, "King Adam," 73.

39. EvFL, "Moving Picture and Prayer," *LR* 6.1 (May 1919): 71 (see chapter 8 for a full discussion of this poem based on Robert F. Logan).

40. Thomas L. Scott, Melvin J. Friedman, with the assistance of Jackson R. Bryer, *Pound/The Little Review: The Letters of Ezra Pound to Margaret Anderson—The Little Review Correspondence* (New York: New Directions, 1988), 261.

41. EvFL, "Buddha," *LR* 6.9 (January 1920): 19–20; Chauncey, *Gay New York*, 15; Joyce, "*Ulysses*, Episode xii," *LR* 6.9 (January 1920): 55.

42. Lola Ridge, F. E. R., Chicago, and Jane Heap are all writing in the same column under the heading "Concerning Else von Freytag-Loringhoven," *LR* 6.6 (October 1919): 56; Maxwell Bodenheim, "The Reader Critic," *LR* 6.7 (November 1919): 64.

43. Evelyn Scott and Jane Heap, "The Art of Madness," *LR* 6.8 (December 1919): 48–49.

44. EvFL, Evelyn Scott, and Jane Heap, "The Art of Madness," *LR* 6.9 (January 1920): 27.

45. See, for instance, Williams's *Kora in Hell* in WCW, *Imaginations,* ed. Webster Schott (New York: New Directions, 1970), an exercise in automatic writing, later reviewed by the Baroness (see chapter 10 for details). Psychological writings were mushrooming, as seen in Wilhelm Stekel's *Psyche and Eros* (1919) and in Freud's *Beyond the Pleasure Principle* (1920), the latter written in the wake of the war and now acknowledging the death instinct, the drive of all living beings to return to inorganic matter.

46. Francis Picabia, *391: Revue publiée de 1917 à 1924,* ed. Michel Sanouillet (Paris: Terrain Vague, 1975), 13.

47. Hanne Bergius, *Das Lachen Dadas: Die Berliner Dadaisten und ihre Aktionen* (Giessen: Anabas, 1989); Hermann Korte, "Dada Berlin," *Die Dadaisten* (Reinbeck bei Hamburg: Rowohlt, 1994), 59–86.

48. EvFL, Scott, and Heap, "The Art of Madness," 29. The Baroness's charge was also directed against John Quinn, who was highly selective in his support of contemporary art and artists. He helped Duchamp, who was always careful not to offend American patrons, and the Baroness would later charge Duchamp with catering to the business spirit and thus prostituting himself; see EvFL to Jane Heap, ca. Winter 1922, "Dear Heap—You would please me a heap" (*LR* Papers, GML), *LCR, 4.*

49. Jean Cocteau, *Vanity Fair* (October 1922), reprinted in "Vanity Fair: The Early Years: 1914–1936," *Vanity Fair* (March 1999): 163.

50. Joyce, "*Ulysses,* Episode xiii" [Nausicaa], *LR* 7.2 (July–August 1920): 43–44.

51. Edward de Grazia, *Girls Lean Back Everywhere: The Law of Obscenity and the Assault on Genius* (New York: Vintage, 1992), 10.

52. EvFL, "The Modest Woman," *LR* 7.2 (July–August 1920): 37–40. See also Helen Bishop Dennis, "The Modest Woman," *LR* 7.1 (May–June 1920): 73–74.

53. John Rodker, "'Dada' and Else von Freytag-Loringhoven," *LR* 7.2 (July–August 1920): 36.

54. Jane Heap, "Art and the Law," *LR* 7.3 (September–December 1920): 6. For homophobic responses, see, for instance, the gender-insensitive Williams, who in the *Autobiography* (p. 164) writes on first visiting the couple's apartment: "Jane Heap looked like a heavy-set Eskimo, but Margaret, always more than a little upstage, was an

avowed beauty in grand style." Heap's "Art and the Law" is followed
by Margaret Anderson's "An Obvious Statement (for the Millionth
Time)," *LR* 7.3 (September–December 1920): 8–16.

55. EvFL, "Appalling Heart," "Blast," "Moonstone," "Heart (Dance of
Shiva)," "Cathedral," "Is It?" "Gihirda's Dance," "Das Finstere Meer
(an Vater)," *LR* 7.3 (September–December 1920): 47–52.

56. Mina Loy, "Love Songs," *Others* (November 1915), reprinted in *The
Lost Lunar Baedeker: Poems of Mina Loy,* ed. Roger Conover (New
York: Farrar Straus Giroux, 1996), 225.

57. For Loy's response to *The Little Review* court case, see Carolyn Burke,
Becoming Modern: The Life of Mina Loy (Berkeley: U of California P,
1997), 289, 288–95 passim.

58. For the debate between Rodker and Loy, see John Rodker, "The
'Others' Anthology," *LR* 7.3 (September–December 1920):
53–56; and Mina Loy, "John Rodker's Frog," *LR* 7.3 (September–December 1920): 56–57. The frog metaphor refers to a sentence in Rodker's *Hymns* ("I'd have loved you as you deserved had
we been frogs," 56), but the frog imagery also refers to the
Baroness, as Rodker's subsequent response, "To Mina Loy," *LR* 7.4
(January 1921): 45, makes clear: "Yet were I, regardless of consequences to my more delicate anatomy, to love in a froggy way the
carcase of American poets and poetesses whose very very cast-iron
entrails have so lately been sung by the noble Baroness, would not
my very froggy embrace strenuously impel it to that not too remote
star on which it has how long and how painfully striven to hitch itself?" Given this insider joke, both were obviously in the know regarding the Baroness's work.

59. Flanner, "A Life on a Cloud: Margaret Anderson," 325.

60. Harriet Monroe, "Summer Versus James Joyce," *LR* 7.4 (January–
March 1921): 34.

61. Emmy V. Sanders [Ezra Pound], "Apropos Art and Its Trials Legal
and Spiritual," *LR* 7.4 (January–March 1921): 40–43; Ezra Pound to
Margaret Anderson, ca. 22 April 1921, 265–68, and 29 April–4 May
1921, 270–74, both in Scott et al., *Pound/The Little Review.*

62. Baggett, "The Trials of Margaret Anderson and Jane Heap," 169.

63. *Ulysses* "Might be called futurist literature," is "disgusting in portions, perhaps, but no more so than Swift, Rabelais, Shakespeare,
the Bible," "inciting to anger or repulsion but not to lascivious

acts," Quinn told the judges during the trial in his defense of the editors, while the Baroness's "The Modest Woman," had stated: "Goethe was grandly obscene [. . .] Flaubert—Swift—Rabelais—Arabian Nights—Bible if you please! only difference—Bible is without humor—great stupidity!" She had celebrated the novel for its "obscenity." Quinn also stated: "I myself do not understand 'Ulysses'—I think Joyce has carried his method too far in this experiment," while the Baroness had written she did not really understand the novel, "As story it seems impossible." EvFL, "The Modest Woman," pp. 39–40. Quinn is quoted and paraphrased in Margaret Anderson, "'Ulysses' in Court," *LR* 7.4 (January–March 1921): 22-25.

64. Jane Heap, "Ulysses," *LR* 9.3 (Stella number) (Autumn 1922): 34–35.

65. Andrew Field, *Djuna: The Formidable Miss Barnes* (Austin: U of Texas P, 1985), 108.

66. EvFL to DB, ca. Spring 1924, "Djuna Sweet—If you would know," 20. In this letter, the Baroness also included her *Ulysses*-inspired poem, "Kindly," in which God gives permission "to fart" (21). "I had great admiration for JJ [James Joyce]," said the Baroness in this 1924 letter, urging Barnes to connect with Joyce and solicit his help for the Baroness (21).

67. Anderson, *My Thirty Years' War,* 182.

68. EvFL to *LR,* ca. 1921–23 (*LR* Papers, GML), *LRC,* 13.

69. Charles Henry, "What About the Independent Exhibition Now Being Held on the Waldorf Astoria Roof?" *LR* 6.11 (April 1920): 37.

70. A. Reverdy to EvFL, postcard, undated.

71. Anderson, *My Thirty Years' War,* 193–195.

72. Anderson, *My Thirty Years' War,* 193–195.

Chapter 10

1. WCW, *The Autobiography of William Carlos Williams* (New York: New Directions, 1967), 164.

2. WCW, *The Autobiography,* 137, 253–54.

3. Paul Mariani, *William Carlos Williams: A New World Naked* (New York: McGraw-Hill, 1981), 160. Mariani writes that Williams met the Baroness in April.

4. WCW, "Prologue II," *LR* 6.1 (May 1919): 79. The "Prologue II" directly follows Freytag-Loringhoven's "King Adam," which in turn follows Ezra Pound's "Avis."

5. Ezra Pound to John Quinn, 22 February 1918, *The Selected Letters of Ezra Pound to John Quinn, 1915–1924,* ed. Timothy Materer (Durham: Duke UP, 1991), 144; Pound to Marianne Moore, 16 December 1918, *The Letters of Ezra Pound, 1907–1941,* ed. D. D. Paige (New York: Harcourt, Brace, 1950), 144.

6. "I knew that I wanted reality in my poetry and I began to try to let it speak." WCW, *I Wanted to Write a Poem: The Autobiography of the Works of a Poet,* ed. Edith Heal (Boston: Beacon, 1967), 17.

7. WCW, *Autobiography,* 175.

8. WCW, *Contact* (December 1920): 1; WCW, *Autobiography,* 174.

9. WCW, *Autobiography,* 164. Williams details his friendship with the Baroness in "The Baroness," in his *Autobiography,* 163–69.

10. EvFL to WCW, ca. 1921, "Do not hate me" (*LR* Papers, GML), *LRC,* 14.

11. WCW, *I Wanted to Write a Poem,* 26.

12. WCW, "Sample Prose Piece, The Three Letters," *Contact* 4 (Summer 1921): 11–12.

13. WCW, "The Baroness Elsa Freytag von Loringhoven," dated 11 March, no year (WCW Papers, YCAL).

14. WCW, *Autobiography,* 165.

15. Berenice Abbott, BAI-a, 6. Had there been any recurrence of syphilis in the Baroness's life, she would surely have mentioned it in her memoirs or letters; but there is no mention anywhere in her extensive private writings other than the treatment for syphilis in 1896. In one of her prefaces, Djuna Barnes refers to the hoarseness of Baroness's voice as a remnant of her syphilis. Yet given the Baroness's intensity and volubility, the hoarse voice could simply be the result of overstraining her vocal cords. Medically, a treated and cured syphilis condition can be in remission for life.

16. WCW, "*Kora in Hell,*" in WCW, *Imaginations,* ed. Webster Schott (New York: New Directions, 1970), 77.

17. EvFL to *LR,* ca. 1920, "I wish for you to read this letter" (*LR* Papers, GML), *LRC,* 12. She also encourages the editors to share this letter with Djuna Barnes.

18. EvFL to *LR,* ca. 1920, "To know this letter will simplify so many things" (*LR* Papers, GML), *LRC,* 13.

19. EvFL to WCW, "Do not hate me," ca. 1920 (*LR* Papers, GML), *LRC,* 17–18.

20. See WCW, *Autobiography,* 165. He writes that she pursued him for two years, bombarding him with letters and photographs of herself, one of them an "8 × 10 nude, a fine portrait said to have been taken by [Marcel Duchamp]." Williams says that he eventually handed over the photograph to Berenice Abbott (a blurred nude was found by Hank O'Neal (EvFl Papers, CPL)). See also Robert McAlmon, "Post-Adolescence," in McAlmon, *McAlmon and the Lost Generation: A Self-Portrait* (Lincoln: U of Nebraska P, 1962), 116, where Williams uses the phrase "That damned woman," and charges the Baroness with leaving big packages of photographs on his door steps in Rutherford.

21. WCW, *Autobiography,* 169.

22. WCW, "Comment: Wallace Stevens," *Poetry* 87.4 (1956): 234. See also Glen MacLoed, *Wallace Stevens and Company: The Harmonium Years 1913–1923* (Ann Arbor: Research P, 1983).

23. WCW, *Autobiography,* 169. This story is also similar to Ida-Marie Plötz's hiding in a neighbor's attic and refusing to return home. The Baroness never mentions these events, nor does she ever mention William Zorach or Wallace Stevens.

24. WCW, *Autobiography,* 169. See also Margaret Anderson's version, *My Thirty Years' War* (1930)(New York: Horizon, 1969), 210–11, and Matthew Josephson, *Life Among the Surrealists: A Memoir* (New York: Holt, Rinehart, and Winston, 1962), 76, which cites the Baroness as saying: "'William Carlos Villiams,' she cried hoarsely, '*I vant you,*'" a parody of her accent.

25. Anderson, *My Thirty Years War,* 210: "He said such stupid things in these letters (all of which, including her infinite pages of replies, we had to hear read out loud in a strong voice), and gave her such opportunity to refute his ideas, that we began to despair of getting out the next number of the L.R." See also Berenice Abbott, BAI-a, 5.

26. McAlmon, "Post-Adolescence," 116. During the same Sunday afternoon walk in New Jersey, McAlmon announced his mock wed-

ding with Bryher, H. D.'s lover and the daughter of a wealthy English shipping magnate. The wedding took place in New York's City Hall a month later, in February 1921, followed by an impromptu reception at the Brevoort. Bryher soon went traveling with H. D., while McAlmon—now nicknamed "McAlimony"—abandoned his journal for more exciting editing and publishing ventures in Paris.

27. Anderson, *My Thirty Years' War,* 211.

28. EvFL, "Graveyard," ca. 1921 (*LR* Papers, GML), *LRC,* 55.

29. EvFL to George Biddle, ca. Spring 1927. In this letter she reviews her failed love affairs in the United States, including Robert Fulton Logan, Biddle, and Williams.

30. Anderson, *My Thirty Years' War,* 211.

31. Francis M. Naumann, *New York Dada 1915–23* (New York: Abrams, 1994), 169.

32. EvFL, "Resolve," Postcard, postmarked 15 April 1922 (*LR* Papers, GML), *LRC,* 22.

33. EvFL, "Thee I Call 'Hamlet of Wedding-Ring': Criticism of William Carlos William's [sic] 'Kora in Hell' and Why . . . ," pt. 1, *LR* 7.4 (January–March 1921): 53.

34. EvFL, "Thee I Call 'Hamlet of Wedding-Ring,'" 1: 54. The title "Kora in Hell" was inspired by Pound; the two friends had discussed Kora, the Greek version of Persephone, which Williams read as the "legend of Springtime captured and taken to Hades." Williams effectively thought of himself as springtime: "I felt I was on my way to Hell (but I didn't go very far)." "Kora" was an experimental work written in a highly personal style; it included the poet's "day-to-day notations, off the cuff, thoughts put down like a diary in a year of my life."

35. EvFL, "Thee I Call 'Hamlet of Wedding-Ring': Criticism of William Carlos William's [sic] 'Kora in Hell" and Why . . . ," pt. 2, *LR* 8.1 (Autumn 1921): 110.

36. EvFL, "Thee I Call 'Hamlet of Wedding-Ring,'" 109.

37. Dickran Tashjian, *Skyscraper Primitives: Dada and the American Avant-Garde 1910–1925* (Middleton: Wesleyan UP, 1975), 99–100.

38. EvFL, "Thee I Call 'Hamlet of Wedding-Ring,'" 2: 110.

39. Rudolf E. Kuenzli, "Baroness Elsa von Freytag-Loringhoven and New York Dada," in *Women in Dada: Essays on Sex, Gender, and*

Identity, ed. Naomi Sawelson-Gorse (Cambridge: MIT P, 1998), 454.

40. WCW, "Sample Prose Piece," 10–13.

41. EvFL, "Thee I Call 'Hamlet of Wedding-Ring,'" 1: 54.

42. WCW, "The Baroness Elsa von Freytag-Loringhoven" (WCW Papers, YCAL). Williams's memoirs reveal a strong interest in Europe. In 1924, he spent his sabbatical in Europe meeting Joyce, Pound, and dada artists. Of the *Autobiography*'s fifty-eight chapters, four are devoted to Pound: "Ezra Pound" (56–66). "Ezra in London" (113–117), "The F.B.I. and Ezra Pound (316–15), "Ezra Pound at St. Elizabeth's" (335–44): four to Paris; one to *The Wasteland;* and one to the Baroness (163–69).

43. Abel Sanders [Ezra Pound], "The Poems of Abel Sanders," *LR* 8.1 (Autumn 1921): 111. For the explication of the pseudonym, see Pound to John Quinn, 29 and 30 December 1917, in Materer, *The Selected Letters of Ezra Pound to John Quinn,* 135: "Abel Sanders is a spoof person, and I intended him for parody of puritan ass whom such matters excite." In disguise Pound could publicly deal with matters otherwise too risqué.

44. In an April 1921 letter to Marianne Moore, Pound had referred to Williams's "own dago-immigrant self": "I hope he will contribute to the new L[ittle] R[eview] out of respect to his Hispano-French mother." Ezra Pound to Marianne Moore, ca. April 1921, in Paige, *The Letters of Ezra Pound,* 168.

45. Eva Hesse, letter 14 July 1998. My thanks to Eva Hesse, a Pound scholar and Pound's German translator, for generously sharing her insights into Pound and into this poem.

46. Abel Sanders [Ezra Pound], "Poem No. 2," *LR* 8.1 (Autumn 1921): 111.

47. Richard Sieburth, "Dada Pound," *South Atlantic Quarterly* 83 (1984): 49. Focusing on Pound's interest in Picabia, Sieburth documents the dada traces in Pound's *Cantos.* The early Cantos are traversed by dark images of Poundian eros, which Sieburth links to Picabia's images of sexual violence. Sieburth further provides a plethora of stylistic evidence that the Cantos are laced with formal dada poetics (63–66). Leon Surette, *A Light from Eleusis: A Study of Ezra Pound's Cantos* (Oxford: Oxford UP, 1979), 32, has argued that the images of sexual violence that permeate the 1919 cantos are

"domestic images of the communal violence of war." See also Andrew Clearfield, "Pound, Paris, and Dada," *Paideuma: A Journal Devoted to Ezra Pound Scholarship* 7.1–2 (Spring–Fall 1978): 113–40. Clearfield writes that the cantos "incorporate one salient technique also characteristic of Dada: collage (or montage) verse" (131). In passing, Clearfield refers to the Baroness, calling her "one of the most bizarre characters in the whole mad pantheon of Dada" (120–21), yet his main focus is on Picabia.

48. Ezra Pound to Margaret Anderson, ca. 22 April 1921, in *Pound/The Little Review: The Letters of Ezra Pound to Margaret Anderson—The Little Review Correspondence,* ed. Thomas L. Scott, Melvin Friedman, with the assistance of Jackson R. Bryer (New York: New Directions, 1988), 265: "Roughly speaking the men who matter [. . .] are Cocteau, Morand, Cros, Cendrars, Picabia, P[ound]." He adds Williams, Marianne Moore, Mina Loy, Anderson, Ben Hecht, as well as illustrations by Brancusi, Picasso, Picabia, and Lewis (265–66). "Also possibly Gertrude Stein," he writes (266).

49. Pound to Anderson, ca. 22 April 1921, in Scott et al., *Pound/The Little Review,* 268.

50. Pound to Anderson, 29 April–4 May 1921, in Scott et al., *Pound/The Little Review,* 273–74. "I have told Mary we probably wont be able to use her novel" (p. 274), effectively eliminating her before even consulting with the editors. Pound was assuming control over *The Little Review:* "[The] Picabia [. . .] number must make a clean break [. . .] otherwise all my push goes to waste and Picabia's effort to get the number placed here in Paris will come to nothing" (273–74).

51. Ezra Pound, "Historical Survey," *LR* 8 (Brancusi number) 8.1 (Autumn 1921): 40.

52. Already the Baroness regularly referred to her death in her correspondence with the *Little Review* editors, as in the letter that begins, "Maybe I have been naughty," *LRC,* p. 1, where she imagined her funeral: "my cemetery idea will cause *a remarkable draught of mourners on decoration day.*"

53. Jane Heap, "The Art Season," *LR* 8.2 (Spring 1922): 60.

54. Pound to Wyndham Lewis, 14 July 1922, quoted in Scott et al., *Pound/The Little Review,* 283.

55. Pound [Abel Sanders], "Stop Press," *LR* 8.2 (Spring 1922): 33.

56. Harriet Monroe, "Our Contemporaries: New International Magazines," *Poetry: A Magazine of Verse* 19.4 (January 1922), reprinted (New York: AMS, 1966), 227.

57. Jane Heap, "Dada," *LR* 8.2 (Spring 1922): 46.

58. Hart Crane to Matthew Josephson, 14 January 1921, *The Letters of Hart Crane 1916–1932,* ed. Brom Weber (New York: Hermitage, 1952), 52.

59. Hart Crane to Gorham Munson, 11 February 1921, in Weber, *The Letters of Hart Crane,* 53. He complained about Virgil Jordan and Robert McAlmon's published "wet dream explosions" in *Contact:* "I will be glad to receive stimulation from the sky or a foetid chamber or maybe a piss-pot but as far as I can make out they have wound their *phalli* around their throats in a frantic and vain effort to squeeze out an idea. In fact they seem very 'Dada' in more sense than one" (53).

60. Hart Crane to Gorham Munson, 22 July 1921, in Weber, *The Letters of Hart Crane,* 62. He had clearly read "The Modest Woman" and "Hamlet of Wedding Ring."

61. The spring 1923 issue featured poems and prose by Ernest Hemingway but no contributions by Freytag-Loringhoven. The autumn and winter number of 1923 featured articles on dada, articles by Paul Eluard, Louis Aragon, and Jacques Breton, and artwork by Max Ernst and Hans Arp, while spring 1924 featured articles by Tristan Tzara and Richard Huelsenbeck. The Baroness would have been perfect company for this crowd of dadaists but was not included. Thus with the exception of a few short pieces and passing references, the Baroness was gone from the pages of *The Little Review,* although the magazine continued to feature subversive topics in its spring 1923 Exiles number, including lesbianism (Bryher's "Chance Encounter" and Hemingway's "Mr and Mrs Elliot") and female promiscuity (McAlmon's opening poem). The Baroness continued to barrage the editors with poetry and letters, yet her valiant efforts were in vain.

62. WCW, "The Reader Critic," *LR* 9.3 (Stella number) (Autumn 1922): 59–60.

63. Francis Picabia, "Le Saint des Saints: C'est de moi qu'il s'agit dans ce portrait," *LR* 8.2 (Spring 1922): following 16; Jean Crotti, "Tabu," 45; Picabia, "Anticoq," 44.

64. Guillaume Apollinaire, "Aesthetic Meditations on Painting: The Cubist Painters," trans. Mrs. Knoblauch for the Société Anonyme, *LR* 9.1 (Stella number) (Autumn 1922): 55, 59. Incidentally, Laurencin later spent a twenty-some-year intimate relationship with Yvonne Crotti, the first wife of Jean Crotti and the person Duchamp took to Buenos Aires in 1918; my thanks to Francis M. Naumann for this reference.

65. EvFL to Jane Heap, Winter 1922 (*LR* Papers, GML), *LRC,* p. 5.

66. EvFL to Margaret Anderson, ca. 1921–22, "Now *here*—Margaret" (*LR* Papers, GML), *LRC,* p. 35. The poems listed in this and the following paragraph submitted from around 1918 to 1923 are all included in *The Little Review* Papers. Among the poems submitted were her German poems about her Kentucky experience, including "Altar," "Sirocco," "Weg in Kentucky," "Edeldirn," "In Mondes Nächten," "Sinnlieb," and "Krater," as well as childhood poetry including "Analytische Chemie der Frucht" and "Merklich." Her love poetry included "Lullaby," "Graveyard," "Misfit," "Wedding Imperial" (a poem running in two word columns), "Desirous (Love Prayer)," "Aphrodite to Mars," "Lucifer Approachant" (the latter hits the reader with the opening line "Ejaculation"). Others include "July" (later published in the *transatlantic review* as "Novemberday"), and "Coronation."

67. EvFL to *LR,* "This letter read please" (*LR* Papers, GML), *LRC,* 28.

68. EvFL to *LR,* "Jane Heap, understand *one* thing" (*LR* Papers, GML), *LRC,* 29.

69. EvFL, "Subjoyride" (*LR* Papers, GML), *LRC,* 96.

70. Her dada focus was ruthlessly anticommercial like Kurt Schwitters's *Merz* collages and poetry, which were derived from *kommerz* (commerce) to highlight his critical engagement with commercial culture. Her syntax is choppy, erratic, disjointed, crushed under the poet's efforts to gather and amass America's new items.

71. EvFL, "Tailend of Mistake: America," unpublished poem (*LR* Papers, GML), *LRC,* 87.

72. Claude McKay, *A Long Way from Home* (1937) (New York: Harcourt Brace, 1970), 104. In a letter to Djuna Barnes, ca. 1923–25, "Djuna I adore this," the Baroness later recalled: "*Liberator* has some beloved poems in its smirchy pages—could you find them?" Although *Liberator* would also publish "Loss" and "Chill" in October 1922, she re-

calls, specifically, "Dornröschen" (January 1922): "Stabb for me—
[. . .] I wait for thee—/Numb—breathlessly—Messire—/Since
yore!"

73. McKay, *A Long Way from Home,* 104–05.

74. DB, "Elsa—Notes," 24 April 1933, 3.

75. DB, "Elsa—Notes," 1.

76. George Biddle, *An American Artist's Story* (Boston: Little, Brown,
1939), 139–40.

77. Biddle, *An American Artist's Story,* 139.

78. Biddle, *An American Artist's Story,* 139.

79. EvFL to *LR,* ca. 1921 (EvFL Papers, CPL).

80. EvFL to *LR,* ca. Winter 1922, "Dear Heap—You would please me
a heap" (*LR* Papers, GML), *LRC,* 7.

Chapter 11

1. Maria van Rysselberghe, *Les cahiers de la petite dame* (4 vols.) (Paris:
Gallimard, 1973–77), 1: 85–86. My thanks to Gaby Divay for this
reference.

2. Berenice Abbott, BAI-a, 3–4.

3. EvFL to JH, ca. Winter 1922, "Dear Heap—You would please me a
heap" (*LR* Papers, GML), *LRC,* 5.

4. Francis M. Naumann has traced *Rrose Sélavy* to Charlie Chaplin's
cross-dressing in *A Woman,* a movie released on 12 July 1915,
in "Marcel Duchamp: A Reconciliation of Opposites," *Marcel
Duchamp: Artist of the Century,* ed. Rudolf E. Kuenzli and Francis M.
Naumann (Cambridge: MIT P, 1996), 21–23. In "Eros, That's Life,
or the Baroness' Penis," in *Making Mischief: Dada Invades New York,*
ed. Francis M. Naumann with Beth Venn (New York: Whitney Mu-
seum of American Art, 1996), 238–47, Amelia Jones translates
Duchamp's *Rrose* as "Eros," *Rrose Sélavy* thus functioning as a radical
dismantling of gender binaries and conscious eroticization of every-
day life, a central feature of New York dada. For a discussion of "The
Ambivalence of Rrose Sélavy and the (Male) Artist as 'Only' the
Mother of the Work," see Jones's *Postmodernism and the En-Gendering
of Marcel Duchamp* (Cambridge: Cambridge UP, 1994), 146–90. For
a discussion of *Sélavy* as Levy—that is, Duchamp's adoption of a Jew-
ish identity—see Rosalind E. Krauss, *Bachelors* (Cambridge: MIT P,
1999), 42–50.

5. Jones, *Postmodernism and the En-Gendering of Marcel Duchamp,* 147. For a description of the Baroness's pose, see Jones, "'Women' in Dada: Elsa, Rrose, and Charlie," in *Women in Dada: Essays on Sex, Gender, and Identity,* ed. Naomi Sawelson-Gorse (Cambridge: MIT P, 1998), 157.

6. EvFL to JH, ca. Winter 1922, "Dear Heap—You would please me a heap," (*LR* Papers, GML), *LRC,* 3.

7. Calvin Tomkins, *Duchamp: A Biography* (New York: Holt, 1996), 230. Man Ray's memory on the invention of his signature was fuzzy; see *Self-Portrait* (New York: Bulfinch, 1998), 213. "I recalled my first visit to Picabia, when, signing on his guest canvas I had added prophetically, Director of Bad Films—written in bad French—as a Dada gesture. Or was it in memory of my recent abortive experience with Duchamp in New York?" As for the *merdelamerde* pun on America, the Baroness had a preoccupation both with *merde* and *America.* And while Man Ray would have known the meaning of *mer* and *merde,* the grammatically complex use of possessive article (*de la* and *de l'*) and the elegant French play would also suggest Duchamp's possible hand in the pun. Still, Man Ray's agreement mistake in the signature, "directeur du mauvais movies," now wrongly matching the singular possessive article (*du*) with the plural noun (*movies*) may be a deliberate use of bad French.

8. Man Ray to Tristan Tzara, n.d., postmarked 8 June 1921 (Tristan Tzara Papers, BLJD). See Francis M. Naumann, *New York Dada 1915–23* (New York: Abrams, 1994), 205, for a first citation of this letter and description of the scatological joke; see also Jones, "Eros, That's Life," 245, for a reading of the Baroness's pose as signifying "Americanness/Dada/the stripping bare of the bride of capitalism."

9. "I am international——mentally American——temperamentally Polish," as she would write to Peggy Guggenheim in 1927, 23.

10. Lynda Nead, *The Female Nude: Art, Obscenity and Sexuality* (London: Routledge, 1992), 6.

11. EvFL to Peggy Guggenheim, ca. August 1927, 29.

12. Man Ray, *Self-Portrait,* 213.

13. Man Ray to Tristan Tzara, n.d. postmarked 8 June 1921. For a discussion of Dreier, see Aline B. Saarinen, "Propagandist: Katherine Sophie Dreier," in *The Proud Possessors: The Lives, Times and Tastes*

of Some Adventurous Art Collectors (New York: Random House, 1958), 238–49; and Naumann, "Katherine Dreier," in Naumann *New York Dada,* 155–61. Richard Cavell has juxtaposed the Baroness's *Amerique*-pose with Richard Boix's *Da-Da* drawing designed to commemorate the meeting of the Société Anonyme on 1 April 1921. Placing the Baroness side by side with the central figure in Boix's drawing—a caricatured androgynous figure placed on a pedestal and titled "La femme"—we are struck by the geometric body pose, which repeats the triangles of the Baroness's *Amerique* pose. Also, "La Femme" holds an apple in one hand, while a cup is strangely dangling from a string attached to her nose, an allusion to the Baroness's use of domestic objects on her body. Boix made the Baroness the center of New York dada—albeit in safely displaced, anonymous, and caricatured form. Richard Cavell, "Baroness Elsa and the Aesthetics of Empathy," *Canadian Comparative Literature Review/Révue canadienne de littérature comparée* (forthcoming). See also Francis M. Naumann, "New York Dada: Style with a Smile," in Naumann with Venn, *Making Mischief,* 16, for his argument that *La Femme* was modeled on Alexander Archipenko's *Seated Woman,* a work that Archipenko showed at the Société at the time.

14. EvFL to JH, ca. Winter 1922, "Dear Heap—You would please me a heap" (*LR* Papers, GML), *LRC,* 4. By the spring of 1921, dada had finally aroused the interest of New York's media; see Naumann, *New York Dada,* 192–211; for a listing of "Early Articles on Dada in the New York Press: 1920–23," see 249. On Dada Events and media coverage to 1922, see also Susan Noyes Platt in *Modernism in the 1920s: Interpretations of Modern Art in New York from Expressionism to Constructionism* (Ann Arbor: UMI Research P, 1985), 91–103.

15. Man Ray, *Portemanteau* [Coat Stand], 1920, Musée national d'art moderne, Centre Georges Pompidou, Paris, reproduced in Naumann with Venn, *Making Mischief,* 138. Julia Van Haaften, "Modelling the Artist's Life: Baroness Elsa and Berenice Abbott," In Memoriam FPG: An International Symposium, 30 September 30–2 October 1998, Winnipeg, Manitoba, suggested that Berenice Abbott may be the model for *Portemanteau.* Man Ray took a photograph of Abbott titled *Portrait of a Sculptor* (my thanks to Francis M. Naumann for this reference), yet the body shape displayed in

Portemanteau matches the Baroness's nudes: her thighs as in the INP photographs (figures 1.1, 1.2, 6.5,); her breasts as captured by Theresa Bernstein (frontispiece).

16. Angela Carter, "A Well Hung Hang-up," in *Nothing Sacred: Selected Writings* (London: Virago, 1982), 103.

17. EvFL, "Yours with Devotion: Trumpets and Drums," *New York Dada* 1.1 (1921): 4. The entire page is reprinted in Naumann, *New York Dada,* 206.

18. Dates for Man Ray are taken from *Man Ray: La Photographie à l'envers,* Exposition du Musée national d'art moderne / Centre de création industrielle présentée au Grand Palais, Paris, 28 April–29 June 1998, Exhibition Catalogue, 54–55.

19. EvFL to Tristan Tzara, n.d., postmarked 22 September 1921 (Tristan Tzara Papers, BLJD). See Naumann, *New York Dada,* 205–06, for a discussion of this letter and for a translation of excerpts from the Baroness's second undated letter to Tzara. The second letter identifies the poem submitted as "Teke," a sound poem that is found in the *LR* Papers, GML, *LCR,* p. 63, indicating that she had submitted this poem also to *The Little Review.*

20. See my chapter "Parading Sexuality: Modernist Life Writing and Popular Confession," in *Confessional Politics: Women's Sexual Self-Representations in Life Writing and Popular Media,* ed. Irene Gammel (Carbondale: Southern Illinois UP, 1999), 47–61, for a comparison of the Baroness's autobiography with Kiki de Montparnasse's best-selling memoir.

21. See William Wiser, *The Crazy Years: Paris in the Twenties* (New York: Antheneum, 1983), 75–77, for a discussion of Cocteau's *Antigone* production.

22. EvFL to JH, "Dear Heap—You would please me a heap," *LRC,* 3.

23. EvFL to JH, "Jane Heap, understand one thing" (*LR* Papers, GML), *LRC,* 29.

24. EvFL to JH, "Jane Heap—You would please me a heap," *LRC,* 3.

25. Joseph Stella, *Marcel Duchamp, LR* 9.1 (Autumn 1922): following 32. This issue, the Stella number, also contains Man Ray's photograph of Stella and Duchamp on its opening page and features Man Ray's rayograph *Rose Sel à vie,* following 60; reproduced in Naumann, *New York Dada,* 216.

26. EvFL to *LR,* ca. Fall 1922, "Little Review—You seem to ignore my queries" (*LR* Papers, GML), *LRC,* 39–40.

27. EvFL, *Portrait of Marcel Duchamp* (ca. 1920–1922), sculpture photographed by Charles Sheeler, *LR* 9.2 (Winter 1922): following 40. Duchamp's partnership in a feather-dyeing business in New York in 1922 is described in Tompkins, *Duchamp,* 245. The composition date of *Portrait of Marcel Duchamp* thus could be as late as 1922. EvFL to Jane Heap, "Dear Heap—You would please me a heap," 6, 4.

28. EvFL, "Affectionate," *LR* 9.2 (Winter 1922): 40.

29. EvFL, "The Independents," *LR* 9.2 (Winter 1922): 47.

30. EvFL to JH, "Jane Heap, understand one thing," *LRC,* 30.

31. Arturo Schwarz purchased the work from a woman in London who had never even heard the name of the Baroness. My thanks to Gisela Baronin Freytag v. Loringhoven, who interviewed Arturo Schwarz in Milan on 1 March 1991 and provided me with a color photograph of the painting.

32. EvFL to *LR,* "Little Review—You seem to ignore my queries," *LRC,* 40. On the same page, she also mentions that "[t]hat rich brute—Bobby—went to bed—when he had an appointment with a distinguished mysterious woman—went to bed *alone.*" "Bobby" is probably Robert (Bob) Chanler and the "distinguished mysterious woman," of course, is herself. The new Hotel Hudson address is also printed underneath her "Coronation" poem, submitted to the *Little Review* editors, *LRC,* 77.

33. EvFL to JH, ca. 1922–23, "My Dear Jane Heap, I think it very unkind from you not to receive me," *LRC,* 19.

34. [JH] to EvFL, Unidentified Letter #3, n.d. While the writer has been categorized as "unidentified," the blunt tone, the style, the generally supportive spirit, as well as the critical (or jealous) references to Georgette Leblanc, make Jane Heap the most likely candidate.

35. EvFL to George Biddle, ca. 1927.

36. EvFL to *LR,* "Jane Heap, understand one thing," *LRC,* 30.

37. DB, "Elsa—Notes," 24 April 1933, 4.

38. EvFL to *LR,* "Maybe I have been naughty" (*LR* Papers, GML), *LRC,* 2.

39. EvFL to George Biddle, ca. 1927.

40. EvFL to Berenice Abbott, ca. 1926.

41. EvFL to *LR,* n.d. ca. 1922–23, "Since you made that appointment with me" (*LR* Papers, GML), *LRC,* 23. The word "hate" in "I hate this country" is underlined four times.

42. EvFL to *LR,* ca. 1922–23, "Little Review—Anthony has not shown up" (*LR* Papers, GML), *LRC,* 38.

43. EvFL to *LR,* "Jane Heap, understand *one thing,*" *LRC,* 29.

44. EvFL to *LR,* "Jane Heap, you must have misinterpreted my letter," *LRC,* 25–26.

45. EvFL to Charles Duncan [copy of letter], "This I wrote to Duncan," written on Hotel Hudson letterhead, ca. 1923.

46. Tristan Tzara, "Manifesto of mr. aa the anti-philosopher," in *The Dada Painters and Poets: An Anthology,* ed. Robert Motherwell (New York: Wittenborn, 1967), 85.

47. Quinn specifically singled out the names of "Djuna Barnes," "Mark Turbyfill," and "Max Michelson." See *The Selected Letters of Ezra Pound to John Quinn, 1915–1924,* ed. Timothy Materer (Durham: Duke UP, 1991), 154–55.

48. Ezra Pound to Margaret Anderson, 29 December 1922, in *Pound/The Little Review: The Letters of Ezra Pound to Margaret Anderson—The Little Review Correspondence,* ed. Thomas Scott, Melvin J. Friedman, with the assistance of Jackson R. Bryer (New York: New Directions, 1988), 291. The *Genius: Zeitschrift für Werdende und alte Kunst* (1919–21) was published in Leipzig; *Der Querschnitt* (1921–36) was published in Berlin and "manifested strong Dada leanings at the time," as Andrew Clearfield writes in "Pound, Paris, and Dada," *Paideuma* 7.1–2 (Spring–Fall 1978): 126.

49. Ezra Pound to Margaret Anderson, n.d. ca. January–March 1923, in Scott et al., *Pound/The Little Review,* 298.

50. Ezra Pound, *The Cantos of Ezra Pound* (New York: New Directions, 1971), 646.

51. Jacob Epstein, *Let There Be Sculpture: An Autobiography* (London: Joseph, 1940), 70. My thanks to Erica Rutherford for a copy of this autobiography. In 1909, Epstein had been commissioned to design Oscar Wilde's tomb in the Père Lachaise Cemetery in Paris; he scandalously endowed his angel figure with genitals. For a discussion of the *Rock Drill* sculpture as a male technological fantasy ("Die Machismo-Maschine"), see Eva Hesse, *Die Achse Avantgarde—*

Faschismus: Reflexionen über Filippo Tommaso Marinetti und Ezra Pound (Zurich: Arche, n.d.), 145–49.

52. Pound to Anderson, 28 February 1954, and Anderson to Pound, 4 March 1954, both in Scott et al., *Pound/The Little Review,* 319, 329.

53. EvFL, "Circle," *Broom* [Berlin] 4.2 (January 1923): 128. Harold Loeb's Introduction, *The Broom Anthology,* ed. Harold Loeb (Boston: Milford House, 1969), xv–xvi. Incidentally, when Loeb proposed to print a piece by Gertrude Stein, Lola Ridge—the New York editor of *Broom* and the Baroness's old nemesis, who had so vehemently objected to the "Cast-Iron Lover"—resigned in protest. Stein, as the other "mother of dada," was not welcome.

58. WCW, *The Autobiography of William Carlos Williams* (New York: New Directions, 1967), 169.

59. EvFL to DB, ca. 1924, "Djuna Sweet—If you would know," 26.

60. EvFL to *LR,* 1923, "Maybe I have been naughty" (*LR* Papers, GML), *LRC,* 1.

61. EvFL to *LR,* 1923, "Maybe I have been naughty," *LRC,* 2. This quote is part of a paragraph that follows the letter.

62. EvFL to *LR,* 1923, "Little Review—Anthony has not shown up," *LRC,* 37. She calls Endell "my 2 hub," although he is really her first.

63. Deutsche Botschaft to EvFL, 23 June 1922 (EvFL Papers, CPL).

64. EvFL to *LR,* 1923, "You must have misinterpreted my letter," *LRC,* 24; and EvFL to Eleanor Fitzgerald, December 1923, reprinted in *BE,* 197.

65. EvFL to *LR,* "Jane Heap / You must have misinterpreted my letter," *LRC,* 26.

66. See Norddeutscher Lloyd Gepäckbeförderungsvertrag (baggage receipt); Überfracht Quittung (excess baggage receipt); and Gepäck-Versicherungsschein (baggage insurance), for travel on 18 April 1923 (EvFL Papers, CPL).

67. EvFL to *LR,* "Jane Heap / You must have misinterpreted my letter," *LRC,* 26.

Part IV

Chapter 12

1. EvFL to Mr. Jacobson, ca. 1927, 4-page manuscript.

2. EvFL to DB, ca. September 1924, "I will be saved Djuna."

3. EvFL to DB, ca. 1923–24, "Djuna Sweet—if you would know," p. 22; excerpts of this letter are in *BE*, 201–206.

4. Robert McAlmon, *Being Geniuses Together 1920–1930,* rev. and with supplementary chapters by Kay Boyle (New York: Doubleday, 1968), 107.

5. McAlmon, *Being Geniuses Together,* 110.

6. "The Weimar Republic," *Questions on German History: Ideas, Forces, Decisions from 1800 to the Present,* Historical Exhibition in the Berlin Reichstag Catalogue (2nd ed.), Bonn: German Bundestag Press and Information Centre, 1984, 247–98.

7. EvFL to DB, ca. 1923–24, "Dear Djuna [. . .] I am gone to my deathtrap."

8. EvFL to DB, 1923–24, "Djuna Sweet—if you would know," 31, in *BE*, 205.

9. Reichspensionsamt für die ehem[alige] Wehrmacht Abt[eilung] Preussen, Nr. 4612.23 III/1, Registered Letter (*Einschreiben*) to Frau Else, Freifrau von Freytag-Loringhoven, dated June 14, 1923. This letter requests her to await the court's official decision regarding her widow's pension and returns the Baroness's papers (*Urkunden*), which she had submitted in person on 12 June 1923. My thanks to Gisela Baroness Freytag v. Loringhoven for providing me with a copy of this letter.

10. Rechtsanwalt (lawyer) for Freytag-Loringhoven family to Freifrau Else v. Freytag-Loringhoven, p. Adr. American Express Co, Berlin, Charlottenstrasse, n.d. ca. Spring 1923. The lawyer's signature is difficult to decipher; he refers to the Baroness's earlier correspondence from 1920.

11. EvFL to DB, Fall 1923, "Djuna—now—listen carefully"; a brief excerpt of this letter is in *BE*, 196.

12. Gisela Baronin Freytag v. Loringhoven, personal communication, August 2000.

13. Standesamt 1 in Berlin to Gisela Baronin Freytag v. Loringhoven, 4 September 2000, confirms that Adolf Julius Wilhelm Plötz died on 3 July 1923 in Swinemünde; my thanks for sending me a copy of this letter. See also EvFL to Eleanor Fitzgerald, December 1923, where she writes, "My father . . . *disinherited* me!" Excerpts of this letter are reprinted in *BE*, 197–98.

14. EvFL [to lawyers], ca. 1923, "Da die zweite Frau Plötz."

15. EvFL, "Djuna Sweet—If you would know," 31, in *BE,* 205.

16. EvFL to Peggy Guggenheim, Summer 1927, 20–22, a 35-page type-script of this letter was prepared by Peggy Guggenheim, see Guggen-heim's letter to Freytag-Loringhoven, 29 August 1927, in which she sends the typescript to the Baroness and writes that she is "delighted to own the original."

17. EvFL to [Charlotte Plötz Kannegieser], 1923, "Du Erbschle-icherin—Dirne des Lebens."

18. EvFL to DB, ca. May 1924, "Dearest Oh! Sweetest Djuna—*I am frantic again*"; excerpts of this letter are reprinted in *BE,* 209–11.

19. EvFL to DB, 12 July 1924 or 1925, "Sweetest Djuna—I kiss your hands"; a brief excerpt of this letter is in *BE,* 211–12.

20. EvFL to Sarah Freedman, Spring 1927 15; a brief excerpt of this 24-page letter draft is in *BE,* 223–24.

21. EvFL "Djuna Sweet—If you would know," 1, in *BE,* 201.

22. EvFL to DB, "Sweetest Djuna—I kiss your hands," 2. In this letter she also acclaims America's "chemical value of race mixture."

23. From April 1918 on, the Berlin dadaists met in the quarters of the Berlin Secession at Kurfürstendamm 232 for their dada soirées. From 1921 to 1926, Baader organized dada *Faschingsbälle* with costuming. This information is drawn from Kristin Makholm, "Chronology," in *The Photomontages of Hannah Höch,* Exhibition Catalogue, Walker Art Centre, Minneapolis, 1997, 190.

24. EvFL, Note on a piece of cardboard, "Seit einem Monat," ca. fall 1923.

25. Claude McKay, *A Long Way from Home* (New York: Harcourt Brace, 1970), 105, 241. In his memoirs, McKay recalls the city's hostile and resentful atmosphere, the strong anti-French sentiment, and the signs in his hotel prohibiting the use of French. McKay also recalls that Marsden Hartley was in Berlin.

26. Parker Tyler, *The Divine Comedy of Pavel Tchelitchew: A Biography* (New York: Fleet, 1967); Lincoln Kirstein, *Mosaic, Memoirs* (New York: Farrar, Straus & Giroux, 1994); and Mark Kelman, e-mail, 28 December 2000.

27. EvFL's Passport, issued 19 October 1923 by the Polizeiamt Berlin Charlottenburg. The color of her hair is described as brown.

28. EvFL, Note on a piece of cardboard, "Seit einem Monat," ca. fall 1923.

29. EvFL to Eleanor Fitzgerald, December 1923, in *BE,* 197. Djuna
 Barnes's 1925 address book lists "Fitzi" at 45 Grove Street in New
 York City. See Djuna Barnes, Address Book, 1925 (Djuna Barnes
 Papers, CPL); in another undated address book, Barnes marks
 Fitzgerald's professional address, "Dramatic Workshop—247 West,"
 while noting Pauline Turkel's New York City address, "333 W 57"
 (Djuna Barnes Papers, CPL). On Fitzgerald, see also Phillip Herring,
 Djuna: The Life and Work of Djuna Barnes (New York: Penguin,
 1995), 120–21.

30. EvFL to Eleanor Fitzgerald, December 1923, in *BE,* 197.

31. EvFL to Tristan Tzara, n.d. ca. 1923–24 (Tristan Tzara Papers,
 BLJD).

32. See EvFL to Sarah Freedman, Spring 1927, 14–16 in which she
 identifies her relative's party as "deutschnational" and continues to
 define it: "Meaning: reactionary—trying to turn time clock back."
 The different political parties are described in "The Weimar Repub-
 lic," in *Questions on German History,* 264–267. See also McAlmon,
 Being Geniuses Together, 110, where he describes bribing a German
 clerk at the passport office after having been denied an exit visa. In
 her autobiography *Drawn from Life* (1941) (Kent: Mann, 1974), Ford
 Madox Ford's wife Stella Bowen, an Australian, similarly acknowl-
 edges the difficulties of obtaining legal papers for their stay in Paris
 (157) (see also chapter 14).

33. EvFL to DB, "Djuna—now—listen carefully"; in *BE,* 196.

34. EvFL to DB, ca. 1925, "Dearest Djuna: Here—in this Potsdam."

35. EvFL to Richard Schmitz, ca. 1923.

36. EvFL to Tse [August Endell], ca. 1923. Although this letter is filed
 under "Unidentified German Correspondence," fragment Nr. 5, the
 Baroness's intimate addressing of "Tse" and the content of this
 German letter unequivocally identify August ("Tse") Endell as the
 recipient of this letter.

37. Lou Andreas-Salomé, *Lebensrückblick* (Frankfurt am Main: Insel,
 1974), 266.

38. EvFL to Marcus Behmer, 23 July 1924 postcard with pictures of
 Prince Wilhelm, Wilhelm, and Prince Louis Ferdinand: "This is pil-
 fered—swiped (stolen)," she gleefully notes about her uncharacteris-
 tically patriotic postcard; the second postcard (without picture) is
 postmarked 29 July 1924; and the third postmarked 31 July 1924.

39. Just a few months before her death in 1927, she referred to one of her letters as "not any more a letter—but a *memorable document of artistic pretentions—that should be printed*—and—I hope—*will* in *time*—I kept a copy." She ultimately considered her correspondence part of her artistic oeuvre; EvFL to DB, ca. 1927, "This Letter—Djuna—is not the one I mentioned to you." That the Baroness avidly shared her correspondence, including the letters she had written, can be seen in many references, as in her letters to Barnes (e.g., "I am frantic again": "Did you read what I wrote to Darling old nice Rose McDougal?"). Of course, it is also possible that the letters were sent back by August Behmer after a quarrel or that Djuna Barnes solicited the letters for her biography, as Paul Hjartarson and Douglas Spettigue have conjectured, "Appendix," in *BE,* 193.

40. EvFL to [Stefan George], ca. 1924. Although this letter is filed under "Unidentified English Correspondence," Fragment Nr. 2, the addressee is likely Stefan George.

41. *BE,* 123.

42. EvFL to DB, Summer 1924, "Djuna—By a mere accident"; excerpts of this letter are in *BE,* 214–17.

43. Richard Huelsenbeck, *Memoirs of a Dada Drummer,* ed. Hans J. Kleinschmidt (Berkeley: U of California P, 1991), 54.

44. EvFL to DB, ca. Winter 1924–1925, "Dearest Djuna [. . .] I have become ungerman."

45. These journals included *Courrier Dada, Der Blutige Ernst* (Bloody Ernest) (edited by Grosz and Carl Einstein, 1919), *Jedermann sein eigner Fussball* (Every man his own football) (edited by Grosz and Franz Jung, 1919), *Die Rosa Brille* (Rose-colored spectacles). Another dada-friendly magazine was *Die Pleite* (a German slang word for bankruptcy), featuring Huelsenbeck's work as well Grosz's politically satiric drawings.

46. Huelsenbeck, *Memoirs of a Dada Drummer,* 74; Hans Richter, *Dada Art and Anti-Art* (London: Thames and Hudson, 1997), 110. EvFL to DB, Spring 1924, "Djuna Sweet—if you would know," 20: "I send you another picture [. . .] it was in a magazine '*Querschnitt*' [.] It was '*Georgette Leblanc*' *too* purposely 'ravishingly' dressed—together with Brancusi and Léger." As Richter reports, the *Bauhausfest* had been launched in Weimar in May 1922 with participation of Doesberg, Arp, Tzara, Schwitters, and Richter himself. The Baroness

refers to Weimar in a letter to Djuna Barnes, "I will be saved Djuna," ca. Fall 1924, in *BE,* 214: "I do not earn now *a cent*—but in about *a month* I *can* have posing again—here—or even better—*in Weimar.*"

47. Huelsenbeck, *Memoirs of a Dada Drummer,* 116.

48. EvFL to DB, "Djuna—now—listen carefully," Fall 1923, in *BE, 196;* "Djuna—forgive me dear," early summer 1924.

49. Dada Banner at the First International Dada Fair in Berlin in 1920, quoted in Gerald Early, "Dumbstruck by Dada," *Our Times: The Illustrated History of the Twentieth Century,* ed. Lorraine Glennon (Atlanta: Turner, 1995), 153.

50. Huelsenbeck, *Memoirs of a Dada Drummer,* 75.

51. For a description of the abusive relationship, see Ute Scheub, "'Für Frauen, wie wir es sind, gibt es aber heute noch keine Männer': Dada: Ein bürgerliches Trauerspiel—Hannah Höch und Raoul Hausmann," in *Verrückt nach Leben: Berliner Szenen in den zwanziger Jahren* (Reinbek bei Hamburg: Rowohlt, 2000), 153–73. Scheub describes Berlin dada as a "Herrenclub," the club of the rebelling sons, in which the only woman inevitably found herself on the margins.

52. Makholm, "Chronology," 188.

53. The parallels with the Baroness's education are striking. Hannah Höch grew up in a bourgeois family in Gotha, attended the Girls' High School (Höhere Töchterschule), then the School of Applied Arts (Kunstgewerblerschule) in Berlin-Charlottenburg, and finally the School of the Royal Museum for Applied Arts (Königliches Kunstgewerbemuseum), a school also attended by Georg Grosz. Assignments included posters for the war effort. Höch was subsequently hired as a designer for Ullstein Press, a job that allowed her to support her lover Hausmann. See Makholm, "Chronology," 185–194. In 1926, just as the Baroness settled in Paris, Höch published a woodcut in *The Little Review* (Spring–Summer 1926), illustrating Ernest Hemingway's "Banal Story"; Makholm, "Chronology," 194.

54. Richter, *Dada Art and Anti-Art,* 132.

55. Hannah Höch, *Schnitt mit dem Küchenmesser Dada durch die letzte weimarer Bierbauchkulturepoche Deutschlands,* 1919, Photomontage, 114 × 90 cm, Berliner Nationalgalerie. See Maud Lavin, *Cut with the Kitchen Knife: The Weimar Photomontages of Hannah Höch* (New Haven: Yale UP, 1993).

56. EvFL to Sarah Freedman, Spring 1927, 16.

57. Richter, *Dada Art and Anti-Art,* 126. The journal *Der Dada* (1919–20) was thoroughly male, edited by Hausmann, with texts by Baader, Huelsenbeck, Hausmann, and Tzara. See also Herman Korte, *Die Dadaisten* (Reinbek bei Hamburg: Rowohlt, 1994), 153, for a chronology of Berlin dada activities. In September 1922, German dadaists met for a conference in Weimar, later in the month in Jena, and then again at the end of the month in Hannover bringing together Schwitters, Hans Arp, Tristan Tzara, Raoul Hausmann, and Theo and Nelly von Doesburg. In December 1923, a last important Dada MERZ-Matinée involving Schwitters and Hausmann took place in Hannover.

58. Grosz, for instance, was known as "Dada Marshall," while Baader called himself the "Oberdada" (dada captain) and "President des Erdballs" (president of the world); in Richter, *Dada Art and Anti-Art,* 127.

59. See Maud Lavin's "Hannah Höch's *From an Ethnographic Museum,*" in *Women in Dada: Essays on Sex, Gender, and Identity,* ed. Naomi Sawelson-Gorse (Cambridge: MIT P, 1998), 330–59.

60. See Maud Lavin, "Androgyny and Spectatorship," in *Cut with the Kitchen Knife,* 187: "[I]n keeping with representations of the New Woman and certain leftist ideologies of Weimar, her androgynous images depict a pleasure in the movement between gender positions and a deliberate deconstruction of rigid masculine and feminine identities." During his visit to Berlin in the 1920s, Robert McAlmon noted that androgyny appeared to mark the entire city and was reflected in the recent founding of Magnus Hirschfeld's revolutionary sexology institute. McAlmon notes in *Being Geniuses Together,* 107: "Hirshfeld [sic] was conducting his psychoanalytic school and a number of souls unsure of their sexes or of their inhibitions competed with each other in looking or acting freakishly, several Germans declared themselves authentic hermaphrodites, and one elderly variant loved to arrive at the smart cabarets each time as a different kind of woman: elegant, or as a washerwoman, or a street vendor, or as a modest mother of a family."

61. Anita Berber quoted in Ute Scheub, "Berlin, du tanzt den Tod," in *Verrückt nach Leben,* 80. My discussion of Berber is indebted to Scheub's chapter and to Leo Lania [Herrmann Lazar], *Der Tanz ins Dunkel—Anita Berber: Ein biographischer Roman* (Berlin: Schultz, 1929).

62. Klaus Mann, quoted in Scheub, *Verrückt nach Leben,* 94.

63. Lania, *Der Tanz ins Dunkel—Anita Berber,* 139.

64. Châtin-Hofmann is described in Lania, *Der Tanz ins Dunkel—Anita Berber,* 180–185 and Scheub, *Verrückt nach Leben,* 94.

65. Berenice Abbott, BAI-a, 5.

66. See Lania, *Der Tanz ins Dunkel—Anita Berber,* 185.

67. EvFL to DB, Summer 1924, "Djuna—forgive me dear," 10.

68. Janet Flanner, *Paris Was Yesterday 1925–1939,* ed. Irving Drutman (New York: Viking P, 1972), 39.

69. EvFL to DB, 1924–25, "Djuna—By a mere accident" (excerpts of this letter appear in *BE,* 214–17). The number of candles—fifty— suggest that the Baroness's performance act took place in 1924 in honor of her fiftieth birthday; however, corroborating evidence is missing, so that the date could also be 1925.

70. EvFL, "Spring in the Middle," unpublished poem, ca. 1924.

71. EvFL draft to George Biddle, ca. Winter 1923, "To Biddle / Where I American born," in *BE,* 200.

Chapter 13

1. Berenice Abbott, BAI-a, 5.

2. These references to photography suggest that the portrait's composition date is 1923 or later, after Abbott was hired as Man Ray's studio assistant. Abbott had no connection with photography before she started as Man Ray's studio assistant.

3. EvFL to *LR* (*LR* Papers, GML), *LRC,* 25.

4. EvFL to DB, ca. 1924, "I must *now* ask friendship's leniency."

5. In her correspondence, she also compares her plight in Berlin to the literal treadmill that was imposed as punishment on Oscar Wilde during his prison incarceration; EvFL to DB, April–May 1925, "Djuna—I have nothing much to say," 1.

6. Berenice Abbott, BAI-a, 5.

7. For a discussion of Barnes's relationship with Wood, see Phillip Herring, "Thelma," *Djuna: The Life and Work of Djuna Barnes* (New York: Penguin, 1995), 156–70.

8. EvFL to DB, postcard dated December 1924.

9. EvFL to DB, 12 July 1924, "Sweetest Djuna—I kiss your hands and feet"; excerpts of this letter are in *BE,* 211–12. See also EvFL's letter to DB, ca. 1924, "Djuna—I send you"; an excerpt of this letter is in

BE, 206–09. "My mother is my possession!" proclaims Freytag-Loringhoven, now offering to Barnes the gift of her mother's memory in feminist and idealizing terms: "she is an unknown beautiful saint-martyr—she *gave* me what I *am*—even as to that father of mine [. . .]. I am her trumpet—have I not now all spiritual ability [. . .]? No! She *is I.*"

10. EvFL to DB, "Djuna Sweet—if you would know," 16–19. This letter is, in part, a response to Barnes's message from London, as well as a response to Barnes's telegram and package sent from Paris. The length of this thirty-two-page letter and the frequency of contact from Barnes suggest that this was a time of intensive contact between the two friends.

11. EvFL to DB, May 1924, "Dearest Oh! sweetest Djuna—*I am frantic again,*" 16–17.

12. EvFL to DB, ca. 1924, "I must *now* ask friendship's leniency."

13. EvFL to DB, ca. February–April 1925, "Dearest and sweetest Djuna—I am again astonished at your long silence."

14. EvFL to DB, postcard dated 17 June 1924. The postcard makes it clear that the position of "private secretary" is meant as a strategic ruse only to obtain a visa for the Baroness.

15. EvFL to DB, "Djuna Sweet—if you would know," 22; EvFL to DB, ca. 1924; 21–22. "Dearest Djuna [. . .] It is marvelous how you love me"; Lynn DeVore, "The Backgrounds of *Nightwood:* Robin, Felix, and Nora," *Journal of Modern Literature* 10.1 (March 1983): 76; "Clock," unpublished long poem, manuscript, 41.

16. EvFL, Postcard to DB, ca. 1924–25, "Got your letter!"

17. EvFL to DB, ca. Fall 1925, "Djuna thanks—I got that magazine."

18. DB to Ford Madox Ford, ca. Summer 1924 (DB Papers, CPL). The street number 36 may be wrong; see note 21 below.

19. EvFL, "Guttriese" and "Walküren," *LR* 11.1 (Spring 1925): 13–14.

20. EvFL to Peggy Guggenheim, 1927, 17: "Already once [. . .] you assisted me in jaws of monster Germany."

21. EvFL to DB, 17 June 1924 postcard with the Baroness's address: Berlin West, Neue Winterfeldstrasse 10. Andrew Field, *Djuna: The Formidable Miss Barnes* (Austin, U of Texas P, 1985), 87, cites a letter by playwright Eugene O'Neill sent to Djuna Barnes in Berlin in August 1924, thus placing Barnes in Berlin.

22. EvFL to DB, ca. 1924–25, "Djuna–I *adore* this."

23. EvFL to DB, "Djuna Sweet—if you would know," 27: "I once was in [the] same line with 'James Joyce' as artist by so many words put by J.h." Emily Coleman to Djuna Barnes, 24 November 1935 (DB Papers, CPL), aligns the Baroness with the "original genius" of several ancients and moderns: "(Blake was ahead of his time). Lawrence has some of it. Joyce. Eliot. The Baroness. Barnes. Muir."

24. EvFL to DB, "Djuna Sweet—if you would know," 21–25; EvFL to DB, "Dearest Djuna [. . .] It is marvelous how you love me," 22.

25. EvFL to DB, "Djuna Sweet—if you would know," 23–25.

26. EvFL to DB, ca. 1924, "Djuna—another question."

27. EvFL to DB, February 1925, "Tedious—I must strain myself for too small results." 6 page letter fragment.

28. EvFL to DB, ca. 1924, "Dear Djuna [. . .] I am gone to the death-trap."

29. EvFL to DB, "Dearest oh sweetest Djuna—*I am frantic again.*" Mary Roberts Rinehart, "The Red Lamp," *Cosmopolitan* (January–April 1924): 18–25, 231–50. *The Red Lamp* is a mystery novel, with elements of black magic. In addition, the Baroness reads British fiction: Thomas Hardy's *Tess of the d'Urbervilles,* Robert Louis Stevenson, and George Bernard Shaw. She especially admires Shaw and composes a letter to him, yet does not receive an answer.

30. EvFL to DB, postcard postmarked 26 June 1924.

31. EvFL to William Carlos Williams, ca. 1924.

32. EvFL to DB, 1924, "I must *now* ask friendship's leniency."

33. EvFL to DB, ca. February 1925, "Dearest and Sweetest Djuna—I am again astonished at your silence." She reports on two poems and corrections that she had sent in an earlier package.

34. EvFL to DB, "Djuna Sweet—if you would know" 18.

35. EvFL to DB, "Djuna Sweet—if you would know" 21.

36. DB, "Preface," one-page typescript dated 7 December 1924.

37. EvFL to DB, "Djuna Sweet—if you would know," 16–17.

38. EvFL to DB, May 1925, "Dearest oh sweetest Djuna—*I am frantic again.*"

39. EvFL to DB, ca. February 1925, "Tedious—I must strain myself for too small results" (6-page letter fragment; a brief excerpt of this letter is in *BE,* 217–18).

40. EvFL to DB, ca. 1925, "Dearest Djuna—I hope fervently."

41. Pastor Braune, Report for Geheimrat von Brandis, dated 19 March 1925 (Gottesschutz Papers, AHA). My thanks to Gisela Baronin Freytag v. Loringhoven for providing me with a copy of this letter.

42. EvFL to Pastor Braune, ca. March 1925 (Gottesschutz Papers, AHA); my thanks to Gisela Baronin Freytag v. Loringhoven for providing me with a copy. EvFL to DB, ca. February 1925, "Dearest and Sweetest Djuna—I am again astonished."

43. Pastor Braune, Report for Herr Geheimrat von Brandis, dated 19 March 1925. Registrar of Gottesschutz, Erkner, No. 45, admission date 21 February 1925, release date 23 April 1925, signed by "Else Baronin von Freytag-Loringhoven" Gottesschutz Papers, AHA).

44. EvFL to DB, April–May 1925, "Djuna—I have nothing much to say."

45. My information is based on interviews with Frau Dr. med. Angelika Grimmberger and Manfred Haupt, Technischer Leiter, Landesklinik, Eberswalde, 25 August 2000. My thanks to both Dr. Grimmberger and Herr Haupt for generously providing information regarding regulations, treatments, and facilities, as well as providing a tour of the entire Landesklinik, which was undergoing renovations in August 2000.

46. EvFL to DB, April 1925, "Dearest Djuna—I do not know how to tell you the terrible circumstances," an excerpt from this letter is in *BE* 222–223.

47. EvFL to DB, April 1925, "Dearest and sweetest Djuna—I am again astonished."

48. EvFL, Note to Frau Dr. Simsa, in *BE,* 192 n. 7.

49. *BE,* 125.

50. *BE,* 147, 165.

51. EvFL to DB, April–May 1925, "Djuna—I have nothing much to say," 1.

52. *BE,* 67.

53. Irene Gammel, "'No Woman Lover': Baroness Elsa's Intimate Biography," *Canadian Review of Comparative Literature* 20.3–4 (September 1993): 451–67.

54. *BE,* 99.

55. EvFL to DB, "Dearest oh sweetest Djuna—I am frantic again."

56. Barnes's process of composition is described in detail in Hank O'Neal's informal memoir of Djuna Barnes, *Life Is Painful, Nasty and Short . . . in My Case It Has Only Been Painful and Nasty: Djuna Barnes, 1978–1981—An Informal Memoir* (New York: Paragon House, 1990), passim.

57. Lynn DeVore, "The Backgrounds of *Nightwood:* Robin, Felix, and Nora." *Journal of Modern Literature* 10.1 (March 1983): 79.

58. DB, "Else, Baroness von Freytag-Loringhoven," [with handwritten note: died Dec. 14, 1927], undated manuscript, ca. 1933, 13.

59. Djuna Barnes, *Nightwood* (1936) (New York: New Directions, 1961), 41.

60. Moreover, Wood's pet name was Simon (suggesting the male role she played in the relationship), and Barnes's pet name was Irine (Greek for "lover of peace," suggesting the female role). The Canadian writer John Glassco, for instance, recalls his one-night stand with Wood, whom he describes in his memoirs as a "tall, beautiful, dazed-looking girl [. . .] who had the largest pair of feet I had ever seen." Yet sex was disappointing. In a scene that today's reader would be tempted to call date rape, Glassco described his sex partner as dazed, if not passed out, unable to experience sexual pleasure. John Glassco, *Memoirs of Montparnasse,* with an introduction and notes by Michael Gnarowski (Toronto: Oxford UP, 1995), 33.

61. See Phillip Herring's chapter "Thelma," in his biography *Djuna,* 156–70. See also Andrew Field, *Djuna: The Formidable Miss Barnes* (Austin: U of Texas P, 1985), 150–51, who writes that features of the Paris flats in which Barnes lived with Wood are amalgamated into the novel's settings.

62. Barnes, *Nightwood,* 42.

63. Barnes, *Nightwood,* 34–37.

64. DB, "Baroness Elsa," undated Preface written ca. 1933, 3 Waverly Place, New York City.

65. EvFL to DB, ca. fall 1924, "Darling Djuna—In a few days."

66. Barnes, *Nightwood,* 169.

67. Barnes, *Nightwood,* 170.

68. Shari Benstock, *Women of the Left Bank: Paris, 1900–1940* (Austin: U of Texas P, 1986), 256.

69. Victoria L. Smith, "A Story Beside(s) Itself: The Language of Loss in Djuna Barnes's *Nightwood*," *PMLA* 114.2 (March 1999): 195. Smith writes that earlier critics have "overlooked the positive aspects of the melancholic mechanics of the text" and in her analysis emphasizes the "range of mechanics of melancholia, whereby one creates a text and self through melancholic remembering of the lost object" (202–03).

70. Emily Coleman to DB, 1 August 1935 (DB Papers, CPL); and Emily Coleman, to DB, October–December 1935 (DB Papers, CPL), alluding to an earlier conversation with Barnes: "I think you said she [the Baroness] looked at you and said, 'Can I trust you?' That's all right, quite human, but the way you said it, as if you were a dog and she were a saint, or rather as if she were an angel and the world muck [. . .]."

71. Emily Coleman to DB, October–December 1935 (DB Papers, CPL).

72. T. S. Eliot to DB, dated 28 January 1938 (DB Papers, CPL). Again, on 8 February 1938, he writes: "So don't worry about either the Baroness OR yourself, worry about the book" (DB Papers, CPL).

73. Emily Coleman to DB, July–December 1939 (DB Papers, CPL).

Chapter 14

1. Morley Callaghan, *That Summer in Paris: Memories of Tangled Friendships with Hemingway, Fitzgerald, and Some Others* (Toronto: Macmillan, 1963), 113–14.

2. See biographer Michael Reynolds, *Hemingway: The Paris Years* (Oxford: Blackwell, 1989), 161–86. Hemingway's brief stint with Ford's review was profoundly influential for his later career as a writer. Hemingway wrote his fiction in the morning and read incoming manuscripts in the afternoon, as well as writing the editorial columns for the review.

3. Ford Madox Ford, *It Was the Nightingale* (Philadelphia: Lippincott, 1933), 333–34.

4. The entire August issue had a decidedly American tang with contributions by Nathan Ash, Guy Hickock, John Dos Passos, and Gertrude Stein (in addition to the British writers Mary Butts, Bryher and Dorothy Richardson). Under the heading "*An Americanization*,"

perhaps alluding to the "Americanization" of the Baroness in *The Little Review,* Ford put the responsibility for the issue squarely on shoulders of "Mr. Ernest Hemingway, the admirable Young American prose writer." He continued, "we imagine, the other contributors to this number to be American by birth, marriage, adoption [. . .]. May they help to hoist the flag of U.S. Art a little higher on the National flagstaff and so provide the Banner with a fortyninth star," *transatlantic review* 2.2 (August 1924) (New York: Kraus Reprint, 1967), 213.

5. EvFL, "Novembertag" and "Novemberday," *transatlantic review* [Paris] 2.2 (August 1924) (New York: Kraus Reprint, 1967): 138–39.

6. EvFL, "Enchantment," *transatlantic review* 2.2 [Paris] (August 1924) (New York: Kraus Reprint, 1967): 140.

7. See EvFL's notes on the "Enchantment" manuscript, written in the right, left, and bottom margins but then crossed out, presumably by Barnes or Hemingway. In her emendations, the Baroness proposed to omit all "of" prepositions ("Out ~~of~~ this hole slips moon") to tighten the lines. She also wanted to replace "commonplace" words like "crawl" with neologisms like "trowel": "'Here / trowels / moon / out / this / hole' gives absolutely what I want—[. . .] the 'tr' has that round trundling effect! 'Crawls'—compared with that—has a laboring sense [—] *you* decide." Similarly, she wanted to replace "turn me rigid" with "smite me rigid" because it is "more sudden arresting—hence more descriptive—gripping." Yet none of the Baroness's editorial preferences—all of them heightening the poem's musicality, sensuality, and drama—appeared in the published version. The editor's choice was clarity: "crawls" instead of "trundles"; "turn me rigid" instead of "smite me rigid"; and "out of this hole" instead of the more Germanic "out this hole."

8. James R. Mellow, *A Life Without Consequences: Hemingway* (Boston: Houghton Mifflin, 1992), 258. Williams performed the circumcision on Hemingway's eight-month-old son, Bumby, a scene to which the macho writer reacted with much squeamishness.

9. Hemingway to Pound, 1926 (Ezra Pound Papers, YCAL).

10. Hemingway was busily writing stories for the *Querschnitt*: "Got an order from the 'Schnitt' for something every month and they are making big money now and I got a commission to write a book on bull fighting." In the same letter, he also referred to his "dirty poems

to be illustrated by Pascin." Hemingway to John Dos Passos, 22 April 1925, in *Hemingway: Selected Letters 1917–1961,* ed. Carlos Baker (New York: Scribner's, 1981), 158.

11. Hemingway to Isabel Simmons, Paris, 24 June 1923, in Baker, *Hemingway: Selected Letters,* 83.

12. Hemingway to Gertrude Stein and Alice B. Toklas, 9 August 1924, 14 September 1924, and 10 October 1924, in Baker, *Hemingway: Selected Letters,* 121, 125, 127. This close friendship with Heap is also reflected in Hemingway's dig against "Georgette Leblanc," who figures in *The Sun Also Rises* (1926) (New York: Scribner's, 1954) as the prostitute with bad teeth. Hemingway admired and trusted Heap for her daring, for she had printed his "Mr and Mrs Eliot," with its references to lesbianism uncensored, whereas Horace Liveright asked Hemingway to cut the respective passages for the book publication in 1925. "Jane Heap ran it in its original form and did not get into any trouble," Hemingway wrote to Liveright, yet he does as he is told and removes the "dynamite." 22 May 1925, in *Hemingway: Selected Letters,* ed. Baker, 161.

13. Cf. Hemingway to Stein and Toklas, 9 August 1924, in Baker, *Hemingway: Selected Letters,* 121.

14. Hemingway to Pound, ca. 2 May 1924, in Baker, *Hemingway: Selected Letters,* 116.

15. [Hemingway], "And Out of America," *transatlantic review* 2.1 (1924) (New York: Kraus Reprint, 1967): 103.

16. Bernard J. Poli, *Ford Madox Ford and the "Transatlantic Review"* (Syracuse: Syracuse UP, 1967), 148, see also 104–05.

17. Richard Huelsenbeck, *Memoirs of a Dada Drummer* (Berkeley: U of California P, 1991), 85. In October 1924, Hemingway had published two profane verses about Pound in the *Querschnitt* and was called on it. "We believe you're on the wrong track," warned Eugene Jolas, the journalist and soon-to-be Paris editor of *transition:* "If you don't watch out, Dr. Summer [sic] will give a raft of free publicity." Jolas, "Open Letter to Hemingway," *Paris Tribune* (16 November 1925), reprinted in *The Left Bank Revisited: Selections from the Paris "Tribune," 1917–1934,* ed. Hugh Ford (University Park: Pennsylvania State UP, 1972), p. 100. See also Hemingway's vituperative language, as when he calls "[Robert] McAlmon—that disappointed, half assed fairy English jew ass licking stage husband literary figure," Letter to Ezra Pound [Lieber Herr Gott], 1926 (Ezra Pound Papers, YCAL).

18. DB, "Elsa Notes," 1933, 3.

19. Ian Littlewood, *Paris: A Literary Companion* (New York: Harper and Row, 1988), 132; Ernest Hemingway, *A Moveable Feast* (1964, New York: Touchstone, 1996), 81. Rue Vavin is located close to the beautiful Luxemburg Gardens and is only a close walk away from the Pantheon quarters, the area frequented by gays and lesbians in *The Sun Also Rises*. There is no evidence, however, that the Baroness actually met the American author, whose star was now rising fast and who was distracted by his recent affair with the affluent and attractive *Vogue* editor Pauline Pfeiffer. Having risen above his Montparnasse life of poverty, Hemingway had moved to richer quarters.

20. See Thérèse Lichtenstein, "A Mutable Mirror: Claude Cahun," *Artforum* 8 (April 1992): 64–67; and François Leperlier, *Claude Cahun: Masks and Metamorphoses,* trans. Liz Heron (London: Verso, 1997).

21. My thanks to Julia Van Haaften for the reference of the Baroness's visit to Abbott's exhibition; personal communication 23 February 2001. Djuna Barnes jotted down the reference "Beach of La Crotois" and further references to the Baroness's lack of cleanliness on a single sheet found among the "Beggar's Comedy" draft. In her "Elsa-Notes," 1933, 2, Barnes also refers to her walk with Elsa on "the beach of Crotoix." The Baroness's beloved playwright George Bernard Shaw had dramatized the Joan of Arc legend in a 1922 play. See EvFL to DB, ca. 1924, "Djuna—By a mere accident," in *BE,* 214–15. Here she writes: "*Bernard Shaw is the Shakespeare of our time!*"

22. DB, "Elsa—Notes," 1933, 2.

23. EvFL, Note with Constantin Brancusi's address written in the Baroness's handwriting, unidentified English papers.

24. George Antheil, *Bad Boy of Music* (New York: Doubleday and Doran, 1945).

25. Berenice Abbott, BAI-a, 4.

26. EvFL to George Antheil, ca. 1926.

27. EvFL to Peggy Guggenheim, Summer 1927, 35-page typescript prepared by Guggenheim, 31–32.

28. Abbott, BAI-a, 4.

29. EvFL to Berenice Abbott, ca. 1926. Abbott was now taking photographs of Cocteau, Gide, Flanner, Anderson, and Guggenheim. My thanks to Julia Van Haaften, who explains that Berenice Abbott always

insisted on being paid for her services, as a principle never taking photographs free of charge. Personal conversation, 23 February 2001.

30. Hugh Edwards, ed., *Surrealism and Its Affinities: The Mary Reynolds Collection—A Bibliography* (Chicago: Art Institute of Chicago, 1973). See also Calvin Tomkins, *Duchamp: A Biography* (New York: Holt, 1996), 257–58, for a discussion of Reynolds.

31. Berenice Abbott, BAI-a, 5–6; Thelma Wood, Daybook 1927 (DB Papers, CPL).

32. See Amanda Vaill, *Everybody Was So Young: Gerald and Sara Murphy—A Lost Generation Love Story* (New York: Broadway, 1998), 174–85. The well-to-do American artists Gerald and Sara Murphy organized the Antibes parties in the spring and early summer 1926, attracting Scott and Zelda Fitzgerald, Pauline Pfeiffer, the Hemingways, and Anita Loos (the author of *Gentlemen Prefer Blondes*).

33. EvFL to George Biddle, ca. 1927.

34. EvFL to Peggy Guggenheim, 17.

35. EvFL, "Chimera," unpublished long poem.

36. EvFL to Peggy Guggenheim, 18.

37. EvFL to Sarah Freedman, ca. Spring 1927, 17–19, in *BE,* pp. 223–24.

38. See Billy Klüver and Julie Martin, *Kikis Paris: Künstler und Liebhaber, 1900–1930* (Cologne: DuMont, 1989), 161. Kiki de Montparnasse's paintings found favor with important agents and collectors, including Roché and Quinn. She became a legendary figure as Man Ray's model, her posing much less "virile" and disruptive than the Baroness's. On Kiki de Montparnasse, see my chapter "Parading Sexuality: Modernist Life Writing and Popular Confession," in Irene Gammel, ed., *Confessional Politics: Women's Sexual Self-Representations in Life Writing and Popular Media* (Carbondale: Southern Illinois UP, 1999), 47–61; and Whitney Chadwick's "Fetishizing Fashion/Fetishizing Culture: Man Ray's *Noire et blanche,*" in *Women in Dada: Essays on Sex, Gender, and Identity,* ed. Naomi Sawelson-Gorse (Cambridge: MIT P, 1998), 294–329.

39. EvFL, "Are You Asleep with Somnolent Models," Advertisement, 1927.

40. EvFL to Mary Reynolds, n.d., poststamped 28 July 1927, 3; the return address is 7 Impasse du Rouet, Avenue Chatillon (Metro Alesia) Paris 14.

41. EvFL to Mary Reynolds, n.d., postmarked 28 July 1927, 4.

42. Tomkins, *Duchamp,* 278.

43. Peggy Guggenheim, *Out of this Century: Confessions of an Art Addict* (Garden City: Doubleday, 1980).

44. EvFL to Peggy Guggenheim, Summer 1927; Peggy Vail [Guggenheim] to EvFL, 29 August 1927.

45. Arturo Schwarz, *Almanacco Dada* (Milan: Feltrinelli, 1976), 121.

46. EvFL to Mary Reynolds, n.d., poststamped 28 July 1927.

47. EvFL to DB, ca. Summer 1927, "This letter—Djuna—is *not* the one."

48. EvFL to DB, ca. Summer 1927, "This letter—Djuna—is *not* the one."

49. For a brief history of *transition,* see Hugh Ford, Foreword, *transition* [Reprint] (Troy: Whitson, 1980): viii. Sold at Shakespeare and Company at 12 rue de l'Odéon, this new journal seemed made for the Baroness, for the editors assured their contributors that "neither violence nor subtlety would repel them" and featured Ball, Schwitters ("Anna Blossom Has Wheels," *transition* [June 1927]: 144–45), and Arp, as well as expatriate American writers including Stein, Hemingway, the Crosbys, and Kay Boyle. Jolas featured a plethora of translated works, including Else Lasker-Schüler (April 1927).

50. Rue Vavin is only minutes away from the boulevard de Montparnasse with its array of cafés and bars, including the Jockey, the Rotonde, Closerie des Lilas, Coupole, and the famous Select, all catering to Americans. In *A Moveable Feast* (1964) (New York: Touchstone, 1996), 101, Hemingway passes by the Rotonde, "scorning vice and the collective instinct, [and] crossed the boulevard to the Dome. The Dome was crowded too, but there were people there who had worked."

51. EvFL, "Café du Dome" and "X-Ray" published in *transition* [Paris] 7 (October 1927): 134–35.

52. MJ [Maria Jolas], [*transition*] Secretary, to EvFL, dated 12 October 1927; Jolas added: "With regard to your request for proofs we regret that it is impossible to send proofs to each contributor." The rejected long poem "Contradictory Speculation on My Own Hook's Fallibility," 9-page typescript, has remained unpublished. "Chill" had, in fact, been published already in *Liberator* 5.10 (October 1922): 29, along with the poem "Loss," 21.

53. EvFL, "A Dozen Cocktails—Please," unpublished poem.

54. José Pierre, *Investigating Sex: Surrealist Discussions 1928–1932,* trans. Malcolm Imrie (New York: Verso, 1992).

55. EvFL to DB, "This letter—Djuna—is *not* the one," 1927. See also EvFL to Mr. Jacobson, ca. 1927, 4-page manuscript. Mr. Jacobson was an American benefactor whom she accused of having treated her like a beggar; his gift of 25 francs seemed too shabby; such charity was more insult than help. In the same letter to Jacobson, she described herself with reference to Samuel Taylor Coleridge's poem, "The Rime of the Ancient Mariner," as quoted in the part opener epigraph to these Berlin and Paris chapters.

56. EvFL to Mary Reynolds, n.d., postmarked 21 September 1927. Reynolds lived on 14 Rue Montessuy (Champs du Mars) in an apartment above Loeb and Cannell. See Harold Loeb, *The Way It Was* (New York: Criterion, 1959) 204.

57. In her memoir *Drawn from Life,* (Kent; Mann, 1974) Ford Madox Ford's wife Stella Bowen describes the complexities of obtaining legal paperwork for their stay in Paris: "It is true that we had to pay complicated taxes and occupy ourselves with obtaining *Cartes d'Identités* and that any foreigner could be expelled from France without an explanation, and was usually debarred from working for a wage. It is true that anyone whose papers were not in order or who had no visible means of support had to dodge any contact with the police" (157).

58. Ford, *It Was the Nightingale,* 333–34.

59. Alfred Perlès, "Gobelins Tapestries," *Paris Tribune* (26 April 1931), reprinted in *The Left Bank Revisited,* ed. Ford, 41.

60. EvFL to DB, ca. Spring 1924, "Djuna—I send you," in *BE,* 207–08.

61. EvFL to DB, "Djuna Sweet—if you would know," p. 17; in *BE* 204; a longer excerpt of this passage and a photograph were published in *LR* 12 (May 1929): 34–35.

62. EvFL to George Biddle, Spring 1927, 24–25.

63. EvFL to Peggy Guggenheim, 22.

64. EvFL to Peggy Guggenheim, 4.

65. EvFL to Melchior Lechter, November 1927, quoted in Marguerite Hoffmann, *Mein Weg mit Melchior Lechter* (Amsterdam: Castrum Peregrini, 1966), 177.

66. "To Show Art of Madmen: Paris Exhibition Hangs Works of Asylum Inmates," *New York Times,* December 14, 1927.

67. "Paris Is Stirred by Lindbergh's Feat: News of It Is Flashed in Movie Houses and Broadcast by Radio," *New York Times,* December 15, 1927.

68. EvFL to Peggy Guggenheim, 16.

69. EvFL to DB, in "*Selections From the Letters of Elsa Baroness von Frey-tag-Loringhoven,*" *transition* 11 (February 1928), 27.

70. An excerpt of this letter is quoted in Rudolf E. Kuenzli, "Baroness Elsa von Freytag-Loringhoven and New York Dada," in *Women in Dada: Essays on Sex, Gender, and Identity,* ed. Naomi Sawelson-Gorse (Cambridge: MIT P, 1998), 456: "Carnivorous beast as timid as a rabbit. I admire her skill and couldn't go near her. It's a loss to have her gone, a loss I'm damn glad of. What the hell, she had a rare gift. I never thought her insane. This is ridiculous, talking this way—for I understand she had deteriorated like hell toward the end. But this small tribute has been in me several months, now it's out."

71. DB, Obituary, *transition* 11 (February 1928): 19. See also Williams, *The Autobiography of Williams Carlos Williams* (New York: New Directions, 1967), 169. He writes that she was "playfully killed by some French jokester [. . .] who turned the gas jet on in her room while she was sleeping." "That's the story," he writes, the reference to "the story" highlighting that evidence is missing.

72. Abbott, BAI-a, 6.

73. The French death certificate states that Else Ploetz, a writer, born in Swinemünde (Germany), whose parents' names are unknown, widow of Baron von Freytag-Loringhoven, died at an unknown hour, at 22 rue Barrault. The death report was drawn up on 15 December at 6 p.m. and signed by Jean Fouiloux in the municipality of the 13th Arrondissement following the report made by André Gouet, thirty-three years old and employed at 3 rue Bebillot. My thanks to Gisela Baronin Freytag v. Loringhoven for a copy of this report filed with the mairie, 13th Arrondissement.

74. [Marc Vaux], "Death Mask of Elsa Baroness von Freytag-Loringhoven," *transition* 11 (February 1928): follows 49.

75. See Phillip Herring, *Djuna: The Life and Work of Djuna Barnes* (New York: Penguin, 1995), 198, on the preparation of the mask by Marc Vaux, which Barnes intended to use for the biography. In 1933, she wrote to Charles Henri Ford, asking him to obtain the death mask and to deliver it to Mary Reynolds. See also Hank O'Neal, *Life Is Painful, Nasty, and Short . . . in My Case It Has Only*

Been Painful and Nasty: Djuna Barnes, 1978–1981—An Informal Memoir (New York: Paragon, 1990), 57, on Barnes's keeping the death mask in her closet.

76. Jean Demorand, Chef du Service des Cimetières, Mairie de Paris, Letter 7 February 2001.

77. This funeral episode is relayed by Djuna Barnes to Emily Coleman. I am grateful to Phillip Herring for a summary of this letter, e-mail communication, 21 December 2001.

78. See Richard Huelsenbeck, *Memoirs of a Dada Drummer,* ed. Hans J. Kleinschmidt, trans. Joachim Neugroschel (Berkeley: U of California P, 1969), 50.

79. "Crosby, Poet of Suicide Pact, Gave Promise of World Fame," *Paris Tribune* (13 December 1929), reprinted in Ford, *The Left Bank Revisited,* 119.

80. "All Montparnasse Assembles at Grave of Popular Artist," *Paris Tribune* (8 June 1930), reprinted in Ford, *The Left Bank Revisited,* 204.

81. EvFL quoted in Emily Coleman's Diary, 5 July–1 September 1934, 30.

82. Mary Butts, "The Master's Last Dancing: A Wild Party in Paris, Inspired by One of Ford Maddox [*sic*] Ford's," *The New Yorker* (30 March 1998): 111.

83. Nathalie Blondel, *Mary Butts: Scenes from the Life* (Kingston: McPherson, 1998) 327.

84. Butts, "The Master's Last Dancing," 110.

85. Butts, "The Master's Last Dancing," 112.

86. Butts, "The Master's Last Dancing," 112.

87. Butts, "The Master's Last Dancing," 113.

88. Eugene Jolas, "Logos," *transition* 16–17 (June 1929): 25–27.

89. EvFL, "Ostentatious: Westward; Eastward; Agog," *transition* 16–17 (June 1929): 24. Jolas's "Logos" is followed by Harry Crosby's "The New Word," described as "a direct stimulant upon the senses, a freshness of vision, an inner sensation," *transition* 16–17 (June 1929): 30.

90. EvFL to Peggy Guggenheim, 32.

91. EvFL, Marginal note accompanying her poem "Stagnation."

Selected Bibliography

1. Sources for Elsa von Freytag-Loringhoven's Work
Artwork

Cathedral. ca. 1918. Wood fragment, approx. 4 in. high. Mark Kelman Collection, New York.

Dada Portrait of Berenice Abbott. ca. 1923–24. Mixed media collage, 8 5/8 × 9 1/4 in. Mary Reynolds Collection. The Museum of Modern Art, New York.

Earring-Object. ca. 1917–1919. Mixed media, 4 3/4 × 3 × 3 in. Mark Kelman Collection, New York.

Enduring Ornament. ca. 1913. Found object. Metal ring, approx. 3 1/3 in. diameter. Mark Kelman Collection, New York.

Forgotten—Like This Parapluie. ca. 1923–1924. Gouache and ink. Photograph of painting. EvFL Papers, CPL.

God. [With Morton Livingston Schamberg]. 1917. Plumbing trap on a carpenter's miter box. Philadelphia Museum of Art. The Louise and Walter Arensberg Collection. Photograph by Schamberg. 1917. The Metropolitan Museum of Art, New York. The Elisha Whittelsey Collection.

Limbswish, ca. 1917–1919. Metal spring, curtain tassel, approx. 18 in. high. Mark Kelman Collection, New York.

Oggetto (Object), ca. 1918–20. Woven fabric with buttons, wire, key, springs, and metal. Reproduced in Arturo Schwarz, *Almanacco Dada*, Milan: Feltrinelli, 1976. p. 121.

Ornamental Pipe for Rose McDougal. 1925. Found object. Broken pipe repaired and decorated "with rose leaves in poetical allusion." No longer extant but described in a letter to Djuna Barnes, "I am again astonished," EvFL Papers, CPL.

Portrait of [Baron Leopold von Freytag-Loringhoven]. ca. 1919. Pencil drawing on paper on a sheet with the poem "Tod eines Schwerenöters." Series 3—Poems. Subseries III—Poems, German. Box 4. EvFL Papers, CPL.

Portrait of Marcel Duchamp. ca. 1920–1922. Assemblage of miscellaneous objects in a wine glass. No longer extant. Photograph by Charles Sheeler. Francis M. Naumann Collection, New York.

Portrait of Marcel Duchamp. ca. 1922. Pastel and collage, 12 3/16 × 18 1/8 in. Vera, Silvia and Arturo Schwarz Collection of Dada and Surrealist Art, Israel Museum, Jerusalem.

Visual Poetry

Guttriese. The Little Review 11.1 (Spring 1925): 13.

Matter Level Perspective. ca. 1923–1925. Series 3—Poems. Subseries II—Prose Poems. EvFL Papers, CPL.

Keiner <Literarisch Five-o-clock>. ca. 1918. Series 3—Poems. Subseries III—Poems, German. EvFL Papers, CPL.

Perpetual Motion, ca. 1923–1925. Visual Poem. Series 3—Poems. Subseries II—Prose Poems. EvFL Papers, CPL.

Walküren. The Little Review 11.1 (Spring 1925): 14.

Wheels Are Growing on Rosebushes. ca. 1920–1921. Series 3—Poems. Subseries II—Prose Poems. EvFL Papers, CPL.

Modeling for Painting, Photography, and Film

[Anonymous]. *Djuna Barnes with Baroness Elsa von Freytag-Loringhoven on Beach.* ca. 1926. Djuna Barnes Papers, CPL.

Bernstein, Theresa. *Elsa von Freytag-Loringhoven* [nude standing]. ca. 1916–1917. Oil painting. Collection Gisela Baronin Freytag v. Loringhoven, Tübingen, Germany.

———. *The Baroness* [nude standing]. ca. 1916–1917. Pencil on paper. Collection Francis M. Naumann, New York.

———. *The Baroness* [nude standing]. ca. 1916–1919. Oil on panel, 12 × 9 in. Collection Francis M. Naumann, New York.

————. *The Baroness.* ca. 1917. Oil on canvas, 35 × 27 in. Collection Francis M. Naumann, New York.

Biddle, George. *The Baroness Elsa von Freytag-Loringhoven.* 1921. Lithograph, 14 1/8 × 17 7/16 in. Collection Francis M. Naumann, New York.

International News Photography. *Baroness von Freytag-Loringhoven* [with aviator hat, vertical pose], December 1915. Photograph. Bettman/Corbis Archives, New York.

————. *Baroness von Freytag-Loringhoven* [with aviator hat, horizontal pose]. December 1915. Photograph. Bettman/Corbis Archives. New York.

————. *Baroness von Freytag-Loringhoven* [with crown.] December 1915. Photograph. Bettman/Corbis Archives, New York.

Lechter, Melchior. *Orpheus.* 1896. Oil painting, 80 × 106 cm. Westfälisches Landesmuseum fur Kunst und Kulturgeschichte, Münster.

Man *Ray.* *The Baroness Elsa von Freytag-Loringhoven* [with hat]. ca. 1920–1921. Photograph. EvFL Papers, CPL.

————. *The Baroness Elsa von Freytag-Loringhoven* [with large web hat]. ca. 1920–1921. Photograph. EvFL Papers, CPL.

————. *The Baroness Elsa von Freytag-Loringhoven* [profile with necklaces]. ca. 1920. Photograph. Reproduced with crown and EvFL signature as frontispiece in *LR* 7.3 (September–December 1920): 4.

————. *The Baroness Elsa von Freytag-Loringhoven* [front with hat decorated with feathers]. Photograph. Reproduced in *New York Dada* 1.1. (April 1921). Philadelphia Museum of Art.

————. *The Baroness Elsa von Freytag-Loringhoven* [profile, nude]. Photograph. Reproduced in *New York Dada* 1.1 (April 1921). Philadelphia Museum of Art.

————. *The Baroness Elsa von Freytag-Loringhoven Shaving Her Pubic Hair.* ca. 1921. Film experiment [with Marcel Duchamp]. Still reproduced on Man Ray's letter to Tristan Tzra, 8 June 1921. BLJD, Paris.

————. *Coat-Stand [Portemanteau].* 1920. 41 × 28.6 cm. Centre Georges Pompidou, Paris.

————. *Standing Figure in Female Attire* [Elsa von Freytag-Loringhoven]. 1920. Gelatin silver print, 4 5/8 × 3 7/16 in. The J. Paul Getty Museum, Malibu. Reproduced in Francis M. Naumann, *New York Dada 1915–23* (New York: Abrams, 1994), 169.

[Marc Vaux]. *Death Mask of Elsa Baroness von Freytag-Loringhoven*. Reproduced in *transition* 11 (February 1928): follows 89.

Exhibitions

Making Mischief: Dada Invades New York. Curated by Francis M. Naumann with Beth Venn. Whitney Museum of American Art. New York. 21 November 1996–23 February 1997.

Exhibition, Kestner Society, Hannover, Germany, 1979.

Selected Auto/biographical Writings

Baroness Elsa (BE). Autobiography [based on the Baroness's three-part autobiography manuscript in CPL] and excerpts of selected letters. Ed. Paul I. Hjartarson and Douglas O. Spettigue with an introduction by the editors. Ottawa: Oberon P, 1992.

"[Baroness] Elsa." Typescript of the Baroness's autobiography prepared by Djuna Barnes with running head "Elsa" and pagination. 205 pp. Series 1—Autobiography. Box 1. EvFL Papers, CPL.

"Baroness Elsa." Typescript of the Baroness's letters prepared by Djuna Barnes. 37 pp. Series 1—Autobiography. Box 1. EvFL Papers, CPL.

Letters to Djuna Barnes, 1923–27. Unpublished letters except for excerpts published in *Baroness Elsa,* ed. Hjartarson and Spettigue. Ottawa: Oberon, 1992. Series 2—Correspondence. Box 1. EvFL Papers, CPL.

Letters to Berenice Abbott, George Antheil, Marcus Behmer, George Biddle, [Charles Duncan], Tse [August Endell], Eleanor Fitzgerald, Sarah Freedman, [Stefan George], Mr. Jacobson, *The Little Review,* Charlotte Plötz Kannegieser, Mary Reynolds, Richard Schmitz, Olga Seniowifisch, Pauline Turkel. [William Carlos Williams]. 1922–27. Unpublished letters except for excerpts published in *Baroness Elsa,* ed. Hjartarson and Spettigue. Ottawa: Oberon, 1992. Series 2—Correspondence. Box 1 and 2. EvFL Papers, CPL.

Letters to *The Little Review*. 1921–23. 18 letters to Jane Heap and Margaret Anderson. 1 letter to William Carlos William submitted for publication to *LR*. Poetry submissions. *The Little Review Papers,* GML. Typescript of entire correspondence prepared by Kim Tanner, University of Prince Edward Island (*LRC*), 1996. 130p.

Letters to Pastor Paul Braune. March 1925. Gottesschutz Papers, AHA.

Letter to Peggy Guggenheim. Unpublished, paginated typescript prepared by Peggy Vail [Guggenheim], August 1927. 34 pp. EvFL Papers, CPL.

"My heart is abode of terror and a snake." Excerpt from a letter to Anderson and Heap, 1923–1924. With an introductory note and a photo of the Baroness. *LR* 12 (May 1929): 34–35.

"Selections from the Letters of Elsa Baroness von Freytag-Loringhoven." *transition* 11 (February 1928): 20–30. Edited and foreword by Djuna Barnes, 19.

"Seelisch-Chemische Betrachtung." Unpublished German manuscript. EvFL Papers, CPL.

Published Poetry

The Little Review 5.2 (June 1918): 58–59—"Love-Chemical Relationship."

5.8 (December 1918): 41—"Mefk Maru Mustir Daas."

6.1 (May 1919): 71–73—"Moving-Picture and Prayer," "King Adam."

6.5 (September 1919): 3–11—"Mineself-Minesoul—and—Mine—Cast-Iron Lover."

6.9 (January 1920): 18–21—"Buddha," "Father!"

6.10 (March 1920): 10–11—"Irrender König (an Leopold von Freytag-Loringhoven," "Klink Hratzvenga (Death Wail)/Narin-Tzarissamanili."

7.2 (July–August 1920): 28–30—"Holy Skirts," "Marie Ida Sequence," "Prince Elect."

7.3 (September–December 1920): 47–52—"Appalling Heart," "Blast," "Moonstone," "Heart (Dance of Shiva)," "Cathedral," "It Is?," "Gihirda's Dance," "Das Finstere Meer (an Vater)."

9.2 (Winter 1922): 40–41—"Affectionate," Charles Sheeler's photograph of the Baroness's *Portrait of Marcel Duchamp* assemblage.

11.1 (Spring 1925): 13–14—"Guttriese," "Walküren" [visual poems].

New York Dada 1.1 (April 1921): 4—"Yours with Devotion: Trumpets and Drums." Poem printed upside down and accompanied by two photographs of the Baroness by Man Ray.

The Liberator 5.1 (January 1922)—"Dornr[ö]schen."

5.10 (October 1922): 21, 29—"Loss," "Chill."

Broom [Berlin] 4.2 (January 1923): 128—"Circle."

transatlantic review [Paris] 2.2 (August 1924): 138–40 (New York: Kraus Reprint, 1967)—"Novemberday," "Novembertag," "Enchantment."

transition [Paris] 7 (October 1927): 134–35—"Café du Dome," "X-Ray."

16–17 (June 1929): 24—"Ostentatious: Westward; Eastward; Agog."

Freistatt: Essler, Fanny [pseud. Felix Paul Greve and Else Plötz]. 6.35 (27 August 1904): 700–01—"Gedichte."

6.42 (10 October 1904): 840–41—"Ein Portrait: Drei Sonette."

7.12 (25 March 1905): 185–86—"Gedichte."

Poetry Reprints in Recent Anthologies

Bohn, Willard, ed. *The Dada Market: An Anthology of Poetry.* Carbondale: Southern Illinois UP, 1993. 87–89: "Affectionate," "Holy Skirts."

Divay, Gaby. *Poems by / Gedichte von Felix Paul Greve / Frederick Philip Grove and Fanny Essler.* Winnipeg: Wolf, 1993. 40–47: The Fanny Essler poems: "Gedichte," "Ein Portrait: Drei Sonette," "Gedichte."

Filreis, Alan. English 88 [Web course readings]. University of Pennsylvania. "A Dozen Cocktails—Please."

Kostelanetz, Richard, ed. *Text—Sound Texts.* New York: Morrow, 1980. 226: "Klink Hratzvenga (Death Wail)."

Palmer, Cynthia, and Michael Horowitz, eds., *Shaman Woman, Mainline Lady: Women's Writings on the Drug Experience*. New York: Morrow, 1982. 125: "Appalling Heart," with a brief introduction by the editors.

Rothenberg, Jerome, and George Quasha, eds. *America: A Prophecy—An Anthology*. New York: Random House, 1974. 339–41: "Love-Chemical Relationship," 299–301: "A Modest Woman," 258–59: "Appalling Heart."

Rothenberg, Jerome, and Pierre Joris, eds. *Poems for the Millennium*. Vol. 1: *From Fin-de-Siècle to Negritude*. Berkeley: U of California P, 1995. 325–27: "Affectionate," "Holy Skirts."

Schwarz, Arturo, ed. *Almanacco Dada: Antologia letteraria-artistica, Chronologia, Repertorio delle riviste*. Milano: Feltrinelli, 1976. 110: "Mefk Maru Mustir Daas" (Italian trans. Ida Levi).

Prose Poems, Essays, and Reviews

"The Art of Madness" [debate with Evelyn Scott and Jane Heap]. *The Little Review* 6.9 (January 1920): 25–29.

"The Independents." *The Little Review* 9.2 (Winter 1922): 47.

"The Modest Woman." *The Little Review* 7.2 (July–August 1920): 37–40.

"Thee I Call 'Hamlet of Wedding-Ring': Criticism of William Carlos William's [sic] 'Kora in Hell' and Why . . . " Part 1. *The Little Review* 7.4 (January–March 1921): 48–55, 58–60.

"Thee I Call 'Hamlet of Wedding-Ring': Criticism of William Carlos William's [sic] 'Kora in Hell' and Why . . . " Part 2. *The Little Review* 8.1 (Autumn 1921): 108–111.

Unpublished Poetry

Long Poetry

"Caught in Greenwich Village." Fragment of a poetry play. *The Little Review* Papers, GML.

"Chimera," ca. 1927. Draft manuscript. 5 pp. Series 3—Poems. Subseries II—Prose Poems. Box 3. EvFL Papers, CPL.

"Clock," ca. 1925. Draft manuscript. 42 pp. Series 3—Poems. Subseries II—Prose Poems. Box 3. EvFL Papers, CPL.

"Coachrider," ca. 1924. Draft manuscript. 24 pp. Series 3—Poems. Subseries II—Prose Poems. Box 4. EvFL Papers, CPL.

"Contradictory Speculations," ca. 1927. Typescript. 9 pp. Series 3—Poems. Subseries II—Prose Poems. Box 3. EvFL Papers, CPL.

Poetry

Circa 120 unpublished poems in English (some translations from German poems), including "Tryst," "Thistledownflight," "Palermo," "Solitude," "Kentucky Trail," "Ejaculation," "Equinox," "Desire," "Café du Dome," "Adolescence," "Chill," "Verses from: 'The Inn on the River Lahn,'" "Aphrodite Shants to Mars," "Spring in the Middle," "November Day," "Orgasm," "A Dozen Cocktails Please," "Buddha," "Kindly," "Orgasmic Toast," "Stagnation." Series 3—Poems. Subseries I—English. Boxes 2 and 3. EvFL Papers, CPL.

Circa 26 unpublished poems in English, including "Lullaby," "Fastidious," "Graveyard," "Bereft," "Dreams," "Teke" [sound poem], "Caught in Greenwich Village" [dramatic poem], "Sense into Nonsense: 2. Subjoyride," "Lucifer Approachant," "Knight," "Coronation," "Tailend of Mistake: America," "July" [early version of "Novemberday"], "Subjoyride," "Vision," "Desirous (Love Prayer)" "Eigasing—"[sound poem], "Aphrodite to Mars," "Fantasia," "Perpetuum Moile." *LR Papers,* GML.

Circa 70 unpublished poems in German, including "Adolescence," "Five-o-Clock," "Es hat mal einen Ernst gegeben," "Schalk," "Puckellonders sonderbare Geschicht," "Indianischer Sommer am Ohio," "Camp am Ohio," "Novembertag," "Wetterleuchte," "Lacheule in Kentucky," "Herr Peu à Peu," "Gespenst," "Herbst," "Altar," "Du," "Palermo," "Wolkzug," "Tod eines Schwerenöters—Hamlet in America." Series 3—Poems. Subseries III—Poems, German. Boxes 4 and 5. EvFL Papers, CPL.

Circa 22 unpublished poems in German, including "Analytische Chemie der Frucht," "Lager Feuer am Ohio," "Keener," "Genie," "Indiansommer am Ohio," "Weg in Kentucky," "Sirocco," "Altar," "Krater," "In Mondes Nächten," "Merklich," "L. U. H.," "Frühling," "Blindes Gesicht," "Ver-

rat," "Guttriese" [visual poem], "Sinnlieb," "Schwärmerei," "Juli" [early version of "Novembertag"], "Edeldirn," "Herzliches Zwiegespräch." *LR* Papers, GML.

2. Sources Focusing on Elsa von Freytag-Loringhoven

Anderson, Margaret. *My Thirty Years' War: The Autobiography, Beginnings and Battles to 1930.* 1930. New York: Horizon, 1969.

———. "William Carlos Williams' 'Kora in Hell' by Else von Freytag-Loringheven [sic]." *The Little Review* 7.3 (September–December 1920): 58–59.

Anon. "His Model and His Soul Mate, Too. Artist's Infatuation for Baroness Told by Wife." *New York Evening Sun* (26 January 1917): 16.

Barnes, Djuna. "Baroness Elsa." Biography draft commenced November 12, 1932, Paris. 23 pp.

———. "Baroness Elsa." Typescript. 13 pp. [Typed biography draft manuscript. Written at 3 Waverly Place, New York City.] Series 1—Autobiography. Box 1. EvFL Papers, CPL.

———. "The Beggar's Comedy." ca. 1932–1937. Typescript. ca. 54 pp. [Elsa biography draft in multiple versions with title revisions, "The Living Statues," "Elsa," "Fury." Written at 60 Old Church Street, Chelsea, England.] Series 1—Autobiography. Box 1. EvFL Papers, CPL.

———. "Elsa Baroness von Freytag-Loringhoven" [Obituary]. *transition* 11 (February 1928): 19.

———. "Elsa—Notes." 24 April 1933. Unpublished manuscript. 10 pp. [Notes in preparation for the biography with details of the Baroness's life in Swinemünde, Cincinnati, and New York.] Series 1—Autobiography. Box 1. EvFL Papers, CPL.

———. "Else, Baroness von Freytag-Loringhoven." Typescript with note "Died Dec 14, 1927" following title [biography]. 24 pp. Series 1—Autobiography. Box 1. EvFL Papers, CPL.

———. "How the Villagers Amuse Themselves." *New York Morning Telegraph Sunday Magazine* (26 November 1916). Reprinted in Djuna

Barnes. *New York*. Ed. Alyce Barry. Los Angeles: Sun and Moon P, 1989. 246–52.

———. "Letter to Eleanor Fitzgerald. 10 May 1926. Djuna Barnes Papers, CPL. Excerpt in Hanscombe and Smyer, *Writing for Their Lives,* 99–100.

———. *Nightwood*. 1936. New York: New Directions, 1961.

———. "Notes from Elsa." ca. 1924. Typescript, [written on a sheet of butcher's paper]. 3 pp. [Summary of the Baroness's letters.] Series 1—Autobiography. Box 1. EvFL Papers, CPL.

———. "Preface." December 7, 1924. Typescript. [Preface for the proposed book of the Baroness's poetry.] Series 1—Autobiography. Box 1. EvFL Papers, CPL.

Biddle, George. *An American Artist's Story.* Boston: Little, Brown, 1939.

Blodgett, E. D. "*Alias* Grove: Variations in Disguise." In Blodgett, *Configuration: Essays on the Canadian Literatures.* Downsview: ECW P, 1982. 112–53.

———. "Grove's Female Picaresque." Review of Grove's *Fanny Essler,* trans. Christine Helmers. *Canadian Literature* 106 (Fall 1985): 152–54.

Bodenheim, Maxwell. "The Reader Critic." *The Little Review* 6.7 (November 1919): 64.

———. "The Reader Critic." *The Little Review* 6.11 (April 1920): 61.

Bouché, Louis. "Autobiography." Unpublished manuscript. Louis Bouché Papers, AAA. Smithsonian Institute. Washington, D.C. Microfilm roll no. 688, frame 700.

Bouhours, Jean-Michel, and Patrick de Haas, eds. *Man Ray: Directeur du mauvais movies.* Paris: Éditions du Centre Pompidou, 1997. 7–11.

Brooks, Charles S. "A Visit to a Poet." *Hints to Pilgrims.* New Haven: Yale UP, 1921. 92–102.

Burke, Carolyn. *Becoming Modern: The Life of Mina Loy.* Berkeley: U of California P, 1997.

Butts, Mary. "The Master's Last Dancing: A Wild Party in Paris, Inspired by One of Ford Maddox [sic] Ford's." *The New Yorker* (30 March 1998): 110–13.

Cavell, Richard. "Baroness Elsa and the Aesthetics of Empathy." *Canadian Review of Comparative Literature / Revue canadienne de littérature comparée* (forthcoming).

Churchill, Allen. *The Improper Bohemians: A Recreation of Greenwich Village in Its Heyday.* New York: Dutton, 1959.

Coleman, Emily. Diary 1934. Box 78, Folder 633. Emily Coleman Papers. UDL.

Conover, Roger, ed. *The Lost Lunar Baedeker: Poems of Mina Loy.* New York: Farrar Straus Giroux, 1996.

Crane, Hart. *The Letters of Hart Crane, 1916–1932.* Ed. Brom Weber. New York: Hermitage, 1952.

DeVore, Lynn. "The Backgrounds of *Nightwood:* Robin, Felix, and Nora." *Journal of Modern Literature* 10.1 (March 1983): 71–90.

Divay, Gaby. "Abrechnung und Aufarbeitung im Gedicht: Else von Freytag-Loringhoven über drei Männer (E. Hardt, A. Endell, F. P. Greve / Grove)." *Trans-Lit* 7.1 (1998): 23–37.

———. "Fanny Essler's Poems: Felix Paul Greve's or Else von Freytag-Loringhoven's?" *Arachne: An Interdisciplinary Journal of Language and Literature* 1.2 (1994): 165–97.

Ernst, Jutta, and Klaus Martens, eds. *Felix Paul Greve–André Gide: Korrespondenz und Dokumentation.* St. Ingbert: Röhrig, 1999.

Field, Andrew. *Djuna: The Formidable Miss Barnes.* Austin: U of Texas P, 1985.

Flanner, Janet. "Baroness von Freytag-Loringhoven (1875–1927)." *Paris Was Yesterday, 1925–1939.* Ed. Irving Drutman. New York: Viking P, 1972. 39.

Ford, Ford Madox. *It Was the Nightingale.* Philadelphia: Lippincott, 1933.

Freytag v. Loringhoven, Gisela Baronin. Interview with Berenice Abbott, 28 March 1991, in Monson, Maine, recorded in two unpublished typescripts, "Besuch bei Berenice Abbott" (BAI-a) and "Berenice Abbott und Elsa von Freytag-Loringhoven: Die Fotographin und die vergessene Dichterin" (BAI-b).

Gammel, Irene. "The Baroness Elsa and the Politics of Transgressive Body Talk." *American Modernism Across the Arts*. Ed. Jay Bochner and Justin D. Edwards. New York: Lang, 1999. 73–96.

———. "Breaking the Bonds of Discretion: Baroness Elsa and the Female Sexual Confession." *Tulsa Studies in Women's Literature* 14.1 (Spring 1995): 149–66.

———. "The City's Eye of Power: Panopticism and Specular Prostitution in Dreiser's New York and Grove's Berlin." *Canadian Review of American Studies* 22.2 (Fall 1991): 211–27.

———. "The European Dada Avant-garde in Greenwich Village: Feminist Street Performances." Paper presented at the Fifth Conference of the International Society for the Study of European Ideas (ISSEI). University for Humanist Studies, Utrecht, The Netherlands. 19–24 August 1996.

———. "German Extravagance Confronts American Modernism: The Poetics of Baroness Else." *Pioneering North America: Mediators of European Literature and Culture*. Ed. Klaus Martens. Würzburg: Königshausen & Neumann, 2000. 60–75.

———. "'No Woman Lover': Baroness Elsa's Intimate Biography." *Canadian Review of Comparative Literature* 20.3–4 (September 1993): 451–67.

———. "Parading Sexuality: Modernist Life Writing and Popular Confession." *Confessional Politics: Women's Sexual Self-Representations in Life Writing and Popular Media*. Ed. Irene Gammel. Carbondale: Southern Illinois UP, 1999. 47–61.

———. *Sexualizing Power in Naturalism: Theodore Dreiser and Frederick Philip Grove*. Calgary: U of Calgary P, 1994.

———. "Visualising Diaristic Selves: L. M. Montgomery, Baroness Elsa, and Elvira Bach." *InterFaces: Visualizing and Performing Women's Lives*. Ed. Sidonie Smith and Julia Watson. Ann Arbor: University of Michigan Press, 2002 (in press).

Greve, Felix Paul. *Fanny Essler: Ein Berliner Roman*. Stuttgart: Juncker, 1905. English trans.: Frederick Philip Grove. *Fanny Essler*, 2 vols. Trans. Christine Helmers, A. W. Riley, and Douglas Spettigue. Ottawa: Oberon P, 1984.

———. *Gustave Flaubert: Reiseblätter.* Ed. Felix Paul Greve. Trans. Else Greve. Minden: Bruns, 1906.

———. *Maurermeister Ihles Haus.* Berlin: Schnabel, 1906. English trans.: Frederick Philip Grove. *The Master Mason's House.* Trans. Paul P. Gubbins. Ottawa: Oberon P, 1976.

Grove, Frederick Philip. *Our Daily Bread.* Toronto: Macmillan, 1928.

———. *In Search of Myself.* Toronto: Macmillan, 1946.

———. *Settlers of the Marsh.* 1925. Toronto: McClelland and Stewart, 1984.

Hardt, Ernst. *Der Kampf ums Rosenrote, Ein Schauspiel in vier Akten* (2nd ed.) (The struggle for the rosy red). 1903. Leipzig: Insel, 1911.

Heap, Jane. "Art and the Law." *The Little Review* 7.3 (September–December 1920): 5–7.

———. "The Art of Madness." *The Little Review* 6.8 (December 1919): 48–49.

———. "The Art of Madness." *The Little Review* 6.9 (January 1920): 27–28.

———. "Dada." *The Little Review* 8.2 (Spring 1922): 46.

Hecht, Ben. "The Yellow Goat." *The Little Review* 5.8 (December 1918): 28–40.

Henry, Charles. "What About the Independent Exhibition Now Being Held on the Waldorf Astoria Roof?" *The Little Review* 6.11 (April 1920): 35–38.

Herring, Phillip. *Djuna: The Life and Work of Djuna Barnes.* New York: Penguin, 1995.

Hjartarson, Paul. "Of Greve, Grove, and Other Strangers: The Autobiography of the Baroness Elsa von Freytag-Loringhoven." *A Stranger to My Time: Essays by and About Frederick Philip Grove.* Ed. Paul Hjartarson. Edmonton: NeWest P, 1986. 269–84.

———. "The Self, Its Discourse, and the Other: The Autobiographies of Frederick Philip Grove and the Baroness Elsa von Freytag-Loringhoven."

Reflections: Autobiography and Canadian Literature. Ed. K. P. Stich. Ottawa: University of Ottawa P, 1988. 115–29.

Hoffmann, Marguerite. *Mein Weg mit Melchior Lechter.* Amsterdam: Castrum Peregrini, 1966.

Hughes, Robert. "Camping Under Glass: The Ghost of Florine Stettheimer, Remote and Glittering, Evokes a Period Between the Wars in a New Show at the Whitney." *Time* (18 September 1995).

———. "Days of Antic Weirdness: A Look Back at Dadaism's Brief, Outrageous Assault on the New York Scene." *Time* (27 January 1997).

Hutton Turner, Elizabeth. "Transatlantic." *Perpetual Motif: The Art of Man Ray.* Ed. Merry A. Foresta. New York: Abbeville, 1988. 150.

Januzzi, Marisa. "Dada Through the Looking Glass, Or: Mina Loy's Objective." Sawelson-Gorse, *Women in Dada,* 578–612.

Jones, Amelia. "Eros, That's Life, or the Baroness's Penis." Naumann with Venn, *Making Mischief,* 238–47.

———. "Practicing Space: World War I–Era New York and the Baroness as Spectacular Flâneuse." *Living Display.* Ed. Jim Drobnick and Jennifer Fisher. Chicago: U of Chicago P, 2001.

———. *Sex, War, and Urban Life: New York Dada, 1915–22.* (forthcoming).

———. "Women ' in Dada: Elsa, Rrose, and Charlie." Sawelson-Gorse, *Women in Dada,* 142–72.

Joost, Nicholas. *Ernest Hemingway and the Little Magazines: The Paris Years.* Barre: Barre, 1968.

Josephson, Matthew. *Life Among the Surrealists: A Memoir.* New York: Holt, Rinehart, and Winston, 1962.

Kane, Marie Louise. "Within Bohemia's Border." *Antiques and the Arts Weekly* (4 January 1991): 1, 36–38.

Kimmelman, Michael. "Forever Dada: Much Ado Championing the Absurd." *New York Times,* 22 November 1996, C1, C24.

Kuenzli, Rudolf E. "Baroness Elsa von Freytag-Loringhoven and New York Dada." Sawelson-Gorse, *Women in Dada,* 442–75.

The Little Review. Ed. Margaret Anderson and Jane Heap. Chicago, New York. Vols. 1–12 (1914–29).

Mariani, Paul. *William Carlos Williams: A New World Naked.* New York: McGraw-Hill, 1981.

Martens, Klaus. "Franziska zu Reventlow, Prince Yussuf, and Else Greve: New Roles for Women Writers." *Canadian Review of Comparative Literature / Revue canadienne de littérature comparée* (forthcoming).

———. *F. P. Grove in Europe and Canada: Translated Lives.* Edmonton: U of Alberta P, 2001. Translation of *Felix Paul Greves Karriere: Frederick Philip Grove in Deutschland.* St. Ingbert: Röhrig, 1997.

———, ed. *Literaturvermittler um die Jahrhundertwende: J. C. C. Bruns' Verlag: Seine Autoren und Übersetzer.* St. Ingbert: Röhrig, 1996.

McAlmon, Robert. *"Post-Adolescence: 1920–1921"* In McAlmon, *McAlmon and the Lost Generation: A Self-Portrait.* Ed. Robert E. Knoll. Lincoln: U of Nebraska P, 1962. 105–139.

McKay, Claude. *A Long Way from Home.* 1937. New York: Harcourt Brace, 1970.

Mellow, James R. *A Life Without Consequences: Hemingway.* Boston: Houghton Mifflin, 1992.

Meyer, Jochen, ed. *Briefe an Ernst Hardt: Eine Auswahl aus den Jahren 1898–1947.* Marbach: Deutsches Literaturarchiv, 1975.

Monroe, Harriet. "Our Contemporaries: New International Magazines." *Poetry: A Magazine of Verse* 19.4 (January 1922): 224–27. Reprinted New York: AMS, 1966.

Moore, Alan. "Dada Invades New York at the Whitney Museum." *Artnet* (12 September 1996): www.artnet.com.

Morgan, Margaret A. "A Box, a Pipe, and a Piece of Plumbing." Sawelson-Gorse, *Women in Dada,* 48–78.

Motherwell, Robert, ed. *The Dada Painters and Poets: An Anthology.* New York: Wittenborn, 1967.

Naumann, Francis M. "Baroness Else von Freytag-Loringhoven." *New York Dada 1915–23.* New York: Abrams, 1994. 168–75.

——— with Beth Venn, eds. *Making Mischief: Dada Invades New York*. New York: Whitney Museum of American Art, 1996.

Nelson, Cary. *Repression and Recovery: Modern American Poetry and the Politics of Cultural Memory, 1910–1945*. Madison: U of Wisconsin P, 1989.

O'Neal, Hank. "Djuna Barnes and the Baroness Elsa von Freytag-Loringhoven." Unpublished typescript of Barnes's "Baroness Elsa" biography drafts, 1992. 76 pp.

———. *Life Is Painful, Nasty and Short . . . in My Case It Has Only Been Painful and Nasty: Djuna Barnes, 1978–1981—An Informal Memoir*. New York: Paragon House, 1990.

Pacey, Desmond, ed. *The Letters of Frederick Philip Grove*. Toronto: U of Toronto P, 1976.

Parry, Albert. *Garrets and Pretenders: A History of Bohemianism in America*. New York: Dover, 1935.

Pichon, Brigitte, and Karl Riha, eds. *Dada New York. Von Rongwrong bis Readymade. Texte und Bilder*. Hamburg: Nautilus, 1991.

Poli, Bernard J. *Ford Madox Ford and the "Transatlantic Review."* Syracuse: Syracuse UP, 1967.

Pound, Ezra. "Rock-Drill de Los Cantares: XCV." *The Cantos of Ezra Pound*. New York: New Directions, 1971. 643–47.

———. *Pound / The Little Review: The Letters of Ezra Pound to Margaret Anderson—The Little Review Correspondence*. Ed. Thomas L. Scott, Melvin J. Friedman, with the assistance of Jackson R. Bryer. New York: New Directions, 1988.

———. [Abel Sanders]. "The Poems of Abel Sanders." *The Little Review* 8.1 (Autumn 1921): 111.

Ray, Man. *Self-Portrait*. New York: Bulfinch, 1998.

Reilly, Eliza Jane. "Elsa von Freytag-Loringhoven." *Women's Art Journal* 18.1 (Spring–Summer 1997): 26–33.

Reiss, Robert. "'My Baroness': Elsa von Freytag-Loringhoven." *New York Dada*. Ed. Rudolf E. Kuenzli. New York: Willis Locker & Owens, 1986. 81–101.

————. "Freytag-Loringhoven, Baroness von." *Dictionary of Women Artists: An International Dictionary of Women Artists Born Before 1900*. Ed. Chris Petteys. Boston: Hall, 1985.

Rexroth, Kenneth. *American Poetry in the Twentieth Century* (New York: Herder and Herder, 1973), 77.

Rhoads, William B. "To the Editor." *Chronicle of Higher Education* (27 March 1998): B10.

Ridge, Lola, F. E. R., and Jane Heap. "Concerning Else von Freytag-Loringhoven." *The Little Review* 6.6 (October 1919): 64.

Roché, Henri-Pierre. *Victor, Ein Roman* Foreword by Jean Clair. Munich: Schirmer/Mosel, 1986.

Rodker, John. "'Dada' and Else von Freytag-Loringhoven." *The Little Review* 7.2 (July–August 1920): 33–36.

Rysselberghe, Maria van. *Les cahiers de la petite dame*. 4 vols. Paris: Gallimard, 1973–1977.

Sawelson-Gorse, Naomi, ed. *Women in Dada: Essays on Sex, Gender, and Identity*. Cambridge: MIT Press, 1998.

Schmidt, Wilhelm. "Glühbirne auf dem Hintern: Eine Begegnung mit Dada in New York." *Süddeutsche Zeitung* 151 (3 July 1991): 13.

Schmitz, Oscar A. H. *Dämon Welt*. Munich: Müller, 1926.

————. "Klasin Wieland." *Der gläserne Gott. Novellen*. Stuttgart: Juncker, 1906. 88–160.

————. "Tagebuch." Typescript. Deutsches Literaturarchiv Marbach.

Schröder, Hans Eggert. *Ludwig Klages: Die Geschichte seines Lebens*. Bonn: Bouvier Verlag, 1966.

Schwarz, Arturo. "Else von Freytag-Loringhoven." *L'Altra metà dell-avanguardia 1910–1940: Pittrici e scultrici nei movimenti delle avanguardie storiche*. Lea Vergine. Milan: Mazzotta, 1980. 161–63.

Scott, Evelyn and Jane Heap. "The Art of Madness." *The Little Review* 6.8 (December 1919): 48–49.

Spettigue, Douglas O. "Felix, Elsa, André Gide and Others: Some Unpublished Letters of F. P. Greve." *Canadian Literature* 134 (1992): 9–38.

———. *FPG: The European Years.* Ottawa: Oberon P, 1973.

Spettigue, Wendy J. "Elsa Ploetz: Her Past and Presence in the Fiction of Frederick Philip Grove." Thesis, Queen's University, Kingston, Ontario, 1986.

Tashjian, Dickran. *Skyscraper Primitives: Dada and the American Avant-Garde 1910–1925.* Middletown: Wesleyan UP, 1975.

Unterecker, John. *Voyager: A Life of Hart Crane.* New York: Farrar Straus Giroux, 1969.

Van Haaften, Julia. "Modelling the Artist's Life: Baroness Elsa and Berenice Abbott." In Memoriam FPG: An International Symposium, 30 September–2 October 1998, Winnipeg, Manitoba.

Watson, Steven. *Strange Bedfellows: The First American Avant-Garde.* New York: Abbeville P, 1991.

Wetzsteon, Ross. "The Baroness of Greenwich Village: The Mother of American Dada Sparks a New Show at the Whitney." *Village Voice,* 26 November 1996: 47–49.

Williams, William Carlos. "The Baroness." *The Autobiography of William Carlos Williams.* New York: New Directions, 1967. 163–69.

———. "The Baroness Elsa Freytag von Loringhoven." 11 March, n.y. Typescript. WCW Papers, YCAL, n.p. Published in Williams, "The Baroness Elsa Freytag von Loringhoven." *Twentieth-Century Literature* 35.3 (1989): 279–84.

———. "Comment: Wallace Stevens." *Poetry* 87.4 (1956): 234–39.

———. *I Wanted to Write a Poem: The Autobiography of the Works of a Poet.* Ed. Edith Heal. Boston: Beacon, 1967.

———. *In the American Grain.* New York: New Directions, 1956.

———. "Sample Prose Piece: The Three Letters." *Contact* 4 (Summer 1921): 10–13.

Zabel, Barbara. "The Constructed Self: Gender and Portraiture in Machine-Age America." Sawelson-Gorse, *Women in Dada*, 22–47.

3. Sources Focusing on Gender and Dada

Allen, Carolyn. *Following Djuna: Women and the Erotics of Loss.* Bloomington: Indiana UP, 1996.

Anderson, Margaret. "'Ulysses' in Court." *The Little Review* 7.4 (January–March 1921): 22–25.

Ankum, Katharina von. *Women in the Metropolis: Gender and Modernity in Weimar Culture.* Berkeley: U of California P, 1997.

Arp, Hans. "Dada Was Not a Farce." Motherwell, *Dada Painters and Poets,* 293–95.

Aschheim, Steven. *The Nietzsche Legacy in Germany 1890–1990.* Berkeley: U of California P, 1992.

Avrich, Paul. *The Modern School Movement: Anarchism and Education in the United States.* Princeton: Princeton UP, 1980.

Baggett, Holly. "The Trials of Margaret Anderson and Jane Heap." *A Living of Words: American Women in Print Culture.* Ed. Susan Albertine. Knoxville: U of Tennessee P, 1995. 169–88.

Ball, Hugo. *Flight out of Time: A Dada Diary by Hugo Ball.* Ed. and intro. John Elderfield. Trans. Ann Raimers. Berkeley: U of California P, 1996. Excerpt in Motherwell, *Dada Painters and Poets,* 51–54.

Barker, Pat. *Regeneration.* London: Plume/Penguin, 1993.

Barnes, Djuna. *The Book of Repulsive Women.* New York: Bruno's Chapbooks, 1915.

Bell, Shannon. *Reading, Writing, and Rewriting the Prostitute Body.* Bloomington: Indiana UP, 1994.

Benjamin, Walter. *Illuminationen: Ausgewählte Schriften.* 1977. Frankfurt: Suhrkamp, 1977.

———. *One-Way Street and Other Writings.* Trans. Edmund Jephcott and Kingsley Shorter. London: New Left Books, 1979.

Benstock, Shari. *Women of the Left Bank: Paris, 1900–1940.* Austin: U of Texas P, 1986.

Bergius, Hanne. *Das Lachen Dadas: Die Berliner Dadaisten und ihre Aktionen.* Giessen: Anabas, 1989.

Bloemink, Barbara J. *The Life and Art of Florine Stettheimer.* New Haven: Yale UP, 1995.

Blondel, Nathalie. *Mary Butts: Scenes from the Life.* Kingston: McPherson, 1998.

Bohn, Willard, ed. and trans. *The Dada Market: An Anthology of Poetry.* Carbondale: Southern Illinois UP, 1993.

Boone, Joseph Allen. *Libidinal Currents: Sexuality and the Shaping of Modernism.* Chicago: U of Chicago P, 1998.

Bowen, Stella. *Drawn from Life.* Kent: Mann, 1974.

Buffet-Picabia, Gabrielle. "Some Memories of Pre-Dada: Picabia and Duchamp." Motherwell, *Dada Painters and Poets,* 255–67.

Burke, Carolyn. "Recollecting Dada: Juliette Roche." Sawelson-Gorse, *Women in Dada,* 546–77.

Bürger, Peter. *Theory of the Avant-Garde.* Minneapolis: U of Minnesota P, 1983.

Butler, Judith. *Excitable Speech: A Politics of the Performative.* New York: Routledge, 1997.

———. *Gender Trouble: Feminism and the Subversion of Identity.* New York: Routledge, 1990.

———. "Performative Acts and Gender Constitution: An Essay in Phenomenology and Feminist Theory." Case, *Performing Feminisms,* 270–82.

Calinescu, Matei. *Five Faces of Modernity: Modernism, Avant-Garde, Decadence, Kitsch, Postmodernism.* Durham: Duke UP, 1987.

Callaghan, Morley. *That Summer in Paris: Memories of Tangled Friendships with Hemingway, Fitzgerald, and Some Others.* Toronto: Macmillan, 1963.

Camfield, William A. "Marcel Duchamp's *Fountain:* Its History and Aesthetics in the Context of 1917." Kuenzli and Naumann, *Marcel Duchamp,* 64–94.

Camhi, Leslie. "A Photographer's Surreal Transformations: How Emmanuel Radnitsky Became Man Ray." *New York Forward* (8 January 1999): 11–12.

Carter, Angela. *Nothing Sacred: Selected Writings.* London: Virago, 1982.

————. *The Sadeian Woman: An Exercise in Cultural History.* London: Virago, 1979.

Case, Sue-Ellen, ed. *Performing Feminisms: Feminist Critical Theory and Theatre.* Baltimore: Johns Hopkins UP, 1990.

Cavell, Richard. "Felix Paul Greve, the Eulenburg Scandal, and Frederick Philip Grove." *Essays on Canadian Writing* 62 (Fall 1997): 12–45.

Chadwick, Whitney. *Mirror Images: Women, Surrealism, and Self-Representation.* Cambridge: MIT P, 1998.

————. *Women, Art and Society.* London: Thames & Hudson, 1996.

Chauncey, George. *Gay New York: Gender, Urban Culture, and the Making of the Gay Male World, 1890–1940.* New York: Basic Books, 1994.

Claus, Doris. "Wenn die Freundin ihrer Freundin lila Veilchen schenkt: Zum Selbstverständnis lesbischer Frauen am Anfang des 20. Jahrhunderts." *Lulu, Lilith, Mona Lisa . . . : Frauenbilder der Jahrhundertwende.* Ed. Irmgard Roebling. Pfaffenwiler: Centaurus, 1989. 19–31.

Clearfield, Andrew. "Pound, Paris, and Dada." *Paideuma: A Journal Devoted to Ezra Pound Scholarship* 7.1–2 (Spring-Fall 1978): 113–40.

Crosby, Harry. "The New Word." *transition* 16–17 (June 1929): 30.

Davidson, Phoebe, Jo Eadie, Clare Hemmings, Ann Kaloski, and Merl Storr. *The Bisexual Imaginary: Representation, Identity and Desire.* London: Cassell, 1997.

De Grazia, Edward. *Girls Lean Back Everywhere: The Law of Obscenity and the Assault on Genius.* New York: Vintage, 1992.

D'Harnoncourt, Anne, and Kynaston McShine, eds. *Marcel Duchamp.* New York: Museum of Modern Art, 1973.

Dijkstra, Bram. *The Hieroglyphics of a New Speech: Cubism, Stieglitz, and the Early Poetry of William Carlos Williams.* Princeton: Princeton UP, 1969.

————. *Idols of Perversity: Fantasies of Feminine Evil in Fin-de-Siècle Culture.* New York: Oxford UP, 1986.

Doane, Mary Ann. *Femmes Fatales: Feminism, Film Theory, Psychoanalysis.* New York: Routledge, 1991.

Dolan, Jill. "Gender Impersonation Onstage: Destroying or Maintaining the Mirror of Gender Roles." Senelick, *Gender in Performance,* 3–13.

Duncan, Nancy, ed. *Body Space: Destabilizing Geographies of Gender and Sexuality.* London: Routledge, 1996.

Duve, Thierry de. "Resonances of Duchamp's Visit to Munich." Trans. Dana Polan. Kuenzli and Naumann, *Marcel Duchamp,* 41–63.

Duchamp, Marcel. *Duchamp du Signe, Écrits.* Ed. Michel Sanouillet. Paris: Flammarion, 1994.

————. "Marcel Duchamp's Letters to Walter and Louise Arensberg, 1917–1921." Ed., trans., and notes Francis M. Naumann. Kuenzli and Naumann, *Marcel Duchamp,* 203–27.

Edwards, Hugh. *Surrealism and Its Affinities: The Mary Reynolds Collection—A Bibliography.* Chicago: Art Institute of Chicago, 1973.

Elliot, Bridget, and Jo-Ann Wallace. *Women Artists and Writers: Modernist (Im)positionings.* London: 1994.

Endell, August. *Die Schönheit der grossen Stadt.* Stuttgart: Strecker & Schröder, 1908.

————. *Um die Schönheit: Eine Paraphrase über die Münchner Kunstausstellungen.* Munich: Franke, 1896.

Faber, Richard. *Männerrunde mit Gräfin: Die "Kosmiker" Derleth, George, Klages, Schuler, Wolfskehl und Franziska zu Reventlow, Mit einem Nachdruck des Schwabinger Beobachters.* Frankfurt: Lang, 1994.

Felski, Rita. "The Art of Perversion: Female Sadists and Male Cyborgs." *The Gender of Modernity.* Cambridge: Harvard UP, 1995. 174–206.

Flanner, Janet. "A Life on a Cloud: Margaret Anderson." *Janet Flanner's World: Uncollected Writings 1932–1975.* New York: Harcourt Brace Jovanovich, 1979.

Flynn, Tom. *The Body in Three Dimensions*. New York: Abrams, 1998.

Fontane, Theodor. *Effi Briest*. Stuttgart: Reclam, 1977.

———. *Meine Kinderjahre: Autobiographischer Roman*. 1893. Berlin: Aufbau Verlag, 1997.

Ford, Hugh, ed. *The Left Bank Revisited: Selections from the Paris "Tribune" 1917–1934*. University Park: Pennsylvania State UP, 1972.

Forte, Jeanie. "Women's Performance Art: Feminism and Postmodernism." Case, *Performing Feminisms,* 251–69.

Foster, Stephen C. *Dada Dimensions*. Ann Arbor: UMI Research P, 1985.

Foster, Stephen C., and Rudolf E. Kuenzli, eds. *Dada Spectrum: The Dialectics of Revolt*. Madison: Coda P, 1979.

Foucault, Michel. *The History of Sexuality,* Vol. 1: *An Introduction*. Trans. Robert Hurley. New York: Vintage, 1980.

Franklin, Paul B. "Beatrice Wood, Her Dada . . . and her Mama." Sawelson-Gorse, *Women in Dada,* 104–38.

———. "Object Choice: Marcel Duchamp's *Fountain* and the Art of Queer Art History." *Oxford Art Journal* 23.1 (2000): 23–50.

Freud, Sigmund. *Beyond the Pleasure Principle*. Trans. James Strachey. New York: Norton, 1961.

———. "Screen Memories." 1899. *The Standard Edition of the Complete Psychological Works of Sigmund Freud*. London: Hogarth, 1962. 3: 303–22.

———. "The Uncanny." 1919. *The Standard Edition of the Complete Psychological Works of Sigmund Freud*. London: Hogarth, 1962. 17: 219–52.

Fritzsche, Peter. *Reading Berlin 1900*. Cambridge: Harvard UP, 1998.

Gale, Matthew. *Dada and Surrealism*. London: Phaidon P, 1997.

Garber, Marjorie. *Vested Interests: Cross-Dressing and Cultural Anxiety*. New York: HarperPerennial, 1993.

Glassco, John. *Memoirs of Montparnasse*. Intro. and notes Michael Gnarowski. Toronto: Oxford UP, 1995.

Goffman, Erving. *The Presentation of Self in Everyday Life*. New York: Doubleday, 1959.

Goldberg, Roselee. "Dada Performance: 'The Idea of Art and the Idea of Life.'" *Performance: Live Art 1909 to the Present*. London: Thames and Hudson, 1979. 34–48.

Goldstein, Lynda. "Raging in Tongues: Confession and Performance Art." *Confessional Politics: Women's Sexual Self-Representations in Life Writing and Popular Media*. Ed. Irene Gammel. Carbondale: Southern Illinois UP, 1999. 99–116.

Gordon, Mel, ed. *Dada Performance*. New York: PAJ, 1987.

The Greenwich Village Quill (1917–1929).

Greve, Felix Paul. *Wanderungen*. Berlin: von Holton, 1902.

Grossman, Manuel L. *Dada: Paradox, Mystification, and Ambiguity in European Literature*. New York: Pegasus, 1971.

Guggenheim, Peggy. *Out of this Century: Confessions of an Art Addict*. Garden City: Doubleday, 1980.

Haftmann, Werner. Postscript. Richter, *Dada Art and Anti-Art*. London: Thames and Hudson, 1997. 215–22.

Hanscombe, Gillian, and Virginia L. Smyers. *Writing for Their Lives: The Modernist Women 1910–1940*. London: Women's P, 1987.

Hart, Lynda, and Peggy Phelan, eds. *Acting Out*. Ann Arbor: U of Michigan P, 1993.

Hartley, Marsden. "The Importance of Being 'Dada.'" *Adventures in the Arts: Informal Chapters on Painters, Vaudeville, and Poets*. New York: Boni and Liveright, 1921. 247–53.

Heap, Jane. "Push-Face." *LR* 4.2 (June 1917): 4–7.

———. "War Art." *LR* 4.4 (August 1917): 25.

Heinrichs, Hans-Jürgen, ed. *Materialien zu Bachofen's "Das Mutterrecht."* Frankfurt: Suhrkamp, 1975.

Hemingway, Ernest. *Ernest Hemingway: Selected Letters, 1917–1961*. Ed. Carlos Baker. New York: Scribner's, 1981.

———. "And Out of America" [unsigned editorial]. *transatlantic review* 2.1 (1924), New York: Kraus Reprint, 1967. 103.

———. *A Moveable Feast*. 1964. New York: Touchstone, 1996.

———. *The Sun Also Rises*. 1926. New York: Scribner's, 1954.

Herz, Rudolf and Brigitte Bruns, ed. *Das Hof-Atelier Elvira 1887–1928, Astheten, Emanzen, Aristokraten*. Exhibition Catalogue. Munich: Münchner Stadtmuseum, 1985.

Hesse, Eva. *Die Achse Avantgarde–Faschismus: Reflexionen über Filippo Tommaso Marinetti und Ezra Pound*. Zurich: Arche, n.d.

Hildebrandt, Irma. *Bin halt ein zähes Luder: 15 Münchner Frauenporträts*. Munich: Diederichs, 1993.

Hoffman, Frederick J. *The Twenties: American Writing in the Postwar Decade*. New York: Collier, 1962.

Homer, William Innes. *Alfred Stieglitz and the American Avant-Garde*. Boston: New York Graphic Society, 1977.

———. "Picabia's *Jeune fille américaine dans l'état de nudité* and Her Friends." *Art Bulletin* 58.1 (March 1975): 110–15.

Huch, Roderich. "Die Enormen von Schwabing." *Atlantis* 3 (March 1958): 142–50.

Huelsenbeck, Richard. "En Avant Dada: A History of Dadaism" (En Avant Dada: Eine Geschichte des Dadaismus) (1920). Excerpted in Motherwell, *Dada Painters and Poets,* 23–48.

———. *Memoirs of a Dada Drummer*. Ed. Hans J. Kleinschmidt. Trans. Joachim Neugroschel. Foreword Rudolf Kuenzli. Berkeley: U of California P, 1999.

Hutcheon, Linda. *The Politics of Postmodernism*. London: Routledge, 1989.

Jelavich, Peter. *Munich and Theatrical Modernism: Politics, Playwriting, and Performance, 1890–1914*. Cambridge: Harvard UP, 1985.

Jolas, Eugene. "Logos." *transition* 16–17 (June 1929): 25–30.

Jones, Amelia. *Body Art / Performing the Subject*. Minneapolis: U of Minnesota P, 1998.

———. *Postmodernism and the En-Gendering of Marcel Duchamp.* Cambridge: Cambridge UP, 1994.

Joyce, James. "*Ulysses,* Episode xii." *LR* 6.9 (January 1920): 53–61.

———. "*Ulysses,* Episode xiii" [Nausicaa]." *LR* 7.2 (July–August 1920): 42–58.

Kaltenbrunner, Gerd-Klaus. "Zwischen Rilke und Hitler–Alfred Schuler." *Zeitschrift fuer Religion und Geistesgeschichte* 19.4 (1967): 333–47.

Keller, Marie. "Clara Tice: 'Queen of Greenwich Village.'" Sawelson-Gorse, *Women in Dada,* 414–41.

Kime Scott, Bonnie, ed. *The Gender of Modernism: A Critical Anthology.* Bloomington: Indiana UP, 1990.

Kirstein, Lincoln. *Mosaic, Memoirs.* New York: Farrar, Straus, & Giroux, 1994.

Kleinschmidt, Hans J. "Berlin Dada." Foster and Kuenzli, *Dada Spectrum,* 145–74.

Klüver, Billy and Julie Martin. *Kikis Paris: Künstler und Liebhaber, 1900–1930.* Cologne: DuMont, 1989.

Kluncker, Karlhans. *"Das geheime Deutschland": Über Stefan George und seinen Kreis.* Bonn: Bouvier, 1985.

Koestenbaum, Wayne. *Double Talk: The Erotics of Male Literary Collaboration.* New York: Routledge, 1989.

Korte, Hermann. *Die Dadaisten.* Reinbeck bei Hamburg: Rowohlt, 1994.

Krauss, Rosalind E. *Bachelors.* Cambridge: MIT Press, 1999.

Kuenzli, Rudolf E., ed. *New York Dada.* New York: Willes Locker & Owens, 1986.

———. "The Semiotics of Dada Poetry." Foster and Kuenzli, *Dada Spectrum,* 51–70.

———. and Francis M. Naumann, eds. *Marcel Duchamp: Artist of the Century.* Cambridge: MIT P, 1996.

Lania, Leo [Herrmann Lazar]. *Der Tanz ins Dunkel—Anita Berber: Ein biographischer Roman.* Berlin: Schultz, 1929.

Lavin, Maud. *Cut with the Kitchen Knife: The Weimar Photomontages of Hannah Höch*. New Haven: Yale UP, 1993.

Lefebvre, Henri. *La vie quotidienne dans le monde moderne*. Paris: Gallimard, 1968. *Everyday Life in the Modern World*. Trans. Sacha Rabinovitch. Harmondsworth: Penguin, 1971.

Lehman, Peter. *Running Sacred: Masculinity and the Representation of the Male Body*. Philadelphia: Temple UP, 1993.

Leperlier, François. *Claude Cahun: Masks and Metamorphoses*. Trans. Liz Heron. London: Verso, 1999.

Lichtenstein, Thérèse. "A Mutable Mirror: Claude Cahun." *Artforum* 8 (April 1992): 64–67.

Loeb, Harold, ed. *The Broom Anthology*. Boston: Milford House, 1969.

———. *The Way It Was*. New York: Criterion, 1959.

Loughery, John. *The Other Side of Silence: Men's Lives and Gay Identities—A Twentieth-Century History*. New York: Holt, 1988.

Loy, Mina. *The Lost Lunar Baedeker: Poems of Mina Loy*. Ed. and intro. Roger L. Conover. New York: Farrar Straus Giroux, 1996.

Lucie-Smith, Edward. *Sexuality in Western Art*. 1972. London: Thames and Hudson, 1991.

Ludington, Townsend. *Marsden Hartley: The Biography of an American Artist*. Ithaca: Cornell UP, 1992.

MacGowan, Christopher. *William Carlos Williams's Early Poetry: The Visual Arts Background*. Ann Arbor: UMI Research P, 1984.

Man Ray: La Photographie à l'envers. Exposition du Musée national d'art moderne / Centre de création industrielle présentée au Grand Palais, Paris, 28 April–29 June 1998. Exhibition Catalogue.

Marek, Jayne. *Women Editing Modernism: "Little" Magazines and Literary History*. Lexington: UP of Kentucky, 1995.

Marinetti, Emilio Philippo Tommaso. "Manifesto on the Foundation of Futurism." *Figaro* (1909). In Enrico Prampolini. "The Aesthetic of the Machine and Mechanical Introspection in Art." *The Little Review* (Autumn–Winter 1924–25): 49–51.

Martin, Biddy. *Woman and Modernity: The (Life)Styles of Lou Andreas-Salomé.* Ithaca: Cornell UP, 1991.

McAlmon, Robert. *Being Geniuses Together 1920–1930.* Rev. and with supplementary chapters by Kay Boyle. Garden City: Doubleday, 1968.

MacLeod, Glen. *Wallace Stevens and Company: The Harmonium Years 1913–1923.* Ann Arbor UMI Research, 1983.

Melzer, Annabelle. *Dada and Surrealist Performance.* Baltimore: Johns Hopkins UP, 1994.

Meskimmon, Marsha. *The Art of Reflection: Women Artists' Self-Portraiture in the Twentieth Century.* New York: Columbia UP, 1996.

Metzger, Michael M., and Erika A. Metzger. *Stefan George.* New York: Twayne, 1972.

Miller, Nina. *Making Love Modern: The Intimate Public Worlds of New York's Literary Women.* New York: Oxford UP, 1999.

Naumann, Francis M. "Man Ray and the Ferrer Center: Art and Anarchy in the Pre-Dada Period." *Dada/Surrealism* 14 (1985): 10–30. Reprinted in Kuenzli, *New York Dada,* 10–30.

———. "Marcel Duchamp: A Reconciliation of Opposites." Kuenzli and Naumann, *Marcel Duchamp,* 20–40.

———. *Marcel Duchamp: The Art of Making Art in the Age of Mechanical Reproduction.* New York: Abrams, 1999.

———. "The New York Dada Movement: Better Late Than Never." *Arts* 54.6 (February 1980): 143–49.

———. *New York Dada 1915–23.* New York: Abrams, 1994.

———, ed. *How, When, and Why Modern Art Came to New York: Marius de Zayas.* 1996. Cambridge: MIT Press, 1998.

Nead, Lynda. *The Female Nude: Art, Obscenity, and Sexuality.* London: Routledge, 1992.

The New York Times (1917–21).

Nietzsche, Friedrich. *Ecce Homo: How One Becomes What One Is.* Trans. R. J. Hollingdale. London: Penguin, 1992.

Noyes Platt, Susan. *Modernism in the 1920s: Interpretations of Modern Art in New York from Expressionism to Constructionism.* Ann Arbor: UMI Research P, 1985. 91–109.

O'Neal, Hank. *Bernice Abbott, American Photographer.* New York: McGraw-Hill, 1982.

Paglia, Camille. *Sexual Personae: Art and Decadence from Nefertiti to Emily Dickinson.* New York: Vintage, 1991.

Phelan, Peggy. "Reciting the Citation of Others; or, A Second Introduction." *Acting Out.* Ed. Lynda Hart and Peggy Phelan. Ann Arbor: U of Michigan P, 1993. 13–31.

———. *Unmarked: The Politics of Performance.* London: Routledge, 1993.

Peterson, Carol. *Stefan George.* Berlin: Colloquium, 1980.

Picabia, Francis. *391: Revue publiée de 1917 à 1924.* Ed. Michel Sanouillet. Paris: Terrain Vague, 1975.

Pound, Ezra. "Historical Survey." *The Little Review* (Brancusi number) 8:1 (Autumn 1921): 39–42.

Pound, Ezra. *The Letters of Ezra Pound, 1907–1941.* Ed. D. D. Paige. New York: Harcourt, Brace, 1950.

———. [Emmy V. Sanders]. "Apropos Art and Its Trials Legal and Spiritual." *The Little Review* 7.4 (January–March 1921): 40–43.

———. [Abel Sanders]. "Stop Press." *The Little Review* 8.2 (Spring 1922): 33.

———. *The Selected Letters of Ezra Pound to John Quinn, 1915–1924.* Ed. Timothy Materer. Durham: Duke UP, 1991.

Questions on German History: Ideas, Forces, Decisions from 1800 to the Present. Historical Exhibition in the Berlin Reichstag, Catalogue, 2nd ed. Bonn: German Bundestag Press and Information Centre, 1984.

Rainey, Lawrence. "The Cultural Economy of Modernism." *The Cambridge Companion to Modernism.* Ed. Michael Levenson. Cambridge: Cambridge UP, 1999. 33–69.

Reliquet, Philipe, and Scarlette Reliquet. *Henri-Pierre Roché: L'Enchanteur collectionneur.* Paris: Ramsay, 1999.

Reventlow, Franziska zu. *Von Paul zu Pedro, Herrn Dames Aufzeichungen oder Begebenheiten aus einem merkwürdigen Stadtteil.* Frankfurt: Ullstein, 1987.

—. *Tagebücher 1895–1910.* Ed. Else Reventlow. Hamburg: Luchterhand, 1992.

Reventlow, Franziska zu. "Viragines oder Hetären." 1899. In *Autobiographisches: Novellen, Schriften, Selbstzeugnisse.* Ed. Else Reventlow. Frankfurt: Ullstein, 1986.

Reynolds, Michael. *Hemingway: The Paris Years.* Oxford: Blackwell, 1989.

Rexroth, Kenneth. *An Autobiographical Novel.* New York: Doubleday, 1966.

Richter, Hans. *Dada Art and Anti-Art.* 1967. London: Thames and Hudson, 1997.

Roché, Henri-Pierre. *Carnets 1920–1921. Les années Jules et Jim.* Marseille: André Dimanche, 1990.

Roebling, Irmgard, ed. *Lulu, Lilith, Mona Lisa . . . : Frauenbilder der Jahrhundertwende.* Pfaffenweiler: Centaurus, 1989.

Rubin, William S. *Dada and Surrealist Art.* New York: Abrams, 1968.

Saarinen, Aline B. *The Proud Possessors: The Lives, Times, and Tastes of Some Adventurous Art Collectors.* New York: Random House, 1958.

Sabin, Stefana. *Gertrude Stein.* Reinbek bei Hamburg: Rowohlt, 1996.

Sanger, Margaret. *Pioneering Advocate for Birth Control: An Autobiography.* New York: Cooper Square P, 1999.

Scarpetta, Guy. "Érotique de la performance." *Performance, Text(e)s and Documents.* Ed. Chantal Pontbriand. Montreal: Parachute, 1980. 138–44.

Schafarschik, Walter. *Theodor Fontane: Effi Briest, Erläuterungen und Dokumente.* Stuttgart: Reclam, 1999.

Scheub, Ute. *Verrückt nach Leben: Berliner Szenen in den zwanziger Jahren.* Hamburg: Rowohlt, 2000.

Schlösser, Manfred, ed. *Karl Wolfskehl 1869–1969, Leben und Werk in Dokumenten.* Darmstadt: Agora, 1969.

Scott, Bonnie Kime. *The Gender of Modernism.* Bloomington: Indiana UP, 1990.

Schmitz, Walter. *Die Münchner Moderne: Die literarische Szene in der "Kunststadt" um die Jahrhundertwende.* Stuttgart: Reclam, 1990.

Schuler, Alfred. *Fragmente und Vorträge aus dem Nachlass.* Intro. Ludwig Klages. Leipzig: Barth, 1940.

Schutte, Jürgen, and Peter Sprengel. *Die Berliner Moderne 1885–1914.* Stuttgart: Reclam, 1987.

Schwarz, Arturo. *Almanacco Dada.* Milan: Feltrinelli, 1976.

Schwitters, Kurt. "Anna Blossom Has Wheels." Motherwell, *Dada Painters and Poets,* xxi–xxii.

Scott, William B., and Peter M. Rutkoff. *New York Modern: The Arts and the City.* Baltimore: Johns Hopkins UP, 1999.

Sedgwick, Eve Kosofsky. *Epistemology of the Closet.* Berkeley: U of California P, 1990.

Seehaus, Günter. *Wedekind.* Reinbek bei Hamburg: Rowohlt, 1974.

Senelick, Laurence, ed. *Gender in Performance: The Presentation of Difference in the Performing Arts.* Hanover: UP of New England, 1992.

Shields, Rob. *Lefebvre, Love and Struggle: Spatial Dialectics.* London: Routledge, 1999.

Showalter, Elaine. *Sexual Anarchy: Gender and Culture at the Fin-de-Siècle.* New York: Penguin, 1990.

Sieburth, Richard. "Dada Pound." *South Atlantic Quarterly* 83 (1984): 1–17.

Sochen, June. *The New Woman: Feminism in Greenwich Village, 1910–1920.* New York: Quadrangle Books, 1972.

Stephan, Inge, and Sigrid Weigel. *Weiblichkeit und Avantgarde.* Berlin: Argument, 1987.

Suleiman, Susan Rubin. "A Double Margin: Reflections on Women Writers and the Avant-Garde Circle in France." *Yale French Studies* 75 (1988): 148–72.

———. *Subversive Intent: Gender, Politics, and the Avant-Garde.* Cambridge: Harvard UP, 1990.

Surette, Leon. *A Light from Eleusis: A Study of Ezra Pound's Cantos.* Oxford: Oxford UP, 1979.

Tashjian, Dickran. "From Anarchy to Group Force: The Social Text of *The Little Review.*" Sawelson-Gorse, *Women in Dada,* 262–91.

———. "Authentic Spirit of Change: The Poetry of New York Dada." Naumann with Venn, *Making Mischief,* 266–71.

———. "New York Dada and Primitivism." Foster and Kuenzli, *Dada Spectrum,* 115–44.

Tomkins, Calvin. *Duchamp: A Biography.* New York: Holt, 1996.

Tyler, Parker. *The Divine Comedy of Pavel Tchelitchew: A Biography.* New York: Fleet, 1967.

Tzara, Tristan. *Dada est tatou. Tout est dada.* Notes, bibliography, and chronology by Henri Béhar. Paris: Flammarion, 1996.

———. "Seven Dada Manifestoes." Translated and reprinted in Motherwell, *Dada Painters and Poets,* 75–98.

Vaill, Amanda. *Everybody Was So Young: Gerald and Sara Murphy—A Lost Generation Love Story.* New York: Broadway, 1998.

Vanderham, Paul. *James Joyce and Censorship: The Trials of "Ulysses."* New York: New York UP, 1998.

Webb, Peter. *The Erotic Arts.* New York: Farrar Straus Giroux, 1975.

Weiss, Peg. *Kandinsky in Munich: The Formative Jugendstil Years.* Princeton: Princeton UP, 1979.

———. "Kandinsky, Wolfskehl, und Stefan George." *Castrum Peregrini* 138 (1979): 26–51.

Wharton, Edith. *House of Mirth.* New York: Penguin, 1986.

Wickes, George. *Americans in Paris.* Garden City: Doubleday, 1969.

Williams, William Carlos. "*Kora in Hell.*" In Williams, *Imaginations*. Ed. Webster Schott. New York: New Directions, 1970. 3–82.

———. "Prologue II." *LR* 6.1 (May 1919): 74–80.

Wiser, William. *The Crazy Years: Paris in the Twenties*. New York: Atheneum, 1983.

Wolzogen, Ernst von. *Wie ich mich ums Leben brachte, Erinnerungen und Erfahrungen*. Braunschweig: Westermann, 1922.

Wood, Beatrice. *I Shock Myself: The Autobiography of Beatrice Wood*. Ed. Lindsay Smith. San Francisco: Chronicle, 1988.

Yaeger, Patricia. "Toward a Theory of Play." *Honey-Mad Women: Emancipatory Strategies in Women's Writing*. New York: Columbia UP, 1988. 207–38.

Zurbrugg, Nicholas. "Towards the End of the Line: Dada and the Experimental Poetry Today." Foster and Kuenzli, *Dada Spectrum,* 225–48.

Zwiebel, William. *Theodor Fontane*. New York: Twayne, 1992.

Index